# Heat Wave

## Also by Donald Bogle

*Dorothy Dandridge:*
*A Biography*

*Bright Boulevards, Bold Dreams:*
*The Story of Black Hollywood*

*Primetime Blues:*
*African Americans on Network Television*

*Brown Sugar:*
*Over 100 Years of*
*Black Female Superstars*

*Blacks in American Films and Television:*
*An Illustrated Encyclopedia*

*Toms, Coons, Mulattoes, Mammies, and Bucks:*
*An Interpretive History of Blacks in*
*American Films*

# Heat Wave

The Life and Career of
**Ethel Waters**

# Donald Bogle

HARPER

*An Imprint of* HarperCollins*Publishers*
www.harpercollins.com

HarperCollins books may be purchased for educational, business, or sales promotional use. For information, please write: Special Markets Department, HarperCollins Publishers, 10 East 53rd Street, New York, NY 10022.

FIRST EDITION

*Designed by Suet Yee Chong*

All photographs not otherwise credited are from the author's private collection.

Library of Congress Cataloging-in-Publication Data

Bogle, Donald.
Heat wave : the life and career of Ethel Waters / Donald Bogle.—1st ed.
p. cm.
Includes bibliographical references.
ISBN 978-0-06-124173-4
1. Waters, Ethel, 1896–1977. 2. Singers—United States—Biography. I. Title.
ML420.W24B64 2011
782.42164092—dc22
[B] 2010029230

11 12 13 14 15 OV/RRD 10 9 8 7 6 5 4 3 2 1

*To Catherine Nelson,*
*my beloved Kay*

*And to my parents, Roslyn and John,*
*and my brother John,*
*and my cousin Clisson,*
*now all gone but forever in my heart*

# Contents

# • Part Three •

# Opening Night

**W**ITH ONLY A FEW MINUTES to curtain time, Ethel Waters stood in the wings of Broadway's Empire Theatre, ready to take her place onstage on the evening of January 5, 1950, in the drama *The Member of the Wedding*. Though nervous, she knew she could not let her nerves get the best of her. After all, she had made countless entrances countless nights before in countless theaters and nightclubs around the country. Her long years of experience had taught her how to gauge an audience's mood, how to play on or against an audience's expectations, while always remaining in character. But for a woman who had been in show business for some four decades, first appearing in tiny theaters, sometimes in carnivals and tent shows, often in honky-tonks, and then in the clubs in Harlem and on to Broadway and Hollywood, there was much, almost too much, at stake tonight. This opening night was different from all others.

The past five years had been hell. Engagements had fallen off. Friends had gone by the wayside. Lovers had disappointed her. Worse, she was broke. The Internal Revenue Service was hounding her for back taxes. Lawyers and accountants were scrambling to get her finances in order. And there had been the physical ailments, the shortness of breath, the problems walking and standing, the sharp pains that suddenly pierced her back and abdomen, and the great weight gains. At one point in her career, she had been called Sweet Mama Stringbean. She had been so sleek and slinky that in London the Prince of Wales had made return visits to see

her perform at one of the city's chic supper clubs. But now she weighed close to three hundred pounds.

Then there was show business gossip. Almost ten years had passed since she had appeared in a major Broadway show, and some people wondered if she still had what it took. Word had spread throughout entertainment circles of her explosive outbursts on the movie set of *Cabin in the Sky*, which had led to her being blacklisted from Hollywood for six years. Her temperament—the quarrels, the fights, the foul language—were almost legendary now. If any man or woman ever crossed her or even looked like they might do so, she hadn't hesitated to tell them all to go straight to hell. No bitch or son of a bitch was ever going to tell her what to do. Though she had been able to defy the odds and come back strong in the movie *Pinky* and would even win an Academy Award nomination, it was still a struggle to crawl back to the top. Broadway was the place Ethel Waters respected most. She also wanted to show the young playwright, a mere slip of a girl named Carson McCullers, that her faith in Waters was justified, that indeed the notoriously difficult old star could breathe life into McCullers' character in *The Member of the Wedding*, the one-eyed cook Berenice Sadie Brown.

Her current problems, in some ways, were nothing new. Her life had already been a turbulent, stormy affair, with frightening lows and extraordinary highs. She had grown up in the depths of poverty in Chester, Pennsylvania, and the nearby city of Philadelphia. Almost on a lark, she had started singing, and the effect on audiences had been startling as she worked her way up on the old chitlin' circuit—Black clubs and theaters— around the country where she was first known for her sexy bumps and grinds and her "dirty" songs. Most of her life had been spent on the road. Yet in the early 1920s, she had been one of the first Black performers in Harlem whom whites from downtown rushed to see. Then through the 1920s and into the 1930s, she had made records that shot to the top of the charts, first with Black record buyers and later with white ones. With such songs as "Shake That Thing," "Am I Blue?" and "Stormy Weather," as well as the later show tunes "Heat Wave" and "Taking a Chance on Love," she had changed the sound of popular song, ushering in a modern style of singing—and a modern, independent tough-girl persona.

At a time when African American entertainers, especially women, found doors closed to them and one barrier after another in front of them, she had audaciously transformed herself from a blues goddess into a Depression-era Broadway star in *As Thousands Cheer*, a white show in which she was the only major Black performer. She became known as a woman who could do everything. She could sing, dance, and act with the best of them. Later, on the Great White Way, she had done the impossible: she had a brazen, unexpected triumph as a dramatic star in *Mamba's Daughters*. Never had Black America seen a heroine quite like her: stylish, bold, daring, assured, assertive. Still, throughout, she had been subjected to all types of racial and sexual slights and indignities. Traveling through the South during much of her career, she came face to face with the most blatant forms of racism. The body of a lynched Black boy had once been dumped into the lobby of a theater where she performed. Even in sophisticated New York, one white costar always greeted her by saying, "Hi, Topsy." At another time, her white costars were said to have balked at having to take curtain calls with her. That may have bothered her, but she ended up walking away with the show itself. Sweet revenge, but it had taken a toll on her.

Through the years, there had also been the complicated relationships with her mother and her sister. Then there was a series of bawdy love affairs and steamy liaisons. A steady stream of men had rolled in and out of her life, some boyfriends, some husbands, others lovers who were known as "husbands," men whom she had spent lavishly on, buying them cars, clothes, diamond studs, putting them on her payroll. One had robbed her blind and put her in the headlines. And there had been female lovers, the gorgeous "girlfriends" who sometimes appeared in her shows, sometimes worked as her "secretaries" and assistants, sometimes stayed in her homes.

There had also been the heated feuds, quarrels, and confrontations with such stars as Josephine Baker, Bill "Bojangles" Robinson, Billie Holiday, and Lena Horne as well as with nightclub owners, managers, agents, directors, and producers. Sometimes the battles were professional. Other times, they were personal. She had been cheated out of money, and she felt betrayed and abandoned in the backbiting, backstabbing environment of show business. In time, at the root of many battles was her growing

paranoia and deep suspicion of most of the people around her. Still, some of the most accomplished and famous artistic figures and movers and shakers of the twentieth century had been eager to work with her: Duke Ellington, Irving Berlin, George Balanchine, Harold Arlen, Elia Kazan, Count Basie, Darryl F. Zanuck, Vincente Minnelli, Fletcher Henderson, Andy Razaf, Moss Hart, Sammy Davis Jr., Benny Goodman, Tommy and Jimmy Dorsey, James P. Johnson, Dorothy Fields and Jimmy McHugh, Guthrie McClintic, Harold Clurman, Carson McCullers, Julie Harris, and later Joanne Woodward, Harry Belafonte, and others.

But while many in show business were quick to call her a hot-tempered "bitch on wheels," she was also known as being pious and extremely religious. She kept a cross and a framed religious poem in her dressing room, and before each performance, she bowed her head in prayer. Still, as one performer said, *that* never stopped her from cussing you out.

That night at the Empire Theatre, as the stage manager called, "One minute," Ethel Waters took her place onstage. She carefully adjusted the patch on her eye. She also must have taken one long deep breath, silently prayed, and realized that everything in her life—the troubled early years, the reckless relationships, the unending fears and doubts, the constant stomach problems—had led to this moment.

She was no doubt aware even then that if she triumphed and made it back to the top, her story would still not be over. When she appeared to turn her back on her illustrious career in order to rededicate herself to Christ, there was still more to come. Unknown to her vast public, the old high-living Waters would still kick up her heels and have some discreet fun and an unexpected love affair. But that was looking ahead.

Throughout her life and career, she would remain an enigmatic figure, too complicated for most to fully understand. But as she knew, part of the key to unlocking the mystery might be found in the small city of Chester, Pennsylvania, in that painful childhood, and in the two women there whom she would always love more than any others in her life.

# Part One

# Two Women, Two Cities

I N THE SMALL HOUSE on Franklin Street in Chester, Pennsylvania, Louise Anderson was frightened, nervous, bewildered. She was pregnant and had gone into labor and would soon deliver a child. No doctor was with her. No midwife. Just her Aunt Ida and, at the crucial moment, a woman in the neighborhood to assist with the birth. Louise must have asked herself how this could have happened. She had always been religious, reading her Bible and living very much by the tenets of her faith. She even had dreams of one day becoming an evangelist. Of all her mother's children, Louise had shown the most promise. But now she was in pain and basically alone. She had no husband, no boyfriend. She still knew nothing about sex. There had just been a terrifying encounter with a young man she barely knew. What would she now do with her life? How would she care for this child? Those were questions she must have asked then and in the future. But on that day—October 31, 1896—Louise Anderson, despite her fears, gave birth to a baby girl. Louise herself was only thirteen years old, by some accounts, a few years older, by others. She named the baby Ethel.

Those were the circumstances of Ethel Waters' birth; circumstances that both she and her mother, Louise Anderson, relived in the years that followed. From the very beginning, nothing came easy for Ethel. There were no happy celebrations of her arrival into the world, no bright smiles and hearty laughter, no shouts of congratulations to her mother. Instead she would always bear the stigma of being born "illegitimate." Yet, ironically,

Waters would turn the stigma and shame into a badge of honor. She'd take pride in the fact that she had overcome it and survived.

The way in which she was conceived, however, was, as Ethel Waters herself would tell it, a harrowing experience. One day an eighteen-year-old, John Waters, had come to the home where Louise lived with her mother and siblings. Only Louise and her sister Vi were in the house. For some time, John Waters, who had cast his eye on Louise, had asked her sister if Louise was a virgin, if she had been "broke in" yet. Left alone with her, he grabbed Louise. When she resisted his advances, he threw her down and threatened her at knifepoint. Before the day ended, John Waters had raped her and gone on his way. As overblown as the story may sound, it appears to be true. The domestic situation that Ethel had been born into was hardly a calm one. The same could be said of the racial politics of the nation in which she grew up.

IN THE YEAR OF ETHEL'S BIRTH, America was a sprawling nation with wide-open spaces, connected by its railroads and its newspapers. The major news event of 1896 was that William McKinley, a Republican, defeated Democratic candidate William Jennings Bryan to be elected president of the United States. For the Black population, presidents came and went, but not much changed in their daily struggles in a racially divided nation; struggles to find employment and make a decent living; struggles for achievement and recognition; struggles to combat a political system of vast inequities and injustices. In the 1896 case of *Plessy v. Ferguson*, the United States Supreme Court upheld the doctrine of "separate but equal," which in turn led to the rise of Jim Crow laws in the South. Three years later the National Afro-American Council called on Black Americans to have a day of fasting in protest of lynchings and racial massacres. In 1896, 78 lynchings of Black Americans were reported; in 1897, 123. In 1901, the nation was horrified to learn that President McKinley was assassinated in Buffalo, New York. Afterward, Theodore Roosevelt was sworn into office, and several months later, the South was outraged because the Negro leader Booker T. Washington dined at the White House at the invitation of Roosevelt. The United States was openly seg-

regated in the South; other forms of discrimination and segregation existed in the North.

Yet Chester, the city of Ethel's birth, had been fairly progressive. In the late nineteenth century and the early years of the twentieth, Chester, located along the Delaware River about fifteen miles south of Philadelphia, was a thriving urban area. Its long history stretched back to 1644, when it was a Swedish colonial settlement called Finlandia at one time and Upland at another. In 1682, William Penn had landed in Pennsylvania on the ship *Welcome* and renamed the area Chester, after the city in England. In the mid-1800s, Chester had also been a first stop on the Underground Railroad for runaway slaves from nearby Delaware and the Chesapeake Bay area seeking freedom in the North. In 1857, a bloody battle had taken place between twelve fugitive slaves and ten slave hunters. From Chester, the slaves could be taken to Philadelphia. There, at the city's Arch Street wharf, horse-drawn wagons carried the runaways to parts of New Jersey. Chester's shipyard also supplied ships for the Union during the Civil War.

By 1880, the city was a bustling shipping center. The Sun Shipbuilding and Dry Dock Company provided employment for many residents. Early in the twentieth century, the Scott Paper Company came to town. So did the Ford Motor Company, an oil refinery, and a chemical manufacturing plant. Because of these industries and the consequent economic growth, immigrants from Poland and Ukraine moved to the city in search of work. So did Blacks from the South, hoping not only for economic advantages but also opportunities for an education and a better lifestyle.

Even more migrated to nearby Philadelphia, a far more developed and sophisticated area with a storied history. Philadelphia had been at the geographical center of the original thirteen colonies where many of the ideas and ideals that led to the Revolutionary War had taken shape. It had hosted the first Continental Congress, and during the second Continental Congress, the Declaration of Independence had been signed there. As the nation's first capital, Philadelphia was the city of the Liberty Bell and Ben Franklin.

Before the Civil War, Philadelphia also had the largest population of

free Blacks in the country and was a center of the abolitionist movement. In 1897, the American Negro Historical Society was established in the city to document and preserve the history of the Negro. In time, an established Black middle class emerged in the city with its own set of manners and mores, its own cotillions, its own powerful churches, ambitious professionals, well-designed and well-appointed homes, class distinctions and, yes, its own biases, too.

PHILADELPHIA AND CHESTER may have been beacons of hope for the matriarch of Ethel's family, Sally Anderson. Born Sarah Harris in Maryland around 1852, Sally had been brought to Pennsylvania to work for a white family. She had three sisters and a brother but had little to do with them except for her sister Ida. At age thirteen, she had married Louis Anderson, who was called Honey and whose family lived in the Germantown section of Philadelphia. Sally bore her husband three children, Viola (called Vi), Charles, and Louise, but theirs was a short-lived marriage. Honey Anderson was a heavy drinker, and the two parted. Sally was left to raise the children on her own. Though she could read and write and had, for a colored woman of the time, a semblance of an education, Sally made her living by cooking and cleaning for white families all her life. There was not much else a colored woman could do. Mostly, she worked in Philadelphia where she lived, but she also worked in Chester and spent years commuting between Chester and Philadelphia, as did her children.

When Sally arrived in the city, the colored sections of Philadelphia were about to undergo a population explosion. By 1910, some 84,459 Blacks lived in the city—with more streaming in each month. Within the next ten years, the number would jump to 134,229, the largest increase occurring between 1915 and 1920. Some worked in the shipyard; others did maintenance work on the railroads or took jobs in meatpacking or steel production. Housing was hard to find, particularly adequate housing. Temporary structures shot up. Sometimes newcomers stayed in tents or even boxcars; others lived in tight, congested areas in apartments that faced back alleys. Committees were formed to remedy the housing situation, and attempts were also made to ensure that the new arrivals secured

work. From the start, the influx of new residents was altering the very nature of the city itself, and many of those residents found themselves on a treadmill without the opportunities they had dreamed of.

That was certainly true of Sally Anderson. As a girl, Ethel watched her grandmother travel back and forth in the area to wherever her work took her. The jobs were backbreaking and exhausting. Often Sally was a live-in servant in the homes of her white employers. A small room would be provided for her, but being a live-in meant that she was up at the crack of dawn to prepare breakfast and her workday never really ended. Live-ins were basically on duty or on call twenty-four hours a day. The pay was barely enough to live on. Sally, said Ethel, "never earned more than five or six dollars a week."

For her, the whites who controlled everything and whose racial attitudes were readily apparent would be the "ofays," who could never be trusted. At the same time those Negroes who had been educated and had attained a certain social position and who often had lighter complexions would be the "dictys," who you always had to keep your eye on. Her granddaughter would feel exactly the same way.

Complicated and proud, Sally Anderson envisioned a different way of life for her grown children and stayed on their backs, fussing, berating, and arguing with them to better themselves. "Sally could fight like a sonafabitch," said Ethel. "She had a fiery temper, and there was a terrible pride in her." One time she became so angry with one of her daughters that she actually "bit a whole piece of flesh" out of the girl's arm. Rarely did Sally Anderson feel her battles paid off. Her children would always be a disappointment for her. What sustained Sally was her religious faith. She was drawn to the Roman Catholic Church, though she never formally became a member.

Yet Sally's religious beliefs never conflicted with her feelings about love or sex. Sally Anderson would have several lovers, yet Ethel never believed she was promiscuous. It was just another way of looking at sex. Desires didn't have to be denied. One of Sally's relationships led to the birth of another daughter, Edith, who was called Ching. But the main man in her life for years was a huckster, Pop Sam Perry. Often Sally referred to herself as Mrs. Perry. Young Ethel always thought of herself more as Perry's grand-

daughter than John Waters' child, and thus she was known for years as Ethel Perry.

The one person Sally despised was John Waters, the man who had raped Louise. At first, Sally had thought her daughter had been deceptive and hypocritical, a loose girl who had pretended to be pious but whose morals were no better than those of an alley cat's. But after her daughter Vi explained that it was she who had let Waters enter the house on that fateful day, Sally confronted the Waters family, speaking to John Waters' mother. So light-skinned that she looked white, and indeed was sometimes rumored to have been a white woman who had married a Negro, Lydia Waters was an imperial middle-class matron—a dicty—who clearly looked down on Sally and her brood. Born Lydia Timbers in 1857 in Harpers Ferry, Virginia, one of three children of James and Emily Ann Timbers, she had become the second wife of William Waters in a Methodist marriage ceremony in Philadelphia in 1877. She had not yet turned twenty. From his first marriage, to Mary Williams, William Waters fathered three children. He and Lydia had five.

Upon meeting Sally, a condescending Lydia informed her that her son John admitted to having had sex with Louise but insisted it had been consensual. Sally, however, was now convinced that her daughter had been raped and afterward had nothing more to do with the Waters family, to the point where nothing was ever asked of John Waters for Ethel's care. Waters quickly married and fathered four sons, named Charles, Richard, John, and Carlos. Around the time Ethel was five years old, Waters died. Though she had some curiosity about her father, Ethel never knew him. His rejection of her and his early death, however, deepened Ethel's feelings of abandonment and betrayal.

Not only had John Waters turned his back on the girl, but so had Louise. During these years, her shame was so great that she could not show Ethel any affection. Confused and, as Ethel said, "slow-thinking," Louise seemed to have given up on Ethel and herself. Not long after Ethel's birth, she married a man named Norman Howard and had another daughter, Genevieve Howard. Genevieve represented a kind of redemption for Louise. For Ethel, however, Genevieve, clearly favored by Louise, was another sign of her mother's rejection.

Louise worked as a housekeeper for white families, an attendant in a hospital, and a chambermaid at a hotel. But she suffered emotional and mental problems most of her life. Her marriage to Norman Howard was rocky, with repeated arguments and separations, and accusations that she was not fulfilling her wifely (i.e., sexual) duties. The emotionally fragile Louise retreated more and more into the safety of her religious faith.

As a girl, Ethel yearned for affection but found little. She also grew quickly and was taller than other children her age, which didn't help matters. "Seems like I was born too old and too tall—my mother was so young when she had me, she didn't have much lap to hold me on," Ethel once said. "I was always too big for laps. A child growin' up needs laps to cuddle up in . . . that never happened to me . . . never. It's a real tragic hurt, wantin' to be wanted so bad." She also said: "My close kin didn't even like me. I was a gangly gal and unwanted. When you're my size and you want to jump in somebody's lap, they just look for the strongest chair."

The fact that she had a large gap between her front teeth also made her an outsider. Such a gap was said to be a sign that a person was a liar and couldn't be trusted. She endured countless comments and jokes about the gap.

The family always stayed on the move, it seemed, between various apartments and houses in Chester, Philadelphia, and Camden, New Jersey. Often lonely, Ethel was left on her own and suffered a series of childhood accidents and illnesses. One day as she was wandering through Philadelphia, she was hit by a trolley and taken to a hospital. Ethel later said that the main concern of her Aunt Ching was the amount of money the family could get from the trolley company as compensation. Another time she became ill with double pneumonia and typhoid fever. On another occasion, when she contracted diphtheria, her grandmother was so frightened that the authorities would have the home quarantined that she moved the girl out and took her to Chester. On two other occasions, she suffered burns on her hand and face.

Yet with all her feelings of isolation and alienation, she somehow had the idea that maybe, just maybe, life might hold something quite different for her than for those around her. "I was imaginative," she said. Her

view of the world, her dreams for herself, though still unformed, set her apart from just about everyone around her. Her aunts and other family members fell victim to the disillusionment and despair of their environment. Vi drank heavily and had one man after another in her life. The most easygoing of her aunts, Ching, was also a heavy drinker who had two children and no husband. One—a boy named Tom—died when he was three. Blanche, a sweet-tempered, warmhearted cousin—"I loved her," recalled Ethel—fell into prostitution and drugs, contracted syphilis, and died young. The drinking caused chaos in the house. "They were just girls . . . and they weren't bad. But they were wild," said Ethel. "When they were sober, they were the sweetest people on earth. But when they were high, they took a certain—almost hatred to me." At such times, the women became abusive, shouting, screaming, walking nightmares for Ethel. Even her mother drank on occasion, but never as much as the others: Louise was too immersed in her religion and her sense of a vengeful God. No matter what home or city Ethel lived in, there were rarely peaceful, tranquil times.

But her grandmother Sally was different from everyone else. Though she too found it hard to show her emotions, Sally had other ways of letting the child know she cared. She was the one member of the household who took an interest in Ethel's daily activities. Always concerned about the girl's welfare and fearful of what might happen when she was not able to protect her, Sally would "park" young Ethel in the kitchens of friends in Philadelphia while she went off to do domestic work. At the homes of her white employers, she would sneak leftovers into a pocket in her apron and take them back home to her granddaughter, who would scream in delight at these goodies. A stickler for cleanliness, Sally would bathe the girl and even smell her afterward to make absolutely sure she was clean. She spent time with her as well, and the traits and values she had unsuccessfully tried to instill in her children, she now sought to pass on to her grandchild.

For Ethel, Sally was the mother she longed for. She called Louise "Momweeze," but it was Sally whom she always called Mom. Though Louise left "the bringing up to my grandmother," she seemed resentful of the attention Sally gave the girl. "She would come and get me from Mom and

make me go to Chester to be with her." Somehow, even as a girl, Ethel understood her mother Louise's predicament and her shame, and while Momweeze's neglect tormented her, it never stopped the girl from loving her deeply and rather desperately. There was always a wall between the two. "I always wanted to break down that thing. . . . I felt if I could get to know her and she could get to know me, she'd like me better." These two women, Sally and Louise, so different in the way they treated the young Ethel, would forever haunt her and be the most important people in her life. Throughout the years that followed, she longed to explain the lives and heartaches of these two women who were invisible to most of the world. Ultimately, she would define them most clearly to others and herself with two of her greatest performances, first in *Mamba's Daughters*, then in *The Member of the Wedding*.

LIFE FOR LITTLE ETHEL was a hustle-and-bustle, nomadic existence. At one time, she stayed with her Aunt Ching in Philadelphia; at another, she was with her Aunt Vi in Camden, New Jersey, before she moved back to Morton Street in Chester where Momweeze lived with her husband and Genevieve. Ramshackle shanty homes or apartments were hastily rented and later hastily departed. Sometimes there might be no bathtubs in these places. Often there was no privacy. At night, there were bedbugs and rats and loud noises from outside.

The entire family only lived together one time: for about fifteen months they all occupied a house in a back alley on Clifton Street in Philadelphia. Though communities in Philadelphia were often divided along racial and class lines, the neighborhood on Clifton was racially mixed; whites, Blacks, Chinese, and Jews all lived together harmoniously, according to Ethel. The house was located in Philadelphia's Eighth Ward in a red-light district, and Ethel quickly learned to live by her wits. She became friendly with the whores, the sporting men, the gamblers, and the no-accounts who surrounded her. To earn pennies, she ran errands for the prostitutes or served as a lookout for the pimps. Theirs could be a violent world, yet Ethel came to admire the ladies of the evening, who knew exactly what they were selling; they had no illusions or pretenses

and often enough could be kind and generous, like her doomed cousin Blanche. "I've always had great respect for whores," she said. "Whatever moral qualities I have, come, I'm afraid, from all the sordidness and evil I observed firsthand as a child."

On Clifton Street, she honed her survival skills and grew tough. It was about claiming her turf, protecting herself, and not letting anyone walk over her. Like Sally and Vi, she had a temper; she could curse like a sailor and she could fight. It didn't take much to set her off. She would have that temper for the rest of her life; it was a way of not only defending herself but going on the offensive too. It made those around her terrified of upsetting her. "I didn't fit nowhere," she said, "so I made it up with a certain amount of don't-cares till you would have said I was rough and repulsive."

In an environment where sex in the red-light districts was always available, where attitudes about sex were quite different from those of the ofays and the dictys, her sex education began at the age of three, when she slept "in the same room, often in the same bed, with my aunts and transient 'uncles.' I was fully aware of what was going on." Though she professed to have no interest in sex, there was nothing about it that she didn't know by the age of seven. As a young woman, she also enjoyed going to the drag shows, where female impersonators were dressed in high fashion. Throughout her life, she would always view sex rather casually and without moral judgments. At an early age, no doubt, she was exposed to same-sex relationships as much as heterosexual ones, yet she never considered one type of sexual liaison more moral than another.

THOUGH NO ONE THOUGHT much about it, the family was a musical one. Her aunts Vi and Ching sang around the house, often enough the blues. Ethel's father, John Waters, was a talented pianist, as was his eldest son, Charles Elvi Waters, who died early. Her half-brother Johnny Waters became a highly skilled pianist and later performed with her. Her nephew, Junior Waters, also proved to be a talented musician, and his daughter, Crystal Waters, would become a pop diva in the early 1990s. Without formal training, Ethel learned much by observing her aunts and the people

in her community or in the churches. She picked up on the sounds, the rhythms, the dramatic pauses and punches. "I never had a singing lesson, and I never learned to play anything or read music," Waters said. "I could always sing a song after hearing it played or sung a couple of times. Then I would just sing it the way it made me feel." In one home, there was an old organ, and often Ethel's grandmother would ask her to sing a favorite song, "His Eye Is on the Sparrow," a devotional piece that offered solace and hope for the despairing. Despite the troubles of the world, the disappointments, and frustrations, there was a God who sees everything, is everywhere, and cares about everyone, including the song's otherwise despairing narrator. That song stayed with Ethel all her life. Her musical debut occurred at the age of five when she was billed as the "baby star" and gave her first public performance in church.

But singing wasn't her only musical outlet. "I loved to dance. My specialty was the choreography of the body shakes . . . best shimmier in our neighborhood. . . . And my grandmother fixed it for me to go to a dancing school three times a week. I lived in the red-light section of Philadelphia, and my grandmother fixed it for a policeman to bring me home every night after school. . . . The men around there would go for anything in skirts."

Her education was at best spotty. "I was constantly in and out of schools," she said, "while my darling grandmother worked so hard to provide for her brood." At one time, she attended the Friends School run by Quakers in Philadelphia, and later she was enrolled in the John A. Watts Grammar School and another school in north Chester. Moving about so much, she wouldn't get far in school, but surprisingly, she learned quickly and she learned well. For much of her life, she could do a fast read whether it was a script or the lyrics of a song she was to perform. Her grammar was usually good, though she enjoyed using double negatives, as did many of those around her. She also knew when *not* to use a double negative and when to speak like the dictys. Her diction was perfect, and it would become one of the hallmarks of her singing style. Her writing skills were solid too. She enjoyed writing, and over the years, when she had the time, she sent off missives to friends and secretaries. There might be occasional misspellings or lapses in grammar or punctua-

tion, but for the most part, the letters were well written and clearly expressed her ideas, her anguish, her obsessions, her fears, her frustrations, and her humor.

But the Catholic school for white and colored children in Philadelphia, in which her grandmother enrolled her, opened a door for her religious beliefs. "The only place I found affection was in the Catholic schools," she said. "When I was very little I thought of the pictures of the little Jesus as my doll in my child's mind. The schools made God so simple and so close." "I used to be a holy terror," she said, but the sisters, who showed patience, "were the best psychologists in the world when it comes to handling children's minds and develop[ing] them." She was touched by the kindness of the nuns. At lunchtime, when everyone gathered for a meal, "I didn't have no lunch," she remembered, "and I didn't have no breakfast to begin with." Often, the nuns were "nice enough and considerate enough where my feelings was concerned to find little chores I could do." As "payment," they shared their meals with her. For years, she considered herself a Catholic and donated large sums to a monastery in Allentown, Pennsylvania.

But she attended Protestant churches too. Different denominations appealed to her for different reasons. There was the "inner spiritual sense" of the Methodists, then there was the "free-swinging, uninhibited" preaching style of the Baptists. A turning point came during a children's revival in Chester. A kindly, charismatic Reverend Williams saw young Ethel's inner confusion and—after several days—led her to open her heart to the Lord and be "saved." Most of her life, she loved the heat of fire-and-brimstone ministers, who passionately preached the gospel and admonished their congregations about the sins of the world. No wonder. With her own quick temper, she could unleash her own brand of fire and brimstone. But she was always moved by the power of religious services for the ordinary Black men and women she saw in Chester and Philadelphia. "The beauty that came into the faces of the very old men and women excited me," she said. "All week long so many of them were confused and inarticulate. But on Sunday, in the church, they had no difficulty expressing themselves both in song and talk. The emotion that had invaded them was so much bigger than they." Later she rarely at-

tended any denominational services, preferring to communicate privately with her Lord. "But all my life," she said, "I had one powerful weapon and that was prayer. Only thing that kept me going was prayer."

STILL, SHE LAMENTED that she didn't have much of a stable, loving childhood. "I began to grow up fast and big. Why, when I was fourteen years old, I was as tall and heavy as I am now. Five feet nine and one-half inches and 155 pounds. That's a whole lot of girl for fourteen years, and I didn't see any reason why I couldn't pitch in and help get that rent and eating money for Grandma Sally and me. I hired out for day work, and I really worked. Laundry, cooking, dishes, and taking care of babies. And $1.35 a day they paid me. That money looked good to Sally and me. It helped a lot."

BUT THE REAL LOSS of her childhood occurred when a young man named Merritt Purnsley came into her life. Born in 1890, Buddy, as he was called, was six years older than Ethel, lived with an uncle and his family, and worked for the Pennsylvania Steel Casting Company. Ethel met him at a dance but had no interest in him. Still, before she knew it, Purnsley wanted to marry her. Because Ethel was then thirteen and in the sixth grade, he couldn't marry her unless Momweeze agreed to the match, which she did. "I felt betrayed," said Ethel, "and thought she'd agreed only because marrying me off to Buddy was an easy way of eliminating me as a problem." Momweeze also left Chester to live for a time in Atlantic City.

A local minister performed the ceremony. Their wedding night, said Ethel, was unpleasant, really a disaster from her vantage point. She was repelled by having sex with her new husband. Now there was no turning back. The two set up a home together, and his Aunt Martha, whom Ethel liked, moved in with them. She tried to be the model wife, which meant she was to cook, clean, do the laundry, and basically keep her mouth shut. She also still had to go to school until the term ended in June. But from the beginning, life with Buddy was a mess. He was jealous, possessive,

domineering. One thing Ethel never was able to do, then or later, was take a back seat to anybody. It didn't matter that it was supposed to be a man's world and that a woman, or a wife, should be grateful to be in it. By now, having taken care of herself for so long, she had too strong an independent streak to be a meek and submissive wife.

During this time, she had her greatest heartache. Her grandmother took ill and was living in the home of her sister Ida in Chester. Ethel believed that her beloved Mom was just worn down, exhausted inside and out. At her home with Buddy, Ethel hadn't been close enough to visit, but she knew she had to see her. On the day that she arrived at her Aunt Ida's, she found her grandmother frail and desperately ill. She asked Ethel to sing her favorite song, "His Eye Is on the Sparrow," which the girl performed. As Ethel soon learned, Sally was dying of cancer. A few days later, she heard Sally had taken a turn for the worse. She rushed back to Ida's home to hold her grandmother in her arms, but it was too late. Sally Anderson had died.

At the funeral, the entire family was heartbroken. Curiously, Ching—who Ethel always believed was Sally's favorite child—did not attend. She had been too drunk to show up. But as they moved the casket out of the house into the alley to head for the cemetery, Ching sat in her window looking out and sang a song Sally had always loved: "Flee as a Bird." The next day, Ethel visited Ching. Though not much was said, she understood Ching's remorse and regrets. Several months later, Ching died.

As Ethel resumed her life with the jealous Buddy, she knew nothing would ever be the same. Buddy threatened, cursed, and argued with her, and also struck her. Still, she tried to hold the marriage together, until she discovered that Buddy, who accused her of being unfaithful, was actually involved with another woman. After she left him to stay with Momweeze, he begged her to return. She did, briefly, but finally she walked out the door of their home and their life together. The marriage had lasted a year.

Her school days ended and she was back at work. Cooking. Cleaning. Dusting. Mopping. Washing. Ironing. Fortunately, she never disliked hard work. In fact, she seemed to thrive on it. "I had done practically every type of work there is to do," she remembered. Years later, when a

young college interviewer asked about her education, Waters said she had gone through Swarthmore College, not far from Chester, in two weeks— "on my knees, as a cleaning woman." The hard work just meant she didn't have time to think. That same relentless pursuit of jobs and activities, to ward off too much self-reflection and possibly her despair, continued the rest of her life. Once she began her professional career as an entertainer, her schedule—the tours, the personal appearances, the charity benefits, the social gatherings, even the horseback riding she would come to love as a form of exercise and relaxation—would be altogether astounding. Not a minute of her day would be left unoccupied; there was no time to sit and mope.

Perhaps because she was now free of Buddy, able to support herself and live on her own, she was even more outgoing, more social, eager to play as hard as she worked. Both Philadelphia and Chester were full of clubs, taverns, after-hours joints, and dance halls where the young could gather, let off steam, and have a good time. She also went to see vaudeville shows. At the major theaters in Philadelphia, Blacks were sometimes relegated to the balconies or barred altogether. But a showplace like the Standard Theatre eventually featured great Negro acts. In time, Ethel got to see performers like the Whitman Sisters, the comedy duo Butterbeans and Susie, dancer Alice Ramsey, the ventriloquist Johnny Woods, and the great blues singer Ma Rainey.

She hit the rummage sales and welfare shops, scavenging for colorful clothes that enabled her to dress in a more theatrical way; that set her apart from the other girls in town and, in essence, helped give her a new identity. One of Ethel's great pleasures, her form of relaxation then and in the future, would be hopping off to a dance club like Pop Grey's, where—all dolled up in her rummage-sale clothes—she shook, shimmied, and kicked up her long legs. Local people in those clubs and dance halls got to know who she was. She loved it when they asked if she was in the theater. People remembered her. Even then, she must have had that big personality and that big gap-toothed smile that would later be known to audiences everywhere. The energy, the glamour, the crowds themselves at such places excited her. Though she fantasized about being up there on the stage herself, never did she consciously think about a

career. The most she hoped for in her life was to become the maid to a rich white woman who liked to travel. Maybe that would be a way of seeing the world.

During this time, no special boyfriend came into her life, though many a guy flirted and laughed with her. And although she liked the attention and flirted back with them, she didn't let them get too close. One bellhop at a place where she worked made advances, but she cursed him out and he backed off. She also had friendships with girls her age. Perhaps she felt more comfortable with them—less threatened. Perhaps they answered her need for womanly companionship or approval. It's not known, but Ethel may have had some lesbian relationships, either at this time or earlier, when she hung out with the neighborhood kids and admitted she knew so much about sex.

THEN CAME A JOB at the Harrod Apartments in Philadelphia. Ethel told different stories about the way she got the job. One was that a friend recommended her. The other was that her mother, Louise, was working as a scullion but took ill and Ethel replaced her for a time, then landed a job there as a chambermaid. "I got $3.00 a week steady with tips, and room and board free." She picked up an extra $1.25 by doing laundry at home for guests. "'Well, Ethel,' I said to myself, 'You're on Easy Street now.' Nicest thing about that hotel were the big mirrors in the bedroom doors. I posed and acted in front of them until I found myself thinking I really was an actress. Grand ideas," she recalled. "Lord knows, I had no thought how much trouble and work it takes to be a success on the stage."

During the hot, humid Philadelphia summers, many residents fled to cooler places on the New Jersey shore, which were packed with vacationers who wanted to be near the beach or amusement parks. Atlantic City, Asbury Park, Ocean City, and Wildwood were favorite summertime resort destinations, full of hotels—some upscale, others distinctly low—as well as boardinghouses, amusement arenas, saloons, dance halls, restaurants, and cafés that catered to folks with their families or friends. Each summer a whole new crop of workers also came to town. The pay was all right, but the tips were better. People spent freely. So festive and lively was the at-

mosphere in such resort towns that the workers felt like they were on holiday too. They strolled along the boardwalks, ate hot dogs, played in the arcades. Usually, there was a colored part of town where they could hang out together. With all that in mind, no doubt, Ethel went with friends to Wildwood—considered something of a poor man's Atlantic City—to work as a waitress in one of the big hotels.

"Each Saturday and Sunday evening all of us hotel workers went to a little saloon where there was a piano. I sang and danced for the cooks, busboys, cleaning women, and other waitresses."

When she learned that her father's mother, Lydia Waters, had a home in Wildwood, she was persuaded to visit her, but Ethel could never feel warmly toward her. Still, she believed she had inherited from the white-looking grande dame "poise, dignity, and whatever intelligence I have."

WHEN SHE RETURNED FROM WILDWOOD after the summer of 1917, her life underwent another great change that lifted her out of a seemingly aimless existence, full of fun and dreams, to one that gave her direction, purpose, and goals. It started out as simply a night on the town with friends at a place called Jack's Rathskeller on Juniper and South streets. It was October 31. Halloween. It was also Ethel's birthday.

"They let me go into a little nightclub to do my shake-dance and to sing a couple of songs," she said. It was amateur night. A prize would be given to whichever singer won first place. "They just shoved me out on the stage." On nights like this one, the crowd was accustomed to hearing singers good and bad, and no one would have much time or sympathy for the bad ones. Ethel, however, would always be a confident woman. That didn't mean she had no doubts or fears about herself or an audience, but once the moment came to open her mouth, she was ready to go. "The song I sang I remember was 'When You're a Long, Long Way from Home.' Of course I lived right around the corner from the nightclub . . . but if I told anybody about that, they'd all be chasin' me home."

Her voice was then high and girlish with a bell-like clarity. Every word could be understood. She also obviously enjoyed herself. Her eyes seemed

to be dancing. Her face was lit up with a broad smile. That gap between her front teeth somehow added to her charm and her authenticity. Her sexually charged sound and movements must have also drawn the audience in. When she finished singing, the crowd called out for encores. She won first prize. Her friends were impressed, as were two men in the tavern that night, the theatrical agents known simply as Braxton and Nugent. The pair supplied entertainment for the chitlin' circuit, that network of Black theaters and clubs around the country, theaters like the Lincoln in Baltimore, the Howard in Washington, the Regal in Chicago, but also tiny places in the South and Midwest that no one had ever heard of. Braxton and Nugent looked her over and made their pitch. If she would let them handle her, they would guarantee her work at $10 a week, more than twice the amount she made at the Harrod Apartments. The first stop would be two weeks at Baltimore's Lincoln Theatre. Not that far away. Not much of a loss if things didn't pan out.

Though Ethel wouldn't tell the truth about her age for decades, shaving off four years, saying she was born in 1900, she actually had just turned twenty-one. It was a crucial year. No longer a girl, she considered herself a woman now. If her life was ever to change, if she was ever to pull herself out of the slums of Philadelphia and Chester, if she was ever to make something of herself, as Sally had hoped, then now clearly was the time. Braxton and Nugent insisted she have her mother's permission. Momweeze had no problem granting it; in fact, Ethel believed her mother was glad to get rid of her. Besides, what could really come of this engagement?

But the girl who had never been coddled or wanted or appreciated was about to begin her professional career. Ultimately, it would be the kind of career few in the United States would ever have, and the kind no one in a million years could ever have conceived for Ethel. As she set off for Baltimore, she was leaving her childhood and her past behind her— or so it seemed. In truth, that troubled childhood would always be a part of who she was. Her fears, her moods, her suspiciousness, her hunger for love, her fierce temper, her attitudes about sex and religion, her reactions to men and women—all had taken root in Chester and Philadelphia. Few would get close to her. And almost no one would be able to keep her

content. Many who later met her believed the early wounds never healed. "She had a tough childhood," said actress Maude Russell, "and she went through life fighting that, which was unnecessary. But she did." "She had a very hard time coming up," said Lena Horne, "and that leaves a blot on you. I don't care how strong you appear to be." She never asked anyone for anything, writer Carl Van Vechten later told her, and she never thanked anybody either. Much as Ethel Waters wanted to close the door on the past, even she knew she never really escaped it.

CHAPTER 2

# On the Road

A ND SO JUST LIKE THAT, she left Philadelphia to begin life on the road—the kind of constant traveling that, unknown to her then, would be a part of her life, her very existence, almost to the end of her life.

In 1917, she was also something of a pioneer. When Ethel arrived at the Lincoln in Baltimore, there wasn't a long history of Blacks in a structured entertainment setting, but there was a history nonetheless, which she knew a little about. Black performers had first cracked the world of popular entertainment by way of the minstrel show. Originally, the traveling minstrel companies of the mid-1800s had been all-white, all-male productions. Audiences saw a lineup of singing, dancing, prancing, grinning, grimacing figures with large gaping mouths, thick lips, and dark faces—dark only because of the burnt cork that the white male performers had smeared onto themselves. Thus made up, the performers strutted and strolled across the stage and parodied the language, the music, the humor, the attitudes, and the antics of African Americans. In some respects, not only were they answering a mass audience's need for entertainment; they were also satisfying a certain curiosity that audiences had about race. In the North and the East, the Negro was something of a mysterious other, an incomprehensible figure who was at the center of an ongoing debate about slavery. By portraying these "darky" figures as wildly funny, childlike souls with thick dialects and without much sense, the minstrel shows made the Negro seem safe and relatively

acceptable and alleviated any threat or fear that the colored population might elicit. Comic coons who mangled the English language and didn't seem capable of putting two and two together to come up with four. Docile dimwitted Toms. Some might argue that the routines and jokes and banter offered simple truths that the audience could apply to everyday life. But such insights came only from the Negro who was presented as a dolt or a clown. At the same time, the minstrel shows, while emphasizing Black inferiority, also reassured the white audience of its own superiority.

When Negroes in significant numbers began to appear in professional entertainment, they did so, more often than not, in Black minstrel companies, which had sprung up after the Civil War. Two decades later—in the census of 1890—of the 1,490 Negro performers listed, most were in minstrel companies, which continued into the early years of the twentieth century.

"Minstrel shows were in one big tent," recalled the great drummer Lee Young. Coming from a showbiz family, Lee, along with his future saxophonist brother Lester and his sister Irma, began his career as a kid working on the old Black vaudeville circuit. "They were tent shows," said Young. "There was a large tent, not as big as the Big Top with the circus, but [it] was a big tent." The shows had "maybe ten or twelve acts, and they would put on a two- or three-hour show, with intermission. And they used to sell the programs and they would sell photographs. That's really the thing you do. You sell your act. . . . You wouldn't sell too many when the show would start, but at the end of the show, the acts that they really loved, they really would buy the photographs."

The Black minstrels also put on blackface and performed heavily caricatured songs and comedy. Coming out of the minstrel tradition, Billy Kersands rose to stardom in the 1870s, formed his own company in 1885, and during his forty-year career repeatedly had audiences laughing uproariously over his songs, his dances, and mainly his comedy. He sang songs like "Mary's Gone with a Coon" and "Old Aunt Jemima" and helped popularize such dances as the Essence of Old Virginia and the Buck and Wing. His comic persona was that of a slow-moving, slow-thinking, yet sometimes crafty roustabout. With large, bulging eyes, Kersands made use

of his enormous mouth, into which he could stuff billiard balls or an entire cup and saucer. His career carried him far and wide. He performed in England for Queen Victoria and, still in character, he told her if his mouth were any larger, they'd have to move his ears. Also popular was the team of Bert Williams and George Walker, who billed themselves as the "Two Real Coons" and strutted about in blackface. Despite the coonery, the two were immensely talented, especially Williams, and eventually appeared in their own shows on Broadway. The minstrel companies, along with the medicine shows, the circuses, the carnivals, and the Wild West cavalcades, all led to the rise of vaudeville. Those stereotyped images of Negroes also moved on to vaudeville and later movies. Black audiences might complain, but they also laughed and applauded among themselves in Black theaters and venues, sifting through the minstrelsy to detect covert messages on African life and culture, and on race as well. The Black audiences also always responded to the sheer vitality, the talent, and the timing of the entertainers.

For a time, no significant place existed for Black women in popular entertainment, either as major stars in front of the lights or behind the scenes. Those women who chose careers as entertainers were viewed by the church and society at large as little more than floozies, ladies of easy virtue not much better than streetwalkers who plied their trade in gaudy makeup and tight dresses. Women belonged at home with their husbands and children. But some women broke through the barriers fairly early. By 1851, a poised, dignified operatic singer, Elizabeth Taylor Greenfield, known as the Black Swan, performed concerts in New York and, later, at Buckingham Palace. By 1892, another operatic diva, Sissieretta Jones, sang at the Jubilee Spectacle and Cakewalk in Madison Square Garden. Later she performed at the White House for President Harrison. Then a show was created around her troupe, which was known as the Black Patti Troubadours. Amid the acts that came and went, Madame Jones—Black Patti herself—performed her arias, always maintaining her dignity and composure. In the early twentieth century, Aida (Ada) Overton Walker performed on Broadway with her husband George Walker and his comedy partner Bert Williams in their highly successful shows. For almost two decades, she was considered the greatest Negro female entertainer.

By then, there were Black chorus girls, comediennes, singers, and danc-
ers. Then came Ma Rainey.

Rightly called the "Mother of the Blues," Rainey was the first distinc-
tive female blues singer that anyone knew of. Born Gertrude Pridgett in
1886 in Columbus, Georgia, she made her debut at the age of fourteen,
when she walked onstage and stunned the crowd with her big voice. At
eighteen, she married Will "Pa" Rainey, and she was afterward known
as Ma as the two traveled together mostly through the South and the
Midwest, appearing wherever, whenever they could, not just in clubs and
theaters but in circuses, carnivals, you-name-its—sometimes in open fields
where platforms could be set up. Dark-skinned with broad features and
physically rather squat, she was sometimes called the "ugliest woman in
show business." But no one ever called her that to her face, and they cer-
tainly didn't call her that onstage. Wearing horsehair wigs and dresses
studded with sequins and rhinestones, flashing diamonds around her neck,
her wrists, and dangling from her ears, she represented an emotional, well-
traveled woman who had been everywhere and seen everything and now
was coming back to tell her chillun the ins and outs of survival. Black
audiences never could get enough of her. With her blues songs, she made
a place for herself in popular entertainment. Thereafter, a permanent slot
on a theater's bill had to be reserved for a powerful African American
female star.

Vaudeville was now the way most entertainers, Black and white, made
their living, hopscotching from one town or city or theater to another,
performing on a bill that had many different types of performers. Usually,
in such vaudeville productions, there was a little of everything, a hodge-
podge of entertainment. There would be dancers: Those long-legged cho-
rus girls. Or loose-limbed comedic dancers, twisting and turning their
bodies joyously. Or jaunty cakewalkers or masters of tap. Singers would
also be on the bill. Some might perform the still popular coon songs.
Others might do sentimental love ballads. But by the time Ethel started
working, those singers looked old-fashioned as blues singers came to prom-
inence, performing new-style music that told stories of lives in disarray or
tales of those caught in the grip of a passionate love—music that dramati-
cally documented love and life.

On the vaudeville lineup, there would always be comedians, often teams, who would work the audience up. In a team, there would be the low-key, slow-thinking dupe and the jive-talking, conniving huckster. Sometimes the humor was slapstick. Sometimes it was crude. Other times sexual innuendos could fly all over the place. Dialects were thick and heavy. With the comics, the blackface tradition yet endured. "Your makeup was cork," explained Lee Young, who performed in blackface in his youth. "You know, it was cork, and you used greasepaint, make your lips white, you know, with white greasepaint." No one was quite sure why the blackface tradition wasn't dropped long ago. Some believed it was partly due to the fact that if whites saw the Black companies, they might not realize there were actual colored performers onstage. Regardless, the burnt-cork tradition persisted for too long.

Onstage, individual entertainers might also perform a variety of material. There were also musicians—sometimes just a two-man orchestra or a piano player—to back the singers and help keep the show moving along. Usually, the productions were fast-moving, or at least they tried to be. If the entertainers were not of the top rank—and Ethel felt most the entertainers at the Lincoln in Baltimore clearly were not—then a show could seem mighty slow.

UPON HER ARRIVAL IN BALTIMORE, she was primed for action. In Philadelphia, she had heard a female impersonator sing a new song called "St. Louis Blues," one despairing woman's tale of a man who has left her for "that St. Louis woman, with her diamond rings." Torchy and melodic, "St. Louis Blues" was not the kind of song Waters would become famous for; it wasn't the narrative of a woman calling the shots, setting the agenda for the man in her life. But the song afforded her a chance to create a character in song. Contacting its composer, W. C. Handy, and his business partner, Harry Pace, she was granted permission to sing it, which meant that Ethel would be the first woman to actually perform what would became a very famous song. For a time, she would make "St. Louis Blues" her signature piece.

Her first sight of the Lincoln Theatre was a disappointment, how-

ever. Small and rickety, it wasn't much of a place, certainly not like the large and grand Standard back in Philadelphia. Nor did it have any of the amenities she might have expected. No real dressing rooms, not even any wings to speak of. Everything about it was makeshift. Performers had to dress and change costumes behind partitions. It was a sign of things to come, of other small broken-down theaters she would play. But Ethel was good at adapting, and she was too much the novice to complain.

In Baltimore, she became friendly with another act that Braxton and Nugent handled, the Hill Sisters. Composed of real-life siblings Maggie and Jo Hill, the Hill Sisters were from North Carolina, had been in show business a few years, and believed they were off on an adventure to see the world. Even though Ethel didn't have a professional portfolio, she was already tougher and shrewder, less trusting and gullible, than Maggie and Jo.

AT THE LINCOLN, Braxton and Nugent decided to make her the third Hill Sister. But billing her simply as one of the Hill Sisters didn't say anything about her. Nor was Ethel Waters a name to draw anybody in; nothing enticing or commanding about it. Finally, it was decided to make use of her appearance. She was long, lanky, really skinny, but with curves and good-looking legs. On the Black vaudeville circuit, a husband-and-wife comedy team was called Stringbeans and Sweetie. He wore tight pants that emphasized how skinny and loose-jointed he was. Ethel would become the female version, but she had to have some sexy come-on too. In the end, she was called Sweet Mama Stringbean, a catchy show name that helped give her a stage persona, an evolving identity on the vaudeville circuit.

At the Lincoln, there weren't long rehearsals. Ethel had to work with the musicians—a two-man orchestra—to make sure they played in the right key, that they understood where her dramatic pauses and surges might be. Shrewdly, she never underestimated the importance of musicians. But there wasn't much time for discussion at the Lincoln, and besides, she was still too green to make demands. Ethel was recruited to perform a kiddie dance routine with Maggie and Jo. There was safety in

numbers. If someone messed up or missed a cue, another could cover for the mishap.

But it was a whole other matter when Ethel suddenly had to perform "St. Louis Blues" alone. Before she went on, she prayed; this would be part of a lifelong preperformance ritual. Even at that, Nugent had to grab her arm and literally pull her onstage. The prelude to her solo was a little comedy skit between Nugent and herself, the kind of husband-and-wife squabble that was typical of vaudeville entertainment as a lead-in to a longer comedy sketch or a song. Once Nugent left the stage, she must have seen the audience for the first time. It wasn't that group of neighborhood folks she had performed for at Jack's Rathskeller. Out there was a group of strangers. They had paid their nickels and they wanted a show. For a few seconds, she didn't know how she'd sing. But a few seconds, which must have felt like hours, was all she had. Braxton and Nugent and everyone else was waiting to hear what came out of her mouth. "I was so frightened that I had to sit on a chair to do my song," she said. Somehow she got through it and she wasn't half bad. In fact, she was pretty good because the audience threw money onto the stage. Her initiation into professional showbiz had formally begun.

During and after the two weeks at the Lincoln, she learned that a key to performing was to understand the paying customers, adjusting to their whims, moods, attitudes, or demands. If the weather was bad outside, you might have to work like crazy to warm the crowd up. If they weren't interested in a performer, they'd talk during the show. Or they'd eat. Or they'd make jokes. Or they'd shout at the person onstage. Or they'd boo. The audience demanded the absolute best. With the performer onstage and with the Black patrons in their seats, it was a communal experience. "The audience there was called the hardest to please in the country. But when they liked you, you knew it, and when they didn't you knew it quicker," she recalled. "But they were also the most appreciative audiences in the world if they liked you. They'd scream, stomp, and applaud until the whole building shook. Years later, when I first stepped before a white audience, I thought I was a dead duck because no one tried to tear the house down. They merely clapped their hands. Such restraint is almost a sneer in the colored vaudeville world I came out of."

At the end of the first week, a jubilant Ethel collected her $10 pay. Part of it was immediately sent home to Momweeze. That was how it was to be for the rest of her life. No matter how conflicted she felt about her family and no matter how much or how little she earned, she sent money home and eventually supported them. By the end of the second week, Ethel was gearing for the next stop on the schedule that Braxton and Nugent had set up. But after most of the entertainers had left the theater that night, Ethel overheard a conversation between the two men, who argued about splitting up profits from her salary. The theater was paying Ethel $25 a week, not $10. The two men were dividing the other $15. Waters cursed them out. They could forget about her goddamned future bookings. She was walking out.

When she explained to Maggie and Jo Hill what had happened, they also decided to leave Braxton and Nugent and invited Ethel to join their act, again as a third Hill Sister. The young women had contacts at theaters and set up bookings themselves. They believed they could earn $50 a week, which they would split three ways. Though Ethel had no idea where any of this might lead, she joined them. And now, as she and the Hill Sisters traveled to such "faraway" places as Cincinnati, Lima, Ohio, Chicago, Lexington, Richmond, Charleston, Savannah—even a quick stop at Gibson's North Pole Theatre in Philadelphia—her real indoctrination into show business began. It was her college education, her apprenticeship, her period of learning the ropes—and, ultimately, mastering all the basics for building a career and surviving in a business that could be debilitating and humiliating. Mainly, it was becoming attuned to life on the road.

Right away with this first tour, there were things to learn that quickly became second nature to her. In the beginning, she and the two sisters made their own travel arrangements. The money for the train tickets would be deducted from their pay. Always there would be suitcases and trunks to pack. She had to learn to stock up on cosmetics, toiletries, personal items and to be prepared for weather changes in various cities. Also there had to be things to occupy her during her off time. Perhaps a deck of cards. Or a magazine to read. Or writing paper to send notes or letters to people back home, letters in which she also sent money.

On the road, she had to learn how to use makeup, how to apply it in a dressing area that might not have a mirror, how to pick the costumes—or stitch them together herself—that best caught an audience's eye or further expressed the songs she sang. On the road, she had to learn to quickly check out a theater where she performed. What was the backstage area like? Where would she change clothes? Were there dressing rooms? Or dressing areas?

Then, having grown up in the North, she had to learn the ways of the South: its racial rules and color codes. Baltimore was part of the South even if she hadn't thought of it as such. Still, the city—and the state of Maryland—was not the Deep South. *That* she'd encounter and the Jim Crow laws and the open racism that came with it. Sometimes she traveled by car, but on trains she learned to go to the colored section, where there were often families traveling together, which meant crying children or bickering couples. Food had to be packed for the train rides too: dining cars were off-limits. Once they arrived in a town or city, they headed for the local colored boardinghouses, where there might not be any indoor plumbing or electricity. Once at the boardinghouse, she would have to quickly unpack and head to the theater to do a spot-check. She had to make sure she got paid, and if that meant arguing with the man who ran the theater, she'd have to do that too.

Though in some respects she was shy, especially around people who were more educated and experienced, she had to master a certain showbiz etiquette, learn how to constantly meet new people she might have to work with. Never a trusting or naïve girl, she kept her guard up. With her natural suspiciousness, it didn't take her long to become distrustful of all the men who owned or operated the theaters and clubs.

During this time, she also saw Negro entertainment for what it was, its contours, parameters, borders, and barriers. For a Negro to make it in the big time was not the same as for a white, in terms of the theaters that a Negro played or the money a Negro made or the respect accorded a Negro by the whites around. Major white entertainment circuits like the Keith and the Orpheum booked acts into their vast network of theaters around the country. For most Black entertainers, it wasn't easy to crack the color barrier. With his smooth, polished taps, a dancer like

Bill "Bojangles" Robinson was able to work his way up into white vaude-ville, but he was an exception. Scattered smaller Black circuits existed but were not well organized. Most prominent was the Theatre Own-ers Booking Association, known as TOBA, which booked Black acts into the South and Midwest. Black entertainers said TOBA stood for "Tough on Black Actors" or "Tough on Black Asses." Most theater own-ers on the circuit were white, and the theaters themselves often looked as if they were on their last legs. Some of the owners genuinely appreci-ated the talents of the colored performers they employed. Others simply wanted to make a quick buck. Often enough there were scheduling has-sles. Or there were several shows a night—more than performers might have expected. Then, too, the entertainers knew they better get their paychecks right away. Sometimes they might arrive in a town and find out that, for whatever reason, the show was canceled. But the theaters pulled in Black audiences.

When Ethel started, TOBA was just growing. Within a few years, though, it would prove important for Black stars. "I think it was a god-send, really, for professional Black performers at the time, because that was probably the only chance they had to work, other than working on carnivals and circuses," said Lee Young. "In the South and the Midwest, for a Black performer [there was TOBA]. Ethel Waters came off of it. The Whitman Sisters. Butterbeans and Susie."

Ethel also had to learn how to deal with men because show business was a man's world. They were the producers, directors, writers, agents, managers, theater and club owners. Women like Black Patti and Ada Overton Walker could call some of the shots. The Whitman Sisters, whom Ethel admired, were shrewd enough businesswomen to launch their own company, creating new shows almost every year and deciding what worked and what didn't. The great blues singer Ma Rainey also had clout. And another blues singer, Bessie Smith, still on her rise to stardom, was known not to take much guff from anyone. Still, these women were exceptions to the rule of life in entertainment, and the women who did make it to the top of their profession could find themselves locked in fierce battles with the men, who still controlled the purse strings and the bookings, to express their ideas and mold their destinies.

The producers, the stage managers, and the theater owners were in pursuit of pretty young things on the road. And then there were the stage-door johnnies—the flashy sporting men, the gamblers, the connivers, even the young college boys who were forever hot on the trail of women in show business. The men would buy them drinks, flirt, snuggle up to them, whisper sweet nothings in their ears, basically working overtime to see if they could get from first base to second to third and then make it home. There was never anything very subtle about what the men wanted.

On the road, Ethel was also exposed to the aspect of show business that she declared she detested—the professional rivalries, the backstage feuds, the shouting matches, the malicious whispers, the days when no one wanted to talk to anyone else, the times when actual fights broke out. Every entertainer heard not only his or her applause but also the applause accorded another performer. They all knew they had to claim their turf and then own it. There was only so much room at the top, and if you moved an inch up the ladder, you had to stay ahead of those behind you. Sometimes you had to walk twice as fast just to stay in place. Yet as much as Ethel might be loath to admit it, once she staked her claim, once she had the first glimmer of her power over audiences, she was determined not to let anyone else get anywhere near her territory. She respected talent and wanted to have it around her in her shows—but as support. In the years to come, she became notoriously tough on other entertainers, especially young women.

But at this point in her career, she was still trying to find her bearings. Yet it wasn't long before she, Maggie, and Jo were billed as

## THE HILL SISTERS
### Featuring Sweet Mama Stringbean,
### singing "St. Louis Blues"

Neither Hill sister was happy with the billing or the crowds that called out for Sweet Mama Stringbean—and threw all those coins her way. But otherwise Maggie and Jo loved all the attention and luxuriated in the flattery, especially when it came from the college boys who were studying to be doctors, lawyers, teachers. Of course, Ethel still couldn't abide

the dictys. Nor did she care much for the other men hanging around. She had seen too much on Clifton Street to be taken in. In no uncertain terms, she let them know she neither drank nor smoked. She didn't even like being around people who smoked because she was always concerned about her voice. Though she loudly professed not to be susceptible to any sweet talk, she enjoyed at least some of the come-ons. In Pittsburgh, she dated and actually grew fond of a young man who wanted to be a boxer. The two would spar together, and she enjoyed the sexy physical give-and-take. One day he asked her to marry him, but Ethel wasn't ready for another union. To get him to back off, she told him she had syphilis, which wasn't true. But he still wanted to marry her! He'd wait, he said, until after her treatment for the disease.

But she also found herself around a lot of very attractive young women in the various shows. On the road, some grew lonely. Some might be homesick. Others might have boyfriends back in their hometowns that they planned to one day marry. Some were leery of the men around them. Though it would be difficult to say exactly what transpired between Ethel and some of these young women, she didn't shy away from close friendships. During road tours, same-sex relationships flourished for some women and at times were even commonplace. "Often, we girls would share a room because of the cost," entertainer Maude Russell once told an interviewer. "Well, many of us had been kind of abused by producers, directors, leading men—if they liked girls. In those days, men only wanted what they wanted, they didn't care about pleasing a girl. And girls needed tenderness, so we had girl friendships, the famous lady lovers, but lesbians weren't well accepted in show business."

For Ethel, her same-sex alliances, if they had not started earlier, certainly began during this period. Perhaps she enjoyed the control she could exert with women, control that she felt she had to relinquish with men. One of her partners may even have been Jo Hill, with whom she shared a bed while the two traveled. Both Ethel and Jo had boyfriends. Ethel herself loved to recount the time the two had turned in for the night and were in bed together when they heard strange noises. As it turned out, underneath the bed was a man named Willie who had been in hot pursuit of Ethel and had hidden in her room to find out if she was seeing anyone

else. Waiting outside the room was Jo Hill's boyfriend, who was trying to find out if *she* was seeing someone else. What neither man apparently considered was that the women may have been "seeing" each other. Regardless, Ethel once confided to her friend Joan Croomes that she was a lesbian, and "best that did it." Yet her same-sex relationships were never exclusive. She would always have some man in her life.

WITH THE HILL SISTERS, there were high times and low ones. When theater bookings weren't coming in, they appeared in a carnival. At one point, they slept in a stable, along with the carnival's fat man, Big Jim, and traveled with him in an open freight car. After an engagement in Savannah, Maggie Hill left the trio to marry another entertainer, while Jo and Ethel continued their travels. It had to be hard for Jo Hill because Sweet Mama Stringbean's popularity grew. When they arrived in cities, theater managers and audiences didn't care so much that now there were only two Hill Sisters, just as long as that long, skinny one was still in the act.

A big stop for Ethel and Jo was Atlanta, a bustling city with lots of clubs and many entertainers out to make their mark. The competition was stiff. There were two popular theaters on Decatur Street, only a few doors apart. Originally, Ethel and Jo were booked into 81 Decatur. There, Ethel had her first chance to try her hand at acting in olio shows, which were mini melodramas. The olios were hardly serious theater, but there was something to be gained from them. With dialogue that performers often made up as they went along, the olios provided an opportunity to improvise and learn more about timing and punching up dialogue to create a character or a mood. It also taught performers something about rhythm in a dramatic piece, building to a climax or bringing the action down after a high point. But Ethel's booking at 81 Decatur ended abruptly. As Ethel later told the story, she panicked when she learned that the jealous woman of another performer had decided to go for dramatic realism and planned to stab Ethel onstage. Ethel told her boss she was sick and couldn't go on. He didn't believe her and fired her on the spot. She and Jo ended up performing at 91 Decatur, where Ethel's idol, Bessie Smith, was headlining.

The two biggest female blues singers of the time were Bessie Smith and *her* idol, Ma Rainey. For Ethel, both were queens to be treated with respect. Each had her legion of devotees, dedicated, passionate followers as fascinated by the women offstage as on. For a time, Chattanooga-born Bessie Smith had been a protégée of Rainey's. Born in 1894 and orphaned by the age of ten, she sang and danced on street corners to earn pennies, nickels, and dimes. Soon she entertained in road shows where she was seen by Ma and Pa Rainey, who took a liking to her. Smith and Rainey performed on the same bill with such troupes as the Rabbit Foot Minstrels. At first, Bessie wore street clothes onstage. Later she wore the horsehair wigs, the flashy glamorous gowns, and the jewelry that could be blinding. Early in her career, Bessie also danced as much as she sang. A large woman, heavier than Ethel, and brown-skinned with a big broad glorious smile, she had a powerful voice that earned her the title "Empress of the Blues."

Ma Rainey and Bessie Smith were called moaners and shouters. Each went deep into the lyrics—the emotions—of their music, pulling from their guts their unique sounds, styles, feelings. Sometimes they could be risqué, which audiences loved. They also sent out messages in their music to women. In her song "Sleep Talking Blues," Ma cautioned that if a papa talked in his sleep, he better make sure his mama was not awake. Men got the message of the song as well. Smith and Rainey could play with sexuality and gender roles too. In one song, Rainey sang that she liked to dress up like a man. In another, she sang of a fellow switching gender roles, which in the end caused her to lose her man. "Now all the people wonder / why I'm all alone," she sang. "A sissy shook that thing / and took my man from home." She also could be somber and aching with pain, as in "Leaving Tomorrow," in which she sang of heading out of town, going somewhere else, because things just hadn't worked out right.

Bessie's songs communicated various moods and attitudes too. During her career, which stretched into the 1920s and 1930s, she had a signature hit with her song "Nobody Knows You When You're Down and Out," the story of a once high-living woman now down on her luck without money or friends. In "Taint Nobody's Business If I Do," she announced her independence by singing that if she had the notion to jump in the

ocean, then 'taint nobody's business if she did, and if her man should say he ain't got no money and if she should tell him to take all hers, honey, then 'taint nobody's business if she did. Eventually, audiences would love Bessie's bawdy songs, numbers like "Do Your Duty," "You've Got to Give Me Some," "Need a Little Sugar in My Bowl," "Kitchen Man," and "I'm Wild About That Thing."

Both women had larger-than-life lives, which put them at the center of many outlandish escapades and much gossip and speculation, some of which was based on fact. Bessie was a heavy drinker and a rowdy party gal. Both she and Ma loved having a good time, and this came across in their music. Always there were stories about their sexuality. Ma and Bessie were known to have their husbands *and* their girlfriends. Once when Ma was partying in Chicago with a group of lady friends, their clothes were strewn about and Pa Rainey was nowhere in sight. The police suddenly showed up in the middle of their revelry, and Ma was arrested. There was the tale of the time that Bessie had taken a fancy to a young woman. Once Bessie openly kissed her lady friend, who balked at such a public display of affection. "The hell with you, bitch," Bessie reportedly said. Thereafter she ignored the young woman, who fell into a suicidal depression. She recovered, but thereafter realized that she would be kissed whenever and wherever Bessie pleased. Most significant, though, neither seemed to give a damn what anyone might have to say about their sexuality. There were no public pronouncements, but in show business circles, these were hardly closeted stars. Neither lived by the prevailing sexual attitudes of their day, and nor would Ethel. But as her fame broadened, she understood the importance of a certain public discretion.

Few women commanded as much respect from Ethel as did Ma and Bessie. She understood—and was in awe of—the depth of emotion that went into their music. Aware of their struggles to make names for themselves, she respected their fame, what it meant for a colored woman to rise as high as they did. But Ethel also understood that her approach to music was entirely different. "I was as crazy about her shouting as everyone else," said Waters of Bessie, "even though hers was not my style."

Though Bessie's lyrics could be understood far better than Ma's, still there were times patrons in the theaters—and later record buyers—might

not understand exactly what either woman said in her music. Instead, the mood conveyed by each woman was more important than whatever story there was in the song. That would never be the case with Ethel, even in these early years. Every word, every lyric, was clear and commanding. As a girl, she had not been understood or appreciated in her family, but in her music she seemed to be insistent that listeners hear every word she uttered. She was announcing herself to the world, and words were crucial to her. As Ethel termed it, she was becoming known as a low singer, who gave a sweet, more restrained sound. Though she would always be able to give a blues singer's growl, going down low into her gut, she would never be a moaner or a shouter, and rarely would she have the big sound of her idols.

AT 91 DECATUR STREET, she was nervous for two very good reasons. For one, appearing on the bill was the team Stringbeans and Sweetie. How would Stringbeans respond to her use of his stage moniker? As it turned out, Stringbeans—Butler May—was gracious about the matter, and Waters became friends with the couple. But she was also nervous because of the headliner, Miss Bessie Smith, who was clearing between $50 and $75 a week and raking in large sums of coins thrown onstage. Ethel estimated that Bessie was averaging a couple of hundred dollars a week. This was what the big time looked like. Before Ethel was officially hired at 91 Decatur, she had to be approved by the Empress of the Blues, who might not want a younger blues singer coming onto her turf. Ethel was asked to sing for Bessie, who appeared to like her and may even have had an eye for her: looking her over, Bessie called Ethel "long goody." But whether she liked Ethel or not, Miss Bessie, as Ethel always called her, let it be known in no uncertain terms that Ethel was not to sing blues. Ethel agreed.

But in the first show that evening, when Ethel performed only non-blues songs, the audience shouted out for her to sing the blues. There was such a ruckus that the theater manager rushed backstage to tell Bessie that Sweet Mama had to be permitted to sing the blues. Reluctantly, Bessie said that Ethel could perform "St. Louis Blues," but she also complained about these "northern bitches." Throughout the run of

the engagement, the requests for Ethel to sing the blues kept coming and Ethel always acquiesced. When the show closed, Miss Bessie said, "Come here, long goody. You ain't so bad. It's only that I never dreamed that anyone would be able to do this to me in my territory and with my own people. And you know damn well that you can't sing worth a fuck!" As far as Ethel was concerned, Bessie would always be the Empress, the most royal of blues royalty, yet she understood, at least intuitively, that a shift might be coming in the way the blues were performed. Audience tastes were always changing.

WATERS AND JO HILL went onward with their travels. There was the thrill of meeting more famous stars like Ma Rainey and the Whitman Sisters. Rarely did Waters seem disappointed with the great women of the era or appear to compete with them. It became almost second nature to know what parts of town to stay away from, what stores or restaurants to avoid. On the road, entertainers jokingly said that they sometimes saw signs that read:

Nigger, read and run.
If you don't read, then run anyway.

On the tour, she heard the word "nigger" shouted and witnessed indignities heaped upon Negroes by Southern whites. Once she saw a young boy shot in the stomach by a cop.

A frightening experience occurred in Birmingham. Waters always loved high-style automobiles, partly because they represented a chance for adventure and escape, but also because the design of the cars dazzled her. Sometimes a company automobile carried cast members from one town to another, and when a group of friends from the show badgered her to join them for a ride in a spiffy Buick, she agreed. Three women and three men piled in, along with the driver. But there was an accident when the driver swerved to avoid hitting a horse and buggy, and the car flipped over. Four passengers and the driver were able to get out, but Ethel and another woman were pinned underneath. Scalding water from the automobile's

radiator burned Ethel's stomach and breasts. One man stayed, trying to get help. The others disappeared.

The white passersby did nothing to help, but made loud taunts about ignorant "niggers" and "nigger bitches." They didn't care if she lived or died. Ethel prayed for some kind of relief or rescue. Finally, she and the other young woman were taken to a hospital in Anniston, Alabama. There, a white doctor discovered that Ethel had a torn tendon. A long cut ran from her knee to her hip. But the physician showed little sympathy. Though in excruciating pain, she was made to walk to the Negro quarters. There, she was ignored or left unattended. Her money was stolen. Her bandages were not frequently changed, and no one took her complaints seriously. Perhaps more than anything else that occurred during this period of her life, her treatment by whites and those in the colored wing of the hospital left her resentful and embittered. The treatment fed her suspiciousness of people around her—and also her enduring feelings of being an outsider.

Yet the accident opened her eyes to something else. A white nurse took pity on her and helped at one point. In the colored community, word spread about the accident, that Sweet Mama Stringbean had been seriously injured, that there would be a large medical bill to be paid. Though without much themselves, people took up a collection, donating whatever they could. After she was released from the hospital in Anniston, a crowd showed up when her train arrived back in Birmingham. A sympathetic Negro surgeon also tended to her injury and led her on the long and painful road to recovery. Ethel would never forget this kindness, this other side of human nature, this goodness of the common people, white as well as Black. In the years to come, these two sides would be at war with one another: the resentful, angry Ethel who expected only the worst from everyone and the gracious, warmhearted Waters, appreciative and grateful to those who had helped.

MONTHS OF RECUPERATION FOLLOWED. Twice a day her leg had to be rebandaged. But she had to work, partly to pay off her medical bills. Thinking Ethel would be unable to perform again, Jo Hill had found another partner, but when audiences still wanted to see Sweet Mama

Stringbean, Jo dropped the new partner and entertained again with Ethel at theaters in Birmingham, Anniston, and Ensley, then Petersburg, Virginia. By now, Ethel, feeling homesick, wanted bookings that would carry her back to Philadelphia. She and Jo made their way to Washington, D.C., where they gave a special Sunday performance at the Howard Theatre. Though they weren't headliners and though Ethel was resentful of the Howard's Sunday policy—to admit only light-skinned Negroes—there was the thrill nonetheless of appearing at one of the great Negro theaters. Finally, Ethel arrived in Philadelphia and did so in style, with an engagement at the Standard. She still wasn't the main event on the lineup of entertainers, but her old friends and family were aware that the local girl had done all right for herself.

Once back home, she became aware of events both around the globe and in her own backyard. On April 6, 1917, President Woodrow Wilson informed Congress that "the world must be made safe for democracy," and the United States entered World War I. Young men, Black and white, were called into service. Though there was the new policy of segregation in government agencies, official records revealed that 370,000 Black soldiers and 1,400 commissioned Black officers served during the war, half of them stationed in Europe. At home, long-festering racial tensions reached the boiling point in 1917: in Houston, Black soldiers of the 24th Infantry Regiment clashed with white citizens, with deadly results. Two Blacks and eleven whites were killed. Later, thirteen Black soldiers were hanged for their involvement. In East St. Louis, Illinois, between forty and two hundred people were killed in a race riot. Martial law was finally declared. A congressional committee concluded that at least "thirty-nine Negroes and eight whites were killed outright and hundreds of Negroes were wounded and maimed. 'The bodies of the dead Negroes,' testified an eyewitness, 'were thrown into a morgue like so many dead hogs.'" During the summer of 1918, bloody race riots had also erupted in Chester and Philadelphia, resulting in the deaths of four Blacks and five whites. On the road, all anyone thought about was the next show. With no radio broadcasts and few available newspapers, it was easy to lose sight of the bigger picture, of a world outside one's own. But in the future, Ethel never lost sight of major events at home and abroad.

Ethel moved in with her mother and her aunt Vi, then living on Fawn Street in Philadelphia. Genevieve was around too, along with a family newcomer, her baby daughter whom she named Ethel. Though Ethel would never be fond of her sister, Genevieve may have looked up to her more than Ethel ever realized. She also had seen the money that Ethel sent home, money that had benefited the entire family. The household was as chaotic as ever. The baby, whom Ethel adored, might be crying. Vi might be drunk. Her Uncle Charlie might show up, disoriented and disconnected and asking for money. Charlie's perpetual state of bewilderment led to his being briefly sent to the psychiatric ward of the Philadelphia General Hospital, but soon he was back at Fawn Street. Through all these comings and goings, Momweeze would loudly praise the Lord, at times in such a religious fervor that she ran through the house, demanding that the whole family get on their knees to pray.

Once the Standard engagement ended, surprisingly, Ethel took a job clearing dishes at the Horn and Hardart Automat—for 75 cents a day and one hot meal as well. Perhaps not anxious to return to life on the road, perhaps enjoying some semblance of a home life on Fawn Street, she didn't seem to have thoughts of a career uppermost in her mind. Only after the drummer Toots Moore told her she had to start singing again did she take an engagement—in the beginning as a fill-in—at Barney Gordon's saloon on the corner of Kater and Thirteenth streets. At first, she earned $2 a night. Later she pulled in $20 a week. Again Sweet Mama Stringbean was singing the blues like no one else. Because her leg still bothered her, she couldn't dance much for the patrons, but she shimmied like crazy. Of course, the shimmy, with its fierce shaking of the shoulders and hips, was a powerfully sexy dance. But part of her appeal at Barney Gordon's also must have been her personality. That broad smile was her sign of survival, of being able to enjoy life and invite an audience along for her joyride. By now, too, she was becoming a striking woman, tall, with a deep brown complexion and vibrant eyes.

Ethel soon had boyfriends in pursuit. Twice her age, the gambler West Indian Johnny was protective and big-brotherly and apparently a proficient lover. A seemingly platonic relationship developed with the former lightweight boxing champ Louis Brown. Then there was a serious

relationship with a young man she referred to as Rocky, who possessed the characteristics that Ethel came to prefer in the men in her life. Well built, he was a smooth talker, a good dresser, and always in charge of any given situation. Now and in the future, she was drawn to men with physical strength and power; men she couldn't walk over though she would test them; men with a potent sexuality. Also exciting was Rocky's sense of danger. He was a drug addict, as Ethel said, "a three-letter man." "He took C, H, and M. In dopehead language, C means Cocaine, H Heroin, and M Morphine." On dope, he was a charmer. Off dope, he was mean and aggressive. As she told the story, she learned to inject him with heroin. Whenever he was thrown in jail, she came to his rescue and bailed him out. Theirs was never a stable relationship, rarely a minute of peace and quiet. He cheated on her. He beat and abused her. She broke up with him. She went back to him. One day she flushed a stash of dope down the toilet, and he went after her. He also asked her to marry him, but wisely she never accepted. With Rocky, she walked to the edge but pulled back before falling over. All that turmoil that she had grown up with— the fights, the arguments, the recriminations, the substance abuse, the emotional flux and lack of stability—appeared replicated in her affair with Rocky. Finally, the relationship came to an end when Rocky was drafted into the army. Ethel was free of him.

When there was a drop in business at Barney Gordon's, which she attributed to the war, her nightly appearances were cut back. Nervous, she took part-time work at Horn and Hardart's again. Finally, the war came to an end; the armistice was signed on November 11, 1918.

In 1919, a break came when she was booked to appear at Leroy's Cabaret in New York. That offered her a glimpse into the big time, what life could be like for her if she could take her career to the next level—indeed, if she started to seriously think of having a career. Afterward she joined the cast of a musical called Hello, 1919! that opened at New York's Lafayette Theatre. It was a revue with skits, songs, and dances, typical vaudeville fare, all loosely tied together thematically with the idea that a new year had come and was in need of celebration. In the show, she performed a number in blackface dressed in typical plantation-style gingham, making her look like a young mammy in waiting. The irony, of course, was

that underneath this old-style makeup and imagery was a young woman who would soon usher in a whole new contemporary style for young African American women.

SHORTLY AFTERWARD, she apparently returned to Philadelphia and to the Horn and Hardart Automat. Then an actor-producer friend whom she had met on the road contacted her with an offer for a show he was doing at the Lincoln Theatre in New York. It was only a week's worth of work, but perhaps now she wanted out of Philadelphia, at least for a spell, to make a little money. Though she still was not fully conscious of it, she loved performing. She accepted the offer, but she also asked a friend to hold onto her job at the automat until she got back.

Now, though, she was saying her real good-bye to Philadelphia. Her ties to the city and her family would always be there, but she would never really be able to go home again. She was on the brink of something new in her life. Her period of apprenticeship had ended. The big time might still be a ways off. But it was on the horizon.

# Part Two

CHAPTER 3

# The Big Apple

**E**THEL WATERS ARRIVED IN NEW YORK—that delicious Big Apple, that city of grand dreams and high hopes—full of optimism and burning with ambition. Better than anyone else, she understood what she had going for herself. She knew she could put a song across. Not lost on her was her own sexy appeal. She had also begun to make something of a name for herself on the road in all those rickety theaters and then in Philadelphia. Unlike countless other newcomers to the city, she was not looking for work. She came armed with a booking at the Lincoln Theatre in Harlem.

Yet Waters was also a clear-eyed realist, aware of obstacles and uphill battles. Indeed she seemed to thrive on them. Tall, shapely, and sexy as she was, she was also brown-skinned and proud of it. On the road, her deep brown complexion hadn't mattered to those audiences of farmhands, day laborers, cooks, maids, even the teachers. But things might be different here. She realized that there would be a preference for light-skinned beauties in the chorus lines in the nightclubs and the Black musicals that would soon become so popular in the Apple. She also still felt hampered by her background. New York, more than anyplace else, had its dictys, those upper-class, educated Negroes who might look down on her as a rough, untutored girl from the wrong side of the tracks.

Yet overriding all of that was something else. Waters, then twenty-four years old, though she would say she was four years younger, had a hard-edged, fierce kind of drive, which, along with her talent, would be the key

to her survival. Maybe she wasn't sure if a career in showbiz was for her, but maybe such a career might work out after all. Onstage, she could be hot but also exude a sexy cool and a sense of control. Offstage, rarely was she a relaxed woman. Her mind was always racing, always sizing up a person or a situation. Except when onstage, her emotions were never settled, her mood never calm. Those who soon worked with her would usually describe her as high-strung or quick-tempered or just impossible. Though Ethel Waters always thought of herself as an outsider, a loner, who somehow managed to maneuver her way around the odds to attain success, in truth, she would never waste time maneuvering. Instead she was always fighting to beat the odds head-on.

And so work began at the Lincoln. In business since 1909, the Lincoln on West 135th was Harlem's first theater and eventually boasted of a 1,000-seat auditorium, a $10,000 Wurlitzer organ, and, for a time, its own stock company. Between the live performances at the Lincoln, silent films were shown. Ethel had already performed at the Lincoln's rival, the Lafayette Theatre, which had opened in 1912, with a 1,200-seat auditorium. It too had its own stock company—a prestigious one at that—and took pride in its serious dramatic presentations, which sometimes were melodramatic but crowd-pleasing versions of downtown successes that had "a great appeal to Harlem audiences," said James Weldon Johnson. "To most of the people that crowded the Lafayette and the Lincoln the thrill received from these pieces was an entirely new experience; and it was all the closer and more moving because it was expressed in terms of their own race." Both the Lincoln and the Lafayette also provided audiences with wildly innovative vaudeville shows and jazz programs, with musical and comedic entertainment that could be raucous and racy, steamy and sexy, with singers, dancers, and comics who knew how to put on one heck of a show.

Waters sailed through her engagement at the Lincoln Theatre. It couldn't have been much different from what she did in Philadelphia. The audiences loved her, and she was held over for a second week. More than anything else that holdover indicated that she had a chance to make it in New York. She had become friendly with the dancer Alice Ramsey, who suggested that Ethel stay in the city. All the action was here, and so were the contacts and opportunities for advancement.

In this period following World War I, New York City was coming alive, humming, swaying, and then jumping to the beat of its sexy nightclubs, its packed theaters, and its one-of-a-kind entertainers, all of which were altering long-held attitudes and perceptions about women, about race, about entertainment itself. After the horrors of the Great War, residents in the big cities, be it Chicago, Los Angeles, Philadelphia, or primarily New York, grew eager and restless to break free of past restrictions, past inhibitions, past hang-ups. Often underlying the new heightened energy was a basic apprehension that no one knew what to expect tomorrow, so it was best simply to enjoy today and seek excitement and satisfaction whenever, wherever possible. The enforcement of Prohibition, the Eighteenth Amendment in 1920, which prohibited the manufacture and sale of alcoholic beverages in the United States, added to an atmosphere of fun, frivolity, and open rebellion, the idea of not living by anyone else's trumped-up rules. Whether they were denizens of the Jazz Age or the Lost Generation, many in and out of the big cities just ignored Prohibition and drank bootleg liquor or bathtub gin whenever the authorities were not hovering over their shoulders. Nightclubs, speakeasies, after-hours joints, and private clubs became places where a new generation sought not only the booze and the furiously fast new dances like the Charleston and the black bottom, or the sexually charged atmosphere, but also the delirious pleasure of indulging in the latest fad or trend. Soon the flapper, with her bobbed hair and flat chest, and the would-be playboy were fixtures on the social scene. So, too, were the sporting men—the gamblers, the hustlers, the guys always on the make with their big wallets, their slicked-back hair, and their smooth-talking ways around the ladies—who frequented the colored clubs.

The Roaring Twenties were about to begin. Al Jolson, Helen Morgan, Sophie Tucker, Fannie Brice (sometimes spelled Fanny), and later Rudy Vallee were some of the music stars of the era. Of such singers, Ethel liked Jolson, who she felt could put over a song, work it to death without ever killing it, and almost always keep his smile intact as he did it. At this stage in the game, his use of blackface didn't seem to bother her. It was just part of an accepted leftover from minstrelsy. Greatest among the Black stars was Bert Williams who, following the death of his partner

George Walker, eventually crossed the color barrier and became the sole Black star in the white *Ziegfeld Follies*. There was also Bill "Bojangles" Robinson. Born in 1878 in Richmond, Virginia, the grandson of a former slave, Robinson, orphaned at an early age and reared by his grandmother, had run away from home, had teamed with a partner in an act called Butler and Robinson, and then went solo. Credited with having created the staircase dance and having coined the word "copacetic" (meaning everything's just fine), Robinson would continue his upward swing when he appeared in such Broadway shows as *Blackbirds of 1928*, *Brown Buddies*, and *Hot Mikado* and then in Hollywood films with Shirley Temple. Offstage, he was known as a gambler and a mean-spirited brawler, an all-around tough customer.

Waters was fascinated by the heady atmosphere of New York, its skyscrapers, its theaters, its fashions, its busy, crowded streets, its fast cars and fast people, its luxurious style of living, and its vibrant Negro community. Downtown, however, left her cold. Unlike the South, there were no signs that read FOR WHITES or FOR COLORED, but color barriers existed nonetheless, just as they had in Philadelphia. She did not care to go into a restaurant or department store where she would be made to feel she had no business being. Her attitude was to let the ofays have downtown Manhattan. Give her uptown anytime. Harlem was the best place to be.

Yet Harlem wasn't yet Harlem, at least not the Harlem to come of legend and lore. Harlem, Waters could see as she settled into the city, was still growing. Originally settled by the Dutch, who called it "Nieuw Haarlem," Harlem had later become home to German immigrants as well as the Irish and Jews. African Americans hadn't started to move into Harlem in significant numbers until 1905. That exact year could easily be pinpointed. What with a national depression at the time as well as an overflow of residences in Harlem, a building at 31 West 135th Street had found itself with far too many vacancies. Then following a shocking murder on the premises, the building became practically empty. Its desperate owner turned to a Black realtor, Philip A. Payton, who sent the word out to well-to-do Negroes that deluxe apartments were available. In a short time, he filled the building. Afterward African Americans moved into other residences uptown. During the war, even more African Americans flooded into New

York to work in local munitions plants or simply to have a chance for a better life. But there was, as might be expected, resistance from the whites then living in the community. At one point, the Harlem Property Owners Protective Association considered constructing a twenty-four-foot-high fence at 136th Street to keep out the Negro invaders.

"Harlem was anything but an exclusively Negro section," Ethel said of the time she took up residence there. "One Hundred and Twenty-fifth Street was still a white boulevard and we weren't welcome there. Colored people could buy seats only in the peanut gallery in B. F. Keith's Alhambra Theatre, and none at all in the other white showhouses."

As Waters hit town, the great shifts in Harlem were just about to occur. Between 1920 and 1930, its Black population would rise to more than 200,000. In 1920, there still was not any central club that just about everyone, Black and white, knew about. But in 1923, that would change with the arrival of the Cotton Club, which would be famous for its great Negro entertainers as well as its restrictions against Black patrons. Other fabulous clubs would sprout up. A nightspot like the Shuffle Inn at 2221 Seventh Avenue, which opened its doors in 1921, was later renamed Connie's Inn and became the place to go for blockbuster revues like *Keep Shufflin'* and *Hot Chocolates* with hit songs by Fats Waller and Andy Razaf. In 1925, Small's Paradise would open at 2294½ Seventh Avenue. It too catered mainly to whites. Yet such Black artists of the era as Countee Cullen and that noted Negrophile Carl Van Vechten came to see the elaborate floor shows and eventually to hear the music of Fletcher Henderson and James P. Johnson. Still more establishments opened: the Savoy Ballroom, "the home of happy feet"; and the Nest Club, a snazzy jazz joint that opened by 1925 and was but one of the clubs that lined the blocks of 133rd Street between Lenox and Seventh avenues and was known as Jungle Alley.

Like the rest of the country, Ethel would also witness an unprecedented outpouring of creativity within the Black communities in the large urban centers, primarily but not exclusively in New York. In this age of the Harlem Renaissance a dazzling lineup of novelists, poets, playwrights, and artists dramatically altered American culture with a steady flow of innovative and provocative work that challenged mainstream America's traditional view not only of the African American community but of it-

self as well. In the world of literature, such artists as Langston Hughes, Zora Neale Hurston, Countee Cullen, Claude McKay, Nella Larsen, and Jean Toomer came to prominence. An artist like Aaron Douglas, whose illustrations appeared in books and publications as diverse as the NAACP's *Crisis* and Condé Nast's *Vanity Fair*, became Black America's "premier visual artist" during this era. Playwrights like Hughes and Wallace Thurman, along with composers like Noble Sissle and Eubie Blake and crackerjack pop writers like Flournoy Miller and Aubrey Lyles, would inject a new style, a new vitality, a new rhythm, and a new point of view into American theater, redefining what a Broadway show, be it a drama or a musical, could and could not do. Towering dramatic performers like Charles Gilpin, Rose McClendon, and Paul Robeson would give startling and powerful performances in such productions as *The Emperor Jones, In Abraham's Bosom, Porgy, All God's Chillun Got Wings,* and *Black Boy.* And onstage and off, the much talked about Washington sisters, Fredi and Isabel, would turn heads with their new-style high-toned glamour. At the same time, among the more sophisticated city dwellers, the old dividing lines between the races were being torn down, especially at the nighttime in the right-time places.

"This was the era in which was achieved the Harlem of story and song," said James Weldon Johnson, "the era in which Harlem's fame for exotic flavor and colorful sensuousness was spread to all parts of the world; when Harlem was made known as the scene of laughter, singing, dancing, and primitive passions, and as the center of the new Negro literature and art; the era in which it gained its place in the list of famous sections of great cities." Johnson added: "But there is the other real and overshadowing Harlem. That commonplace, work-a-day Harlem. The Harlem of doubly handicapped Black masses engaged in the grim, daily struggle for existence in the midst of this whirlpool of white civilization."

To Ethel, it was clear that something extraordinary was in the air, something that would dramatically transform the place and position of the Negro in America. Deciding to stay, she moved into an apartment with her friend Alice Ramsey and another entertainer, Lola Lee. Now she had to find work. Ramsey was performing at a club called Edmond's and advised Ethel to see the club's proprietor, Edmond "Mule" Johnson.

Located at 132nd Street and Fifth Avenue, Edmond's Cellar was tiny, congested, a tad claustrophobic with a low ceiling; it seated between 150 and 200 customers, all clustered at tables in front of a small stage. Upper Fifth Avenue was hardly a fashionable area for Black nightclubs. Ethel soon learned of the club's reputation: for entertainers it did not mark a chance for the start of a career; rather it was considered a dead end. "After you worked there," she said, "there was no place to go except into domestic service." With little on his mind other than finding performers who made his customers happy, kept his tables full, and, in short, guaranteed that the money rolled in, owner Edmond was gruff and known for calling women "bitches" or slapping them on the backside. He was also white, which meant that for Waters he was automatically suspect. Waters never forgot the day she auditioned. "All I've seen her do so far is shake her behind," Edmond told Ramsey. Yet he decided to try her out. Ethel shrugged off his comments, but she didn't forget them. She would never forget any slight, be it professional, social, or personal. Edmond also insisted that her money had to go into the kitty, the big pot into which everyone's tips were dropped and later divided among the performers and the musicians.

At the club, she quickly assessed the other performers, sizing up any competition while at the same time remaining on the lookout for any sparkle that would enhance the entire show. Never one to prefer a performer who was a pushover, she enjoyed challenging herself to be better than everyone else she worked with. But she liked top-notch competition. "I'll show them bitches," was a comment she eventually made when she had to deal with female rivals, perhaps some male rivals too, who she believed might have the audacity to try to compete with her. At Edmond's, she felt she was in good company. There was an energetic dancer like Ramsey, another singer, and an oddball female entertainer—an eccentric dancer—named Edna Winston, who was known "for showing her laundry." Apparently, the customers liked what they saw because they quickly dropped money into the kitty.

Mainly, though, Ethel gravitated to the musicians. If a musician knew his stuff, he earned her respect whether that musician was the piano player, the trumpeter, the saxophonist, the trombonist, the drummer, or the orchestra leader. By now, she could quickly spot and appreciate a

musician's capabilities, his skill at innovation, his ability to give her what she needed to make a song work. She wanted the best musicians to back her up, and she never took a drummer or saxophone or piano player for granted. Here she enjoyed working with a three-piece band, which included pianist Johnny Lee and drummer Georgie Barber.

Onstage at Edmond's, Waters learned all the more that New York audiences had seen the best and expected nothing less. Her clear and crisp diction became more so now. Unlike rural Southern audiences in those towns and communities where she had appeared earlier, New Yorkers and patrons in other metropolitan areas—especially once whites started hitting the Black clubs and buying the records of Black singers—weren't as easily satisfied with the gut-bucket grunts and groans, the earthy sounds of a Ma Rainey or sometimes even a Bessie Smith. Instead they wanted to understand each and every line of a lyric. Some music critics might later say that Waters, with her diction, partly appropriated the style of white stars. But in truth, she had grown up in Philadelphia without a Southern accent or dialect. Her diction came naturally to her.

On the tiny stage at Edmond's, she was developing a style, both cool and hot, for which she would become famous. Standing onstage, she still had a rush of energy and could kick up her heels, if she felt the song required that. But because she still had not completed her recovery from the leg injury in Birmingham, sometimes she didn't move much, instead performing a slowed-down version of her bumps and grinds. That made her performances all the sexier. It also set her apart from most of the female entertainers of the era. Her slow-burn style wasn't there yet, but it was on its way.

Some of her songs were risqué, others just fun, the titles themselves revealing their sexy perspective, songs like "I Want to Be Somebody's Baby Doll So I Can Get My Loving All the Time" and "Shim-Me-Sha-Wabble." She also performed "Chinese Blues," for which she wrote the lyrics, and, of course, "St. Louis Blues." Yet Ethel didn't always feel comfortable with some of her naughty songs, which were "ungodly raw"—nor with her belly shakes. "I was just a young girl and when I tried to sing anything but the double-meaning songs, they'd say, 'Oh my God, Ethel, get hot,'" she once said. Having to please the nightclub crowd that "didn't come up to Harlem

to go to church," she added, "I never was like that inside. I wanted to sing decent things, but they wouldn't let me. They didn't even know I could— I, who at home, to get things off my chest, would rip loose with a good, rousing spiritual." Waters also began—at the urging of the piano player Lou Henley—to expand her repertoire and experiment with ballads. "It's the story told in the songs that I like," she explained to Henley. Within a short period of time, Waters began drawing in new customers. Some of the old crowd from Barney Gordon's in Philadelphia came. Downtown whites also started coming to Edmond's.

Her schedule at Edmond's—six nights a week, three or sometimes four shows a night—left her little free time. "I used to work from nine to unconscious," she said. During her off-hours, she liked to catch the drag shows in Harlem—those elaborate musicals where gorgeous women were revealed to be delicate or robust young men, sumptuously glammed up in wigs, makeup, and fabulous gowns to look like the goddesses they believed they were. Waters even lent some of the men her costumes to wear at the shows. Other times she liked to zip off to Coney Island not only for the rides but to see the freak shows too. The bearded ladies. The midgets. The two-ton fat men. On other occasions, she went to see other entertainers in shows at the clubs or ballrooms.

Though Waters grew fond of Edmond and once said that her first year at his club was one of her happiest, in time she clashed with her boss, whose determination to control her—as well as his basic crudeness— led to fights and quarrels. On one occasion, when he slapped her on her backside, she responded by kicking him on his. Another time, he stopped her in the middle of a performance and insisted that she stop singing the blues. Another performer might have wilted, but Ethel told him—in front of everyone in the club—that these were the songs people wanted to hear. Still, he insisted he didn't want to hear them, but after customers started walking out of the club, he relented and told her to go back to the blues.

During the summers when New York clubs and theaters were not air-conditioned, when there seemed to be no relief from the sweltering heat and the deadening humidity, everything in the city's entertainment world slowed down. Clubs like Edmond's temporarily closed up shop. Johnson

packed his bags and took himself and Ethel and some of his other enter-tainers to Atlantic City, where he leased a club called the Boathouse for the summer. Waters was glad to still be working, but she complained about the musical accompaniment at the Boathouse, which was a bigger arena. A small combo might work in a tiny club, but not here. When she asked Edmond to give her a larger backup of musicians, an argument ensued. Edmond wouldn't budge. Finally, Ethel walked out on him and went to perform at a Black club called Egg Harbor, then landed at Rafe's Paradise where the patrons were white. In the band at Rafe's was her uncle Harry Waters, playing mandolin. Not only did the swells turn up at Rafe's Para-dise but other celebrities came to see her, including Bert Williams and Sophie Tucker, who was known as a "coon shouter." So impressed was Tucker that she paid Waters to come to her hotel and give her lessons in this new style of singing.

In the autumn, Ethel returned to Edmond's Cellar. Word spread, and more whites from downtown, elegantly turned out in their tailored suits and their glitzy gowns and jewels, ventured to 132nd and Fifth to hear this colored woman's distinct style and sound. So did some of the biggest names in Black show business. Bill "Bojangles" Robinson. Florence Mills. The team of Buck and Bubbles. The comedy team of Butterbeans and Susie. In time she became friends with the comedy team, who offstage were Mr. and Mrs. Joe Edwards. Neither Edmond nor upper Fifth Avenue had ever seen anything like it. Ethel would become annoyed with Edmond and leave to perform elsewhere. But, eventually, she would return. "For three years, Ethel Waters packed his basement and made it one of Harlem's landmarks," said the writer Geraldyn Dismond. "From an obscure colored cabaret she turned it into an institution which was patronized by all the smart people of Gotham. In speaking of her three years with Edmund, Miss Waters laughingly admitted that she only quit him three times."

During the time Ethel had first worked in New York at LeRoy's Caba-ret, she had attended a performance of a dazzling dancer, Ethel Williams, and her partner Rufus Greenlee at a Harlem ballroom. Immediately struck by the young woman, Ethel returned to see her perform on other occa-sions, and a friendship developed.

Considered one of the best dancers around who was known by ev-

eryone in Black showbiz circles, Ethel Williams had been on the scene for over ten years. "The Williams woman is almost white," was the way one observer described her, with the "form of a Venus and the eyes of a devil." Her breakthrough came in the J. Leubrie Hill show *Darktown Follies*, which had opened at the Lafayette Theatre in 1913. Not only did it play "to great local crowds," James Weldon Johnson recalled, but it also "brought Broadway to Harlem." It "became the vogue to go to Harlem to see it," said Johnson. "This was the beginning of the nightly migration to Harlem in search of entertainment."

Legendary producer Florenz Ziegfeld was so taken with *Darktown Follies* that he optioned parts of it for his own *Follies* downtown. He included the big number "After the Ball," which had closed *Darktown's* first act. "The whole company formed an endless chain that passed before the footlights and behind the scenes," said James Weldon Johnson, "round and round, singing and executing a movement from a dance called 'ballin' the jack,' one of those Negro dances which periodically come along and sweep the country. This finale was one of the greatest hits the *Ziegfeld Follies* ever had." When Ziegfeld included the number in his show, he didn't credit creator J. Leubrie Hill, nor did he use any of the great Black dancers. But Ziegfeld hired Ethel Williams to come downtown and teach the steps to his white chorus girls. Williams also performed with dancer Rufus Greenlee at top theaters on the Keith circuit. She and Waters had also worked together in *Hello, 1919*, and her career had been in high gear until she was sidetracked by an injury. After pricking her foot on a nail file, Williams had suffered blood poisoning. An operation left her in pain. Afterward, she became depressed. Reclusive and no doubt lonely, she grew fearful that she would never appear on a dance floor again. Williams' mother pleaded with friends to try to cheer her daughter up, Waters recalled.

Visiting the young woman, Waters grew close to her and set out to help Williams reestablish her dance career. When she approached Edmond about giving Williams work, he just about laughed in her face. But Waters offered to let him cut her pay by $10 a week, which he could then put into Williams' weekly salary. Edmond hired her. Onstage, Waters and Williams did a routine together. Offstage, they were inseparable. The friendship did not go unnoticed. As singer Alberta Hunter would later say,

Ethel Williams was known as Ethel Waters' girlfriend. Or sometimes as "one of her girlfriends."

Still seeking control in her life, control over her circumstances, control over the people she dealt with, Waters may have been drawn to Williams because of the dancer's professional self-doubts and insecurities. And in all likelihood, Ethel had no fears of Williams abandoning her. She could mother or baby Williams if she chose. She could lay down the rules, too. Waters also liked the idea that Williams was socially at ease in a way that she herself was not at that time. Whether it was the dictys or other big-name stars, Waters admitted not knowing what to say to some of them when they came backstage to congratulate her on a performance or invited her to socialize. Williams, however, had no such problems. No one ever thought twice as to whether the women were lovers. In showbiz circles, it was obvious that they were.

DESPITE THE CROWDS AT EDMOND'S, Waters was growing restless and even weary of her club work, with its unending grind of several performances a night—in a smoke-filled, alcohol-fueled atmosphere with men who sometimes got out of hand. Edmond himself remained difficult and demanding. She thought she saw an escape when news broke of a Black show about to be produced. Originally called *Mayor of Jimtown*, it was later renamed *Shuffle Along* with music by Black composers Noble Sissle and Eubie Blake and a rowdy book by the popular comedy team of Flournoy Miller and Aubrey Lyles. Willing to do almost anything to get into the show, Ethel was ready to accept even a spot in the chorus. But the producers of *Shuffle Along* were notorious for preferring light-skinned chorines. Blues singer Alberta Hunter never got over her disappointment at not being able to get into *Shuffle Along*—and was quick to let everyone know that she blamed Noble Sissle, who had a "color complex" and considered her "too dark to be in his show." "I lived to tell him what I thought about him," she later said. Josephine Baker also tried out for one of the road show versions of the musical but was turned down, she said, because she was "too young . . . too small, too thin, too dark." Wearing light face powder, Baker later re-auditioned for the show and was finally hired, but

as a dresser backstage. She landed a spot in the chorus only after substituting for a chorus girl who couldn't make it to a performance. But Ethel wasn't even able to do that. Successful as she was uptown, she wasn't considered "classy" enough for a big Broadway show. To *Shuffle Along*'s producers, she was nothing more than a low-down honky-tonk singer. When *Shuffle Along* ended up becoming a huge hit, her disappointment was all the greater. So was her resentment.

But Ethel Waters' consolation for having missed out on *Shuffle Along* was something called the race record, which would dramatically change her career and her life. Since the advent of the phonograph record, music companies had produced recordings exclusively for mainstream audiences, mainly white audiences. Record companies weren't interested in colored singers, even though everyone in New York and Chicago knew the most innovative music, whether it be the blues or jazz, was coming from Negro artists. But music executives did not believe there was a Negro market that would buy colored music. Then, in 1920, the white Okeh Recording Company signed the singer Mamie Smith. The full-figured Smith was appearing at the Lincoln Theatre in a revue, *Maid of Harlem*, by Perry Bradford.

When Smith recorded "That Thing Called Love" and "You Can't Keep a Good Man Down," news traveled in the Negro community that a colored girl had cracked open the door of the music industry to become, in the words of W. C. Handy, "the first colored girl to make a record." But Okeh did nothing to push her records or even to record Smith again. Only after the company failed to get white blues mama Sophie Tucker to record (the same woman who paid Ethel Waters for style lessons), did Okeh bring Mamie back into the studio. This time around, she sang "Crazy Blues"— with a flip side "It's Right Here for You." Black record buyers liked what they heard, and soon they were snapping up the Smith recordings. Some 75,000 copies flew off the shelves in Harlem in the first month. A music star was born. So was a music movement.

Afterward other record companies, out to duplicate Okeh's success, recorded other colored performers singing the blues. Women such as Edith Wilson, Lucille Hegamin, and Gertrude Saunders, who had won the plum lead in *Shuffle Along*, were actually vaudeville performers who might use a

blues song in their acts but who were basically singing pop tunes. Others, like Trixie Smith, Alberta Hunter, Ida Cox, Sara Martin, Victoria Spivey, and Clara Smith, who had been called a "coon shouter," were authentic blues singers who found themselves in demand. Still others, like Bessie Smith and Ma Rainey, who were signed once the rush had taken off, were actually classic blues divas, the greatest.

In their music, the blues singers examined the issues: they might sing about money, heartache, or men. Sometimes they were disseminators of news, as Ida Cox proved in her song "Broadcast Blues." Or sometimes they might just dish out some sex. Theirs were tales of women tied to oppressive men. Yet men also completed the stories of their lives. In the game of gender and sexual politics, the blues singers ultimately won because they lived to tell the tale—from their perspectives. With their bawdy material, they could reverse gender roles, demanding sex when they wanted and on their terms. Bessie Smith made that loud and clear in her song "Do Your Duty," in which she insisted that a fellow do what was required of him: if she called for him three times a day to chase her blues away, then he should do his duty. Jazz historian Sally Placksin said that "once they'd drawn the world in as commiserators and conspirators, they managed to conquer—or at least diminish—the very plight (or truly celebrate the joys) of which they sang. They may have been abandoned, hopeless, too passive even for suicide. . . . They may have been making a strong statement, as in Bessie Smith's 'Poor Man's Blues' or Victoria Spivey's 'T. B. Blues.' But even if they had nothing else in the world—no other love, no other hope, no other platform—they had their song, and for the moment, they had power. With their singing of the song came the very antidote to the plague of the blues." With such music, the blues singers brought Black women from behind the shadows and positioned them front and center in the music industry and American popular culture. Black record buyers responded enthusiastically. Eventually, so did whites.

But it all started with Mamie Smith, and Mamie's success was not lost on Ethel, who would actually help lead the way to the blues explosion before some of those other singers snared their recording contracts. Whether Ethel actively sought a record deal is not clear, but she certainly was ready for one and probably was putting out feelers. When a scout

from Cardinal Records heard her, he brought her to the attention of the company, which quickly signed her up. At Cardinal Records, she made her first recordings in 1921: "The New York Glide" and "At the New Jump Steady Ball," backed by the group Albury's Blue and Jazz Seven. But Cardinal was a small outfit without the muscle to promote her or even record her in the best way. Waters left the label.

Not long afterward, she was contacted by the Pace Phonograph Company for discussions about recording for its Black Swan label. A black-owned company, it was an outgrowth of the Pace & Handy Music Publishing Company, which had been the brainchild of the Black composer W. C. Handy—known as the "Father of the Blues" and whose "St. Louis Blues" Waters had been singing—and his partner, the young entrepreneur Harry Pace. In advertisements, Black Swan's motto read: "The Only Genuine Colored Records—Others Are Only Passing for Colored."

Pace had entered the recording business via a circuitous route. Born in 1884 in Covington, Georgia, the son of a blacksmith who had died while Harry was still a child, he was reared by his mother. Everything about young Harry seemed remarkable. At age twelve, he completed elementary school. Seven years later, he graduated—as class valedictorian—from Atlanta University, where he studied under his mentor W. E. B. Du Bois. For a time, Pace lived in Memphis where he and Du Bois ran a printing business. In 1905, the two published a short-lived but important publication, *The Moon Illustrated Weekly*, the first-known African American journal. Also in Memphis, Pace met Handy, who was impressed. He "was a handsome young man of striking personality and definite musical leanings. Pace had written some first-rate song lyrics and was in demand as a vocal soloist at church programs and Sunday night concerts," said Handy. "It was natural, if not inevitable that he and I should gravitate together. We collaborated on songs." Once they formed the Pace & Handy Music Publishing Company, Pace moved to New York City, married, and eventually settled in a brownstone—as well as into a very middle-class lifestyle—at 257 West 138th Street on Strivers Row, the most celebrated neighborhood uptown, known for its sedate but posh brownstones and its high-minded residents.

Working in the music business, Pace soon realized that, with rare

exceptions like Bert Williams and then Mamie Smith in 1920, the white phonograph companies were still not recording African Americans. Pace was determined to change that. There was too much Negro talent around. Before the boom in Black blues singers took off, Pace borrowed $30,000, broke off his partnership with Handy, and organized the Pace Phonograph Company, which produced Black Swan Records. He opened up shop in the basement of his home. The label was named in tribute to Elizabeth Taylor Greenfield, that nineteenth-century slave-born singer who rose to become a renowned soprano called the Black Swan. On the label itself, there was a drawing of a swan.

Many a famous African American would walk through Black Swan's door. At one time, a slender young green-eyed beauty named Fredi Washington was its secretary and bookkeeper. That was until she heard about *Shuffle Along*, went down to see its casting people, and got herself in the chorus of the show. Later she came to national prominence when she played the light-skinned young Black woman who passes for white in the original film version of *Imitation of Life*. Her younger teenage sister, Isabel Washington, also worked at the company and even recorded two songs there. Then she was bitten by the showbiz bug and ended up on Broadway in such productions as *Harlem* and *Bamboola*. Later she gave up her career to become the first wife of Adam Clayton Powell Jr.

At one point, Black Swan's business manager was Lester Walton, a shrewd, highly skilled and talented journalist who had left St. Louis in 1906 to come to New York to join the staff of the *New York Age*. Walton loved show business, the personalities, the perpetual razzle-dazzle, the nail-biting tensions—a show might open today and close tomorrow, a star might be born today and be a has-been tomorrow—and the steady stream of social activities. He ended up producing such early Black musicals as *Oyster Man*, *Meet Mose*, and *Darkeydom*. Later he became a columnist for the *New York World* (one of the first, if not the first, Black journalists at a major white newspaper), and from 1935 to 1946 he served as the U.S. ambassador to Liberia.

Black Swan's recording manager was the very young Fletcher Henderson. Born in Cuthbert, Georgia, in 1898, his background was that of a well-brought-up member of the Southern Black bourgeoisie. His mother

was a piano teacher who trained him to play classical music. One of his favorite pastimes was baseball, which he was so good at that he was nick- named Smack: he was a kid who could smack the ball with his bat right outside the baseball diamond. Like Pace, Henderson had graduated from Atlanta University, where he majored in chemistry. Coming to New York for graduate studies, he needed money and took the Black Swan job. Also at Black Swan in the position of its music director was the future composer William Grant Still, who was a member of the Harlem Sym- phony. Among the members of the board were Du Bois and John Nail, the brother-in-law of James Weldon Johnson and the largest real estate broker in Harlem.

There would always be conflicting stories about how Ethel came to Black Swan's attention. Fletcher Henderson recalled that he first spotted Ethel performing in a Harlem basement and afterward had her come to the studio to cut some sides. Harry Pace remembered it differently. "While in Atlantic City," he said, "I went to a cabaret on the West Side at the invitation of a mutual friend who stated that there was a girl there singing with a peculiar voice that he thought I might use. I went into the cabaret and heard this girl and I invited her over to my table to talk about coming to New York to make a recording. She very brusquely refused but at the same time I saw that she was interested and I told her that I would send her a ticket to New York and return on the next Wednesday. I did send such a ticket and she came to New York and made two records." Waters herself always said that the talent scout who had first taken her to Car- dinal took her to Black Swan. There is probably some truth in all three versions.

Regardless, Waters never forgot that day in 1921 when she first walked into Black Swan's office, then still operating out of the basement of Pace's home at 257 West 138th Street. There she saw that smart, young whipper- snapper of a college grad Fletcher Henderson, looking "very prissy and important." Like Pace, Henderson was light-skinned, which Waters would not have failed to notice. Nor would she have failed to observe the very proper decorum and manners of Pace, Henderson, and the rest of the staff at that time and in the very near future.

The men at the company dressed in suits and ties, except, of course,

when in the studio. The suits would be perfectly pressed; the shirts, a blinding white, freshly laundered, starched, and ironed. Shoes were polished and probably spit-shined. The young women, like Fredi and Isabel Washington, who were not at the company during Waters' initial days, nonetheless were well groomed, well mannered, well spoken, and for the time, well educated. In the case of the Washington sisters, it also didn't hurt, as far as the company was concerned, that they were light-skinned with straight hair. For Ethel, everything about Black Swan must have reeked of upright middle-class Negro respectability. Though she might not admit it, she was both impressed and perhaps intimidated by the educational backgrounds of its employees. Here was a staff that personified the highfalutin dictys whom she never felt at home with and often was suspicious of. After all, for all its promise and for all of Pace's aspirations of doing something for the race, this was the company that would turn down a recording deal with Bessie Smith, who was deemed too loud and raucous, too ethnic, basically too *cullid* for the taste of this very proper company. Their idea was to do music that in essence was culturally relevant and would uplift the race rather than hinder it. The men who ran the company had doubts about some of the popular music that a new generation was listening to. Yet they were in show business, and they understood that the "less cultured" music could not be ignored. Their early recordings—of a fine baritone balladeer, C. Carroll Drake, of vaudevillian Katie Crippen, and of soprano Revella Hughes—may have appealed to the highbrow Negro middle class, but their sales went nowhere. Ethel Waters could change all of that.

Despite any reservations about the dictys, Ethel respected Harry Pace, whom she referred to as "Mr. Pace." Too ambitious to turn down any offer the company made, for her it was better to work with the dictys than the ofays. In turn, the men at Black Swan saw possibilities in this young woman who was becoming so well known. No "coon shouter," no gutbucket blues-er. "There was much discussion of whether I should sing popular or 'cultural' numbers," said Waters. "They finally decided on popular."

"Fletcher was in charge of the record dates," musician Garvin Bushell recalled. "He might pick the numbers in the office, present them to the vocalists, then we'd have rehearsal and get it together. Often there

were only two pieces of music, one for the piano and one for the trumpet (or violin). Sometimes everybody had a part." Recording itself was then a complicated procedure, often a matter of logistics, that could unnerve a performer. Alberta Hunter, who also recorded at Black Swan, remembered the company's "little bitty studio." At her first recording session, Ethel was instructed to stand and sing into a big horn that was connected to a small square window. Behind Waters were the musicians who were to accompany her, Cordy Williams' Jazz Masters—a sextet with Williams on clarinet, Fletcher Henderson on piano, Ralph Escudero on tuba, Chink Johnson on trombone, Edgar Campbell on clarinet, and an unknown trumpet player. In an adjacent room, the record was actually made: there, as Hunter observed, "a needle cut into a thick brown wax on the revolving matrix, spinning off a curlicue shaving that a technician brushed off onto the floor." Aside from the awkwardness of recording itself, Ethel had to adjust to performing without an audience to give her feedback. Most performers felt isolated at first, unsure how they were coming across, puzzled by the way their voices were actually recorded. If she was apprehensive, she didn't show it. Nor did she sound it. That wasn't her style. Relatively quickly, she mastered the art of making records, modulating her sound, knowing when to come on strong and when to turn her voice soft or lower, for this new medium.

Her first recordings—recorded in May 1921—were "Down Home Blues" and the sexy "Oh, Daddy." The former was a standard female blues lament. Well, almost. "My friend has quit me / He's gone for sure / He broke my heart / For I loved him true" were among the opening lines of "Down Home Blues," in which Ethel was cool and collected. But she was full-blast on the chorus: "Woke up this morning / the day was dawning / And I was feeling all sad and blue / I had nobody to tell my trouble to / I felt so worried / I didn't know what to do." What was surprising was the forceful delivery of what in another singer's hands might be soft and sentimental. Instead she seemed to announce that, yeah, she might be blue but not that blue. It would take more than a man to bring her down. The song ended with the comment that there was no use grieving "because I'm leaving / I'm broken-hearted and Dixie-bound / Lord, I been mistreated, ain't got time to lose / My train is leaving / And I got the

down-home blues." Here "Down Home Blues" touched on a theme that turned up in many other songs of the period, the effects of the Great Migration and the idea that city life might lead to heartache, that perhaps some aspects of life were better in the South: the down-home place of family, warmth, comfort. Nonetheless, with "Down Home Blues," Ethel had a sensational debut.

Upon releasing the record, Black Swan saw astounding results. Some estimates were that "Down Home Blues" sold some 100,000 copies, but Pace said, "I sold 500,000 copies of these records within six months." Whether or not Pace's numbers were inflated, Waters had a hit. "The next month," said Pace, "I had her make two other records." At that next session, which was actually in August 1921, she recorded "There'll Be Some Changes Made" and its reverse side, "One Man Nan." Backing her were Garvin Bushell on clarinet; Charlie Jackson on violin; Fletcher Henderson on piano; and an unknown player on trumpet and trombone. Thereafter, said Pace, "for a long time she made a record a month." There followed such songs as "That Da Da Strain" and "Georgia Blues," as well as "Brown Baby" and the reverse side "Ain't Goin' Marry," and "Memphis Man" and its reverse side "Midnight Blues." Advertisements were taken out with pictures of her and by the next year Black Swan was billing her as "Queen of the Blues."

Pace never believed her other recordings "measured up to the 'Down Home Blues' record," but that did not matter because she got Black Swan out of debt. At the end of Black Swan's first month, cash receipts had been a paltry $674.64. By the end of the year following the release of Waters' records, the company's average monthly receipts were $20,000. For the first year, income from record sales was $104,628.74. "I then began to invite other well-known singers and performers," recalled Pace, "and within a year I was issuing about twelve records a month and selling them in every state in the United States, and in a good many foreign countries." Almost single-handedly, Ethel Waters put Black Swan on the map.

Her Black Swan recordings also put her on the map, marking the first upward swing of her career. Never again would she be thought of simply as Sweet Mama Stringbean; never again would she be just another blues singer. The recordings broadened her audience, set her on the road

to becoming famous, and put money in her pockets. From her past club bookings, she had saved most of her earnings as well as sent money home to her family. But now, flush with the big bucks, she became giddy with excitement. She bought gifts for friends. She was also, even now, a soft touch for fellow entertainers down on their luck. But Ethel Waters was also good to Ethel Waters. She just about emptied out her savings account to plunk down $1,200 for a mink coat. Afterward, she only had $15 left in the account, but she never had any regrets.

Pace soon devised a plan to pull in even heftier profits—and also make Ethel and the label even better known. He would set up a tour for her, to be accompanied by Fletcher Henderson and the Black Swan Jazz Masters. A few other performers would also be hired to create a vaudeville style program. The entire company would be called the Black Swan Troubadours and would appear on bills with other vaudeville acts at individual theaters.

On October 12, Waters agreed to the tour that would begin in November 1921 and eventually ended in July 1922, carrying her to twenty-one different states and fifty-three cities. Among those to travel with her was a talented group of musicians: Joe Smith and Gus Aiken on trumpets; Gus's brother Buddy Aiken and Lorenzo Brashear on trombone; Raymond Green on drums; and Garvin Bushell on clarinet. By now, she understood better the type of sound her music needed. Waters liked strong piano accompaniments. In the years to come, she would hire two remarkable pianists—Pearl Wright and Reginald Beane—to travel with her, and on some recordings, Waters' only accompaniment would be a skilled player on the piano. Later she would also hire pianists Herman Chitterson and Marion Roberts. Among her favorite piano players were Willie "The Lion" Smith, Charlie Johnson, and especially James P. Johnson, who later accompanied her on the recording "You Can't Do What My Last Man Did" in 1923. "Men like him, Willie 'The Lion' Smith, and Charlie Johnson could make you sing until your tonsils fell out," she said. "They stirred you into joy and wild ecstasy. They could make you cry. And you'd do anything and work until you dropped for such musicians." But none could touch James P. Johnson. "All the licks you hear, now as then, originated with musicians like James P. Johnson. And I mean *all* of the hot licks

that ever came out of Fats Waller and the rest of the hot piano boys."

But that was not the case with Fletcher Henderson. During rehearsals, she let Henderson know—in very direct language, to put it mildly—that he had to alter his style. She even bought piano rolls of James P. Johnson in hopes that he'd understand what was best for her music. Henderson would later lead his own jazz band, one of the best and most influential, at New York's Club Alabam, the Cotton Club, and the Roseland Ballroom, and he would work with such major talents as Louis Armstrong, Bessie Smith, Don Redman, Rex Smith, Benny Carter, and his pianist brother Horace Henderson. He would be credited with ushering in the big band movement that included the groups of Chick Webb, Jimmie Lunceford, Cab Calloway, Count Basie, and Duke Ellington. But at this time, the "prissy" Henderson, whose family had looked down on work songs and other popular music, still had to learn how to play popular music. He had to be loosened up, or so Ethel believed. "Ethel had been in caba-rets all her life. She didn't sing real blues, though," said Garvin Bushell. "She syncopated. Her style was influenced by the horns she heard and by church singing." It was a style that Ethel believed Henderson hadn't yet mastered. She nagged, argued, hounded, and berated him. Every other word out of her mouth could be a "shit" or a "damn" or a "goddam"—and when she did so, this was the *restrained* Ethel—to get him to give her what she called "'the damn-it-to-hell bass,' and that chump-chump stuff that real jazz needs." She said she would "practically have to insult Fletcher Henderson to get him to play my accompaniments the way I want."

For Henderson, it had to have been an exasperating experience to be bossed around by this ghetto girl who had no education, no class (when it came to working with people), and who cussed like a sailor. He also had to deal with the fact that she couldn't read music. "Very few singers could read in those days," said Garvin Bushell. "Fletcher never wrote out anything for Ethel." Instead he relied on her remarkable ability to pick up the melody. "Ethel had a great memory for lyrics, though, and a great ear, like Ella Fitzgerald," recalled Bushell. Despite whatever insults she hurled his way, Henderson, like so many others in Ethel's early years and in the years to come, must have realized she knew what she was talking about. And working with her, as trying and upsetting as it often was, must have

also excited him. He would always be respectful of her great talent. That to him was undeniable.

Henderson wrestled with the prospect of touring with her, but for reasons other than her temperament. His real concern was that it might look improper to travel with a young woman. He became so worried that he sent for his family—his mother, his father, his sister Irma, too—to come from Georgia to New York to meet Ethel. He wanted their approval. Or maybe he felt he had to have it. It's not hard to imagine what Waters thought about that. By now, Ethel was shrewdly aware of her audience, onstage and off. In a studio or rehearsal room, she might be rowdy and profane, but offstage, she had begun to carry herself in a somewhat queenly fashion, especially when decked out in her new mink coat. Her height—all five feet nine and a half inches—and carriage would always serve her well, and her budding high-diva style signaled to all observers that she could not be trifled with and would have to be taken seriously. Like royalty, she also knew when to be tough and mean as well as when to turn on the charm. Meeting Fletcher Henderson's family, she must have been on her best behavior because the Hendersons liked this "sweet" girl from the other side of the tracks. Fletcher won the family approval he had sought.

"BEFORE THEY LEFT NEW YORK, they undoubtedly performed various gigs of which there is no surviving record," said Fletcher Henderson authority Walter Allen. "The nucleus of the band did record three instrumental numbers under Ethel Waters' name but without vocals."

Once the tour began with a quick stop in Washington, D.C., Ethel was in high gear. Traveling on the road was now second nature to her, and throughout Harry Pace used his business and marketing skills to pave the way for her arrival in one city after another. Shrewdly, he enlisted the network of Negro newspapers—such as the *Chicago Defender*, the *Baltimore Afro-American*, and the *New York Age*—to cover the tour, to build up Ethel even more, to make her seem all the more a larger-than-life being who had deigned to descend from a world up high to meet her subjects. As early as October 1921, an ad in the *Chicago Defender* announced:

Coming Your Way—
Black Swan Troubadours
Featuring the Famous phonographic star
**ETHEL WATERS**
The World's Greatest "Blues" Singer and
Her Black Swan Jazz Masters,
Company of All-Star Colored Artists.
Exclusive Artists of the Only Colored
Phonograph Record Company.
Lodge, Clubs Societies and Managers
wire or write terms and open time.
T. V. Holland, Mgr.
275 W. 138 St, New York City.

Pace also enlisted Lester Walton to serve as booking agent and publicist. Walton proved to be a master at keeping the Negro press informed of all that transpired on the road, not an easy feat, what with the constant changes and new schedules. Pace and Walton both understood that Ethel was the drawing card, and there had to be an ongoing publicity campaign that highlighted her activities. Neither man concocted any publicity stunts, but they were aware of the curiosity about this good-looking young woman's romantic life, which they had to make use of. Consequently, among the publicity "leaks" sent to the Negro press was the "revelation" of an unusual agreement between Waters and Black Swan. "Ethel Must Not Marry—Signs Contact For Big Salary—Providing She Does Not Marry Within A Year," read the headline in the *Chicago Defender.*

Ethel Waters, star of the Black Swan Troubadours, has signed a unique contract with Harry H. Pace, which stipulates that she is not to marry for at least a year, and that during this period she is to devote her time largely to singing for Black Swan records and appearing with the Troubadours. It was due to numerous offers of marriage, many of her suitors suggesting that she give up her professional life at once for domesticity, that Mr. Pace was prompted to make this step.

The article also stated: "Miss Waters' contract makes her now the highest salaried colored phonograph star in the country." All of this made terrific copy, depicting Waters as a sexy singer hotly pursued by numerous men on the make. For those who would come to see the woman they had been reading about, the publicity was beginning to turn her into a legendary (even at this early time in her career) phenomenon. Though some items probably padded Ethel's already growing ego, she must have howled over some of the copy that she read about herself. The truth of the matter was that Ethel, though still pursued by any number of men, some perhaps with honorable intentions, others clearly without, had no plans whatsoever for marriage. Among the creature comforts that Waters made sure to have with her on the road were her Pekinese named Bubbles and her lover, the sprightly dancer Ethel Williams, who was signed to perform with the company.

First stop after Washington—on November 23—was Waters' old stomping grounds, the Standard Theatre in Philadelphia. Located at 1124-1128 South Street, the Standard had originally been the South Street Baptist Church. Then in 1889, architect Jacob J. Hitchler converted the church into a theater that extended 120 feet to Kater Street and was designed with an orchestra level, a balcony, a gallery, and deluxe box seats. The stage itself was forty feet deep and seventy-eight feet wide from wall to wall. Its proscenium opening was thirty-two feet wide and forty-two feet high. From 1897 to 1900, the Standard Theatre Stock Company was in residence.

Then in 1915, Philadelphia impresario John Gibson bought the place and turned it into a vaudeville house. In 1920, after new seats and new lighting fixtures were installed, it was promoted as Gibson's New Standard Theatre. Gibson also owned Philadelphia's other major Black vaudeville houses: the Dunbar on Broad and Lombard streets, and the Royal, also located on South Street. All three theaters, along with the numerous clubs, bars, and music haunts around town, made Philadelphia a great location for musicians and entertainers. Stock companies like the Lafayette Players in New York came to town with their productions, giving the locals the chance to see what the big-timers could do. But the Standard was Philadelphia's premier establishment for Black vaudeville. It seated some fifteen

hundred people, and over the years, legendary performers would showcase their talents on that large stage: great acts like Louis Armstrong, Adelaide Hall, Buck and Bubbles, and the comic Dewey "Pigmeat" Markham. Sitting in the audience to watch rehearsals and performances during this period was a wide-eyed little boy named Fayard Nicholas, who with his baby brother Harold grew up to become part of the famous dancing Nicholas Brothers. His father, the drummer Ulysses Nicholas, led the band at the Standard, and his mother, Viola, played the piano there. When Ethel had played the Standard in 1918, she had felt pretty good about herself, about the fact that folks in town had seen she had made something of herself. But now she came back as a recording star and a big attraction on a bill that headlined former heavyweight champion Jack Johnson.

Gibson had scheduled the show during Thanksgiving week in order to cash in on the crowds of Black Americans who were pouring into the City of Brotherly Love for the big football game between Howard and Lincoln universities. These were two of Black America's great institutions of higher education, and their gridiron battles always drew record turnouts of both the high and low in the African American community. The city's Negro newspaper, the *Philadelphia Tribune*, called the game the "Greatest Social Event of [the] Year" and predicted "20,000 People Will Attend The Great Football Classic." It was Black America's equivalent of the Army-Navy game that excited mainstream America. Gibson knew the football fans would want other activities while in the city, and thus they could head to the Standard. Here Gibson had been shrewd. The December 9, 1921, edition of *Variety* would report that approximately twelve thousand entertainment acts had been out of work in 1920. Affected by the popularity of movies and radio, vaudeville would continue for some years, but in hopes of boosting attendance, agents were now booking famous athletes in theaters. Gibson had signed Johnson, confident the champ would pack 'em in. By now, Johnson's fighting days were over, and there would be both pleasure and sadness in seeing him.

Born John Arthur Johnson in Galveston, Texas, in 1878, he had a storied life. Quitting school after the fifth grade, he worked a series of menial jobs. But fascinated by prizefighting, delighting in his innate abilities at the sport, Johnson began training, then became a professional in 1897 at

the age of nineteen. Quickly rising up the ranks, he defeated one Black boxer after another, and by 1903 was considered the "unofficial" colored heavyweight champ. Too ambitious to stop there, Johnson knew that in order to make it as a great boxer on the national scene, he had to fight the white champs, but none would go near him. Such fighters as John L. Sullivan and Jim Jeffries turned him down, but in 1908, he finally got a bout with white heavyweight boxer Tommy Burns—in Sydney, Australia. Defeating Burns, Johnson instantly became a hero for Black America and a nightmare for the rest of the nation. During the next two years, he fought five other bouts with white boxers, and he defeated them all. In the ring, there was nothing humble or subservient about him. Proud and defiant, he was known for taunting his opponents. Considered the "Great White Hope," Tommy Burns was pressured to come out of retirement and enter the ring with Johnson for a rematch. Again Johnson pummeled him, but this time in the States—in Reno, Nevada, in 1910. Afterward there were race riots.

Outside the ring, Johnson also shocked his fellow countrymen when, in 1911, he married a white woman, Terry Duryea, who later committed suicide. Johnson took a second white wife, Lucille Cameron; then, in 1913, he was convicted of violating the Mann Act: transporting women across state lines for "immoral purposes." It didn't seem to matter that Johnson had married the women he transported; the marriages themselves were considered immoral. To avoid prison, Johnson moved to France, where he conducted boxing exhibitions, but the lure of the ring led him to a bout in Havana with Jess Willard in 1915. Johnson lost. He eventually returned to the States and served a year in prison. Afterward he ran the Club Deluxe in New York, which he later sold and which was transformed into the Cotton Club. Johnson also turned to public appearances. The roar of the crowd, screaming his name and cheering him on, was now something he thrived on. And so he turned up on the bill at the Standard.

For about ten cents, a patron could see a movie and a complete vaudeville show. Among the acts, there were not only big stars but the talented midlevel stars too, as well as female impersonators and animal acts. Though Johnson was clearly the draw, Gibson knew that once

patrons got inside, it was the Black Swan Troubadours, led by Ethel, who would provide the real entertainment. A few days before Ethel's arrival, the theater had taken out a large ad in the November 19 edition of the *Philadelphia Tribune*:

Gibson's New Standard Theatre
South Street at Twelfth
John T. Gibson,
Sole Owner and Directing Manager
WEEK Beginning NOV. 21

### GALA HOLIDAY BILL

3 Shows Thanksgiving Night 3
First Show Begins at 6 o'clock
By Special Request
JACK JOHNSON
In PERSON
The greatest boxer of all times in one of
his Clever Boxing Exhibitions.
Black Swan Troubadours
*with*

### ETHEL WATERS

World's greatest Blues Singer and Jazz Band
Ethel Williams and Slick White
Black Swan Records are made by the only
Colored Phonograph Company in Existence.
Sandy Burns Co.
Act Entitled "Ephraim's Got to Go"
Baker & Baker Singing, Dancing, and Pianologue

### TUCKER & GRESHAM

Clever Arrangement of Comedy and Song
Slayter & Hollins. Song, Dance and a Little Bit of Jazz

On opening night, the Standard was packed. A musical comedy bit was performed by blackface comedian Sandy Burns and his company. Then nonstop songs, dances, and humor were provided by such teams as

Tucker and Gresham and Slayter and Hollins. Even the musicians with the Troubadours' Jazz Masters put down their instruments at one point in the evening to do a comedy skit. "Like every band that got onstage," Garvin Bushell recalled, "we had to do a specialty of some kind. So we had an act in which I was a cop and [drummer Raymond] Green was a preacher. He'd be standing there on the street preaching at what looked like an altar, but it would be his xylophone, covered up. I'd come out in a cop uniform and chase him off the street. Ray Green was a very funny character, and a good drummer, too." When Jack Johnson came on, the applause was thunderous. Johnson performed a funny burlesque of a fight with Sandy Burns, but mainly it was a personal appearance. "He did some shadow boxing and some talking. People just wanted to look at him," said Bushell.

But the performance at the Standard—the one audiences wouldn't forget—was Ethel with the Black Swan Troubadours. Pepped up and ready for action, she was dressed—throughout the tour—to the nines, usually in long gowns and perhaps what would be her trademark, dangling earrings that sparkled and brought light to her face. "She literally sang with a smile," reminisced Garvin Bushell, "which made her voice sound wide and broad."

At the Standard and throughout other cities on the tour, she must have been surprised to discover that, because of the recordings, she was accorded a new level of respect. To record buyers and soon those patrons who would pack the theaters and clubs where she now performed, she was like a goddess touched by the magic of mysterious modern technology. Not yet were recordings fully taken for granted. The entire technical process of making a record, just like making a movie, mystified everyone. How was it done? Much like early movies, which audiences took literally (ducking when a train raced toward them on the big screen) and whose stars were viewed as godlike or goddessy beings—hordes of ordinary folk went into a frenzy at seeing Charlie Chaplin, Gloria Swanson, Mary Pickford, or Douglas Fairbanks in person—so too did early Black recording stars like Ethel seem touched by unfathomable powers. Glamorous photographs or posters were in the lobby of a theater, as again Harry Pace showed his business and marketing skills.

For Ethel, the tour would expose her to the full extent of her fame. People could go into a dither at merely seeing her. All the commotion might have thrown someone else. Indeed show business was littered with performers unable to cope with or understand or feel deserving of their fame. But Waters adjusted very quickly. Fame became a second skin to her, and that adjustment started with the engagement at the Standard.

There also had to be a great satisfaction that her family and the old crowd from Chester and Clifton Street were more aware than ever that Ethel, once Sweet Mama Stringbean, had attained a new level of stardom. Perhaps that hincty grandmother Lydia Waters was aware of her success. Yet for Ethel there would always be a nagging sadness that Sally Anderson had not lived to see any of this—Sally, the one person who had always believed in her.

In Philadelphia, she also got to know Johnson. Ethel was impressed; however, she kept her distance. After all, this was the man known to have no interest in Black women; his marriages were an open affront to them. Yet any number of Black women pursued him at the Standard. For his part, Johnson was intrigued by Ethel, who could perform up a storm and have the crowd cheering but who had nothing to say to him. Backstage she always greeted him cordially. But she said little else. One afternoon he sent his valet to her dressing room with an invitation for her to come see the champ. "All right," she told the valet, "it is exactly the same number of steps from his dressing room to mine as it is from mine to his. So tell him to drop over." Unaccustomed to being treated in such a way, Johnson nonetheless showed up in the doorway of her dressing room and asked if he could come in. Why was she unfriendly to him, he wanted to know. Their conversation turned to the subject of white women and his lack of interest in African American ones. Johnson responded that he had nothing against Black women. He also invited her to dinner, which she declined. But now they were on friendly terms, and at other times in other cities, the two would run into each other, and each time, Johnson and Waters had friendly conversations. Often he flirted. "I could like a woman like you, Ethel," he would say. "Now, Jack," Waters would respond.

In the end, Ethel liked him and felt she understood his predilection for white women. No doubt to the dismay of other African Americans, she

once said, "I guess we Negro women could take lessons from white women and light-colored women. We might learn a lot about flattering the vanity of our men, catering and playing up to them more." Part of Johnson's appeal to Ethel may have been the way he handled his unprecedented fame, his defiance in the face of a racist culture that tried to cut him down at every opportunity. Part of his appeal also was his sheer physical power. Boxers—prizefighters—would always draw something out of her that others could not. Even that early boyfriend, with whom she had sparred, had a strength she admired. In the years to come, her admiring eyes would turn to another famous prizefighter, Joe Louis.

After his gig at the Standard, Johnson performed at other theaters. His business ventures continued. In 1924, he took a third white wife, Irene Pineau. Still a hero for Black America, Johnson was killed in an automobile accident in Raleigh, North Carolina, in 1946.

NEXT STOP FOR THE TROUBADOURS was a three-day engagement at the Regent Theatre in Baltimore. "Preceding Miss Waters' appearance her eight jazz boys treated the audience to as fine an exhibition of jazz playing as have [sic] ever been heard here white or black," the *Baltimore Afro-American* reported. "When Miss Waters—a stately very handsome young woman of a real 'teasing brown' complexion—made her appearance beautifully gowned in a costume of blue pan velvet and gold brocade, the audience burst into prolonged applause."

Following Baltimore, she was off on a series of whirlwind one-nighters in Pennsylvania and Ohio, hitting one city after another at breakneck speed. "We didn't play any white theaters with Ethel, only ballrooms or TOBA theaters, and then, naturally, we went on after the movie," Garvin Bushell recalled. "We made about fifty dollars a week, I guess. Conditions of traveling didn't bother us too much, I guess. If you had to walk the streets all night or sleep in a church, you did it. Sometimes we couldn't get a room and we'd have to call up the Black preacher. He'd say, 'Well, you can sleep over in the church. I'll send the janitor down and he'll open it up. You can sleep on the benches there until you get ready when your train comes in.' We also stayed in Black hotels and in people's houses.

In Dayton we stayed in a rooming house, I remember. Or they'd have a family picked out, and say, 'You can go to 24 Dearborn Street.' Accommodations in Negro neighborhoods could be lousy—with bad food and a lot of bedbugs. But being young, we didn't care. We were having a ball on the road."

During those first days on the road, there was no time to get to know those cities. Ethel would often leave one place in the morning, arrive in another in the afternoon or the next day, and then be ready to go on that night. After that performance, there might be parties and get-togethers, and some carousing. The musicians were always ready to meet the local girls. And there might be scrapes with the law. But by the next morning, everything would have to be worked out, and everyone would have to be packed up and ready for the next move.

While the company was in Pittsburgh, Lester Walton arrived from New York. From there, he traveled with the Troubadours, publicizing them, serving as an advance man and road manager, making sure theaters were in order and money was paid, and then setting up new engagements and accommodations as they went along.

Around Christmas, the troupe appeared at the Lincoln Theatre in Louisville, Kentucky, and then on New Year's Day, at the Booker T. Washington Theatre in St. Louis. Located on a cobblestone street at 23rd and Market, the Booker T. Washington was promoted as the "home of Mirth, Music, and Merriment." Like the Standard, the Booker T. Washington held memories for another rising star, soon to be a rival of Waters. The young Freda J. McDonald, daughter of a washerwoman and a father she didn't know, had sat in this theater—sometimes playing hooky from school to do so—observing great colored acts, longing for some of the magic to rub off on her. Her first appearances as a teenager were here at the Booker T. Washington. Then she ran off with a colored troupe. Later known as Josephine Baker, she became a major star. But when Waters performed at the Booker T. Washington, she knew none of this. The main thing on her mind was to give the audience a raucous good time. "Congratulations on your wonderful show," C. H. Turner, the manager of the theater, quickly telegraphed Harry Pace.

In mid-January, Waters arrived in Chicago for appearances at the

Grand Theatre. Full of clubs, theaters, and innovative, ambitious musicians, Chicago was then a major music center for African American performers. One of the first stops of Blacks from the South on their Great Migration odyssey, the city had more than 150,000 Black residents in 1920 and was sometimes called the Promised Land. All the big names passed through at some point. Success there was as important as making it in New York. Performances at the Grand not only held the promise of luring in big crowds but also of greater record sales for Black Swan. Lester Walton had come to town early, on January 3, 1922, to prepare for the engagement and drum up some press. Black Swan pulled out all the stops. An ad in the *Chicago Defender* on January 14 announced the big event:

One week only—Starting Monday, January 16 . . . Walton & Pace present the Black Swan Troubadours featuring Ethel Waters—World's Greatest Singer of Blues and Her Jazz Masters, New York's Leading Exponents of Syncopation. Also Ethel Williams and Froncell Manley in a whirlwind Dancing Specialty. Grand Theatre, State @ 31st, Chicago, Nightly at 8:30.

Ethel spent some time with blues singer Alberta Hunter, with whom she had become friendly and who was briefly under contract to Black Swan before moving on to Paramount Records. At the age of twelve, this Memphis-born daughter of a chambermaid and a father who was a Pullman porter had run away to come to Chicago where she had heard that singers made $10 a week. Small, pixieish, but also feisty, Hunter started performing in a honky-tonk that was little more than a brothel where sporting people came for entertainment. Afterward, she moved from one club to another, working her way up the entertainment ladder. With hits like "How Long, Sweet Daddy, How Long?" she personified the sexually assertive young woman but also the vulnerable one whose heart could so easily break. "When she sang the blues," Eubie Blake said of Hunter, "you felt so sorry for her you would want to kill the guy she was singing about." In 1923, she would write the Bessie Smith hit "Down-Hearted Blues," which sold some 800,000 copies in less than six months. "Made me a little change, too," Hunter said, referring to her royalties for the song. Like Wa-

ters, she also gave Sophie Tucker lessons on how to put a number across, in this case "A Good Man Is Hard to Find." And in the late 1920s, she would board an ocean liner to sail to England to appear as Queenie opposite Paul Robeson in *Show Boat* on London's West End. In a career that would span seven decades, Hunter appeared throughout the States and abroad and worked with such stars as Louis Armstrong, Sidney Bechet, Fats Waller, and Lil Armstrong.

One evening, Waters arrived with Ethel Williams for a dinner at Hunter's apartment on Prairie Avenue. The night had to be an unusual one for Hunter because she was hardly known for giving dinner parties. Most likely, Black Swan's publicity people had a hand in the evening. What could be better promotion than the idea of two Black Swan performers breaking bread with a group of friends during their downtime? What was not reported, however, was that also in attendance was Carrie Mae Ward, who was then Hunter's live-in girlfriend.

Waters and Hunter appeared to be relatively open with one another about their same-sex relationships. Show business was full of such liaisons, but they had far different attitudes about appropriate behavior with one's companions. For the sedate and reticent Hunter, discretion was of the utmost importance. Ethel, however, had other ideas. If one of Ethel's girlfriends did something that annoyed or even mildly bothered her, she didn't waste any time in letting her know it, and she didn't care who was around to hear her. Hunter cringed on those occasions when Ethel publicly got into fights with one of her girlfriends. "What will people say?" Alberta would ask. No doubt Waters' response would have been something along the lines of: "What the hell do I care what some son of a bitch might say!" Waters' attitude was similar to that of Bessie Smith. Yet both Bessie and Waters kept such public displays confined to show business folk.

Though Waters probably felt comfortable around Hunter because of their mutual sapphic preferences, she would have an off-and-on, occasionally turbulent, friendship with Alberta Hunter for years. Sometimes Waters was agreeable and fun. Sometimes she could even be kind and would invite Hunter to stay at her home. But other times, as Hunter later revealed, Ethel was short-tempered, even mean. And always, she called

the shots. She believed Alberta was talented and consequently accorded her a certain respect, but the queenly competitive Ethel already knew that Alberta was not in her league. For her part, Hunter harbored no illusions of grandeur. She knew she was no match for Waters. Or Bessie Smith. But in 1922, Hunter felt a professional rivalry, and many believed that Hunter "was disenchanted with Black Swan for doing so little promotion of her records in contrast with the big buildup it was giving Ethel Waters."

THE GRAND BOOKING was another hit. "The work of the Black Swan Jazz Band is worth the price of admission," the *Chicago Defender* exclaimed on January 21. Afterward Ethel and company were held over "by popular demand" for a second week. But before the engagement ended, Ethel was faced with a problem that threatened to close down the tour. Following the next engagements in the Midwest, Lester Walton and Pace had added Southern cities. Pace wanted to make inroads into this important market, those Southern Black belts where Black audiences were in need of entertainment and more records might be sold. But four of the tour's musicians—Bushell, the Aiken brothers, and Charles Jackson—balked about the new schedule. In 1920, fifty-three lynchings had been reported. In 1921, fifty-nine were counted. "In those days," recalled Bushell, "you went South at the risk of your life. It would be very uncomfortable, very miserable touring the South then. So many incidents occurred. You weren't even treated as a human being."

The situation reached a crisis when the four men decided to drop out of the tour. A meeting was called with the entire company. Naturally, Lester Walton was the man in charge who all the guys looked up to, but at a crucial point, Ethel stepped forward. She let the musicians express their feelings, then she pointedly asked the rest of the company if anyone else wanted to leave the tour. No one else responded. Waters ended the discussion by telling the musicians that she understood that traveling in the South could be treacherous, but that was not going to stop her from taking her music to her people. "She felt it her duty to make sacrifices," the *Chicago Defender* reported, "in order

that members of her Race might hear her sing a style of music which is a product of the Southland." Afterward four new musicians were hired. The publicity following in the wake of the musicians' walkout worked to Waters' advantage. The Black press was now ready to depict her as a fiery young woman—a Race Woman—who was doing something for the Negro and who wouldn't be held back from anything because of some dimwitted crackers below the Mason-Dixon line. "Ethel Waters is on her way Southward," wrote the *Chicago Defender*. "She has made up her mind to appear before Colored audiences in Dixie, and says it will take more than members of her company to quit before she changes her mind about visiting the Southern states."

The blatant racism of the South was no different than it had been when Waters first traveled with the Hill Sisters, no different from the time of that automobile accident in Birmingham. But it was a fact of life she had to work her way around. She'd fight when she had to, but she also knew which battles to wage.

Afterward, the company hit the Orpheum in Gary, Indiana, and Emery Hall in Cincinnati; followed by the Palace Theatre in Memphis; then on to Pine Bluff, Arkansas, for two days; then Little Rock, Hot Springs, and Fort Smith in February. Bookings in Oklahoma—Muskogee, Ardmore—followed. Then it was on to Texas—Paris, Fort Worth, Waco, Dallas, Austin, Galveston, and Houston. In parts of the South, she saw glimmers of change. Shortly before the group arrived in Paris, Texas, a lynching had occurred, and everyone was obviously tense and anxious. The hardest thing was that none of the Troubadours could really say anything or openly protest. Yet the whites they encountered in Paris seemed cordial and friendly. The Troubadours even performed at a dance attended by both white and colored. In Houston, the Troubadours were stranded. Nothing new about that for showbiz folk, but they got out of the city safe and sound.

For Ethel, a significant sign of some change in the South occurred once the tour reached New Orleans in April for a week's engagement at the Lyric Theatre. "It has been voted the cleanest and strongest company of vaudeville performers offered at the Lyric in a long time," wrote the *New York Age* on April 29, 1922. Waters broke attendance records at the

theater. So much talk about the troupe spread that one of the city's big daily papers, the *New Orleans Item*, invited "the company's star and its jazz band to go to its office on Friday night and have their work radio phoned all over the city and the surrounding territory." With Henderson and the Jazz Masters, Ethel would be broadcast over WVG radio. This fast-growing medium of radio was already proving important to performers. But African Americans would have a long struggle to get a foothold in the medium. Thus the invitation to perform on WVG was surprising. So, too, was the behavior of the station's representative. Members of the band entered through the back of the building into the studio, but Waters and Lester Walton were led through the front entrance.

For Ethel, the experience of standing before the "live" mike had to be reminiscent of her first day in the recording studio. The radio technician had to position her. Someone else had to explain what her cue would be. Another had to indicate when she should go soft with the volume, when she should turn up the heat. Again she had to imagine the audience out there. No matter how good she was, there would be no applause. If she fell flat on her face, there would not even be any boos. And whether she liked it or not, felt comfortable with it or not, she would be playing on the "white time," which meant mainly for white listeners, not Black ones. No doubt her nerves were on end, but whatever her fears or anxieties, she, Henderson, and the guys in the band were ready for their cue. With this first appearance, she learned—quick study that she always was—to work in yet another new medium.

The next morning, Ethel woke up to see that the *New Orleans Item* ran a front-page article, informing its readers of the way Waters and company had "stirred" radio fans. "The concert was heard in five states and in Mexico and thousands of radio fans listened to a colored girl sing through the air," the *Savannah Tribune* reported. "Miss Waters, who has broken many records on this trip, adds another star to her laurels by being the first colored girl to sing over the radio." On that Saturday night, Ethel and the others were invited to be guests of honor at a special event in the Red Room of the city's Astoria Hotel.

While in New Orleans, Henderson almost signed up a new member for his Jazz Masters. "I heard this young man playing trumpet in a little

dance hall," Henderson recalled. "I decided that that youthful trumpeter would be great in our act. I asked him his name and found he was Louis Armstrong. Louis told me that he would have to speak to his drummer, because he couldn't possibly leave without him. The next day, Louis was backstage at the theater to tell me that he'd have to be excused, much as he would love to go with us, because the drummer [Zutty Singleton] wouldn't leave New Orleans."

From New Orleans, Waters and company continued on to Birmingham, then to stops in Tennessee and Georgia. While in Macon, Georgia, Ethel witnessed a shocking incident that turned her stomach and made her realize the South could still be a treacherous, deadly place. Shortly before Ethel's performance, the body of a young Black boy was dumped in the lobby of the theater. He had been lynched because he had "talked back" to a white man. "They threw it there to make sure many Negroes would see it," she said. She spoke to the boy's family, and later she relived the horror of seeing that lynched boy's body to give emotional definition to one of her greatest songs, Irving Berlin's "Supper Time."

THE COMPANY TRAVELED ON—to Columbia, South Carolina, and then the Academy of Music in Wilmington, North Carolina. In these cities, neither fans nor the Negro press had seen anything like this show. "Ethel Waters and her jazz masters have come and gone but their memory will linger for months," wrote Wilmington's newspaper, the *Dispatch*. "The Black Swan Troubadours played an engagement at the Academy of Music last night and were so much better than had been expected [that] the crowd was left wide eyed and gasping with astonishment and delight for the company has class written all over it." The *Dispatch* added: "Ethel Waters' blues numbers closed the program and with her jazz masters under perfect control and rendering jazz music that is only possible with Negro artists, she backed all colored competitors who have ever appeared here completely off the boards. The Waters aggregation is in a class to itself. It is so much better than other colored shows that have appeared here that a comparison is unfair to others." Also singled out was Ethel Williams, who was called "a dancer of more ability than two-thirds

of those who have ever played Wilmington. Her act, including shimmies and shivers, is done with Roscoe Wickman and it sent [the] crowd into paroxysm of the wildest delight. . . . She lifted the audience up and up until it literally overflowed with delight." Such praise simply confirmed what most on the tour knew, that Williams was a gifted artist who had regained her confidence.

From Wilmington, the company moved on to Norfolk and Richmond, to Baltimore, and the Howard Theatre in Washington, D.C. By the end of June, Ethel was once again at the Standard in Philadelphia. By July 1922, everyone was back in New York.

FOR ETHEL, it must have seemed as if the tour would never end. Other times, especially now that it was over, she must have felt that everything had rushed by too quickly without time to reflect on it or her life. But the Black Swan tour had altered the way she viewed herself. On the tour, she had been cheered, celebrated, adulated, and adored by audiences and the Negro press. Not only did she pack in the crowds but her records continued to sell. For her, there had been the thrill of performing, entering onstage to applause and then knocking the folks dead with her music, surprising them when she might dance, delighting them when she had a funny line or two to say. At age twenty-five, she was beginning to understand the range of her talent, the possible scope of her imagination. In those cities and towns, she could look out from the stage at those people up in the balconies who had saved their pennies to come see her—as well as the big shots who sat in the front rows. She loved it all. The audience in turn loved her right back and could always tell that she was giving them everything she had. The energy and wild enthusiasm were all there. Thus a legend was developing that would take hold within a few years and into the following decades: Ethel Waters looked as if she might be one of the great live performers of the twentieth century. Some recording stars, some movie stars, even some radio stars might be disappointing when standing before a large live audience, when there was no script to guide them, when there was no chance to redo a number or reshoot a scene as one could in a record-

ing studio or on a movie set. But that was never the case with Waters. Great entertainers have to love the audience; in a sense, they have to live for the audience. That was now happening to her. Even at this early stage in her career, every person who ever saw her live in a club or theater would find her unforgettable. Waters was most at home before an audience, most alive, most composed, most confident about herself, most willing to do absolutely anything to ensure that the people out there got their money's worth. At the end of the tour, Ethel Waters was exhausted but also ecstatic. She knew she wanted a career.

Yet, ironically, when she returned to New York, she discovered she was almost back to square one. The city had its own demands, its own standards, its own status symbols. But the important producers and the managers of the major nightclubs still considered her a low-down trashy honky-tonk singer, not much more. She also no doubt knew that a career in vaudeville might not mean what it once did. Those theaters where she had played had often shown movies, which Waters understood would emerge as the dominant form of entertainment for most of the twentieth century. Yet she was a colored girl. Could she realistically envision movies as part of her future? Broadway, however, remained vital—and might provide her with a forum. The success of *Shuffle Along* had given Waters and the rest of the Negro showbiz community hope that Broadway would toss down the welcome mat for Negro talent. That was the great dream: to make it on that Great White Way. The white producer Morris Guest, who first saw her perform in Atlantic City, had approached her about appearing in a white show on Broadway. The agent Jack Goldberg had wanted to represent her. The Selwyn brothers also expressed interest in her. But Ethel herself was conflicted about her goals as well as her aspirations to perform on Broadway. Even now, as popular entertainment was offering more opportunities for colored performers, she did not want to appear in white shows or nightclubs with mostly white patrons sitting there. She still preferred Negro entertainment—mainly for Negro audiences, *her people*. Though whites had come uptown to hear her at Edmond's and had attended some of her shows on the Black Swan tour, she was a colored star who did not give a hoot about crossing over. The downtown whites at Edmond's had come uptown to her turf—she had

not gone to theirs. That might have to change, however, if her career was to move forward. Still, she was not ready to make that move.

But a young Black man, who had heard her at Edmond's, had kept his eye on her, and had aggressively sought a friendship, was confident that she had the talent to make it on what was known as the "white time"— working in theaters or clubs where most of the clientele was white. That young man, an entertainer himself, was Earl Dancer, who had already been dismissed by Waters time and again. But, finally, it would be Dancer who persuaded Waters to take the leap into the next phase of her career.

# Back in the City

S HE TOOK LITTLE TIME OFF. Black Swan made sure of that. The Pace Phonograph Company had moved up in the world. Having relocated the offices from Harry Pace's basement to a new building the company bought at 2289 Seventh Avenue—with a recording facility and a pressing plant in Long Island City—Harry Pace and his staff knew that Ethel's hits had built this company. Black Swan was now recording other artists and other musical genres: opera, choral groups, and symphony orchestras. Harry Pace's dream of a Black record company that had product not only for the Negro masses but also for the educated Black middle class—and some white record buyers as well—looked as if it were about to come true. At her first session in July, Waters cut four new songs: "Jazzin' Babies Blues," "Kind Lovin' Blues," "Georgia Blues," and "That Da Da Strain." Backing her on the last recording were musicians Joe Smith on cornet; George Brashear on trombone; Fletcher Henderson on piano; and possibly Clarence Robinson on clarinet. At another session a few months later, around October, she made two more recordings, backed by the same musicians: "At the New Jump Steady Ball" (a remake of the song she had originally recorded for Cardinal) and "Oh Joe, Play That Trombone." Of all these songs, "That Da Da Strain" became the big hit. Ethel remained the undisputed queen of the label.

Her career was now built significantly but not exclusively on her recordings. Not only did the records bring her hefty royalties, but they also led to other bookings and assured her of headliner status in her personal

appearances. The two went hand and hand, one feeding the other. For later generations, this type of recording-tour promotional strategy would be taken for granted: a big tour would usually follow the release of a new album or CD. But in the 1920s, this was relatively new to Black recording artists. Ethel was also said to be one of the first Black performers to actually earn royalties. Often performers simply received a flat fee for their work. During the Great Depression, when Bessie Smith was making her last recordings, she asked producer John Hammond, "Ain't I gonna get no royalty?" He replied: "I'm afraid there's no room for a royalty."

Ethel understood, however, that it was important not to waste time between the recording dates. Therefore she maintained a busy schedule of engagements at theaters. Soon she was in musical revues and then back on the road. Many producers of Black shows never considered Broadway their goal. Instead their productions could be performed at Black theaters and turn something of a profit. Any number of new comedies, musicals, and revues were in and out of the Lincoln and the Lafayette. The same was true in other cities. Before the success of *Shuffle Along*, writers Flournoy Miller and Aubrey Lyles had created shows for the Pekin Theatre in Chicago. So had a talented, well-respected composer like Will Marion Cook. Because Black audiences were hungry for shows with Black entertainers, far-fetched comic skits, and language and points of view they could identify with, Black shows could tour the country just like the vaudeville acts and make money. Producers such as Lewis Rogers and creative talents J. Homer Tutt and Salem Tutt Whitney threw together traveling shows that reached Black audiences in cities everywhere from Boston to St. Louis and in parts of the South. Though Black entertainers were glad to get the work, such shows could be murder for the entertainers. Production values were low. Sets could be tacky; costumes, worn and dreary. Schedules were hectic. Traveling itself, especially in the segregated South, was still maddening. But Ethel, ever the realist, knew this was meat-and-potatoes work. She just shrugged her shoulders and went about the business of getting into such shows and entertaining the colored masses. Besides, for her there was now the pull and the power of the audiences themselves.

Following the Black Swan tour, she joined the cast of a revue called

*Jump Steady* at the Lafayette Theatre. Little more than a collection of skits and musical numbers, *Jump Steady* featured Waters singing and also performing comedy bits. That same year, she was approached by the two high-rolling producers in the Negro theatrical market, J. Homer Tutt and Salem Tutt Whitney, to appear in their revue *Oh! Joy!* Their plan was to open the show out of town and eventually take it to Broadway. Though pleased to headline in what might be a classy show in New York, Waters turned the offer down because she knew Tutt and Whitney's first choice had been singer Sara Martin, whom Waters liked. But the two men were persistent in urging her to agree to do the show. Finally, she asked for more money than she thought they would pay her: the hefty sum of $150 a week. As would so often happen in the future, the producers surprised her by meeting her demands. "However, there is a bad angle to this," Waters recalled. "I would always have to go out there and work my head off—so I wouldn't feel guilty and a thief." And before signing Ethel to the agreement, the producers also had to provide a part for Ethel Williams.

Their relationship was as strong as ever and continued to be productive for both. The two might argue, but they understood each other: they were almost able to read each other's minds, to anticipate each other's moods. The women also felt comfortable enough to reveal their vulnerabilities to each other, or at least not to hide them. Working and traveling together, they had shared experiences, and each was ready to come to the other's defense. Neither, however, apparently thought of theirs as a lifelong commitment. It would be hard to say if this was Waters' most satisfying relationship, but most likely it did give her a stability she had long craved.

For *Oh! Joy!* Waters created a comedy routine for the two of them which she always enjoyed and used on numerous occasions. Soon after the curtain rose, Williams was seen alone onstage, asking the orchestra leader, "Where's that Ethel Waters?" Shortly afterward, Waters would sashay onstage, dressed in gingham and a funny hat. Thereupon Williams would ask, "Are you Ethel Waters?" "Well, I ain't Bessie Smith." Audiences usually howled over the entrance. The comic dialogue was Waters' way of paying homage to Bessie. She was both associating herself with and distinguishing herself from the Empress. She was now a star in her own right. Aside from the comic bits, Waters performed her Black Swan

numbers, which, of course, proved the high point of the evening. Other acts—the standard comics, dancers, singers—would also appear.

*Oh! Joy!* met with problems during its run at the Arlington Square Theatre in Boston. Basically, *Oh! Joy!* was a weak show that failed to draw an audience. Money was so tight that the producers didn't know if they could keep the revue running. Because they could pay her but not the rest of the cast, Waters agreed to take a salary cut. But later she learned that the producers had also met with the rest of the cast and explained they couldn't pay them because Ethel was demanding her entire paycheck. That didn't win Waters any new friends backstage, and it certainly didn't endear the producers to Ethel.

In Roxbury, outside Boston, Ethel was in a car accident when the vehicle she was riding in slammed into a truck. She was left with a small scar on her face, but, fortunately, she had no serious injuries. She dropped out of the show, but once she had recuperated, Tutt and Whitney wanted her back as they headed to a New York opening. Ethel weighed the offer, but the breaking point occurred when the two men informed her that because no Broadway theater was available, they had decided to convert the Van Kelton tennis stadium into a theater. They rented a large tent for $1,000 and set it up in the stadium. Inside the tent, they installed a stage for $2,000. New York's newest theater was called Bamboo Isle. Waters was assured by the producers that Bamboo Isle would be a novelty that audiences would rush to. "It ain't no novelty to me," she told them. "The days when I worked in a tent are over forever. I slept with the horses for the last time, I hope." She severed her ties with the production. *Oh! Joy!* did have its New York opening, in that large tent no less. But the musical didn't fare well.

Afterward Ethel accepted an offer to do a TOBA tour. Then came the musical *Dumb Luck*, another hodgepodge entertainment piece with skits, sketches, songs, and dances, all loosely tied together, with music by the young writers Donald Heywood and Porter Grainger. *Dumb Luck* headlined Ethel in a large cast of 93 performers that included Alberta Hunter, Cleo Desmond, Boots Marshall, Lottie Tyler, Ethel Williams, and an actress named Edna Scottron Horne, the mother of a little girl who would grow up to become a major star and a chief Waters rival, Lena Horne. But

*Dumb Luck* was another half-baked, ill-conceived production that ran into money problems. Shortly after an early September opening at the Lyceum Theatre in Stamford, Connecticut, *Dumb Luck* folded. "The show was lousy, so they closed," Alberta Hunter recalled. But worse, the producers gathered the cast and informed them that there was not enough money to pay their salaries or even to get cast and crew back to New York. Ethel was so angry, Hunter recalled, that she gathered all the costumes and then sold or pawned them. Her intention was to buy train tickets back to New York for the cast and crew, but Waters became annoyed by someone else. No one could say for sure. Hunter always believed that Ethel became upset because of the affection that Hunter had won from the rest of the cast. That may have been partly true, but it also may have been wish fulfillment on Hunter's part. Still, all anyone knew, according to Alberta Hunter, was that in the end, Waters bought only two train tickets: one for herself and the other for Ethel Williams.

Other tours followed. The next year—1923—she set off with the Rabbit Foot Minstrels, this time traveling through the South with such acts as Big Joe Williams and the Birmingham Jug Band. Then came appearances at New York's Lafayette Theatre and the Alhambra Theatre and then another tour as a headliner, backed by Fletcher Henderson.

Assuming new responsibilities, she decided what songs she'd sing and which skits she'd appear in—skits that she herself often wrote. As it turned out, she enjoyed comedy. Drama would have appealed to her more, but there was no place for it in these traveling shows. For her comedy bits, she liked the down-home bandannas and frumpy gingham. But for her big musical numbers, unlike the old days when she had to grab whatever she could find at the rummage sales, she now hired dressmakers to create stylish, sophisticated gowns. Usually, she preferred full-length slinky dresses that showed off her long, sinuous form and her curves. Throughout each evening's performance, she seemed to relish the idea of transformation: going from old-style backwoods Southern funny gal to new-style, high-flung, sexy urban diva. The makeup was heavily applied with an emphasis on the expressive eyes and mouth and the rich brown coloring. Yet it was never overdone and, offstage, never overly theatrical.

The tours were long and draining, and this in turn made Waters all the more demanding of herself and everyone else around her. By now, word of her temper preceded her: most of the people who worked with her had heard about it even before rehearsals began. If something went wrong or didn't meet her standards, everyone had to be ready for one expletive after another. Then, too, the traveling, the climate changes, the constant performances themselves—several shows a night—began to affect her voice. Her throat might be dry or itchy. Sometimes she had to let her voice rest—and so no doubt there were occasions when she wouldn't speak much offstage, going on voice alert to protect her vocal cords.

What concerned her most, though, was to have the best background sound and support, especially from the musician at the piano. Fletcher had become more adroit at understanding her needs, and though she still argued with him, ultimately, he gave her what she wanted. But by 1923, Fletcher had formed his own band and had his own traveling schedule. Much as she might have wanted to take him for granted, she knew she couldn't. In search of the right pianist to travel with her on those long frantic tours, she tried out various accompanists. Then in New York, while in preparation for an engagement in Chicago, Ethel hired a young African American pianist named Pearl Wright.

At first glance, Wright's personal style and demeanor, much like Fletcher Henderson's, appeared totally different from Ethel's. Having grown up in Georgia, the daughter of a Negro politician named W. A. Wimberly, and a graduate of Atlanta University, Pearl had married a physician named Wright and was the mother of two children, Kathryn and Vivian. But her marriage had failed. To support herself, Wright taught at Jackson Baptist College and later in Nashville. In 1922, she moved to New York for further study. Though she might seem the typical bourgeois young woman, one of those dictys, Wright was adventurous and ready to do all she could to escape a staid existence. Apparently, being a doctor's wife was not what she wanted, nor was she interested in the settled life of a schoolteacher, although stability of some sort was important to her because of her children. She liked the fact that the job with Ethel meant varied experiences that would pay more than she would have earned in the classroom.

Wright also had the right temperament to work for Ethel: patient but no doormat, sensitive, nonjudgmental, with a good sense of humor. Here was someone Ethel could talk to, laugh with, confide in. Wright would see Waters both on and offstage with Ethel Williams, would ultimately be privy to Ethel's ongoing, tangled relationships with Momweeze and Genevieve. Pearl would witness Ethel's high-strung moments and her mellow, vulnerable ones, would know more about the professional woman and the private one than most people. She came to understand the foul moods and to expect the foul language. Wright also saw the ferocious religiosity of Waters, who often seemed puzzled why the good Lord had let so many evil people inhabit the earth. Wright, like Williams, saw it all. Yet Wright would be discreet in discussing Waters. Though it would be expensive for Ethel to hire Wright full-time—to put her on a weekly salary, to assume her traveling expenses when she was on the road, to also pay her during those downtimes when Ethel was not performing—Ethel decided to go the distance. Never regretting that decision, she and Wright became close friends and allies.

Most significantly, on the road and in the recording studio, Pearl Wright was the consummate professional who could be depended on to produce the kind of sound that, as far as Ethel was concerned, Fletcher had only on his best days, after much prodding. Wright's piano accompaniment proved perfect: Pearl Wright's touch heightened Ethel's vocals, gave them breathing space, underscored the clarity of her voice and the precision of her diction, and took the proper pauses on dramatic build-ups, going strong on emotional climaxes. On her own, during the musical introductions or during interludes when there were breaks in the lyrics, she syncopated in a delightful, skilled way. Though strong enough on her own, she never overstepped and certainly never overpowered Ethel. Singer Etta Moten observed that it was always Pearl who was "ever in the background with firm but inconspicuous support on the piano, who knows when Waters is going to wait longer than usual to sing the next word." Wright was there to serve the queen, not usurp her throne. It proved an ideal combination.

She also established a friendship with Williams and let it be known that she was not a threat to Williams' relationship with Waters. No doubt

she became aware of Williams' self-doubts and her need for support. She also understood that at times Williams needed someone to talk to about Ethel: someone to gripe or complain to, someone to compare notes with about what motivated Waters, what upset her, what had to be done to calm her down.

Over the years, Waters and Wright, along with Ethel Williams, shared rather typical vaudeville experiences: dealing with tough club owners and theater managers; maneuvering their way around horny men who'd had too much to drink or smoked too much reefer; rushing to make trains or hop into the company car to keep schedules; demanding that equipment and lighting and sound systems were in top-notch working condition. Wright also understood when she had to recede into the background to give Waters and Williams their private space.

From then on, Ethel and Pearl remained exceptionally close. Ethel came to depend on Pearl to handle a number of her business affairs: getting her income tax returns in order; sending photos to the fans, sometimes acting as her trusted secretary. When money was pouring in, Ethel was often charitable. Pearl was around to select families in need of help. In turn, Pearl could count on Ethel, in good and tough times. One Christmas when work was slow, Ethel told Pearl: "I know you want to send your kiddies something. Take this fifty dollars." Later Pearl learned that Ethel had pawned a watch in order to help her. She never forgot it. In some respects, Pearl, precisely because of her middle-class background, was the kind of woman Ethel would always best relate to. When it came to the men in her life, she preferred the slick, highly sexed smooth-talkers with a street sophistication, who had educated themselves through their life experiences, not necessarily by reading books at college. With the women in her life, Ethel seemed to gravitate to more refined types, attractive, rather ladylike but not prissy, educated and cultivated, with a knowledge, whether basic or formal, of literature and the arts and of the social scene, too: women she could learn from. Ethel Williams possessed some of those qualities, especially the ability to mingle easily among the various echelons of show folk. So, apparently did Pearl. Both women helped give Ethel's life a balance that she needed, and each woman was remarkable in her own right. Together, the three made a pretty good team.

\* \* \*

IN MARCH 1923, the Pace Phonograph Company was formally renamed the Black Swan Phonograph Company. That same month, Ethel—with the Jazz Masters—recorded five new songs: "Brown Baby," "Memphis Man," "Midnight Blues," "Long Lost Mamma," and "Lost Out Blues." Though she may not have known it at the time, these would be her last recordings for the Black Swan label. With its expansion, Black Swan looked as if it was more successful than ever, but the company was in serious trouble. Though Black Swan had been selling seven thousand records a day, its plant could press only six thousand daily. Three additional presses had been ordered in 1923, but before "they were set up and ready for running, radio broadcasting broke and this spelled doom for us," said Pace. "The Black Swan Company had a big moment in the sun," said W. C. Handy. "Then the competition became too swift. The Paramount Record Company and others pressed millions of records of this type through their enormous laboratory facilities, and while they were on the toboggan slide the Black Swan was doomed. The vogue passed and others folded as radio became a reality."

"Immediately dealers began to cancel orders that they had placed, records were returned unaccepted, many record stores became radio stores," said Pace, "and we found ourselves making and selling only about three thousand records daily and then it came down to one thousand, and our factory was closed for two weeks at a time, and finally the factory was sold at a sheriff's sale and bought by a Chicago firm who made records for Sears & Roebuck Company." Competition from radio may have been a factor in Black Swan's ultimate demise. But recordings at other companies continued to sell well, and Black Swan had to deal with competition in signing major Black talent as blues music became more popular. The large white companies were on the prowl, snapping up blues stars, eager to make huge profits off the women. In 1923, Bessie Smith signed with Columbia. By 1924, Paramount signed performers like Ma Rainey, Ida Cox, Trixie Smith, and Edmonia Henderson. The future looked bright for these singers and for the labels that recorded them. But Black Swan's bright days came to an end.

In December, the company declared bankruptcy. Several months later, Paramount announced that it had purchased Black Swan and would carry the Black Swan catalog on its label. For a time, Ethel's music was released on the Vocalion label, then Paramount. For Ethel, the demise of Black Swan marked the end of an era, short as it had been. She never forgot that Mr. Pace had given her the opportunity to make a name for herself and set her career in motion, but she no longer had a record company she considered her home base.

HER LIFE CHANGED in another significant way when she arrived in Chicago with Pearl and Ethel for an engagement at the Monogram Theatre. There, she ran into Earl Dancer, the dapper twenty-eight-year-old young man she had met in New York and long avoided. A man of many faces, Dancer had lived fast and hard, always on the go, always looking for the next outlet for his energies and his ambition. Born in Houston, Texas, around 1896, the son of John and Eliza Pruitt Dancer, Dancer—an extroverted and likable egotist—enjoyed boasting of his lineage. He came from a family—which was "mostly Cherokee Indian, yet tinged with Black and white blood"—that had high standards, which Earl, his brothers Maurice and Johnny, and his sisters Olga and Lillian, were raised to meet. Indeed, theirs was a solidly middle-class, well-tutored family, although Earl looked as if he was rebelling against it. His devout mother had visions of Earl becoming a minister. While still a boy, he was sent to live with a pastor and his wife in San Antonio. A very young Earl quickly learned that those who preached the good book didn't always live by it. Dancer never specified how he was disillusioned by the minister, but he did not stay in San Antonio long.

Smart and good-looking, he must have taken stock of himself to figure out what he could do best and what he would enjoy doing. He had a lyrical tenor voice that he decided to put to use. Before long, he made his way to Fort Cheyenne, where he became the soloist for the 9th Cavalry. There he also became a favorite of the unit's Colonel Young and soon was a member of the Young household. But by 1911, the fifteen-year-old Dancer moved to Denver. Performing at a theater there, he contracted

pneumonia, was hospitalized, and afterward was sent to Saltillo, Mexico, to recuperate. The pneumonia had robbed him of the upper range of his voice, but he performed nonetheless at the city's American club until the Great War broke out in 1914. At that point, he visited his mother, who was then living comfortably in Los Angeles with his stepfather, the attorney Fred Mason. At his mother's urging, he went back to school and later enrolled at the University of Southern California. But he grew bored with his studies and left after seven months.

His next stop was San Francisco's Barbary Coast, where he performed at a club called Purcell's. By now, Dancer, much as he liked being onstage, also enjoyed working behind the scenes—making deals, giving orders, arranging schedules, schmoozing with big shots. Becoming the manager of the house around the age of twenty-three, he transformed Purcell's from a local favorite into a well-known establishment that became the "ultimate" destination for show folk and tourists. One evening, the dancer Cora Green—talented, popular, and attractive—stepped into the club, took one look at the dashing Dancer, and liked what she saw: his style, his smooth way of talking, his drive. "He was very handsome," recalled the actor Lennie Bluett, who knew Dancer in Los Angeles. "Café-au-lait-colored with wavy New Orleans–style hair. He could have passed for Mexican or Brazilian." Dancer never wasted time. Apparently, neither did Cora Green. Before anyone knew it, Dancer and Green were a team touring in vaudeville. Becoming headliners on the Pantages circuit, they opened with twelve weeks in Los Angeles, and for a year, shuttled back and forth across the country for performances in New York, Boston, and Philadelphia.

In New York, Dancer first saw Ethel in high gear at Edmond's. Having gone to the club with a buddy, the dancer Louie Keene, he watched her from afar, struck by her talent and charisma as well as her brazen sexiness. "We heard Ethel singing the most suggestive song I had ever heard, even in my Barbary Coast days," he recalled. "The song was 'I'm Trying to Teach My Man Right from Wrong.' Ethel sang it as only Ethel Waters can sing a song. At Edmond's she topped off the song with a shake dance number that would put the present-day shimmy queens to shame." Dancer, however, was not yet ready to make himself known to her. Perhaps he was

biding his time. Then came the night in December 1920 when he finally met her.

"One evening after we had finished our performance at a neighborhood theater," recalled Dancer, "Cora suggested that we catch the opening of Ethel Waters and Ethel Williams at the Libya Cabaret, then located at 138th Street and Seventh Avenue. I was thrilled by Ethel's artistry, especially her dancing. But what impressed me most was her apparent latent talent and ability. Here was a girl, I said to myself, with an abundance of a thing we call 'stage presence,' a complete command of her audience even in her rendition of suggestive songs and her blues." That night, he turned to Cora and told her, "This girl, Waters, given good clean material and competent direction, could develop into a great songstress and a wonderful entertainer." That was the night that he finally met Ethel. "Cora introduced me to her at the Libya. I didn't see Waters for some time after that because Cora and I were booked out of New York."

Everything for Dancer and Cora Green, however, was suddenly cut short when he broke an arm one night while performing, and Cora went back on tour with another partner. There may have been more to the story, but this was the version Earl told. Excited by New York, he scrambled together money from backers to open an all-night club called the Golden Gate Inn. When the cast of *Shuffle Along* came to his club, Ethel arrived with Ethel Williams to find the place packed with patrons, Black and white. Waters had been invited to join in on the festivities by a woman named Eva Branch, who was working as the head waitress at the nightclub. Branch also had a rooming house that was popular with scores of Black stars. "The Golden Gate Inn, along with Baron Wilkin's place and Mal Frazier and John Carey's Nest Club were receiving what we now call a 'terrific play' from the downtown carriage trade," said Dancer. It was the kind of club where all types of lines could be crossed: racial lines, gender lines, class lines. "In my place that night of the *Shuffle Along* party were many Broadway celebrities." It was also one of those nights when entertainers, among themselves, entertained one another. Such nights could be high-voltage, raucous, and good-naturedly competitive. Standing before your peers, you had to be at your best. One performer after another took center stage—while the bootleg liquor flowed and everybody went

wild. Urged on by the crowd, Ethel, who loved competition, stood up and went into song. Dancer remembered that it was "no exaggeration to say that Ethel Waters topped what was unquestionably one of the greatest impromptu shows ever given in Harlem."

"That night I made up my mind," he recalled, "that I would do something about the great talent demonstrated by the young starlet." Dancer finagled a meeting with Ethel to discuss her career and make a pitch for handling her. Overly confident, he was sure a deal could be cut, but he saw that Ethel had other ideas. "In a conference the next evening at Eva Branch's home," said Dancer, "Ethel told me she was booked to play the Theater Owners Booking Association vaudeville circuit." Ethel was letting Dancer know she had work and didn't need him to give her any suggestions. One can imagine how Ethel must have looked him up and down, rolled her eyes—and then turned her back on him and walked away. "It was not until after I had closed the Golden Gate Inn and hit the road as a single in vaudeville that I saw Miss Waters again. I went to Chicago where Clarence Muse, who was manager of the Avenue Theatre at 31st Street and Indiana Avenue, booked my act to play his house. Ethel was booked into the old Monogram Theatre, 35th and State streets. Trevy Woods and I went together to see her perform. After she finished her act, Trevy and I went backstage to say hello. To our dismay, we found a very ill Ethel. I half carried her home and attended her until her indigestion—an ailment with which she suffered through most of our association—was over. I had to leave Chicago for a few days and didn't see Ethel until after her engagement at the Monogram ended. The Sunday night after closing her Monogram run, Miss Waters and Ethel Williams went to the Entertainers, then the South Side's most famous café at 35th Street and Indiana Avenue. Trevy and I invited them to Trevy's all-night spot . . . where we met and joined George White, the producer, and his star, Ann Pennington."

Nothing had ever clicked for them in New York. "I just didn't like Earl at that time. He was intelligent, a sound showman, and he knew the theater," said Ethel. "I'd insult him every time he tried to talk to me." But Dancer was smoother and more sophisticated now, and more persuasive. "He was a guy who had a lot of moxie. He knew where he was going. Or

where he wanted to go," recalled Lennie Bluett. Ethel saw that Dancer knew his way around the clubs, knew how to talk to showbiz folk, knew how to dress. "Very self-assured," said Bluett. "Very dapper too. Always wore real fine clothes. Always New Yorkish with a hat with the brim pulled down at just the right angle. Like Lucius Beebe." At this point, Ethel's feelings about him started to change. In many respects, Dancer was different from the men who had been in her life: her first husband, Buddy, her thuggish boyfriend Rocky, and all those slick sporting men. His middle-class bearings showed, which she rather enjoyed. But, like other men in Ethel's life, Dancer also had a hard-won street sophistication. He had a different way of looking at show business. Performing at Black clubs and theaters for colored folks was fine, but for Dancer that wasn't quite big enough. Many venues were still closed to colored performers, but maybe they weren't so much closed as in need of the right Negro entertainer. Ethel was precisely that kind of entertainer. In his favor was the fact that Earl Dancer also understood one or two things about women. He could pour on the charm. And he could pour on the sex. He knew how to give them that look, letting them know he thought they were hot. But then so was he. Ethel Williams may have been Waters' partner, but that didn't mean Waters and Williams weren't susceptible to the seductive allure of a good-looking guy. In fact, as Dancer must have noticed, Williams was then dating the dancer Clarence Dotson. Both women remained fluid and flexible in their relationship and their sexuality. Never had either stopped seeing men. And Ethel, at least, may have had other women as well.

That night at the club proved to be a breakthrough for Dancer. Ethel had had it with her current manager, and she wasn't satisfied with her act either. Seeing an opening, Dancer "suggested that since her contract was about up that she let me try my hand at shaping her career. Ethel appeared to like the idea, and since she had a few dates with tentative bookings I was fortunate in getting her considerably more money for these dates than she had been receiving under her other management."

Now Dancer did everything he could to get close to Ethel—flattering her, cajoling her, joking with her, flirting with her, and ever ready to kneel before her talent. Shrewdly playing up to her growing vanity, he was willing to concede that she was a queen and he merely her adoring, willing

subject. He now believed they'd be a great team together in an act. He also constantly told Waters that the colored time was not enough. She had to perform on the "white time," had to get bookings at those important white clubs and theaters with the rich patrons on their turf. Now was the time she had to broaden her audience and make the "white time" her turf. But Ethel loved ruling the roost in Harlem and in the big colored spots of Boston, Philadelphia, and Chicago. She would always cherish the way Negro audiences reached out to her, the way they sent those enthusiastic messages of approval and adulation through their wild applause, their laughter, their screams and shouts of joy. No white audience could ever show that kind of enthusiasm.

But Dancer stayed after her. Shrewdly, he also sought to win the approval of Pearl Wright. When Waters and company traveled to St. Louis to appear at the Booker T. Washington Theatre, something worked in his favor. Ethel Williams' relationship with the dancer Clarence Dotson, who had carved out a successful career on the Keith-Albee vaudeville circuit, had become serious. The two decided to marry in St. Louis, where Dotson was performing at the Rialto, the biggest vaudeville house in the city. For Waters, this marked an end or perhaps just a change in their relationship. Perhaps Williams believed it was the right time to embark on a new phase of her life—with a domestic arrangement that brought her a different kind of security. Often the same-sex relationships that women—and men—developed early in their careers on the road came to an end as they grew older. Ethel had turned twenty-seven in October 1923. No one can say for sure how Ethel felt, but at the wedding ceremony in late February 1924, Ethel and a friend, Jovedah De Rajah, "'stood up' with the couple, and after the ceremony the entire party was a guest of De Rajah at breakfast."

Waters' loss, of course, proved to be Dancer's gain. Now he clearly had an opening, and Waters finally agreed to work with him onstage and also to let him manage her career. "After Ethel Williams left," said Dancer, "I, with the help of Miss Waters and the late Pearl Wright, one of the grandest pianists of her time, arranged our first venture together—our vaudeville act. Ethel Waters and Earl Dancer, with Pearl Wright at the piano."

After those early years as one of the Hill Sisters, Waters had not ap-

peared willing to share the stage with anyone save Ethel Williams. Much as she liked and relied on her accompanist Pearl Wright, Wright was precisely that: her accompanist, always remaining discreetly on the sidelines. Fletcher Henderson had learned to do that too. But Dancer persuaded her that they could be a team of sorts. Arrangements were made by Dancer that they would both be represented by the Pat Casey Theatrical Agency. The Casey people were always more interested in Ethel than Earl and urged her to drop him and perform on her own, but Ethel wouldn't hear of it.

What indeed was the secret of Earl Dancer's charms? Frankly, there was much about him that Ethel found hard to resist. There he was, always strutting about like a bold brilliant impresario in search of his empire. Pushing for the top bookings, he could talk the talk and walk the walk, and, significantly, he wasn't afraid of white people. Nor did he kowtow. Playing submissive wasn't his style. That Ethel had to admire. And he wasn't afraid of her either, no matter how much she cursed him out and laid his soul to rest. That, too, Ethel had to admire. He still needed more experience under his belt. But he never let that stop him from making a deal. He loved serving as Ethel's front man. No doubt he had hoped to do that with Cora Green until his accident. But certainly Dancer understood that Green, for all her talent, was not Ethel Waters. Now he was completely committed to seeing Waters' talent have the platform he believed it deserved.

For Ethel, Dancer was something of a dream come true. Dancer would never let a big-time producer or club owner refer to her as a mere honkytonk singer. Ready to work tirelessly for her, he was the ideal PR man, the ideal companion on the road, the ideal fighter for her. Still able to fight with the best of them, she didn't hesitate to let Dancer join her in the battle, to relieve her of some of the stress and pressure so she could concentrate on her performances. Dancer also courted the Negro press, aware of its importance in further establishing Ethel's career. Mainstream media still had little interest in her, but perhaps that would change. In the meantime, he struck up a friendship with writers like Geraldyn Dismond, who wrote long, major biographical profiles of Ethel *and* Dancer for the *Pittsburgh Courier*.

A breakthrough came very soon. Appearing with Dancer in the show *Plantation Days* at Chicago's Grand Theatre, she was spotted by the influential white critic Ashton Stevens of the city's *Herald and Examiner.* As such Negro shows as *The Chocolate Drop,* Sissle and Blake's *In Bamville,* and *All God's Chillun Got Wings* were about to hit town, Stevens decided he "would need a little preliminary exercise in the Darktown drama. So south on State Street to the Grand Theatre I went." There he watched *Plantation Days,* which was yet another compilation of songs, dances, and comedy routines.

On its own, *Plantation Days* was a good show, said Stevens. But with Ethel, it was a great one. He liked her voice but was knocked out by her personality and her "way of sifting a song through that personality with ease, with certitude and with spell," Stevens wrote. "Her ever so slightly comic gestures are as spare and fluid as were those of the lamented Bert Williams, and her enunciation is as clear as a carving. I know a lot of white women highly placed who could go higher on the lyric stage if they went to articulation school with Ethel Waters." Summing her up, he added: "No part of this remarkable young woman—I should without too much chivalry guess her years as twenty-five—is as remarkable as the whole of her. She has the equipment for the life of song and dance; and she has what the little theater folk call the soul also. In her unostentatious way of dramatizing every song she sang, so that you could see as well as hear it, Ethel Waters reminded me of Yvette Guilbert [a popular performer of the time]. She neither moaned, groaned nor raved her 'Georgia Blues'; she only sighed with satanic rhythm. And when she informed Mr. Dancer that 'Mamma Goes Where Papa Goes,' she did it with a wickedness that was beyond the touch of censorship. She is the most remarkable woman of her race that I have seen in the theater."

"AFTER EXACTLY ONE YEAR and three months," said Dismond, Earl Dancer had done the nearly impossible: he had finally "persuaded her to try white circuits." Bookings on circuits like the Keith, the Orpheum, the Pantages were not easy to secure. Vaudeville remained fiercely competitive, and the headlining stars on such circuits were still the white ones.

But Ethel's name was getting around. Those who had observed her at the colored theaters on the TOBA circuit—and who had heard the records and also paid attention to the records' sales—were persuaded by Dancer and the Casey Agency to book her. It was also apparent that whites at those theaters would find her style entertaining. And so Ethel and Dancer played the B. F. Keith Theatre in Toledo; the Palace and the State-Lake Theatre in Chicago; the Palace Theatre in Milwaukee; the Majestic in Cedar Rapids; the Orpheum Theatre in St. Paul; the Orpheum in Winnipeg, Canada. "As Waters and Dancer they played the Orpheum in its entirety. Their act was marvelously received," said Dismond. "The Keith office then booked them East with equal success. Mr. Dancer, at this point, retired from the stage to take over her management." Dismond also commented: "Miss Waters was acclaimed the greatest feminine artist since Aida Overton Walker."

Soon Negro show business circles were abuzz with stories about the two. Everyone knew they had to be lovers, and soon the word was out that the two had married, that the rapaciously bisexual Ethel had settled into a permanent relationship with a man. Waters was mum on the details of a marriage to Dancer, but Dancer never had any problem in letting people think the two were man and wife. For the next several years, he was often referred to in the Negro press as Ethel's husband, and she did nothing to dispel such assumptions.

During this period with Dancer, she saw even more clearly the difference between white and Black audiences. She recalled that "when I first stepped before a white audience, I thought I was a dead duck because no one tried to tear the house down. They merely clapped their hands. Such restraint is almost a sneer in the colored vaudeville world I came out of."

But during this period, she did not stop appearing at Black theaters and clubs, and continued to experiment with different types of music. Since the days at Edmond's, she had searched for material in which to better tell a story. Blues music—with its suggestive lyrics and wickedly clever double entendres, which no matter what she said at this time and in the future, she somehow enjoyed—nonetheless was considered dirty music, hardly fit for all those Sunday churchgoers. Other popular female

stars of the period stayed close to their musical roots, but Waters ventured into new territory. A song that affected her emotionally was the Hebrew lament "Eli Eli." "A Jewish friend and neighbor in her old stomping grounds," said the writer Alvin White, "had taught it to her, explaining its meaning." Ethel learned to perform it in Hebrew, then had the opportunity to sing it publicly.

In February 1925, she was invited to participate at a midnight fundraiser at New York's Palace Theatre to benefit the Cathedral of St. John the Divine. Located in Morningside Heights on the Upper West Side, the cathedral was one of the city's monumental structures; construction had begun in 1892, but it remained incomplete. Some $15 million was needed. "One who has seen it with the imagination of [an] architect has said, speaking particularly of the lofty nave," reported the *New York Times*, "that nothing comparable to this superb design has ever been conceived or executed in America, and that the cathedrals of Europe may fairly be challenged to surpass or even equal it." But the cathedral was important in another respect. "In its realization, men, women, and children of this community should have part, whatever their affiliations of creed, for it is a free house of prayer and a great common church, where tens of thousands may share in a service or where one may kneel alone. Contributions to its building involves no credal obligation, no lessening of loyalty to one's own church."

Spearheading the theatrical fundraising drive was E. F. Albee. Among the showbiz folk enlisted to perform were some of vaudeville's most famous names: Al Jolson, Fanny Brice, Sophie Tucker, Jack Benny, and Bert Wheeler. Seats for the general public were priced at $2.50. Box seats went for $3. "Every top act in vaudeville scrambled to get on that bill. Since Ethel was a top artist, the committee sent her a special invitation," recalled Alvin White. Actually, the invitation was a sign that New York's entertainment establishment had begun to take her more seriously. "The directors decided that she would close the long show," said White. "That spring night, twenty-two of vaudeville's greatest went on ahead of Ethel. It was nearing three o'clock when her act was announced. The crowd was getting restive but the Waters name was magic. Then, the usual fanfare by the orchestra, the heavy curtain rose. On-

stage, dead center, was a grand piano." There sat Ethel's accompanist. But there was no Ethel.

"Ladies and gentlemen, Miss Ethel Waters was scheduled to appear in this closing act," it was announced, "but she hasn't been seen or heard from, we ask your indulgence." At that point, noise was heard offstage. Then there appeared a "tall, brown skinned woman, in a worn sweater and a gingham apron." "May I help you?" she was asked. "We were expecting Miss Ethel Waters. Who are you?" The woman answered "sarcastically in Harlemeese," "Well, I ain't Sophie Tucker." It was Waters, doing a replay of the old vaudeville routine she had often performed with Ethel Williams. The audience laughed. Waters then "walked slowly over to the piano, took a position and announced, 'I'm ready.'"

Once she opened her mouth to sing, the audience realized it was "no popular song for which she was famous, but the highly emotional Hebrew lament 'Eli, Eli.' . . . Ethel knew full well what she was singing . . . and you'd better believe, she knew how to project that song most effectively to her audience of which, the majority surely was not Protestant. And it listened in stunned, respectful silence. Heck, I didn't know a damned word Ethel was singing, neither did my girlfriend, New York born and bred. When the song ended, Miss Waters stood, bowed in reverence. Slowly, she looked up at the audience, a patented Waters smile lighting up her face. The silence was murder—then it was shattered with thunderous applause that shook the old theater, quite accustomed to applause—but none like this. There was heavy foot stomping before the jam packed theater rose to its feet shouting its pleased approval. They couldn't believe it even if they had heard it—a Black woman singing a cherished Hebrew traditional number in its original tongue. Once again, Miss Waters dropped her head acknowledging the tribute only this time, when she looked up, tears were mixed with that wonderful smile. It had been a magnificent performance by a magnificent performer, Ethel Waters at her very best."

IN LATE SPRING OF 1925, Waters received an offer for an appearance at New York's Plantation Club in a show to be called *Tan Town Topics*. It was precisely the kind of opportunity she and Dancer had

been waiting for. Located at 50th Street and Broadway above the Winter Garden Theatre, the Plantation Club was owned by Sam Salvin; one of many clubs, cabarets, cafes, and late-night joints where theatergoers could be further entertained in the city that never slept. Its management included the Shubert brothers, major players in New York theater. Eager to boost attendance, Salvin had worked with an up-and-coming producer named Lew Leslie to acquire fresh talent in 1922. At the time, Leslie, who would later emerge as an important figure, was still feeling his way around. With Salvin, Leslie hit pay dirt by hiring Florence Mills, who was then appearing in *Shuffle Along*, to perform in late-night floor shows at the Plantation Club.

Mills was an instant smash with swanky downtown patrons. "That's when the Plantation Club began to get popular," recalled Noble Sissle. Afterward the Plantation Club—whose patrons were mostly white— became known for its classy Negro entertainment and its extravagant floor shows. Out of the club had come *The Plantation Revue*, which moved to Broadway starring Mills in July 1922. That show took Negro musical theater in a new direction. Without a real storyline, it was a revue with skits and routines, the kind of thing that had been done on the road. Just as significantly, whereas *Shuffle Along* had featured two men, the team of Miller and Lyles, as heroes off on a set of adventures, in this new revue Florence Mills was a Black woman who stood front and center.

After Broadway, Florence Mills returned to the Plantation Club for other popular revues, and, in the world of Negro entertainment, she became its darling and attained a level of recognition in the States and abroad just about unequaled by any other Black female star before her. The only other Negro female star who had a comparable success had been Aida Overton Walker in her Broadway shows with Williams and Walker. Eubie Blake adored Mills. So did Noble Sissle and Lew Leslie. Audiences adored her, too. Ethel professed to admire her greatly. Yet though Mills was the opposite of Ethel in many respects—she was small, delicate, sweet-tempered, and plucky—Waters was probably too ambitious not to have viewed her as something of a rival. Ethel was also aware that while a producer like Leslie and an owner like Salvin had considered Florence classy, that was hardly the way they thought of her. Now, however, Mills was

temporarily away from the club, and Ethel was offered the chance to step in. At first, Ethel was hesitant, still uneasy about performing for a white audience. That's when Earl Dancer stepped in. He browbeat, hounded, hassled, and nagged Ethel repeatedly. Finally, she agreed to audition.

That day, she stood before Salvin and the songwriters Harry Akst and Joe Howard, who asked her to sing a new number they had written for the show. It was called "Dinah." Waters performed the song—as they wanted—at a rapid pace. But the men were not satisfied. Then Akst and Howard suggested that she sing the song her way. Waters took the material home and worked on it. The next day she stood in front of the men again. This time she performed "Dinah" at a more leisurely pace, savoring the lyrics and the dreamy melody, making it really her own. She was hired. Dancer recalled that he agreed "for Ethel to go in the show only if I could choose or reject her material inasmuch as I wasn't producing the show." At this point, Dancer was trying his best to call all the shots.

Ethel went into rehearsals for *Tan Town Topics*. Will Vodery conducted the orchestra but the production ran into problems. Nothing jelled nor jumped. In need of serious revisions, the show's opening was postponed. Brought in to doctor *Tan Town Topics* and get it into shape was a man Ethel had great confidence in, Will Marion Cook. Considered a master among Black entertainers, Cook's background prepared him for anything but a career in Black musicals. Born in 1869 in Washington, D.C., a thirteen-year-old Cook was sent by his parents to study the violin at the Oberlin Conservatory. Three years later he was in Berlin studying with the violinist Joseph Joachim. In New York, he studied under Antonín Dvořák at the National Conservatory of Music. When the two clashed, Dvořak kicked Cook out. Afterward he knocked about and soon began working in Black musicals. Few people seemed to better understand such shows—what made them work and what spelled doom—than Cook. "Will Marion could take a song and fix it," recalled entertainer Bessie Taliaferro. "He could coach performers. He'd be stomping his feet, trying to get some spirit, some soul in them, and his eyes would be piercing. Ethel Waters wouldn't do anything unless he approved."

While Ethel studiously paid attention to Cook, a young dancer also did so—and to Ethel too, observing the rehearsals closely but silently.

In fact, Cook had brought the young dancer into the show. As fiercely ambitious as Ethel and as hell-bent on stardom, the dancer had made something of a name for herself as a chorus girl in *Shuffle Along* and as a lead in the Broadway show *Chocolate Dandies*. But she had attained nowhere near the success of Ethel. Still, this young dancer, Josephine Baker, was so hungry to make it that those around her must have sensed her day was about to come. Hers had been a childhood every bit as impoverished as Ethel's. She, too, carried the "stigma" of having been born "out of wedlock"—in St. Louis in 1906. Some whispered that her father was the Black musician Eddie Carson. Others gossiped that he was a Spaniard who had taken up with Baker's mother, Carrie McDonald, a washerwoman, who later married a man named Arthur Martin and had three other children. So poor was the family that young Josephine had stolen to eat, had bathed in the same water as the rest of the household, had acquired little more than a fifth-grade education, and by the time she was a teenager, had left home to perform on the road. Again, like Ethel, she had an early teenaged marriage. For Baker, there was a second marriage while she was still a teenager. Her first husband was Willie Wells. Her second, whom she wed in Philadelphia, was Willie Baker. Though she left Baker, she kept his surname for the rest of her life.

Show business was in her blood, her bones, the sum total of her existence, just as it now was for Waters. Though the two women had similarities, they also had great differences, and they would never be friends. Theirs was a rivalry that would last for decades even though their careers would take them down vastly divergent paths, and despite the fact that their images would be polar opposites in subsequent decades. Throughout her six-decades-long career, Josephine Baker would never relinquish her sex goddess status. Ethel, however, would be eager to divest herself of hers, onstage, that is, but not off.

At the Plantation Club, Ethel, the star, may not have thought twice about Josephine, but Baker thought a lot about Ethel and soon was working hard in hopes of grabbing attention on opening night. Having already surprised the critics with her smash performance in *Shuffle Along*—brazenly stealing the show at times—she now envisioned doing the same in *Tan Town Topics*. "I was still in the chorus and might well have passed un-

noticed except for my bobbed hair gleaming with oil and my eyes, which I was learning to roll in all directions," said Baker "I spent . . . my time memorizing Ethel Waters' songs. I enjoyed it, and after all, you never knew."

On opening night—June 23, 1925—an apprehensive Waters said a prayer in her dressing room before going onstage. All the preshow anxieties and tensions went right to the pit of her stomach. As the headliner at the Plantation Club, she was expected to carry the production on her shoulders. If it tanked, she would be responsible. Also on her mind must have been the club itself, which was celebrated as much for its décor and design as its entertainment. "I had never seen anything as magnificent as the Plantation," recalled Baker. "It looked like paradise with its bright lights and starched tablecloths." The Plantation Club, as its name indicated, recalled the days of the Old South. "Lew Leslie had the whole interior taken out and decorated as a plantation," the entertainer Ulysses S. Thompson told an interviewer. "Watermelons . . . and lights—little bulbs—in the melons. There was a well, where you could draw the water out, and statues of hogs and corn." A backdrop also depicted a river scene with a papier-mâché steamboat. Even an advertisement for the show that appeared in the *New York Times* depicted a pickaninny figure eating watermelon. All of this, of course, conjured up the idea of the Negro's nostalgia for the sweet days of the Old South—when everyone knew his or her place, when life supposedly couldn't have been better. "The performers were *white* blacks," said Baker, "in accordance with the vogue for light-skinned entertainers." That may have been true of the chorus girls. But neither Waters nor Florence Mills were considered light-skinned. Seated at the tables were the white patrons—dashing young men and glamorous young women, dressed to the nines, ready to party into the wee hours of the morning.

Still adjusting to the way a white audience responded, Waters was now psychologically better prepared. Not lowering her standards—white people might not understand her work, she said, but "I wasn't going to change it"—she nonetheless understood when she was communicating, what tricks of the trade were most effective, when to employ different techniques or a different approach to reach them. Each evening throughout the engagement, the high point occurred when she stepped forward

to sing "Dinah." Not an earthy gut-bucket blues number, "Dinah" was pure gorgeous melodic pop, a reminiscence of a lovely lass from South Carolina. "Dinah / Is there anyone finer / In the state of Carolina," the song asked. "Dinah / With her Dixie eyes blazin / How I love to sit and gaze in / To the eyes of Dinah Lee." Another lyric stated: "But if Dinah / Ever wandered to China / I would hop an ocean liner / Just to be with Dinah Lee." Waters' clarity not only revealed her complete comprehension of the lyrics but brought its images to life. Yet oddly enough, no one ever questioned that here was a woman singing about her sweet yearning for another woman. As Waters sang it, it might well be a sister recalling a sister. Or a mother recalling her daughter, or an aunt recalling her niece. Or maybe, just maybe, a girl recalling a girlfriend. Nonetheless, her "Dinah" had the Plantation Club patrons humming and sweetly smiling around the tables—and then humming and sweetly smiling as they left the club and wandered out onto the city streets. Later such male stars as Bing Crosby would record the Akst-Howard song and so would other female singers. But because of her dreamy, nostalgic delivery through which she transported the listener to another time and place, "Dinah" would forever be associated with Ethel. It was her song, just as "Stormy Weather" would be in a few years.

In a very short time, Ethel was the talk of downtown folks as not only a great singer but also a consummate entertainer. *Tan Town Topics* afforded her the opportunity to showcase her versatility. Here was a woman who could handle comedy skits and dialogue and also dance. "She is a natural comedienne and not one of the kind that has to work hard," Carl Van Vechten would later say. "She is not known as a dancer, but she is able, by a single movement of her body to outline for her public the suggestion of an entire dance. In her singing she exercises the same subtle skill." "It was in this show that Ethel Waters developed into the greatest comedienne of her day on Broadway's after-theatre spots," said a jubilant Dancer. At the Plantation Club, the uptown girl from Edmond's announced that downtown Manhattan had a new goddess to reckon with. The engagement confirmed that she had made it on the white time, in New York, no less

Nightly, patrons rushed to the club to see her. Among the crowd was a young woman named Caroline Dudley Reagan, who was then searching

for talent for an all-Negro show she planned to launch in Paris. Originally, Reagan had wanted Florence Mills for what became the groundbreaking production *La Revue Nègre*, but Mills was too high-priced for Reagan's budget. Will Marion Cook had then suggested Waters. Dazzled by Ethel, Reagan quickly made an offer. But Ethel was hesitant about making the trip abroad. Dancer may have had reservations. There was now too much going on for her in New York. Why break the momentum? Besides, Dancer had dreams of getting Ethel to Broadway as the star of a show and himself as a producer. As was her custom when she really did not want to commit to a show, Ethel demanded an outrageous salary: $500 a week, or even $750, according to some versions of the story. Though Reagan tried negotiating, Waters wouldn't lower her price.

During the Plantation Club engagement, she was plagued by a voice problem now familiar to her: a persistent dry and itchy throat. "Ethel arrived at the theater one night with a pondful of frogs in her throat," recalled Josephine Baker. "She managed to get through the evening like a true professional, but the next morning she sent word that she had lost her voice completely." Ethel's physician ordered her to take two weeks off. Of course, this was just what Josephine had been waiting for. "I knew all Ethel Waters' songs by heart," said Baker, who rushed to tell the director. He decided to let her go on. Baker went out and kicked up a storm. She also was a giddy comedienne who could cross her eyes and make funny faces. The audience loved her.

"When I returned to the dressing room after the show, the girls were buzzing with excitement. 'You were sensational. Did you hear that clapping for "Dinah"?' 'Dinah's' success didn't much impress me. I could have been a canary for all it mattered. The song was so popular, it practically sang itself. What *did* please me was having added a few songs that appealed to *me*."

By the time she left the club that morning, Baker was set to take over the floor show at the club. But there was something she hadn't counted on: Ethel. "The next evening I found violets in the dressing room and Ethel on the stage. I couldn't believe my eyes."

"Your success cured her fast," a friend told Baker.

"It's not fair," Josephine told the director. "You promised—"

"I didn't promise anything."

"You told me after the show that they liked me better than Ethel because I made them laugh."

"Not *better*. The same. Anyway, she's *lighter* and prettier."

That was how Baker recalled it. But, of course, Ethel was not that much lighter than Baker, if at all. But in Baker's eyes, the color caste system of so many Black shows was still firmly enforced. Ironically, Ethel—in other situations—may have felt exactly the same way.

Still, said Josephine: "It was back to the chorus again. When I ran into Ethel in the wings, she gave me a furious look. That was the last straw. 'Back so soon. Too bad for the show,' I snapped. Ethel was so startled by my rudeness that she muttered something like, 'Stupid darky.' I'm sure she would have pulled my hair if it hadn't been so short. I was ashamed of myself."

But not that ashamed.

Josephine Baker loved telling this story over and over, year after year. But it is doubtful that she actually sang Waters' songs. More likely, she won audiences over with her dancing, which was indeed spectacular and beyond compare. Though she developed into a fine chanteuse in Europe, she was never the singer that Ethel was.

Still, Josephine Baker's timing, on and off the dance floor, proved perfect. In the audience that night was Caroline Dudley Reagan, who still wanted Ethel Waters for her show, despite the stall in the negotiations. Reagan—impressed by Baker—signed Baker to a contract that paid her $250 a week. Months later—on October 25, 1925—Josephine Baker opened in Paris in *La Revue Nègre*—and attained the kind of international stardom that must have surprised everyone, including Ethel. "I preferred to see America first," Waters said. "Josephine ended up with a chateau, an Italian count and all Paris at her feet permanently. . . . *Sacré bleu!*" Ethel, however, was not one to wallow in regrets. Five days before Baker's opening—on October 20, 1925—Ethel recorded "Dinah," which record buyers Black and white snapped up. Its astounding success marked it as the first big hit to come out of a nightclub. "Dinah" also marked Waters' ascension to a new level of stardom—and made her more famous. Let Josephine have Eu-

rope, even bigger things had to be on the horizon for Waters in New York. Still, she never forgot that Baker had triumphed in a show that had been offered to her first.

IN MAY 1925, Dancer had skillfully negotiated two major deals. First was a three-year contract with the Keith-Albee circuit for her appearances in the East and Midwest. He proved pretty good at his game because the contract was reported to have "the highest figures ever paid to a colored woman, and compares favorably with the salary offered to any of the big acts." But that was not the end of his maneuvers to get Ethel into the big time. Also negotiated was a contract with the Columbia Phonograph Company. Dancer and Ethel met with Frank Walker, Columbia's recording manager, who had had inaugurated the company's race record releases—with Bessie Smith as its first Black artist in the series in 1923. Though the company also recorded Eddie Cantor, Ted Lewis, and even Bert Williams (who died in 1923), Bessie Smith's records helped reverse the company's fortunes. Before Bessie's arrival, Columbia, faced with mounting financial troubles, had applied for receivership in February 1922. The next year, two receivers were assigned by the court for the American Columbia Company. Her "Down-Hearted Blues" sold 780,000 copies in less than six months, and Columbia regained some of its momentum. For the next eight years, Walker supervised all of Bessie's recordings and was said to be the only white man that Bessie trusted, though a royalty clause in Bessie's contract had been removed by Walker. Pursuing other artists who might keep the company's accounts in the black, Walker could not have failed to notice Ethel's sales with Black Swan and her growing appeal with a broader audience. She could be a winner for Columbia.

The Columbia contract marked another turning point. The press release that was sent out stated that Ethel's "numbers will not be 'Blues.' She is to specialize in snappy, jazzy, and comedy numbers of her own selection." But in the end, the record label realized she could not completely abandon the blues material that had made her so popular. With the Columbia deal, though, Dancer and Ethel may have seen the writing on the

wall. By the end of the decade, blues music would no longer be as popular. Already the broader audience was in search of a new kind of popular music, of which the success of "Dinah" was clearly a sign. Ethel was already ahead of the curve. Columbia agreed to pay her $250 for each record to be released; $125 a side. She also was guaranteed royalties.

Ethel's early recordings for the company—from 1925 to mid-1928—included not only "Dinah" but such other classic numbers as "Sweet Georgia Brown," "Brother You've Got Me Wrong," "Go Back Where You Stayed Last Night," "You Can't Do What My Last Man Did," "Sugar," "Guess Who's in Town," "Do What You Did Last Night," "My Handy Man," "'Maybe Not at All," and "Take Your Black Bottom Outside."

At Columbia, she worked with such musicians as Joe Smith (on trumpet), Buster Bailey (bass clarinet), Joe King (trombone), Florence Mills's husband U. S. "Slow Kid" Thompson (who did vocals on "You Can't Do What My Last Man Did"), as well as such pianists as Maceo Pinkard, her ideal pianist James P. Johnson, J. C. Johnson, Clarence Williams, Lorraine Faulkner (on "Heebie Jeebies"), and the man and the woman who knew her so well, Fletcher Henderson and Pearl Wright. She also performed the songs of such composers as Ben Bernie, Maceo Pinkard, and Kenneth Casey ("Sweet Georgia Brown"), J. C. Johnson ("You Can't Do What My Last Man Did"), Roy Turk (with Maceo Pinkard on "Sweet Man"), Jack Palmer and Clarence Williams ("I've Found a New Baby"), Boyd Atkins ("Heebee Jeebies"), Andy Razaf and J. C. Johnson ("My Special Friend Is Back in Town," "Lonesome Swallow," and "Guess Who's in Town"). With all these talents, Waters was making expertly produced recordings in which her clarity and her gift for double entendres were on scintillating, brilliant display. Hers was a modern sound, unlike the music of the minstrel shows or old-school vaudeville. As she began to move further away from blues and jazz, she was mastering urban pop.

The melodies of the Columbia recordings were strong and direct, the lyrics precise and clearly understood. There were none of those delirious interludes—as heard in the material of classic blues numbers—when a listener might not be sure what was being said but knew something was implied. Nor was there an overflow of those delicious idiosyncratic moans or soulful groans of the classic blues singer. Yet Ethel could never resist a

good growl at an unexpected moment in a song. The growl was sexy and again very modern, used to punctuate the underlying feeling of a lyric or the flow of the melody. In the future, she would use the growl even when she became a Broadway star. Ethel's double entendres were fairly straightforward and beautifully playful. Listeners delighted in knowing what exactly was on her mind.

With many of the songs, record buyers responded not only to her voice and style but also to her sexy, assured tough-girl persona. On "Go Back Where You Stayed Last Night," she was setting down the law to a fellow who hadn't come home the night before. No weeping willow was she, crying her heart out at being jilted. Instead she was telling him basically to forget her. Similar sentiments were expressed in "You Can't Do What My Last Man Did," in which she informed the guy that he had better learn to live up to her expectations. In "Take Your Black Bottom Outside," she was giving the guy the boot.

On "My Handy Man," Waters performed the Andy Razaf lyrics with a womanly assurance and sexiness that even later generations would be surprised by. As Waters rhythmically talked her way through, making the double meanings all the more apparent, there wasn't much singing at all. "My Handy Man" opened with pianist James P. Johnson, setting the stage for the proceedings to come, quickly preparing listeners for that moment when vocalist (or monologuist) Waters entered front and center, skillfully turning Andy Razaf's playful, bawdy lyrics into a one-woman conversation. Speaking to herself and anyone else who might listen and in just the right tone with just the right attitude, she presented a tale of a woman's sensual delights; elaborating on the pleasures her man had brought her—and about the importance of a man who was proficient at his job. "Whoever said a good man was hard to find / Positively, absolutely sure was blind," she began, savoring each and every word. "He shakes my ashes, greases my griddle / Churns my butter, strokes my fiddle . . . / He threads my needle, creams my wheat / Heats my heater, chops my meat . . . / Sometimes he's up long before dawn / Busy trimming the rough edges off my lawn . . . / I wish that you could see the way / He handles my front yard / My ice don't get a chance to melt away / He sees that I get that old fresh piece every day / Lord,

that man sure is such a handy man." As Razaf wanted, Waters made record buyers actually listen to the lyrics. Record buyers would hang on every word she uttered, waiting to hear what came next. No wonder "My Handy Man" proved to be one of her big hits, one of her signature songs that music lovers and record collectors would long cherish.

With "Shake That Thing," which also soared on the charts, she proved herself supremely skilled at understated control—as well as at masterful storytelling. Some were amused by it; others were shocked. Everyone considered it, at the very least, risqué. Here she told the story of a new dance craze. The song opened with Pearl Wright on piano, lively and steady, laying the groundwork for the arrival of Waters. In a tempo different from Pearl's, Ethel began in a slow, sensuous tone. "Down in Georgia / Got a dance that's new," she sang. "Ain't nothing to it / It's easy to do / Called Shake That Thing." Then she slowed the proceedings down even more as she crooned, "Ah, shake that thing." As part of her story, she announced: "Now the old folks are doing it / The young ones too / But the old folks learn the young ones / what to do / About shaking that thing / Ah, shake that thing." Of course, the thing she sang about could be interpreted in various ways. On the one hand, it was to shake one's derriere. On the other, she may have been telling folks to shake something entirely different. She continued her story with the lyrics: "Now Grandpa Jackson / grabbed Sister Kate / He shook her / like you shake / jelly on a plate / How he shook that thing / Ah, he shook that thing." But there was more to come. "Why, there's old Uncle Jack / The jelly roll king / He's got a hump in his back / From shaking that thing / Yet he still shakes that thing / For an old man, how he can shake that thing." Not only was hers a tale of a sensual cultural phenomenon—this new lowdown dance—but also an invitation to her listeners, male and female, to join her in a sexy pas de deux. For later generations, "Shake That Thing" was not anywhere as naughty as "My Handy Man." But embarrassed as Ethel may have been by the latter song, she appeared more embarrassed by "Shake That Thing" because it was such a huge hit that everyone remembered for a long time.

Some Black critics of the time commented on the "dirtiness" of some of her material. Yet they also were quick to point out how "clean" she kept everything. It wasn't an easy balancing act. Somehow she never let

herself become coarse or vulgar. Perhaps it was that clarity and her delight in playing with words and suggestive metaphors, stretching or amplifying the meaning or sometimes signaling that the true meaning might lie in the ear of the listener. Perhaps it was that control she always maintained. Perhaps it was her attitude in song.

Always calling the shots, she might seem hot and ready for some sexy action but never was she overcome by the throes of passion. Basically, as in a song like "Go Back Where You Stayed Last Night," she gave commands, she didn't take them. Here she was part of a tradition that could be heard when Bessie Smith sang such bawdy numbers as "Do Your Duty," "Need a Little Sugar in My Bowl," and "I'm Wild About That Thing," all songs in which she expressed her desires in what—for a woman at that time—was considered to be a sexually aggressive style. Bessie, who was said to feel uncomfortable with such songs, nonetheless communicated the idea that it was her right, as much as a man's, to enjoy and even ask for sex. That same attitude came across in Waters' music. But a crucial difference between Waters and Bessie, as well as Ma Rainey, was that she never seemed to want sex that badly. Never would she grovel in the mud for a man, begging for his love or for sex. Neither Bessie nor Ma did that either, but they seemed to have stronger sexual impulses. Away from her recordings, Waters had a very powerful sex drive. But in her music, it was another matter altogether. Moreover, in her music, Ethel let it be known that no man would ever tell her what to do. With a hot-cool style that she now took mainstream, Ethel stood above the needs of the man and her own needs as well. Emotionally, Bessie and Ma, those shouters as Waters referred to them, went deeper into the gut of a song. Waters never let herself go that far emotionally.

From this point into the 1930s—during her Broadway years—she was mastering a style that was to influence many of the great pop and jazz stars of the twentieth century: everyone from her contemporaries Adelaide Hall and Elisabeth Welch to Ellington's favorite singer Ivie Anderson were stamped by Waters. Jazz singer Mildred Bailey, who would be popular in the next decade, collected her records. In the 1940s and 1950s, Pearl Bailey—with her asides and double entendres—in a song like "Takes Two to Tango"—had obviously picked up a thing or two from Waters.

Ethel's bell-like clarity would be heard in Ella Fitzgerald. That precise diction would be a hallmark of Lena Horne's style. That dramatic ability to tell a story in the clearest manner and that mellowness—on "Dinah" and "Sweet Georgia Brown"—would echo at times in Dinah Washington. Jazz musicians like Bix Beiderbecke and obviously Fletcher Henderson would also be admirers. Beiderbecke "went to hear her at every opportunity," recalled jazz critic Leonard Feather. Bing Crosby, Mel Tormé, Frank Sinatra, Bobby Short, and Barbra Streisand were all fans. Even Billie Holiday, though she would never admit it, was influenced by Waters.

One critic said that "the source of her genius" could be found "in her mixture of opposites: a combination of earthiness and deep spirituality, of rowdiness and sweetness, all of it molded and bound together by the overriding sense of drama that Waters brought to every word and every story she ever sang." "The subtlety of her diction and intonation," said jazz critic Gary Giddins, "is such that her attitude toward a song sometimes seems to change from line to line. Yet in a performance like 'My Special Friend Is Back in Town,' she strikes a dazzling balance between singing, talking, and joking, and recalls the comedic personality and assurance of Fannie Brice." "With her individual approach," said jazz critic-historian Sally Placksin, "Waters made her songs the standard-setters for all time, and provided a jazz and popular music foundation that influenced countless other singers, from Maxine Sullivan to blues shouter Big Joe Turner, who called Waters the only singer he ever adored."

Her emotional control in the 1920s enabled a broad spectrum of record buyers, male and female, Black and white, to appreciate her and to be affected by the music. Those young flappers of the Jazz Age, on their quests for self-exploration and self-definition, connected to tough-girl Ethel, who was already at the place that they sought to be. The flappers' battle for independence had already been achieved in song by Waters—as well as Bessie and the other blues singers of the era. Though not yet thirty (when she recorded in 1925), she projected the maturity of an older, more experienced, worldly woman, the kind that other women could look up to and hope to emulate. Yet the voice itself still had the vitality and effervescence of a young woman. Waters was also on her way to becoming a progressive symbol as she shattered conceptions about the achievements

possible for Black women. She was part working woman, part high-flung goddess, able to operate in a man's world on her terms.

With its wide distribution system and its well-developed publicity department, Columbia got her records into the stores. Her "first five releases were all on the popular series," recalled Frank Driggs, "and her identity left to the purchaser's imagination." Then Columbia listed Waters in its race record division: music that was being sold exclusively in Black record stores to Black record buyers. A catalog cover from the 1920s featured Ethel with Clara Smith, Barbecue Bob, Reverend J. C. Burnett, and in the center of the page, her idol Bessie. These stars of the African American community were not necessarily known to the larger white culture. But Waters' recordings sold—as Dancer and Columbia had planned—beyond the race record market. Thus, later in 1929 Columbia again included her on its popular lists. In a period before the term "crossover" was used— which meant that a Black artist was reaching record buyers Black and white—Waters was now selling in the white record stores too. The *California Eagle* reported that "Shake That Thing" sold some 800,000 copies. Gradually, too, mainstream media would begin to publicize her.

FOLLOWING THE PLANTATION CLUB engagement, it was back to the TOBA circuit, playing theaters and auditoriums and doing one-nighters in Washington, D.C., Wilmington, Delaware, and Newark, New Jersey. Various titles were used for the shows that she headlined: *The Ethel Waters Floor Show, Ethel Waters Vanities, Ethel Waters Revue.* In New York, she also played the Lafayette in revues like *Tan Town Topics, Too Bad,* and *The Black Bottom Revue.*

She also moved into a spacious seven-room apartment at 580 St. Nicholas Avenue. Though African Americans continued to move uptown, Harlem still had its share of established white apartment dwellers, and 580 St. Nicholas was just such a residence: fewer than a dozen African Americans lived there when Ethel moved in. But it soon became a lively hot spot; a much-discussed meeting place for poets, essayists, and other artists of the Harlem Renaissance. On any given day or evening, you might see writer Eric Waldron, or the poets Langston Hughes and Countee Cullen,

or artist Aaron Douglas, or literary figure Charles S. Johnson. Johnson's secretary, Ethel Nance, who lived in the building, said, "All you had to say was 580 and they knew you meant 580 St Nicholas." It was that popular and that well known a building.

Living high and caring less, Waters didn't hold back on spending, even though her income fluctuated: sometimes money poured in; other times it was a drought. A woman named Bessie Whitman, described as a personal maid, was hired to keep her personal items in order at home and often at the theater when Ethel was in shows. Sweet-tempered and efficient, Whitman had a cool personality that was apparently well suited to Ethel's hot one. "She was an angel," said actress Maude Russell.

In time another woman, named Bea, was described as the house manager, there presumably to make sure everything in the apartment ran smoothly, no doubt making sure that food was ordered and prepared, the apartment was properly cleaned, linens and clothes were laundered or sent to the cleaners, and the bills were paid. "When the Frigidaire needs a bulb," recalled singer Etta Moten, "it is Bea who sees that it is replaced, a task to be performed. Bea, who is always willing. Silent. Bea, whose devotion is closer than that of a sister." Also living there was Bea's daughter, Marlene. Pearl Wright could also be counted on to double-check, supervise, inspect, and micromanage. Different women came and went, some of whom were "assistants," others who were "secretaries to the star." Waters' relationship to Bea was no doubt another that was gossiped about. At one point, Pearl performed secretarial duties for Ethel. At another time, the choreographer Elida Webb was described as Ethel's secretary. "The Waters household and the Waters payroll," said Etta Moten, "is made up of old friends. People who have stuck by her in former days and would stick by her with or without money." As time moved on, professional hairdressers arrived at the apartment to style Ethel's hair. A masseuse would come on a regular basis. So would a woman who cared for Ethel's nails and another who designed her clothes. Another came to alter or tailor outfits. People streamed into the apartment, some ever ready to do whatever they could to please the star: run errands, answer the phone, let guests into the house. Some were simply hangers-on, eager to do anything to be around the glamour and growing fame.

Family members like Momweeze and Genevieve also visited. Though they might disagree or quarrel, that never stopped Ethel from continuing to help them financially. During one of Momweeze's visits, she may have mentioned her need of new furniture; Waters bought her a suite of living room furniture, to be transported back to Pennsylvania. It was a purchase that later created problems for her. No matter, while the money came in, she made sure it went right back out. Waters also still doted on Genevieve's daughter Ethel and even asked if she could have her. Genevieve refused to give the girl up, but that didn't stop Ethel from piling on gifts for her.

Some days a moody or dreamy Ethel liked to stroll through the neighborhood and stand by the Tree of Hope, a mighty elm that stood at 131st Street and Seventh Avenue and was long considered by Black entertainers as something of a good-luck charm. If a performer stood under it and made a wish for work, those prayers would be answered. Bert Williams, Paul Robeson, Josephine Baker, Aida Ward, and Bill Robinson were among those who believed in the power of the Tree of Hope. For Ethel, those times when she sat or stood under the tree were intensely private moments when she paused to think seriously about where she was headed and where she wanted to be headed—and ask to be blessed. (Much to the dismay of Ethel and others, the Tree of Hope was cut down by the city's parks department in 1934. It was eventually replaced.)

Neither she nor Dancer could have predicted the inroads that she was now making into New York's music and theater establishment. Though she was still not at the place Dancer believed she should be, Ethel was on her way. The Italian artist Antonio Salemme sculpted a bronze bust of her. He also sought her company, won her favor, and squired her through the homes and studios of other artists in Greenwich Village. Through Salemme, she was introduced to Paul Robeson, whom she admired, as well as his wife, Eslanda. Everyone seemed eager to meet her. That included one of the arbiters of New York's cultural scene, the writer Carl Van Vechten.

Born in 1880 in Cedar Rapids, Iowa, Van Vechten was the youngest child of a socially and culturally progressive couple. His mother, Ada Fitch Van Vechten, was a committed suffragist who fought for women's rights and was influential in establishing the first Cedar Rapids Free Public Library.

His father, Charles Van Vechten, who had amassed a small fortune in the insurance business, helped establish the Piney Woods School for Negro Children in Mississippi. Young Carl was reared to never address members of the colored population in Iowa by their first names. Instead, Black Americans were to be referred to as Mr., Mrs., or Miss, something rarely done by whites at the time. Growing up as something of a misfit, Carl was already six feet tall by age thirteen, gangly, and boldly effete, with protruding buck teeth. Interested in literature and the arts, his soul mate and sweetheart was Anna Elizabeth Snyder, herself almost six feet tall. They were together constantly until they graduated from high school. Anna went off to Wellesley College; Carl, to the University of Chicago. Fascinated by Chicago's cultural life, Van Vechten especially enjoyed the Black nightclubs, ragtime, and those wild, far-out, highly imaginative Negro performers. Upon graduation in 1903, he took a job as a reporter with the Hearst newspaper *Chicago American*, but he was fired for poking fun at a leading socialite in an article. Later he moved to New York, where he first did freelance work and then became a reporter for the *New York Times*. But he took a leave of absence from the *Times* to head to England, where he married his childhood sweetheart, Anna. Europe's cultural scene also excited him. Upon his return to the States, he became an assistant music critic at the *Times*. Always on the lookout for daring, innovative, cutting-edge talent, he wrote about Isadora Duncan and Anna Pavlova. In 1913, he left the *Times* again, then worked at the *New York Press*, but was again fired. He also divorced Anna, and when he refused to pay her alimony, he was thrown into jail for a month. Afterward he married the actress Fania Marinoff. Considered to be "flippantly fastidious and a voyeur," Van Vechten was the subject of much discussion and speculation. There were always whispers about his possible male lovers, notably the literary publicist Mark Lutz, as well as writer Harold Jackman, a friend of the African American poet Countee Cullen.

During those New York years, Van Vechten, the writer, came into his own. His essays on music and the ballet, titled *The Music After the Great War*, were published in 1915. There followed *Music and Bad Manners*, released by Alfred Knopf in 1916; *The Music of Spain*, in 1918; and seven novels. An admirer of Black writer Walter White's novel *The Fire in the Flint*, Van Vechten won an introduction to social activist and race man

White through Knopf. Afterward he met such African American luminaries as James Weldon Johnson, Langston Hughes, Countee Cullen, and Paul Robeson. Believing the work of African Americans heralded a new cultural awakening, Van Vechten did much to promote the essays, novels, poetry, and music of Black artists in New York. His commitment to the growing Harlem Renaissance proved invaluable. In 1925, he persuaded *Vanity Fair* to publish poems by Hughes and Cullen. And he successfully lobbied Knopf to publish the twenty-three-year-old Hughes' first volume of poetry, *The Weary Blues,* for which Van Vechten wrote the preface. Also published by Knopf were such writers as James Weldon Johnson and Nella Larsen, as well as others who were pushed and promoted by Van Vechten. During this time and in the years to come, Van Vechten also photographed a virtual Who's Who of African Americans in the arts in the first half of the twentieth century: Bessie Smith, Ella Fitzgerald, Billie Holiday, Zora Neale Hurston, Leontyne Price, William Warfield, James Baldwin, Alvin Ailey, and Mahalia Jackson. In addition, he photographed William Faulkner, Truman Capote, Martha Graham, Lotte Lenya, and Edward Albee. In time, because of his ties to Black figures of the Harlem Renaissance, he was dubbed a Negrophile or, as Zora Neale Hurston said, a Negrotarian.

Together, he and his wife Fania were very much a New York couple, always on the scene at the theater, at the clubs, at parties, openings, dinners, and receptions. Their apartment on West 55th Street was the site of many glittering gatherings, filled with the movers and shakers of the art and literary worlds: H. L. Mencken, Sinclair Lewis, Eugene O'Neill, the critics Jean Nathan and Alexander Woollcott, Cole Porter, Noël Coward, Somerset Maugham, Gertrude Stein, Alfred and Blanche Knopf, Salvador Dali, Mabel Dodge Luhan, and Fannie Hurst, who later wrote *Imitation of Life.* After 1924, the parties were very much integrated. Among those in attendance were Paul Robeson, James Weldon Johnson, Walter White, and Nella Larsen. Langston Hughes recalled one party at which "Chief Long Lance of the cinema did an Indian war dance, while Adelaide Hall of *Blackbirds* played the drums, and an international assemblage crowded around to cheer." Of the Van Vechten parties, Hughes once said: "They were so Negro they were written up as a matter of course

in the colored society columns just as though they occurred in Harlem."

Most within the Black artistic scene were at ease in socializing with him. Others were not. Countee Cullen and Jessie Fauset kept a guarded distance, and for a time, so did Bessie Smith. Having first seen her perform at the Orpheum Theatre in Newark, New Jersey, on Thanksgiving 1925, Van Vechten wrote about her the next year in *Vanity Fair*. Two years later she attended one of his parties; this event became the stuff of legend. Much like Ethel, she preferred being with her "own people." The ways of the ofays could be baffling. At Van Vechten's, she performed for his guests. She also had quite a bit to drink. Finally, she was ready to leave. With her ermine coat wrapped around her and with friends by her side, Bessie headed for the door. At that point, Fania ran up to the Empress of the Blues and threw her arms around her. "Miss Smith, you're *not* leaving without kissing me good-bye," said Marinoff. Annoyed and then enraged by this presumptuous display of affection from a woman she barely knew, Bessie hauled off and knocked Fania to the floor. "Get the fuck away from me!" she exclaimed. "I ain't never heard of such shit." The room turned silent. Helping his wife up and trying to make the best of a very awkward moment, to say the least, Van Vechten said quietly, "It's all right, Miss Smith. You were magnificent tonight."

Others were outraged in 1926 when Van Vechten's novel, *Nigger Heaven*, a tale of life among Harlem's social and artistic sets, was published. Its sales soared, and so did controversy. The use of the derogatory word in its title by a white writer was offensive and insulting to many. Though Walter White and James Weldon Johnson defended Van Vechten's novel, others, like W. E. B. Du Bois, condemned it. "A blow in the face, an affront to the hospitality of the blackfold and to the intelligence of whites," said Du Bois. But *Nigger Heaven* proved important to the Harlem Renaissance primarily because it brought Harlem and its artistic scene into the consciousness of mainstream America.

Ethel also despised Van Vechten's use of the word. "I'd heard of his book *Nigger Heaven* and had condemned it because of its obnoxious title—without reading it." Moreover, she was as suspicious of Van Vechten as she was of most whites. Far more aware of white perceptions or misconceptions of Black women than her rival Baker, Waters was not going to be

anybody's idea of an *exotique*. Nor was she going to let herself be viewed as forbidden fruit: the sexy or oversexed "primitive" Black woman who represented freedom from the restraints of a dying Western culture. Years later Van Vechten himself admitted that early in his career he had viewed blacks as possessing "an appealing primitivism" that might "save a rotting civilization."

But for Ethel, still trying to fully establish herself on the "white time," it also meant being a part of the white time's social world. *That* Ethel had no interest in whatsoever. "White people generally bored me," she said, "and we didn't speak the same language." But Dancer must have prodded her to mix and mingle in new circles. After all, she had enjoyed the company of white artists she'd met in the Village. For some time, Van Vechten had sought to meet her. In fact, he appeared almost desperate to do so. He had first heard her perform "Georgia Blues" at the Lafayette Theatre when James Weldon Johnson had taken him there. Afterward Van Vechten followed her career closely.

In 1926, he wrote a groundbreaking piece for the March issue of *Vanity Fair*, one of the nation's most sophisticated publications, highlighting significant trends and accomplishments in the arts. His article was titled "Negro 'Blues' Singers: An Appreciation of Three Coloured Artists Who Excel in an Unusual and Native Medium." Numerous Black women were making names for themselves, but he focused on three great blues goddesses: Clara Smith, Bessie Smith, and Ethel Waters. Writing about the performance of Bessie Smith on that Thanksgiving evening in 1925 when he had first seen her in Newark, he noted her astounding effect on an audience that was hardly your bourgeois or artsy-fartsy Negro set—"not a mulatto or high yellow visible among these people. . . . These were all chocolate browns and 'blues.'" He commented on "the power and magnetic personality of this elemental conjure woman and her plangent African voice, quivering with pain and passion, which sounded as if it had been developed at the sources of the Nile." He also noted the way "the crowd burst into hysterical shrieks of sorrow and lamentation." He added: "If Bessie Smith is crude and primitive, she represents the true folk-spirit of the race. She sings Blues as they are understood and admired by the coloured masses."

Of Clara Smith, he wrote that she was "a crude purveyor of the pseudo-folksongs of her race. She employs, however, more nuances of expression than Bessie. Her voice flutters agonizingly between tones. Music critics would say that she sings off the key. What she really does, of course, is to sing quarter tones. Thus she is justifiably billed as the 'World's greatest moaner.' She appears to be more of an artist than Bessie, but I suspect that this apparent artistry is spontaneous and uncalculated."

But Van Vechten's greatest praise was reserved for Ethel, whose subtlety, clarity, and sophistication were, for him, beyond compare. He called her the best of the blues singers, even though he realized she was not quite a blues singer in the classic sense. "In fact, to my mind, as an artist, Miss Waters is superior to any other woman stage singer of her race. She refines her comedy, refines her pathos, refines even her obscenities. She is such an expert mistress of her effects that she is obliged to expend very little effort to get over a line, a song, or even a dance," he wrote. "Some of her songs she croons; she never shouts. Her methods are precisely opposed to those of the crude coon shouters, to those of the authentic Blues singer, and yet, not for once, does she lose the veridical Negro atmosphere. Her voice and her gestures are essentially Negro, but they have been thought out and restrained, not prettified, but stylized. Ethel Waters can be languorous or emotional or gay, according of the mood of her song, but she is always the artistic interpreter of the many-talented race of which she is such a conspicuous member."

For later generations, Van Vechten's language would smack of a certain condescension and at times a cultural misreading—indeed a fundamental cultural bias—of who the women were and what they represented. Still, he was introducing the cultural elite as well as mainstream America to remarkable talents, and he was demanding that that mainstream reconsider its definitions of popular music and popular art. "When Mr. Van Vechten," said James Weldon Johnson, "by his article in *Vanity Fair* and other publications, and by his personal efforts, was doing so much to focus public attention upon the recent literary and artistic emergence of the Negro and upon the individual artists, he did not neglect the singers of this important and not fully evaluated genre of Negro folk-singers."

Johnson also commented: "It was Carl Van Vechten who first pointed out that the blues-singers were artists."

Like any star, Waters had a healthy ego, and surely she loved reading Van Vechten's comments. But, still, she showed no great interest in meeting him. Van Vechten, however, kept pushing. Finally, upon being introduced to him, a cordial Ethel maintained a very obvious distance. Carl Van Vechten's style may have struck her as perhaps too precious, too artsy, too prissy. Here was a man whose letters were typed on lavender or canary yellow or raspberry stationery. Here was a man who dressed like a dandy in bowler hats and fine tailored jackets and suits with colorful and flashy handkerchiefs in his lapel pockets. That was when he was being sedate. On one occasion, he arrived at a party decked out in "red and gold Oriental robes looking like the Dowager Empress of China, gone slightly berserk." Literary critic Alfred Kazin said that Van Vechten "thrived on his own affectations." If he was bisexual or gay, that meant nothing to Waters. If anything, that, as well as his style of dress, would simply have amused her and made him interesting. But affectations and prissiness were not her style, nor that of the people she chose to be around.

Still, Van Vechten appeared drawn to her far more than many of the other Black artists with whom he hobnobbed. Oddly enough, it looked as if he wanted her approval. And he continued his attempts to ingratiate himself and to have her become a part of his social world. Like Earl Dancer, he put up with her initial standoffishness and her basic rejection. Apparently, he was respectful, even admiring, of her hauteur and her refusal to fall at his feet. Whenever she appeared in Harlem, he went to see her and kept up his pursuit. Eventually, it paid off. "Occasionally, she came to our apartment for dinner or a party," said Van Vechten. "When I got there," said Ethel, "it was filled with beautiful things—paintings, rare old books, sculptures, and antiques. But none of those things meant a damn thing to me. They still don't. Nothing in my life has geared me to like or appreciate works of art." Ethel even hated the food that was served. "It was rich white folks' food, and they started off with borsch. *Cold borsch!* That is nothing but soap and clabber," she said. "I don't eat caviar when I go to white folks houses just because it is the correct thing

to do. Caviar to me is, and will always remain, just a lot of buck shot on bread. I'm strictly against colored artists getting high hat—or against any artist forgetting that first of all he's a child of God." In some respects— with her bluntly expressed opinions—Ethel must have seemed like the dinner guest from hell.

Yet Van Vechten may have detected a side of Ethel that few understood. Despite her outspokenness, she also had a reserve, especially during these years when attending social affairs. Part of it may have been her perpetual insecurities about her lack of a formal education. "I've seen a lot of Ethel & taken her around a lot," Van Vechten once wrote Langston Hughes. "She is very human when you know her—but very shy & on the whole doesn't trust either jigs or ofays. So, quite inconsistently, tells them both what's on her mind." The writer Geraldyn Dismond observed: "Her innate shyness and reserve have often been misinterpreted for snobbishness, but she is unaffected, simple, and generous to a fault."

Still, Van Vechten and his wife Fania continued to go out of their way to gain Waters' trust. "At any rate, it was not too long before we became great friends," said Van Vechten. At his apartment, she met leading artists of the period: Eugene O'Neill, Sinclair Lewis and his wife Dorothy Thompson, and important critics and social movers. Through him, she was introduced to some of the leading lights of the Harlem Renaissance. She was on friendly terms with Langston Hughes, and one of her treasured possessions was a signed copy of his first book, *Weary Blues*. In turn, those who met her were often fascinated by her—and in awe of her talent and her growing fame. When Hughes traveled by train through Central Asia, he carried with him a Victrola and the records of Ethel Waters and Louis Armstrong. When he worked on his autobiography *The Big Sea*, he kept a copy of a Van Vechten photograph of Ethel in front of him.

Also fascinated, perhaps even smitten by, Ethel was Zora Neale Hurston. "She came to me across the footlights. Not the artist alone, but the person," said Hurston, "and I wanted to know her very much. I was too timid to go backstage and haunt her, so I just wrote her letters and she just plain ignored me. But I kept right on. I sensed a great humanness and depth about her soul and I wanted to know someone like that." Finally, Van Vechten "gave a dinner for me. A great many celebrities were there,

including Sinclair Lewis, Dwight Fiske, Anna Mae [sic] Wong, Blanche Knopf," Hurston recalled. "Carl whispered to me that Ethel Waters was coming later." Hurston and Waters talked and "got on very well. I found what I suspected, was true. Ethel Waters is a very shy person. It had not been her intention to ignore me. She had felt that I belonged to another world and had no need of her. She thought that I had been merely curious. She laughed at her error and said, 'And here you are just like me all the time.' She got warm and friendly, and we went on from there." When she was about to leave at the end of the evening, Waters "got her wraps, and said, 'Come on, Zora, let's go uptown.' I went along with her, her husband, and Faithful Lashley, a young woman spiritual singer from somewhere in Mississippi, whom Ethel has taken under wing."

Once she got to know Waters better, Hurston observed that she was "one of the strangest bundles of people I have ever met. You can just see the different folks wrapped up in her if you associate with her long. Just like watching an open fire—the color and shape of her personality is never the same twice. She has extraordinary talents which her lack of formal education prevents her from displaying." Hurston added, "Her struggle for adequate expression throws her into moods at times."

Ethel's friendship with Van Vechten also clearly worked to her advantage professionally, although Waters was never the kind of woman to play up to anyone she did not in some way care for. As her greatest champion, Van Vechten proved important by expressing in print what everyone else was beginning to see. Through him, she even began to look at some whites in a new light—some whites, though she still had her guard up. "I broke down part of her prejudice against pink people," Van Vechten said. He also was influential in making some of the dictys see her in a new light. "I broke down part of social Harlem's prejudice against her," he said. Yet he never took credit for her success. "I am probably the only person in America, pink or brown, connected with her early life in any way, who doesn't claim that he discovered her." Van Vechten also never ignored her stormy moods or her raging temperament. And he was fairly forthright in pointing out the occasions on which she was ungrateful. "Ethel, you never ask anyone for anything," he told her, "and you never thank anyone for anything."

\* \* \*

IN 1926, Ethel's act had changed in one crucial respect. Earl was now her full-time manager-producer and obviously the man in charge. Often overbearing and dictatorial, he insisted that all offers for her services had to come by him. Yet Ethel never meekly took a backseat to Dancer. And she never backed off from a fight with him, especially if Earl was caught paying too much attention to one showgirl or another.

Nonetheless, the show was always the main thing for her. She still wrote material, staged numbers, and maintained a very active role in most production decisions. Nothing of importance got by without her approval as they crisscrossed the country on the Keith and TOBA circuits. Together she and Dancer meticulously built up a company of top-flight singers, dancers, and comics. The two created tab shows, which were short or tabloid productions of revue-style entertainment. Dancer's goal was to whip such a show into shape for Broadway. In March, Ethel headlined a revue called *New Vanities* that seemed to have possibilities. At Pittsburgh's Elmore Theatre, the show caused a near-riot as hundreds clamored "for admission to the theater, blocked traffic the entire length of the block, and caused a hurry call for the police in order to check the rush and half the fist-fights. . . . Night after night, people had been turned away."

The Negro press considered the show "one of the most spicy and risqué ever to appear in the city." Much criticism centered on the near nudity in the show, with its "high-toned group of scantily clad chorus girls, wriggling their bodies in their own interpretation of the latest in dance hits, and holding rather suggestive poses for more than a minute in the full glare of the spotlight." Ethel too was criticized when she "sent her audiences into convulsions of mirth by rather pointed allusions to Earl Dancer, the dapper manager of the show."

On the road, *New Vanities* had other problems. When it played TOBA's Bijou Theatre in Nashville, white patrons in the city demanded seats, and a special midnight performance was scheduled. But Black patrons were enraged that priority seating was given to whites, reported the Negro press, on "the main floor—and this, too, in a strictly colored theatre! Negroes who resented being seated in the gallery were forced to purchase box

seats at enormous prices, and to this humiliation was added the presence of policemen who insulted race patrons who attempted to purchase seats. The situation is unprecedented here and is rendered the more embarrassing in that Negroes are barred from all white theatres except one. In this theatre race patrons are forced to gain entrance through a dark unsanitary gallery, on uncomfortable wooden benches." The Negro press also said it deplored "this injustice and suggests that Miss Waters and future actors prevent such occurrence by refusing to play under such humiliating terms." Segregated seating in cities would dog Negro productions for years to come. Frankly, much as Ethel was angered by the segregation, she found herself contractually unable to do anything about it. In the end, thoughts of developing the show for New York vanished.

THE COUPLE'S COLLABORATIVE EFFORTS centered on one of their most ambitious projects, a show titled *Miss Calico*, which they also created in 1926 with the young writer Donald Heywood. Partly a reworking of other shows they'd performed and partly a loose satire of David Belasco's Broadway hit *Lulu Belle*, about the rise of a mulatto in Parisian society, the musical played the Alhambra in Harlem and later moved to Pittsburgh where it was praised for its entertainment value but again criticized for its "smut." Still, Ethel traveled with *Miss Calico* to Chicago for a December opening at the Princess Theatre. Included in the large cast were comic Alex Lovejoy, the Taskiana Four quartet, a new child star called Little Kid Lips Jr., as well as the standard lineup of chorus girls, comics, singers, and musicians. Pearl would be at the piano.

Owned by the Shubert brothers, the Princess marked a transition up from the kind of vaudeville house Ethel had previously played in Chicago to first-class theater. Dancer had ingeniously worked out a deal with the Shuberts in which he signed a $3,500 guarantee for the use of their theater. Whether the house was packed or empty, the Shuberts would get their money. The budget would be tight for Dancer, but he was confident he could pull it off, and if he had a hit, the profits could be huge. But mainly, Dancer envisioned taking Ethel to Broadway in *Miss Calico*. In a sense, Chicago was a tryout city.

The venture started off well. *Miss Calico* wowed patrons and critics alike. "This class of performance, which appeals to all classes of white people, even if only to the higher grade of colored people," wrote the *Pittsburgh Courier*, "is all and is what is desired to make of Miss Waters what she is now proving, that she and her company [are] a box office attraction."

In her shows and revues, there were always acts in which she performed some of her hit songs, whether the music really fit into the storylines or not. Audiences expected such interludes, even demanded them. By now, the song that audiences everywhere most wanted to hear was the indolently raunchy "Shake That Thing." There were probably times when she didn't even want to think about "Shake That Thing," let alone sing it, but Ethel had to oblige the masses in Chicago and other cities. For Ethel, the question had to be when she might be able to perform another type of material, the kind of experimentation pulled off with "Eli Eli." Still, the results were always the same. "Miss Waters created a furor when she sang 'Shake That Thing,' by request," wrote one critic, "but the public must know that she put it over artistically clean and unadulterated."

*Miss Calico* looked like a hit for Dancer. But his $3,500 deal backfired. The costs for the cast, crew, costumes, sets, and musicians drained his financial resources, and Dancer had trouble meeting his payroll. Problems with the musicians' and carpenters' unions, which were almost exclusively white, sprang up. A major complaint was that Pearl Wright was not a member of the musicians' union. Dancer hammered out an agreement. Then the carpenters' union insisted on being paid, and the actors, whose salaries were on hold, demanded back pay. An important comedian became fed up and walked out of the show. Afterward things fell apart.

Already, Ethel had been in too many productions that ran out of money, when *she* had not been paid. Always she identified with her fellow entertainers in need of that paycheck. To see them denied—or "cheated of"—their salaries, rankled her in the worst way. Backstage and at her hotel, Ethel and Dancer apparently fought constantly. Finally, she told him she would not continue in the show. With the actors and crew hounding him and the unions refusing to budge—and now with Ethel's decision—Dancer was up against a wall. All came crashing down on New Year's Eve 1926, precisely when a packed house at the Princess sat waiting

for *Miss Calico* to begin. "In consequence of the revolt," wrote the *Courier*, "Mr. Dancer was obliged to appear and announce to the large audience that Miss Waters was ill and their money would be refunded." *Miss Calico* closed.

The Negro press supported Ethel and sharply criticized the unions, the Shubert organization, the inherent racial tensions backstage, and also Dancer's inexperience in mounting such a sprawling vehicle. "While there was more than one cause, the demand of the union head was the first step toward disaster," wrote the *Pittsburgh Courier*. "Had these men accepted of the half loaf instead of the white man's authority, the actors would have given in and the show which was already billed for the next week in the Sunday papers, would have continued on." The paper added: "But if in the question of far-sighted diplomacy Earl Dancer had been able to adjust all the differences in the trying hour of success in spite of the heavy overhead . . . with determination not to give up and by keeping the entire company intact, Ethel Waters would have landed high and dry on Broadway."

THE MESS AT THE PRINCESS marked a serious fracture in the Waters-Dancer relationship, yet Dancer still talked about Broadway. In the meantime, Ethel and Dancer knew she had to keep working. By mid-January, she opened at Chicago's Café de Paris and was a smash.

But by now, both were sensitive to criticism. While the two were still in Chicago, an African American critic, the blues singer James Gentry, known as "Gentle Jimmy," wrote that Ethel's bawdy material was a kiss of death for the image change she hoped to effect. Waters' handlers were "probably deluding themselves," Gentry commented, "with the confidence that she can put through a purifying process that is not clean. The sooner they quit fooling themselves, the better it is going to be for themselves and for her. Vulgarity is just vulgarity and as expressed by a performer with the talent Miss Waters has, it is accentuated rather than diminished . . . [and] will have the effect of making her notorious on our stage. . . . The way is open to be known and remembered as a great artist. If she prefers not to be, more popularity and money, too, awaits her in

the trail of Josephine Baker whose vulgarities have set the Parisian mob howling."

Dancer was furious. When he ran into Gentry at the club where Ethel was performing, the two men argued loudly. Later, at about four in the morning, as Gentry was leaving another club, two bottles "were hurled from the depths of a dark street by an apparent enemy," reported the *Courier*, "who cursed at him. Mr. Gentry was unable to identify his assailant." He didn't have to. Everyone knew it was Earl Dancer. None of this was good for Ethel's image.

IMPATIENT AND STILL FEELING he had to prove himself, Dancer went to work with Ethel and Donald Heywood on yet another tab show, a revamped version of *Miss Calico* called *Black Cargo*. With visions of getting it to Broadway, Dancer took the show on the road. Amid the touring, Ethel went back into the studio for Columbia in New York. In April 1927, she recorded "Smile," "Take Your Black Bottom Outside," "Home," and "Weary Feet." In June, *Black Cargo* closed in Atlantic City; in July, Ethel recorded "I Want My Sweet Daddy Now."

But for Mr. Dancer, nothing was more important than getting Mrs. Dancer to Broadway. Even to the most casual observer, he appeared obsessed by the idea of a Broadway show and labored tirelessly to put together a deal. Florence Mills had gotten there. So had women like Adelaide Hall and Gertrude Saunders. Even Waters' nemesis, Josephine Baker, had appeared on the Great White Way in *The Chocolate Dandies*. Convinced that Waters was greater than them all, Earl finally began negotiations to get her in a first-class New York legitimate theater in a show to be called *Africana*. Of course, as Ethel knew all too well, Broadway meant not only her name in lights but his as well. A marquee announcing EARL DANCER PRESENTS ETHEL WATERS was part of the bold dream.

CHAPTER 5

# Broadway Beckons

B Y 1927, AFRICAN AMERICAN SHOWS and stars had already made it to Broadway. For some years, the Great White Way had been invigorated by remarkable, exciting, and highly innovative Black talents: actors, actresses, singers, dancers, comedians, composers, choreographers, writers, directors, and producers. It hadn't happened overnight, but it *had* happened. Prior to 1895, Broadway—with its posh and elegant legitimate theaters—had been off-limits for colored entertainers. Black characters had appeared in such productions as *Uncle Tom's Cabin* and *The Octoroon*, but the roles were played, as in the minstrel shows, by white actors in blackface. A great nineteenth-century African American dramatic performer like Ira Aldridge—born for great roles on the New York stage—was celebrated, respected, and honored for his powerful portrayals—in Europe. In his own country, he garnered some attention and acclaim, but he was forced to appear in minor stock companies, not on Broadway. Looking at the fate of an actor like Aldridge, Black performers joked that the Great White Way intended to keep itself that way, lily white. Actually, Broadway had been called the Great White Way because of the blinding blitz of lights that lined the avenues where the theaters sat.

The arrival of Blacks on Broadway came not with drama but with music: the work of African American composers, or sometimes imitations of their work. Black songwriter Ernest Hogan first made a name for himself when he wrote a hit titled "All Coons Look Alike to Me." Though

it was really a love tune, it led to a wave of "coon songs," often created by white composers—coarse, dimwitted numbers that presented African Americans in the most stereotypical terms. The coon songs, which became popular with white audiences, ended up making their way to Broadway in white shows in the late nineteenth and early twentieth centuries. One of the white stars of the era, May Irwin, became known as a "coon shouter" when she appeared in the 1895 Broadway musical *The Widow Jones*.

But the historic breakthrough occurred in 1898 with the Black musical *A Trip to Coontown* by Bob Cole and Billy Johnson, the first Broadway show to be written, directed, and produced by African Americans. It opened at the Third-Avenue Theatre, then considered part of Broadway's network of theaters. That same year the operetta *Clorindy, the Origin of the Cakewalk*, by Will Marion Cook and Paul Laurence Dunbar, made it to Broadway, opening at the Casino Theatre roof garden. Not only did *Clorindy* popularize the cakewalk, a dance that had originated among slaves on plantations, but also Cook's outlandish song, "Who Dat Say Chicken in Dis Crowd." Though later generations would cringe at the title of Cook's song, it was through Cook, said James Weldon Johnson, that "New York had been given its first demonstration of the possibilities of Negro syncopated music, of what could be done with it in the hands of a competent and original composer. Cook's music, especially his choruses and finales, made Broadway catch its breath." Cook's next musical, *Jes' Lak White Fo'ks*, was not as successful as his first, but the show kept him in the game, and he would remain a Black showbiz fixture for years to come. So would Bob Cole, who wrote music for white shows with another partner, J. Rosamond Johnson, and also collaborated with Johnson's brother, James Weldon Johnson. They were not related to Billy Johnson.

Bob Cole and Will Marion Cook pushed open the portals of Broadway for Black musicals—and other Black composers. Cook, Cole, and the Johnson brothers were all well-educated, sophisticated men of the theater. J. Rosamond Johnson had studied piano at the New England Conservatory in Boston for six years before joining a touring company. James Weldon Johnson was a graduate of Atlanta University and for a time taught mathematics in Jacksonville, Florida, where he and younger brother, Rosamond, had grown up. Cole and the Johnson brothers loved musical the-

ater, so much so that they were not willing to let prevailing barriers hold them back. With energy and élan, they knew how to pitch their work for the white producers who controlled New York theater, and they knew that in theater perseverance and perspiration—in the face of the most blatant kinds of racism—might lead to success. So could the ability to create hits and trends.

All three men understood that theater people and audiences often enjoyed Negro entertainment, but they usually preferred to be one step removed from it; that is, they preferred ersatz Negro entertainment performed by white stars and created by white composers. The men understood it was crucial to persuade the producers and directors to use the real thing—if not Black stars, then certainly Black composers. Uphill battle that it was, the men continued to make new dents in Broadway's color system: against the racial odds, they got their song "Louisiana Lize" to white entertainer May Irwin—yes, again, that well-known alabaster coon shouter—who liked it and performed it in 1900 in her show *The Belle of Bridgeport*. Other stars, such as Lillian Russell and Anna Held, the wife of Florenz Ziegfeld, also performed their songs. The men also wrote the hit "Under the Bamboo Tree," which was used in the white show *Sally in Our Alley*. Just as important for the three creators was to move away from the stereotypes that were already so deeply ingrained in American popular culture. The Johnson brothers wrote the emotionally powerful "Lift Every Voice and Sing," a tale of racial pride and fortitude that was considered by Negro America to be its national anthem. In 1907, Cole and Rosamond Johnson saw their Black show *The Shoo-Fly Regiment* open on Broadway, followed two years later by another Cole-Johnson musical, *The Red Moon*.

Will Marion Cook stayed in the business too. His career changed once he saw the celebrated Black comedy team of Bert Williams and George Walker on Broadway in the white show *The Gold Bug*. The two men also starred in their own shows: *The Policy Players* and *The Sons of Ham*. Having originally worked in minstrel companies, where they billed themselves as "Two Real Coons," Williams and Walker were masters of a ribald comic style that enabled them to rise to the top ranks of the theater. Cook worked with the team on such shows as *In Dahomey* in 1903, which

was the first Black show to play a major Broadway theater; *Abyssinia*, in 1906; and *Bandanna Land* (or *Bandana Land*). While marveling over the timing and rhythm of Williams and Walker—Williams being the slow-moving, slow-thinking half of the team; Walker being the now familiar fast-talker—Broadway audiences were also bowled over by the dancing, the singing, the beauty, and the charisma of Walker's wife, Aida Overton Walker. Afterward, no Black musical would be complete without a gorgeous, glamorous Black female star.

In some disturbing respects, despite their originality, the comedy in the early Black shows traded in the old stereotyped minstrel images. Those images led to heated debates between Cole and Cook as to what Black shows could or should do: the concepts underlying them and the artistic goals of the productions themselves. Cole was determined that Black shows should rival white ones and should have the same standards and outlooks as white productions. "Cole believed that blacks should strive for excellence in artistic creation," said theater historian Allen Woll, "and must compete on an equal basis with whites. His musicals therefore had to rival those of white composers and lyricists, and thus demonstrate that the Negro was capable of matching whites in all realms of cultural production." That no doubt meant moving away from the old types and perhaps a less obvious kind of ethnic theater.

Cook's attitude was radically different. Forget about white standards and white productions. Cook believed that "Negroes should look to themselves for the wellsprings of creativity, developing artistic endeavors that reflected the soul of Black people." Ironically, Cook, having studied classical music, appeared to reject his training. James Weldon Johnson said that Cook "had thrown all these standards over; he believed that the Negro in music and on the stage ought to be a Negro, a genuine Negro; he declared that the Negro should eschew 'white' patterns, and not employ his efforts in doing what 'the white artist could always do as well, generally better.'" In his pursuit of a more ethnic theater, however, Cook would be criticized for replicating the familiar stereotypes that grew out of the minstrel shows, the kind of stereotypes that would plague Black productions (and eventually Black films and television too) for decades to come.

Regardless, Cook was considered a man blessed with musical genius,

able to work a song like crazy. The mass Black audience would often delight in the work of an artist like Cook, sorting through the stereotyped nonsense to uncover the moments of cultural truth and the stylistic achievements of the work itself. Ethel would hold him in high regard.

No matter the debate, shows of Will Marion Cook and Cole and Johnson were important to the theater. Black artists now had the opportunity to express their talents, to invigorate theater with new styles, with a new energy, a new use of language, a new kind of music and dance, a new kind of rhythm.

After 1910, much changed for Blacks on Broadway. That year George Walker died. His former partner, Bert Williams, rose to even greater stardom when Ziegfeld signed him for his *Follies* in 1910. But as James Weldon Johnson recalled, the early peak period for Black musicals—1898 to 1910—was followed by a "term of exile" for the next seven years. The major Black creative artists soon disappeared. Some, like Ernest Hogan and Bob Cole, had died. Others, like Rosamond and James Weldon Johnson, pursued other interests. Broadway's loss, however, led to a boost for Black theaters. At the Lincoln and Lafayette, Black shows created expressly for Black audiences flourished. Such performers as Charles Gilpin, Abbie Mitchell, Frank Wilson, Jack Carter, Edna Thomas, and Clarence Muse emerged as stars. Actress Anita Bush established her own stock company. During the lean years, some Black shows occasionally reached Broadway. So did some of these new Black stars.

The Broadway term of exile came to an end, so Johnson believed, by 1917, with the arrival of such Black productions as *The Rider of Dreams*, *Granny Maumee*, and *Simon of Cyrenia*, all of which played the Garden Theatre. Four years later *Shuffle Along* appeared. Everything changed once again. The jazz-pop music of the show—such songs as "I'm Craving for That Kind of Love," "Love Will Find a Way," and "I'm Just Wild About Harry"—broke with European traditions. The show also pointedly had a love interest. *Shuffle Along* also broke down some, but certainly not all, of the segregated seating policies in Broadway theaters.

The audiences for Black musicals on Broadway were mostly white. It wasn't that African Americans were not interested in the theater. Those who saw it loved the shows and relished the idea that African Americans

had moved into the upper echelons of the theater world. Rather, it was that African Americans did not always feel welcomed at downtown theaters. Usually, Black patrons were seated in segregated sections. The conditions at the theaters were "humiliating," said James Weldon Johnson. "In the 'Broadway' houses, it was the practice to sell Negroes first balcony seats, but, if their race was plainly discernible, to refuse to sell them seats in the orchestra. The Metropolitan Opera House, Carnegie Hall, and in general, the East Side and West Side theaters were exceptions. The same practice was and still is common in most of the North; it is not necessary to mention the practice in Southern cities. In Washington, where race discrimination is hardly less than in any city in the South, Negroes are not allowed to enter the National Theatre." On those occasions when prominent African Americans like James Weldon Johnson or the poet Claude McKay had purchased orchestra seats, there were usually problems. Ushers might ignore them or tell them their seats were for another evening.

At *Shuffle Along*, most of the orchestra section remained reserved for whites, yet some Negro theatergoers did find orchestra seats. In the end, more African American patrons felt welcomed on Broadway. Following *Shuffle Along*, other Black musicals made their way to Broadway for the duration of the 1920s: such shows as *Strut Miss Lizzie* with its hit "Way Down Yonder in New Orleans"; *The Plantation Revue*; *Liza*; and the Miller and Lyles musical *Runnin' Wild*, in which Elisabeth Welch performed the hit "Charleston." When that show played Philadelphia, the song and the dance craze took off. Such other shows as *The Chocolate Dandies*, *Dixie to Broadway* with Florence Mills, and *Bottomland* also turned up on Broadway. Most spectacular was David Belasco's melodrama *Lulu Belle*. Written by Charles MacArthur and Edward Sheldon, it recounted the rise of a light-skinned colored heroine from Harlem to a plush life in Paris. In most important respects it was not a Black show. Its Black leading characters were played by white performers Lenore Ulric and Henry Hull. But three-fourths of the entire cast, including the actresses Evelyn Preer and Edna Thomas, was African American. James Weldon Johnson recalled that "because of the large number of coloured performers in a mixed cast playing important roles, *Lulu Belle* was extremely significant in the history of the Negro theatre in New York."

* * *

WITH THE BELIEF that the time was now right and that it was better to take the leap before another "term of exile" might begin, Dancer had initiated his boldest negotiations to bring Ethel to Broadway in a musical that would be an amalgamation of the tab shows *Miss Calico* and *Black Cargo*. The new show would spotlight her versatility. Not only would Waters sing, but she would also do comedy and dance too. Eventually, under the title *Africana*, it would be an all-Black production.

No one was more thrilled by the prospect of getting Ethel to Broadway than Carl Van Vechten. The woman he believed in so fiercely must have the opportunity to show everyone that she was every bit the great talent he had been saying she was. Van Vechten encouraged and worked with Dancer to secure a major backer and quite probably helped Dancer wrangle a meeting with the financier-philanthropist Otto Kahn. A man about town and no doubt considered a Negrotarian like Van Vechten, Kahn was known in Black social, artistic, and entertainment circles. He was once so taken with the young light-skinned actress Fredi Washington that he told her she could have a great career if she crossed the color line and passed for white. He offered to finance her dramatic education if she did so. But Washington told him she could never be anything other than who she was. Kahn was said to have "combined noble sentiments with keen market analysis." Feeling that *Africana* could be a hit, Kahn invested $10,000 in the production. What really gave him confidence in the show? It was Ethel. For Ethel, *Africana* would be a supreme challenge. Finally en route to the Great White Way and perhaps to establishing a new image in an arena from which she had felt herself excluded ever since her failed attempt to get into *Shuffle Along*, Ethel knew she had to pull out all the stops.

The year 1927 would be an important year for African Americans in the theater. It would mark the debut of the Jerome Kern–Oscar Hammerstein II dramatic musical *Show Boat*—in which Jules Bledsoe would powerfully perform the song "Ol' Man River" and in which white star Helen Morgan would play the tragic mulatto Julie, and DuBose and Dorothy Heyward's drama *Porgy*—the story of a crippled beggar in love with the carnal and doomed Bess—would also open that year.

\*    \*    \*

ONCE FINANCES WERE IN PLACE, everything about *Africana* came together quickly. Not long after *Black Cargo* closed, rehearsals for the new show began under Dancer's direction. A new Black musical, *Rang Tang*, by Flournoy Miller and Aubrey Lyles, was scheduled to open soon, and Dancer was eager to establish *Africana*. Like producers of Black productions before him, he knew his chance of getting the show into a Broadway theater was best during the summer months: in the era before air-conditioning, some shows closed down because of the heat and humidity and reopened in the fall; consequently, numerous theaters were vacant, and theater owners were eager to have just about anything play in their otherwise empty houses.

As it turned out, *Africana* opened at Daly's 63rd Street Theatre on July 11 in the middle of a blistering heat wave, but the weather didn't prevent a glittering turnout. Among those in attendance were Oscar Hammerstein II, actress Belle Baker, George Olsen, theatrical manager-attorney Harold Gumm, future power broker agent Abe Lastfogel, and naturally—and most visibly—Carl Van Vechten and his wife, Fania Marinoff. Outside the theater stood a large sign with a quote from an excited critic who had written that he would rather hear Ethel sing than Raquel Miller, who was then a major star known to everyone. The critic: Van Vechten.

Divided into two acts with thirty different scenes and a cast of sixty, *Africana*'s musical score was by Donald Heywood. The book was by Dancer himself. The dance numbers were staged by Louis Douglas, then celebrated for his work with Josephine Baker in Paris in *La Revue Nègre*. Basically, *Africana* was a revue that was similar to the floor shows of the clubs. There was no story to speak of—just a group of fantastic entertainers performing in skits and sketches and individual routines. The cast, providing a backdrop for Ethel, was excellent. Among the masterful entertainers: the comedians and dancers Henry Winifred and Billy Mills, performing in burnt cork; the tenor Paul Bass; the acrobatic dancers Babe and Bobby Goins; the Taskiana Four quartet; a "chorus of bronze beauties"; and "the Southland Syncopaters, a crack jazz orchestra of a dozen torrid 'blues' specialties, directed by Allie Ross." One number—described

as "Harlem Transplanted to Paris"—took a satirical poke at Josephine Baker. Here Margaret Beckett performed a giddy "Banana Maidens" that had the house rocking. The title itself—*Africana*—was a salute to the glory and rhythms of the motherland.

Yet despite the talented cast, *Africana* might as well have been a one-woman show because everyone was there to see Ethel. In the first act, she led an uninhibited rendition of the latest dance craze, the black bottom, that just about stopped the show. Her "wiggling" was so sexy that one critic wrote that "her movements virtually constituted a cooch." And the exuberant Waters personality—the broad smile, the large expressive eyes, the throaty laugh, the sensual come-hither-if-you-dare attitude—was a part of every skit and every dance step she took. But the moment that everyone had been waiting for—*Africana's* feverish, energetic high point—occurred during the second act when Ethel stood center stage to sing her hits: "Dinah," "Take Your Black Bottom Outside," "I'm Coming, Virginia," "Shake That Thing." As one hit followed another, the audience was provided with a clear perspective on her career. And no one was more enthusiastic than Van Vechten, who some thought looked as if he was losing his senses. "You know, I don't like to talk about it, but I was rather embarrassed last night by Carl Van Vechten," recalled one observer. "He'd clap his hands with resounding smacks each time Ethel appeared, and in the midst of her second act specialty he began yelling things. He called for songs, among them being, as best I remember, 'Dinah' and ['Take Your Black Bottom Outside].' I was seated immediately behind him, and I became uneasy for fear the assemblage would think I was yelling at Ethel. I make it a rule never to shout at colored ladies." Commented another observer: Waters "gave a generous series of her repertory of songs, which was apparently so familiar to an ecstatic audience that they hardly waited for her to finish one before they began pleading for another—a chorus led by the insistent voice of Carl Van Vechten firmly demanded 'Dinah.'" There was Van Vechten, one of the city's major critics, shouting and screaming like any other star-struck fan. Theatergoers would talk about it for weeks to come.

One observer, however, detected something else in Ethel's performance that evening. "Each time she answered a cue and went through her

prescribed part," he said, "I watched her eyes, and in them I read that still she sought and groped for an elusive something which did not come. And therein she is a true artiste, battling mightily, unconsciously, to improve perfection as we know perfection."

FEW CRITICS, HOWEVER, thought much of the show itself. One griped: "It has no music at all that is not dimly imitative." Burns Mantle of New York's *Daily News* complained, "Strange the colored folk cannot get together on some form of revue that would be a real credit to their race. But the thing they produce is usually in cheap imitation of a cheap model." Nor did Mantle think much of Ethel. "Miss Waters, with talent for singing character songs, even without a voice, casts it aside to do the rowdy sex patter of the honky-tonks and promptly brings the tone of *Africana* down to the level of the sub-basements of Harlem."

But Mantle was the exception. Most praised Ethel, even though some mainstream theater critics were admittedly unfamiliar with her. The critic for the *New York World* referred to her as *Edith* Waters. He commented that "while Edith is around entertainment is plentiful. The records show this long, tall, brown-skinned gal to be a person of some reputation uptown, and she richly deserves whatever acclaim has been hers."

Nor did the critic for the *New York World-Telegram* know much about her, but he wrote that the musical was glorified "by the presence of the dynamic personality, new to this spectator but well known, we are told, to diverse entertainments on the outskirts of Harlem. Her name is Ethel Waters and she makes and stops the show." "For the most part, *Africana*, is a good dancing show, starring the towering Ethel Waters, who, although new to this commentator, seemed to have a generous, mixed following," wrote E. B. White in *The New Yorker*. "With her sleek, boyish bob, tall frame, and cavernous jaw of white ivories, she possesses the tall, supple beauty of an African gun-bearer."

Both Ethel and Dancer were excited by the wide coverage *Africana* had won from the mainstream media. Yet the most observant comments came from Black critics, who were aware of her history and could better understand what she accomplished with the show. James Weldon Johnson

believed that *Africana* was far fresher than Miller and Lyles' *Rang Tang*, which was a sign that the "traditional pattern of Negro musical comedy was a bit worn." *Africana*, however, was "a swift modern revue." He raved that Ethel "dominated the show," and he examined her work within the context of Black theater history and its leading ladies. "Miss Waters gets her audiences, and she does get them completely, through an innate poise that she possesses; through the quiet and subtlety of her personality," he wrote. Johnson also recognized the power of her slow-burn style, of her hot-cool sexuality. "She never 'works hard' on the stage. Her bodily movements, when she makes them, are almost languorous. Indeed, she is at her best when she is standing perfectly still, singing quietly. Her singing corresponds to her bodily movements; she never over-exerts her voice; she always creates a sense of reserved power that compels the listener," said Johnson. "Miss Waters also has a disarming quality which enables her to sing some songs that many singers would not be able to get away with on the stage. Those who have heard her sing 'Shake That Thing' will understand."

In the *Pittsburgh Courier*, W. Rollo Wilson also assessed her place in theater history. "They do say that comparisons are odious. Sometimes they're odorous," he wrote. "But what better method have we to determine the value of a jewel, a meal, an incident, a person than to compare or contrast it with one or more of its kind which has or have gone before? Answering my question—none. So Ethel Waters. In the musical comedy field two of our women have stood out since Aida Overton Walker. One of these is Miss Waters. And Miss Waters is nearer to the immortal Aida, whose brilliance illumed the turn of the century, than is the other star. In *Africana* she is as near perfect as mortals get, and yet Miss Waters is not satisfied, even though she may not realize it."

To the African American critics, *Africana* represented a grand new day in theater. It was valued as "pure African, made entirely by race people, not only as to its performers, but also its management, direction, dances, music and sketches and doubtless, too, where authorship can be identified, as to its songs. It is truly a revue in the general acceptance of that term in theatricals, yet it is different from the same thing when offered by white people, except in the spots where the offerings are imitations of the white." In this respect, *Africana* might be recognized as part

of that creative outpouring of the Harlem Renaissance, but *Africana* was *Africana* only because of Ethel, around whom all those creative energies swirled and were unified.

Shrewdly, Dancer hired African American writer Geraldyn Dismond as a press agent for the show. Dismond, a feature writer for the *Pittsburgh Courier* and "a pioneer in a new field for women, being owner of a bureau for specialized publicity," was considered "perhaps the race's most distinguished woman journalist." Using her wide range of contacts, she managed to get the endorsement of New York Black ministers for the show, no easy feat. Show people were still often thought of as doing "the devil's work." Among them was the Reverend W. H. Moses, the father of actress Ethel Moses. Along with other prominent clergymen, Moses attended the show. Afterward a statement was issued for the press: "When any of our group is fortunate enough to gain and hold a place on 'Broadway,' even the clergy who find many objectionable features about the stage in general, is proud of and anxious to encourage him. Unfortunate, indeed, is the man who doesn't appreciate the subtle contribution to serious observation on American life, though lightly presented through the song and dance, wit and wisdom of our sorely tried and tired people. Miss Waters' rending, 'Tired (Weary) Feet' is typical and touching." Touched by Ethel's performance of the song "Smile," which "whispers hope into my body," Reverend Moses added: "I have just returned from the Mississippi flood region, where we are giving aid to the sufferers. . . . You have caught and finely expressed in the 'Smile' song and scene the spirit of our people in disaster. May you continue to do well and draw audiences such as I saw last night." No comment was made as to how the ministers responded to Ethel singing "Shake That Thing."

Black celebrity endorsements also appeared. Hall Johnson, the leader of the Hall Johnson Choir, commented that it "is one of the most satisfying things Negroes have ever done in the theater." Edna Thomas, one of Harlem's most gifted dramatic actresses, called Ethel "incomparable" and "the brightest luminary" and said that no show since *Shuffle Along* had "proven so consistently entertaining." Of course, Van Vechten joined the chorus of praises. He talked about the show whenever he could and excitedly wrote Langston Hughes, who was out of town: "Ethel Waters'

*Africana* is marvelous & sure to be running when you come back."

Reading the reviews, Ethel knew that she still had not completely cleaned up her image, but now she was being taken seriously as an entertainer and was recognized as a worthy successor to Aida Overton Walker and as a theater diva every bit as accomplished as Florence Mills.

DESPITE THE SWELTERING HEAT, patrons lined up at Daly's 63rd Street Theatre, including celebrities who had missed the opening night: Lester Walton; writer Eric Waldron; Claude A. Barnett of the Associated Negro Press in Chicago; Bill "Bojangles" Robinson and his wife, Fannie; Lenore Ulric, star of *Lulu Belle*; millionaire banker Edward Wasserman; artist Aaron Douglas; Theophilus Lewis, editor of the *Inter-State Tatler*; poet Witter Bynner; Otto Kahn; even *Rang Tang* stars like Aubrey Lyles and his wife. Actress Evelyn Preer came to the show. Returning were Van Vechten and his wife, Fania.

*Africana* opened other doors for Ethel socially. Private parties were given in her honor. One week it was at Nella Larsen's. Another week it was a tea in her honor, given by the millionaire banker Edward Wasserman, who struck up a friendship with her. So did dancer-actress Rita Romilly, known for her integrated parties attended by Black writers and artists. For a time, Ethel and Romilly appeared to have developed a close relationship. And, of course, no lineup of parties, receptions, luncheons, and dinners in Ethel's honor would be complete without one at Van Vechten's. On this occasion, the poet Witter Bynner, who was reported to "possess one of the finest collections of jade in this country," presented Ethel with a large oval jade that he had acquired while on a trip to China. He brought two with him. Ethel was to select the one that appealed most to her.

The Columbia Phonograph Company also took out ads for Ethel's new recordings:

> Ethel Waters, now starring in her new New York hit "Africana,"
> sings for you "I Want My Sweet Daddy Now" and "Smile!"
> It's a safe bet that Daddy won't be missing for long
> when he hears these selections.

Ethel had also already signed an endorsement deal for the cold cream Golden Brown, created especially for African Americans.

With all the fanfare, Dancer was said to have considered buying twelve hundred acres of land in Sorrento, Maine, which was a deluxe summer colony some eight miles from Bar Harbor. Though he later denied the story, he was reported to have had visions of creating a race colony that would include not only Ethel and himself but Paul Robeson, Florence Mills, and other members of the Black elite.

ETHEL TOOK IT ALL IN STRIDE—the constant attention, the ongoing scrutiny, the never-ending expectations that another success must quickly follow, the continued wave of people wanting the star's time and attention. But she relished being able to high-hat the high-hatters, to turn down invitations, to arrive late at parties and leave early. If the ofays or the dictys wanted her company, they'd follow *her* rules. Yet paradoxically, many of those childhood fears and doubts could still creep up. She never forgot she was from Chester, which she was proud of, and she knew she still lacked the education and social graces of so many in the world into which she was now thrust. Nor was Ethel Williams around to smooth over awkward social moments. Earl seemed his socially confident self wherever he was, although at times Ethel didn't need him as much as she may have once thought.

Now she began constructing an image for the press that she felt comfortable with—this continued into the next decade. The raunchy woman on the records was one kind of image. But the woman offstage—the more personal Ethel—was another matter altogether. It had to be stressed that she was a lady. Though she had done nothing to prevent anyone from assuming that she and Dancer were married, to be living together in sin was not part of the image. So the pretense of a marriage continued. She had also become more exposed to African American history, in which she took pride. One of her great heroes was the fiery orator and great race leader Frederick Douglass. Before anyone knew it, Ethel informed the press that Douglass was her great-grandfather! Also publicized was her strong religious faith and the influence that the Catholic nuns had on her.

Waters also told the press that at heart she was shy and insecure. That was probably partly true. Zora Neale Hurston and Geraldyn Dismond certainly believed that. At this point, she stressed having had a rather strict upbringing in which she had "found considerable opposition at home to a career on the stage." Her grandmother was mentioned but not Momweeze. Not yet discussed were details of her impoverished childhood, the hard knocks and deprivations, the humiliations and setbacks she had to overcome. But all of that would be revealed publicly in the years to come. In time, just about everyone in show business would know something about the hardships of this girl from Chester.

DESPITE THE FANFARE, *Africana* ran into problems that eventually led to additional difficulties in the Waters-Dancer relationship. The show's competitor *Rang Tang* was pulling in $13,000 weekly, but in its fifth week, *Africana* had a weekly gross of only $7,000 to $8,000. Was the Daly not accurately reporting grosses? Dancer had problems getting box office receipts from the theater, and soon he discovered that he could not cover his production costs. Word leaked out that salaries for the *Africana* cast were not being paid. A little after a month of the show's opening, Dancer saw that there was standing room only for audiences on August 16. Yet only $500 was reported at the box office. Two hundred tickets were unaccounted for. Infuriated, after the performance that Tuesday evening, Dancer shockingly announced that he would close *Africana*. The next day many cast members scrambled to find work in other shows. Louis Douglas was even reported to have booked passage to London.

Shrewdly, Dancer negotiated a deal with the Shuberts to open the production at their National Theatre on 41st and Seventh Avenue, a larger house than the Daly. But he needed money to do so. He discussed the situation with Van Vechten, who arranged a meeting with Otto Kahn. "Through my friend Carl Van Vechten," said Dancer, "Otto Kahn . . . provided me with the funds to move *Africana* from Daly's." On the following Saturday evening, *Africana* was back in business. All cast members returned, and Ethel was relieved. But Dancer's contract with John Cort, owner of the Daly, stipulated that the play was to be performed at his

theater until September. An angry Cort reminded Dancer of the terms of the contract, and a suit was filed in New York's Supreme Court to block the show from continuing at the National until after its eight-week run at the Daly. Cort was asking for $25,000 in damages. Dancer, the Shubert Theatrical Corporation, and Ethel were all named in the suit.

Waters put on a brave face, but some of these problems—legal proceedings; casts and crews, which she felt responsible for; unending hassles over money; repeated conflicts with advisers, producers, managers, and lawyers in whose hands she felt her future was cast—had dogged her career in the past. The lawsuit led her to question Earl's capabilities. Having once believed he could handle her professional affairs, she was now losing confidence in him. Preparing herself for the worst, she began negotiations for appearances at New York's Palace Theatre.

Eventually, the ongoing legal hassles with *Africana* took their toll. "*Africana*, the Earl Dancer revue starring Ethel Waters, gave its final performance at Shubert's National Theatre last Saturday," reported the *Pittsburgh Courier* on September 24, 1927. "Although New York is alive with various tales as to the sudden and unannounced closing, it is generally believed that the impending Daly Theatre suit was the cause. Whatever may have been the reason, the fact remains that the National is dark and Miss Waters is appearing at Keith's Palace Theatre this week." In the end, Dancer told Lester Walton that he had lost $30,000 on the show.

Much as she hated seeing the show close, she was also relieved. With the booking at the Palace, she had landed on her feet and was back on Broadway in a major appearance. Not many Black entertainers got to headline this huge house. Opening in 1913, the Palace was a three-level theater with 1,733 seats. Such stars as Sarah Bernhardt, Ed Wynn, Fannie Brice, Sophie Tucker, and George Jessel had made the Palace the place all vaudeville acts dreamed of playing. Earl, of course, took credit for the booking. "We were offered," he said, "a date at Keith's Palace Theatre, then the apex of vaudeville. Ethel and I had played the Palace before as a team but this time it was offered her as a single and a headliner. Ethel Waters was the first Negro woman to ever play the Palace Theatre as a single headliner." On the bill with Ethel were such performers as Jack Benny, Eddie Foy Jr., Benny Fields, and Blossom Seeley.

But at the Palace, Ethel was beset by new headaches, the biggest of which was Blossom Seeley. Along with such vaudeville stars as May Irwin and Sophie Tucker, Seeley was yet another white star who had attained success initially as a coon shouter. Having been a performer since the early years of the century, she had also recorded at Columbia such songs as "Way Down Yonder in New Orleans, "Everybody Loves My Baby," and "You Said Sometin' When You Said Dixie." Enjoying her reputation for being able to put across a song with a colored sound, she "is considered a great imitator of Negroes by some whites," wrote the *Pittsburgh Courier*. But now she shared the bill with Ethel—an authentic colored artist who didn't have to fake an ethnic sound. Worse, as Dancer said, Ethel "was billed over everyone, including Blossom Seeley."

Backstage was a nightmare for Ethel. The management didn't know where Ethel should appear in the lineup of white entertainers. At one point, she was told she'd perform just before intermission. Then she learned they wanted her to appear after intermission. Said Dancer: "Ethel was shoved all over the bill. From next to closing intermission—to closing the show." "As is usual in placing Negro acts or actors," reported the *Pittsburgh Courier*, "the management gave Miss Waters the hardest spot on the program, loaded down with stars, following Pathé News and the intermission." The paper also commented that Waters was "billed as the 'greatest actress of the race.' Why of her race?—ability unusual, unexcelled, unrestrained, like that possessed by this queen of the footlights, knows no race limitation."

She may have had the hardest spot on the program, but that didn't faze Waters once she got onstage. Performing "I'm Coming, Virginia," she had the audience in the palm of her hand "while another number created such vociferous applause" that "it sounded like hailstones falling on the roof." "On opening performance," said Dancer, "Ethel was forced by the audience to do over forty-five minutes, a time which was only topped by Jolson." In an appreciative yet condescending manner, the critic for the *New York Times* wrote: "Probably honors went, by what might possibly be termed a shade, to Ethel Waters, the engaging dusky songstress, who recently appeared in *Africana*. Miss Waters was handicapped not a little by the fact that she was placed after Blossom Seeley and Benny Fields,

whose specialties are jazz and ragtime done fortissimo, but she delivered 'Dinah' and 'Shake That Thing' in an easy, slight detached fashion that her auditors found extremely to their liking. It [was] a big afternoon for Miss Waters' public, who seemed to be there in numbers."

Blossom Seeley apparently seethed at the way Waters had taken over the whole show. Backstage, she and Ethel clashed. But Blossom Seeley did not understand that if there was a clash with Ethel, only one person would win it: Ethel, who didn't care now if she clashed with anyone, be it he or she, Black or white. This was Ethel's first major battle with a white star, but that didn't stop her from unleashing her temper. She wasn't going to tone down her act or cut anything out to please anyone.

The Waters-Seeley episode became the talk of the Black entertainment world. "White Star Quits" read the headline in the October 11, 1927, edition of the *Pittsburgh Courier*. "Ethel Waters at the Palace last week sang and danced herself into such favor with the audiences that Blossom Seeley, famous Keith star, Negro song and chatter impersonator, quit cold—refused to continue on program with our versatile Ethel. Just another convincing sign that class will tell. If you've got the goods you can deliver. Ethel is broken out as a delivery artist. Sing 'em Ethel! Sing 'em." The publicity that followed in the Black press no doubt endeared Ethel to Black readers. Here was a Negro woman who would not take a backseat to anyone. At the same time, the incident added to the growing stories about Waters' hot temper. But the incident drained her and embittered her all the more about racial attitudes even in the supposedly "open" and liberal world of professional entertainment.

IN OCTOBER, she was back in the studio to record "Someday, Sweetheart" and the onetime Sophie Tucker hit "Some of These Days."

Shortly after the Palace, Ethel and Earl created a new revue in which she starred. Though she was under contract with the Keith organization, a deal had been worked out for her to do the show at the 300 Club at Broadway and 54th Street, reportedly at $1,200 a week. During the engagement, the club was renamed the Ethel Waters 300 Club. Backing her was a white cast, not typical backup for a Black star. Earl might bask in throwing to-

gether such a deal, but after one week, Ethel quit the show. The club had failed to pay her.

IN LATE OCTOBER, the news broke that Florence Mills had become ill and was rushed to the hospital. Suffering from acute appendicitis, she was operated on twice. Then on November 1, 1929, Mills, at age thirty-two, suddenly died. Ethel was as stunned by the news as the rest of the theatrical community. Dancer immediately stepped in to help with funeral arrangements and a memorial. Eight female stars were selected to be honorary pallbearers: Cora Green, Edith Wilson, Gertrude Saunders, Maude Russell, Aida Ward, Lena Wilson, Evelyn Preer, and Ethel. At the funeral, five thousand mourners jostled for seats at Mother Zion AME Church. Outside an estimated 150,000 people—many there to see the dignitaries and stars in attendance—lined the streets of Harlem from morning to dusk. For Dancer, Mills' funeral was something of a major theatrical event. "He had blackbirds flown over Harlem," said performer Maude Russell—in a tribute to Mills' signature song, "I'm a Little Blackbird Looking for a Bluebird." Interviewed by the mainstream press, he was quick to discuss Mills' career, her death, and the tributes to her. Dancer even had a hand in selecting the reported $10,000 casket in which Mills was buried.

But within Black entertainment circles, Earl Dancer looked like an opportunist who had overstepped his bounds. "The white newspapers played him up as a special friend of the Mills family," reported the Negro press, "when it is known among colored performers that Florence was no particular friend of Dancer's, or his wife, Ethel Waters." Dancer, however, brushed the criticism aside and continued with plans for memorials for Mills in other cities, but the criticism in the Negro press could not have pleased Ethel—and no doubt added fuel to her growing disillusionment with Dancer.

IN A SHORT TIME, she was back onstage, first in Chicago and then in *Africana* at the Lafayette Theatre. Aware there was money to be made on

the road, Dancer took *Africana* on tour. An elaborate opening at the Gibson Dunbar Theatre in Philadelphia drew a crush of Black and white Philadelphians to see the hometown girl who had become a Broadway star. One of the city's major white dailies, the *Philadelphia Inquirer*, called her "the most dynamic colored comedienne." Held over for a four-week engagement, *Africana* raked in a reported $100,000. Next the production traveled to the Nixon Theatre in Pittsburgh. Ten years earlier, when Ethel performed with the Hill Sisters in Pittsburgh, she earned $9 a week; now her name was above the title on the marquee. When she moved on to Milwaukee, where the white newspapers never ran photographs of Negro performers, her picture appeared in the theatrical page of at least one white publication. She also made news by breaking the local color barrier when she secured accommodations for herself and her company at the city's new Plankinton Hotel. Even Ethel must have been surprised by some of the mainstream coverage. Caught up in the excitement and with an eye on future profits, Columbia took out ads for such Waters records as "Smile," "Satisfyin' Papa," "Take What You Want," and "Some of These Days."

So promising were prospects for the future that Ethel and Dancer thought the time might be right for her to appear abroad in London and Paris. Negotiations began as Dancer worked on a production to be called *From Harlem to Paris*. He quickly threw together another play, in which Ethel would perform two roles, called *Born Black*.

But heady as the times were, Ethel's personal relationship with Earl was still in trouble. She complained that he constantly nagged her about work and that he still wanted to dictate decisions about her career. Curiously, she also appeared to have grown jealous. Other women were always around—at the theater or at parties or at the after-hours clubs. She was aware of the eye contact, the flirtatious smiles, the whispers. At one point, Earl became chummy with a chorus girl named Billy Cain. When the gossip about the two reached Ethel, she approached the young woman, let her know precisely what she thought of her, and by some accounts, physically attacked her. Afterward Earl was on his best behavior, but there was new gossip among theater folk and audiences alike about Earl's ever-roving eye, which the Negro press also reported. None of these stories

were good for the Waters ego. Nor, perhaps, in her mind, was it good for her image. How could it be that some chorus girl had won the favor of the Queen's man? When it came to Earl and other women—as with just about everything else in her life—Waters seemed always on edge, and her temper was more out of control than ever. At one point, she somehow got hold of a handgun, which she carried with her. One evening in Chicago in 1928, an obviously distressed Ethel ran into Carl Van Vechten at a nightclub. She was carrying "a revolver looking for sweet papa Earl, the dirty mistreater," Van Vechten confided to Langston Hughes. Other times she had to question his professional judgment. When *Africana* was set to open at the Shubert-Rialto Theatre in St. Louis in May, the performances were canceled because the musicians demanded to be paid in advance. Earl had tried to negotiate, but he still couldn't come up with the money. The Shubert-Rialto was not a vaudeville house but "a legitimate theater" for classy productions. Running out of money, Dancer also had to cut cast members, from sixty to forty-two. One night, six hundred people seated in the audience were told, in essence, to go home: there would be no show. For Ethel, it was another embarrassment, another nightmare. The plans for London and Paris also fell through. "Everything appeared to be in readiness for our departure," Dancer told the press, "when last week we received word that the English Labor Commission had thrown a monkeywrench into the works. They will not permit the invasion of foreign theatrical stars, and it is because of this fact that our arrangements for a trip abroad had to be cancelled."

Aside from everything else that upset her, the constant touring was backbreaking. When Ethel returned to Philadelphia to perform at the Standard Theatre in June 1928, she was booked, as always, to do three shows a day—a matinee at 2:30, an evening show at 7:30, and another at 9:30—plus midnight shows on Thursdays and Sundays.

When she returned in *Africana* at New York's Lafayette in July, another pay dispute erupted. "At the close of the week, everybody was looking for their dough," reported Black columnist Chappy Gardner. "There was none forthcoming." Earl announced that salaries were to be paid by the theater's owner, Frank Schiffman, not him. Schiffman in turn informed the press that he "had paid Miss Waters' husband, Earl Dancer,

the sum of $4,100 for the week and that all money was coming from him. Dancer could not be found when it was time to pay the girls and much confusion was the result." Earl, however, somehow worked it all out. But for Ethel, the question remained: would this kind of thing never end?

Aware of Earl's predicament, she could sympathize to a point. He was, after all, a Black producer operating in a business still controlled by white male producers, theater owners, agents, managers, and executives. As a Black woman, maneuvering around in the same business, she understood the particular pressures, his battles just to be granted respect and equanimity from the white men he had to negotiate with. But if he was going to manage her, he had to manage her. If he was going to be her producer, then he had to be her producer. No excuses. Perhaps the breaking point occurred when angry cast members from *Africana* stood outside her residence on 138th Street and screamed up at her apartment, "We didn't get paid! We want our money."

In mid-July, while in Cleveland, Ethel confided in Van Vechten that she and Dancer were separated for good. Upset by the breakup, she asked Van Vechten's help in getting her into a show, any show. Surprisingly, she appeared at a loss in finding someone to represent her, but she confessed that Earl had always kept agents and managers away from her. All she needed Van Vechten to do was pass the word around that she was free and available for work. With Van Vechten's vast array of contacts, she might find someone to handle her professional affairs. Van Vechten most likely put her in communication with the theatrical attorney Harold Gumm, who would soon help her sever her professional ties with Dancer.

IN AUGUST, Ethel returned to the recording studio for two separate sessions. First, she recorded "Lonesome Swallow," "Guess Who's in Town," and two of her sexiest hits, "My Handy Man" and "Do What You Did Last Night." A few days later, she recorded "West End Blues," "Organ Grinder Blues," "Get Up off Your Knees," and "My Baby Sure Knows How to Love." The songs were suggestive and raunchy, and so were the splashy advertisements in the Negro press, all of which reinforced the sexuality with their racy illustrations and copy. The advertisement for "Get Up off Your

Knees" and its flip side "Do What You Did Last Night" had a drawing of a woman standing above a man who was on his knees. The copy read:

"Get Up off Your Knees"
Sung by Ethel Waters
"Anyhow, stand up when you're making your pleas.
No use wearing out your knees."
All you straying papas better listen to this one.
Ethel sure does her stuff. And listen, Mamas,
before you tell papa to turn in his keys,
give him a chance to be a caveman.
The coupling, "Do What You Did Last Night," is sizzling hot.

The illustration for the advertisement for "Organ Grinder Blues" depicted a woman lounging on a chair with one arm behind her head. In the background, to the right, a man was seated at an organ. The copy read:

"Organ Grinder Blues"
Sung by Ethel Waters
Here's the song about the wonderful organ grinder man—
Put over as only Ethel can do it.
He's just the organ grinder you've been waiting for.
Invite this record in today.
The coupling is "West End Blues."

Though she may have been annoyed by the company's reliance on an old image, her records still sold, and Columbia's promotion of her as a sexy, take-charge goddess remained part of the publicity machinery that helped keep her on top.

ONCE SHE FULFILLED her recording dates, she was faced with yet another publicized incident. In September, a warrant was issued for her arrest on the charge of "secreting mortgaged property." The complaint had been filed by a woman who said Waters had purchased furniture—on

an installment plan—in the amount of $530 from Levine Brothers on August 20, 1926. The furniture was for Momweeze, who was at the time staying at Ethel's home on St. Nicholas Avenue. When Ethel had fallen behind on her payments and still owed $195, the woman seeking redress had confronted Ethel backstage at the Lafayette Theatre. Arguing with the woman, who was white and identified as Jessie Brinn, an enraged Ethel was "said to have slapped Miss Brown across the face." Before an arrest could be made, Ethel turned herself in to the authorities.

Appearing before the magistrate, Waters said she had no intention of defrauding anyone, that she had made an additional payment the previous week, that the furniture was in the possession of her mother, who had returned to Philadelphia, that there had been a similar charge against her in July of that year, and that the charge had been dropped. The magistrate dismissed the case and advised the complainant to seek redress in civil court. Not a major story—but a story nonetheless that was reported and was yet another embarrassment.

A major story, however, occurred in late September. Faced with seemingly insurmountable financial problems from *Africana*, Ethel filed a petition for bankruptcy. Listed were $143,812 in liabilities and $40 in assets. The petition stated: "Miss Waters owes $50,000 to her husband Earl Dancer, who was the nominal producer of 'Africana.' She also assumes responsibility for any liabilities arising out of the actions or conduct of her husband and his two brothers, John and Maurice Dancer." Additional liabilities included the $10,000 that Daly's Theatre demanded plus $15,000 for the Brooks Costume Company, $5,000 to the Shubert Theatre Corporation, plus other theaters. It all sickened her to the stomach, no doubt literally.

OTHER PRESSING MATTERS were on her mind: the kind that had nothing to do with contracts or court cases or show business itself. For the past few years, with all the traveling and even more press coverage, she believed her life was incomplete. She became preoccupied with long-held hopes of being a mother and a real wife. "I thought that being a wife and mother would convince me that I belonged to the human race," she

later said. Nothing, however, could really compete with her career. But she was struck an emotionally devastating blow, from which it took a long time to recover, when her sister Genevieve's daughter Ethel—whom Waters still adored—suddenly died of diphtheria and whooping cough. That threw her equilibrium off and proved to be a test of her faith. "I was bitter with God," she said. "I told Him. He was unkind to take her because I would have brought her up good if He hadn't interfered. But in the end, of course, I made my peace with Him." That had been her chance at motherhood, and she grieved for a long time.

AS 1928 WAS DRAWING to a close, Ethel was about to turn thirty-two years old—not ancient, but time was moving on. A total reassessment of everything in her life had to be made. First, she put professional matters in order. To get out of the legal entanglements still pending on *Africana*, she signed with Harold Gumm of Goldie and Gumm, whose theatrical agency handled such Black performers as actress Georgette Harvey and later Lena Horne. Tough, shrewd, and knowledgeable, Gumm knew his way around town. In agreeing to set her affairs in order, Gumm asked for 5 percent of her earnings "exclusive of my pay for vaudeville dates." He proved effective.

In October, she returned to the Palace with an act pared down to the essentials. Onstage, there were only Ethel and her accompanist. Afterward there were dates in Manhattan and Brooklyn as well as Newark, New Jersey, and Syracuse, New York, then on to Toronto to appear at the Hippodrome. An offer also came in to head a revue for the Shuberts, but she turned it down because the Keith circuit, which she was already signed to headline, offered consecutive bookings and some much-needed money. So it was on to Keith theaters in Ohio—Youngstown, Cleveland, Dayton, and Akron—and then back to Winnipeg and Calgary in Canada. The tour was long and murder on her vocal cords. She also did a paid endorsement for a skin-lightening cream, which was out of character for a woman so proud of her brown complexion. But she was earning top dollar and loosening herself from Earl's grip. She was reported to earn over $2,000 a week for the tour.

At times, she may have had doubts about leaving Dancer, but she was determined to go it alone. No longer were there accounts of forthcoming projects for Waters and Dancer. Instead, Earl was said to be putting together a new Broadway show, but when he spoke about it, not a word was uttered about Ethel. Earl must have told himself it was just one of Ethel's moods, that nothing would really separate them permanently. He understood her as others had not, had worked night and day for her, had been aware of Ethel Williams as well as other women in her life. And he had not cared. But Ethel remained distant and cold. Then he panicked. When Ethel unexpectedly went to Philadelphia to spend time with her friends, the comedy team Butterbeans and Susie, Earl followed. He confronted her and pleaded with her to let things be as they once were. But she wouldn't budge. Now Earl Dancer, the most composed of men, saw his world falling apart. On December 1, 1928, it was reported that Dancer, now referred to as "former manager for Ethel Waters" and busy at work on a new play for his old flame, Cora Green, had been taken to the Wiley Wilson Sanitarium on a Sunday morning. Suffering from "la grippe and acute tonsillitis," he had "suddenly turned for the worse on Saturday." No matter what the stated cause for his hospitalization, Dancer seemed to have had had had some type of emotional collapse. He appeared unable to cope with a stark reality. Ethel had dumped him.

In later years, Waters would always credit Dancer for the shrewd manner in which he helped maneuver her career into a new direction. That she would never denigrate nor dismiss, but in another respect, she wiped Earl Dancer from her official record. She never opened the door again for him, never reconsidered her actions. Eventually, but not immediately, she made it known loud and clear that she had never married him. She didn't care what the newspapers had once written about the two, didn't care what impression she had previously given of their relationship. None of that mattered. As always, when there were two sides to a story or an argument, Ethel saw only one: hers.

The break with Earl may have represented for her a second coming of age. Like other female stars, she had benefited from a strong professional and personal relationship with a man in the world of entertainment—a man who saw himself as her Svengali. Other great stars would also have

such professional and personal unions and breakups. In Paris, Baker's career was guided for a time by Count Giuseppe Pepito Abatino, whom she told the press she had married. Abatino was no more a count than she was, and the two were no more married than were Waters and Dancer, but Abatino put sweat and tears into establishing her as a major European star. Later Lena Horne would have Lennie Hayton, the white composer-arranger at MGM, to help her navigate her way through the internecine intrigues and politics of the studio and the nightclubs. Horne and Hayton actually married. Horne once said that she believed he could take her places where a Negro man could not. Still later Dorothy Dandridge—midway in her career while on her quest for nightclub stardom—had arranger-composer Phil Moore, one of the first Black men to work in MGM's music department, to help shape her nightclub act, not only working out musical arrangements but advising her on everything else, from costumes to makeup to hairstyles. Moore also fell madly, hopelessly in love with her. Still later, the powerful director Otto Preminger would make it his goal to turn Dandridge into a major movie star. When Dandridge received an Oscar nomination as Best Actress for her performance in the Preminger-directed *Carmen Jones*, he prided himself in having guided her to this achievement. And later Diana Ross would capture the eye and the imagination of Motown chief Berry Gordy Jr. All these women, including Ethel, had the talent and drive to rise to the top ranks of stardom without these men, but the partnerships with the men did not hurt the women—or the men. The men saw these women as their creations. But in time, Ethel and the others—with the exception of Horne—grew weary and resentful of the way such men attempted to control them or take credit for their success. Ethel and the others would break loose and remain determined in the future not to answer to anyone, onstage or off, or in the bedroom. All the men—once the women had moved on—appeared rueful (or in the case of Abatino, devastated). It might be fair to say that otherwise their lives, no matter how successful, were never the same. The excitement of seeing a magnificent career blossom and flower was gone. So, too, was the pleasure of basking in the glory of these women. Yet the men would always publicly praise the women—and no doubt they cherished the idea of being part of the women's success and their legends.

Ethel was a free woman. Now no one, other than herself, would ever decide what path her career should take. She might talk things over with Pearl Wright. But Pearl understood you could *advise* Ethel, if she seemed receptive, but you could never *tell* her anything.

Though hardly known for acting rashly or impulsively, within the next year or so Ethel Waters would announce she had married and become the mother to a young girl. And the career that so dominated her every moment would briefly carry her to Hollywood, that place with all the sunshine and the idea of new promise and potential. Then, finally, she would head to Europe.

# Stretching Boundaries: Hollywood and Europe

**B**ACK ON TOUR AT THE START OF 1929, Waters hit the Orpheum theaters on the West Coast with an itinerary that took her to Seattle, San Francisco, Oakland, and then on to Los Angeles. Nonstop, hectic, and maddening as ever, the tour nonetheless invigorated her. She still loved performing for that vast audience out there in the dark, still loved the feedback, the energy, the applause and approval.

Her life had undergone two significant changes. Her hopes for motherhood were realized when she "adopted" a little girl named Algretta Holmes. One of Ethel's friends from the early days at Edmond's, Mozelle Holmes, had given birth to a daughter and was living in Detroit. During an engagement in the city, Ethel met and was enchanted by the little girl. Seeing that Mozelle had hit hard times, Ethel must have felt her friend's living situation was not a healthy one in which to raise a child. In a letter to Carl Van Vechten, she made an indirect reference to Mozelle possibly being a prostitute. What Ethel was not saying was that Mozelle might possibly have been her lover at one time. For years, theirs would be a fairly tangled, complicated relationship. Ethel asked Mozelle to let her care for the girl and Mozelle agreed. No lawyers were consulted. No formal papers were signed. If Algretta ever wanted to return to her mother, Ethel and Mozelle agreed that the girl could do so. Ethel was overjoyed, but Ethel being Ethel, she didn't feel there was any great need to explain how

she had suddenly become a mother. And show business being show business, there were raised eyebrows and rumors. Was this child the result of a secret liaison? Could it be a daughter by Dancer? Eventually, Ethel explained that her daughter was adopted but went into almost no details. By her own account, Ethel admitted to being a strict disciplinarian, who would "whip" the child, much as Ethel might be pained to do so. After a whipping, Ethel insisted that Algretta apologize for having upset her. Of course, this was the way Ethel had been reared. Nonetheless, she also showered the girl with affection and attention.

The other significant change was the new man in her life, a sporting fellow named Clyde Edward Matthews. Ethel once said she had met him in Akron, Ohio; another time, she said it was Cleveland. They probably got together in mid-July 1928, when she finally separated from Dancer—and when she may have needed some cheering up—although columnist Sidney Skolsky said that she had known Matthews "for eight years before she gave him a tumble." Regardless of where or when they actually met, she got to know him in Philadelphia. "They decided to become friends—then lovers," said Skolsky. "Marriage came later," said Ethel. "I didn't want to take any chances. I wanted to make sure I liked him."

A good dresser and a good talker, Matthews was "a handsome devil, with a courtly air, a real charmer," she recalled. He was also a ladies' man, who was proud of his sexual prowess and liked to refer to himself as The Lover. He expected Ethel to do the same. Though stories still circulated of Waters' eye for women, and though women were still often in and out of her New York apartment and special women friends were a part of her traveling companies, she seemed to feel more comfortable when there was a man in her life: someone who could walk into a restaurant with her and tell the head waiter the table they should have; someone who would compliment her on her looks; someone who could drive her automobile for her; someone who could push aside anyone who hassled or annoyed her.

While appearing in *Africana*, Ethel had already become involved with a young man, whom she later caught cheating on her: He had driven her Locomobile for a date with another woman. When she caught up with the two in the young woman's apartment, she forcefully threw him against the wall. She then turned to the young woman, who was clearly fright-

ened. "I don't intend to beat you up—today," she told her. "But I'll get you some other time when I'm more in the mood." Ironically, the Locomobile he had driven was a present from Earl. In later years when Waters spoke of the incident, she never publicly named the man. It might well have been Earl Dancer himself, and the young woman may have been the chorus girl Billy Cain.

Once she had Earl out of her life, she flirted with the men who came on to her, but none seemed as in control and reliable as Matthews. And control, whether her own or someone else's, would always be something Ethel respected. Early in their relationship Matthews, who was very free with money, urged her to depend on him if she were ever in need of a loan. Short on cash, she accepted. "I was somewhat leery about him and didn't want to get involved or obligated," she recalled. Yet cautious as she was, she let her guard down and did the wholly unexpected. "He said I was a real tonic for him and when he asked me to marry him, I consented." What Clyde Edward Matthews actually did for a living—where all his money came from—was open to speculation, but in time he was known to handle Ethel's "business affairs." In a short time, he was traveling with her and helping to manage her career.

IN EARLY FEBRUARY, she arrived in Los Angeles for her appearance at the city's Orpheum Theatre. She was now a grand star accompanied by her entourage: Eddie Matthews, little Algretta, Pearl Wright, the female cornetist Dijau Jones, with whom Ethel had developed a friendship, and in all likelihood her personal maid, Bessie Whitman.

As she settled into Los Angeles, Ethel realized that the movie capital was in the midst of a technical revolution that had taken off just two years earlier. In 1927, Warner Brothers had released *The Jazz Singer*, in which Al Jolson had performed the songs "Blue Skies" and "Toot, Toot, Tootsie, Goodbye" and then, in full blackface, had swung his arms and performed the song "Mammy." Though this was not the birth of sound in the movies—there had been experiments with it for several years, including a 1923 DeForest Phonofilm short in which Eubie Blake and Noble Sissle had performed—*The Jazz Singer* marked the mass movie audience's

full enthusiastic acceptance of the new medium. Around the country, people flocked to see it, and eventually all the movie studios had to construct huge sound stages for their new features. The talkies had arrived. Though there were uncertainties and confusion about the new medium, the studios nonetheless aggressively began their search for sound projects. Already aware of the success of Negro recording stars, some filmmakers thought that sound was the perfect medium for African Americans. There were even rumors that the Negro voice recorded better than a white one. In Los Angeles, studio scouts, who had long gone to the nightclubs that lined Central Avenue in the Negro part of town, were on the lookout for talent. But attention was also focused on those Black stars in the clubs and theaters in New York. In New York, blues singer Bessie Smith was snapped up by Vitaphone to star in the short *St. Louis Blues*. Duke Ellington—with his orchestra—and Fredi Washington starred in the short *Black and Tan Fantasy*.

In Los Angeles, new sound films with African Americans went into production. At the low-budget Christie Studios, Black writer and later director Spencer Williams worked on a series of quickly made, short Black films. At Fox Studios, plans were made for a Black-cast feature film, *Hearts in Dixie*, which starred Clarence Muse, LA glamour girl Mildred Washington, Clifford Ingram, and a lanky newcomer named Stepin Fetchit, who had already worked in silents. At MGM, Texas-born King Vidor, a major director, fought with the studio to let him do an all-colored talking film that would sensitively and entertainingly focus on African American life and culture, especially the Black religious experience, as Vidor saw it. When the executives expressed doubts that such a movie could make money, Vidor put up his own salary to film *Hallelujah*. In New York, he found stage actor Daniel Haynes and a sexy sixteen-year-old kewpie doll of a newcomer named Nina Mae McKinney, then a chorus girl in Lew Leslie's *Blackbirds of 1928*. Having gathered his cast, he went on location to Tennessee—the Memphis area—and Arkansas to shoot exteriors for the film. Interior scenes were filmed at MGM in Culver City.

The Hollywood studios would soon hire Duke Ellington and Louis Armstrong for musical spots in the respective feature films, the 1930 Amos and Andy haunted house movie *Check and Double Check* and 1931's

*The Ex-Flame*. Armstrong received no billing and the film was later lost to future generations. But before those films and before a long line of extraordinary Black musical talents worked in the movies, Hollywood turned its sights to Ethel. Though Daniel Haynes and Nina Mae McKinney proved to be terrific in *Hallelujah*, neither had been director King Vidor's first choice. "I wanted Robeson for the male lead, and I wanted Ethel Waters for the female lead," said Vidor. Unknown to Ethel, Vidor's aides had searched for her in New York. "The talent man Vidor sent East to wave money bags at me," said Ethel, "was stalled on the job by colored theatrical people unfriendly to me. He reported that he was unable to find me. But I never was so small and inconspicuous that picture people can't locate me, particularly when the price is right." Had the brown-skinned Ethel played the fiery, glamorous lead in *Hallelujah*, Black Hollywood movie history might have taken a different course. Instead the light-skinned McKinney became the first of Hollywood's mulatto-style Black leading ladies—and its first Black movie love goddess.

Though King Vidor had missed locating Ethel, studio chief Darryl F. Zanuck did not. Both Ethel and the Los Angeles Orpheum Theatre caught the eye of people in the motion picture industry. Designed by G. Albert Lansburgh, located at 824 South Broadway, the recently built (1926) theater was the fourth and final home of the Orpheum circuit in the City of Angels and was considered almost the last word in West Coast swanky extravagance. Architect Lansburgh had sought to create a theater like the Paris Opéra. Entering the Orpheum, patrons marveled at the deluxe details of the house. Doors were polished brass. There were silk wall panels, brocade drapes, marble pilasters, and dazzling large chandeliers. In 1928, a thirteen-rank, three-manual Wurlitzer organ—with metal and wood pipes that could "simulate more than 1400 orchestral sounds"—was installed. This new Orpheum would showcase such stars as Al Jolson, Sophie Tucker, Will Rogers, Jack Benny, and later Lena Horne. Ethel could not have asked for a grander house, and the Orpheum could not have asked for a grander star. "Crowds from all over the city caused a sell-out of the house every night," reported the *Pittsburgh Courier*. Immediately, she became the talk of the town—in both LA's Black East Side and in the mansions of Hollywood and Beverly Hills.

In her dressing room at the Orpheum, Ethel was visited by songwriter Harry Akst. By now, the two were old acquaintances, if not old friends. Akst had written her hit "Dinah." Working with Grant Clarke, Akst was composing the music for a new movie, *Broadway or Bust*, which would be retitled *On with the Show*. A backstage love story with plenty of musical numbers, *On with the Show* was to be one of Warner Bros.' big pictures, to be filmed not only in sound but in color, something altogether revolutionary for Hollywood at the time. Warner's head of production, Darryl F. Zanuck, wanted Ethel for the picture, not for a role but in musical sequences in which she would perform two new songs by Akst and Clarke. One was a lively number called "Birmingham Bertha"; the other, a moody song of love gone wrong called "Am I Blue?" Hedging his bets that the former would be the big hit, Akst wanted Ethel to look over the material and see what she thought. With her in the dressing room was Pearl, who would be of great help obviously because Ethel still couldn't read music. "I just match the words to the music and keep in time," she often said. Ethel and Pearl worked together to arrange the material to conform to Ethel's style.

When an appointment was set up for Ethel to meet Zanuck, Akst took her to Warner Bros. Studios in Burbank. With her height and hauteur and her eye for fetching clothes, she carried herself in a queenly manner, and as she was ushered into Zanuck's office, she knew how to make an entrance. There Zanuck listened to her rendition of "Am I Blue?" Immediately, he was ready to make a deal. The studio would need her for two weeks. Considered a tough negotiator, Zanuck appeared both impressed and charmed by her, especially in light of their discussions about her salary. She explained that she was currently being paid $1,250 a week. Because she would have to break her commitment at the Orpheum for more than two weeks in order to do the film while in Los Angeles, she asked for a four-week guarantee at $1,250 a week. "You drive a pretty good bargain for yourself," Zanuck said, but he agreed to her terms. What she hadn't told him was that Pearl Wright was scheduled to have surgery while in Los Angeles; Ethel might have wanted to break her Orpheum commitment anyway.

"Ethel Waters to Make Vitaphone Picture for Warner Brothers" read the banner in the February 15, 1929, edition of the *California Eagle*. "Mu-

sical Comedy Songbird Gets First Big 'Talkie' Role" read the headline in the February 23, 1929, edition of the *Pittsburgh Courier*. Already Blacks in movies were confined to walk-ons or supporting parts as ditzy maids or befuddled butlers. Within the Negro press, there was the assumption that Ethel—along with the stars of *Hearts in Dixie* and *Hallelujah*—might pave the way for important roles for Black entertainers—and real star treatment—in the movie capital. But once *On with the Show* was released, audiences saw that Waters was left completely out of the storyline. Directed by Alan Crosland and starring Sally O'Neill, Joe E. Brown, Betty Compson, Louise Fazenda, and Arthur Lake, the film focused on its white stars. Still, the Black dancers, the group called the Four Covans, which consisted of the brothers Willie and Dewey Covan and their talented young wives, nearly wiped the screen clean with their rousing performance, part stylized vernacular dancing, part jazz dancing. When Ethel performed her numbers, *On with the Show* went in a wholly new direction.

Coming on for "Birmingham Bertha" with a dapper, handsome young dancer, she was decked out in a snazzy, satiny suit and turban with a festoon of feathers protruding from it. Somewhat campy. Somewhat too flashy and too much an exaggeration of a high-gloss style. Yet it was also glorious. "Birmingham Bertha" touched on the extroversion and high spirits of the rip-roaring 1920s, which were about to end.

Her other number, "Am I Blue?", which appeared first, was a different story altogether. It was a reflective piece that took everyone by surprise and which—for later generations—sounded as if it was straight out of the Depression. Costumed in a ruffled polka-dot dress with a kind of matching bandanna, she was first seen backstage where she is referred to as Ethel Waters. The idea is that Ethel Waters is playing a character in a show within the show. With a cotton field setting, she goes onstage while carrying a large basket of what looks like freshly picked cotton. With little buildup, Waters quickly glides into the emotional turmoil of the song—and the idea of an emotional plea from a woman whose man has left her. "Am I Blue?" she asks. "Am I blue? / You'd be too. Aren't these tears in my eyes / telling you." Before the number ends, she's joined by a Black quartet, the Harmony Emperors—dressed as field workers

in overalls and straw hats—who provide the chorus for the song. The filmmakers still could not leave behind the familiar Old South imagery despite the fact that Waters was performing a very modern song. Nonetheless, it was hard for viewers and later listeners who bought the recorded version of the song not to feel for her. Yet true to Waters the singer, she still held back from emotional chaos or emotional collapse. Her version of the song is edgier and harder here—it was in essence filmed "live" for the camera—than her later recorded version for record buyers. Her heart may be broken, but her style leads one to understand that she's strong enough to pick up the pieces. The overriding emotion is still that hard-won control coupled with a kind of resignation, which ironically makes her later rendition all the more affecting. In the years to come, Ethel would be quite open about drawing on personal experiences to play some of her most important dramatic roles and also to perform another song of a love gone wrong, "Stormy Weather." Interestingly, one can only ask if she had reached inside and pulled out memories of past loves in her life, especially Earl Dancer—the freshest emotional wound—in order to put the song across with such feeling. Both "Birmingham Bertha" and "Am I Blue?" best represented the Ethel Waters of nightclubs, the singer-performer that urban audiences could never get enough of.

At Warner, executives viewed Ethel's dailies and became so excited that the company offered her the job of dubbing the voice of a white star in the film. But she refused, even when they reportedly upped the ante to $10,000.

*On with the Show* introduced her to a broader audience, in some cases people who were just hearing about her and were eager to see what all the fuss was about. Here Waters was making way for a lineup of other striking African American women who came to Hollywood and somehow retained their originality, their glamour, and their fundamental composure: such women to follow as Theresa Harris in the nightclub sequence of *Thunderbolt*; Lena Horne in her MGM musicals of the 1940s; Hazel Scott at the piano as she sang "The Man I Love" in *Rhapsody in Blue* and other movies of the 1940s; Billie Holiday, when she ditched the maid's uniform and stood next to Louis Armstrong to sing in *New Orleans*; and

the radiant Dorothy Dandridge, performing with Count Basie's orchestra in *The Hit Parade of 1943*, with Louis Armstrong in *Pillow to Post* and ironically singing one of Waters' later hits, "Taking a Chance on Love," in *Remains to Be Seen*. Generally, Hollywood did not know what to do with its Black glamour goddesses. But Waters proved that at least in the musical sequences—despite the costumes—such a woman could hold on to her sense of identity.

As it turned out, "Am I Blue?" rather than "Birmingham Bertha" became the big hit. By the time the film was released, the music for "Am I Blue?" was heard under the opening credits. The song—which marked her ongoing shift from blues-jazz to melodious pop—was later recorded on May 14, 1929, with Ethel backed by white musicians: Tommy Dorsey on trombone, Jimmy Dorsey on clarinet, Manny Klein on trumpet, Frank Signorelli on piano, and Joe Tarto on bass. For fifteen weeks, "Am I Blue?" soared to number one on the music charts and endured as a classic for decades.

IN LOS ANGELES, Waters also performed at the Hill Street Theatre, and she enjoyed some of Los Angeles's social life. A visit to MGM was arranged. Though the Hollywood studios rarely thought twice about the servant roles that African American actors and actresses were relegated to, industry leaders nonetheless respected certain Black stars from the East whose records and nightclub and theater appearances had made the news—and had won the admiration of the critics. Duke Ellington was one of the stars that Hollywood filmmakers were clearly impressed with, even awed by. So was Armstrong. Ethel was another. When she arrived at MGM in Culver City, followed by a now familiar group—Eddie, Algretta, Pearl, and cornetist Dijau Jones—she was accorded major star status. MGM's first lady, actress Norma Shearer, not only a huge star but also the wife of production chief Irving Thalberg, was on hand to chat with Ethel. So too was *Hallelujah*'s director, King Vidor, who then informed Ethel that she had been his first choice for the lead in his film. Ethel never quite got over the loss of the *Hallelujah* role. Technicians, extras, and grips also must have been curious about this colored performer being

ushered around the lot and sound stages. Accompanied by Pearl, she also performed some of her music for the studio brass.

She was also in full regalia in March when she attended the Colored Artists Motion Picture Ball at Elks Hall. Now Black Los Angeles's film colony was eager to meet her. Greeting Ethel were *Hallelujah* stars Nina McKinney and Daniel Haynes as well as the team of Buck and Bubbles and members of the Lafayette Players, who were in town on a tour, and performers from Hollywood's *Hearts in Dixie*. For most in attendance, it was a hopeful evening. More Black films looked destined to be produced by the Hollywood studios. Ethel herself contemplated the idea of future film work, but, sadly, it would be seven years before the studios did another Black feature, *The Green Pastures*.

The one unsettling occurrence was Pearl Wright's hospitalization for a surgical removal of a tumor. No one was eager to discuss Wright's condition, but it marked the beginning of Wright's health problems. Ethel was alarmed, and during Wright's recuperation, she canceled several appearances.

**LEAVING LOS ANGELES,** Waters resumed her tour, which took her to Chicago, St. Louis, Minneapolis, Rochester, New York, Philadelphia, Baltimore, and other cities. By June, when she returned to New York for an engagement at Brooklyn's Albee Theatre, gossip was swirling about her new man, Eddie. In time, perhaps to keep the gossips at bay, she let everyone know that she and Eddie had married, but no details were provided as to when or where such a union had taken place. The Negro press was informed that Ethel, with husband and child, was setting sail for Europe. First stop would be Paris. Later: London. As far as she was concerned, nothing more need be said. That was not the outlook of the Negro press. In a series of headlines in its August 10, 1929, edition, the *Baltimore Afro-American* posed questions that were on the minds of many:

WHO'S ETHEL WATERS' NEWEST HUSBAND?

ETHEL WATERS WITH BABY IN PARIS

ACTRESS AND HUBBY AMONG FEW FIRST-
CLASS PASSENGERS ON *LA FRANCE*

SPECULATION HERE

ACTRESS WAS THOUGHT WED TO
EARL DANCER, MANAGER

The *Afro-American* commented on the obvious: "Speculation is rife here as to who is the 'husband' referred to. In Miss Waters' engagements in Baltimore, theatergoers have heard her refer to Earl Dancer, one time her manager, as her husband. The existence of a child, reported in the dispatch is Baltimore's first knowledge of the event." The paper also reported something else: "Recently, the engagement and approaching marriage of Dancer and Cora Green was carried in this newspaper, puzzling theatergoers still as no notice of a divorce from Miss Waters has been published."

Interestingly, the reporter who broke the story was entertainment writer Maurice Dancer, Earl's brother. "To the best of my knowledge Miss Waters was married some years ago in Philadelphia to a man named Burke," wrote Maurice Dancer. "That was some years before she met Earl Dancer. She is not married now to anyone. In regards to the baby, Algretta, Miss Waters legally adopted her a year ago in Detroit, Michigan, and she is three years old." No one then or later had any idea who this Burke was, if such a person existed. Indeed, no such person did. Ethel had managed to keep Merritt Purnsley's name out of the public record. Another writer, Floyd Snelson, however, stated emphatically: "Ethel Waters not married. She legally adopted five-year-old child last year in Chicago." But no one was able to say with certainty what Ethel's marital situation was. Nor did anyone know Algretta's actual age. Some years later, Ethel said the adoption had taken place when Algretta was eighteen months old, which meant the child was about three and a half years old in 1929.

In Black entertainment circles and within the African American community at large, this, of course, was a juicy scandal. If she and Dancer had not married, had they been living in sin? If they had married, was Ethel now a bigamist? Was Algretta a secret love child? All the debate and discussion about her personal life added to the image of Ethel found

in her risqué songs: that of a headstrong, sexually liberated, high-minded, hincty star who didn't play by anybody's rules but her own. Silent screen stars like Gloria Swanson and Pola Negri had made headlines with their love affairs and marriages. But few, if any, Black women drew such attention. In its own way, the Waters-Dancer-Matthews triangle was the kind of high-flung romantic shocker that would make headlines decades later with such highly publicized "mainstream" tales of sexual intrigue and marital switch-hitting as that of Ingrid Bergman and Roberto Rossellini in the late 1940s or Rita Hayworth and Aly Khan in that same era or the scandal to end all scandals, Elizabeth Taylor and Richard Burton in Rome while filming *Cleopatra* in the 1960s. Like Ethel, these women openly challenged the attitudes and assumptions of their eras, when gender roles were strictly proscribed and when any deviation from them could bring condemnation.

Bergman and Taylor met with brutal public censure. Ethel, however, in this era before an international press corps could pursue anyone everywhere and before Black stars' intrigues were fodder for the mainstream press, had simply skipped town and escaped such scrutiny from the Negro press. By not offering an explanation for her behavior, she also seemed to be telling people she didn't give a damn what anybody thought or what questions anyone had. To readers of Black newspapers around the country as well as those who listened to the stories on the Black grapevine—that blogosphere of an earlier age—when all sorts of rumors, stories, and tall tales flew about with a wild abandon, there was, ironically, not so much censure but curiosity about her. What had gone on behind closed doors between Ethel and Dancer? What now transpired behind closed doors between Ethel and Matthews? Did she pick up and discard men at her whim? Of course, ironically, as this "scarlet woman" traveled abroad, she carried her Bible with her. She still prided herself on her staunch religious faith and her relationship with her God. A week after the article in the *Baltimore Afro-American*, the *Chicago Defender* ran a photo of Ethel in her giddy fluted dress and towering headdress from *Africana* with a banner that read: "Hits Boulevards of Gay Paree."

\* \* \*

HER APPARENT "MARRIAGE" to Matthews may have been impulsive, but her decision to travel abroad had not. Her association with theatrical attorney Harold Gumm continued to produce solid results. She was now also represented by the William Morris Agency. Perhaps an agreement could be worked out finally to secure her engagements in France and England. But another far more important matter was on Ethel's European agenda. The voice problems that had plagued her for so long had taken a turn for the worse. The itchy throat. The hoarseness. The laryngitis. Few things frightened her, but now she feared that her very future as an entertainer was in jeopardy. Eddie was alarmed. In New York, her physician had recommended a long rest—and a consultation with a prominent French throat specialist, Dr. M. Wicant in Paris. "As well as being my husband," Ethel told writer J. A. Rogers, it was Eddie "who saw my voice failing and arranged to give me five or six months of complete rest." There may also have been another condition that she dared not discuss publicly.

When passage was booked on the luxury liner *Ile de France* to take her from New York to Paris, she decided to go in style. First-class accommodations were what she required. The sight of a stylish Negro woman, with a well-dressed husband and an adorable child in tow, in the first-class section was not an everyday occurrence. Ethel remembered the stares she drew—and the gratuitous, cruel insults. Seated at the dinner table in the first-class section, she endured the chatter of the white women around her, who looked her up and down, if they looked at her at all, and talked about how wonderful their maids were. Clearly, they intended to let this colored woman—Ethel's professional identity was unknown to the other passengers—know that she was out of her element. But that didn't deter her. She had earned the right to travel this way, and once again to hell with what anyone had to say. An exception to the snobbishness and cruelty was the kindness of a young officer on the ship. Each morning, he graciously inquired how she felt. Also on board were Ethel's fellow entertainers—all white—Tess Gardella, who was known for performing in blackface, and Lou Clayton. Ethel spent time with both.

Just before the voyage ended, a special benefit concert was arranged to aid the widows and children of seamen. When Ethel was asked to perform, she at first took it as an insult because she had not received a formal

invitation from the ship's chief purser. Finally, that was rectified when flowers and a note with the request were sent to her stateroom. As she was about to enter the room for the benefit, the young officer, who had always been so gracious, escorted her. Only then did she learn that he was the chief purser. True to her nature, she never forgot his kindness, but also true to her nature she never forgot how others had treated her. That evening many of the women who had snubbed her sought her out after her performance. "None of you spoke to me. Not one of you," she told them angrily. "Yet I'm the very same person as I was yesterday. I have the same face, same body, and same color." When she debarked from the ocean liner, "several of Europe's leading managers met her at the pier," said writer J. A. Rogers. As she stepped onto foreign soil, it was obvious she would not get as much rest as she had hoped.

ONCE IN PARIS, she delighted in seeing the City of Lights, its sweeping boulevards, its chic cafés, its towering monuments and landmarks, from the Eiffel Tower to the Cathedral of Notre Dame. Also in the city were such other African American entertainers as trumpet player Valaida Snow and the whirling Berry Brothers, great dancers, second only to the Nicholas Brothers, who were appearing in a French production of Lew Leslie's *Blackbirds of 1928*. She also spent time with the bantamweight boxer Al Brown, who took her out dancing. Eddie didn't seem to be around while she cavorted with Brown. Nor did Ethel ever say anything about where he was when she was introduced to writer Radclyffe Hall, whose tale of lesbian love in the novel *The Well of Loneliness* had been a scandalous success. Of all the people she met in Paris, Ethel always maintained that Hall was the most interesting.

Then there was Bricktop, the light-skinned, red-haired, gregarious entertainer from West Virginia and Chicago who had made a name for herself as the proprietor of a very successful nightclub in Paris. She had helped the teenage Josephine Baker learn the ropes—and the pitfalls—of being in the spotlight in France. Through the decades, Bricktop would teach the Prince of Wales the black bottom, wear the gowns of designer Schiaparelli, and wine and dine with a who's who of twentieth-century

artists and celebrities: Gloria Swanson, Barbara Hutton, John Steinbeck, Frank Sinatra, Jelly Roll Morton, Tallulah Bankhead, Legs Diamond, Mabel Mercer, Elizabeth Taylor and Richard Burton (in Rome) and Europe's crowned heads, some on their best behavior, others on their worst. Salty and brassy, Bricktop loved the big names, be they famous or notorious. Ethel's reputation had preceded her. Bricktop, like all of Paris, was ready to open her arms to Ethel. "She was the talk of the town," recalled Bricktop, "but she took me aside and confided, 'Brick, I'm starving to death.' It wasn't a matter of money, but of food. Right in the middle of Paris, with all those fabulous restaurants, Ethel was starving for some real American food, so I let her move into my place for about three weeks and she cooked greens to her heart's content. Ethel was never one to stay out or to drink. I was able to turn Paris for her from a nightmare into a place where she could really enjoy herself in her own way." During Ethel's well-publicized stay, La Baker, as Josephine Baker was now known, was out of the city, which probably was for the best, although both women were such professionals that had they run into each other, they no doubt would have smiled for the public, kissed and embraced, and afterward expressed their real feelings about one another to their entourage.

But, most important, Ethel visited the office of the specialist Dr. Wicant, who determined that a growth—a wart—on her left vocal cord would have to be removed in a highly experimental and dangerous procedure that, if she consented, he planned to perform by Ethel's birthday on October 31. Originally, Waters had hoped to spend more time at the residence of Bricktop, but because she needed rest, she stayed outside Paris in St. Cloud. In October, she contacted Carl Van Vechten, informing him of her plans. On the day of the operation, a tense Ethel feared that should something go wrong, her career would be over. Dr. Wicant had her sign a release absolving him of any negligence should the operation prove unsuccessful, but fortunately, everything went smoothly.

Planning to leave for London on November 10, she was scheduled to open at the city's world-famous Palladium on November 25. Before her engagement, so she informed Van Vechten in a letter dated October 31, 1929, she wanted some time to adjust to London. Arrangements were made for her to stay at the home of the expatriate Black American entertainer John

Payne. She also told Van Vechten she was sending a letter care of him for her friend, dance instructor Rita Romilly. But mainly, in her correspondence, she seemed eager to let Van Vechten know that she was doing everything required to get her vocal problems taken care of—mainly through rest and exercises—so she could sing again. She also was homesick for "spades"—colored people, she said. She planned to be in London for three weeks. But if audiences there didn't like her, she didn't care, because that way she could return to the States even sooner. Clearly, she did not feel at home staying abroad. During this trip, she frequently wrote Van Vechten, which marked the beginning of a correspondence between the two that continued up to the time of his death decades later. Her letters could be playful and chatty. She referred to him as "Darling Carlo" or "Divine Carlo" or "My Nordic Lover" and might sign off as "Your Native Mama." To Van Vechten, she revealed her anxieties, her anger, her nervous exhaustion, and her professional and personal dilemmas.

BUT SOMETHING ELSE may have happened during this time in Paris. Years later Waters would say she suffered two miscarriages in her lifetime. "I never birthed no children," she said. "I lost two." But she would never specify when or where the miscarriages had occurred. What with the length of her stay in Paris and some delays, could she have lost her first child at this time? It wasn't like her to spend so much time just having fun, not doing much of anything. Was her recuperation the reason for a change of plans she would soon have? Or had the recuperation taken place earlier when she left Bricktop's to spend time in St. Cloud? Had the rush to leave the States with Eddie been to get away from prying eyes that might detect her pregnancy and perhaps to marry before her pregnancy was obvious? Was the loss the result of an abortion?

A few weeks later, Waters contacted Van Vechten again, this time to inform him of her plans to head for London a few days later than originally planned, on November 15. Waters reminded Van Vechten that she'd be staying in London with John Payne, whom she referred to as "Madam J. Payne." Van Vechten, she wrote, would recognize him as one of their "lodge members," possibly a code term for someone who was African

American. Or homosexual. By now, Ethel must have been as hip to Carl's sexual interests as he was to hers. She also spoke of Eddie—who still insisted that she call him "The Lover"—and Algretta, who "at this present age gives great promise of following in her own mother's footsteps, which is prostitution. *Ah la, première class.*" One can only wonder what led her to make such a pronouncement. Later she commented on the little girl's attempt to smoke a cigarette and sip alcohol.

In her new communication with Van Vechten, she asked to be remembered to the Robesons. She also let him know that she was still waiting to hear from Rita Romilly. Finally, she wrote that her voice had improved to the point where she could scream "real loud for assistance should one attempt to seduce me on my way home at nite [*sic*] in the country." Sending love from Eddie and the baby, she closed her missive by referring to herself as "your native Thrill."

Before leaving Paris, Ethel posed for pictures, soon to be circulated to the Negro press, in Dr. Wicant's reception room. With her were Matthews, looking spiffy in suit and tie; Algretta, actually looking glum; Dr. Wicant; Black writer J. A. Rogers, who covered cultural events for the Negro press; and Gene Ballard, a musician who had also served as an aviator during the Great War and had been decorated for valor by the French government.

By now, *On with the Show* had opened in the States and England—to mixed reviews. In the *New York Times*, Ethel was listed in the credits, but nothing was said about her performance by critic Mordaunt Hall in his initial review. But he must have had second thoughts. because later, in a longer piece, he commented: "Ethel Waters as Bernice from Birmingham, however, does well with her bits of Negro melody." *Variety* made note of her: "The stage portion is mostly numbers. More than customary doses of girls, with several songs and a specialist without a 'part' in the plot, Ethel Waters, colored. Miss Waters has two songs. Preferred is the 'Blue' song for that sounds like a selling hit." The film, however, would have a place in movie history. "For anyone who wants to know what the Broadway musical comedy of the 20s was like, this film is indispensable," critic Pauline Kael later wrote. "Sally O'Neil is hard to take, but the compensations include Ethel Waters, slender and torchy, singing 'Am I Blue?' and 'Birmingham Bertha.'"

A few days before her opening at the Palladium, Ethel, apprehensive about her British debut, was invited to the Tivoli Theatre, where *On with the Show* was playing. The excited reception of the crowd—people cheering and applauding—helped ease some of her anxieties but also awakened her to the power of film. Just as audiences on her Black Swan tour had rushed to see in person the magical goddess of recordings, now they yearned to see the woman in the flesh whose face and body had been blown up to Olympian proportions on the screen. Ethel was perhaps as entranced as everyone else at seeing herself in larger-than-life dimensions.

Ethel soon confided to Van Vechten that she hoped she'd get another movie deal. Clearly bitten by the movie bug, she wished to "get one to star in with a story, to prove I can do some decent acting in a speaking play as well as sing a lot of songs. It seems the other people feel that I can do only one kind of work. Oh: well we'll change the subject." That short time in the movie capital had captured her imagination. So had the city itself, seemingly so open and free of the congestion of the East. Though Ethel Waters would always be thought of as a quintessential New York theater star, she was already lured by the magical sunshine of the City of Angels.

Finally came the big night—November 25—at the Palladium. The press revealed that a clause in Ethel's contract permitted the venerable theater "to select," actually, if necessary, censor her songs. Some may have wondered how Waters would fare with the staid British public, but, nightly, the crowds cheered and begged for encores, which Ethel had to decline. Suffering from laryngitis, on many nights she could barely speak once she came offstage. Panicky about her voice, she kept performing nonetheless.

Following the Palladium engagement, she canceled her plans for an immediate return to the States. Other offers had come in. She accepted an engagement at the Kit Kat Club and then performed at the ultrachic Café de Paris, a favorite haunt for the rich and famous, the titled and the privileged, the top of Europe's very tony international set. "Half the fashionable world was at the Café de Paris to hear Ethel Waters make her first appearance in cabaret in England," reported London's *Daily Sketch*. Some in the club like the King of Greece and the Queen of Spain may have seen Florence Mills when she had been the toast of the town. Others surely

had seen Baker. But the onetime Sweet Mama Stringbean, whose records had sold abroad, had now come to town. Onstage, she appeared with a new short curly hairdo, a gown that shimmered and sparkled, and dangling earrings, which were a gift from Fania Marinoff. The audience went wild. "Ethel Waters continues to be the sensation of London, and nearly all the London papers and society columnists are singing her praises," an excited J. A. Rogers reported. "There was no question about the enthusiasm of her audience," the *Daily Express* exclaimed. "They cheered and encored her again and again, especially when she sang the appealing '[My] Handy Man.'"

There was one number, however, she refused to perform: "She could not, nevertheless, be prevailed on to give what is perhaps her best song—'Shake That Thing.'" This classic song that audiences still loved would eventually be removed from her repertoire, especially as she continued to try to clean up her image. "My Handy Man" wasn't much cleaner, but it wasn't as famous. The engagements kept her in London through Christmas and the New Year.

Invitations to parties and dinners poured in. With Matthews by her side—he proved the perfect escort—she attended one event after another with Britain's theatrical set. But often she felt uncomfortable and came to detest the gossipy stories about her that she knew were making the rounds. She confided to Van Vechten that at entertainer Plunkett Green's home, she believed that because she neither smoked nor drank nor "necked" with Eddie, it was assumed that she was a "man hater" and that she might even be having an affair with African American performer-columnist Nora Holt. She believed some onlookers had the mistaken idea that Eddie was hopping in the sack with John Payne. Or Madam John Payne, as she had referred to him. In truth, all the gatherings simply made her yearn even more, as she confessed to Van Vechten, for "Colored Heaven." Close as she was to Van Vechten, she refused to use his term to describe Harlem. She broke records at the Café de Paris, and after some time off to rest her voice, she returned to the nitery in February for another four weeks where again she performed to a packed house of the high and mighty. Tallulah Bankhead came to see her. So did Olga Baclanova and Lord Furness.

But the talk in Britain and the States was of the attention that the Prince of Wales showered on Waters. "Prince of Wales at Café De Paris 3 Times in Week to Hear Ethel Waters Sing," was front-page news in the *Chicago Defender* on February 22. Perhaps just as much as the Palladium, the Café de Paris put her on the international map. She accepted a date at another of London's music halls, the Holborn Empire Theatre, and another offer came for her to finally make her Paris debut at the Plantation nightclub on Rue Pigalle, which was owned by Black American Lou Mitchell. Her salary in London was $1,250 a week. The Plantation, however, offered her a mere $300 a week. She turned it down and thus never played Paris. Still, her fame spread to other parts of Europe and to China, where jazz and Western dance steps—namely, the Charleston—were becoming popular. Duke Ellington's records were being sold in China, but nothing was selling like the blues, and Ethel ranked on the list of China's favorites.

But fears about her voice persisted. Might she permanently damage her voice by singing improperly and then never be able to sing again? She took voice lessons with noted specialist Louis Drysdale. Aside from the fact that Drysdale was considered one of the best on the continent, Ethel no doubt was pleased that he was also a musician who understood the vocal apparatus. Just as important, he was a man of color. With Drysdale, she worked long and hard to learn to use her voice differently, to sing in another range.

ON MARCH 12, 1930, she boarded the *Aquitania*, along with Eddie and Algretta, for her return to the States. Having enjoyed the sights of both Paris and London, she felt a sense of accomplishment. Though the trip had been important for her career, she never had the desire to remain abroad. Perhaps that was because of a kind of continental sophistication that she did not altogether feel comfortable with, though Waters by now had become a very sophisticated woman. Perhaps it was because of the simple fact, as she had indicated to Van Vechten, that there were not enough of her "people" around. Regardless, Waters would always be a supremely American brand of star. Her personal narrative, which she soon

discussed almost relentlessly in interviews, was a distinctly American one: the poor girl from nowhere who had risen to the top through hard work and a fierce talent. Though she could appreciate the attention of nobility, she would always respond most to others like herself who crawled out of the pit, be it an economic or emotional one, and made a name or place for themselves. That included the men and women currently in her life like Eddie and Pearl or even Dancer or those of the future, be it be composers like Harold Arlen and Irving Berlin or a writer like DuBose Heyward or directors like Vincente Minnelli and Elia Kazan.

# Depression-Era Blues, Depression-Era Heroine

I N THE FEW MONTHS that Ethel had been out of the country, the nation had been dealt a devastating blow, the results of which would reverberate throughout the decade. On October 29, 1929, the stock market had crashed, leaving in its wake a nation in social, economic, and political turmoil. Everyone would be affected by it. Jobs would grow scarce. Banks would close. Homes would be lost. Soup lines, bread lines, and unemployment lines would sprout up in city after city, state after state. A fourth of the nation would be left unemployed. President Herbert Hoover would practically be booted out of office as Franklin Delano Roosevelt was ushered in, bringing with him plans for an economic recovery for a frightened, fatigued populace.

In retrospect, the era opened—for Black entertainers—on a surprisingly optimistic note with the success of Marc Connelly's comedy drama *The Green Pastures*, a fantasy about a Negro heaven that debuted on Broadway in February 1930. As De Lawd, actor Richard Harrison gave a warm and winning portrait of a world-weary but humane heavenly father frequently perplexed by the doings of colored humankind. Often patronizing, *The Green Pastures'* dramatic sequences nonetheless proved oddly moving and—for the Black theater community—offered hope for future "serious" stage productions with African Americans. The play won the Pulitzer Prize. But the optimism was short-lived. Within two years, the

number of Broadway shows would dwindle from a record high of 270 in 1927 to 180 in 1932. The Hollywood studios that Ethel dreamed about struggled to keep their doors open. In time, the nation would seek relief from its woes by going out to the picture show or turning on the radio or buying tickets to the dramas and extravaganzas on the Great White Way. But that was still to come. In the meantime, Black performers struggled to hold onto their careers.

Obviously, Ethel was in a better position than most. Energized after her trip abroad and still able to command as much as $1,500 a week, she threw herself back into work. At first, the jobs flowed. In April, she drew packed houses at the Victoria Theatre in New York. There followed the revue *Jazzland in 1930* at the Lafayette, then the revue called *Zonky* with Butterbeans and Susie and her friend, the cornetist Dijau Jones. Once it traveled to Chicago, *Zonky* was called "the greatest show that has ever played the Grand theater." But in a very short time, Ethel, too, was affected by the crash. Budgets for shows were tighter. Producers scrambled to get financing for projects now considered risky. Her schedule was far from full. A large household and staff had to be maintained. Algretta had to be cared for. Pearl Wright had to be kept on salary. Her maid Bessie had to be paid. Her family members in Philadelphia had to be provided for. Naturally, Eddie had to be able to live in style. Ethel was responsible for them all. Then, too, even during these financially tough times, there was an image to maintain. Both she and Matthews were seen about town, each looking like a million dollars, each driving his or her own swanky automobile. One evening when she arrived at the Lafayette Theatre, all eyes were on her. "Dressed in the latest mode, with a magnificent pointed fox scarf and a close-fitting turban, the one and only Ethel created quite a stir," reported the *Pittsburgh Courier*, "as she walked with queenly air down the aisle of the crowded theater. Oh, yes, there were those famous jade earrings, the gift of Fannie Marinoff (Mrs. Carl Van Vechten), long pendants, just the finishing touch to the attire of the most outstanding comedienne of the race." Being a fashion plate was nothing new to her, but it cost money. She had to keep working.

A promising prospect was a new *Blackbirds* revue being put together by Lew Leslie. Since his days at the Plantation Club, Leslie had become a

major player in New York's Black musical theater. He was also a colorful character, crafty and manipulative, and a showman through and through. Born Lewis Lessinsky in 1886 in Orangeburg, New York, he had begun his career as an impressionist, then teamed up for a time with entertainer Belle Baker, but eventually switched to promoting talent. One of the first productions he was involved in was *George White's Scandals of 1921*, in which white actress Tess Gardella appeared in blackface as Aunt Jemima. It was a hit. Immediately, Leslie saw the commercial potential of authentic Negro entertainers and was on the lookout for the real thing. Once he brought Florence Mills to the Plantation Club, he took her to Broadway and Europe. He also created dazzling floor shows for the Cotton Club.

While Ziegfeld had become famous for his *Follies* and his great stars and while such other producers as Earl Carroll with his *Vanities* and George White with his *Scandals* had also created franchise productions, Leslie made a name for himself by parading top-of-the-line colored talent, indeed by "glorifying the Negro." Sometimes called "the Negro Ziegfeld"—despite the fact that he was not a man of color—he "was the pioneer of the Negro nightclub revue, the first to glamorize Negro girls and the one who set the pattern for such clubs as the Cotton Club, the Alabam, and others," said Noble Sissle. From his shows came such standards as "On the Sunny Side of the Street," "I Can't Give You Anything but Love," and "Diga Diga Doo." He, too, developed franchise productions, his *Blackbirds* shows, which were lavish, feverishly energetic Black musical revues that were showcases for Black stars. He had wowed the critics and audiences alike with *Blackbirds of 1928*, in which he had starred a fifty-year-old Bill "Bojangles" Robinson, who showed no signs of slowing down, with the lush and lovely young Adelaide Hall. The pair had set the stage ablaze. The revue, which ran for 518 performances, was the longest-running show of the 1928–1929 season. A year later his $250,000 show *International Revue* bombed.

Still, everyone knew Leslie to be imaginative and innovative. Black performers were eager to work for him, but they were leery of him too because he was known to be paranoid, foul-tempered, reckless, unpredictable, and next to impossible to figure out. During a performance of one of his shows, Leslie—openly dissatisfied with a musician—had actually jumped into the orchestra pit and yanked the poor guy out. Often

he could be found outside Lindy's, the legendary restaurant and showbiz hangout at Broadway and 49th Street, where, while puffing on a cigar, he might pull a wad of money from his pocket and peel off some dough if a needy passerby came his way. On those occasions when he was charitable, Leslie wanted to be seen. Otherwise he had the reputation of being the worst kind of producer: for performers and musicians, that meant they might not get their paychecks.

Despite the gloomy economic forecasts, an undaunted Leslie began work on his new *Blackbirds of 1930* and assembled a remarkable creative team. First, he visited the Brooklyn home of *Shuffle Along* composer Eubie Blake, who had recently split from his professional partner of fifteen years, Noble Sissle. Leslie made Blake an offer he couldn't refuse: a $3,000 advance to do the music for the revue. Leslie also hired the supremely talented lyricist Andy Razaf to work with Blake. One of the theater world's most intriguing characters, Razaf had been born Andrea Razafkeriefo in Washington, D.C., in 1895. His father was a member of a Madagascar's royal family. His mother was the daughter of a former American slave who had become the United States consul in Madagascar. She had fled Madagascar only weeks before Razaf's birth. As a teenager, he quit school and worked as an elevator operator. Briefly, he played baseball with a semiprofessional Negro team, then he turned to entertainment. Working with the melodies of Fats Waller, Razaf had created memorable scores for the great shows at Connie's Inn. Through the course of his career, his sophisticated lyrics would range from the haunting "Black and Blue" (which some considered an early type of protest song, which, though performed by Edith Wilson in 1929, was recorded by Ethel in 1930) to such delights as "Ain't Misbehavin'" and "Honeysuckle Rose." He also wrote the lyrics and the music for the resoundingly clever, naughty, double-entendre number "My Handy Man," which had been such a hit for Ethel in 1928. Having worked for Leslie before and having complained bitterly about not being paid, Razaf nonetheless came on board for the new *Blackbirds*. Flournoy Miller, whose partner Aubrey Lyles had died, was signed to do the book for the show and also appear in it.

Putting together his cast, Leslie got top A-list performers: the dancers Buck and Bubbles as well as the dancing Berry Brothers; singer Minto Cato; the Cecil Mack Choir; Jazz Lips Richardson; Blue McAllister;

Marion Harrison; and the comedian Mantan Moreland, who later be-
came famous as the deliriously frazzled chauffeur Birmingham Brown in
the *Charlie Chan* movie series. All in all, *Blackbirds of 1930* would boast
a company of "100 Colored Artists." Choral arrangements were by J.
Rosamond Johnson.

But with all this talent, Leslie still did not have a big-name female
star. No doubt he would have preferred working again with ladylike Ad-
elaide Hall, but she was currently appearing with Bill Robinson in *Brown
Buddies*. Everyone knew Ethel had returned to the States; everyone also
knew she would be the perfect fit. The only problem—as Ethel herself
knew—was that Leslie reportedly couldn't stand her. In his mind, she
was still, after all her success, little more than a low-down trashy singer.
Nonetheless, Leslie was in a bind. Harold Gumm was contacted and Ethel
came on board. For her, here was a possible chance to return to Broadway.
Though the Negro press frequently referred to her as a Broadway star,
Waters understood that a true Broadway star keeps working on Broadway.
One Broadway show does not make a Broadway star.

As always, the rehearsals, which began in mid-July at the Alhambra
Ballroom, were long and grueling and right away Ethel grew suspicious of
the show's future. At one time, *Blackbirds of 1930* was to open in Atlantic
City. Then it was New Haven. When the show finally did open, it would
be Brooklyn. Paychecks were late. Sometimes Leslie had to give his cash-
strapped cast members money to take the bus home. As far as Ethel was
concerned, that was almost par for the course. Instead Ethel had other
issues. Part of Leslie's reputation as being difficult grew out of stories about
the way he constantly and unexpectedly made changes in a show during
rehearsals. He was now living up to that reputation. Repeatedly, everyone
had to learn new routines, new blocking, new entrances, new exits. He
also had a foul temper. But by now, he must have known that if he ex-
ploded with Ethel, she'd explode right back.

As was true of other Leslie shows, *Blackbirds of 1930* also reverberated
on stereotyped imagery. Leslie still loved those homages to the Old South.
As staged by Leslie, the revue would open on a Mississippi levee with the
song "Roll Jordan." Throughout Black comedians would appear in black-
face. Some performers would be speaking with heavy, exaggerated dialects

and broken English. There were also satirical skits on *The Green Pastures* and Erich Maria Remarque's antiwar novel *All Quiet on the Western Front.* Nonetheless, the score by Blake and Razaf included several songs that Ethel must have sensed would become hits. The loveliest, as well as the most musically intricate and difficult to sing, was the hauntingly melancholy "Memories of You." But the song was given to Minto Cato, who was Razaf's live-in girlfriend at the time. It's not hard to imagine how Ethel felt about that. Still, Waters had a gem of a song: "You're Lucky to Me," and also a sexy sequel to her earlier Razaf hit, "My Handy Man," which was called "My Handy Man Ain't Handy No More."

Opening at Brooklyn's Majestic Theatre, *Blackbirds of 1930* drew favorable reviews. But true to form, Leslie tampered with the show. "Sure enough," Eubie Blake recalled, "when that asbestos curtain came down, [Leslie] called a rehearsal at one in the morning. Threw this out, changed that—tore the whole show apart." *Blackbirds of 1930* then went to Boston's Lyric Theatre before arriving at Broadway's Royale Theatre on October 22, 1930. The critics were mixed in their response. Most liked the performers, but several took issue with other aspects of *Blackbirds.* The matter of images—who was creating them—and of cultural and racial distortions as well as the blackface tradition itself was now coming to the fore. The critic for the New York *Sun* questioned the necessity of "blacking brown faces." "You take a Negro, apt to have naturally certain qualities which the white race cannot acquire, and Black him up," he wrote. "You lay on his dialect with a trowel—and with no closer relationship with the actual dialect of the Negro than may be found in the phonetic idiosyncrasies of the average white writer about him. You tell him it is funny to twist words, using, for example, 'evict' in place of 'convict,' which ninety-nine times out of a hundred, it isn't. You make him, in short, a bad imitation of what was not a very good imitation in the first place, and you tell him to make the people laugh. He—and I shall never know why—believes you."

In the *New York Times,* Brooks Atkinson praised the Berry Brothers' rhythmic gyrations and Miller and Moreland's rambunctious comic routines, but he found the show conceptually thin and quietly questioned its cultural authenticity. "Whether Negro musical entertainment should remain faithful to Negro characteristics or should abide by the white man's

formula for stage diversion is a question for the anthropologists to discuss quietly among themselves. Certainly even the best Negro shows we have are predominantly white in their direction," wrote Atkinson. "But the Negroes as entertainers have an exuberance that crops out in whatever they undertake. . . . In the first edition of 'Blackbirds' Mr. Leslie put their willingness to good use in colorful song numbers and ludicrous comedy sketches. Although he has staged the second edition more lavishly, the material is slender. Not much remains except the willingness of his performers to give."

Most critics agreed that once again Ethel stood at the center of the show. Perhaps the moment that Waters' fans had been waiting for occurred in the second act, when she stepped forward to sing "My Handy Man Ain't Handy No More." "He don't perform his duties like he used to do / He never hauls his ashes 'less I tell him to / Before he hardly gets to work he says he's through / My Handy Man ain't handy no more," she sang. "He says he isn't lazy, claims he isn't old / But still he sits round and lets my stove get cold." The number brought the house down. Then there was the song "You're Lucky to Me." Brooks Atkinson felt the material was not worthy of her talents, but other critics liked the song. Once Ethel recorded it, "You're Lucky to Me" was considered one of her best numbers. "Ethel Waters enjoyed that song," Razaf recalled. "I've never sung changes like that before," she told him. "Neither has anyone else," Razaf told her. She also later recorded *the* song from the show, "Memories of You." That too would assume an iconic position in her song catalog. Still, that wasn't enough to save *Blackbirds of 1930*. Audiences simply were not coming to see the show. Ethel remembered that Broadway's Royale Theatre—where the show opened—was next to a flea circus. "Our show was a flop and the fleas outdrew us at every performance."

WHILE THE SHOW STRUGGLED ON, Ethel made appearances at social and charity events that drew coverage from the press—and which attested to her place in the social strata of New York City. Aware that a performer has to be seen around town, she also knew that such invitations to Black performers were often rare. No matter what her personal feelings, she was

now willing to be a part of the established ofay social scene. On November 2 at the Erlanger Theatre, she joined a galaxy of big-name stars and prominent journalists for the annual New York Press Club Frolic. Among the stars: Ethel Merman, Bill Robinson, Ruth Etting, Mitzi Green, George Jessel, Adelaide Hall, Rudy Vallee, and Major Bowes. Also at the event: Walter Winchell, Heywood Broun, Russell Crouse, Mark Hellinger, Rube Goldberg, and New York's elegant mayor, James J. Walker. But of special importance to Ethel was the benefit on December 7 for the National Association for the Advancement of Colored People (NAACP) at the Waldorf Theatre. Another star-studded evening, but this time with journalists and performers, Black and white, eager to promote and raise funds for the growing civil rights organization. The masters of ceremony were journalist Heywood Broun and critic Alexander Woollcott, who introduced the lineup of talent: Bill Robinson, Adelaide Hall, Molly Picon, Ada Brown, Libby Holman, Alberta Hunter, J. Rosamond Johnson, Richard Harrison, and Duke Ellington and his orchestra, as well as stars from *Blackbirds*. Printed on the program was a letter from Nobel Prize–winning novelist Sinclair Lewis and also original poems by Countee Cullen and Langston Hughes. Carl Van Vechten worked hard to make the evening a success. For Ethel, this was New York at its finest, coming together to speak up for the rights of Negro America. This was a time when the nation's race men—Du Bois, James Weldon Johnson, and countless unknown men—fought for change in the nation's racial and social system, through protests and the passage of laws to ensure full rights for African Americans. Ethel herself emerged even more as something of a race woman. Because of her schedule and the nature of her profession, she would never be able to commit to race work in the way that Mary McLeod Bethune did, but through her participation in benefits, fundraisers, and other charitable events, she would do all she could for African American causes. As she became one of the NAACP's staunchest celebrity supporters, this event at the Waldorf marked one of her forays into public race work.

LEW LESLIE FOUGHT to keep *Blackbirds* running, but after sixty-two performances, *Blackbirds of 1930* closed amid controversy and criticism

from the Negro press. The performers were still owed three weeks' pay. "There is no doubt that Mr. Leslie will take the blame for the closing. At least we suspect that he should do so," wrote Black columnist Chappy Gardner, who believed Leslie had been far more interested in promoting himself than his stars. "I mean that where his show should have read 'Blackbirds' with Ethel Waters and Flournoy Miller, it read instead Lew Leslie's Blackbirds, it was Leslie selling himself to the public. . . . It would seem evident to the erstwhile Lew that his luck changed for the worse when he took money from Negro actors whom he half paid after making him rich."

Much as the performers may have agreed with Gardner, Leslie rallied Ethel and the rest of his cast and took the show to Philadelphia, and then to Newark. He assured them that *Blackbirds* would continue on to Washington, D.C., but during the brief run in Newark, the bottom fell out. Lew Leslie suddenly disappeared, and so did everyone's salary. Not only had Leslie deceived his cast, he had also violated the theater doctrine that the show must go on. Ethel ended up carting as many cast members as she could back to Manhattan in her car. Some of the actors were said to have actually walked back to New York.

THE NEXT YEAR Lew Leslie approached her again with the promise of another production that would make it to Broadway, *Rhapsody in Black*. Leslie pulled out all stops, cajoling, flattering, assuring, and, though it was hard to imagine, perhaps even gruffly charming her to headline the cast. The two argued about her salary. She wanted $1,250 a week. Finally, he agreed to her terms. He also agreed that she could first complete her current tour, then join the cast, which by then would already be in rehearsals.

She was struck by Leslie's concept for *Rhapsody in Black*, which sought to take the colored revue in a new direction by paring it down to essentials. "Knowing the Negro as I do, I know his very soul has been dying for emancipation," Leslie told the press, quick to promote the show and himself. "The routine Negro show is passé. The caricature has become obnoxious. The Negro is fitted for better things in the theater." In *Rhapsody in Black*, there would be no comedians, no chorus girls, and in time, no

scenery. Aiming for a show that would be more like a concert, Leslie decided to spotlight one great act after another without the fuss and adornment that were expected. There would be music by an impressive group of composers: George Gershwin, Dorothy Fields and Jimmy McHugh, and W. C. Handy. Leslie had signed on stars of his previous show—the Berry Brothers and the Cecil Mack Choir—as well as Ethel's friend, Valaida Snow, who had been a hit abroad. Touted as an all-around entertainer, Snow—diminutive, pert, talented—sang, danced, and also played a mean trumpet that earned her the title of the female Louis Armstrong.

But once Ethel completed the tour and caught up with the rest of the cast, she was shocked to see what Leslie had done with the production. It wasn't his new approach that bothered her; it was his new star. Though Leslie might use Ethel's name to lure in an audience, once the patrons got there, Ethel realized, *Rhapsody in Black* had been created to be Valaida Snow's show. All the big numbers were built around her. At one point, Valaida would even be directing the orchestra. And the song that had long meant so much to Ethel—"Eli Eli"—would be performed by the entertainers Avis Andrews, Eloise Uggams, and the Cecil Mack Choir. The show was set to open at the Belasco Theatre in Washington, D.C., in April, but nothing seemed to be coming together. After one rehearsal, Ethel got into a heated argument with Leslie. What exactly would she do in this production? Leslie finally told her just to sing some of her old numbers, the sexy ones. Waters pitched a fit. No one was listening to this kind of music anymore. She would look like she couldn't do anything new. But Ethel realized it was pointless to talk to him. She knew that Leslie was still stewing about her salary, and Leslie now just wanted her out of the show.

Harold Gumm then stepped in to firmly remind—and threaten—Leslie that Waters' contract stipulated her approval of any material she performed in the show. The hassles over Ethel's salary were resolved with an agreement that she would be paid $700 a week plus 10 percent of the gross. But Ethel continued to complain to Gumm about the show and her material. Finally, Gumm brought in songwriters Mann Holiner and Alberta Nichols to create new songs for Waters. Some numbers didn't appeal to her, and she questioned how they would go over with audiences.

Then she started having doubts about the entire show. "It was something quite different from the sort of thing I had been doing heretofore," she said. "However, after getting into the swing of the thing I fell more easily into the mold." Ethel and Pearl worked nonstop with the writers. Even on the train that carried them from New York to Washington for the opening, Ethel, Pearl, and the writers Holiner and Nichols were still at work. Somehow they pulled it all together. The *Washington Post* reported that the audience just about blew "the theatre roof off with applause."

By the time of its opening at Broadway's Sam Harris Theatre on May 4, 1931, *Rhapsody in Black* had become a Black revue unlike any of its predecessors. That night, Gershwin's "Rhapsody in Blue" was performed by the Pike Davis Orchestra, the Cecil Mack Choir provided haunting renditions of spirituals, and Valaida Snow got to blow her horn. Ethel sang "Am I Blue?" as well as four new songs, which marked a decided departure from her usual repertoire: "What's Keeping My Prince Charming?" "Dance Hall Hostess," "Washtub Rhapsody (Rub-sody)," and "You Can't Stop Me from Loving You." In the latter, which she performed with Blue McAllister by her side, she musically set up a romantic comedy-drama. Her gifts as an actress—a girlishly playful and endearing character—enlivened the song and made it amusing. W. C. Handy's "St. Louis Blues" was the evening's finale.

Yet the New York critics were mixed on *Rhapsody in Black*, which led to another discussion as to what could be expected in a Negro musical. "It lacks the punch, the animality, and the high spirits which playgoers have a right to expect of productions of this kind," wrote John Mason Brown in the *Evening Post*. "Worst of all," he added, "the many numbers from which it is made are blessed with precious little of that white-teethed, broad-grinned and insinuating gayety which heretofore has been the redeeming feature of many a brown-skinned revue." Brown's comments, of course, said more about his view of Black entertainment—and African Americans in general—than about the merits of the show, but others had similar opinions. "It is Harlem oratorio," wrote Gilbert W. Gabriel in *The American*. "And, outside of its choral singing and Ethel Waters, it isn't much else—or even just much." Gabriel also took a swipe at Waters' new material. "I yield to none except Carl Van Vechten in my admiration of

the clear and lightsome way she puts her songs across, 'way, far across. But last night they turned her into just a big, tall hydrant of lament."

*The New Yorker's* Robert Benchley, however, best articulated what made *Rhapsody in Black* unique—and a groundbreaker that might mark a new day in Black revues, moving away from some stereotyped images. "After complaining so often about the synthetic quality of Negro revues in their attempts to imitate the worst of Broadway and their insistence that it is funnier to say 'remanded' than 'demanded,' the least that you do is give Mr. Leslie credit for making 'Rhapsody in Black' different. He has given his colored entertainers something to do which is worthy of their talents. It may, at times, be a little too worthy with the unhappy result of slowing up the pace, and those who have come to delight in Negro shows for their racy stomping and loud shouting may resent this attempt to inject a little dignity into the proceedings, but if you like Negro singers and dancers for the things that they do best, 'Rhapsody in Black' will be a welcome relief." In the *Pittsburgh Courier*, Floyd G. Snelson Jr. called *Rhapsody in Black* "a new step forward in Negro entertainment." "Leslie has veritably taken the Negro out of the jungle and given him his rightful place in the theatrical sun," Snelson wrote.

Benchley and other critics also praised Ethel. "This lady's personality has a chastening effect on the meanest of songs," he wrote, "and here, for the first time, her songs do not need any particular chastening." In the *New York Daily Mirror*, Walter Winchell wrote, "Mr. Leslie has tried something different, and those diversion seekers who prefer good vocalizing, good music, excellent hoofing and the artful Ethel Waters are sure to find it worth while."

In the end, *Rhapsody in Black* led Waters even more in the direction she had sought these past years. The new numbers were dramatic pieces in which she could act a part. In later years, she would not hesitate to comment on Leslie's actions and his attitudes about her, but at this time, she surprisingly appeared to give Leslie more credit than she later thought he was due. Or perhaps later she was rewriting her own history with the production. The *New York World-Telegram* reported that when Leslie had first presented her with the songs and monologues she was to perform in the show, she was "mad." "What did this man Leslie mean? What did all her

past success and reputation amount to if he was going to make her change and talk to imaginary people and everything? Now Miss Waters can laugh about it. She says she felt, but didn't understand, the things in herself Mr. Leslie has brought out."

WHEN GEORGE MURPHY JR. of the *Baltimore Afro-American* came to the Sam Harris Theatre to speak to her, Waters shrewdly used the interview to express her goals and her view of life—and to announce to the public that there was a new Ethel on the horizon. In some respects, it was one of her more revealing interviews. Entering Waters' dressing room, Murphy found her in a small space "with its rows of gowns, brightly lighted mirrors, pictures and makeup boxes." There she sat "filing her nails. She had on her tan stocking cap and wore a flowered dress. She looked very fresh and leisurely—not at all in the rush and bustle that one might associate with a person who was to go on the stage in twenty or thirty minutes as the star of the most unusual hit Broadway has seen in many a day."

"How do you like your latest offering, Miss Waters?"

"Well, to be frank about it, I was a little afraid of it at first," she said. "Now I like it. I don't know how long it will last. I only hope that the public will like it well enough to keep it here for some time."

When Murphy turned the discussion to the country's current economic state—"I suppose the Depression in this town has not affected you very much"—Ethel was ready to speak her mind.

"Now you have started talking about something that has become so firmly a part of me," said Waters, "that the shock of a change would unnerve me. I mean just this: I am so used to the bad side of this Depression that the coming of better times will shock me like an electric bolt." She added: "Don't let anybody kid you about being carried along on Broadway. Broadway gives you the reward of hard and consistent work. You have to have the ability and the grit to stick before Broadway notices you. I don't feel that I have reached the point where I can say I am at the top, and there is no more to worry about. As long as I am in this game—and I expect to be in it the rest of my life—I expect to work hard to please my public."

She added: "The public is fickle. That's why I still feel nervous every time I go on the stage. Every entrance is a new challenge to my ability and my best effort. After all, the public is paying the bill to see you and they have a right to say whether they like your work."

Waters also used the interview to discuss acting, which now excited her, and a drama that interested her. "I have always wanted to play some character skits that call for intense emotional moments; something of a Negro theme that carries a deep and moving significance with it. You see what I mean?" When Murphy asked if she'd like to play the role of Scarlet Sister Mary, she stopped filing her nails. Scarlet Sister Mary was the title character of the controversial 1929 Pulitzer Prize–winning novel by Julia Peterkin, who specialized in stories—such as *Green Thursday* and *Black April*—that featured major Black characters in a South Carolina plantation setting. But no one had been quite prepared for *Scarlet Sister Mary*, which created quite a stir. Its heroine was a young Black woman whose first husband deserts her for another woman. Afterward, the surprisingly noble and independent Scarlet Sister Mary becomes, for the time, shockingly "promiscuous" and gives birth to a brood of "illegitimate" children. When Peterkin's story was adapted for the stage, Ethel Barrymore played the character—in burnt cork. Its dialogue had been in the Gullah language of African Americans living on the islands off the coast of South Carolina. Despite its attempts at theatrical innovation, the dramatization had not fared well, but Ethel was still drawn to the character and the story itself.

"I think I could put a lot of realism into that part," she told Murphy. "After all, it takes a definite understanding there. You know the girl in that story was not an immoral person. She was unmoral, if you want to call it that, but the things that she did were not done with the thought of evil that would accompany an immoral act. The sort of things that Scarlet Sister Mary did are a part of the conduct of people, not only in certain sections of South Carolina, but in any place here in New York, for example from Park Avenue to the Bowery."

"Yes, I like that piece," she added. "I think I could bring a real interpretation to the role, but then there is my public. I don't know how they would like it."

When asked about her other interests and hobbies, she answered as frankly as she could. "Well, just this, reading and attending to my own business." Interestingly, she said nothing about the prize fights that she loved, nor about the drag shows with female impersonators that she still enjoyed. Ethel was press-savvy enough to know what best contributed to the image she wanted to project and promote. She also expressed her desire to return to Europe. Yet she hadn't forgotten her feelings of cultural isolation and homesickness during her time spent there. "When I go again," she said, "I want to go with a show. I like all the culture and poise of the continental European. And yet I like to travel with my show people. You know my people are noisy, loud and wrong, a bit uncouth, but I love them for their gaiety and naturalness. They are a part of my life. Some of the dumbest people you want to meet are high up in the show business, but I love them all. I would not know what to do offstage without them. You see, I am one person on the stage and another off the stage. I am dull and uninteresting offstage."

MOST REVEALING about the interview was what Waters did not discuss, namely, her private life. Perhaps Murphy had not asked anything personal, or perhaps he knew better than to try. Certainly, she was not going to volunteer any information. Not a word was said about Algretta or the status of her marriage to Eddie Matthews. During this time and in the years to come, whenever Waters commented on personal matters, it would always be about her past, her troubled childhood. Her current life offstage, which was anything but dull and uninteresting, was rarely mentioned.

The truth was that her career consumed most of her time and her attention. Everything was centered around it. When she was not on the road and in New York in a show like *Rhapsody in Black*, her days were very long. Usually, she was at the theater early to prepare for the performance, often accompanied by her maid, Bessie Whitman, who tended to everything in her dressing room, making sure that her makeup, her costumes, and her props were in order. She also dealt with requests for Ethel's time or presence. Once the show ended, Ethel might spend some

time in her dressing room with people who came backstage to say hello. Or she might go out with Pearl Wright or cast members, at least those she hadn't fought with, to a restaurant or actors' hangout. Often at the end of the night, Eddie picked her up for the ride back to Harlem. Once in her apartment, she might check in with an assistant about the day's events, what Algretta had been up to, who had called, what other members of the household had been doing. Or she might just turn in and ask the next day. She slept late, ate breakfast late, paid some attention to Algretta or Eddie, if he was there, answered mail, paid bills, or returned calls. The regulars often came—a masseuse to give her a rubdown, a dressmaker for fittings, a hairdresser. But mostly Ethel conserved her energy for the evening's performance. On days when she had a matinee, her time was even tighter. Always at the back of her mind, dictating her mood and her actions at home, was the thought of the evening's performance. Nothing was more important.

On those occasions when she had free time, Ethel, always ready to make a few extra bucks, sang at private gatherings. Wealthy white socialites loved those evenings at their homes when invited guests could sit in their spacious living rooms and hear the announcement: "And now, dear friends" or "And now, ladies and gentlemen, may I present Miss Ethel Waters." Accompanied by Pearl or a small backup group, Ethel would stand by the piano and sing her hits. Such a soiree was considered the most exclusive type of private entertainment, and these performances helped Ethel's career. An array of artists, producers, and theater people attended. One evening at the home of Katherine Brush, the author of the novel *Porgy*, DuBose Heyward, and his playwright wife Dorothy heard Ethel sing "Washtub Rhapsody (Rub-sody)" from *Rhapsody in Black*. For Ethel, the evening was another gig, but for years to come the Heywards couldn't get her performance out of their heads. Later the couple would play an important part in her career.

On days off, Ethel, finding it hard to relax, went to the bridle path in Central Park where she would ride horseback for hours. In the late nineteenth and early twentieth centuries, riding stables in the city numbered in the hundreds, and because horses could be boarded at the stables or rented, horseback riding was popular with New York residents. Originally,

Central Park's bridle path looped around the reservoir. In time, additional loops were created to the north and south of Central Park. Most likely, Ethel took the loop to the north, which branched off from the reservoir above 96th Street and turned west into the park at 104th Street. In time, she became a fairly good horsewoman. Dressed in her sporty riding clothes—her jodhpurs, jackets, and boots—and sitting tall in the saddle with her perfect posture, she was a wonder to behold as she galloped under many of the park's arches and bridges. Because most riders were unaccustomed to seeing an African American woman on horseback, she drew stares, even more so when word spread that she was the colored singer who had made so many records and played Broadway.

Though in some respects she would always be the insecure girl from Chester, Ethel now had a fuller sense of her identity and was becoming even more aware of her effect on people. On that first Black Swan tour, the attention had been something of a novelty, but by now she was becoming Ethel Waters offstage as well as on. The line between the personal and professional woman was not yet completely blurred, but it had started to be erased.

Other times she read to unwind. Generally, she preferred books by Black authors like Langston Hughes. But she also loved long, sweeping epic tales in which she could lose herself, everything from *Gone with the Wind* to *Anthony Adverse*. Basically, she was willing to read "anything from dime novels to encyclopedias." "I love detective stories for a diversion, and heavy literature when I am in the mood," she once said. "I like good English and good literature. You learn a lot of these things mingling with interesting people with ideas."

On other occasions, she rushed out to see horror movies, no doubt those starring Boris Karloff or Bela Lugosi during this period, and, of course, enthusiastically went to prize fights. Later she became one of Joe Louis' greatest fans, attending some of his big bouts, and on occasion even going to the gym to see the champ work out. She enjoyed cooking and preparing meals for special friends she'd invite over as people continued to flow in and out of the apartment. She also began taking an interest in children in need of affection and financial help. Gradually, more children visited the apartment with their mothers or other family members, and

were fed and looked after. On more reflective occasions, she listened to music, which she said always affected her emotionally. "It tears my heart open. That's why I'd rather hear it when I'm alone." There were also times of prayer, although she was quick to say, "No, it's not true that I'm so religious that I have an altar in my home. But I try to feel close to God all the time."

With her career, her various interests, her time spent with friends, and her time with needy children, not much time was left for Eddie. People in her circle knew Matthews now, and if they didn't all like him, they at least tolerated his presence. Not only did he look the part of the dashing husband of a star, but he acted the part too. The two remained fashion plates. They were still seen about town, and both still drove sporty cars. Ethel was seen in her Lincoln sedan, Eddie in his Lincoln convertible. Ethel had also bought an Elcar. On some occasions, she might attend a benefit or catch another show, and Eddie might be by her side—or not. He might be spotted driving around town or at the racetrack in whatever city the couple happened to be. Usually, he traveled with her on tour, but, basically, no one cared much about him—except to trade stories. The gossips in town were already having a field day with the couple. The main topic was Eddie's gambling. Though Ethel never played the horses, the *Chicago Defender* reported, "her husband, Eddie Matthews, tossed away thirty grand on Illinois tracks." Another time, the word was that he "made several threats to break away from playing the horses daily and partying at night, but he just can't seem to quit."

Still, to some observers, Eddie made many efforts to please and placate Ethel, to cajole, to flatter, to go the distance to keep her happy. By her own admission, it had been Eddie who had urged her to take time off during the period when her voice problems had become severe. Rob Roy, who wrote for the *Chicago Defender*, recalled many an occasion when Eddie stood at Ethel's beck and call. "What she wanted was companionship after working hours and someone to measure up in dress and popularity to her stately position in life. One such person was her first husband of record, 'Pretty Eddie' Matthews. There never was a more genial person than Eddie. The services he gave Ethel in public places where they dined; the respect he gave her and insisted that others have for his wife is unmatched

in show business. When the pair ate in cafes it was Eddie who first tasted the food to see that everything was right for his wife. If the coffee was lukewarm to Eddie, it was much too cold for Miss Waters and was sent back to the pot for heating. The silver she ate with was wiped off carefully, not by Miss Waters, but 'Pretty Eddie.' He made no mistake where Ethel Waters was concerned. He saw that others followed suit. The price she paid in cash for this service, as many have pointed out matters not to a star who was rolling in the dough at five figures weekly."

Though few seemed to have much sympathy for Eddie, he was deserving of some nonetheless. As cool a customer as Matthews was, he was still, from the start, probably in way over his head. Before Ethel, he was used to calling the shots in his life, being the center of attention in his own world, strutting and showboating with a pretty woman by his side. He liked it when women flirted with him. He also enjoyed being with women pretty enough to draw stares and comments from other guys; pretty enough to compliment Eddie's virility; pretty enough to be a part of the orbit around him. Eddie was not accustomed to playing second fiddle to a woman. Nor was he accustomed to having a woman who outshone him. All of that changed the minute he and Ethel supposedly became Mr. and Mrs. Nothing could have prepared him for Ethel's fame, even in this earlier phase of her career: for the clamor she created wherever she went; for the constant adulation of her admirers; for the demands on her time; for her nonstop schedule; for the invitations to receptions, parties, dinners, get-togethers; for living in a household that was completely centered around her and always ready to cater to her every need, whim, or command; for the fawning of prominent and accomplished men such as Van Vechten or Langston Hughes.

Living with a star like Waters had to be difficult for Matthews. The spouse of a great female star always has to be willing to walk three steps behind her; live by her schedule, her demands, her moods, her whims; and forfeit a part of his own identity. Women in marriages had long understood how questions of personal identity could emerge once they said "I do," but for men of this period, there was the very question of manhood. Unlike Earl Dancer, Eddie Matthews didn't have a strong enough presence on the entertainment scene itself. For him, there had to be the

suspicion that people viewed him as Mr. Waters. There was also Ethel's explosive temper. Could anything ever satisfy her? In the end, perhaps out of frustration, perhaps out of a kind of desperation, perhaps simply to have some fun without answering to anyone else, Eddie spent a lot of time at the racetrack. Ethel spent most of her time working. No one could say there was now trouble in paradise because life with Matthews had never been a paradise. The truth of the matter was that—after less than three years—often Ethel and Eddie went their separate ways.

DURING ITS FIRST WEEKS on Broadway, *Rhapsody in Black* drew crowds, but by its sixth week, its weekly gross slipped to a piddling $7,000. Shortly thereafter, the musical ended its Broadway run. Not discouraged, Leslie took the show on the road. In July, it opened at Atlantic City's Apollo Theatre on the boardwalk. An irony of this progressive Black show was that it now played at a distinctly non-progressive theater. Like theaters in other parts of the country, the Apollo was segregated. "Negroes sit in the gallery—'it's their place,' says the management," wrote columnist Chappy Gardner, who questioned why no one spoke up about the discrimination, especially "the Negroes who have more political sway than most Negroes have anywhere [but] do nothing about it." Nor did Lew Leslie do anything. Audiences in this oceanside city filled the theater, but once again Leslie left his cast and crew in the cold. Paychecks were late or missing altogether. "I learned from good authority that Ethel Waters did not get her money here," reported Gardner, "and hadn't been getting her regular assignment long before 'Rhapsody in Black' hit Atlantic City. WHY?"

The money problems must have been resolved, at least temporarily, because Ethel stayed with the touring version of *Rhapsody in Black* as it made its way to other cities. In September, the musical returned to Washington, D.C., where Ethel and company again found themselves in a segregated theater. From there, *Rhapsody in Black* opened at the Shubert Theatre in Philadelphia. Arrangements were made for Momweeze and other family members to attend a performance. During an encore that evening, Ethel stepped out of character and addressed the audience. She said the next song would be for her mother. For Ethel, it was another attempt to reach

her mother, and, as always, to win her approval and love. But she still couldn't win the affectionate response from her mother that she craved. The fact that almost thirty-five years had passed since Ethel's birth didn't seem to do anything to alleviate her mother's emotional duress—and shame.

Next stop for the show was Boston, then came an opening on December 25 at Chicago's downtown theater, the Garrick. There was no special time allotted to celebrating Christmas. Just about every day was a workday. Afterward she traveled to Detroit, St. Louis, Milwaukee, and New York.

While in Chicago, Ethel and Eddie attended—along with such stars as Fred and Adele Astaire—a special tribute held in Al Jolson's honor. Jolson was then appearing in *Wonder Bar* at the city's Apollo Theatre. Various performers entertained, but as the evening progressed, Ethel realized she had not been introduced, nor had she been asked to sing. Then Jolson himself took center stage. For Ethel, Jolson, despite the history of his blackface numbers, remained a consummate entertainer who went all the way with a song and with keeping an audience enthralled. Once Jolson completed his numbers, Ethel suddenly heard the master of ceremonies, Ben Bernie, call out her name but without announcing that she'd perform. Ethel believed that he assumed no one would want to follow Jolson, which was true. But she rose, took center stage anyway, sang several numbers, and had the crowd going wild. Afterward, there came a booking at a club in Cicero, Illinois, that was run by Al Capone and his brother Ralph. By now, Capone was the most notorious gangster in America, a legendary figure in the annals of crime. Not much frightened Ethel, but this engagement was an exception. There was no way she could turn down Capone, yet she asked herself what might happen if she failed to give anything other than a knockout performance, according to *his* standards? Throughout her whole time in Cicero, she was terrified, as was Eddie. Every time they heard a popping sound, they jumped in fear it might be a gunshot. The tough girl of the streets didn't feel so tough. She got through her engagement successfully but was more than ready to leave town when it ended.

In March 1932, a poll taken by the *Pittsburgh Courier* asked its readers to name their favorite male and female stars. In third place were Adelaide Hall and Stepin Fetchit. Second-place honors went to Nina Mae

McKinney and Richard B. Harrison, the star of *The Green Pastures*. The first-place winners were Ethel and the singing quartet, the Mills Brothers. The poll confirmed what many already believed: Ethel had become Black America's most famous female star, bigger than Bessie and all the blues singers of the past decade, bigger than an up-and-comer like Valaida Snow, bigger than singers Ada Brown and Alice Whitman and actress Evelyn Preer, also as big as such male stars as Ellington and Armstrong. Though she had crossed over and was well known among white theatergoers and record buyers, there remained a level of crossover stardom that she had not yet attained.

In May, when *Rhapsody in Black* again played Chicago, she was asked by the *Chicago Defender* for her opinion on Negro accomplishments in entertainment. In comments that appeared under her byline, she cited Negro spirituals "as one of the foremost contributions to American music." She spoke about the serious dramas of Eugene O'Neill, Paul Green, and DuBose and Dorothy Heyward but added that she believed "the field in which our people have shown to greater advantage is on the musical stage. From the crowded dance halls of Harlem in New York City to the starlit cotton field of Georgia, the Race has proven itself the finest natural singers in the world." She praised Jules Bledsoe, Taylor Gordon, Daniel Haynes, and especially Paul Robeson, "who has shown that his voice can be heard to advantage on the concert stage and has raised his own folk songs to the dignity of classical music. And on the popular musical stage he is unsurpassed in the natural exuberance of his singing and dancing." She was now considered something of a spokeswoman for the race. Yet she would always steer clear of direct comments on the nation's politics or its social and racial questions.

BY JUNE, *Rhapsody in Black* was back in New York at the Paramount. Leslie had created a shortened version that could play the movie houses and proved a huge success, which was a windfall for Ethel. She still collected 10 percent of the show's gross. Leslie grew even more resentful of the deal he had made, but she had too much else on her mind to think much about Leslie. During these tough times, the main thing was to

continue working and rebuild her financial base after the *Africana* fiasco, which meant that she always had to decide what engagement would follow the current one. Her other concern was her relationship with Eddie. The two had grown even further apart. But she didn't seem to know what to do about the situation.

Then an incident occurred that unsettled her. Following her last performance at the Paramount—when she was believed to be carrying anywhere from $2,000 to $3,000—she entered her apartment building in Harlem and was heading to the elevator when a group of young toughs stopped her in the hallway. One grabbed the elevator operator. The others pulled revolvers on Ethel and a companion. The men grabbed her purse and then ran off. But as Ethel later told the press, she had been carrying only about $25. The large sum of money she had received earlier in the day had already been deposited at the bank. The Negro press let readers know that the gang of robbers had been white and had preyed on other well-to-do Harlem residents. Ethel was left shaken.

As she continued with the show, Lew Leslie was back to his old tricks. He kept reshaping the revue, changing its name, and bringing in new cast members. At one point, Ethel was now publicized as the star of *Dixie to Broadway* with costars Adelaide Hall and the Mills Brothers. When the show played the Lafayette in late November, it was called *Broadway to Harlem*. Another time, Leslie changed the title simply to *Blackbirds*. When it again played New York City's Paramount in 1932, Ethel was not billed at all. The reason for all these changes? Leslie didn't want to pay her the weekly salary or her percentage of the gross. The only way to handle Leslie was to threaten him. Harold Gumm let the producer know he had set up a deal for Ethel to play the Roxy Theatre, the great rival of the Paramount, at the same time that *Blackbirds* was set to start. Leslie backed down, and Ethel was back in the show.

AS 1932 DREW TO A CLOSE, the nation's financial crisis had deepened. Some 2 million people were left without homes or farms or jobs. The banks had foreclosed on many of them, and then the banks themselves closed. People roamed the country, dazed and disoriented as they strug-

gled to survive. Others resided in Hoovervilles, the name given to communities of makeshift shelters set up along river banks or railroad lines. Some spoke of revolution against the capitalist system itself, looking to communism or socialism as a remedy for the nation's economic and social ills. But mainly the populace seemed numbed by their despair. A sign of hope was the election in November of Franklin Delano Roosevelt as the next president of the United States, to be sworn into office in March 1933.

At the start of 1933, *Rhapsody in Black* was back on the road. But Ethel had a new song in the first act, the somber "Brother, Can You Spare a Dime," which was almost an anthem of the Depression. The show moved east in February.

Relieved once she was in New York again, she wasn't sure what was next for her. No doubt she'd have to pack her bags again and hit the road. Without a flood of offers pouring in, her career was in a slump. She'd stick with *Rhapsody in Black* for as long as she could. But when the show played at the Lafayette Theatre, she clashed again with Leslie, who insisted she take a pay cut. She quit the show. She knew such bookings were fillers, something to bring in the money and keep her before the public. But a career needs more than fillers; it has to have new peaks, new challenges. Broadway was still a destination point, yet it remained difficult for a Negro star to sustain a Broadway career. Ethel also had to deal with another fact: before the end of 1933, she would turn thirty-seven. Not ancient. But in show business, a crop of fresh faces was always standing in line, waiting for the big break, the opportunity to replace whoever had previously stepped out of that line to make a name for herself. "Who Will Be the Bojangles, Waters or Mills of Tomorrow?" was the question the *Pittsburgh Courier* had asked two years ago in its October 3, 1931, edition. Other Negro publications had written of young, upcoming women as being the future Ethel Waters. Too ambitious to rest on her laurels, Waters still sought new ways in which to showcase her talents, to keep herself on top and ahead of the pack. She also became suspicious and distrustful of the young women then making records or appearing in shows. Unknown to her was the fact that right around the corner, in the midst of the Great Depression, was a prized booking that would lead to an even higher level of stardom and also a return to Broadway.

# Broadway Star

I N EARLY 1933, HERMAN STARK, the manager of the Cotton Club, contacted Ethel about the possibility of appearing at the famous nightclub. For Ethel, no establishment could match the Cotton Club in sophistication, top-notch entertainment, and sexy exoticism. Its moneyed, glamorous patrons demanded the best. Located at 142nd Street and Lenox Avenue, its space had formerly been occupied by the Douglas Casino and the Club Deluxe. The latter had once been under the management of heavyweight champ Jack Johnson. Run by the gangster Owney Madden—who at first used the nightclub mainly as a place to unload his bootleg beer at steep prices—the Cotton Club's extravagance was unprecedented for a Harlem nightclub: it seated over seven hundred people, had elaborate floor shows that offered "the cream of sepia talent, the greatest array of creole stars ever assembled, supported by a chorus of bronze beauties." Its knockout chorus girls were celebrated for being "tall, tan, and terrific." The club had an exotic interior that would have been the envy of any Hollywood set designer. Its main room—designed by Joseph Urban—was shaped like a giant horseshoe and filled with fake palm trees, which helped give the club its naughty jungle-style motif that was talked about everywhere.

From the year it opened, the stage was alive with the brilliance and razzle-dazzle of legendary Negro musicians and entertainers. There were the bandleaders Duke Ellington, Jimmy Lunceford, Cab Calloway, and Ethel's old orchestra leader, Fletcher Henderson. There was the fiercely

innovative musical genius Louis Armstrong. There were the great danc-
ers: the smooth-as-silk Bill "Bojangles" Robinson; the perfectly coordi-
nated team of Buck and Bubbles, with the superb Bubbles tapping up a
storm; and those precocious, shockingly talented wunderkinds the Nicho-
las Brothers, who would later tap, spin, twirl, flip, and somersault their
way to major stardom on Broadway, in Hollywood, and around the world.
There were also singers like the mellow and moody Ivie Anderson as well
as Adelaide Hall, Aida Ward, George Dewey Washington, and Leitha
Hill. And in 1933, there was a very young, very pretty chorus girl named
Lena Horne. The Cotton Club's shows were the talk of the town, covered
by major columnists, including Ed Sullivan, Walter Winchell, and Louis
Sobol. "There was good food too," said Cotton Club producer Dan Healy,
"and a cover charge of $3. There was practically every kind of drink. Good
booze, too—it was the real McCoy."

But with all its glamour, the Cotton Club was also notorious for the
fact that while it spotlighted great Negro entertainment, few African
Americans were actually allowed in as patrons. "There were brutes at the
door," Carl Van Vechten said, "to enforce the Cotton Club's policy which
was opposed to mixed parties, [although] sometimes somebody like Bill
Robinson or Ethel herself could get a table for colored friends."

Each year, the Cotton Club offered two new productions. And every
night, two extravagant shows were energetically performed: the first at
midnight, the second around 2:00 a.m. In the early 1920s, Lew Leslie had
produced many of the shows with songs by Jimmy McHugh and Dorothy
Fields. In 1926, Herman Stark hired Dan Healy to produce the produc-
tion, and much then changed. Healy was credited with creating the type
of show that the Cotton Club would remain famous for. "The chief in-
gredient was pace, pace, pace!" Healy once said. "The show was generally
built around types: the band, an eccentric dancer, a comedian—whoever
we had who was also a star. The show ran an hour and a half, sometimes
two hours. We'd break it up with a good voice." There would also be a
"special singer who gave the customers the expected adult song in Har-
lem, a girl like Leitha Hill." The year 1930 marked another changing of
the guard as Healy brought in songwriters Harold Arlen and Ted Koehler,
who then created music for the club's dazzling floor shows.

In the years to come, Arlen would be considered one of America's great but sometimes underrated composers; to some music critics, he would be as important as Irving Berlin, George Gershwin, Richard Rodgers, and Cole Porter. The son of a cantor and his doting wife, Arlen had been born Chaim Arluck in Buffalo, New York, in 1905. His twin brother had died the day after their birth. His name, *Chaim*, was Hebrew for "life." Growing up around music, he sang, at age seven, in the choir at his synagogue. At nine, he was playing the piano. By fifteen, he formed his first band, Hyman Arluck's Snappy Trio. A year later, he left home. At age twenty-three, in 1928, he was a vocalist, a pianist, and an arranger. He had also become Harold Arlen. His breakthrough came when he was teamed with lyricist Ted Koehler, and the two created the song "Get Happy." Throughout his career, Arlen would write eight Broadway shows and thirty movies, and working with a series of talented lyricists, he would create such classic popular songs as "I've Got the World on a String," "One for My Baby (One for the Road)," "Ac-Cen-Tu-Ate the Positive," "That Old Black Magic," "Blues in the Night," and "Over the Rainbow."

When working with Koehler, Arlen was always thinking music. One evening at a party, Arlen fooled around with a melody that he thought might be perfect for Cab Calloway at the Cotton Club. Before the party ended, Koehler came up with the lyrics. "Don't know why, there's no sun up in the sky," was the opening line. Both men realized that what they were creating was really not a guy's number at all but a soulful ballad for a woman. The song was "Stormy Weather," and when Herman Stark heard it, he knew he had to find the right woman to sing it—and to draw in a large audience at the same time. He knew that woman was Ethel. Before it would be heard at the club, "Stormy Weather" was recorded by the Leo Reisman Orchestra for RCA Victor in February 1933. It was a hit, but Stark, Arlen, and Koehler must have realized that with Ethel singing it, "Stormy Weather" could become an entirely different kind of hit. The Cotton Club had previously done a special "Ethel Waters Night" tribute, which Ethel had enjoyed. Perhaps this would help the club sign her for its new edition. In the end, that may have helped, but so did the fact that Herman Stark was willing to agree to her salary demands. A meeting was set up. Different parties would claim credit for working out the

details of the deal. According to one version, Ellington's manager, Irving Mills, stepped in to handle Waters' negotiations. Ethel, however, credited Gumm.

Accompanied by Pearl Wright, Ethel met with Herman Stark, Arlen, and Koehler. She liked Arlen, his style, his attitude, his music, his relaxed down-to-earth way of relating to her as an African American woman. He is "the Negro-est white man I know," she said. Sometimes she referred to him as "my son." With his dark, wavy hair, his broad nose, and his dark coloring, Arlen even looked to some like a light-skinned Negro. While she was openly impressed with "Stormy Weather," she didn't like the concept for presenting it. There were plans for special effects, with the sound of thunder and wind. The effects should be dropped, she informed them. What was important was the human emotion of the song.

"I'll work on it with Pearl," she told them. "This song should be given a dramatic ending. I'm gonna see if I can't give it that. But if I do, I will only want to sing it at one show a night. I want to give it everything I got. That will take too much out of me if I have to sing it more than one show." Of all the songs Ethel Waters sang in her long career, "Stormy Weather" would be one that affected her emotionally. Another would be "Supper Time," but the latter, so she believed, would tell the story of her race. "Stormy Weather" told the story of the inner workings of her soul and her romantic despair. The song said something about her life with Eddie Matthews. It brought to mind a question that often preoccupied her: where was her marriage headed?

The situation with Eddie had grown worse. Though she refused to discuss it publicly in the years to come, she felt betrayed by Matthews. Whether it was other women or his indifference to her, no one could say for sure. Still, Ethel seemed to need something that Eddie offered. Maybe it was his fundamental masculinity, or maybe it was that same charm that had first won her over. Regardless, she had become depressed about her situation, which brought to the fore her vulnerability and her deep personal insecurities. Worse, she had no idea what to do about the marriage, how to save it or how, if necessary, to end it.

\* \* \*

REHEARSALS FOR the twenty-second edition of the *Cotton Club Parade* proceeded without major problems. Also on the bill were the Nicholas Brothers, singer Sally Gooding, comic Dusty Fletcher, Cora La Redd, and George Dewey Washington. The orchestra was Duke Ellington's. Having already recorded "I Can't Give You Anything but Love" and "Porgy" with Ellington, Ethel considered him a master and would say later that Ellington's "is the greatest of all orchestras." Ellington would also be quoted as having said that Waters "was one of the finest singers he had ever listened to." Yet Ellington, in the years to come, said little about her. In his memoirs, he would comment on a cavalcade of stars he met, from Stepin Fetchit to Orson Welles; musicians he knew or worked with, such as Fletcher Henderson, Louis Armstrong, Sonny Greer, and Lawrence Brown; and singers, like his favorite Ivie Anderson, as well as Herb Jeffries, Mahalia Jackson, Tony Bennett, and Lena Horne. But he chose to say nothing about Ethel. According to Lena Horne's daughter, Gail Buckley, he joked privately, both tongue in cheek and with a degree of sincerity: "My dear, she wrote the history of jazz." That was how Ellington may have believed Ethel felt about her own importance. But these would have been private feelings, not public ones.

Her opening night, in April, was a sold-out star-studded affair, with the likes of Ethel Merman, Sophie Tucker, Johnny Weissmuller, Jimmy Durante, and Milton Berle all seated at tables around that horseshoe-shaped room. With a cast of fifty artists and eighteen chorus girls, the show was divided into acts and comprised skits, dances, comedy routines, and of course, great songs. In some respects, it was high-gloss vaudeville but with everything polished to perfection and without any sign of the old crudeness or makeshift quality that could make vaudeville such an enjoyable guilty pleasure. Ellington and his orchestra opened the proceedings with the overture. The first scene of the first act was a comedy skit called "Harlem Hospital"; it was rather typical fare, wickedly funny and naughty, with Sally Gooding as the head nurse and Dusty Fletcher as Dr. Jones. The evening was off to a lively start. In the ninth scene of act one, Sally Gooding returned to do the ribald song "I'm Lookin' for Another Handy Man." This was precisely the kind of number Ethel may have at first feared she'd be asked to perform, but she was now in another league. Not until

the eleventh scene of the first act, which was called "Cabin in the Cotton Club," did she finally appear. It was the moment the crowd had been waiting for.

Behind her was a backdrop showing a log cabin. In the foreground, Waters stood under a lamppost. Her face was illuminated by a midnight blue spotlight. The mood—one of melancholic isolation—was set. Because of her own domestic trials, she sang "Stormy Weather" in the most personal way. Refusing to perform the song as a wail, instead she was about to dramatically tell a story of discontent and despair, of love gone bad, of a woman's effort to hold on to herself. And so she began. "Don't know why, there's no sun up in the sky / Stormy weather / Since me and my man ain't together / Seems to be raining all the time." She continued: "Life is bare / Gloom and misery everywhere / Stormy weather / Just can't get my poor self together / I'm weary all the time . . . / All I do is pray the Lord above will let me walk in the sun once more." In "Am I Blue?" she had communicated heartache but in a more melodic, controlled way. In that song, she was speaking of the lover who had hurt her. In "Stormy Weather," she sang about the way in which a broken love affair, or marriage, altered the way she looked at the world. When she sang "Am I Blue?" she was over Earl Dancer. When she performed "Stormy Weather," she was still caught in the grip of emotional distress and pain about her relationship with Eddie.

"That song was the perfect expression of my mood. I was working my heart out at that time and getting no happiness," she said. "I have some unflattering things to say about most of the Negro men I have known romantically. My second husband, Clyde Edward Matthews is a prime example." Marrying him "was a bad decision. If there's anything I owe Eddie Matthews, it's that he enabled me to do one hell of a job on the song 'Stormy Weather' when I did it for Herman Stark at the Cotton Club."

"I found release in singing it each evening," she said. "Only those who have been deeply hurt can understand what pain is, or humiliation. Only those who are being burned know what fire is like." "Stormy Weather" made it clear that there was no turning back with Matthews.

On that opening night, the audience, unaware of the turmoil of her domestic life, knew nonetheless that emotionally Ethel Waters was going

the distance. When she completed the song, the Cotton Club was silent. Then there was thunderous applause. Dan Healy recalled that Waters was called back for a dozen encores.

The first act continued with performances by the Nicholas Brothers and others. At the end of the act, Waters reappeared for an entire company finale. Her next and final appearance—in a skit—was at the opening of the second act. But with the exception of the performance of the Nicholas Brothers, Waters had already brought the show to its high point. The following day she was the star that the town was talking about. Bing Crosby would remember slipping off to the Cotton Club to see Ethel. Then chorus girl Lena Horne would never forget Ethel's rendition. On May 3, Waters recorded "Stormy Weather" with the Dorsey Brothers Orchestra. It became a number one hit that stayed on the charts for eleven weeks. "Stormy Weather" became "the biggest song hit of the past ten years," *Variety* reported. Though "Stormy Weather" was recorded later by Guy Lombardo and Ted Lewis as well as by Ellington with Ivie Anderson and still later by Lena Horne, no recording had the impact of Waters'. The spring edition of the Cotton Club show itself was such a hit that a shortened version of it—with Ethel, Buck and Bubbles, and Florence Hill—played the Capitol Theatre for two weeks beginning on May 26.

AMONG THE MANY famous people who heard Waters at the Cotton Club was the composer Irving Berlin, who was then working with Moss Hart on a new show called *As Thousands Cheer*. Seeing her standing alone under the lamppost with the midnight blue spotlight, he didn't have to study her performance. He didn't have to think about it. Berlin was powerfully moved by her. That night, he decided that he wanted Waters for the revue, which was about to go into rehearsals. The next day a call was made to Dan Healy. Berlin wanted to buy out Waters' contract—but there was no actual contract. Afterward Ethel met with Berlin, Hart, and producer Sam Harris to discuss the production.

At this point in his career, Berlin was already a major American songwriter. He was a self-made man who had the fierce upward-climb-from-out-of-nowhere drive that Ethel respected. Born Israel Baline in 1888, the son

of a cantor who immigrated with his family from Russia to New York, he had grown up poor on the Lower East Side in a section that was then referred to as "Jewtown." His father died when Israel was eight. Later changing his name to Berlin, he threw himself into show business and pitched his songs to Tin Pan Alley. By 1913, he had his first Broadway show, *Watch Your Step*, which starred the legendary Vernon and Irene Castle.

Berlin's career would span decades, but it would not be free of controversy. In the early part of the twentieth century, Berlin wrote "coon songs." His show *Yip! Yip! Yaphank* featured a minstrel section with the song "Mandy" as its centerpiece. Performed by a male chorus in blackface and in drag—Mandy herself was played by a Black actress—the number was considered tasteless and racist. He had also contributed the story and several songs to the 1930 Al Jolson film *Mammy*, one of which was a little number called "To My Mammy." There were also often accusations and gossip that Berlin, influenced early on by ragtime, hadn't written some of his material—that instead he had a personal ghostwriter, a "little nigger boy" whom he kept hidden away. Once Berlin had asked an associate, "Did you ever hear the story of the little nigger boy?" "Yes, I have," the man told him. "Do you realize," asked Berlin, "how many little nigger boys I'd have to have?" In time, Berlin would write some fifteen hundred numbers and the scores for nineteen Broadway shows and eighteen Hollywood films. Among his most famous songs were "Alexander's Ragtime Band," "Cheek to Cheek," "God Bless America," "Blue Skies," "A Pretty Girl Is Like a Melody," and "White Christmas."

Moss Hart was another self-made man. The son of a one-time cigar maker, he had grown up in a tenement on New York's East 105th Street. He had previously worked with Berlin on the lackluster revue *Face the Music*, but his great collaboration was with George S. Kaufman. The two first worked together on *Once in a Lifetime* in 1930. In the years to come, Kaufman and Hart would create such classic productions as *You Can't Take It with You* and *The Man Who Came to Dinner*. In 1949, Hart would write the screenplay for the groundbreaking film on anti-Semitism, *Gentleman's Agreement*. He would also direct such major theater productions as *My Fair Lady* and *Camelot*. In time known as the "Prince of Broadway," Hart would win the Pulitzer Prize and Tonys as well as earn Oscar nominations.

These men of the theater wanted Ethel for their new Broadway venture. It was the very kind of production she had been working toward ever since Earl Dancer had pushed her to play the white time.

Changes in the economy had now brought about changes in taste in Broadway entertainment. The old fare wasn't working as it once had. Those studied operettas were no longer as popular, and extravaganzas with all those giddy chorus girls were becoming too expensive to produce. Besides, the Hollywood musicals offered a bevy of chorus girls amid dazzling choreography devised for the camera. Audiences had become captivated by the brash, snappy new talkies. To compete and offer something new, Broadway was about to open its arms to smart, sexy, sophisticated revues with glamorous, witty stars. Such shows would become popular, and As Thousands Cheer would be among those leading the pack.

Ethel learned that As Thousands Cheer would be a satirical topical revue with sketches and musical numbers developed around the format of a daily newspaper. There would be "headline" numbers about political figures, society folks, international celebrities. There would also be human interest stories, even a weather report. One sketch would look at the end of Prohibition. Another would poke fun at the divorce of Joan Crawford and Douglas Fairbanks Jr. Still another, under the banner "Franklin D. Roosevelt Inaugurated Tomorrow," would look at what outgoing President Herbert Hoover and Mrs. Hoover really thought about a number of things, including their successors, Franklin and Eleanor. Others sketches would be performed on Mahatma Gandhi, Aimee Semple McPherson, Noël Coward, and John D. Rockefeller Jr. The title "headline" of each sketch would be projected onto the curtain at the theater. Moss Hart wrote the material. Hassard Short would stage it.

During her discussions with Berlin, Hart, and producer Harris, Ethel also learned that As Thousands Cheer would feature three other stars: Clifton Webb, Marilyn Miller, and Helen Broderick. Webb, who had been in show business from the age of three, was then a song-and-dance man with impressive credits. In 1929's The Little Show, he had performed what came to be a standard, "I Guess I'll Have to Change My Plans." Later he would make such a name for himself in Otto Preminger's Laura, Titanic, and the Mr. Belvedere series that most moviegoers would have

no idea that he had been so big a musical theater star. Tall, slim, elegant, and a stylish dresser, Webb was a rather prissy, arrogant, fussy performer. Because he was so devoted to his mother, Maybelle, he was gossiped about as a mama's boy.

The leading lady was the then very popular Marilyn Miller. Blond and delicate, the daughter of vaudevillians, she had been on the stage since she was six years old. Though she didn't have a big voice, she knew how to put a number over, and she was a good dancer. She was already a figure of legend and lore with a list of admirers who were some of the most celebrated and powerful men in the theater. In 1920, she had introduced "Look for the Silver Lining" in Jerome Kern's *Sally*. Quite taken with her, Kern wrote "Who?" for Miller. George Gershwin wrote "How Long Has This Been Going On?" for her. A Ziegfeld star, Miller had been pursued by Ziegfeld himself. She'd also had two well-publicized marriages. One was to a younger man, Frank Carter, who was killed in an automobile accident. When Miller, then appearing in a show, heard the news backstage, she reportedly said: "I've never missed a performance, and I'm not going to miss one now." She went on that night. Her second husband was Jack Pickford, the dissolute brother of screen star Mary Pickford. He was rumored to have died of syphilis. Miller had been away from Broadway since 1930, and she was ready—with *As Thousands Cheer*—to let the customers know what they had been missing.

The other star, Helen Broderick, was a scene-stealing deadpan comedienne, whom Moss Hart had once described as "part vitriol and part my favorite person in the world." Broderick would also go to Hollywood, where she would appear in such Fred Astaire-Ginger Rogers musicals as *Top Hat* and *Swing Time*. She was also the mother of future Academy Award–winning actor Broderick Crawford.

Well aware that these were seasoned pros who were accustomed to backstage battles as well as being in the center of the spotlight, Ethel understood that they might possibly be territorial. No one was going to upstage them. No one was ever going to steal their thunder. To a novice, they could be a fearsomely intimidating trio. Even to a veteran, they could be formidable. But Ethel was no novice, and veteran that she was, she wasn't frightened of anyone. Her vulnerabilities were always offstage,

never on. She was confident enough to know that she could hold her own. If someone pushed her, she would push back. Perhaps she mumbled her motto to herself: "I'll show them bitches."

Ethel soon learned, however, that her white costars would receive billing above the title. She would not. The ads would read:

SAM M. HARRIS
*presents*
MARILYN MILLER
CLIFTON WEBB
HELEN BRODERICK
in a new musical revue
AS THOUSANDS CHEER
by IRVING BERLIN and MOSS HART
with ETHEL WATERS
Staged and Lighted by
HASSARD SHORT

For a woman who had sold huge numbers of records, who had played the Palladium and the Café de Paris with European café society at her feet, who had already starred in three Broadway shows, who was known to the theatergoing public and critics alike as a one of a kind star, this may have seemed like a slap in the face. What it boiled down to was that *As Thousands Cheer* was a white show with a special guest star appearance by a colored artist. Was this second-class treatment? Yes, but Waters knew that this was a unique opportunity to expand her horizons and to further stretch the boundaries of her career. Her other shows had not been long-running hits. Perhaps this one would put her into a whole new ballgame.

Then, too, Irving Berlin let Waters know there would be four songs for her in *As Thousands Cheer*. One would be a deliciously playful, sexy piece called "Heat Wave." Another would be a dreamy lament called "Harlem on My Mind," relating the mood of a Black star in Europe, missing her hometown. The other was "To Be or Not to Be." But most significant and perhaps surprising for Ethel would be the fourth song.

Berlin hoped to inject social content into the show, something new to this type of entertainment. Perhaps he was also trying to make amends for his past coon songs. The new song, "Supper Time," which he believed was "the most unusual song in my whole catalogue," would be the tale of a woman preparing an evening meal for her family, knowing that her husband has been lynched. For Broadway, this would be powerful stuff. It could also be risky. Carefree theatergoers might reject it. Critics might find it overreaching and even exploitative of a real social and racial issue. Ethel knew, however, that the four Berlin numbers were among the best material she would ever have for a Broadway show. She had no second thoughts about joining the production.

Her schedule was packed. Almost immediately—in late summer—she went into rehearsals for *As Thousands Cheer* at the Amsterdam Theatre. At the same time, she performed on radio. Waters knew the radio appearances were important to broadening her audience. It was also good money. In August, she starred in a production of *Stormy Weather*—a revue put together with Waters, George Dewey Washington, and the Mills Blue Rhythm Band, that was to play movie theaters, beginning at New York's Loew's State Theatre. Harold Gumm had informed her of offers that had come in for appearances in Europe. During this time, she also received a movie offer for one of Warner Bros. short Vitaphone films, to be directed by Roy Mack and to be shot quickly in Brooklyn. Eager to be back in front of the camera, she agreed to do it. Called *Rufus Jones for President*, the sixteen-minute movie starred Ethel, along with Hamtree Harrington, Edgar Connerly, the Will Vodery Girls, and a pint-sized six-year-old wonder named Sammy Davis Jr.

As always, work invigorated her. Or perhaps it helped her ignore or forget other anxieties. But the rehearsal period proved both physically and psychologically grueling. She still hadn't officially called it quits with Eddie, and it was hard to be around him. She needed space to think, to reflect, and of course, to prepare for the show, which soon consumed her thoughts. Finally, she sent Matthews and Algretta to Atlantic City to stay with friends. Still, she was so nervous and anxiety-ridden that she became ill. "I couldn't sleep," she said. "I was sick every night and suffering from psychic insomnia." Too much was riding on this production. As always,

she also had stomach problems. Then on a visit to Atlantic City, she discovered that Algretta had taken ill. After consulting a physician, she was stunned to learn that the prognosis was infantile paralysis. Ethel sank into a depression but somehow quickly rebounded. From Atlantic City, Pearl, who had accompanied her, wrote Van Vechten: "Thought you'd like to know that Ethel is feeling greatly improved. It's lonely here. Hope you are well." Frightened yet aware that she had to return to New York for the ongoing rehearsals, she sent Algretta to stay with her friends the Websters in Cambridge, Massachusetts. In time, Algretta recovered but remained in Cambridge, where she later went to school. The fact that she might have failed as a mother was apparently something Ethel either pushed to the back of her mind or didn't think about at all. Most important was the fact that she had a show to do.

IF THE OFFSTAGE TENSIONS kept her awake at night, so did her conflicts at the theater. As Thousands Cheer proved demanding and often nerve-racking, primarily because Ethel found herself in a professional situation that was wholly new to her. For one thing, there was none of the camaraderie that she had found in Black shows, where, from her vantage point, everyone spoke the same language. Never did she have to think about any kind of discrimination with her fellow Black cast members. If anything, the Black actors and actresses were unified in their awareness of the discrimination they might face from white theater owners or managers. But in As Thousands Cheer, she was repeatedly subjected to slights and snubs from other cast members. Had she been their maid or had she been playing a small role as a maid, they might have been able to patronize her. But Ethel carried herself like a star who wasn't about to eat humble pie. That famous smile could instantly turn into a scowl. She was aware that the other performers did not want to socialize with her, and none appeared eager to be seen in public with her. Often theater folk might go out to a restaurant after a rehearsal or a performance and hash over the events of the day, but Ethel was never made to feel she was a part of that kind of theater camaraderie. Not that she really cared about that, but the sheer presumptuousness of it irritated her.

"Her attitude to her white co-workers in *As Thousands Cheer* was sane and intelligent," said the writer Marvel Cooke. "She realized that she was a distinct addition to the show—that the producers weren't doing her a favor, but even though she contributed in great measure to the show's success, she knew that her co-workers weren't overly anxious to eat with her. Even though they recognized her as a talented, finished artist they still [were] not sure that she [wouldn't] shame them in public by eating with a knife. They were particularly anxious to get on with her backstage. When they found out she could do that, they were satisfied." Ethel recalled that one actor "with a dash of lavender," meaning he was gay, greeted her daily by saying, "Hello, Topsy!"

Finally, Ethel had enough and responded to his greeting by saying, "Hello, Nellie!" He never called her Topsy again.

Hart and Berlin, however, extended themselves—and their homes— to Ethel. Columnist Earl Wilson recalled that they would invite Ethel to the weekly parties they gave for important theater folk. But by then Ethel had become defensive, and she would never attend. "Hart asked her why. Miss Waters replied in effect, 'If it is important to you, I'll be glad to come and sing and entertain your guests, providing you do not consider it objectionable if I have to leave immediately afterward.'"

In a short time, the daily grind of the rehearsals got to her. Her temper frequently flared up. Her understudy, the tall and elegant Maude Russell, called the Slim Princess in Black theater circles, recalled that she could be impossible to work with. Now she lashed out at just about anyone. "You might just as well get used to sitting in this dressing room," she told Russell, "'cause 'tis as close as you'll ever get to the stage." In time, her white costars knew to stay out of her way, which was just the way she wanted it. "I'm the kind of woman, if I was mad at you, I'd just as leave kill you as look at you," Ethel said. "I can fight and love to fight. I got a look that's poison ivy and will gorge you." The explosions from this woman of God could be fierce. "She was very religious. She talked about God all the time," said Russell, "until she got ready to curse you out. Then when she was ready to curse you out, she'd lay God on the side. And curse you out. And then she'd go back and get Him."

The situation became even more difficult when the cast went to

Philadelphia for tryouts at the Forrest Theatre prior to the New York opening. Tryouts, of course, were often as intense as Broadway opening nights, sometimes more so because audience reactions had to be carefully watched, studied, and analyzed; problems had to be worked out; artistic disputes resolved; individual rivalries, if possible, put on hold. One un-resolved issue for Berlin and Hart was the song "Supper Time." What exactly should they do with it? Some involved with the show believed the song just was not right for a lighthearted romp. Who wanted to come to the theater—to a white show—and have to think about the issue of race? Producer Harris insisted that the song stay in the show until Philadelphia. If there were problems at this point, then it would be dropped.

Ethel grew tenser. The song drained her and recalled scorching memo-ries of the time she had seen the body of the boy who had been lynched and then dumped into the lobby of the theater in Georgia. Nightly, she would have to relive that terrifying experience. "The song is a very mov-ing, plaintive cry sung by a woman who has just learned that her husband has been lynched. She receives the news just as she is making his dinner and she is confronted with the fact that he ain't coming home no more. I was so emotionally moved when I first let myself go at the dress rehearsal, that I sobbed uncontrollably for 10 minutes after the number was finished. Seems like I found myself pouring out the soul of the whole colored race." No matter how painful, she remained committed to performing the song. In her view, it could not and should not be cut. She knew she had to make it work in the show.

Audiences proved the cynics wrong about "Supper Time." They were openly moved by Waters' performance. In fact, Ethel stopped the show. The two-week run at the Forrest was sold out. But there was a new prob-lem, namely Clifton Webb, who had to follow the Waters number with a sketch on Walter Winchell. Infuriated, he felt—rightly—that he couldn't compete with "Supper Time." Moss Hart and Irving Berlin now had to deal with an irate Webb, who threatened to leave the show if the order of the numbers was not changed—or if he were not given a better number. "It's your show," an exasperated Sam Harris told Hart and Berlin. They'd have to make the decisions. Finally, Hart, Berlin, and Harris were in agreement: "Supper Time" would stay. Actually, because of Ethel's perfor-

mance, the three men became passionate about the matter. "You go back and tell [Webb]," Harris informed the actor's agent, Louis Schurr, "that he not only doesn't have to open in New York on Saturday, he doesn't even have to play the show here tomorrow night." Webb stayed in the show, but Berlin and Hart gave him a new number to sing, as it turned out one of Berlin's most memorable songs, "Easter Parade," which closed the first act.

According to another story, the three white stars did not want to take curtain calls with Ethel. Whether true or not, the behind-the-scenes conflicts were resolved, although none of the principals involved were likely to forget them. But Ethel was already clearly bruised by the production. No matter how high she might climb in entertainment, some things might never change, the old prejudices, the long-standing racism. Maybe it would be a grip backstage who didn't want to take an order from her. Or a stage manager who thought she was uppity. She had never trusted ofays—why should she start now? She also knew that her talent was too big to be bogged down by their limitations. As for having to follow somebody else's act, she didn't care one iota who it was. Hadn't she already performed *after* Jolson at that tribute to him? Nothing could daunt her now. "There's nothing I like better than workin' on a hot stage," she said.

On Saturday, September 30, 1933, *As Thousands Cheer* opened at Broadway's Music Box Theatre, which Berlin and Sam Harris owned. Webb's number "Easter Parade," which was the first-act finale, gave him the kind of hit he wanted. The other performers were also scintillating and sparkling in their sketches. Still, it was undeniable that while many theatergoers came to see the white stars, especially Marilyn Miller, they left talking about Ethel. The sketch for her song "Harlem on My Mind" had the headline "Josephine Baker Still the Rage of Paris." Here Waters performed a tale of an expatriate star, dining with dukes and earls, but longing for the folks back home. Wearing a silky wig with a spit curl, with eyes darkly made up, and dressed in a glamorous gown, Waters might easily have turned the song into an attack on the pretensions of her one-time rival. Instead, aware of her own homesickness while in Europe just a few years before, "Harlem on My Mind" became a wistful, at times somber, yet dreamy song of yearning; a reminiscence of the things a star might have to leave behind in order to become a star; a tale as well, as performed

by Ethel, of cultural dislocation—similar to what she experienced with the white cast of *As Thousands Cheer*. Entertainer Bobby Short said that Greta Garbo, a Hollywood star who never forgot her Swedish roots, took a liking to the song, which touched on her longings for home no doubt as much as it had touched on Ethel's.

Then there was the "Heat Wave Hits New York" sketch, in which Waters, dressed in a red-and-gold outfit and wearing a colorful turban, unleashed her high-voltage sexy energy. Here she showed her ability to invite an audience to join in for an evening of fun. Following an instrumental introduction, Waters began her performance in a low, husky register: "A heat wave arrived into town last week / She came from the isle of Martinique." From there she went into a higher register as she told her audience: "We're having a heat wave / A tropical heat wave / The temperature's rising / It isn't surprising / She certainly can can-can." Swaying her hips and shoulders and moving across the stage with her lanky long-legged dancer's strides—her movements every bit as glamorous and distinct as those of Garbo when the movie goddess walked across the screen with her distinctive rhythmic thrust—Waters was a marvel to behold. Sexy in a sometimes subtle, sometimes bold way. Inviting as all get-out. And seemingly having the time of her life. Her years as a blues singer were apparent in this pop tune (as they were in "Harlem on My Mind"). With her love of language and playing with words and sounds, Ethel openly relished the lyrics "She started the heat wave / By letting her seat wave / And in such a way / That the customers say / That she certainly can can-can."

Later in the song—which was recorded on October 10, 1933, with Benny Goodman on clarinet—she imaginatively mixed musical styles as she delivered the lyric "Gee, her anatomy / made the mercury / Jump to ninety-three." She stretched the "Geeeeee," then quickly moved into a blues singer growl as she sang the word "her" and shifted to play with the pronunciation of the Broadway-style lyrics "*anatomy*, made the *mercury* / Jump to ninety-three." Then she closed it with a modified street yell, "Yeah man!" The little girl from Chester seemed to delight in showing her mastery of different styles and the uncanny way that she could fuse all those styles to put a song across in a totally new, unexpected way.

Years later Berlin would insist that Twentieth Century Fox have Mari-

lyn Monroe sing "Heat Wave" in an overproduced segment for the film *There's No Business Like Show Business*. Monroe's version would be slower and sultrier and more blatantly sexy. But even Monroe no doubt would have appreciated the way Waters put her brand on "Heat Wave." No one would ever surpass Ethel's enthusiasm for Berlin's song itself, her pleasure in the cleverness of its lyrics, her sheer delight in the utter breeziness of its melody.

In the sketch built around the number "To Be or Not to Be," she performed with comic actor Hamtree Harrington, who played her lazy good-for-nothin' husband. But that sketch—and its familiar racial stereotyping—seemed to get lost and become forgotten because of the daring "Supper Time" in the second act. "Unknown Negro Lynched by Frenzied Mob" was the headline for the sketch. Ethel was seen preparing dinner for her family. "Supper time / I should set the table / 'Cause it's supper time," she sang. "Somehow I'm not able / 'Cause that man of mine / Ain't comin' home no more." The typical Broadway audience was being asked to think about the country it lived in and the torment of its second-class citizens who were often invisible. Her rendition may have brought to mind the first 1931 trial of the Scottsboro boys, nine young Black men accused of raping two white women on a freight train. Many feared the young men might not even make it through the trial. Lynchings were very much on the minds—and part of the protests—of the NAACP. James Weldon Johnson had long fought for an anti-lynching bill. The struggle for legislation would continue into the next decade when the NAACP's Walter White repeatedly appealed to President Roosevelt for an anti-lynching bill. Too many African American men had already been left hanging from a rope. "If one song can tell the whole tragic history of a race, 'Supper Time' was that song. In singing it," recalled Waters, "I was telling my comfortable, well-fed, well-dressed listeners about my people."

"Supper Time" marked an important shift in mainstream culture. Here in popular song, a social, racial, and political issue received comment. "Supper Time" may not have been a searing protest song, but it was an acknowledgment of festering racial disparities and injustices. Some might argue that the song itself raised questions only because of the context (the sketch) in which it was presented; that on its own,

"Supper Time" could be performed without any thoughts of race in America. But few would ever think of this song in any other context than that of the sketch. Six years later, Billie Holiday would perform the haunting "Strange Fruit," the story of a Southern lynching, which would be considered the first race protest song with explicit lyrics. But Waters may have felt all the fuss about "Strange Fruit" tended to overlook the fact that her "Supper Time" had signaled the first social and racial commentary in popular song. She would never like Billie Holiday, for a number of reasons other than "Strange Fruit," but Holiday's "Strange Fruit" didn't help matters for Waters, a woman who took pride in her accomplishments and the way she repeatedly broke new ground in entertainment. "Supper Time" became part of her race work.

"Supper Time" also revealed the power of Waters as an actress. In song, she had created a compelling character, mournful, angry, devastated, altogether moving. For her, the song may also have been a sign of the dramatic powers within herself—and the dramatic possibilities she hoped would come in the future. Among those who saw Ethel perform the song was a little girl who would grow up to be an important entertainer herself, Carol Channing. It marked the first time she had ever seen a musical. Having persuaded her family to take her to see it, Channing remembered that as Ethel "moved slowly down to the footlights, my heart started to pound . . . when she began to sing I got so thrilled it was embarrassing. I looked around and no one else seemed to be reacting that way. And I looked at Ethel Waters and lost my breath. I was throbbing all over. It was like being in love—and you can't criticize a person when you're in love—it's beyond judgment. And I was hooked." Channing became a lifelong fan of Waters and her brilliant rendition of the Berlin song.

PATRONS LEAVING the Music Box Theatre knew they had seen a major new musical. Reviewing *As Thousands Cheer* in the *New York Times*, Brooks Atkinson called it "a superb panorama of entertainment." "As for Berlin, he has never written better tunes or more sparkling lyrics; and Mr. Hart has never turned his wit with such economical precision." Of

the performers, Atkinson commended Webb, "the king of the decadent pants," who "sings and dances with a master's dexterity." He commented that Miller "brings to the show not only the effulgence of her personality but a sense of humor." Broderick was "the perfect stage wit." And what of the woman whose name was below the title? "Ethel Waters takes full control of the audience and the show whenever she appears. Her abandon to the ruddy tune of 'Heat Wave Hits New York,' her rowdy comedy as the wife of a stage-struck 'Green Pastures' actor and her pathos in a deep-toned song about a lynching give some notion of the broad range she can encompass."

Despite the show's rave reviews, backstage attitudes had not changed. "Once the show got to New York, that same attitude prevailed among her white co-stars," said Marvel Cooke. "So as soon as work was over, she came 'Home to Harlem'—that is unless she was asked specifically to go to some affair in which the entire cast was invited." Still, everyone was now aware of an undeniable fact. Broadway already knew the likes of great musical stars like Ethel Merman and Mary Martin, whose careers would span decades. With As Thousands Cheer the colored girl from Chester had made a permanent place for herself among Broadway immortals.

SO MUCH HAPPENED that the rest of the year may have been a blur for Waters. Even before As Thousands Cheer opened, Ethel had performed on radio shows, most notably on a series of NBC broadcasts in New York. Then she signed a contract with CBS for a radio show—The American Revue—with a coast-to-coast hookup. "For several weeks, Ethel has been singing on the CBS chain but with only a sectional hookup," reported the Chicago Defender. Now all of that changed. Sponsored by the American Oil Company, The American Revue aired on Sunday evenings from 7:00 to 7:30, beginning October 22, 1933. Accompanying Ethel was Pearl Wright. Also appearing weekly was the Jack Denny Orchestra. For a Black woman to be starring in her own radio program, though that was not how CBS chose to publicize it, was a major coup for Waters. Within the African American press, there was again great excitement about yet another career

breakthrough. Her pay was $1,500 a week. As with everything else, she was optimistic and ready for the hard work she knew the show would require. Doing a radio show on one of her days off from the theater obviously meant even less time at home.

So did her recording commitments. She went back into the Columbia studio on October 10 to record "Heat Wave" and "Harlem on My Mind" with Benny Goodman's orchestra. At age thirty-seven she was still conscious of the competition of a new generation of singers such as Ivie Anderson and, soon, Ella Fitzgerald, most of whom idolized her. She rarely viewed them as fans and admirers. Her determination to hold claim to her turf brought out her paranoia—and also her ruthlessness. "If there was the possibility of another female vocalist sharing a bill with her, Waters would often make the proprietor or promoter take her off the program," said music producer-promoter George Wein. "A long and arduous path in show business had left her jaded and a bit insecure. She was highly insecure, and she was mean." On November 27, 1933, when Ethel was back at the studio to record "I Just Couldn't Take It Baby" and "A Hundred Years from Now," she heard that a young singer, then making a name for herself in clubs in Harlem, was also in the studio about to make her first recordings. The singer was eighteen-year-old Billie Holiday. Ethel sat in a chair at the back of the studio watching the young Holiday. She said nothing. Ironically, Ethel was then making her last recordings for the Columbia label.

Major changes had come about at Columbia that affected her music career. In 1932, the record company, faced with a new financial dilemma, had filed for bankruptcy and was taken over by the American Record Company. Brunswick, its top label, released Ethel's "You've Seen Harlem at Its Best" and "Come Up and See Me Sometime," in which she talked as much as she sang, in a sweet send-up of Mae West. Also on the Brunswick label were her songs with Ellington's orchestra—"Porgy" and "I Can't Give You Anything but Love"—as were "Stormy Weather," "Love Is the Thing," "Don't Blame Me," and "Shadows on the Swanee." But there were problems at Brunswick. Some of her material was uninspired. Then, too, said Frank Driggs, the "quality of their [Brunswick] recording suffered by using small, cramped and heavily damped studios." In 1934, Brunswick's

top recording man, Jack Kapp, left the company to form American Decca. He took with him top Brunswick stars, including Bing Crosby, the Mills Brothers, the Boswell Sisters, Dick Powell, Guy Lombardo, and Ethel. She recorded eight songs for Decca in 1934, one of which was a new version of "Dinah" plus such stunners as "Miss Otis Regrets" and "Moonglow," as well as "Sleepy Time Down South," "Give Me a Heart to Sing To," "I Ain't Gonna Sin No More," "Trade Mark," and "You're Going to Leave the Old Home, Jim?"

During this time, a major shift had come about in her style and material. Many of her new recordings—including the later ones for Columbia—were dramatic pieces or show tunes. Gone was the raunchy Ethel. Then, almost shockingly, Decca dropped her. Except for two recordings for the Liberty Music Shop in 1935, she did not record again until 1938. Her career in the theater was still going strong. But in the world of popular music, four years is a very long time without regular record releases.

**PUBLICITY ABOUT THE GOOD** Ethel continued as she received even more coverage in mainstream publications. Few stars were more media-savvy than Waters, who knew when to smile and laugh while never showing the temper that everyone backstage was familiar with. She also appeared as determined as ever that the public understand her struggles. "When you hear Ethel Waters crooning 'Stormy Weather' and other blues songs into the microphone," Nelson Keller recounted in the magazine *Radio Stars*, "you might think that the mournful tones she gets into her voice are just good showmanship. In reality, she is pouring out the heartbreaks and disappointments, the struggles and trials of her early life, for this colored girl has overcome terrific handicaps. Now she is successful. But when she remembers those other days, well, she's got a right to sing the blues." In the "Talk of the Town" section of the December 23, 1933, issue of *The New Yorker*, Waters was the topic of a piece titled "Success." The theme was—as Ethel had intended—the triumph of talent and drive over adversity. "Ethel Waters is having such a delightful present that she doesn't brood over her past, which is well, perhaps. She used to be a

scrubwoman in a Philadelphia hotel, and before that she did washing and ironing. Now she has a seven-room apartment on Seventh Avenue and automobiles, and makes $1,500 a Sunday for one radio broadcast, $3,000 apiece for movie shorts, a lot more from phonograph records and still more from 'As Thousands Cheer.'"

Throughout the interviews, she portrayed herself as basically humble, although there were always suggestions of her toughness. The story that Waters told the writers from *Radio Stars*, *The New Yorker*, and other publications was fundamentally true, but she also altered some of the facts and presented a sanitized version of her tough life. The press was not told that her mother had been raped. "Her mother and father were poor, hard-working people," wrote *Radio Stars*. "Ethel was born in a poverty-stricken little shack in Chester, Pa. Her father died when she was a baby and her mother, unable to keep the infant and work, sent Ethel to live with her grandmother." The circumstances of her birth no doubt were still too painful for her to deal with publicly—and they might well have been too shocking for the public to hear at that time. Shrewdly, Waters used the mainstream press to further construct an image and a narrative she felt appropriate, especially in light of the Depression: now she presented herself as a heroine who had survived an impoverished childhood, a heroine with yearnings for acceptance and approval. Unlike other stars who often had a phalanx of publicists, managers, agents, and assistants to create and promote a public image, Waters basically did it on her own. She intuitively understood what would work best for her public during the Depression. She also appeared to believe her own publicity. Waters continued to express pride in her "people." "When people say I put little tricks in my songs, I laugh. It may be a trick to white people, but it's just natural to Negroes. I love my people. We get along like cats and dogs, but I love 'em," she told the press.

If publications weren't writing about the good Ethel, then they were writing about Ethel, the larger-than-life star. In December, the *Pittsburgh Courier* spotlighted the glamorous Ethel with a headline and subheads that read:

Lovely Jewels and Clothes Have Not "Made"
the Great Ethel, But They Have Glorified Her

Radio, Stage Star Has Some Gorgeous Gowns—She Is
Tall and Slender and Knows How to Wear Clothes,
The Modistes Say—Looks Ritzy, But She Is Not High-Hat

It was a seemingly paradoxical image that she promoted. On the one hand, Ethel understood—and enjoyed—the fact that fans wanted her to be glamorous like the Hollywood stars. A woebegone ghetto girl image only worked for her if it was something she had overcome. Yet it could never look as if success had gone to her head. She remained the down-to-earth Ethel. Still, as the *Pittsburgh Courier* pointed out, almost as an afterthought when it spotlighted her glamour: "Miss Waters has promised to tell Courier readers more about her intimate life. You will want to learn more and more about this great star, who climbed, by her own efforts, to a place in the sun." For as long as she could, she kept those intimate details about her life private. She closed 1933 with the lid still tightly locked on details about the problems with Eddie, and the possible estrangement from little Algretta.

WITH THE GREAT SUCCESS of *As Thousands Cheer*, other opportunities came that she refused to pass up. She accepted an offer for late-night performances at the nightclub Palais Royal where she was the only African American performing. Music for the show was written by Jimmy McHugh and Dorothy Fields. She also signed up for two movies. One was a musical short called *Bubbling Over*—an RKO Radio film directed by Leigh Jason and shot at a studio in the Bronx—in which she appeared with Hamtree Harrington and Frank Wilson. For *Bubbling Over*, she earned $3,000. The other, *The Gift of Gab*, was a Universal feature film starring Paul Lukas, Gloria Stuart, and Edmund Lowe. Waters was one of a series of big names making cameo appearances or performing musical numbers: such stars as Bela Lugosi, Boris Karloff, Andy Devine, Binnie Barnes, singer Ruth Etting, Victor Moore, and critic Alexander Woollcott. Ethel's cameo was filmed in New York. Still, with the play, the nightclub work, the movies, the recordings, and the radio show, she was now possibly the highest-paid entertainer on Broadway.

But her radio show *The American Revue* ran into problems. In January 1934, just as Ethel's contract was to be renewed by CBS, the radio network's Southern affiliates complained. "Rumors are going the rounds of New York," reported the Negro press, "that Ethel Waters may not sign the contract to star on the American Oil Co.'s program each Sunday as heretofore, because the arms of the prejudiced 'cracker' South are reaching across the Mason Dixon line to halt her in her flight as one of radio's leading luminaries." By February, headlines in the Black press reported that Southerners were protesting to sponsors of this show with a colored woman as its star.

"Ethel Waters' Sponsors Cut Georgia and Florida from CBS Broadcasts," read one headline.

Entire Radio World Awaiting Result of South's Attacks on
Famed Star's Air Appearances Sunday Evenings at 7—
Will She Get New Contract?

South Demands Ethel Waters Quit the Radio.

"One of the most vicious forms of race prejudice is attributed to the rumored withdrawal of Ethel Waters, singing comedian, from the radio," reported the *Chicago Defender* in its February 17 edition. "Southern listeners are said to have complained of the star of *As Thousands Cheer* in their letters to the sponsors." Walter Winchell also reported that the South was angry about the program. The very problem confronting her in 1934 would face an entertainer like Nat "King" Cole more than two decades later when his television program *The Nat "King" Cole Show* also ran into problems from Southern affiliates. After little more than a year, Cole's show was also canceled. Not known as a fighter, Cole nonetheless gave a fairly hard-hitting interview to *Ebony* magazine in which he stated that the real problem lay on Madison Avenue, which failed to find him a major sponsor. Always the movie studios, the radio networks, and the television networks showed perhaps too great a concern about the Southern market. Waters was one of the early Black stars whose radio career would be in jeopardy because of that market.

The radio show was important to Ethel. Nightly, families gathered around the big box in their living rooms, listening to songs or jokes or suspenseful dramas, or to headline news. Radio—that great new national collective experience—made the country and the world smaller places. For entertainers—white entertainers, that is—radio could be a gold mine. On a single broadcast, as a guest, a performer could reach a huge audience, broaden his or her fan base, and quickly become nationally known. Others hosted their own shows and became top radio stars. Past vaudeville stars such as Jack Benny, George Burns and Gracie Allen, and Fred Allen were all able to use their radio careers to settle permanently in one place without the constant stress of packing up and traveling for months at a time to one city after another. For Ethel, radio could also give her a chance not to have to return to performing on the road. Movies also offered stability. You got up in the morning, went to the studio, and then returned home to your family and friends. But as negotiations and discussions went on with CBS, Ethel knew such a settled life might not happen for her. Finally, it appeared as if the network had given in to pressure from the South. The last airdate for *The American Revue* was February 25, 1934. Other reports surfaced that Waters had been undermined on her show by jealous white blues singers. Another stated that Ethel herself had decided not to renew her contract. Neither of those reports had much credence.

True to her nature, Ethel issued no public statements about her anger over the cancellation of the show. Important as her program had been, the rug had been pulled from under her.

BY MARCH 1934, she had finally come to terms with the sad fact of life that it was officially over between Eddie and herself.

### ETHEL WATERS, HUBBY SEPARATE
#### Blues Queen Sings "Eddie Doesn't Live Here Anymore"

So read the headline in the April 7 edition of the *Pittsburgh Courier*. "It was the right thing to do," she said, "but I guess every woman

knows that breaking up a marriage is never anything to celebrate. It is the toughest of all good-byes, even when your man is a louse. You have put in years trying hard to make your marriage work. When it fails, you, the wife, are the loser. I knew all this then, but it had become simply impossible to go on."

Harold Gumm informed the press of the couple's separation. Also revealed was a little-known fact about the two: they had not married before the trip to Europe as everyone had generally assumed, and as Ethel had led the public to believe, even though she had never issued a public statement. Instead the marriage had not taken place until *Rhapsody in Black* was touring Chicago in 1931. Indeed, Waters and Matthews had been living "in sin." None of this seemed to bother Ethel—this very religious, seemingly devout woman, who still lived according to her own rules and her personal standard of morality. As with Dancer, Ethel would not look back on her relationship with Eddie, nor would she reconsider her decision. But her feelings may have run deeper. In later years, she would confess having loved "Pretty Eddie" more than the others. Yet no one was certain if the "Pretty Eddie" she referred to was Matthews or another Eddie who would soon come into her life.

The Negro press cornered Dancer for a comment about the breakup. Then living in California where he managed the career of dancer Jeni Le Gon and where he sought work at the studios, Dancer said that he "knew all the time the match wouldn't hold out." He also tried to appear diplomatic. Ethel was "a fine girl," he said. "I like Eddie. He is a fine chap. Just didn't figure they'd last long together."

Her marriage hadn't worked out. Neither had her hopes for motherhood, but Ethel had not given up the idea. By now, she had begun "adopting" other children. It must have surprised her friends. But Ethel appeared to see herself as something of an earth mother, there to care for the unwanted or those in need of special attention and love. Her apartment on St. Nicholas Avenue was full of kids, at this time twelve, whom Ethel helped support and looked after—or rather had her staff look after. Some children stayed overnight at her apartment. Others went home at the end of the day. Always Ethel was in contact with the parents, some of whom would be in and out of the apartment, most of whom were thrilled that

such a big star had taken an interest in the welfare of their little ones. Three children actually lived with her and they all called her "Mom." Singer Etta Moten recalled that during a visit to Waters' "sumptuous seven room apartment," the children were all over the place, in and out of one room or another, making requests, asking questions, playing games, and clearly vying for Ethel's attention. After a light breakfast, Moten recalled that she and Ethel had gone into "the large Venetian blinded . . . [tastefully] furnished living room. Scarcely had we been seated ere a lovely little two and a half year old baby girl came into the room and without a word except a clear hello to me, climbed up into Ethel's lap. She settled her little brown head upon her 'Mommie's' bosom and very soon her measured breathing told us that she was asleep. This was Marlene, one of the many god-children." Shortly afterward other children "came in at ten minute intervals, to bring a message, make a request, or to thank 'Mommie' for some favor which had been granted." That day, one nine-year-old ran up to Ethel and asked, "Mommie, Mother and Dad want to know if I'm going to camp this year." "Yes, both you and your sister," Ethel told the girl. "Another wanted to know how to adjust the General Electric ice box," said Moten, "which Mommie had had moved into her home. There was a pile of clothing and a trunk to be packed, Ethel explaining by saying they were clothes and toys which she was sending to a half brother who had a family of six." By taking in children in need of a stable, comfortable, loving environment, often it looked as if she were desperately trying to relive her own childhood, to make things turn out differently, not only for the children but herself as well.

In some respects, it had to have been madness for Eddie Matthews. Perhaps he could tolerate one child or two or even three. But twelve children—and the prospect of more to come—was another factor that had to have damaged an already frayed marriage. And, of course, Eddie realized that despite Ethel's protestations of wanting to be a good wife and do all she could to please her husband, there really was no way to talk to her, to have a conversation about what would work for the two of them.

Ethel herself could preside over it all with a queenly air. There was Bessie Whitman to clean up after the children. A new secretary, Laura Baxter, would also help out. So would Pearl Wright and other friends and

young women who were often at the apartment. Still, her home had to have been something of a three-ring circus.

ONCE THE MARRIAGE and her radio show ended, she seemed, as always, restless, unable to sit still or relax. Always she craved movement, as if she needed a round of activities so she would not have time to think or reflect—as if she still needed such activities to convince herself that she was on her way somewhere, that she was still climbing some ladder. Even now, she didn't appear to accept the fact that she was indeed a huge star, bigger than any Black woman in America before her. Baker had triumphed in Europe, and Waters understood that it was not the kind of success that could be taken lightly. But she had made it in the United States. She liked the fact that she had, yet she believed there was still more to do.

Her participation in well-publicized events, most for charity, continued full-force. In early May, as "the premiere singing actress of the Race," she was the honored guest at the year-old $1 million YMCA on West 135th Street. The new building, which had been funded by John D. Rockefeller, became a significant cultural center in Harlem for years to come.

That same month, she participated in one of the year's most ambitious and significant series of fundraising events. In desperate need of money for its National Defense Fund, which offered legal counsel to Black Americans and waged court battles against discriminatory practices around the country, the NAACP joined forces with the *Pittsburgh Courier* to stage benefits in several cities. Enlisted to perform at the events were major Black stars, who would travel to New York, Pittsburgh, Philadelphia, Cleveland, Columbus, Chicago, St. Louis, and Los Angeles. For a Black fundraiser, few events, if any, of this magnitude on the national scene had ever before been organized. Engineering this campaign was Maurice Dancer, whose weekly columns on the entertainment scene now appeared in the *Courier*. In the lineup of stars in support of the NAACP-*Pittsburgh Courier* fundraiser were some of the major names in Negro entertainment: Bill Robinson, Fats Waller, Andy Razaf, Aida Ward, Ada Brown, Lucky Millinder, Jimmie Lunceford, W. C. Handy, Etta Moten, the dazzling young Nicholas Brothers, and Ethel. The theme song for the

galas would be a new number by J. C. Johnson titled "Little Black Boy."

At the kick-off gala at New York's Apollo Theatre on West 125th in late May, Harlem had rarely seen a night as splashy and glamorous as this. Stepin Fetchit flew in from California. Cab Calloway, who had been in Philadelphia and who originally had planned to perform alone, ended up arriving at the Apollo with his entire orchestra. Over sixteen hundred people—paying tickets priced at 50 cents, 75 cents, and $1—jammed the theater and lined the street, waiting to enter. Onlookers also stood outside, hoping to see the celebrities. There was such a crush that the police were called in to control the excited crowd. Finally, traffic came to a halt on West 125th Street.

Backstage, stars greeted one another, as caught up as the adoring fans in seeing another famous face. Onstage one entertainer after another performed at a high level, aware of the competition and determined not to be overshadowed. But no one was quite prepared for Ethel. She had arrived early at the Apollo, perhaps to best prepare herself emotionally. But as she stepped onstage, it was almost as if she were the only star of the evening. The crowd gave her a thunderous greeting. Then all turned eerily quiet as she performed the theme song "Little Black Boy." Waters "acted" the song and performed it—just as she done with "Eli Eli"—with a depth of emotion usually associated only with the old Negro spirituals. Many that night were moved to tears. "The response of the audience should convince Miss Waters of her stupendous popularity," wrote the *Pittsburgh Courier*. "The vociferous applause that greeted her entrance, the cries for 'more,' 'more' that followed her rendition of 'Little Black Boy' should confirm the oft-told story that Ethel is our greatest woman star and she is sincerely loved and honored by her people." Her encore was "Stormy Weather." The crowd again went wild.

Her next stop for the National Defense Fund campaign—on June 17, a Sunday night when there was no performance of *As Thousands Cheer*— was the Nixon Theatre in Pittsburgh where she was again joined by other stars. Accompanying Ethel to Pittsburgh was Pearl Wright, who also now acted as one of Ethel's secretaries, and the young trumpet player Eddie Mallory. No one seemed to know much about Mallory, why he was a part of Waters' entourage, or if perhaps he would soon be working with Ethel

on a forthcoming recording. But his presence nonetheless was noted. Already there were whispers.

Upon her arrival at the theater, Ethel was besieged by "a seemingly endless troop of autograph hounds [who] file[d] in and out of her dressing room." Everything about her was now being discussed, from the clothes she wore, to her makeup, to her hairstyles, to the light chatter she might have with an adoring fan. In the past, stars like Bessie Smith and Ma Rainey had been pursued, discussed, and adored, but nothing compared to the response to Waters. That maddening excitement of seeing the recording star *in person* had now intensified to a fever pitch—to an unprecedented level for an African American performer. For days, weeks, and months, she was all that anyone who had actually seen her could talk about.

But after the next stop in Philadelphia, the fundraising tour became embroiled in controversy and then scandal. Suddenly, events coordinator Maurice Dancer was arrested in New York and charged with embezzlement amid angry accusations that proceeds for the Defense Fund had been mismanaged. Funds were missing and had to be accounted for. Had Dancer walked off with the money? The whole messy business was recorded in the Negro press. Defending himself, Dancer publicly explained precisely what the expenses for the fundraisers had been. He detailed the cost to use the Nixon Theatre in Pittsburgh and also the travel costs to bring in entertainers. As was true of such other charitable events, sometimes the expenses canceled out huge profits for the charity. But what surprised many were details pertaining to Ethel, who it had been assumed had donated her services. In one respect, she had. In another, she hadn't. Through Pearl Wright, Ethel had insisted on being paid $250 for the evening in Pittsburgh, in addition to her expenses, which included three train tickets and drawing room accommodations for Waters, Pearl Wright, and that mystery man, trumpeter Eddie Mallory. The total paid her was $400. When the fundraiser had moved to Philadelphia, Waters, through Pearl, again insisted on payment. In desperation, Dancer had explained to Wright that the Philadelphia theater was smaller, and he simply couldn't shell out much money. But Pearl insisted on a payment of $400. Because the benefit was already heavily publicized, Dancer knew he couldn't cancel Waters' appearance. At one point, he stood by the box

office, watching patrons pay. Once the box office tally went to $250, he literally took the money and rushed with it to Pearl Wright.

After Dancer informed the press of Miss Waters' demands, her fellow entertainers were outraged. Bill Robinson hit the roof. Robinson had actually driven to Philadelphia with family and friends in his Duesenberg. He hadn't charged a dime, nor had anyone else as far as he knew. Expenses were one thing, but an actual payment was another. Robinson had never liked Ethel, apparently from the moment he met her. Call it professional jealousy, but he had gotten to the point where he loathed even being in her presence and was said to have trained his dog to growl whenever Ethel was near. Needless to say, none of this was good publicity. But as far as anyone knew, the queenly Ethel was unfazed. If anything angered her, it was most likely the fact that people seemed upset by her demands.

DURING THIS PERIOD, the fundraiser incident was one of the few instances when she received bad press, but another occurred once the short film *Rufus Jones for President* played theaters. Despite Ethel's enthusiasm for the film, the end results, in many respects, proved disappointing, not because of her work but because of the images. On the one hand, the movie provided glowing pleasures. In his dance sequence, little Sammy Davis Jr. was a whirling marvel as he tapped his way to glory. Precocious is hardly a strong enough word to describe this kid with so much talent. Ethel herself seemed above the film's misconceived highjinks. Dressed in a long white gown and maintaining her poise, she sang "Am I Blue?" and "Underneath a Harlem Moon." Then and especially in the years to come, the iconic sequence occurred when Ethel held Davis on her lap and rocked him to sleep. But that was not enough to stop the criticism of the short film. Partly a fantasy about a little boy (Sammy Davis Jr.) who dreams of becoming president of the United States, *Rufus Jones for President* was at times a shocking display of racist imagery—with its talk about pork chops, watermelons, and razors and its depiction of rigidly stereotyped dice-rolling Black characters. During little Rufus' presidential campaign, a placard read:

Vote Here for Rufus Jones
Two Pork Chops Every Time You Vote

There was also a covert message even in this fantasy about a child's aspirations. Ethel tells little Sammy: "The book says anybody born here can be president." But she also warns him: "Stay on your own side of the fence. Don't cross the line. . . . And no harm will come to you." Even in a fantasy, African Americans were being reminded of their place in American society.

African American columnist Ralph Matthews, who in most respects was an adoring fan, questioned Ethel's professional choices, in general and in particular, in accepting the role in *Rufus Jones for President*. In an open letter to Ethel in the *Baltimore Afro-American*, Matthews stated his objection to "the subtle implication in the song 'Stay on Your Own Side of the Fence.' That seemed to propagate the ugly desire of the whites who want us to accept Jim Crow and segregation without a squawk." He also wrote, "The scene showing the Congressmen and Senators shooting craps and checking their razors outside the Senate chamber might have been good satire if it were not for the fact that this caters too much to the diabolical belief of the cracker that Black folk never rise above the primitive." His concluding remarks attacked the very direction in which Ethel had taken her career.

Now that you are singing on the radio and appearing in "As Thousands Cheer" and are making movies, primarily intended for white houses, I can see how you can ignore, after a fashion, what colored folks think about you. Now your dollars are all white dollars and white people have queer appetites where their colored entertainers are concerned. You are trying to please that appetite. . . . As one who is anxious that you always remain our most "beloved" darling of the stage, a true successor to Black Patti, Aida Walker, and Florence Mills, as a favor to me, won't you exercise a little more care in your selection of vehicles and songs? It makes me sore to hear people saying mean things about you; I don't like it.

Matthews' comments must have stung her in the most personal way. Now her work was being dissected—as well as her decision to perform it on the white time. Her other short, *Bubbling Over*, had similar disturbing images: a lazy husband; rowdy, triflin' in-laws; a shyster swami. How could so "modern" and forward-looking an entertainer as Ethel, a woman who represented a new era, have made such appalling and racially offensive choices? By now, discussions and debates had been ignited within the African American community about movie images. No longer should Black Americans simply be satisfied that Black actors and actresses were finally getting film work and becoming known to the large movie audience. Now those performers should think of the distortions inherent in those roles, most of which were dimwitted comic servant characters; of the harm those images did to Black America's self-image—and also to the way in which Black Americans were being perceived by the larger culture. Ethel may have been too angry to seriously consider his comments because Matthews had dared to criticize her. But that would change.

# A Woman of the People, Back on Broadway

**D**URING THE SUMMER, replacements had to be brought in for stars Clifton Webb, Marilyn Miller, and Helen Broderick, who were out of *As Thousands Cheer* either because of vacations or because of illness. But Ethel the mighty remained, and in doing so, became the drawing card for the revue. Out-of-towners had heard so much about her performance and the power and poignancy of "Supper Time" that she was the star most theatergoers wanted to see. If she were to leave the show, was there any Negro female performer who could replace her, any as famous and as celebrated? Simply stated, no, there really was no one else who could do the role. Berlin knew it. So did Sam Harris. So did Moss Hart. When the musical closed in September 1934, Webb, Miller, and Broderick had all gone their separate ways. Miller's case was particularly sad: she died in 1936, at the age of thirty-eight, reportedly as a result of a brain infection after surgery for a sinus condition. According to theater gossip, however, the real cause of her death was syphilis, contracted from her reckless husband, Jack Pickford. Nonetheless, the decision was made to take *As Thousands Cheer* to such cities as Boston, Toronto, Detroit, and Chicago with Ethel as the major star. For a woman who had started in the show with below-the-title billing, that decision must have been sweet vindication. Briefly, Berlin and Hart also talked about doing a follow-up revue to their smash success, but it

never materialized. Traveling with her on tour would be Dorothy Stone in the Marilyn Miller role and such original cast members as Hamtree Harrington and Ethel's understudy, Maude Russell.

The tour was yet another whirlwind experience, a dizzying blur of cities, theaters, people. Everywhere she went, she was wined and dined, celebrated and adored. She glided through a steady round of teas, dinners, and parties, as fans, Black and white, eagerly sought to meet the Broadway star. Throughout, she traveled in high style in a custom-built roadster that always drew attention as she entered or stepped out of it.

When the company played Chicago, Ethel granted one of her "infrequent interviews" to the *Pittsburgh Courier*. As usual, she was guarded. Within the Black press, there was still outrage that her radio program *American Revue* had been canceled. Asked about the show, she answered that she enjoyed "broadcasting because it brings me close to people who cannot see me, but I really prefer appearing before an audience." But when pressed for a statement about the program's cancellation, she stated that contracts had not been renewed. "Of course, there isn't any doubt that in some sections my efforts were not appreciated, but I do not care to comment upon that at this time." She then changed the subject. "I am enjoying my work in 'As Thousands Cheer' and now that we are on the road," she told the writer, "I feel that we will have the same success which we had in New York. Of course, I always hold optimistic beliefs, partly because I am a Catholic and partly because I subscribe to the ideas which 'unity' teaches. I am proud of the fact that I am trying to do my best and I hope that my own people will appreciate my efforts."

In the interview, she expressed some personal opinions. "There are many things which the public does not know about me. I boast of being a good housekeeper and love children and dumb animals. Women smoking does not interest me. I like to see women smoking if they can smoke. For myself, I abide by health rules, at least to a certain extent." Why she discussed the topic of women smoking was anyone's guess. Perhaps she had grown annoyed with some woman or other in her life who smoked. She also commented on Black theater productions. "They are all right if they get the right sort of backer. 'The Green Pastures' is still going good. I am not prepared to comment upon the merits of 'Green Pastures,' however,

because I have opinions of my own and what I say might be misconstrued if I made a statement favorable or unfavorable. A person in my position can't talk too much." With that comment, Ethel "smilingly dismiss[ed] the interviewer."

There was another comment that readers may not have given much thought to, yet it expressed a career goal that had been on her mind for some time. "Of course, people only think of me as one who can be funny, but actually, I want to prove to the world some day, that I can become a tragedienne." Ethel had once stated she wanted to play Sister Scarlett. That hadn't happened, but she still hoped somehow to perform a dramatic role. Was she also suggesting that she had tired of her singing career?

BY OCTOBER, when she arrived in Detroit, high Negro society eagerly sought her out. She was also now a "guest in fashionable white society parties and written up in the society pages." "Happiness was heavy in her eyes as she waved to those who welcomed her, the hand she waved sparkling with many large and expensive jewels," reported the *Detroit News*. So much a style maven had she become that the Negro press, more than ever, reported on what she wore. When nearly four hundred guests greeted her at an informal tea given by a local club, the readers of the *Courier* were informed that "Miss Waters was attractively gowned in black. Her dress was cut with beige neckline in front and low in the back; with this she wore a chic black hat and waist length pointed fox cape. A shoulder bouquet of gardenias presented [to her] was her only accessory."

On another occasion, she seemed to be glowing, perhaps more than ever, as the guest of honor at an after-theater party at the home of a Mr. and Mrs. B. Mitchell. Her most significant accessory that evening was Eddie Mallory, the trumpeter who had accompanied her on that fundraising trip to Pittsburgh. Mr. Mitchell, it turned out, was Eddie's cousin. Eddie's brother, Frank, was also at the party. Ethel was in seventh heaven with two dashing young men by her side, especially Eddie. Could the suave and sexy Mallory, known to be a favorite of the ladies, be the new man in Ethel's life, even though she was not yet divorced

from the other Eddie, Mr. Matthews? No one could say for sure. And no one was asking Ethel. But the gossip had started.

Mallory was born in Jacksonville, Illinois, and grew up in Chicago. An accomplished and serious musician, he had studied at Chicago's Conservatory of Music and New York's Juilliard School of Music. Eddie began performing in Chicago clubs and theaters with a band called the Alabamians. Playing saxophone as well as trumpet, he was also a talented arranger. After four years, Mallory left the Alabamians to work with bandleader Tiny Parham. Briefly, he took control of Parham's band but soon moved to New York, where he performed with Benny Carter, the Arcadians, and the Mills Blue Rhythm Band. Mallory was playing with this latter band at the Cotton Club during the 1933 season when he and Ethel first met—"while she was singing 'Stormy Weather,'" according to the press. Ethel was hooked. She apparently had helped him secure a job as a musician on *As Thousands Cheer*.

Unlike Matthews, Eddie Mallory understood and liked show business, the comings and goings, the audiences, the backstage intrigues, the camaraderie of the band members, the sights and sounds of the towns and cities where he performed. He also liked the girls. In Chicago, Mallory had married a young dancer named Florence Hill in 1930. The couple had a son, John, but after Eddie moved to New York and became well-connected, he appeared to have forgotten all about Mrs. Eddie Mallory. For a spell, Hill joined him in New York, where she appeared in various shows. But the marriage was over—at least as far as Eddie was concerned. Women flocked around him as they had always done. They liked looking at him. Eddie could understand that because he apparently liked looking at himself, too. Solidly built, muscular but trim, with a broad forehead, penetrating eyes, a seductive smile, and a rakish mustache, he was athletic and worked hard to stay in shape. His interests were varied. An ardent amateur photographer, he made his own home movies. He was a golfer, too. In other respects, he fit the profile of the kind of man Ethel gravitated to. Mallory was a sharp dresser, a smooth talker, fairly sophisticated, and given to smoking a pipe. Around town, he was known as "Pretty Boy Eddie," or just "Pretty Eddie." Eddie Matthews had also sometimes been

called "Pretty Eddie," but the name seemed more appropriate to Mallory, as much because of his manner as his looks. Mallory looked like he might have been the ideal well-spoken, middle-class hero for one of Oscar Micheaux's race movies had Micheaux not favored lighter actors for his leads. Mallory was hardly a high-yaller fellow. Instead he had a rich brown complexion, which for Ethel was just right.

Ambitious, aggressive, at times calculating, determined to make it to the upper echelons of show business—and have a good time along the way—Mallory was impressed by Ethel. When she took an interest in him, he was excited, never having seen a Negro woman with such stature and allure. Her entourage always hovered about as people stood waiting to cater to her every whim. Around the country, women now emulated her, noticed her clothes, her jewelry, her movements. Men looked her over. Crowds turned out for her performances. And now this very woman was beckoning him to become a part of her world, was having arrangements made so that he could travel with her, was eager to meet his family and friends, was clearly delighted in having him by her side when she entered a theater or attended some benefit or gathering. Like others, he had to have heard the rumors about her interest in women. But that was a minor matter. This kind of woman obviously went more than one way.

Mallory was similar to Matthews in one respect, however: he was in a bit over his head. But with show business running through his veins, Mallory felt confident he could handle it all. Yet no one could ever be prepared for Ethel: even as shrewd a show business pro as Earl Dancer could have told Eddie Mallory that. Of course, Mallory would never have listened. He was fortunate in one crucial respect: he was talented and never would be considered just a hanger-on. No one was quite sure when he was born. Some accounts said it was 1907; others placed his birth year in 1905; still others in 1902. Regardless, everyone knew he was younger than Ethel. People seeing the two together also noted something else. Although Eddie stood five feet nine and a half inches, Ethel looked taller. Because of her height, she usually preferred flats or low-heeled shoes, now more so than ever when she made an appearance with Eddie by her side. As could be expected, Ethel stayed mum on the subject of Mallory, but it was apparent they were a couple.

\* \* \*

BY NOVEMBER 1934, Ethel returned to Chicago where *As Thousands Cheer* opened at the Grand Opera House in the Loop. Stopping the show night after night, she was proclaimed "the one artistic genius" in the whole production. The bad press she had received for the Defense Fund events didn't deter her from continuing her charity work. On Thanksgiving morning, she appeared at one of the city's benefits to aid the needy. On another occasion, hundreds of people—Black and white—rushed to see her at a charity ball for Local 444 of the Cooks, Waiters, Bartenders, and Waitresses Union. So what if this was not one of those splashy, hoity-toity, star-studded charitable events? Proving herself to be a woman of the people, she crowned the "Queen of Waitresses" at the event and performed "Moon Glow" and "Stormy Weather." On December 14, she appeared at the *Chicago Defender*'s midnight Christmas Basket Fund drive at the Regal Theatre. Ethel, wearing a fashionable cloche hat, was photographed smiling flirtatiously at Chicago's mayor, Edward J. Kelly, as she sold him tickets to the event. Still able to quickly read a person, to figure out what someone had on his or her mind, especially when it pertained to sexual interests, perhaps she detected something in the way the esteemed mayor looked at her—and was simply knowingly smiling back. Over three thousand people turned out to see her at the Christmas Basket drive. All these activities were part of her ongoing role as Ethel Waters, Race Woman. But it didn't stop there. In an article for the December 15 edition of the *Chicago Defender*, she urged Chicagoans to see the play *Stevedore*, a searing social drama focusing on a nation's racism and its terrifying lynchings that had previously opened in New York and was now playing in Chicago. "One of the most thrilling plays I have ever witnessed," she wrote. "It is a smashing indictment of racial persecution. It makes its audiences understand the 'Negro problem,' the lives and troubles of Colored workers in the South."

AS THE TOUR CONTINUED, backstage nothing was calm and ordered. Her understudy Maude Russell gave notice that she would leave the pro-

duction following its run in Washington, D.C. Always publicly respectful of Waters, Russell sometimes privately bristled at even hearing her name. She'd seen enough of the tirades, the pettiness, the constant need for attention, and the chaos. Curiously, Ethel would always have some cast members who became her allies. Usually, these were performers whom Ethel was pleasant to and had shown kindness and concern. The entertainers Avis Andrews and Eloise Uggams, both relatives of future singer Leslie Uggams, always adored Ethel. But Ethel was still Ethel—still easily rattled and upset by minor infractions, still making demands, still barking out orders with an onslaught of profanity. Russell felt that, yes, Waters had had a tough childhood, but you couldn't carry that around with you all your life. Wasn't it time she got over it? Russell joined her husband, George Bynum, in Chicago, and Monette Moore was hired to replace her.

The show was about to embark on a tour of the South: Birmingham, Louisville, Little Rock, Nashville, Memphis, Knoxville, and Chattanooga were all on the schedule. The codes and restrictions of the South were nothing new to Ethel, but now she was traveling as the star of a white revue booked into theaters with audiences that rarely saw an integrated production, or at least this type of integrated production. Past presentations might have Negro actors in bit parts as maids or butlers but not as leads performing in scenes with white entertainers. Aware that taking Ethel to the South in this production was a daring venture, producer Sam Harris and his staff prided themselves on this move, which was indeed groundbreaking. But they were realists. Precautions had to be taken not just to appease white Southerners but ensure that they showed up and the theaters themselves weren't burned down.

Consequently, Ethel's scenes were reworked and restaged. The "Supper Time" sequence was no problem. But her "Harlem on My Mind" sketch, in which she had been surrounded by whites, now had her with Black cast members. The "To Be or Not to Be" number would be Ethel and Black performer Hamtree Harrington. "Heat Wave" was now a colored sequence. In various cities, the Southern press would be informed that Ethel would not appear in scenes with white stars. Too realistic to be surprised or even openly annoyed by the changes, Ethel rehearsed the changes and kept in mind the importance of playing such theaters in the South, break-

ing down some barriers. At some theaters, there might be occasions when Black theatergoers, eager to see their "Queen," would find themselves relegated to the balcony or not even admitted to the performance. That was another reality Ethel was aware of.

In the South, it would also be out of the question for her to stay at the big hotels. Instead special accommodations had to be made for Waters, Hamtree Harrington, and the other Negro cast members. This was nothing new for Ethel, who was accustomed to staying at Negro boardinghouses or at the homes of "friends." Now it was worked out for her to reside at the dwellings of prominent African Americans in the different cities—Black doctors, attorneys, ministers, or schoolteachers, members of the Black bourgeoisie, the dictys. Ethel didn't care about that either. But it was still an embarrassment that the white entertainers who had replaced Webb, Miller, and Broderick, none of whom was as big a name as she was, could walk into any hotel in the land without a word being said. Negro stars like Marian Anderson, Bill Robinson, Billie Holiday, Katherine Dunham, and scores of others were confronted with the same dilemma. On the surface, Ethel might have appeared to grin and bear it, but inside she never did. Even so, she still preferred to be among her "people," and she was flattered at the attention that those doctors, attorneys, ministers, and schoolteachers lavished on her; she was impressed and delighted to see the beautiful, well-run, and well-kept homes in which they lived and the extraordinary meals they prepared for her and the fancy gatherings they planned in her honor. These special occasions she would not forget.

But the segregated theaters and the whites-only hotels were not forgotten either. She seemed to have compiled a list of resentments or grudges about the white world, but that list brought out the contradictory sides of her personality. Her religion taught her to forgive, to be tolerant, understanding, and loving—but there was no way she could love the people who treated her in such a way. "She was a unique combination of old religiosity and free-floating hatred, always ready to overflow," said director Elia Kazan. For decades to come, especially during the 1950s and 1960s, when Las Vegas emerged as a major entertainment venue, Black stars such as Lena Horne, Nat "King" Cole, Sammy Davis Jr., and Dorothy Dan-

dridge would be signed to play at the important hotels and casinos, but they would not be permitted to stay there. Vegas was described by many as a racist town. Consequently, the audiences were almost exclusively white for many years. Even in sophisticated New York, the entertainment capital, there were nightclubs and restaurants with whites-only policies. For Ethel, as for other Black stars, there was an ironic dichotomy. Onstage, she was clearly a great talent, an entertainment goddess, celebrated by white audiences with deafening applause and adoration. But offstage, it was still back doors, side entrances, and, in the South, being relegated to the colored part of town. Surely, the source of some of those outbursts and explosions at the theaters had to be her anger at her treatment and her frustration at not being able to change the situation.

STAYING AT THE HOMES of prominent Black Americans, however, presented a different kind of problem for Ethel since she was traveling with Mallory. Producer Sam Harris no doubt just assumed the two had married, although he must have wondered when, precisely, the divorce from Matthews had been granted. Attorney Harold Gumm had learned not to question such matters, at least not openly. But Gumm understood that any prying questions of the press and the public had to be kept at bay. The press was already identifying Eddie Mallory as her husband, just as it had done with Eddie Matthews and Earl Dancer. When someone asked, "Who's the good-looking guy with Waters?" there must have been sly smiles and smirks in some circles when the answer came back: "He's the new husband."

AS THE TOUR MOVED into the South, new indignities were imposed on Waters. In March, when she played Knoxville's Elis Auditorium, the manager, Colonel Charles A. McElravy, informed the press that he had consulted with "locals" to learn if they wanted to see the show with Ethel. None objected, especially after he informed them that none "of the white actors or actresses will even be on the stage when Ethel is performing. Hence, there could be no objection on the ground that she is working

with the white players." Instead she will do "her famous specialties assisted only by Hamtree Harrington, another dusky performer." The show went on. The audience loved her.

In Memphis, another problem reared its head, one that was not necessarily unexpected. Of the more than eight hundred seats in the gallery section of the theater where *As Thousands Cheer* was booked, only two hundred and fifty were allotted to Negro patrons. But far more blacks arrived at the theater. Though there were vacant seats in the balcony, the Black patrons were not permitted to take them. Some theatergoers were told to stand in the doorway. Others were allowed to sit in seats that were brought up from the basement. Others sat on the stairs. The message was clear. No Black theatergoer would be seated next to a white one. Just going to see a star like Ethel could be a humiliating experience. But she was such a beloved star that Black patrons put up with the indignities.

For Ethel, the worst leg of the tour was at the Tivoli Theatre in Chattanooga. Upon her arrival, a member of the Black press informed both Ethel and Hamtree Harrington that Black theatergoers would not be seated in any part of the Tivoli Theatre. The same thing had happened when *The Green Pastures* had played the theater only a few weeks earlier. "Ridiculous," said Harrington. "Tragical," said Ethel. There had been similar problems, she told a reporter, seating Black patrons at a theater in Washington, D.C. Exasperated and frustrated, Ethel explained that the play had been changed in order not to upset white theatergoers. This statement was the closest she came to publicly revealing her anger. But when asked what she'd do about the situation, she explained that she could do nothing, "inasmuch as the local theatre management had full charge of the ticket selling and seating." She added, however, that she wanted to return to the city in her own production for race audiences. Later generations might question why she did not simply refuse to go onstage. But contractually, as she told the press, she was obligated to perform. In some Southern cities, she socialized even more with members of the Black community, attending parties and receptions in her honor, as if this might in some way show that she understood and respected them.

\*   \*   \*

BY APRIL, the tour carried her to Los Angeles. As she stepped off the train at the station, a band and a jubilant crowd was there to greet her. There was an official welcoming committee consisting of entertainers as well as prominent members of Los Angeles' Black community, some of whom were present, others in absentia: Bill Robinson, Stepin Fetchit, Fats Waller, editor-publisher of the *California Eagle* Charlotta Bass, Etta Moten, actor Clarence Muse, and the drum corps of the American Veterans of Foreign Wars. Afterward, when *As Thousands Cheer* opened at the Biltmore Theatre, it was another smash success.

Though the city had Negro hotels, such as the Clark and the posh Dunbar, where entertainers like Ellington and Armstrong stayed, she took up residence at the home of the Reverend L. B. Brown, the father of three daughters who entertained under the name of the Brown Sisters. Cute and lively, the trio was popular on the West Coast. Ethel took them under her wing, serving as their mentor. For the next few years, she did much to help the sisters secure new bookings. Ethel saw "promise" in them, recalled Etta Moten, and later "introduced them to the New York public— and whenever an opportunity. . . . [arose] . . . helped them get work." The girls were soon "on the Waters payroll."

Waters relished Los Angeles' social life, where one party after another was planned for her. An all-get-out glamorous bash was held at the Club Araby, a Black nightclub. A very grand, elaborate affair was arranged at the Elks Auditorium. For Ethel, there was again LA's golden sunshine, its open spaces, its blue sky, and of course, those magnificent movie studios. As in the past, she was still considered a deluxe item from the East. In the large audiences that turned out to see her in *As Thousands Cheer*, there were not only the local folks but also the moneyed socialites of Los Angeles and the Hollywood hot-shots. As scores of people came to her dressing room to congratulate her on her performance, she realized this was a prime opportunity not only to meet many of those movie stars she had seen on the screen but also to be introduced to directors and producers. Maybe she could get some movie work. Warner Bros.—where she had made *On with the Show*—expressed some interest. But nothing developed.

But while in Los Angeles, another matter was on her mind, perhaps a golden opportunity in the East. Gumm had informed her of plans for a new

Broadway revue, another white musical, eventually to be called *At Home Abroad*, in which the producers—the all-powerful Shubert brothers—wanted to include Ethel. If all fell into place, she could be back on the Great White Way by the fall. It was what she needed, another important show that would cement her position as a Broadway star. Trusting Gumm to work everything out, she knew no announcement could be made until every detail was in place. In show business, it could be a kiss of death to speak too soon. If she went into the show, rehearsals would begin in New York in July. In the meantime, she had to fulfill her other commitments.

Ethel also received reports about the formation of an organization in which she took great interest. In New York, a group of leading Black performers had decried the lack of opportunities for African Americans in entertainment, primarily in theater but also films. The few parts offered to Negroes remained those stereotyped maids and butlers—bit parts with quick entrances and exits. Someone had to speak up for the Negro performer. There had to be a united front to fight for more significant roles and more significant African American productions. As the most successful African American female performer in the nation, Ethel was asked to support the establishment of the group, to be called the Negro Actors Guild. A charter had to be written. Incorporation was necessary, as well as additional support. As everything was starting to fall into place, Ethel joined others in launching the new organization.

IN LATE APRIL, *As Thousands Cheer* moved to San Francisco. Then came Denver. By early June, she arrived in Chicago for two back-to-back engagements. The first engagement was for the week of June 7. She appeared at the Chicago Theatre in the Loop, performing numbers from the Berlin revue with cast members from *As Thousands Cheer* but also adding new material, including Cole Porter's "Miss Otis Regrets," which she had recorded almost two years earlier, on August 20, 1934. It was just the type of dramatic narrative Ethel liked best. The song tells the story of a well-to-do woman who has murdered her lover and thereafter finds a lynching mob awaiting her. The song is narrated by the woman's maid. Waters' powers as an actress were again put to brilliant use.

Though Ella Fitzgerald and Mabel Mercer later recorded the song with great feeling and great phrasing, Waters set the stage, establishing two characters in the song, the maid and Miss Otis. At times, she might appear to overdo the pathos of the ballad—yet she never let herself slip into bathos, and she never lost track of the narrative line. Here again when it was essential that listeners understand the story, she had a total mastery of lyric and meaning. "Nobody else in this country, white or sepia, sings the run-of-the-mill song of the hour so painlessly and so persuasively," wrote Ashton Stevens, that critic who had hailed her years earlier and now again celebrated her in the pages of the *Chicago Evening America*. "There is no tin, of course, in Cole Porter's polite but terrific tragedy 'Miss Otis Regrets She's Unable to Lunch Today.' But cheap singers have put their own cheap price on this priceless ballad by jittering it and hot-jazzing it. It's just as well to have Miss Waters retract their libels. Her singing of it attests a great song worthy of a great songstress. 'Miss Otis Regrets' has been called Miss Waters' second lynching song. But I think it is her first. It is more indirectly poignant than her heartbreaking 'Supper Time.'"

DURING HER SECOND WEEK in Chicago, Ethel headlined a show at the Black Regal Theatre. She took home $3,500 a week. Of course, she had matinees and late shows, but she still earned top dollar. Despite a rain storm on opening night, she packed the house. She again performed some numbers from *As Thousands Cheer*, as well as "Miss Otis Regrets." She also danced and did comedy routines, still revealing herself to be an all-around entertainer with skills that few others could match. Some stars could sing. Some could dance. Some were comediennes. But none could do it all—at least not with her bravura.

In Chicago, word came that negotiations had been worked out and an announcement was made: Ethel was to return to Broadway in *At Home Abroad*, with a salary of $1,000 a week. It wasn't what she was now pulling down, but she wouldn't have to carry the whole production. Nor would she have several shows a day. Her hopes high, an exultant Waters arrived with Mallory at the offices of the *Chicago Defender*. As photographs taken that day revealed, they were a great-looking couple. Splendidly

dressed in a tailored double-breasted suit, Mallory held his pipe in his hand, smiled graciously, and behaved like the perfect consort that he was. Ethel was stylishly dressed. Yet there was one aspect about her appearance that may have surprised her fans—and which would clearly distress Ethel herself in the years to come. Ethel Waters, the sexy Black goddess who had once sung those naughty songs and who still was considered a hot mama, looked heavier and rather matronly. Not huge. Not fat. Just heavier. There was no way she could appear in *At Home Abroad* without doing something about her weight. When she stepped onto the scale, she weighed 217 pounds.

SHORTLY AFTERWARD, she was back in New York, where she was set to appear at Harlem's Apollo Theatre. Despite the heat and humidity, she was relieved to resume her regular routine at the apartment on St. Nicholas. It was as chaotic as ever, with children in and out of the place, the usual hangers-on, and Mallory now trying to find his place in the scheme of things. Bessie Whitman still tended to Ethel's personal needs. Pearl and others could be relied upon to keep everything else in order. Every day some word or other came from Gumm or the Shubert organization about *At Home Abroad*: rehearsal schedules, costume fittings, publicity stills. Ethel attended to all that was required of her, but she also had to prepare herself for the Apollo.

Like the Cotton Club, the Apollo, located on West 125th Street, had become another Harlem entertainment landmark. The theater was built in 1914, but in 1934, Frank Schiffrin and Leo Brecher took over the theater to present major Black entertainers; Ellington, Bojangles, Bessie Smith, and Buck and Bubbles—and later stars like Nat "King" Cole and James Brown—all appeared there. The Apollo also became famous for its gorgeous chorus girls and its amateur nights, where unknowns like Ella Fitzgerald, Sarah Vaughan, and Billie Holiday introduced themselves to the world. Unlike the Cotton Club, however, the Apollo opened its doors to Black audiences. It could be a tough place because the Black audiences could be quite vocal if they didn't like what they saw. On the bill with Ethel were her protégées the Brown Sisters; comedian Pigmeat Markham;

Jimmy Baskett (who would later play Uncle Remus in Disney's *Song of the South*); the Apollo's MC, Ralph Cooper; and former child star Sunshine Sammy. Among the numbers Ethel would perform were her standards, as well as "Miss Otis Regrets." Since she hadn't played Harlem in almost three years, this engagement was special to her, yet she also considered it a fairly routine booking. Still, it was grueling work. There were sometimes five shows a day, and because the Apollo was not yet air-conditioned, the sweltering heat made some patrons restless and irritable. For Ethel, it was hard to be gowned and fully made up and then to perform her numbers with the temperature steadily rising outdoors and indoors. Before her entrance, Ralph Cooper made jokes and had the crowd laughing, perhaps getting them in a mood for a different type of performance. It is hard to say what went wrong, but the Apollo audience just didn't seem excited by Ethel's material.

Marvel Cooke wrote that the "incomparable" Waters had to contend with the Apollo's "whistling, wise-cracking, gum-snapping, foot-stomping audience . . . an audience which romps raucously with Ralph Cooper and returns his 'Hup' with a 'hup, hup, hup' . . . an audience which itself goes to the theatre to display its uncertain talents—not especially to enjoy the performance of others—to an audience which mistakes smut for art. In that audience Ethel shone like a jewel in a bucket of mud." Cooke believed the audience "was laughing in all the wrong places. During her serious interpretation of 'Miss Otis Regrets,' for instance, I heard many a snicker when Miss Otis was being lynched!" Cooke recalled that Ethel looked weary when she saw her offstage one evening, weary because of the audience's reaction. She had a loud altercation with Cooper, letting him know that some of his banter had to be toned down. But the real question on her mind was: Had she lost her touch? The Black audience had always been her barometer. They were the most appreciative audiences in the world if they liked you. Did they still prefer that she sing the old "dirty" songs? Was a new generation in search of a different kind of singer, a different kind of star? Was she now considered part of the established mainstream entertainment world? Between the nightly performances, Ethel retreated outside the theater where she sat in her luxurious Lincoln sedan, which was parked by the stage entrance. Friends and members of

the Negro press knew that's where they could find her if they wanted to chat. In the end, playing the Apollo was not one of her stellar engagements. And it may have led her to question what success on the white time was worth—if she was to lose her Black following.

MUCH WAS AT STAKE with *At Home Abroad*—for Ethel, for the revue's young director, and for the producers, Lee and J. J. Shubert. With what he envisioned as a prestige production with major stars, Lee Shubert believed he could further establish his brother and himself as producers of quality shows. With that in mind, he had already selected a relative newcomer, Vincente Minnelli, not only to design the costumes and sets for the musical but also to stage it.

Born Lester Anthony Minnelli in 1903 in Chicago, he had grown up in a bustling show business atmosphere. His parents had been performers in tent shows before leaving their careers behind to settle in Delaware, Ohio. Upon graduating from high school, young Les, as he was known, headed to Chicago. Sensitive, artistic, and burning with ambition, he took courses at Chicago's Art Institute. But mainly he learned on the job, at first as a fourth-assistant display artist at the Marshall Field Department Store, later as an assistant to the photographer Paul Stone, and then as the chief designer for the Balaban and Katz organization, which was Chicago's chief movie theater chain. By this time, he had also changed his first name, dropping the Lester and adopting his father's name, Vincente. In 1931, Minnelli moved to New York, where he had his first Broadway job designing for Earl Carroll's *Vanities*. Later came a major break when he was hired not only to conceive but to direct the elaborate stage shows at Radio City Music Hall. At this time, he got an offer from Lee Shubert to do a Broadway show.

Though wildly successful, both Lee and his brother J. J. were not yet taken seriously. "The Shuberts had started producing plays as far back as 1901, and they had great financial success in supplying the lowest common denominator to popular musical theater," said Minnelli. Having produced operettas and revues that often looked as if they had been thrown together without much creativity, the brothers "were a schlock

operation," said Minnelli, "the theater's bargain basement." Nor were the brothers particularly close. Often the two didn't even speak to one another. "Lee and Jake waged a love-hate relationship and had no personal dealings with each other." Nonetheless, they had reached an audience. "They flourished by never underestimating the gullibility of the public. The Shuberts hired the finest musicians for a show's opening, then after the reviews were in, replaced them with lowly scale performers. If they had a success with a production one season, they'd open a ragtag version the following year, run it for two weeks, and then ship out to the provinces as 'direct from Broadway.'" But now, said Minnelli, Lee Shubert, having already produced two top-flight productions, *The Ziegfeld Follies* of 1933 and *Life Begins at 8:40*, and having worked with such stars as Fannie Brice, Ray Bolger, and Bert Lahr and such composers as Ira Gershwin, Harold Arlen, and Yip Harburg, "wanted respectability." "I want to move on to quality shows," Shubert told Minnelli, "and I think you should be with us."

Minnelli's contract gave him total control over his show's content. "I would also have the authority to hire everyone connected with the venture, from crew to musicians to cast members." He then set about putting together a revue, the type of show that *As Thousands Cheer* had been and Depression theatergoers had enjoyed. It would hop from one sketch to another with music, plenty of costumes, and lots of scenery changes. "The concept was to do a geographical revue, a musical holiday trip through Europe, Africa, Japan, and the West Indies," said Minnelli. "Our original title was *Not in the Guidebook*, but it was soon changed to *At Home Abroad*."

Signed to create the score for *At Home Abroad* were Howard Dietz and Arthur Schwartz. In 1931, they had written the music for *The Band Wagon*, and during their career, they would be the authors of such classics as "Dancing in the Dark," "I Guess I'll Have to Change My Plan," and "By Myself." New York–born Dietz also served as director of advertising at MGM and later as a vice president in charge of publicity at the studio. Dietz would also write sketches for *At Home Abroad*, along with Marc Connelly, Dion Titheradge, and Raymond Knight.

Signed to star was comedienne Beatrice Lillie. Born in Toronto in

1894, she had first performed as part of a children's act with her two sisters. At fifteen, she sailed to England, where her career took off. Appearing in revues both in England and in the States, she had a reputation as being the funniest woman alive and was known for her trademark long cigarette holder, her close-cropped hair, her fezlike cap, her acerbic wit, and her association with Noël Coward. In 1920, she had married the future Sir Robert Peel, who died in 1934 at the age of thirty-six. Hence, she was known as Lady Peel, but she appeared not to take that title too seriously.

Much as Minnelli was always in awe of Lillie's talent, he wanted his revue to be new-style, innovative, and modern—to have an extra kick. During his Chicago years, he had been aware of that tall ebony singer-dancer-comedienne who was in and out of the city in any number of Negro productions and who had dazzled the critic Ashton Stevens. That same entertainer had also transformed *As Thousands Cheer* into precisely the kind of audience pleaser that he hoped *At Home Abroad* would be. She had changed the very concept of what a Negro woman could do on Broadway. Early on, Minnelli wanted Ethel in the show. So did Lee Shubert. Ethel realized this could be a major production. But like Minnelli, she was cautious about working for the Shuberts.

"We started rehearsing in July of 1935 and were scheduled to open almost three months later in New York," said Minnelli. The production's budget was an estimated $130,000. Tap dancer Eleanor Powell was signed for the show, as was ballet dancer Paul Haakon, Hoosier radio comic Herb Williams, British comedian Reginald Gardner, Eddie Foy Jr., the young dancer Vera Allen, and the African American group Six Spirits of Rhythm. Thomas Mitchell would direct the dialogue of the sketches. Minnelli would be credited with directing and staging the entire work. "Nobody told me I couldn't continue performing all my music hall roles," said Minnelli. "With the longer lead time, I convinced myself that I could direct, design costumes, decorate sets, and supervise the lighting."

*At Home Abroad* was another show that Ethel had to brace herself for. To break down racial barriers in yet another white Broadway production meant there would be familiar challenges, to put it politely. Again there

was discussion about the billing. Though she did not expect to be billed above Beatrice Lillie, this time around Ethel insisted that her name be above the title, like Lillie's. But Beatrice Lillie's representatives balked at the idea. Mock-ups of ads were sent back and forth in attempts to get approval from both sides, and in the end, though both names were above the title, Lillie's name was still slightly higher than Ethel's.

Again Ethel would have four songs to perform, though no one thought any of the numbers matched the quality of those in *As Thousands Cheer*. But Ethel went into rehearsals confident that she could make her magic work on the numbers, "A Thief in the Night" and "Steamboat Whistle." Another number, "Got a Bran' New Suit," to be performed late in the show, would feature Ethel singing while Eleanor Powell tap-danced. With the fourth, "Hottentot Potentate," which attempted to have some of the zing and heat of "Heat Wave," she would be accompanied by the Six Spirits of Rhythm. In the orchestra was Eddie Mallory on trumpet.

Beatrice Lillie was considered the show's top banana. "She was a huge star, and Bea, unconsciously I'm sure, assumed all her rightful prerogatives," recalled Vincente Minnelli. "Her career was at its height. Her every gesture onstage was hilarious. All she had to do was turn her profile or move a certain way or raise a finger." Minnelli remembered: "Offstage, Bea was not very talkative, and she was seldom funny. But she was wonderful company, and had an enormous number of friends." That number did not include Ethel. Though the two remained cordial, the theater community was abuzz with stories that the women had come to "loathe" one another.

Still, one thing was very much in Ethel's favor. Not for a minute did Minnelli ever undervalue her talent or her importance to *At Home Abroad*. Because of the times, the ways of the theater, and the racial attitudes in the nation itself, he understood she would not be considered a star quite in the ranks of Bea Lillie, but he also knew that no one could really compete with Ethel. Theatergoers might indeed leave the show thinking more about her performance than anyone else's, even if that was not always openly acknowledged. For Minnelli, who would always admire not only great talent but great star personas as well, Ethel possessed both. For one number, Minnelli designed an elaborate costume for

her with thick sparkling gold bands around her arms and neck, a striking blue gown, and an extravagant headdress. As over-the-top as the outfit was, Ethel, just as she had done with her costume for "Heat Wave," would know how to move in it, to bring the design itself to life. She would wear it. It would never wear her.

Minnelli, a pure colorist, as would be demonstrated later in his Hollywood musicals, understood the way the colors would play on Ethel's vibrant brown complexion. The costume might both eroticize and exoticize her, in a way similar to what her "Heat Wave" costume had done. But Ethel would bring the colors to life. Minnelli had a masterful understanding—or intuitive grasp—of the way that the skin tones of some Black women, especially those who knew how to move, as Ethel and Josephine Baker did, could intensify the colors and the textures and designs of the fabric. For Baker in the 1936 *Ziegfeld Follies*, he designed "a shimmering sari" for one number. For another, he created a dress of gold mesh. "With it Josephine wore a plum-colored ostrich cape," said Minnelli. "Critics may have complained that her thin, reedy voice didn't fill the theater, but none of them denied that her gorgeous figure did more than ample justice to the costumes." In some respects, he was ahead of Parisian designers of the 1970s like Hubert de Givenchy, Karl Lagerfeld, and most notably, Yves Saint Laurent, all of whom daringly used the Black model Mounia for colorful fantasies; they ended up stunning audiences, and in turn helped to revolutionize the fashion world. By the time Ethel took the stage in Minnelli's costumes, something else would have transpired: through controlled dieting, fasting, and exercise—that daily romp around the bridle path on horseback—that matronly looking woman in the photo in the *Chicago Defender* would have completely vanished. Somehow she was looking hot again. Ironically, *At Home Abroad* would mark the last of her sexy, goddessy performances.

Even as Minnelli worked with her, even as he saw her short temper and her suspiciousness, he must have envisioned a future in which the two would work together again. Of the men who would direct her, Minnelli and later Elia Kazan and Fred Zinnemann appeared to understand her best. Each took time with her and studied her to discover the best way of working with her. Some stars needed a tough hand, a disciplinarian direc-

tor who would bark out commands. Others needed a more sensitive approach. Despite her temper, Ethel fell into the latter category. Kazan said she had to be treated as if she were intelligent, which both he and Minnelli immediately recognized she was. And she seemed to need patience, despite the fact that she could be so unwilling to give it to others.

Minnelli also had to contend with the young Eleanor Powell. Hollywood had already beckoned. Powell had completed MGM's *Broadway Melody of 1936*, which, ironically, would open across the street from the theater where *At Home Abroad* would play, and she would return to the film capital to become a major dance star of the era in such films as *Born to Dance*, *Broadway Melody of 1938*, and *Lady Be Good*. At this point in her career, Powell felt her name should be above the title, but it was in smaller print. Powell also was angered at the way Lee Shubert treated her. Once she had completed *Broadway Melody of 1936*, an exhausted Powell— "For six weeks, I had no more than five hours sleep a night," she said— boarded the train from Los Angeles to head east. One hour after arriving in town, Shubert's people told her to report immediately to a rehearsal. No one cared how fatigued she was; no one consented to letting her have a day off. At that first rehearsal she worked fourteen hours straight. She was not happy about the situation.

She too had to take a backseat to Lillie. Aside from that, she realized that performing the "Got a Bran' New Suit" number with Ethel might prove daunting. She was not about to tangle with Waters. Ethel appeared to like the younger Powell, who, like herself, was relatively tall—five feet six inches—and whom she apparently never saw as a threat. Young women who looked up to Ethel, whom she could consider one of her "babies," would always appeal to her and bring out her more loving, gentle side. That may have been true of Powell. It certainly would be true of the very young Julie Harris in the years to come. Powell also seemed fairly relaxed and liberal about race. Geri Branton, the first wife of dancer Fayard Nicholas, recalled that in Hollywood in the 1940s, Powell invited the Nicholas Brothers and their young wives—Geri and Dorothy Dandridge—to her home, as did Gene Kelly and wife Betsy Blair. Generally, entertainment folks could be less concerned about race. But many still drew the line at socializing with Black performers.

After long rehearsals, Ethel returned to the apartment tired and no doubt irritable. The slightest thing could set her off. Bessie Whitman and Pearl knew her moods. Eddie Mallory was learning. Always finding it hard for her to leave the show behind, she prayed for guidance. Now with rehearsals consuming most of her time, she hit the bridle path in Central Park whenever possible, trying to ride out her anxieties. But little could really calm her. Her stomach problems flared up again.

The original plans to take *At Home Abroad* to Philadelphia for its tryout were scrapped. Now the musical would open in Boston on September 3 at the Shubert Theatre. Cast and crew traveled north. Minnelli knew the revue still could use more shaping and cutting. With thirty numbers to be performed, *At Home Abroad* ran over three hours. Heated disputes broke out between Minnelli and songwriters Dietz and Schwartz over the numbers "Death in the Afternoon" and "Lady with the Tap," which Dietz felt were not up to par. He wanted them dropped from the show. But Minnelli insisted on keeping the songs. In the end, he was proven right because they were among the revue's biggest hits. Ethel's material remained intact. Though the Boston critics felt the show still needed work, *At Home Abroad* looked destined to be a hit.

On September 19, 1935, *At Home Abroad* opened at Broadway's Winter Garden Theatre. In this musical travelogue, Lillie's numbers took her to London, Paris, the Swiss Alps—where she out-yodeled everyone onstage—and Japan, where she impersonated a geisha. The settings for Ethel's numbers were such places as the British West Indies, where she performed "The Steamboat Whistle," and the Congo, where as a character called the Empress Jones (a takeoff, naturally, on Eugene O'Neill's *The Emperor Jones*) she performed "Hottentot Potentate," in which she tries to enlighten the locals to the ways of Paris and Manhattan, to give "them some hot-cha / Je-ne-sais-quoit-cha." Despite the song's playful cleverness, some might read it as being racially and culturally distorted, at best, if not racist. Reflecting attitudes of the day, the natives are backward, childlike figures without a significant culture of their own. Empress Jones brings European-style culture, glamour, and sophistication to the low-down heathens. But Ethel's talents as a singer and tongue-in-check dramatist took the material to another level. At one point, she gave her now-familiar

blues singer growl, and for those hearing her recording decades later, you can almost see her glide and strut across the stage with that Garbo-like long-limbed androgyny that would make both women enduringly compelling whenever they moved. It was one of Waters' great numbers.

"What gives 'At Home Abroad' its freshest beauty," wrote Brooks Atkinson in the *New York Times*, "is Vincente Minnelli. . . . Without resorting to opulence he has filled the stage with rich, glowing colors that give the whole work an extraordinary loveliness. Nothing quite so exhilarating as this has borne the Shubert seal before." Atkinson praised Beatrice Lillie, "who performs with marvelous subtlety two excellent sketches." Powell, he wrote, did her best work in "The Lady with the Tap," the very number Dietz had wanted cut.

And as Minnelli had hoped, Ethel was singled out for her numbers "Hottentot Potentate" and "The Steamboat Whistle." Calling her "the gleaming tower of dusky regality, who knows how to make a song stand on tip-top," Atkinson pointed out precisely what Minnelli knew when he designed for her. "Miss Waters can sing numbers like that with enormous lurking vitality; but she can also wear costumes. Mr. Minnelli has taken full advantage of that. He has set her in a jungle scene that is laden with magic, dressing her in gold bands and a star-struck gown of blue, and put her in a Jamaica set that looks like a modern painting. Miss Waters is decorative as well as magnetic." Other critics praised her. "Miss Waters can do as much with a song," wrote the critic for *Variety*, "as Heifetz can do with a fiddle." The show business paper added that it was "Miss Waters' way of singing, rather than the song, that gets the gravy." It also noted: "Combination of Powell and Waters dancing and singing in 'Got a Bran' New Suit' does much to send that next-to-last closing item over."

AFTERWARD, her spirits were high, and unable to sit still for long, she socialized as much as her schedule permitted, sometimes more so. Continuing her charity work, she arrived like royalty at benefits, luncheons, receptions, and special performances by stars to raise money. Now an avid Joe Louis fan, she attended his prizefights, cheering, screaming, and yelling for the Brown Bomber.

In late October, a party was held at Small's Paradise to celebrate Ethel's thirty-fifth birthday. Charlie Johnson's orchestra played "Heat Wave" while guests scrambled to wish Ethel the best. Standing by a resplendent Ethel as she cut the six-layer birthday cake was Duke Ellington, as eager as everyone else that night to be seen next to the star. Among the crowd of well-wishers were Pearl Wright and her daughters Kathryn and Vivian; Maude Russell, again her understudy; actress Georgette Harvey; Bessie Whitman; and members of Eddie's family—Mary and Blanche Mallory. Also at Small's that evening were Algretta and her birth mother, Mozelle Holmes. Though the girl no longer lived with Ethel, she visited and was still supported. The same could probably be said, to an extent, of Mozelle. In some respects, Ethel knew she had paid for Algretta. Mozelle knew that too, and apparently, she often reminded Ethel of the fact. Often, too, she received some type of financial help from Ethel. By now, she was apparently ready to move back to New York, if she had not already done so. Of course, what Ethel wasn't saying that night was that it wasn't her thirty-fifth birthday. It was her thirty-ninth.

WHENEVER THE OPPORTUNITY presented itself, her radio work continued. It wasn't the movies, but that box that sat in American living rooms and brought her into the homes of millions. On Thanksgiving, she performed—along with the Hall Johnson Choir and with Eva Jessye and Frank Wilson from *Porgy and Bess*—a special half-hour NBC holiday broadcast that celebrated Negro achievement. Pearl accompanied her.

DESPITE HER REVIEWS, Ethel certainly knew *At Home Abroad* was still not *As Thousands Cheer*. But as she hoped, the show solidified her Broadway stardom. Her success in *At Home Abroad* also moved her further away from her recording career. She recorded songs from the show for the Liberty Music Shop, but she was aware of growing older and of the changing tastes of record buyers. Her own tastes were changing too: no longer the rebellious hot mama of the early 1920s, she had matured. So too had her core following. The critics would long believe that she

marked the great transition among vocalists from the blues to jazz. Yet in the years to come, her music would be made up more of show tunes or standard popular music. And Broadway aficionados would celebrate her as the sepia star of the Great White Way. Waters now triumphed not in Black shows, where the rhythm of the production itself might be built around her particular talents. Instead, she infused the traditional Broadway production with a new rhythm all her own.

As much as she loved singing, she wasn't as satisfied or fulfilled in music as she once had been. As *At Home Abroad* continued its run, Ethel again pondered what would be next for her. Possibly a tour with the show? Or a tour of her own? Eddie had dreams of traveling with his own band. What better way to do that than by accompanying Ethel on tour? That she might do, but ultimately she had to find something that would move her career further, something that would challenge her creatively. The role of Sister Scarlett was still in the back of her mind, but who would ever cast her in such a production? She had also read a novel with a strong heroine with whom she identified strongly: a woman who had murdered a man who threatened her daughter. It was a far-fetched idea to think that the novel would ever become a drama onstage, but little did she know.

# A Chance Encounter

**A**T HOME ABROAD was only one of the shows that added excitement to the 1935–1936 theater season. Also playing were Moss Hart and Cole Porter's *Jubilee*, Billy Rose's *Jumbo*, Langston Hughes' short-lived *Mulatto*, with Rose McClendon, and the 1936 edition of *The Ziegfeld Follies*. The new one starred Fannie Brice, Bob Hope, Eve Arden, the Nicholas Brothers, and Judy Canova and marked the return of Josephine Baker to the United States. But most important was the arrival of *Porgy and Bess*, directed by Rouben Mamoulian, who had also directed the earlier dramatic *Porgy*. With George Gershwin's music, DuBose and Dorothy Heyward's dramatization of the crippled beggar Porgy who falls in love with the wanton Bess would become an American classic.

Excited by the new shows, Ethel decided to pay a visit to Josephine Baker. Originally, Baker had arrived to check in at the St. Moritz Hotel but was turned away, and she settled into the Bedford on East 44th Street. Baker had received an unfair drubbing by the critics, perhaps a backlash to all that European praise she had garnered. "After the cyclonic career abroad, Josephine Baker has become a celebrity who offers her presence instead of her talent," wrote Brooks Atkinson, who added that "her singing voice is only a squeak in the dark and her dancing is only the pain of an artist. Miss Baker has refined her art until there is nothing left of it." *Time*'s comments were even harsher. "In sex appeal to jaded Europeans of the jazz-loving type, a Negro wench always has a head start, but

to Manhattan theatergoers last week she was just a slightly buck-toothed young Negro woman whose figure might be matched in any nightclub show, whose dancing and singing could be topped practically anywhere outside France." Baker was no doubt sulking, and when Ethel arrived at Baker's hotel, Josephine reportedly snubbed her and refused to see her. Actress Nina Mae McKinney was said to have been treated the same way.

A SOCIAL EVENT that proved important for Ethel was an all-star party given in honor of *Porgy and Bess*'s director, Rouben Mamoulian, at the Harlem apartment of actress Georgette Harvey, then playing Maria in the opera. Waters and Harvey had become friends, and Harvey urged Ethel to come to the gathering. In attendance that night would be some of *Porgy and Bess*'s most glowing talents—as well as other Broadway lights. Mamoulian, of course. Composer George Gershwin. Playwrights DuBose and Dorothy Heyward. Todd Duncan, who was playing Porgy, accompanied by his wife, Annie Wiggins Brown, who starred as Bess; Ruby Elzy; also Eva Jessye, director of the choir for *Porgy and Bess* as well as the director of the Theatre Guild, which produced *Porgy and Bess*.

At first, Ethel had no intention of going to Harvey's home, as much as she liked the actress. Some of the reluctance may have been the result of her moodiness. Some of it may have been her familiar feelings of being an outsider. "I still felt like a wet blanket at such get-togethers," she recalled. She did not drink or smoke, and with her concerns about her voice, she still hated smoke-filled gatherings. That night, she recalled, she was about to turn in, but, for some reason, she got dressed and went to the party. She also must have made some phone calls because when she arrived at Harvey's apartment building on Harlem's Manhattan Avenue, Mallory, Pearl, and Harold Gumm were by her side. On the elevator, also heading to the party, was a tall, elegant, but somewhat frail man and his sophisticated wife. When the gentleman spoke, Ethel detected a Southern accent. Georgette Harvey and her friend, the actress Musa Williams, greeted the new guests, and Ethel soon found herself talking to the couple from the elevator. The two were well aware of who she was; they had vivid memories of having seen her in *Rhapsody in Black* and

later, when Ethel gave a private performance at the home of socialite Katherine Brush.

What did Ethel think of *Porgy and Bess?* the woman wanted to know. Openly expressing her feelings, Ethel had had reservations about the dramatic play *Porgy.* Ethel had known the man on whom the character of Porgy was based, an actual beggar in Charleston, South Carolina, named Sammy Smalls. Because Frank Wilson, who played the title role in the dramatic version, was physically too different from the powerful real-life man, she had found it hard to believe the sequence in which Porgy kills a man with his bare hands. Her other complaint was that *Porgy* was a rather genteel production. "There was no 'I'm a bitch' and 'I'm a whore' in it," she told them. "The characters in *Porgy* kept apologizing for being themselves. Like everyone else, I've known a great many bitches and whores in real life. They never apologize for being what they are." But she explained that she felt different about *Porgy and Bess* and its star, Todd Duncan. The opera was far more honest.

"But this is very interesting, Miss Waters," the woman said. "DuBose and I—"

Suddenly, Ethel realized that the woman was Dorothy Heyward. The gentleman with the distinct Southern accent, now seated next to her, was her husband DuBose Heyward, who had written the novel *Porgy.* Together, DuBose and Dorothy Heyward had adapted the novel for the stage, first as the dramatic play, then as the opera. Not much could impress Ethel. But the Heywards did.

"I nearly dropped dead," said Ethel.

With his impeccable manners and sophisticated fey air, DuBose Heyward—born in Charleston in 1885—was part of a dying breed, those cultivated, polished descendants of the old Southern aristocracy. Heyward could trace his ancestors back to the American Revolution. His great-great-grandfather, Thomas Heyward, had been a signer of the Declaration of Independence. The grandparents on both sides of his family had been plantation owners who had lived in grand style and comfort, a style and comfort built on the backs of their slaves. But all that had evaporated after the Civil War. During Reconstruction, DuBose's father, struggling to make ends meet, worked in a rice mill, where he was killed in an accident.

Left to raise DuBose and his sister on her own, Heyward's mother, Jane Screvens Heyward, was almost penniless. For a time, she ran a boarding-house. She also wrote a volume of poetry, *Wild Roses*.

Having grown up with Gullah servants, Jane Screvens Heyward became fascinated by their language, learned to speak it, and lectured to tourists on Gullah customs and traditions. Thought to be Angolans brought to the Americas by slave traders, the Gullahs, who retained their language and customs, first worked in rice fields, many of which were on islands near Charleston. Later studies revealed that their language bore similarities to other languages of West Africa. Some of their words were almost identical to words in Krio, which was spoken in Sierra Leone. Following the Civil War, when rice was no longer a major export, some Gullahs worked on the docks in Charleston or in the cotton fields, while others took jobs as servants in Charleston. Many white families had a "mauma," a Black woman who helped raise children.

DuBose Heyward, like his mother, grew up exposed to the lives and habits of the Gullah people. For a time in Charleston, before the city's great old homes were restored, Black and white lived on the same streets. At age fourteen, Heyward dropped out of school, sold newspapers, and worked in a hardware store. Still young, he came down with a mysterious illness that robbed him of the use of his arms and hands. When an aunt paid for him to travel to Philadelphia's Orthopedic Hospital, he learned he had polio. Undergoing treatment, he recovered but still had a weakened right arm. Sickly for the rest of his life, he later suffered from pleurisy. At age twenty, he took a job as a cotton checker for a steamship company and later became an insurance agent, yet he longed to be a writer. His poetry was published, but he knew he could never make a livelihood on poetry alone. He decided to write a novel, and his inspiration was the crippled beggar Sammy Smalls, whom he had seen on the streets of Charleston. *Porgy* had been published to great success in 1925.

By then, Heyward had married Dorothy Kuhns, whom he met at the famous artists' retreat, the Edward MacDowell Colony in Peterborough, New Hampshire. Born in Canton, Ohio, she had studied at Columbia University and then at the Harvard writing workshop of George Pierce

Baker. When her play *Nancy Ann* won the Harvard Prize for Drama, a production was mounted for Broadway. But the play bombed. Dorothy and DuBose remained in New York. It was she who decided that his novel, *Porgy*, should be dramatized, and the two worked on it together. No matter how later generations might criticize the stereotypes of the Broadway productions based on Heyward's novel, Ethel, who had read the book, believed the story of Porgy was one of the few attempts to seriously examine some aspect of African American life and culture. Following the dramatization of *Porgy*, DuBose Heyward had written the screenplay for Eugene O'Neill's *Emperor Jones*, which starred Paul Robeson and Fredi Washington.

As Ethel chatted with the Heywards, she became animated and told Dorothy Heyward about another novel she had read a few years earlier, which had held her spellbound. A family drama titled *Mamba's Daughters*, it too was set in Charleston and dealt with Gullahs, three generations of Black women. Its title heroine was the crafty Mamba, who works for a once wealthy white Charleston family, caring for two young children, a boy and a girl. But away from the city, Mamba has her own troubled family, a large, big-boned daughter named Hagar and Hagar's delicate young daughter, Lissa. Both Mamba and Hagar see their future in Lissa and are determined that the girl, who has a magical singing voice, have a life better than their own. At a startling point in the story, Lissa is raped by Gilly Bluton, a light-skinned Negro whom Hagar once befriended. Afterward, the half-mad Hagar strangles him, oblivious to the consequences of her act. The novel ends with Lissa leaving Charleston to go to New York, where, as a representative of the New Negro that the Harlem Renaissance so strongly believed in, she becomes a successful singer of opera, not the blues. In the novel, readers learn that Hagar has taken her own life.

"I explained that Mamba's family was just like my own," Ethel recounted, "with Mamba herself almost the image of Sally Anderson, her daughter Hagar like Momweeze, and Hagar's daughter Lissa being a girl like myself, illegitimate and going out into the world to become a successful singer." Yet Ethel had been haunted in particular by Hagar, who was not the primary character of the book. "I told her I knew that if ever I got

the chance, I could play Hagar. I told her that maybe other folks who read the book would think that Mamba or Lissa were the important characters, but to me, Hagar was the one with a real soul."

As she talked excitedly, Ethel did not realize, until Dorothy told her, that DuBose Heyward was the author of the novel *Mamba's Daughters*. At that moment Ethel knew this might be the kind of life- and career-altering moment she had been waiting for. Even she must have been surprised by the words that came out of her mouth. "Would you some day think of making a play out of *Mamba's Daughters* and letting me play Hagar? You see, I am Hagar."

"Well, when she said that they would remember me if and when they decided to dramatize it, I made up my mind right then and there that nothing was going to tie me up so I couldn't do it. I decided that if I had to barnstorm to make a living, I'd stay free for the part. And I did."

The Heywards knew fortune had smiled on them. Upon the publication of *Mamba's Daughters*, DuBose had lamented that Paul Robeson had been born a male; otherwise he would have been perfect for the elemental Hagar with her unreal strength that enabled her to kill Gilly Bluton. Neither he nor Dorothy could imagine an actress capable of playing the role until they saw Ethel in *Rhapsody in Black*. They wondered if she might be what they had been looking for. After they had seen her perform at Katherine Brush's home, they had been so struck by the towering Ethel that upon their return to their home in Charleston, Dorothy began mapping out a dramatization of the novel. Both felt that, despite her inexperience as a dramatic actress, Ethel could bring Hagar to life onstage.

By the end of the evening at Georgette Harvey's apartment, the Heywards were determined to move forward with the dramatization. But there would be problems ahead. First, *Mamba's Daughters* had focused not just on the Negro women but on a cross-section of Charleston society. White characters who were prominent in the novel would have to be altered or dropped. The focus, they knew, had to be on the Black women alone. The other problem would be financing. Ethel, a name commodity, was the great asset. But she was also a liability. Who would finance a

Broadway drama starring a blues singer? Afterward Ethel herself became consumed, really obsessed, with thoughts of playing Hagar. Remaining in touch with DuBose and Dorothy Heyward, she waited to see how things developed.

MEANWHILE, *At Home Abroad* was plagued by a host of problems. Tensions between cast members flared up continually. Beatrice Lillie still saw herself as the revue's true star. Ethel ignored her as much as she could, and feeling confident about her own success, she griped and complained about the way things were done. Many at the Winter Garden Theatre felt she had become arrogant and unreasonable. Perhaps that was her way of defending herself in this production with some white stars who did not want to view her as an equal. Her arrogance was apparent away from the theater too. "Ethel Waters rakes in $2,500 weekly and all Broadway is 100 per cent for her," the *Chicago Defender* reported, "but up and down the rialto in Harlem it is rumored that her chest is almost as big as Cab Calloway's." With the fans and the "little people," Ethel could be Ethel the gracious, Ethel the warmhearted; but sometimes members of the Negro press caught her off-guard. When that happened, she didn't feel she had to play nice. Questions about her personal life, namely Eddie, were off-limits as far as she was concerned.

Much as Ethel might have objected to the *Chicago Defender* comment, she didn't feel compelled to respond. But an item in New York's *Daily News* infuriated her. On January 23, dancer Eleanor Powell had temporarily left the production, so she said, due to illness. Rumors spread that the twenty-two-year-old Powell had suffered a breakdown, presumably because of Ethel! *Daily News* writer Edna Ferguson reported on tension between Waters and Eleanor Powell, stating that Waters was about to drive Powell out of the show, so unhappy was the younger woman over the way she was being treated. Not only was Ethel said to have cut in on Powell's curtain calls, but she reportedly said that she'd be happy if Powell went back home to Connecticut. Her haughty attitude also "had influenced other members of the cast to so embarrass Eleanor Powell that she collapsed." In essence,

Ethel was cited as the factor that might drive Powell out of the show—for good. Ethel hated this kind of story, especially when published in a mainstream newspaper, and from her vantage point the story was also a lie. Worse, she received hate mail and threats. For some angry white theatergoers, the question was simple: Who did this Negro woman think she was to lock horns with a white costar?

"I couldn't hog her bows," said an angry Ethel, "because we were never on the stage at the same time."

Powell sent a telegram to Ethel, informing her that she too was upset by the *Daily News* article. Waters in turn wrote a letter to the newspaper.

> *This article alleged that I had instigated a campaign of snubs and criticism against Miss Eleanor Powell, which resulted in her collapse and subsequent withdrawal from the show. Immediately upon the publication of this article Miss Powell sent a telegram branding it as malicious. She also sent me a telegram denying any part in the affair. Similar wires were sent to the entire cast. I have been unable to get the telegrams sent by Miss Powell published. That would vindicate me in the eyes of the public. As a result of the publication of the article I have been deluged with vile letters threatening to hiss me in the theatre and threatening physical violence. Therefore I am writing to you as a last resort, appealing to your sense of fairness. I cannot believe that you are aware of the damage done me or that you would want to injure me professionally for something I am entirely innocent of. . . . God, who has always answered my prayers and brought me thus far, will eventually exonerate me as well as take ample care of those who wrong me.*
>
> *Sincerely,*
> *Ethel Waters*

Ethel's letter—and no doubt calls from Gumm and the production staff of *At Home Abroad*—persuaded the newspaper to publish Powell's letter to Waters.

> *My dear Ethel:*
> *No statement nor article such as the malicious one that appeared*

*in the Daily News could possibly express a greater untruth or misstatement of the facts. Your friendship, co-operation and help is [sic] something I have always appreciated and I will be glad to get back to work as quickly as the doctors permit, which I hope will be a few days.*

*Sincerely,*

*Eleanor Powell*

Both letters read as if they had been written or edited by press agents or attorneys, which was probably the case, but many observers believed Ethel hadn't upset Powell at all. "The real tiff was between Lillie and Powell," said one writer, "and didn't concern their professional careers at all." Was Beatrice Lillie a thorn in the flesh for both Eleanor and Ethel?

At the same time, stories circulated about conflict between Josephine Baker and Fannie Brice in *The Ziegfeld Follies*. Backstage, cast and crew grumbled about the fact that Baker had a white maid. Fannie Brice let it be known that she had a Black maid. The idea, of course, was that Baker should stop high-hatting it and not forget her place. Accused of snubbing Baker, Brice responded: "I have never snubbed a person in my whole life." When asked if she liked working with Baker, Brice answered: "I don't work with Baker. We are merely in the same show." "I find Miss Brice adorable," said Baker, who everyone felt was lying through her teeth. But Baker's imperious air apparently did not sit well with Beatrice Lillie either. When Baker ran into Lillie at a posh Park Avenue party, she greeted the star by speaking in French about "how much pleasure she took in Miss Lillie's performances, how she envied her wit . . . and was overwhelmed at this so happy and providential concurrence of kindred spirits." Society writer Lucius Beebe reported that Lillie responded by speaking in a Negro dialect: "Honeychile, yo' mighty good yo'self." George Balanchine also recalled that Brice "really didn't like Josephine." During a run-through of the *Follies*, Brice was also put off when she heard Baker speak in French. Brice apparently muttered, "Ah, you nigger, why don't you talk the way your mouth was born?" Interestingly enough, this same comment was attributed to the Black maid of Lorenz Hart who, annoyed when Baker continually spoke in French at Hart's home, finally said: "Talk the way yo' mouth was born." Regardless of which story, if either, is true, it's unlikely

that Baker would have let such a comment pass without responding—and in very strong terms.

Baker and Waters must have realized they had a price to pay by breaking down Broadway barriers. Would they ever be treated as equals?

For the Negro press, Baker was the slim princess, Ethel was the duchess. No one liked seeing the way Black royalty was being treated. "But still certain professional jealousies continue to rage backstage of both shows," commented the *Amsterdam News*. "Lillie (who in private is Lady Peel of London) can't stop the duchess from receiving more applause once they both go into their act. Neither can Fannie Brice halt the roll of applause that greets the slim princess as she makes her flashing entrance. Both are eminently successful in their respective shows. Harlem observers feel that the increase in the number of Negro stars in mixed casts has resulted in a sinister attempt on the part of certain whites to force Negro performers out of the spectacles—and, of course, out of the big money."

Still, Ethel tried to hide her anger at the treatment. "Every performance [for] a Negro singer is opening night because for him every audience reaction is different," she said. "It never achieves the same reliable routine level of appreciation of white actors' performances. Do I ever encounter racial jealousy in the theater? I have never in my whole career in 'downtown' theaters discovered a trace of it. Professional jealousy I encounter everywhere." While she may not have believed Blossom Seeley, Clifton Webb, Marilyn Miller, Helen Broderick, or Beatrice Lillie felt "racial jealousy" toward her, she never said she had not experienced prejudice or bigotry in the theater. But most telling—and honest—was her explanation for her conflict with some white stars. "I just happened to be one Negro who refused to be the goat," she said.

PUSHING HER BACKSTAGE CONFLICTS ASIDE, Ethel performed, in late February, at a benefit for the Scottsboro Defense Fund at Small's Paradise. Her spirits were lifted by word that a famous British authority, William Hickey, cited her as a "perfect example of modern beauty." "Bone structure like a Benin carving; skin-texture like Black marble; primeval rhythm in her blood, yet future, not dead, finicky past, in her voice, tough,

rich, husky, roaring or soughing like an Atlantic gale." Never considered beauties in their own country in the way that Lena Horne would be, Ethel and Josephine never let Western beauty standards define them, so confident were they both of their own beauty.

But the compliment that may have pleased Ethel most at the time came from Bessie Smith, who publicly announced that Ethel Waters was her favorite stage star.

# Waiting for *Mamba*

I N MARCH, *AT HOME ABROAD* closed on Broadway after 198 performances. Afterward, Waters, accompanied by Eddie, returned to Philadelphia where the city's mayor, S. Davis Wilson, held an official greeting for her at city hall. Standing with the mayor, surrounded by floral offerings with flashbulbs popping as photographers recorded the event, Ethel listened intently as the mayor wished her success in her upcoming performances. Not lost on her were memories of a childhood spent running rampant through this city's streets, a time when she thought she had no future. In turn, Ethel, smiling broadly and girlishly, told the mayor that though this was their first meeting, she was "quite familiar with some of the other civic officials, having seen them as a child."

Both Ethel and Bea Lillie, along with dancer Mitzi Mayfair, who had replaced Eleanor Powell, went on tour with *As Thousands Cheer* to such cities as Washington and Chicago.

Then she returned to New York, where she began work on a new act that opened at the Apollo on June 26. Dancer-choreographer Elida Webb assisted Ethel on the show. Well-respected in show business since her days as choreographer for *Runnin' Wild* and as an assistant dance director at the Cotton Club, Webb sometimes worked as Ethel's secretary during professional dry spells, but now Ethel needed Webb to help whip the Apollo show into shape. Andy Razaf had also written some music for her. Mallory would conduct the orchestra for her numbers. On the bill again were comics Pigmeat Markham and James Baskett. Ethel's protégées the Brown

Sisters, were also on the bill, as was Pearl Wright. This time around the Apollo crowd was more enthusiastic. It was a standing-room-only engagement. Her schedule, with five shows a day, was so tight that she had little time to see old friends, even Van Vechten. "I suppose you know I'm just carrying on at the Apollo," she wrote him. "I wish you'd drop in and catch me . . . you know how I react to my own people. I just let go." Ethel felt confident that she hadn't lost her touch.

With things off to such a good start, she was happy to be back in New York with some semblance of a balanced life, returning home nightly to her own apartment, sleeping in her own bed. In the mornings, she resumed her horseback riding on the bridle path in Central Park. She was literally sitting above the rest of the world. And of course, she spent whatever time she could with that brood of rambunctious "adopted" children who called her Mom. But there was always more work to do. A big booking was the radio show of Ben Bernie, a very popular radio star known as "the old Maestro." Performing "Dinah," "Stormy Weather," and "That's What Harlem Means to Me" before a studio audience, she literally stopped the show, disrupting "an entire prepared radio script because the audience absolutely refused to permit this 'queen of the air' to retreat from the microphone without a second encore." This gig reminded listeners nationwide that the great blues singer, now a Broadway star, was still a one-of-a-kind sensation. Bernie sent an open invitation for her to return, which she did on several occasions.

In the midst of all this, an accident occurred that left Ethel shaken—and Eddie and his family devastated. On a bright sunny day in July, Eddie's younger brother, the pilot Frank, offered to take their sister Arenia and a friend, William Roberts, for a spin in a small monoplane owned by a prominent Black dentist, Earl Renfroe. Frank Mallory and Renfroe were members of the Challenger Aero Association—a flyers' club—which was headed by Colonel John C. Robinson, who had been Haile Selassie's airman during the Ethiopian War. A small group gathered at Harlem Airport in Illinois to see the pilot take wing. Arenia was the first scheduled to go up with Frank, but it was decided that she should watch as Frank gave Roberts a ride. The two young men had not been in the air long when Arenia Mallory noticed something had gone wrong. The plane suddenly lost

altitude. Then she screamed in horror as her brother's plane nose-dived and crashed. Later a coroner's jury determined the accident had occurred "due to low wind resistance, overheating of the motor, and overloading of the plane." Both Frank Mallory and William Roberts were killed. Mallory was twenty-five; Roberts, nineteen. Shortly afterward, Eddie and Arenia Mallory flew to Chicago for their brother's funeral and burial in Jacksonville, Illinois, and the entire family sank into a great depression.

ALSO UPSET, Ethel nonetheless had to fulfill a lineup of commitments, including an engagement at Philadelphia's Nixon Grand Theatre. Preparing for the opening on which she headlined with the Brown Sisters, she had one of her most famous run-ins with a rising star, the young Billie Holiday. For Holiday, who had come to Philadelphia from New York to audition for a spot on the bill, this represented a golden opportunity. Equally excited was Holiday's mother. "Mom thought she knew Ethel Waters—she had worked for her in Philly for quite a while as a maid," said Holiday. "Mom was sure this was my big chance, so she blew her whole week's salary to buy me an evening dress with shoes to match and stock arrangements of a couple of songs. This left just about enough for bus fare—one way—and something to eat. At the last minute I used the eating money to buy stage makeup. Then I went into the dime store and bought a tiny little satin handbag to match my dress."

"I still remember that shaky moment I got up on the stage to audition," said Holiday. "I told the piano player to give me 'Underneath the Harlem Moon,' which was popular then. I hadn't finished the first chorus when Ethel Waters bounced up in the darkened theatre." She was on the warpath. "Nobody's going to sing on this goddam stage," Waters informed everyone, "but Miss Ethel Waters and the Brown Sisters." Said Holiday: "That settled that. 'Underneath the Harlem Moon' was Miss Waters' big number. But nobody told me. I didn't have the faintest idea. So the stage manager handed me two dollars and told me to get on the bus and go home. I threw the money at him and told him to kiss my ass and tell Miss Waters to do the same. When I went out the stage door I

didn't have a dime to my name. I stayed around Philly a couple of days before I could scuffle up enough to get back to New York and tell Mom what happened."

Added Holiday: "Later Miss Waters was quoted as saying that I sang 'like my shoes were too tight.' I don't know why Ethel Waters didn't like me. I never did a thing I know of except sing her big number that day for my big Philly audition."

What Holiday didn't know was that something similar had happened to Ethel on *her* way up in Atlanta when she had performed the blues songs that Bessie Smith had told her not to sing—and Bessie thereafter gave Ethel the boot. Great stars (it was as true of Clifton Webb and Marilyn Miller as it had been of Bessie) often ruthlessly protected their territory. The public never saw this side of stars like Waters, Bill Robinson, and later Pearl Bailey, who would be thought of as some of the warmest, most humane of performers. But away from the public spotlight, all three were known by show people to be holy terrors. "Pearl was as mean as a hornet," said Bobby Short. Robinson even carried a gold-plated pistol. The slightest thing could set them off. The story of Ethel's treatment of Holiday made the rounds, which did nothing to endear Ethel to an upcoming generation of new performers. "Billie Holiday had told me she cost her a job once, when she desperately needed it," recalled Lena Horne. "Miss Waters was not notably gentle toward women, and she was particularly tough on other singers." Music producer George Wein felt that in the years to come, Ethel's behavior even affected her place in music history. "Ethel Waters was an influence on Billie Holiday, Lena Horne, Dinah Washington, and a host of other singers. But few ever acknowledged this debt. Billie, whose articulation and phrasing on early recordings clearly evoke Waters, always maintained that her sole influences were Bessie Smith and Louis Armstrong. I think the reason for this slight was Ethel Waters herself."

On September 18, Ethel returned to the Apollo. Then came preparations for a big tour that would eventually carry her back to Los Angeles.

\* \* \*

THROUGHOUT THIS TIME, she remained preoccupied with the prospect of playing Hagar in *Mamba's Daughters*. Would this drama ever come to fruition? Meeting with the Heywards in New York, she learned that not only were they moving along with the dramatization, but they were also vigorously pursuing backers for the play. Talks were in progress with the prestigious Theatre Guild, which had launched *Porgy and Bess*. The couple informed her that her name was important in mounting the play. Because they had to have assurances that Ethel would be available, would she be willing to forgo any long-term commitments? A stack of offers, many of which were bookings at movie houses around the country that would pay $3,500 a week, sat on Harold Gumm's desk. What was the holdup? Gumm wanted to know. Ethel, however, remained committed to the play—at quite a financial loss. Eddie also still wanted to form his own group and urged her to appear with him at engagements, which would mean a return to the old vaudeville-style entertainment. "We got very fond of each other," said Ethel, an understatement if there ever were one, but which explained why, after rejecting the movie house offers, she agreed to tour with Eddie.

Neither Gumm nor anyone else could understand her actions. Gumm, Pearl Wright, Carl Van Vechten, Bessie Whitman, and a host of others had seen her through her relationships with Earl Dancer and Eddie Matthews. They were also aware of the various—still secret—women in her life. But this was a different kind of relationship. What hold did Mallory have over her? No matter what anyone thought, Waters genuinely enjoyed his company and his charged sexuality. Even more so than with Dancer and Matthews, he was a fine-looking escort, the perfect, well-dressed, handsome "husband" on the arm of a star as she made her way through social engagements and professional obligations. Ever ready to speak up for her, he provided a kind of armor that she believed shielded her from the world. Probably no one else saw it that way. Ethel in need of protection? Preposterous! Was there any tougher woman in show business? But like Dancer and Matthews, Mallory offered a certain security as well as a domestic respectability that she no doubt believed she needed. His family still appealed to her—and to her sense of propriety. The deceased brother,

Frank, had been a likable, energetic young man. His educator sister, Arenia, whom Ethel may have known before she met Mallory, was just the type of refined, social woman Ethel had long favored.

The Mallory family's stability was just what her family had lacked. Was she trying to rewrite her own troubled family history by becoming part of a balanced one? From her own family, she still felt pressured and alienated. Her rivalry with her sister Genevieve was as strong as before. So too was her need for some signs of affection from Momweeze. At times, she no doubt felt she had better luck with her father's side of the family, with her half-brothers, with whom she was in communication and who were so proud of her success.

For Eddie's part, could anyone fathom what went through his mind? Still, he remained flattered that the great Ethel Waters had chosen him as her latest man, and now he saw even more clearly the advantages—and opportunities—the relationship could bring him. He kept pushing for the tour.

FINALLY, ETHEL MADE PLANS to head back on the road. Again, Elida Webb and Andy Razaf were brought in to help her create a show, and some forty cast members were hired. Called *Swing Harlem Swing*, the show traversed the country, playing the Royal Baltimore (where it broke records); the Howard in Washington, D.C.; then Chicago, Boston, Chicago again, then Pittsburgh. In Washington, she took additional engagements with Lucky Milliner's band at Loew's Capital Theatre. Then it was on to Philadelphia and Cleveland.

On October 31, 1936, shortly after she arrived in Cleveland, Ethel turned forty. For a female entertainer, such a milestone could be brutal. Ethel understood that the heated sexuality, which helped make her a star and which she both valued and lamented, might be in its waning days. Despite all her success, something still had not clicked for her. Was her life really any different now than it had been in 1929 when she had fled to Paris and London with Matthews and Algretta? Would there ever be that balance that she believed she wanted? Would there ever be any relief from

the unending emotional and physical fatigue? On the day of her fortieth birthday, she wrote Van Vechten:

> *Darling Pal—*
>
> *Thanks loads for your telegram. Its made me feel at home again as I was kinda Blue today here in Cleveland you see I had halfway planned being home in New York to just have one good spree & as usual things turned out different so I had to jump from Phila 2 o clock Fri morning & landing here by car 7 o'clock Fri nite. Tired & weary and I guess everybody that has me in mind don't know where I'm at and you are the only person in the world who can think—does of course I get a package with all the cards & telegrams in them But today is what counts. . . . All this lamenting must be a sure sign that the Rocking chair is trying to overtake me—*
>
> *Well darling Love to Fania & I'll be seeing you when I get home and Im praying I get to Calif-oh yes Im still enroute an help me pray that I get a chance my ability & not my shape-Thank God I'm still happy domestically. Thanks again for your good cheering message*
>
> <div align="right">

*Always your native*

*Mama-Ethel*
> </div>
>
> *P.S. God you don't know what a relief it is to seal a letter without putting a check in it and starting off with enclosed you find check Ha Ha*

FROM THE REST OF 1936 into 1937, she remained on tour, returning to some of the cities where she had already played and packing in audiences all over again. New Year's Eve was spent in performance at Chicago's RKO Palace Theatre. In 1936, a list was published of the top-earning Negro stars for the year. First place went to Bill Robinson, who had pulled in almost $30,000, followed by Stepin Fetchit, who had earned over $28,000. In third place was Ethel, who had earned over $23,000. The movie salaries of Robinson and Fetchit, both under contract to Twentieth Century Fox, had enabled them to earn hefty sums.

Ethel could pride herself in commanding big bucks even without work in pictures.

An offer came from Herman Starks for another appearance at the Cotton Club with Duke Ellington. Perhaps magic would strike again and she would have another hit like "Stormy Weather." The new show was set to open in March 1937.

In late January 1937, she arrived in Los Angeles. As she debarked from the train, accompanied by Mallory, she was once again given a queen's welcome. There to meet her was Bernice Patton, the Hollywood correspondent for the *Pittsburgh Courier*; Black actor Oscar Smith; Harry Levette, whose entertainment columns appeared in the *Los Angeles Sentinel* and the *Chicago Defender*; and a lineup of other admirers who had waited over two hours for her train, which arrived late. A huge gathering in her honor followed.

Most striking about the photographs taken that day was again the appearance of Ethel and Eddie. Mallory, in hat and overcoat, beamed and looked like a heartthrob. Yet Ethel, though stylishly dressed in luxurious top coat and cloche hat with an expensive handbag, again looked heavier and matronly. Her eyes appeared tired, even somewhat distended. Having previously transformed herself for Minnelli's glamorous costumes in *At Home Abroad*, she looked as she had in Chicago shortly before she returned to Broadway. Her weight gain didn't go unnoticed. One columnist remarked that she might have better luck with movie work and "she would sing much better if she lost some of those . . . er . . . hips."

Settling into the home of a Black family, the De Cuirs, she quickly prepared for two major engagements. Still traveling with her were Sunshine Sammy, the Brown Sisters, and a striking young chorus girl named Myrtle Quinland, whom the press promptly dubbed "the girl who came west with Ethel Waters." The first two-week appearance was at the Trocadero nightclub, a favorite hangout for the film colony. Her opening proved to be star-studded with such A-listers as Henry Fonda and his wife; producer David O. Selznick and wife Irene Mayer Selznick; Cesar Romero; Joan Bennett; and Stuart Erwin and June Collyer. Talks began with Darryl F. Zanuck, now at Twentieth Century Fox, about work in a new film. Zanuck continued to be a fan, but in the end, the talks led

nowhere. She also met with Charles Butler, the important Black casting director who helped fill roles for Black performers in major Hollywood features.

But then, Ethel suddenly took ill and was placed under a physician's care at the home of Irene De Cuir. The official explanation was influenza. But it was puzzling. No matter how ill Ethel might feel—be it stomach problems, headaches, nervous anxieties, or plain exhaustion—she inevitably went on with the show. But this illness seemed different from past afflictions. The weight gain had led some to believe she might be pregnant. "Ethel Waters, awaiting a visit from the Stork?" asked the *Pittsburgh Courier*. In the end, this "illness" might have been the second of the miscarriages that Ethel revealed years later. With possible thoughts of motherhood on her mind, she knew that at the age of forty, her chances were turning slim. If this was the second miscarriage, it had to have been all the more heartbreaking for her. Once she recovered, nothing more was said.

Following the Trocadero, Waters performed at the Paramount and then made a special appearance at the Lincoln Theatre, located on Black LA's Central Avenue. The West Coast critics liked her, but there were comments about her weight. Philip Scheuer of the *Los Angeles Times* wrote that she had "triumphed at the Paramount Theatre" but added, "Miss Waters' matronly proportions are no drag on her dusky voice." In a city where there was an even greater emphasis on youth and beauty than in New York, the comments made her all the more conscious of her appearance.

Leaving Los Angeles, the tour moved on to San Francisco and then Kansas City, where Ethel found herself caught in a controversy. Booked into the Mainstreet Theatre, an exhausted Ethel arrived in the city in the early hours of the morning. While preparing for her appearance, she was informed—apparently for the first time—that the Mainstreet Theatre did not admit African Americans. Immediately, she asked if there was a Negro theater where she could give a special performance—just as she had done at the Lincoln in Los Angeles. When told that there was no such theater, she decided to give a midnight performance for Kansas City's Black patrons at the Mainstreet. The price of admission would

be 50 cents. Assuming that was the end of the matter, she was stunned when that midnight performance became the target of a boycott. A prominent Black citizen in Kansas City, the owner of a Negro newspaper, was infuriated that local Negroes would not be admitted to the regular show. Who wants to stand "in the alley until 12 o'clock midnight in order to pay 50 cents to see a Jim Crow performance at the Mainstreet Theatre?" When Ethel learned of the proposed boycott, she dismissed it. "I love my people," she said, "and I want the white people to realize how much my people love me." She was not prepared for the anger and sense of injustice of the Black townspeople. Though the organizer wanted it known that the protest was not against Waters but rather the town's race policies, the boycott was still on. Thousands of handbills with the words "Custom Becomes Law" were distributed to some sixty thousand African Americans in greater Kansas City, who were urged to "sit at home at the time of the special performance." A sound truck with a sign that read "Down with the Show" traveled through the downtown district—as did crowds of protesters.

Ethel ended up playing at midnight to an almost empty theater. Only 117 people showed up. This was one of the rare occasions in her career that she was visibly distraught and "cried onstage because of the ordeal." "The famous singer was so upset by the failure of the special show that she was forced to cancel an engagement at the Lincoln High School where she had been scheduled to sing before the student group."

News of the protest was carried by Black newspapers around the country. Among theater columnists, there was, however, sympathy for Ethel. "One of the advantages of living in the North is that colored actors and theatergoers are seldom forced to take part in such embarrassing incidents as occurred in Kansas City when Ethel Waters was boycotted by members of her own race," wrote theater critic Theophilus Lewis in the *Pittsburgh Courier*. "The Kansas City incident, by the way, is a striking illustration of one of the by-products of race prejudice. It is a problem that is always bobbing up to bedevil the colored actor. The true artist wants the world to enjoy his talent. Certainly he wants the members of his own race to enjoy it. Most of our artists would probably refuse to appear in a theater that refuses to admit members of their race. But artists do not handle

their engagements. They are arranged by their business managers. When the artist discovers that the theater in which he is playing discriminates against Negroes he is usually tied up with a contract which he cannot break without putting his future career in peril."

To Ethel and others in show business, Lewis was stating the obvious, but it was important that the general theatergoer understand the contractual issues by which she and other Negro performers were legally bound.

CHAPTER 12

# Living High

ON MARCH 15, she opened at the Cotton Club, relocated in 1936 to Broadway and 48th Street. Neither the Negro press nor the entertainers wanted to see the club moved out of Harlem, but times were changing. As Ethel knew, Harlem itself was no longer the great social magnet for the rich and the sophisticated, the rebels and the intellectuals, that it had been in the past. Eventually, the Cotton Club would close its doors altogether in 1940.

Staged by Clarence Robinson, the new revue proved to be another dazzling evening of great entertainment, starring Ethel, Duke Ellington, dancer Bill Bailey, and the fantastic Nicholas Brothers, along with a cast of two hundred other performers. Not much new material came from Ethel that evening, with the exception of her song "Where Is the Sun?" But the old songs "Stormy Weather," "Heat Wave," and "My Man" kept the crowd happy. The one snag in the evening? Mallory. With Duke around, many wondered why Eddie was accompanying Ethel. No doubt Herman Starks had asked too. But Ethel most likely had been insistent. "While the show's billing tells you that Duke Ellington is the production's musical dish," wrote one columnist, "you also get the chance to hear and see 15 music mad men under the direction of Eddie Mallory during Ethel Waters' stay on the stage. Like Broadway, the correspondent failed miserably to find a place for the fill-in band or even its right to jam into the picture but [Herman] Starks has asked me to accept 'em and so I must, or did, even though with reservations." Later Frank Schiffman negotiated

to bring a version of the Cotton Club show to the Apollo in order that Harlem's colored folks could see it. Ellington, however, elected not to be a part of the new show.

During the run at the Cotton Club, a special birthday party was given for child star Harold Nicholas. The press noted that little Harold wouldn't give his age. But there were eleven candles on the birthday cake. Like everyone in show business, including stage mothers, Viola Nicholas knew it was best to be mum about her son's age, indeed to keep him a kid as long as possible. Harold was actually at least fifteen. Ethel attended the celebration along with Ellington, the Nicholas family—Viola and her son Fayard—and other stars, including a man from Ethel's past, Earl Dancer, on a visit from the West Coast. By Dancer's side was his protégée dancer Jeni Le Gon. Dancer had promoted Le Gon and secured her work in such movies as *Hooray for Love*, in which she had a delightful dance sequence with Bill Robinson. Though he would never be the kind of forceful figure he had been in vaudeville and New York theater, Dancer had established himself on the West Coast. Having once vowed never to see him again, Ethel was on good behavior. Later, she surprised many when she showed up at the Sky Club for the opening of its new floor show *The Mikado Jumps*, which starred newcomer Jeni Le Gon and was produced by Earl Dancer. For his part, Dancer never completely got over Ethel, whom he considered his greatest "find," his greatest "creation." By now, Earl's presence had little effect on her, although frankly, she still may not have liked the idea of him standing there with another woman.

DURING HER TIME BACK in New York, a row started because of her horseback riding in Central Park. By now it was known that she rode daily, so much so that she appeared to have popularized horseback riding in the Harlem community. Sometimes friends joined her. Other times chorus girls hitched up their saddles. There was always a lot of laughter, a time for showbiz folk to swap stories and gossip and gripe. For cast members, it was fun to be with Ethel away from the pressure cooker of the club—when her wicked sense of humor revealed her warmth and her ability to laugh at herself. But a group of white citizens, who called them-

selves the Equestrian Club, didn't want Ethel or her colored associates anywhere near the bridle path. First they complained to the authorities. But the police department of Central Park said nothing could be done to stop Miss Waters from riding in the park unless there was a charge of disorderly conduct. There was none. The group also attempted to persuade "midtown stables to refuse any mounts to the famous star." That didn't work either. Finally, the very proper members of the Equestrian Club threatened a boycott against the Cotton Club. That went nowhere. But for Ethel, she added the incident to her list of resentments against the ofays. How could anyone find it offensive that she or any other Negro rode in Central Park?

Otherwise life was good. Of course, there were the occasions when she had to set Eddie straight about the girls who flirted with him—and with whom he flirted back—but that was something she could deal with. As for Mallory, life was also good, very good. His publicity machine was working, and he was mentioned in the columns. When he and Ethel entered a room, people stopped to stare and then greet them. Ethel still loved romping at the Savoy with her husband by her side, and her passion for dancing remained as intense as in those early years in Philadelphia. Generally, these were relaxing, happy times. And who cared about the gossip that still circulated about the couple? "Maybe it's a gag, but our Harlem gum beaters and chop beaters deluxe keep on saying," reported a columnist, "that the Eddie Mallorys are expecting a bundle from heaven. Mrs. Eddie Mallory is best known to you as Ethel Waters, first lady of the stage." More important, Ethel also had a new song, "Where Is the Sun?" which Louis Armstrong invited her to perform on his radio program. The old maestro Ben Bernie had her back for another performance on his show. Other radio appearances followed.

As always, money didn't mean much to her. Spending lavishly on clothes and still luxuriating in her deluxe automobiles, she decided that she and Eddie needed better living accommodations, which could also be a shrewd investment. Paying $150,000—a very hefty sum in the years of the Great Depression—she bought a five-story, twenty-family apartment building on the southwest corner of 115th Street and Morningside Avenue. An additional $25,000 was spent to remodel the house. She and

Eddie would occupy the entire second floor, which consisted of eight spacious rooms: a living room, a dining room, a sumptuous master bedroom, and a comfy guest room. Another room served as an office. There was a dressing room for Ethel and, naturally, another for Eddie. And yet another room was expressly designed for him. Loving the fact that her hubby liked to work out and keep himself trim and beautiful, she had the basement transformed into a fully equipped gym "with all the necessary apparatus, including a rowing machine, stationary bicycle, punching bag, ping-pong table, wrestling mat and bar." Ethel had once said that she intended to buy a boyfriend a car that stretched from the corner of one block to the next. That was small potatoes compared to the new digs. She had really bought Eddie this entire house. The other apartments in the building would be rented to tenants. In each, modern appliances and equipment were installed. Throughout brass and copper piping was installed too.

One room was also devoted to Ethel and her Lord. In this, her religious room, "she frequently goes to kneel," said columnist Earl Wilson, "and on the walls are religious images, religious medals, and religious communications, some framed." It was her private place of worship. "I don't go to church, like some people," she said. "I only go when there's nobody there but me and the church. I just go and sit and float away." But those were rare occasions. Though she hadn't been baptized in the Catholic Church, she still considered herself a Catholic. When in need, she sought the counseling of the sisters in a Carmelite nunnery in Allentown, Pennsylvania. For years, she made substantial contributions to the nunnery. And for weekend getaways, Waters purchased a country cottage in Pompton Lakes, New Jersey.

All of this, of course, simply enhanced the image of Ethel as a profligate larger-than-life star with a grand, glorious lifestyle that most could not begin to fathom. The nation was still in the grip of the Depression, but stars somehow were expected to still live like stars. For Waters' fans and admirers, there was the thrill of living vicariously through this one-time-ghetto-girl-now-turned-working-woman who had beaten the odds. For years to come, that would be part of her appeal. Of course, keeping Eddie happy was a priority, too. But Ethel still kept her "other" interests. That comfy guest room in the new house was frequently occupied.

Secretaries were hired. Sometimes they were live-ins, sometimes they became confidantes, but always Ethel kept them busy. When her schedule was tight and hectic, she would have one of her various secretaries write letters for her. One such typed letter was sent to Van Vechten.

If you will accept this note from Ethel as a personal answer to your brief one, I assure you she will be deeply grateful. Before your note came she had mentioned you several times and had tried effectively, though not quite, to remember your phone number. She said many nice things about you which made me eager for her to find your number. She asked me to say she would be so very glad to see you at the club or home. . . . Seriously, Ethel is working very hard and the routine is a bit tiresome until she is content to accept it. I think she has, though can one tell what is behind that fathomless look of hers? This is after all Ethel's letter to you. Sorry for my intrusion. Come and see her she has loads to tell you.

The letter was signed "Tommy Berry." But Ethel had added a hand-written note: "My Darling Carlo—Tommy Berry is a girl and a very lovely one at that who is very eager to meet you as she is a writer who is visiting with me. Let me know when she & I can meet you. I just had to pen this so you would know I haven't gone big time and have a sect . . . again my Love, Ethel."

Hard to say how Eddie felt about the visitors and the secretaries, but at least in their new residence there weren't children always running around.

BUT HER EXCITEMENT about her new home did not last long. In late spring 1937, she heard disturbing news about Pearl Wright. Perhaps having never fully recovered from the problems that led to surgery in Los Angeles years ago, Pearl was reported to have taken a turn for the worse. A panic-stricken Ethel rushed to Pearl's home, only to discover that her accompanist was sitting up in bed and in fairly good spirits. But shortly afterward, on June 21, Pearl Wright died. Funeral arrangements, made by Pearl's daughters, Kathryn and Vivian, and her brother Vernon, were

set for June 25 at St. Thomas Church on 118th Street and St. Nicholas Avenue.

Few things unsettled and saddened Ethel as much as the death of Pearl Wright, with whom she had shared so much. The two had traveled together, performed together, recorded together, gossiped together, and worked together for almost twenty years. Pearl had been with her during those years when she was climbing the rungs in show business, playing all those seedy honky-tonks and tiny theaters and clubs, while falling in and out of love and dreaming of better things to come. Pearl had kept so many of her business affairs in order. Pearl had been her confidante, possibly her closest friend, who had known about Ethel's relationship with Ethel Williams and all the others in and out of Ethel's life. In turn, she knew Pearl's children and cared about their welfare. She had loved Pearl. Their relationship was possibly more complicated than most understood. Now that close friend was gone. Stunned, shaken, heartbroken, she would long be haunted by Pearl's death.

A FEW MONTHS LATER, Ethel learned other distressing news. Bessie Smith had been injured in an automobile accident in the South. Lying on the road with one of her arms nearly severed, she was finally—after a lengthy delay—taken to a Negro hospital. On September 26, Bessie died of internal injuries and loss of blood in Clarksdale, Mississippi. Ethel considered Bessie the ultimate "champ," the undisputed queen of the blues. Two years later, in 1939, her other idol, Ma Rainey, died in Georgia at the age of forty-three.

PULLING HERSELF TOGETHER, Ethel left New York for the big tour that would carry her through Philadelphia, Indiana, Chicago, and parts of the South. Included in the troupe were Ethel's friends, the comedy team of Butterbeans and Susie. Throughout the tour the reception was tremendous. Two thousand fans showed up in Norfolk, Virginia. When presented with bouquets onstage, to the sound of thunderous applause, she openly wept.

Usually, the band and some cast members traveled in the tour bus. Two of Ethel's luxurious cars also traveled with the company. Cast members were seated in the first one, a sparkling Zephyr. Ethel and Eddie and a few other select cast members rode in the second—her chauffeur-driven, custom-styled Lincoln. The tour, as could be expected, brought out the best and the worst in Ethel. By now, she frequently employed former child star Sunshine Sammy, who danced and performed comedy with a partner, Sleepy Williams. Waters apparently had a genuine affection for Sammy, whose real name was Ernest Morrison. In the days of silent movies, he had emerged as one of the first African Americans to make it in Hollywood, becoming the movie industry's first Black child star. Producer Hal Roach had signed him to an important contract and hoped to feature the boy in movies. Exhibitors, however, had rejected the prospect of showing films with a colored star. Nonetheless, Roach kept Sammy working in films with comedian Harold Lloyd and then in episodes of *Our Gang*, a series focusing on the exploits and adventures of a group of children, most of whom were white, with Sammy as their Black friend. Later he was cast as a likable goofy teenager in another series, *The Bowery Boys*. But work often dried up; then he returned to vaudeville. Ernest Morrison spent years on the road. At times, he had a look of fear, exhaustion, and desperation. He seemed like a sweet-natured kid in need of protection. Here the kindly Ethel, the woman who liked thinking of herself as "Mom" to children and lost souls, apparently showed her face, respectful of Morrison's talent and eager to give him work.

For the tour, she also hired her younger half-brother, Johnny Waters. Still possessing a fine ear for a gifted piano player, she had heard him at a club in Camden, New Jersey. "He could play to send you off in a dream, and I was deeply impressed," she said. Later he spent some time at her apartment in New York, and she was surprised that, like her, he couldn't read music and had never had any formal training. She had Eddie put him in the band. She also took an interest in the young musician Lee Young, who hailed from an important musical family in Los Angeles. His brother, Lester Young, was the gifted saxophonist who ultimately befriended Billie Holiday during some of her darkest times and dubbed her "Lady Day." Lee would later become a dazzling jazz drummer with Ellington and Count

Basie; he would teach a young Mickey Rooney how to play the drums for a movie and become Nat "King" Cole's drummer and conductor. He would also be one of the first Black musicians on the staff of a major Hollywood studio. But in 1937, Lee was a young man away from home and on his own for the first time. Ethel knew how musicians on the road behaved. During their off-hours, they could be a rowdy, rambunctious bunch. A little marijuana here, a lot of whoring there—she wanted none of that for this baby. "She thought that they would sway me," said Young, "because I was the youngest guy in the band. She would put me in her car. It was a big Lincoln and I rode through the country with her chauffeur, so I didn't ride on the bus with the other musicians."

But she kept the sharpest eye on Eddie. When the Lincoln pulled in front of theaters in a town, she could always count on seeing a flock of pretty girls standing by. Stepping out of the car, Eddie might strut like a peacock. With his flashing eyes and his flirty smile, he looked as if he were asking them, "How do you like my big, bad car?" Often the girls knew who he was and called out, "Mr. Mallory." Eddie just beamed. On such occasions, he disregarded Ethel completely. For a time, she stood by and took it, watching the action without saying anything. But that passive attitude didn't last long. "After all, it was I who had bought that luxurious car with my hard-sung-for money," she said. "I wasn't going to be just a passenger who 'Mr. Mallory' was courteously giving a lift to." Finally, she laid down the law: henceforth he would ride in the bus with the band. He balked at that, but she reminded him who was in charge, who paid the bills.

IN FEBRUARY, she took a break from the tour to attend meetings of the Negro Actors Guild of America in New York. By now, the organization had been formally incorporated. At an earlier meeting, such speakers as Walter White of the NAACP, Adam Clayton Powell Jr., Fredi Washington, W. C. Handy, Bill Robinson, Irving Mills, actress Edna Thomas, writer Geraldyn Dismond, and others had praised the launching of the Negro Actors Guild in which Blacks and whites had come together in recognition of the need for an organization to fight for the rights of Black artists and to lobby for better roles and more Negro productions. Bill

Robinson was named honorary president. The other officers, those who would have to carry out many of the day-to-day activities, were Noble Sissle, the formal president; Muriel Rahn, the recording secretary; and Cab Calloway, chairman of the executive board. Among the members of the executive board were Paul Robeson, Rex Ingram, Georgette Harvey, Frank Wilson, J. Rosamond Johnson, Duke Ellington, Marian Anderson, and James Weldon Johnson. One of the tireless fighters in the Negro Actors Guild in the years to come was its executive secretary, Fredi Washington, who wrote articles and reviews. Ethel also proved important. Named a vice president, she helped give the organization additional significance and stature by her presence.

On March 4, she joined Duke Ellington, Cab Calloway, W. C. Handy, Fredi Washington, Edna Thomas, Louise Beavers, and Bill Robinson for the organization's inaugural ball at the Savoy. Also there were columnist Billy Rowe; Will Vodery; Clare Boothe Luce, author of the hit play *The Women*; actor Leigh Whipper, who brought along Hollywood actor Wallace Ford; and, not surprisingly, a beaming Carl Van Vechten. Calloway read a letter from President Roosevelt, who expressed his regret that he was unable to attend.

Presiding over the festivities was Ethel, who was introduced by Bill "Bojangles" Robinson as "the foremost lady of the race." He presented the gavel to her. Though Robinson and Ethel were gracious with one another, just about everyone in the ballroom knew the two could barely stand to be in the same room together. Robinson may have still been smarting from that charity incident in Pittsburgh for the NAACP Defense Fund, when Ethel had grandly demanded compensation—but he had never particularly liked her anyway. He may have feared that her achievements might surpass his. For her part, she found him a mean-spirited egomaniac who had to be the center of attention. Of course, Ethel bristled at the notion of taking a backseat to him. Nonetheless, glancing around the large ballroom at the Park Avenue socialites and the lions of the literary world and the theater, Ethel was once again reminded of the old days when Harlem had been so much on the minds of everyone in New York, the days "when the silks and ermines of lower Manhattan paid more frequent visits" uptown. If anything, the turnout at the Savoy

made many reminiscence about Harlem's glory days in the 1920s. The Harlem Renaissance was over. The Depression had wiped it out. Being a Negro was no longer in vogue. Still, this was a night for celebration, and Ethel ended up dancing—lindy-hopping up a storm—into the early hours of the morning.

Two days later—on March 6—a formal announcement about *Mamba's Daughters* appeared in the *New York Times*. Producer Samuel H. Grisman had purchased the script by Dorothy and DuBose Heyward and planned to mount the production in the fall. The *Times* also mistakenly reported that Ethel would play the mulatto Lissa. No one as yet quite envisioned her as Hagar. Also noted was the fact that Ethel "hasn't been around since 'At Home Abroad' in 1935." There had been much speculation that her career had peaked. Members of the press could be quite blunt in asking her if the high points of her career were behind her. "I'm no has-been," Ethel defiantly told one reporter, angry that she even had to address the topic. Though she had not played a Broadway house, she continued to knock 'em dead on her tour, playing to capacity houses in theaters from Norfolk to Memphis to Detroit to Cleveland. But comments about her heyday coming to an end continued. Especially stinging was an article, in the form of an open letter to Ethel by *Pittsburgh Courier* columnist Porter Roberts, who had been angered by comments she had made on a broadcast in Cleveland.

> *Dear Ethel Waters,*
>
> *I hope you won't mind . . . what I have to write about your NBC broadcast via radio station WTAM, Cleveland, Ohio, on Sunday, May 1 at 12:45 p.m. You see Ethel, I, like many others, took time out to hear you sing. Sure, you sang, but you threw cold water on your 15 minute broadcast when the announcer interviewed you! Here's how: When he asked you why you were playing the Goble Theatre, you said you were playing it because you wanted to, and "Because my best friends and most loyal followers are white people." Hey Ethel, have you forgotten that letters written by your "best friends" caused you to lose your job as vocalist with that white band, a few years ago. . . . Ethel Waters, shame on you! See what you have done? Just*

*when I was getting ready to say some nice things about you, I . . .
must tell you to hurry back home and put your BANDANA back on
your head! We are now waiting up to hear Maxine Sullivan and Ella
Fitzgerald. Yeah, that's just what I am trying to tell you. You have had
your day, and I think you are showing poor sportsmanship trying to
ridicule your race. Why not take your last few bows with a smile? . . .
As I have said before I really think you have had your day! Now, may
we forget you in peace?*

Performers like Fredi Washington and the columnist Billy Rowe
quickly came to Ethel's defense, but her comments that her most "loyal
followers are white people" had to draw the ire of her Black fans. When
she had spoken on the Cleveland radio show, she most likely assumed
most listeners were white, and she had been playing up to them. From
her vantage point, she believed her Black followers—and critics—should
understand her motives and actions. Obviously that was not the case.
*Mamba's Daughters* became all the more important to her. The play *had*
to happen. Still, despite the press announcement, nothing was concrete.
Vincente Minnelli, however, contacted her about a musical version of
S. N. Behrman's play *Serena Blandish*, based on Enid Bagnold's novel *A
Woman of Quality*. It told the tale of a young woman, Serena, who was
lent "a diamond for a month by a jeweler and being introduced to society
by an Auntie Mame countess so that she could make a good marriage."
"My approach would be somewhat different from the original," said Min-
nelli. "Though I would stage the play as the same very elegant high com-
edy, it would be with an all-Black cast. To change the concept in any way
because of the cast's skin color struck me as condescension of the worst
sort. I wanted to do a sophisticated Black show because I felt uneasy about
the conventional stereotype of the Negro as simple, naïve, and childlike."

A score had been partially written by George Gershwin, but when
Gershwin died suddenly, in July 1937, Vernon Duke set out to complete
it. For the role of the countess, Minnelli wanted Ethel. For the role of
the young Serena, he considered such singers as up-and-coming Maxine
Sullivan and Ruby Elzy but finally hoped to snag a former Cotton Club
chorus girl who had begun establishing herself as a vocalist—until she

married a young man named Louis Jones and went off to live with him in Pittsburgh. Minnelli had been advised by the Negro Actors Guild that he had to persuade the young woman—Lena Horne—to leave Pittsburgh and become one of the stars of his show. Minnelli also wanted Buck and Bubbles in the cast. So set was he on doing the musical that he had begun to think of set designs for the countess's luxurious bedroom in which *Serena Blandish* was to open. To have a better chance of getting the production financed, he dropped Vernon Duke and replaced him with the incomparable Cole Porter.

Surely, for Ethel, *Serena Blandish* was something to be considered. How she might have felt playing a character role while the young Horne was cast in the title part was a matter Minnelli would have to consider. With his admiration of Ethel's talents and his awareness of Horne's relative inexperience in such a big production, no doubt he would have expanded the role of the countess. In the end, *Serena Blandish* could offer Ethel the kind of highly glamorous role rarely associated with Black women on Broadway. As she waited for *Mamba's Daughters* to materialize, it was good to know there was a backup, just in case. But after months of negotiations, plans for *Serena Blandish* fell through. Yet Minnelli still held hopes, which he would soon carry with him to Hollywood, of working with Ethel again and of casting the young Horne in some production. For years, he kept the script of *Serena Blandish*, believing somehow that such a musical might be launched.

Another offer came to Ethel, from Lew Leslie of all people, who wanted her for a new edition of *Blackbirds*. Given their past history, that seemed out of the question, and when Leslie finally produced his *Blackbirds of 1939*, his star was the young Lena Horne.

ONCE ETHEL HAD RESUMED HER TOUR, she had to make yet another quick trip to New York for more talks about *Mamba's Daughters*. A wire from the theatrical casting agents Liebling and Wood indicated that it looked as if the play was about to happen. Casting was actually beginning. Now set to produce was Maury Greenwood, whom Ethel knew from her *Plantation Revue* days in Chicago. In June, she walked into New York's

Barbizon Plaza Hotel for a meeting with DuBose Heyward, casting agent Bill Liebling, and potential investors. Assuming everything was ready to roll, she took one look at the group and knew otherwise. After much hemming and hawing by the various parties, Ethel was informed that the play still could not find financing. Producer Samuel Grisman liked the Heywards' adaptation, but he had no confidence in Ethel's ability to play Hagar. When the Heywards refused to do it without her, Grisman walked away. Now she learned that Maury Greenwald had also dropped plans to produce. Ethel was the production's stumbling block.

Afterward, DuBose Heyward approached the director Guthrie McClintic, one of the leading figures in theater. McClintic, who was well respected and well connected, had directed such Maxwell Anderson dramas as *High Tor* and *Winterset*, both of which had won the New York Drama Critics Circle Awards. His 1935 production of *Old Maid* had won the Pulitzer Prize. Among the vast lineup of great theater stars he would direct at some point in his career were Ethel Barrymore, Judith Anderson, Burgess Meredith, Lillian and Dorothy Gish, and Mildred Natwick. Of the ninety-four productions he would ultimately direct in his long career, twenty-eight starred his wife, Katharine Cornell, the leading dramatic stage actress of the day. McClintic liked the Heywards' adaptation but thought it was too long and needed to be cut. He also expressed his concern about the actress who would play Hagar. When DuBose Heyward said Waters' name, Guthrie was intrigued. "DuBose arranged an appointment, and I went down with him and had a talk with Guthrie McClintic," Waters recalled. It didn't take McClintic long to realize that Ethel, despite her dramatic inexperience, was absolutely the right choice for Hagar. In fact, it was an inspired choice. In her music, she was always able to tell a story, to know when a song reached its emotional highs as well as its emotional lows. In song, she had created characters. On those occasions when she talked as much as she sang, she provided a dramatic dialogue. She was also physically imposing. He agreed to direct and produce the play with Ethel as Hagar; his schedule was so tight, however, that he wouldn't be able to stage it until the winter. Ethel and Heyward were willing to wait.

In July, she accepted two new offers that would keep her in New York. The first came from impresario Billy Rose to appear in a vaudeville-style

revue called *The Crazy Show,* set to open at Rose's club, Casa Manana. Also on the bill were Ben Blue, Lucille Page, Smith and Dale, and the Savoy Lindy Hoppers. Basically, she would sing many of her old hits. Not expecting much out of the production but glad to be working in New York, she went into rehearsals. But two days before the scheduled opening, Rose suddenly said he wanted her to sing "Frankie and Johnny." "I nearly passed out when Billy Rose made that last minute call on me," she told Carl Van Vechten. There were ten verses to learn. The song itself was the story of a woman done wrong by her man. In the end, she sought to give the song "a Miss Otis Regrets sort of twist." Sexy, bluesy, show-tune-ish, "Frankie and Johnny," which she later recorded, ended up as one of her more memorable numbers of this period.

But Ethel's nerves were on edge, partly the result of waiting for word about the play, partly because of a new development involving Mallory's wife or, as Ethel had assumed, his *former* wife, the dancer Florence Hill. Suddenly, Hill appeared and was making potentially explosive accusations about Ethel and Mallory. For a time, Waters managed to keep the other woman's claims out of the public eye. One of the few people able to comfort her was Van Vechten, who wrote and called. Still, her anxiety grew to the point at which, so she told Van Vechten, she was under her doctor's care "for a nervous rundown condition."

Once she completed the Casa Manana engagement, she wrote Van Vechten, thanking him for his support and telling him that any time "you want me for anything, I'm at your disposal—in fact I think a good chat or better still a good cry on your *understanding* shoulder would do me a world of good. So let me know the time and the place."

Not long afterward she returned to the Apollo with Eddie. By then, she was in the headlines in the Negro press. The situation with Mallory's wife had now gone public. Hill charged that Mallory's 1934 divorce from her was not valid in New York City. In 1935, Hill's attorney had first filed suit questioning the legality of the Chicago divorce, but the suit had been dropped. Now, in early September 1938, Hill was back in court. Hill stated that Mallory had given Ethel an "unbelievable" luxurious lifestyle. There was the spacious eight-room apartment, the country home in Pompton Lakes, the three cars, and everything else. Hill was suing for a $5,000 set-

tlement and a legal New York divorce. Of course, everyone knew it wasn't Eddie who was providing Ethel with a luxurious lifestyle—it was the other way around. If the suit were successful, the $5,000 would come mostly out of her pocketbook. Hill's case, in essence, was that either Mallory was a bigamist or Ethel was his common-law wife. Both Ethel and Mallory were outraged by Hill's actions. For Ethel, there was concern that other matters might be revealed to the public. Had Ethel—a woman of such high religious faith—actually never married Mallory? It was the same dilemma that had faced her with her supposed marriage to Earl Dancer. For Ethel, it was already another scandal. "Much mud will fly," said columnist Billy Rowe.

Ethel informed Rowe that she wasn't "disturbed at all by her name being written into the charges, and will stick by her husband, notwithstanding the claims of one whom she considers just an ex-wife." Waters' attorneys no doubt leaked information to the press about Miss Florence Hill, because soon details about Hill's private life—her various love affairs—appeared. The case went through postponements—Hill herself returned to Chicago to visit her "ailing" mother—then the suit just disappeared from the news. No one could say for sure what had happened, but it was highly likely that the firm of Goldie and Gumm had worked out some arrangement with Hill. The last thing Ethel or anyone else wanted was to have Florence Hill talk some more to the press.

IN THE MIDDLE OF THE HILL MESS, Ethel went back into the recording studio on November 9. Accompanied by Eddie on trumpet as well as by Shirley Clay, Tyree Glenn, Castor McCord, William Steiner, Charles Turner, Danny Barker, and Reginald Beane on piano, she recorded "You're Mine," "They Say," "Jeepers, Creepers," and "Frankie and Johnny," all for the Blue Bird label. Performing with Mallory did not seem to bring out anything particularly new in her voice or style. But Mallory was a skilled musician who knew how to work with her. At times, she sounded more mature, the voice in a lower key and range. On "Jeepers, Creepers," she was playful and clear as a bell. It remains an underappreciated classic, perhaps overlooked because of Louis Armstrong's popular version. On

"Frankie and Johnny," she seemed to relish the lyric, "He done her wrong."

Since Pearl Wright's death, Ethel had employed different accompanists, but rarely had she been fully satisfied until she worked with Beane. He fit the bill not only because of his skill as a musician—he was excellent—but also because of his personality. Attractive in an understated, distinctly nonflashy, non-show-businessy way, Beane was a sensitive, patient young man. "He was tall and slender and nice-looking," recalled Jim Malcolm, who had known Beane. "He was mild-mannered. He was very good. He was also a very collaborative artist. I think he adored her." He and Ethel had met at a party at Georgette Harvey's in 1938. Having now worked with Ethel on her November recordings with Mallory, Beane was calm waters to her stormy seas. She felt fortunate to have found him, and he would accompany her for almost the rest of her career. Like Pearl, he would see her up close. Whether she initially intended to or not, she trusted and confided in him.

With Beane by her side, she also prepared for a two-day festival performing with the Hall Johnson Choir at Carnegie Hall. To play the prestigious concert hall where some of the world's most prominent classical artists had performed was, despite her personal problems, too significant a career move to pass up. Johnson's choir performed spirituals not only on concert stages around the world but also on Broadway and in such films as The Green Pastures. The group had been praised for having "validated" the spiritual, showing it could be high art. Marian Anderson had done the same. For Ethel, the Carnegie Hall appearance marked an opportunity as well as a challenge to perform these tributes to the Lord. She would also sing some of her great hits, which some critics considered jazz. During rehearsals, she knew she had to maintain her discipline—no thoughts about Florence Hill could make her lose her focus. As could be expected, there was the general "nervousness," but this engagement revealed Waters at her most artistically fearless. Having already moved out of her initial comfort zones with "Eli Eli" and Broadway shows, she still refused to settle neatly into one area of accomplishment and never leave it.

On the evening of Sunday, November 20, the hall was packed with well-dressed, cultured concertgoers. The performance opened with the

Hall Johnson Choir "solemnly clothed" as it sang the spirituals that the audience had come to hear. Conducting the group was Leonard De Paur. There was a rustle of excitement when Ethel "appeared wearing a vermillion gown, a golden girdle and a broad smile. From her right hand fell a long vermillion scarf, at the end of which followed her trio of accompanists." On trumpet was Mallory; on vibraphone, Tyree Glenn; on piano, Reginald Beane. She began with "Sleepy Time Down South." Afterward she performed "I Ain't Gonna Sin No More" and "Supper Time." She also joined the choir for "Fix Me" and "I Can't Stay Here by Myself." As an encore, she was full blast with "Frankie and Johnny."

The critics were aware that "it was difficult to accept [some of the material] as jazz." Nor did Ethel's delivery—some of the music was performed "half-conversationally, half-dramatically, with little attempt at rhythmic singing"—have much to do with jazz. But in the end, the critics had to accept Ethel on her terms. "Since Miss Waters is quite a law unto herself, she disarms Fifty-seventh Street criticism, which depends on hallowed traditions and long-established criteria," wrote the critic for the *New York Times*. "Briefly, she was pretty much herself, though for a while she appeared not quite cozy in the solemn air of uplift and propriety that exudes from the red plush seats and pseudo-Greek proscenium of Carnegie Hall. Ultimately, it was dispelled by moanings of 'that man of mine that ain't comin' home no more,' of the tragic fate of Frankie, and of sundry aspirations for salvation. . . . Everybody in the house seemed quite at home and happy." Though she would always be at her grandest with her popular material—which indeed was a bridge to jazz but not jazz itself—and with music that afforded her the opportunity to dramatize, the critics often overlooked the fact that she could also meaningfully deliver music sung for her God. There was a sincerity and beauty in her religious songs that clearly came from the heart.

FOLLOWING CARNEGIE HALL, she participated in an all-star gala to benefit the Negro Actors Guild at the Forty-sixth Street Theatre. Performing that night was an impressive array of stars: Marian Anderson, Louis Armstrong, the Nicholas Brothers, George Jessel, Eddie Duchin, the

Hall Johnson Choir, Cab Calloway, Ben Bernie, Eddie Cantor, Noël Coward, Benny Goodman, Beatrice Lillie, the Radio City Rockettes, Mayor Jimmy Walker, Sophie Tucker, and the guild's honorary president, Bill "Bojangles" Robinson.

The gala raised $8,500 to benefit the guild's charitable work and help unemployed Black actors. But an incident backstage between Ethel and Bill Robinson raised eyebrows. Between the two, one word led to another until "a bitter word-battle" ensued. Robinson became so angry that he threatened to resign from the guild because of Ethel. "Well, go the hell ahead and resign" may have been her choice of words that night. Of course, no one was to talk to Bojangles like this, especially some goddamned woman.

Popular with almost exclusively Black audiences early in her career, Waters developed a tough-girl persona, did sexy bumps and grinds onstage, and was called Sweet Mama Stringbean.

The young Waters also danced and performed comedy but yearned to play dramatic roles.

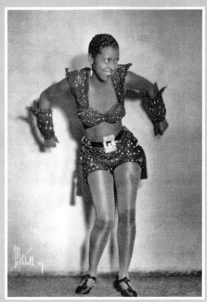

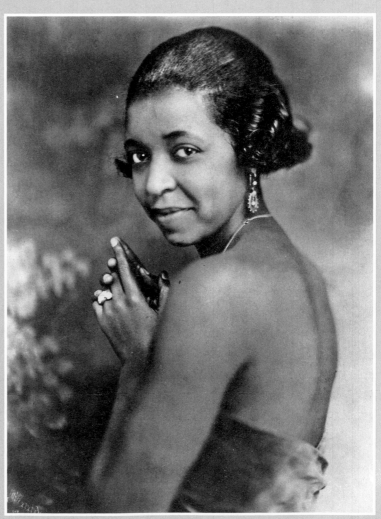

A subdued Ethel, demure and poised, just at the time she was rising to national prominence.

Hollywood knocked on her door in
1929, when Darryl F. Zanuck hired
her to perform "Birmingham Bertha"
and "Am I Blue?" in the early talkie
*On with the Show.*

Once she showed a friend a picture of
herself "dressed in men's clothes." "She
had on pants and a jacket, and she had
short hair," said the friend. "This was
when I was a boy," said Ethel.

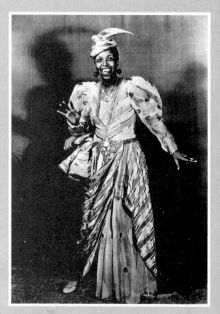

Performing the showstopper—
Irving Berlin's "Heat Wave"—in
*As Thousands Cheer.*

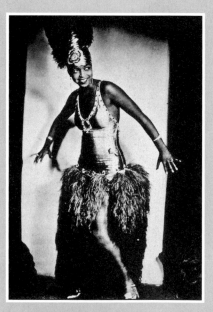

In her elaborate headdress in
1927's *Africana.*

In the 1920s, as her records crossed over and sold to mainstream audiences, she emerged as a slinky, sexy blues goddess.

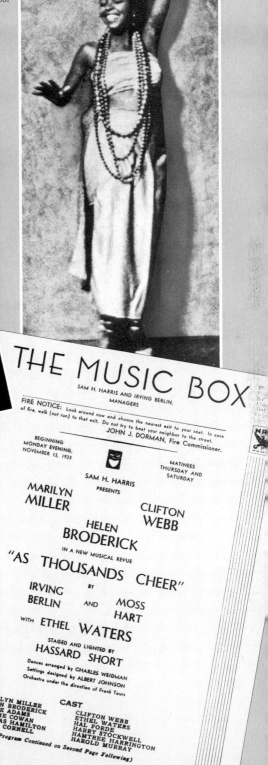

RACE RECORDS

**COLUMBIA RACE STARS**

Columbia "NEW PROCESS" Records
Made the New Way ~ Electrically
Viva-tonal Recording ~
The Records without Scratch

One of Columbia's Race Records stars, along with her idol, Bessie Smith (*in the center*).

THE MUSIC BOX

SAM H. HARRIS AND IRVING BERLIN,
MANAGERS

FIRE NOTICE: Look around now and choose the nearest exit to your seat. In case of fire, walk (not run) to that exit. Do not try to beat your neighbor to the street.
JOHN J. DORMAN, Fire Commissioner.

BEGINNING
MONDAY EVENING,
NOVEMBER 13, 1933

MATINEES
THURSDAY AND
SATURDAY

SAM H. HARRIS
PRESENTS

MARILYN
MILLER

CLIFTON
WEBB

HELEN
BRODERICK

IN A NEW MUSICAL REVUE

"AS THOUSANDS CHEER"

BY

IRVING
BERLIN

AND

MOSS
HART

WITH ETHEL WATERS

STAGED AND LIGHTED BY
HASSARD SHORT

Dances arranged by CHARLES WEIDMAN
Settings designed by ALBERT JOHNSON
Orchestra under the direction of Frank Tours

CAST

MARILYN MILLER
HELEN BRODERICK
LESLIE ADAMS
JEROME COWAN
THOMAS HAMILTON
PEGGY CORNELL

CLIFTON WEBB
ETHEL WATERS
HAL FORDE
HARRY STOCKWELL
HAMTREE HARRINGTON
HAROLD MURRAY

*(Program Continued on Second Page Following)*

Though already an established star, Waters was not billed along with the white stars above the title in 1933's *As Thousands Cheer*. Her revenge? Theatergoers believed she stole the show.

Ethel on the set of *Cabin in the Sky* with Duke Ellington
and director Vincente Minnelli. *(Courtesy of Photofest)*

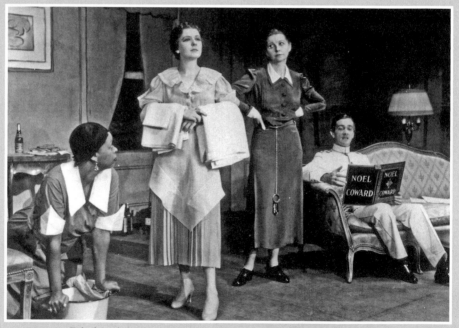

Ethel with her costars in *As Thousands Cheer*: Marilyn Miller,
Helen Broderick, and Clifton Webb. *(Courtesy of Photofest)*

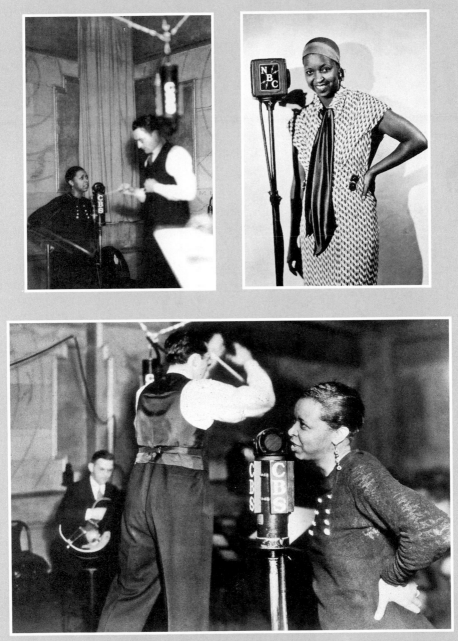

One of the first African Americans to star in her own radio show, Waters grew disillusioned and embittered when complaints from the South drove her from the airwaves. But she performed on other radio programs whenever possible, aware of the huge audience she could reach.

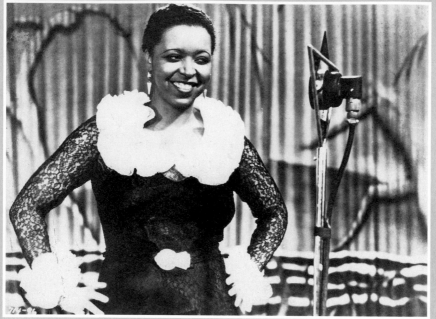

In the movie
*The Gift of Gab.*

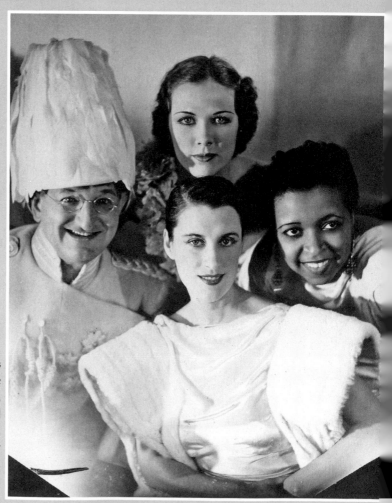

Ethel with her costars
in Broadway's *At Home
Abroad*: Herb Williams,
Eleanor Powell, and
Beatrice Lillie. Onstage,
everything was sugar
and cream. Backstage,
there were fireworks.

A night on the town with friends.

"Mrs. Roosevelt, please hug me,"
Waters reportedly had said upon
first meeting one of her heroines,
First Lady Eleanor Roosevelt.

With one of the prizefighters
she adored, Joe Louis.

A star-studded birth-day party for Harold Nicholas at the Cotton Club. *From left to right:* "Pretty Eddie" Mallory, choreographer Clarence Robinson, Cab Calloway, Harold Nicholas with brother Fayard, Ethel, Duke Ellington, George Dewey Washington, and Viola Nicholas. *(Courtesy of the Rigmor Nicholas Collection)*

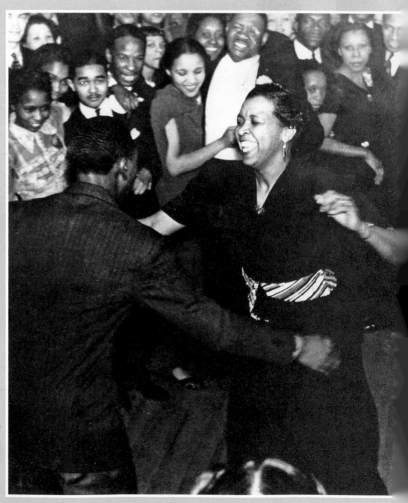

Dancing her blues away at one of the clubs where she loved to let off steam.

# Mamba's Daughters, at Last

INALLY, ETHEL WAS ABLE TO CHANNEL all her energies into *Mamba's Daughters*. Rehearsals had begun in November— precisely when Ethel was in rehearsals at Carnegie Hall and precisely when she was in the middle of that nasty business with Eddie's previous wife.

The Heywards had pared down DuBose's novel by eliminating or minimizing the white characters. Instead there was a tight focus on Mamba, Lissa, and especially Hagar, who now stood front and center. In the play, following the death of Bluton, Hagar has a tender scene with Lissa and then commits suicide—offstage.

Later generations might not fully understand the significance of *Mamba's Daughters*, but for its time the drama was a startling, bold venture. Here was a Broadway play that dramatized the tensions, conflicts, and aspirations of three generations of African American women. The Great White Way had never seen such a drama before, and it would be years before other such examinations as *A Raisin in the Sun* and *For Colored Girls Who Have Considered Suicide/When the Rainbow Is Enuf* would appear on Broadway.

Director Guthrie McClintic gathered an impressive cast. For the role of Mamba, he selected Georgette Harvey, an acclaimed actress who had appeared in such productions as *Stevedore*, *Runnin' Wild*, *Porgy*, and *Porgy and Bess*. She and Ethel had long been friends. For the part of Lissa— delicate, sensitive, vulnerable—there seemed to be but one actress around

who could play the role: Fredi Washington. Light-skinned with keen features, straight hair, and piercing green-blue eyes, Washington had appeared onstage opposite Paul Robeson as the light-skinned girl who passes for white in *Black Boy*; had worked again with Robeson in the 1933 film version of *The Emperor Jones*; and then had stunned moviegoers as Peola, the young woman who again crosses the color line, in the 1934 version of *Imitation of Life*. The latter film had been a huge hit, a classic tear-jerker and one of Hollywood's few Depression-era movies to even suggest there was a race problem in America. For the role of Gilly Bluton, Willie Bryant was selected. Ethel had brought Bryant, a band leader and master of ceremonies at the Apollo, to the attention of McClintic. Also in the cast were the young Canada Lee, fresh off his success as Banquo in Orson Welles' Black-cast version of *Macbeth*; Anne Wiggins Brown; José Ferrer as the young white Southern who becomes embroiled in the lives of Mamba's family; J. Rosamond Johnson; and Ethel's old friend, Alberta Hunter. "I just walked into producer Guthrie McClintic's office, read the role, and was signed," said Hunter. "Simple as that." Ethel even saw to it that Reggie Beane was hired for the role of Slim. The cast, however, had been meticulously scrutinized by McClintic and would shape up as one of the best on Broadway that season.

Although publicity focused on Ethel now going dramatic, the play had been in rehearsal for only two weeks when McClintic and DuBose felt that Ethel could use a moody ballad for Hagar's jailhouse scene. Heyward himself quickly wrote the lyrics. McClintic had to find someone to set the lyrics to music and decided to contact Jerome Kern, who composed the music for *Show Boat*, in Los Angeles. McClintic airmailed him a copy of Heyward's lyrics and the play. Three days later, when McClintic received a call from Kern on the West Coast, he expected to hear that Kern was much too busy. Instead Kern, raising his voice because of a faulty connection, told him, "No, no, no. On the contrary, I want to do it. In fact, I've already done it." The song was "Lonesome Walls." Alberta Hunter was also given a musical number, "Time's Drawing Nigh." The sets were designed by Perry Watkins, marking the first time a Black set designer worked on a major Broadway show. Previously, Watkins had worked with Orson Welles.

Throughout rehearsals, Ethel hoped her dream of telling the story of her mother, Louise, was about to be fulfilled. Playing Hagar was a form of cathartic self-therapy, the chance to examine and understand not only Momweeze's fears but also her own. Perhaps she might arrive at some resolution about her fractured, distant relationship with her mother. Throwing herself into the role, she studied every scene of Hagar's, every line of dialogue, every shift in mood, every subtlety, every nuance. Now nothing, no matter how painful or unattractive, could be held back in order to get at the gut of the character, just as Bessie and Ma Rainey had done with their characters in song.

Ultimately, because of her intense identification with Hagar and her determination to bring the character to a full realization, *Mamba's Daughters* became one of her most ambitious yet disturbing theatrical ventures. Her approach to acting was different from that of most other trained theater actresses. "I don't plan. I don't study," she said. "I don't rehearse much. I meditate about things—problems, roles, anything. I spend hours meditating. I'm so silent when I'm doing this that you'd never know I was in the house at all." That was all well and good when she was at home. But at the rehearsals, Ethel, from day one, was never silent and was often impossible to work with.

"I've got to rest myself," she said. "When I don't rest I get mad and bitter and I'll scream at people. I'm still a mite savage, I guess. Maybe there's real craziness in me. I'll say things I don't mean. I can't help it. I'll say them."

"She was the kind who would cuss out the whole cast with the foulest language you ever heard and then get sanctimonious and say, 'Oh, Lord, they're mistreating me,'" recalled Maude Russell, who later joined the production. Ethel "never had anything good to say about anybody," recalled singer Revella Hughes. Hardest hit in the cast was Alberta Hunter. "Ethel gave me a bad time. She treated me like a dog. Fine artist, but, oh, she was so mean," said Hunter. "She called me every name in the book and wanted to hit me. I wouldn't answer back. I'd just look at her and turn my head and walk away. And that killed her. 'Cause she wanted me to let myself down to her level. But I didn't do that." Hunter always believed that Ethel was especially annoyed by the fact that she also had a song, which

audiences appeared later to be moved by. "I would sing that song at the end, 'Time's Drawing Nigh,'" said Hunter, "and people would come backstage asking for me, not Ethel." "Everybody had to like Alberta or be jealous of her and the way she handled an audience and got applause," said Revella Hughes. Ethel "envied Alberta's sincerity, the person she was."

"She was suspicious of everyone. Just paranoid," recalled Fredi Washington. "She wasn't that way with me, though. But with everyone else. You couldn't say anything to her. Anything could set her off." Interestingly, there was perhaps another psychodrama transpiring onstage. In living out Hagar, Ethel Waters may have seen Fredi—despite the fact that they were not that far apart in age—as a daughter she had never had. Fredi *was* Lissa. From that vantage point, Ethel could never treat her as she did so many other cast members. She even wanted Washington to call her "Mother." At the same time, Waters had seen Washington at the Negro Actors Guild meetings. Articulate, sophisticated, highly intelligent, and fiercely political, Washington commanded respect. Men like Duke Ellington pursued her. Her brother-in-law, Adam Clayton Powell Jr., had the utmost respect for her, even after he later divorced her sister Isabel. Paul Robeson adored her and was even rumored to have had a dalliance with her. And women generally admired her too. Ethel was one of those admirers. Washington's performance as the haunted Peola in *Imitation of Life* had struck a nerve in Black America that even Ethel had been affected by. As always, Ethel saved all her warmth and that great sense of humanity for her character, just as she had done with some of her songs. But during rehearsals, everyone walked on eggshells.

Surely, there were times when even Guthrie McClintic and the Heywards must have wondered what they had gotten into. McClintic, however, understood the tremendous pressure she was under, not only to meet the demands of the role but to brace herself for an audience daring her to prove she had the goods to play the part. McClintic must have noted something else. Because Ethel didn't have the training of other stage actresses, because she hadn't taken acting classes that might have helped her to develop the character, she instead *became* Hagar. There was no line drawn between performer and character. "I am Hagar," she had told the Heywards when they first talked about the character, and that had not

changed. In the long run, McClintic appeared to have no major problems with her. Ethel knew that to make the character come alive, she had to trust him and listen to his advice.

Eddie and everyone else at the apartment on West 115th Street knew to stay out of her way. Most were probably relieved during those times she stayed in her room to meditate on the role. Ethel also dieted, which may have added to her irritability. She got her weight down to 168 pounds, a far cry from the 217 pounds she weighed while touring in *As Thousands Cheer*.

ON JANUARY 3, 1939, when the curtain went up on *Mamba's Daughters* at the Empire Theatre, it was one of the great opening nights in theater history as the elite from the worlds of Harlem and Park Avenue came together to see Miss Waters go dramatic. From the Park Avenue world came Tallulah Bankhead with her husband, actor John Emery; socialite Brenda Frazier; Arturo Toscanini, Katharine Cornell, Aline MacMahon, and columnist Dorothy Kilgallen. From Harlem, there were Adam Clayton Powell Jr. and his wife Isabel; Mr. and Mrs. Will Vodery; Mr. and Mrs. Aaron Douglas; Hazel Scott; Fannie Robinson (without her husband Bill); and Andy Razaf. Of course, Carl Van Vechten was there with his wife, Fania. That evening, the audience may have felt the play was wobbly and still overlong. Some theatergoers might even have shown up to see the great blues singer fall flat on her face. But each moment Waters was onstage, the audience sat spellbound. In one scene as she smoked a pipe, it became an indelible iconic image. In the scenes with Fredi Washington, Waters let all her warmth and love shine through. As she held the girl in her arms, it was for many one of the most moving moments in theater history.

"I was a teenager when I saw Ethel Waters in *Mamba's Daughters*," recalled actress Julie Harris. "She was a woman who worked in cotton fields. And had a baby. . . . And the baby was taken away. And the girl grows up. And they have that confrontation scene. And Ethel was in the field hand's dress. And a cotton handkerchief over head. And this girl— slender and beautiful—sat watching her. And they said, 'This is your

mother.' And Ethel's arms went out. And the girl didn't know what do. But those arms—those arms were out there and out there until the child couldn't resist it and ran to her mother. . . . I'll never forget that feeling. It was just so powerful."

Future television director James Sheldon was another teenager who saw the play. He had collected Ethel's recordings and was a great fan. But he was startled by her heartrending characterization. It was a dramatic transformation that he never forgot, which he would consider one of the greatest theater performances he had ever seen.

When Ethel strangled the character Gilly Bluton, she was so forceful that actor Willie Bryant "was almost rendered null and void as he was bounced off the floor," the press reported. A stagehand actually had to provide smelling salts for Bryant.

"Seldom have I seen a first night audience so excited, so moved, so carried away by 'make-believe,'" said Van Vechten. "The fact is that the audience and the critics were enjoying what is known as 'great' acting, a phenomenon so rare that any generation is granted only a few examples of it, a phenomenon almost unheard of on our contemporary stage."

"I'll never forget that night," recalled actress Rosetta LeNoire. "They took I don't know how many curtain calls. Finally, Ethel Waters just stood there with the company all bowing their heads and the tears came down their faces. Then the house went wild." Barbara Stanwyck proclaimed Waters one of the world's greatest dramatic actresses. Another actor who felt the same way was Ethel's castmate Canada Lee, who watched and studied her nightly. Within a few years, Lee would triumph as Bigger Thomas in Orson Welles' dramatization of Richard Wright's Native Son, work in Hollywood in Alfred Hitchcock's Lifeboat and Robert Rossen's Body and Soul with John Garfield, and then give a poignant performance in Cry, the Beloved Country. His career, however, would be wrecked during the postwar era with the rise of McCarthyism. But for Canada Lee, now at the start of his career, no actress left him as moved and inspired as Ethel. She was "the greatest actress of all time," he said. "Miss Waters has real genius. I've been in the wings and watched her. There is something about her personality that awes you—like being in the presence of a queen."

By one count, Ethel took twelve curtain calls; by another, seventeen. Patrons were "howling for her. They were not applauding. They were screaming."

Backstage, an emotionally drained Ethel sobbed almost uncontrollably. "I just bawled," she said. Obviously, it was hard for her to "come down" after the performance, and to those who then saw her, she appeared to be talking out of her head. "Can't stand there and bow to them," she said in her dressing room. "I get choked and dizzy and I don't know what's going to happen. I'll sing for them. Give me a little cold cream to rub on my face and I'll go out there and sing. I'll get in a chorus line and dance. I'll make them laugh. I can still do that. But I can't stand there and bow when they're like that."

The next day the reviews appeared. Most critics found the play lacking a strong, cohesive narrative, but they couldn't stop praising Ethel. "A performance such as no playgoer can ever forget," exclaimed Alexander Woollcott. "Count this a great democracy and add the name of Ethel Waters to the list of this theatre season's immortals," wrote Burns Mantle in the New York *Daily News*. "Her playing is notable for dignity and comprehension; for the technical assurance which makes her acting seem without technic, as seeming which must always be the aim of technic," wrote Richard Lockridge in the *New York Sun*. "The character which emerges from the grave simplicity of her acting is, it seems to me and seems to almost everyone, of compelling stature."

Van Vechten wrote an essay on *Mamba's Daughters* in which he praised the production as a milestone in "the Negro's progress in American theatre." Past breakthroughs, said Van Vechten, had been the one-act plays of Ridgely Torrence and Eugene O'Neill, *The Green Pastures*, Gershwin's *Porgy and Bess*, and the Negro versions of *Macbeth* and *The Comedy of Errors*. 'Whatever may be said for or against the play, the performance of Ethel Waters in the role of Hagar calls only for the highest superlatives," wrote Van Vechten. "When Miss Waters leaves her dressing room to walk on the stage (the same dressing room employed by Maude Adams when she played *Peter Pan*) she leaves Ethel Waters behind her and steps into the very soul of Hagar. It is not an easy matter to communicate feeling to an audience in an inarticulate part, but Miss Waters succeeds in commu-

nicating that feeling, as only true artists can, the moment she appears in the court-room scene at the beginning of the play. Some actresses would have stopped there. Not Miss Waters. As the play progresses the feeling is intensified, the character grows in stature, until at the very end, just before the play is over, the tension of the emotion created becomes almost unbearable."

Van Vechten also perceptively asked: "What is to become of Miss Waters in the theatre? Few roles immediately suggest themselves as appropriate. . . . I believe a revival for her of *Scarlet Sister Mary*, which Julia Peterkin hoped she would create in the original production, would be an excellent idea, but I cannot help feeling confident that in a Greek play, particularly in *The Medea*, Ethel Waters would more securely establish herself as the world actress of the first rank she indubitably is."

But amid all the accolades, one major critic had been unmoved by Waters. In the *New York Times*, Brooks Atkinson wrote that Waters' "limp, plodding style, which she seems unable to vary, results in a performance rather than in the expression of a character. . . . Although Miss Waters plays with her usual rangy and gleaming wholesomeness, she does not go very deep inside her part."

The *Times* review enraged those first-nighters, none more so than Carl Van Vechten. One of the great heated discussions in Broadway history ensued. Livid that the most influential theater critic in the United States had failed to see the power of her performance, he contacted many of the most important theater artists. An ad ran in the *New York Times* that read:

The undersigned feel that Ethel Waters' superb performance in *Mamba's Daughters* at the Empire Theatre is a profound emotional experience which any playgoer would be the poorer for missing. It seems indeed to be such a magnificent example of great acting, simple, deeply felt, moving on a plane of complete reality, that we are glad to pay for the privilege of saying so.

Judith Anderson, Tallulah Bankhead, Norman Bel Geddes, Cass Canfield, John Emery, Morris L. Ernst, John Farrar, Dorothy Gish, Jules Glaenzer, Helen Hall, Oscar Hammerstein, Ruth Kellogg, Edwin

Knopf, Ben H. Lehman, Fania Marinoff, Aline MacMahon, Burgess Meredith, Stanley Reinhardt, Carl Van Vechten.

The all-powerful critic at the *Times* was not accustomed to this type of backlash. Nor was the newspaper itself. Nor was the theater world. Guthrie McClintic sent the following telegram to Van Vechten:

*Dear Fania and Carl*
*I was deeply moved by your testimonial to ethel waters this morning in the times. It was warming to know you shared my own feelings concerning her. It was an unprecedented and reassuring gesture you made full of high courage. Thank you.*
<div align="right">*Guthrie.*</div>

Van Vechten also received a letter from Ethel:

*Dearest Carlo—Fania*
*This is my first free day of not having to go down & rehearse. Also I've been suffering terrible pain with a sprained thumb. But pain or no pain you'll never know how grateful to you both for that beautiful tribute you paid me in the Times because when I say you'll never know I mean you will never be in a position for me to ever be able to show or prove just how I would go to the mat for you. I'm saying this in my funny way knowing God will explain my meaning to you both. And I'm closing this by saying that my feeling toward you both is what Hagar feels toward Lissa so as long as I live—breathe I'll be your devoted and grateful friend*
<div align="right">*Ethel Waters*</div>

Afterward Atkinson did something theater critics almost never do. He saw *Mamba's Daughters* a second time and re-reviewed it, focusing mainly on Ethel's performance. "Perhaps it was the grippe," he wrote. "When the play at last gets underway, driven on in a whirl of turgid emotions, Miss Waters is magnificently the mistress of them with as much variety as the part permits and tremendous depth of feeling."

In another respect, it didn't seem to matter to Ethel what Atkinson thought. Nightly, her adrenaline shot up, and nightly, she found it as hard as on opening night to "come down," to release Hagar from within herself. When friends and professional associates came backstage afterward, they found her often still wearing her costume. She believed it was Hagar they wanted to see and "would have resented finding Ethel Waters in her place." On such occasions when she spoke to the press, she revealed more about herself, her art, and her moods than she realized, and certainly more so than she had done in the past. Not that she spoke of Mallory or other relationships—that was still forbidden territory. But she spoke of perhaps the one thing in her life that truly had meaning for her: her desire to express onstage, first in song, now in drama, what was in her heart. And sometimes her conversation seemed a stream of consciousness dialogue with herself, when she dropped some of the self-censorship that characterized her past interviews. Always she spoke of the critical response.

"They said such fine things about me, but they don't know," she told journalist Elliott Arnold. "They complimented Ethel Waters. Mister, there isn't any Ethel Waters anymore. I'm Hagar. I'm really Hagar." She added: "They talked about my gestures. The movements with the hands and the head and the mouth. I'm not making them up. They don't understand that. Those are the things Hagar would do. Nobody told me what to do. I'm Hagar inside of me and on the stage I'm living, every night I live through it again.

"We really fight on the stage. I don't know how to play-fight. We get hurt. My thumb has been sprained for a week. When I kill that man I kill him every night. And when my daughter is hurt, it is a real Hagar and a real daughter. I don't know what I'm doing. I just know my daughter has been hurt and I want to die.

"Does it sound crazy? Do I sound crazy? Maybe I am crazy. Listen, mister, I won't feel no offense if you put down I'm a little screwy. When a person says that with no liquor on her breath maybe she is a little screwy. She must be.

"That last line of mine—'I'm free now.' Mister, I'm really free when I say that line. I'm finishing a horrible experience. It's not just saying a line in a play. It's something in my life that is ending, every night.

"Only it doesn't work all the way. I come in here and I'm not really free. Not entirely free. It's still inside me. Hagar, what Hagar went through.

"What does it do to me? What would it do to you, mister? What would it do to you? It's made me cold and numb and I don't feel anything anymore.

"There's nothing I can take for a bracer. I can't get out of it. I don't drink. I don't smoke. I'm just here. I'll go home. Tomorrow it will still be inside of me. Maybe I'll go to a movie. Maybe I'll sit quietly at home."

Later, a calmer, more restrained Waters was able to put her performance in perspective and to regain her control. "The emotion of the part, the kindness of the audience—I can't tell you what it meant to me," she said. "There was nothing in all my phonograph record-making, my nightclub singing or anything I've ever done that could compare with it. I had been impatient waiting from month to month, from year to year, for 'Mamba' to be dramatized, but I knew right then that if the good Lord hadn't arranged it so it would be produced just as it is by Mr. McClintic that I couldn't have done it. When it was over, I felt that it was worthwhile. It's been a long way for a scrub woman to come. I've been singing for twenty-two years now, making them laugh, while all the time I secretly wanted to make them cry."

In the weeks that followed, she was the talk of the town. A gaggle of stars and celebrities went to see her in the play, everyone from Paul Robeson, who praised her, to Joe Louis. In the Sunday edition of the New York *Daily News'* magazine *Coloroto*, her portrait graced the cover, the first time an African American actress had been so honored. A striking Horst photo of her as Hagar was featured in the pages of *Vogue*. England's Lord Peter Churchill, then in the States, threw a big bash for her at the Lido, where a parade of glittering personalities—international socialites, writers, artists, public officials—came to pay homage and feast on a lavish spread. "There were Haig and Haig scotch highballs; twenty year old brandy; the best of bonded rye whiskies; sliced baked chicken and ham; American and imported cheeses; Norwegian sardines; small and large pickles; tiniest of onions and largest of ripe and green olives; dried herring; bread and crackers," it was reported. Attending were the cast members of *Mamba's Daughters* as well as some of the blazing lights of the now

bygone Harlem Renaissance: Claude McKay, Countee Cullen, Richmond Barthe, Bruce Nugent, Harold Jackman.

The crowd was kept waiting for an appearance by Ethel. The air was festive, then electric, as guests pushed one another to get a good look as a "perfectly stunning" Ethel arrived "in a rich caracul coat and a bonnet-shaped chapeau, both of which were trimmed with gorgeous silver fox fur and neither of which she removed while at the Lido." As a glamorous star, she did not disappoint anyone. That statuesque hauteur and goddessy aura were full-blown and dazzling. Eddie was by her side. The guests partied to the early hours of the morning, but Ethel, who was to do a radio broadcast the next day and who was annoyed by the cigarette smoke and the "intoxicating liquors," made a brief speech, thanked everyone, then departed, with Eddie again by her side. What should have been a glorious evening in which she might have relaxed and luxuriated in the praise appeared to be but one more event that she felt it was a duty to attend.

What did impress her was the evening that First Lady Eleanor Roosevelt sat in the audience of *Mamba's Daughters* and then came backstage with Helen Hayes and Charles MacArthur to visit Ethel. Here was another of the few people whom she truly admired. The first lady was a champion in the struggle for the rights of African Americans and women. Having fought to make the New Deal more inclusive of the economic needs of Negro America, she had met with such Negro leaders as A. Philip Randolph, the NAACP's Walter White, and Mary McLeod Bethune. Ethel also knew the story of the time—just a year earlier—when the first lady attended an event in Birmingham, along with Mary McLeod Bethune and other African Americans. But when a segregation ordinance "required her to sit in the white section of an auditorium, apart from Mrs. Bethune and her other black friends, she had captured public attention by placing her chair in the center aisle between the two sections," said historian Doris Kearns Goodwin. "Over the years, she invited hundreds of Negroes to the White House, had her picture taken with them, and held fund-raising events for Negro schools and organizations." In the next month, Eleanor Roosevelt would receive great press coverage again because of her support for Negro rights. When the Daughters of the

American Revolution learned Marian Anderson had been booked for a concert at Constitution Hall in the nation's capital, the DAR, which owned the concert hall, canceled the appearance. No African American had ever performed there. Shocked and outraged, Eleanor Roosevelt had resigned from the DAR and afterward helped plan a public concert to be given by Anderson at the Lincoln Memorial on Easter Sunday 1939. As seventy-five thousand people turned out to hear Anderson, it was one of the great civil rights events at that point in the nation's history. Anderson would be one of the two most famous and admired African American women in the nation. The other, of course, was Ethel.

Upon seeing the first lady, Ethel said, "Mrs. Roosevelt, please hug me." Roosevelt embraced her. Later, in her "My Day" column, Roosevelt wrote that Katharine Cornell had suggested that she see *Mamba's Daughters* because "Ethel Waters really achieved a remarkable dramatic success in the character of Hagar. For me, it was an unforgettable evening, so real that I could hardly believe that I was not actually on the plantation, or on the waterfront in Charleston, S.C. . . . It is to me an extraordinary artistic success." Though by now Ethel was accustomed to being honored by the mayors and officials of the various cities in which she toured, the recognition by Roosevelt moved her.

*Mamba's Daughters* brought Waters her most satisfying artistic achievement to date and also marked a new day in theater history for African American actresses. Before her, there had been the remarkable and celebrated performance of Edna Thomas as Lady Macbeth in Orson Welles' WPA production of *Macbeth*, set in Haiti; additionally, the great Rose McClendon had been celebrated by critics and fellow actors for her dramatic work. Critic Alexander Woollcott told the story of the time that Ethel Barrymore had seen McClendon in the drama *Deep River*. Pressed for time, Barrymore planned to stay a few moments only, but her friend, Arthur Hopkins, whispered: "Stay till the last act if you can, and watch Rose McClendon come down the stairs. She can teach some of our most hoity-toity actresses distinction." Woollcott added: "It was Miss Barrymore who hunted *him* up after the performance to say, 'She can teach them *all* distinction.'" But extraordinary as McClendon, Thomas, and an actress like Georgette Harvey had been, none had the big role

that would have designated her the first great Black dramatic actress of Broadway. Broadway had always been the domain of white dramatic stars like Cornell, Helen Hayes, Tallulah Bankhead, and Ethel Barrymore. Now, with Ethel, Broadway was forced to make a place for a Black dramatic actress. Her triumph was all the more impressive because she was a singer who had changed her career image midstream. Within the African American community, there was tremendous pride, and Waters, accustomed to being adulated and adored, found herself all the more celebrated. Now she had become an actress who would live on in the annals of theater history.

"Being Hagar softened me," said Waters, "and I was able to make more allowance for the shortcomings of others. Before that I'd always been cursing outside and crying inside. Playing in *Mamba's Daughters* enabled me to rid myself of the terrible inward pressure, the flood of tears I'd been storing up ever since my childhood." Of course, she referred to the "shortcomings of others," not her own. She appeared to be examining her behavior and seeking redemption. "Later she wrote me a letter asking my forgiveness," said Alberta Hunter. "She knew she was wrong. She couldn't help it. That was just her disposition. It was professional jealousy. I don't think she meant any harm. She didn't hate me as a person." Now the two women continued a friendship that stretched back to the early 1920s. But actually, the Waters temper was far from subdued, and those who worked with her always had to prepare themselves for a possible explosion.

Yet, surprisingly, some of the women who knew her were relatively sensitive to her. Hunter and Maude Russell sympathized with the effects of her harrowing childhood. Ever a pragmatist, Russell repeatedly believed that Ethel should have just snapped out of it and put the past behind, to learn from it but not be controlled by it, after so many years. Hunter may have seen the temper as the tragic flaw of an immensely talented woman. Fredi Washington appeared to believe that Ethel had to step back, reflect, and further examine herself. The women were enduringly respectful of her talent. Hunter especially admired her work as a singer. Russell appeared to admire her abilities as an all-around entertainer who knew how to put over a song or a dance number or a dramatic

character. Washington was willing to stand back and bow to her larger-than-life dramatic power. Hunter, Russell, Fredi Washington, and others understood the general pressures of show business on a woman as well as the peculiar tensions and conflicts facing an African American woman who made it to the top.

Ossie Davis, who later worked with Waters, had similar observations. "It was obvious that she, in order to protect who she was, had to sometimes pick somebody in the environment to make an example of, to demonstrate the power," said Davis. "What I felt about Ethel Waters was that she was a hard lady who could even be cruel if necessary. But I thought every bit of it was, in a sense, justified by what was necessary in her position in that time, a Black woman out in the world, sort of fending for herself. I always think of her, in a sense, as the exterior of the experience and Billie Holiday as the interior, the one who was soft and was destroyed by the process. Ethel Waters was not soft. And she was not destroyed by the process, though she herself might destroy somebody else to stay where she was, she had the hardness, she had the iron, and she had that power to survive even at somebody else's expense. You know, we can blame her if we want to. But we certainly understand where it came from. She was a great artist. And a mean woman."

BUT WITH ALL THE ACCLAIM and with her own feelings of fulfillment and accomplishment, Waters' inability to release Hagar continued. For the rest of her life, she would always believe Hagar was her most important role, and in later years, in the midst of a conversation, she would sometimes recite from the play and perform as Hagar. The character was always in the back of her mind. In carrying Hagar with her, she was still trying to reach Momweeze, to let her know that she, Ethel, understood, cared, and loved her.

# Eddie

**E**LEVEN CRITICS ON THE PULITZER PRIZE committee, aware that the award would go to the drama that best combined story and acting, wrote in the name of Ethel and *Mamba's Daughters*, even though they knew the play itself was not of the highest caliber. In the end, Lillian Hellman's *Little Foxes* won. Later a group of individual critics—not an official organization—was asked by *Variety* to name the actors who had given the best performances of the Broadway season. The top three were Ethel Waters, Maurice Evans, and Judith Anderson.

Yet despite these accolades, the future of *Mamba's Daughters* was affected by the nation's ongoing economic crisis. Though ticket sales were brisk for a time, they later turned sluggish. Some nights the cast looked out and saw the orchestra section, even parts of the balcony, half empty. The principals were asked to take pay cuts to keep the show running. Their spirits lifted when there was talk of a film version of the play, but Hollywood, with an eye on the box office, could not envision much in the way of profits for a serious drama focusing on African American women.

Away from the theater, Ethel pursued her usual interests. A steady stream of charitable events followed—a benefit for the Negro Actors Guild at the Savoy Ballroom one evening, a fundraiser for the NAACP on another. For sheer fun, there were nights at prizefights where, as always, she could be heard cheering for her hero. She grew all the more fascinated by boxer Joe Louis. One evening when she and Louis were

spied at Harlem's Mimo Club—they arrived separately and were never a couple—an observer remarked: "My, my, there sits a pair of fortunes in flesh; geniuses in ability." On another evening—following Louis's win over boxer John Henry Lewis—Ethel, clearly in a celebratory mood, hit the nightspots, quick to laugh, joke, or relive the bout. Seeing Louis at a club, Ethel sat with him at his table. Photographs taken that night show that her smile was broad and warm but there was an unexpected sweet sadness in her eyes. It was hard to know what she was thinking. Sitting with Ethel and the champ was Alberta Hunter, who actually looked rather glum. Ethel had pushed her treatment of Hunter to the back of her mind. That was all water down the drain. No doubt she assumed Alberta felt the same. Though Hunter showed up at various social engagements with Ethel, her feelings had to be mixed. Much as she enjoyed the outings, Hunter, who had a healthy ego, knew that in the presence of Ethel, she would always be one step removed from the spotlight.

Nights with the champ continued. At an affair sponsored in New York by the *Chicago Defender*, she arrived at the Mimo Club to help Joe celebrate his twenty-fifth birthday. Also on hand were dignitaries and city officials as well as Fredi Washington, Cab Calloway, and Duke Ellington with his entire band. Watching Louis recalled earlier times in her life, the love affair with the rough-and-ready boxer Rocky, the encounter on her Black Swan tour with heavyweight champ Jack Johnson. Still admiring of men possessing physical strength, she was clearly impressed by Louis's powers in the ring. Like the rest of the country, she considered his fights against German boxer Max Schmeling to be political events. But Louis was also something of a country boy: bighearted, friendly, devoted to his mother, perhaps naïve, and certainly vulnerable. The leeches were always after him, and Ethel may have felt protective. For his part, Louis relished the idea that America's great blues singer and now its most acclaimed Black dramatic actress had taken an interest in him.

At other events, Eddie was usually by her side. For Ethel, it meant putting on her public face, that broad smile and outgoing personality. She didn't object to it. In fact, the public performances at the parties and gatherings helped lift her out of an offstage stupor that sometimes enveloped her. The demands of Hagar could make her sullen or brooding at home.

"Every night is an opening night to me," she said. "I'm on the stage all through the performance, and it leaves me with no energy for hobbies or recreation. What little fun that I get out of life comes from my work, which I love, and from washing dishes and doing housework." It was hard to imagine Ethel standing at the kitchen sink. Yet she prided herself on knowing how to scrub, clean, and cook—as well as, if not better than, the people she paid to do such work. Everyone in the household was affected by her moods, as always. Her longtime maid Bessie Whitman—the woman Maude Russell had described as an angel—ended up leaving Ethel's employ. A new maid, Laura, was eventually hired to replace her.

The public events always seemed to please and energize Eddie. And pleasing Eddie was still something she was hell-bent on doing. Hard as it still might be for Waters' friends and associates to understand, she had embarked on a maddening course to keep him happy—at all costs. And as in past relationships, the costs could be high. With Eddie, there was always something new to be done. She had toured with him, as he had wanted, and clearly had helped him establish his name as a bandleader. She had insisted he be on the bill with her at the Cotton Club. She saw to it as well that his extravagant lifestyle was maintained. Tommy Berry, that young woman who stayed at Ethel's home for a time, recalled Eddie's sartorial splendors—and expenses. In his wardrobe, there were "40 suits with shirts, ties, handkerchiefs, and socks to match, including those things that might add a feminine touch, excepting that men wear them too."

There also were "four full dress suits and four tuxedoes in different styles and colors," wrote Berry. "The most outstanding and the one that draws comment from stylists is the dark green tuxedo with vest and boutonniere of canary yellow." There were also "twenty pairs of shoes, several lounging pajamas," as well as tailored shirts and imported tweeds. "His overcoats have a dash and a swagger and hang loosely from his well knit frame. His favorite hat is a mid-night blue Homburg. In fact, he wears only one brand and style hat." Naturally, this wardrobe had to be well taken care of, so there was a manservant around for the job. To top it all off, Berry recalled that Mallory had "two diamond rings, a star sapphire, and a set of diamond studs and pin, a birthday gift from Miss Waters." What

else? Eddie liked to play golf, so naturally, days on the golf course had to be scheduled, and the best golf clubs and attire had to be purchased. And next to the gym in their home where he worked out, there was also a soundproof rehearsal room.

ON MARCH 27, she went back into the studio with Eddie to record "Lonesome Walls," "If You Ever Change Your Mind," "What Goes Up Must Come Down," and "Y' Had It Comin' to You," all on the Blue Bird label. For Eddie, these were important recordings that would only enhance his reputation as an orchestra leader.

But Eddie had other things on his mind as well, a business proposition: he wanted to open a restaurant. He already had a partner, his musician friend, Charles McKinley Turner, who was known throughout Harlem as "Fat Man Turner." A bass fiddler, Turner conducted the band Fat Man and the Arcadians at the Arcadia Ballroom. Friends for twenty years, Eddie and Turner were weary of traveling on the road. Their proposed restaurant would bring in additional income. It would also have fine food and an elegant design. With all the people that Eddie and Ethel knew, the place was bound to be packed nightly with high-paying customers. It couldn't fail. All he needed was seed money to get started. But this was only one of the endeavors that Eddie sought Ethel's help with. There were also real estate deals. Mallory convinced her to invest "a big slice of my savings in some Harlem properties he was interested in, including a bar and grill," she recalled. She also realized she would "lose money and I don't say I was beat out of it. All I knew was that whenever I mixed up romance and my bank account, I seemed to end up with no dough and even less of a love affair."

In the spring, the bar and grill, called Fat Man on Sugar Hill, opened in Harlem's Sugar Hill section. Ads were taken out to publicize it.

When in New York visit
### FAT MAN ON SUGAR HILL
(rendezvous of colored celebrities)
Choice wines and liquors

155th Street and St. Nicholas Avenue, New York City
Famous for its southern barbecue & fried chicken
Eddie Mallory—hosts—Chas. Turner

Fat Man on Sugar Hill indeed drew celebrities, Black and white, all of whom came because of Ethel. On opening night, Tallulah Bankhead with husband John Emery was greeted by a jubilant Ethel at the entrance—and later was photographed eating the restaurant's famous ribs, which Bankhead, a Southerner, exclaimed she loved. On another occasion, Katharine Cornell arrived in diva style and grandeur and had so much fun that she literally fell "off her chair one night; not from intoxication or even excitement—just an accident." Also making their way there were Duke Ellington, Paul Robeson and his wife Eslanda, Cab Calloway, Jimmy Dorsey, Jack Teagarden, Maxine Sullivan, and Artie Shaw. Eddie was pleased. In photographs with Eddie, Emery, and Bankhead, though, Ethel looked rather somber. Perhaps she saw then that her relationship with Mallory, despite this new venture, might be nearing its end.

ETHEL, HOWEVER, found it hard to rest. She also continued to find it even harder to leave Hagar behind. She did all she could to promote the show. A radio broadcast of the play proved successful with listeners. When she appeared on singer Rudy Vallee's popular radio show, she not only sang but performed a dramatic sequence from the play. "*Mamba's Daughters* was the high peak of my career," she said at the time. Such a chance didn't "come anybody's way often, and if I never have another to equal it I'll still be thankful for it. For once I did do something that was big. Guthrie McClintic and Katharine Cornell are my idols because they gave me my chance and believed in me."

*Mamba's Daughters* closed after 161 performances in the spring of 1939. Producers denied that slumping ticket sales caused the demise of the drama. Some believed that Ethel had become so high-strung and so emotionally drained by the role that the "closing was ordered because Miss Waters needed a rest. The role of Hagar is a terrific one and the nightly performances in the role with two matinees tossed in made the

work pretty hard for Ethel Waters." There were tentative plans to reopen the show in the fall.

Then came an offer for an appearance on a pioneering television broadcast as part of the World's Fair of 1939–1940. Having opened on April 30, 1939, the fair was the largest, most sprawling of its kind, with fairgrounds that took up 1,216 acres of Flushing Meadows-Corona Park in Queens, New York. Countries from all over the world participated to spotlight the wonders of the future—"the Dawn of a New Day." Among the exhibits was a time capsule to be opened 5,200 years later in the year 6939. Inside were writings by Albert Einstein and Thomas Mann as well as an assortment of other items that future generations might admire or be puzzled by: a pack of Camel cigarettes; a kewpie doll; a copy of *Life*; a Mickey Mouse watch; a Gillette safety razor. Also on exhibit were a car-based city of the future and television sets.

Since the 1920s, experiments had been conducted on transmitting visual images to a small box that could sit in American homes. Now the National Broadcast Company planned a live broadcast of Ethel and other actors in a sequence from *Mamba's Daughters*. The radio broadcast of the drama had been one thing, but to do a performance that could be *seen* excited her. Of course, there were very few actual television sets in 1939: only the nation's visionaries and eccentrics had them. There were about two hundred sets in the New York area. The night of the broadcast, NBC's studios were packed with hundreds of people eager to see how television worked. Sitting in the control booth were Adam Clayton Powell Jr. and his wife, Isabel Washington; Ethel's accompanist, Reginald Beane; choir director Eva Jessye; and Harold Gumm and his partner, William Goldie, and their wives. About a thousand people actually viewed the presentation.

Performing with Ethel were Fredi Washington, Georgette Harvey, and Willie Bryant. No one knew what to expect. The lights were so hot that the crew wore straw hats. But Ethel and her castmates quickly adjusted to this historic moment. "Miss Waters' performance was glowingly simple and sincere and raised the sketch to an affecting emotional pitch," wrote *Variety*. "To put over that kind of inner-felt underplaying was a demonstration of visio's possibilities as well as thrilling performance."

That evening when the program's announcer asked Ethel which was the great love of her life, singing or acting, she replied that acting was a lifelong ambition. Should it further develop, television might be the medium that afforded her the opportunity to act.

Afterward, the Negro press, excited by the possibilities of television, asked: "Will the fate of the colored artists be the same in television as it is now in radio? Or will it be a new day for the Race. Another item not to be overlooked is how he will be portrayed in television. Will he be made to cut up and act like a fool or shall he portray himself as he is in every day life." Those were prophetic words: as television developed, those very issues pertaining to Black images would be as hotly debated on the small tube as in the theater and the movies.

In late June, Ethel returned to the fairgrounds. There, she and eleven other Black women, including sculptor Augusta Savage, educator Dorothy Height, writer Jessie Fauset, and child prodigy Philippa Schuyler, were honored in the National Advisory Committee building at the World's Fair as among the foremost women in their fields.

**WITH THE CLOSE** of *Mamba's Daughters*, Ethel knew she was back where she always found herself: what would she do next? Talk came of a show with long-standing nemesis Bill Robinson. The two "had been approached—separately—on the possibilities of such a production." When the two had danced together at an event, it looked as if their feud was over. This was pure wishful thinking. For his part, Bojangles' silent rivalry with her was as strong as ever. If she had won acclaim for a dramatic role, why couldn't he do the same? The Negro press reported that he was "shopping for a serious drama in which he will test his dramatic ability. . . . There are those who believe the well-known feud between the dancer and Ethel Waters is the reason for the play." For Ethel, he would always be one evil old coot. There were also reports that DuBose and Dorothy Heyward would write a new Broadway play for her. In the end, nothing materialized. An offer came for *A Midnight Summer's Dream*, a musical comedy, but Ethel turned it down.

On August 15, she was again with Eddie in the recording studio for

six new numbers for the Blue Bird label: "Old Man Harlem," a Hoagy Carmichael-Rudy Vallee song; Carmichael's "Bread and Gravy"; "Down in My Soul," a P. Grainger song; "Push Out," cowritten by Lovejoy and Reed; "Georgia on My Mind," a Hoagy Carmichael–Stuart Gorrell number; and "Stop Myself from Worryin' over You," composed by Ethel and her accompanist Reginald Beane. Backing Ethel on these recordings was a fine group of musicians: Eddie on trumpet, Benny Carter on alto sax, T. Glenn on trombone, C. McCord on clarinet, D. Barker on guitar, and Milt Hinton on bass. On September 22, she recorded "Baby, What Else Can I Do?" and "I Just Got a Letter," with Mallory on trumpet, Benny Carter on clarinet, Gavin Bushell on alto sax, Reginald Beane on piano, and Charles Turner on bass.

On all these songs, her voice was as fine and clear as ever and she still had the ability to draw listeners in, as if they could become a part of the festivities or the emotion. On "Georgia," she sang about a lovely lady without suggesting, as in the later Ray Charles version, that she might be singing about the state of Georgia. "Bread and Gravy" probably had the most traction, a playful tale of a woman pleased with the relationship in her life. Yet the most telling was the number she wrote with Beane, "Stop Myself from Worryin' over You." Here a very assured Ethel sang of a relationship that could drive a woman mad with frustration. But there was none of the sweet, mournful quality of "Am I Blue?" and "Stormy Weather." Well-performed as the songs were, none became the big hits of her past music. Clearly, her focus was now on acting. Still, there was no such thing ever as a bad Ethel Waters recording. Once she was by that mike, she was always eager to get at the dramatic core of the song and ready to give the song something. Though there were rising new singing stars, British critic Baron Christy Kirland named Ella Fitzgerald, Maxine Sullivan, and Ethel Waters as the top female singers of the day.

A *MAMBA'S DAUGHTERS* TOUR was set up with most of the original cast. Georgia Burke replaced Georgette Harvey, and choreographer Elida Webb now traveled with Ethel, functioning much as Pearl Wright had, as an all-around girl Friday. Reginald Beane remained in New York, where

he had won a role in William Saroyan's play *The Time of Your Life*, which he later repeated in the movie version. And Eddie Mallory also remained in New York.

The first stop, in October, was Chicago's Grand Opera House, where she received twenty curtain calls on opening night. "Ethel Waters was doing something to humble, inarticulate human nature that nobody of her race—or of mine, for that matter—ever had done in my presence on the stage before. She was being a tragedy queen without any of the pomps and tearfalls that commonly exalt tragic queenship," wrote Ashton Stevens, the critic who had helped put Ethel on the map so many years earlier.

When she attended the usual run of parties and benefits, she was often accompanied by a friend, Juliette Boykin. At a benefit at Chicago's Savoy Ballroom, she ran into Joe Louis. Yet observers everywhere realized that Ethel, even after her nightly performances, remained consumed with Hagar. At a tea one afternoon where Ethel, actress Georgia Burke, and J. Rosamond Johnson were honored guests of the women's division of Chicago's Urban League, Ethel surprised the group when she unexpectedly took center stage, sang, and performed sequences from *Mamba's Daughters*. At another gathering for the sorority Sigma Gamma Rho, she told the crowd that it was God who had blessed her with success. "I had to overcome many problems before I was given this role, and I am grateful that the serious side of me has been demonstrated. I always wanted to do dramatics." In November, the company traveled to St. Louis, and later to Pittsburgh, Detroit, and Boston. In Cincinnati, Mayor James Garfield Stewart threw a party in honor of the cast and spent much of the time seated next to Ethel.

IN JANUARY, *Mamba's Daughters* opened at the Forrest Theatre in Philadelphia. For Ethel, it meant bringing Hagar back to the place where she had begun, to the origin of so much of Momweeze's heartache and pain. Here, too, her beloved grandmother, Sally Anderson, who had never seen Ethel's success, had lived and suffered. Memories now were even more painful for Ethel. Only a few weeks earlier, while still in Detroit, Ethel

received news that threw her into a tailspin: Momweeze was living with her sister Vi in the home that Ethel rented for her on Catherine Street in Philadelphia. One evening some neighbors were sitting on the stoop and a frazzled Momweeze had asked them to leave. When they refused, she threw hot coffee on them. The authorities were contacted, and the disoriented and emotionally fragile Louise was admitted to the Philadelphia General Hospital. In Ethel's mind, it was a hospital for paupers and the abandoned. "For what was the money I was making if Momweeze could be hustled off like that, without a coat, to be thrown into some dirty, overcrowded ward?"

In a panic, Ethel made arrangements for a quick trip to Philadelphia. Flights were being canceled because of poor weather conditions, but finally a desperate Ethel was able to board a mail plane to New York. From there, she took a train to Philadelphia. Once she arrived at the hospital, she was shocked to see how thin and drawn her mother appeared. She looked as if she hadn't eaten for days, which was partially true: Ethel learned that Vi had advised her mother not to touch the hospital food and instead, had eaten the meals herself.

When Ethel consulted her mother's physician, she learned of plans to send her to the state's mental institution in Norristown. "I tried to be calm. I tried not to cry," Waters recalled. "But the savage irony burned into my soul. Each night for a year many hundreds of white men and women had been acclaiming me for portraying my mother on the stage. These white people had sobbed and suffered with Hagar, who to me was the replica of my mother. . . . And there was the original of my stage portrait, thin, wasted, unfed."

But there was another bitter fact that Waters had to deal with. The doctor knew that her mother was frustrated but not mentally unbalanced, that she had instead withdrawn from the harsh realities around her. Pleading that her mother be permitted to return home, she promised to provide round-the-clock care. In a week's time, Momweeze was back home with Genevieve.

Now as *Mamba's Daughters* played the Forrest Theatre, Ethel's emotions were at a fever pitch. But she performed each night without an emotional collapse of her own.

\* \* \*

NEW PROBLEMS SURFACED as *Mamba's Daughters* prepared for its opening at the National Theatre in Washington, D.C. Ethel received a wire informing her that Black picket lines were scheduled to march around the theater—and also at the Keith movie house where the film *Abe Lincoln in Illinois* was scheduled to open. The protest was against the theaters' refusal to admit African Americans. It was a cruel irony that the theater management would admit only white patrons to see a play that dealt so ardently with Black women. Nor would African American moviegoers be allowed to see a movie that focused on the president who had abolished slavery. Even more ironic was the fact that segregated theaters still existed in the nation's capital. A few months earlier, Black groups in Washington had also threatened to boycott *The Hot Mikado* starring Bill Robinson for the same reason. Leaders of the protest contacted Ethel, once again assuming that she had control of the contractual agreements for the houses where the play was performed. Ethel showed the wire to Fredi Washington, and the entire cast was also informed of the proposed protest. As the executive secretary of the Negro Actors Guild, Fredi responded:

> *Your telegram addressed to Ethel Waters concerning picket activities of your committee was duly referred to me. The entire company agrees wholeheartedly that the segregation which exists in the Nation's capital is a condition of which we are shamed and feel should be fought until improved. Our management sought to have the ban at the National Theatre lifted during our engagement, because they know it is an injustice to our people and because Southern towns such as St. Louis and Cincinnati agreed to admit our people. Though we are justifiably indignant, we must realize that we are bound by contractual commitments. To refuse to play the date would automatically cancel the remainder of our tour. In view of the above fact, to picket Negro shows would seem to defeat a forceful argument. This same propaganda should be carried on during the presentation of white companies. In this way you might eliminate the stigma permanently.*

Perhaps Washington's ability to write a letter that concisely stated the company's dilemma was yet another reason why Ethel respected the actress. Ethel knew that she herself could not have drafted such a response. In the end, the protesters agreed not to picket the play, but the picketers did line the block around the theater on the opening night of the film *Abe Lincoln in Illinois.*

Admirable as Ethel had been in handling the situation, backstage she was as hellish as ever and "reached the non-speaking point." Ethel was still Ethel.

But there were some bright spots amid Ethel's various storms. For one, there were plans to have the play return for an encore engagement in New York in the spring. The second cause for jubilation was that while on a break, Ethel made a special trip back to New York to attend the Joe Louis bout with Arturo Godoy. Afterward she celebrated the champ's victory at the NAACP's party at the Golden Gate ballroom. The joke was that if only Joe had been in *Mamba's Daughters,* maybe then the cast would have had some relief from their high-flying star. Then the play moved on to Toronto.

A couple of offers came in. One was for a musical comedy called *Darn That Dream,* written by comedian Eddie Cantor, who wanted Ethel and Paul Robeson for the leads. If Robeson couldn't do it, Cantor considered costarring—in burnt cork—opposite Ethel. Fortunately, nothing came of the play. Producers Vinton Freedley and Al Lewis also hoped to interest her in a musical fantasy by Lynn Root called *Little Joe,* the tale of a hapless fellow in and out of trouble but forever loved by his faithful religious wife who prays up a storm hoping to get her reformed husband into heaven. Because *Little Joe* was centered on a male lead, she could not see herself doing the show, but the producers wanted her badly enough to consider altering the play. Ethel could play the lead, as a heroine going through the same dim antics originally intended for the hero. That idea did not appeal to her either. But the producers informed Harold Gumm that they would rethink the play once again and get a writer to rework it. Ethel's response was to let them keep working. She still wasn't interested.

In April, the show business trade paper *Billboard* published the results of a cross-section poll it had conducted that listed the nation's all-

time greatest performers, past and present. Topping the list were John Barrymore, Charlie Chaplin, Helen Hayes, Paul Muni, and Enrico Caruso. Also listed were such stars as Clark Gable, Rudolph Valentino, Orson Welles, and Disney's Donald Duck. Significantly, the names of six African Americans appeared: Bert Williams, Marian Anderson, Bill Robinson, Paul Robeson, Louis Armstrong, and Ethel Waters. Among those selecting the performers were critic Brooks Atkinson and producer George Abbott, as well as performers who voted for their peers or sometimes themselves. The results indicated the strides Black performers had made in mainstream entertainment, especially from the days of minstrelsy, even though many doors remained closed to the Negro entertainer. Considering those Black entertainers whose names had not appeared on the list—Florence Mills, Cab Calloway, and, surprisingly, Duke Ellington—the inclusion of Ethel Waters and others was all the more impressive.

ON MARCH 23, *Mamba's Daughters* reopened for a limited engagement at the Broadway Theatre. Ethel welcomed this opportunity to reach audiences that perhaps could not afford to see the play the first time around. The original top ticket price of $3.50 was now $1.65, but the play failed to bring in large crowds and ran only a few weeks. Alberta Hunter, however, said it was Ethel's "meanness" that shut it down. Nor would the play go to Los Angeles, as Ethel had hoped.

Yet Ethel clung to the role of Hagar. When she agreed to play the Apollo in early May, she announced that not only would she sing but she would perform two scenes from *Mamba's Daughters* with Willie Bryant and José Ferrer. Her idea was to bring Hagar to her people—those who did not venture down to Broadway. A dramatic sequence from a play was hardly typical Apollo fare, but the theater's owner, Frank Schiffman, wanted Ethel badly enough that he agreed. "I couldn't do the whole play because they give five shows a day there," she recalled. "So I used the letter scene and the one of the killing of Willie. Those people out in front sat dead still, and ate it up." Afterward there was brief talk of bringing the entire production to the Apollo.

By now, she and Eddie frequently went their separate ways. Ethel remained absorbed in her career, while Eddie pursued other interests, which no doubt included other women. Yet they were still seen around town as a couple. Still not prone to much self-reflection—there rarely was time—she nonetheless tried to understand what was going wrong. Though she wanted and needed affection and tenderness, she admittedly could not show it herself. "Something prevents me from handing it out," she said. Always "a woman with normal physical appetites," she was "also cold-natured. I never could learn to fuss over any man, sweet-talk him, and say, 'I love you!' and all the rest of that stuff." She still was distrustful of most men who, as she once said, seemed to carry a baseball bat with them. The very problems she had backstage with other performers, always on guard, rarely letting her softer side show, had clearly extended to her home life—though it took her a long time to accept that fact. It also took her a long time to let go of Eddie. Still harboring a dream of the kind of settled domestic life she had never experienced as a child, she wanted desperately for the relationship to work. She also turned to her faith for answers.

CHAPTER 15

# On the Run

I N THE MEANTIME, she was back at work and before the public eye, still the only way that she found some semblance of security, direction, and, perhaps not unsurprisingly, meaning in her life—still the only way of revealing emotions without safeguards, without being dominated by her own fears and doubts. In July, she performed with Louis Armstrong at the Paramount. That month she was honored again, as one of forty-one African Americans whose names were inscribed on a Wall of Honor at the New York World's Fair. She was also one of eighteen women honored at the fair by the National Council of Negro Women.

Harold Gumm kept her abreast of the progress of the proposed musical fantasy *Little Joe*. The producers were negotiating with Cab Calloway for the lead role. A score was being composed with music by Vernon Duke and lyrics by John LaTouche, neither of whom, as Ethel would be quick to say, was chump change. The composer of "April in Paris," Duke had been born Vladimir Dukelsky, the scion of an old family of imperial Russia. Under his real name, he wrote music for ballet and symphonies. Virginia-born LaTouche, age twenty-four, was the author of award-winning verse and the "Ballad for Americans." Boris Aronson was designing the sets and costumes and Albert Lewis would direct the dialogue. The entire production would be under the direction of Russian émigré master choreographer George Balanchine.

Balanchine and Duke, who had known each other for fifteen years, had been brought together in Europe by the choreographer Serge Diaghi-

lev. Having long wanted to work together on a Broadway musical, both were excited by the cultural possibilities of a Negro musical and of creating a piece in another musical or dance idiom. Previously, Balanchine had worked with the Nicholas brothers on Broadway's *Babes in Arms*. Now there was the possibility of working with Ethel. The production also came to mean much to him because "after having lived prosperously for several years," Balanchine was "stone broke and having to borrow money from Larry Hart to live on." He needed a hit show. "He tried to persuade Sam Goldwyn and others to back it, and he himself sank several thousands dollars, his savings, into it," said Balanchine biographer Bernard Taper. "Balanchine put more of himself into *Cabin in the Sky* [originally titled *Little Joe*] than any other show that he did." In hopes of capturing "the authentic groove of Negro life and folklore . . . in the music, the choreography, the scenery and the show's general atmosphere," Balanchine, along with Duke, LaTouche, and Aronson, had spent time in Virginia.

Impressive as such talents were, the troublesome issue for Ethel was the very conception and perspective of the play. She bristled at the depiction of religion in the play—and the fact that the character Petunia, whom she was to portray, was in essence wasting herself on such a worthless fellow. In the fantasy, a Negro heaven and a Negro hell would fight for the soul of Little Joe—while Petunia prayed endlessly for his salvation. "Do you think I'd pray to God, that's been so good to me, for a rascal like this Joe—the way you've made him in the story?" she told the producers. "Why, it wouldn't be fair to God. I don't mind the wrong things Joe does, if there's just some little good in him somewhere." Also on Ethel's mind was the fact that this play was her follow-up show to *Mamba's Daughters*. "I was in a spot, though, when it came to finding a show I'd go into after that. It had to be something I could care about. That was one reason I was so stubborn about Little Joe and the way Petunia was going to pray for him. I wanted it to be true. I wasn't stubborn for myself: I was stubborn for God. Because I've got ideas about praying, and I wouldn't stand for giving the audience what I didn't believe in. Petunia couldn't just pray for a man's carcass; it is Little Joe's soul she's got to pray for."

Ethel's high-mindedness must have baffled the producers. True, her

staunch religiosity was known in the theater world, but so were her contradictions. After all, this was the woman who had built a career singing "Shake That Thing" and "My Handy Man." Now she was sounding sanctimonious.

The frustrated producers put out the word that they were considering white blues singer Mildred Bailey, who some thought was African American, but that was just an idle threat. Ethel was always their only choice. Finally, the writer, Lynn Root, beefed up the role of Petunia and cleaned up some of Little Joe's antics. The producers then went back to Ethel. By then, Cab Calloway had withdrawn from the production, which was probably fine with Ethel. She wouldn't have to fight for attention with *that* prima donna. Finally, Ethel agreed to do the role. The play was later retitled *Cabin in the Sky*, and in the end the musical she had taken so long to commit to would be a major production for her. Not since Berlin's *As Thousands Cheer* had she had such a fine selection of songs. She would perform "Taking a Chance on Love," "Savannah," "My Old Virginia Home on the Nile," and the title song, "Cabin in the Sky." The best numbers were hers.

*Cabin in the Sky* drew a top-notch cast. Choreographer-dancer Katherine Dunham was signed to play the temptress Georgia Brown, who tries to lure Little Joe away from Petunia. Coming from Illinois, Dunham had burst on the New York scene in an entirely unprecedented way for an African American dancer and choreographer. Forming her own troupe and perfecting what was known as the Dunham technique, she developed a series of dance recitals titled *Tropics and Le Jazz Hot*. "Her performance with her group," dance critic John Martin would write, "may well become a historic occasion, for certainly never before in all the efforts in recent years to establish the dance as a serious medium has there been so convincing and authoritative an approach." The critics and public had also responded to Dunham's sensuality—she was a very sexy woman—and Dunham's dance company would also appear in *Cabin in the Sky*. All the talk about the remarkable Dunham may have given Ethel pause, but it didn't scare her.

Playing Joe was Texas-born Dooley Wilson, a veteran of vaudeville who had recently appeared in the stage drama *Of Mice and Men*. Within

two years after the opening of *Cabin in the Sky*, Wilson would make a big splash in Hollywood when he played Sam, the man who sings "As Time Goes By" in *Casablanca* with Humphrey Bogart and Ingrid Bergman. Signed to play heaven's archangel was Todd Duncan, who had played Porgy in *Porgy and Bess*. Having studied at Butler University and Columbia, Duncan headed the music department at Howard University. Rex Ingram, a handsome, serious theater veteran who had also portrayed De Lawd in the movie version of *The Green Pastures*, was contracted to play the leader of the devil's henchmen, Lucifer Jr. Also in the cast were J. Rosamond Johnson with his choir and Georgia Burke.

*Cabin in the Sky* immediately drew buzz within the theater community and certainly within Black theater circles. In the September 14, 1940, edition of the *Chicago Defender*, Fredi Washington wrote an article, under the title "Actors' Guild Head Sees Slow Season Ahead for Performers." "The question uppermost in the mind of Negroes of the theatre right now," said Washington, "is what does the coming season offer by way of employment? As things stand now I am afraid the prospect is not very encouraging." Her article noted the changes that had come about in show business for African Americans thus far in the twentieth century. Vaudeville, which had given employment to many in the past, "has long been dead." The old floor shows that had enabled stars like Florence Mills and Ethel Waters to reach a new audience, also seemed "a thing of the past." Radio continued "to keep its doors sealed against colored artists with a few exceptions and this is a condition which should be delved into." She criticized the advertisers on radio, often the cigarette companies. "The revenue received from Negroes is not so small that it could be laughed off. These companies, Chesterfield and Luckies particularly, spend thousands of dollars advertising through radio but not one cent for Negro Talent."

Washington also pointed out the "few small cafes scattered here and there employing performers and in most cases at ridiculously low salaries, long hours and undesirable working conditions." Though the big bands fared better, they were still faced with difficulties in securing bookings. Band members also suffered through a debilitating "traveling condition such that is undermining to their health, coupled with the white manager

code." "Sum up these facts (which are by no means all)," she wrote, "and you can readily see, our future at least for this season, is indeed dark."

Washington had succinctly summed up what Ethel and so many others considered the state of the contemporary African American performer. Ethel also was aware that iridescent Fredi by all rights should have been a leading lady besieged with offers. That hadn't happened. Producers still found it "hard" to cast the light-skinned, green-eyed Washington, which strangely enough may have made Waters more sympathetic and sensitive to her.

CABIN IN THE SKY was set to open in late October at the Martin Beck Theatre. Originally, there was to be an out-of-town tryout in Boston, but Boris Aronson's scenery was too heavy and intricate to move at this point. Instead previews would begin in New York during the week of October 14. That meant everything now was hurried. Rehearsals. Costume fittings. Set designs. Publicity stills. That also meant tempers were short. Ethel's demands seemed unreasonable. The slightest thing was fodder for a tantrum. If an actor missed a cue, she would glare. If an actor seemed about to upstage her—this was clearly in her imagination, for who would dare?—she was ready to curse, cuss, scream. If a costume did not fit right, recriminations and outbursts would follow. Ironically, now, more than ever, everything simply had to be done with an eye to the heavens for the Lord's approval. Stories about Ethel's behavior were leaked to the newspapers. "Ethel Waters' Cabin in the Sky," the Negro press reported, "is being watched with interest because of the feud between the star and other members of the cast." Ethel seemed to be fighting with almost everyone. "Anybody who could make Katherine Dunham cry had to be one very tough customer," said Lena Horne's daughter, Gail Buckley.

One cast member who struck up a friendship with Ethel was Archie Savage, a member of Katherine Dunham's troupe. By all accounts, he was a brilliant dancer, with a bronze, godlike physique. "I used to dance with Archie many, many moons ago," recalled Ethel's friend Joan Croomes. "He had a body that anybody would fight for. A beautiful body. A beautiful man. And he could move every muscle in his body. He was something

to be proud of." He was handsome and sensual and very smooth. When he turned his suggestive smile and bedroom eyes on someone, he seemed to have sex on his mind. Savage, who could be calculating and manipulative, gravitated toward strong, powerful women. How he got close to Ethel is anybody's guess, but he probably knew how to reassure her after one of her outbursts: *he* understood why she was so upset, even if no one else did. But Savage had to be guarded in his attentions toward Ethel: he was rumored to have an intense relationship with Katherine Dunham, who would not have tolerated for a moment Archie landing in Ethel's camp. Both Dunham and Savage also knew that her troupe was his bread and butter. So if he soothed Miss Waters, he had to do so when Madame Dunham was not around. But despite these intrigues, Savage had other things on his mind. The very sexy, very ingratiating Archie, so exciting to some ladies, was far more interested in the fellows. "Oh, everybody knew Archie was gay," said actor Lennie Bluett, who met Savage during his later Hollywood period. "He looked so masculine and all," said Joan Croomes. "I really liked Archie. But I knew that he was gay. And he didn't really deny it."

As for dealing with the temperaments of his stars, Balanchine himself was no shrinking violet. Sometimes at rehearsals, Balanchine, Duke, and Aronson had heated discussions *in Russian*. It drove Ethel to distraction. What were they talking about? she wanted to know.

But it was apparent that Ethel was especially tense. Did she feel she had more at stake with this play because of its quasi-religious theme? "We gave a preview the night before our opening," said Ethel. 'You know how it is when you open cold—it always seems there are so many things that could be better if you had more time. Here in my dressing room I said, 'Lord, the curtain is going up, and I know it wouldn't go up if it wasn't Your will. So please, Lord, just put it in my mouth to do all right.' I went on, and He put it in my mouth."

On October 21, the night that *Cabin in the Sky* opened, "while the orchestra was playing the overture," Ethel recalled, "some of us backstage were singing hymns." "Everybody was scared," said Ethel, "so we just started singing spirituals. You should have seen some of those girls in the choir—how their faces looked and their eyes shone. They're happy when

they sing. That worked off a lot of nervousness." Indeed it did. The critics loved the show.

"Exciting up to the final curtain," wrote Richard Watts in the *New York Herald Tribune*. "Miss Waters is one of the great women of the American stage." Richard Lockridge in the *New York Sun* called it, "Joyful . . . imaginative and gay. Miss Waters has never been more engaging. Miss Dunham's dancers are something to watch." "About the most genuine Negro dancing this side of the hot countries. A Swell show," wrote Arthur Pollock in the *Brooklyn Eagle*. But the comments that probably pleased Ethel most came from Brooks Atkinson in the *New York Times*. "Ethel Waters has never given a performance as rich as this before. This theatergoer imagines that he has never heard a song better sung than 'Taking a Chance on Love.' She stood that song on its head and ought to receive a Congressional Medal by way of award." First Lady Eleanor Roosevelt came to see the play. This "light and amusing" play, she wrote in her column "My Day," had been a "delightful evening" with "one or two songs Miss Waters sings which haunt you afterward."

*Life* ran a spread on the play, and interviews appeared in the *New York Times*, the *New York Post*, and the *New York Herald Tribune*. Ethel remained determined to control the interviews, to gild her image and promote her glamorous lifestyle. When the reporter for the *New York Times* arrived at her apartment for the interview, everything had been set up to present Waters in high-diva style. Her maid Laura ushered the reporter into her apartment, leading him through "a spotless white kitchen and the adjacent breakfast room into the bullet-shaped, elegantly appointed parlor." "The Venetian blinds were down," wrote Sidney Shalett, "and you sat on the rich, gold sofa in the almost dark room." As he waited for Ethel to appear, he noted the baby grand piano with a picture of Eddie sitting on it. "There was plenty of comfortable furniture; an oval coffee table with a heavy marble top; a couple of ash stands, each designed in the figure of a graceful nude." Then he saw that "on the walls everywhere were pictures of Miss Waters—Miss Waters in an ermine wrap, as she appeared in her Harlem Cotton Club days; a full-length, tinted one of Miss Waters in 'At Home Abroad,' and then, right over her favorite chair, strik-

ing character studies of the Negro actress in her revered role of Hagar in *Mamba's Daughters*."

With the stage set for her entrance, he heard a voice say, "Here I come! Awfully sorry to keep you waiting."

"She swept into the room, a striking figure in a black velvet house coat, her right hand extended in greeting and her left hand holding a huge stack of correspondence. A few whisks of her arms and the blinds were up; a few flourishes and she was seated in her favorite chair, under the picture of Hagar and not far from the large crucifix which dominates the entrance to Miss Waters' own private chambers."

Naturally, she said little that was new. There were the usual comments on her childhood and the early part of her career when she had performed "ungodly raw" songs. She also spoke of something that now remained always at the back of her mind. "I'm just beginning to look my age," she said, leading the reporter to believe she was forty. Actually, she was forty-four. She also commented on her distaste for the "torso-shaking" she had once done. "Now I got a little too much to shake!" Despite her diets, her weight, which she joked about, still bothered her. What surprised the reporter was that rather than focusing on *Cabin in the Sky*, she spoke about *Mamba's Daughters*, "to the disparagement of the present vehicle." When the play had closed, "I just wanted to retire," said Ethel. "I didn't want nothing to spoil it. Hagar . . . Hagar, you see, is sort of sacred to me."

DESPITE THE REVIEWS and Balanchine's hopes for a lucrative hit, *Cabin in the Sky* was not a great commercial success. In many respects, as charming and delightful as it was, its view of the Negro as a childlike, fundamentally harmless figure, removed from the social and political realities of the age and placed into a soothing fantasy, was condescending. The characters still spoke in a fake dialect with highly simplified notions of moral issues, of basic right and wrong.

Interestingly, although *Mamba's Daughters* was not as tight and cohesive a play or as artistically shaped, and although one hardly saw the

hand of masters in it the way one could with *Cabin in the Sky*, the Heywards' drama, with its social realism and social consciousness, anticipated some of the dramas of the period following World War II. *Cabin in the Sky* sought to hold onto those comforting images of African Americans of an earlier time. Still, there would never be a film deal for *Mamba's Daughters*, whereas the artistic success and the score of *Cabin in the Sky* caught the attention of Hollywood.

As *Cabin in the Sky* ran on Broadway, Ethel grew aware of a changing world that unsettled her and others in the nation. The news from abroad was devastating and frightening. In 1939, Germany invaded Poland. In May 1940, Germany launched attacks in Belgium, Holland, and France. President Roosevelt met with his cabinet to discuss the ways in which the United States had to prepare for another war. The nation braced itself, hoping somehow that such a war could be averted, but an international crisis seemed inevitable.

For Ethel, there was also an upheaval in her personal affairs. The situation with Eddie had become almost unbearable. She confided to Carl Van Vechten and Fania Marinoff that she tried to keep her mouth shut. "I used to have such a temper that I had to start controlling myself," she told columnist Earl Wilson. "Now I'll let people hurt me and won't strike back." Though such comments never sounded altogether convincing, Waters still wanted the relationship to work. Eddie, however, appeared to have become exasperated by her moods, her demands, her need for attention, the constant swirl of people around her. The two were less often seen in public together. In January, when Ethel spent a night on the town at Jimmy Daniels' club in Harlem, seated next to her was an absolutely stunning young woman named Blanche Dunn. No one was saying much about the young woman, but everyone was aware that Eddie was not to be seen. He spent time at the restaurant. He spent time with his friends. He spent time with the various women who couldn't get enough of him. What a coup, to snare the man of the nation's most famous African American star. Rumors circulated that Mallory and the young singer Maxine Sullivan were spending time together. Slender, smart, and talented, Sullivan was still making a name for herself. She had already gone to Hollywood, where she appeared with Louis Armstrong and the Dan-

dridge sisters in a musical interlude in the movie *Going Places*. For Eddie to be involved with a younger singer—and a talented one at that—was a slap in the face to Ethel.

She focused on her work. She prayed. And she saw more of dancer Archie Savage. In January, there was a benefit performance of *Cabin in the Sky* for the Actors Fund. A new policy was also instituted whereby the show was performed at Sunday matinees and Sunday evenings. In February, she appeared at Fefe's Monte Carlo supper club, where she performed songs by Irving Berlin as well as numbers from *Cabin in the Sky*. With a choir backing her, she performed two spirituals, unusual fare for a nightclub. The song that the crowd went wild for, however, was her recent "Bread and Gravy." Not a naughty song like those of the past, "Bread and Gravy" still was a breezy, subdued, sexy number. Though Ethel might have preferred singing more spirituals at this point in her career, her public still preferred the songs that spoke of a woman's romantic hopes and disappointments.

IN MARCH 1941, *Cabin in the Sky* closed. The producers had seen some cash flow into the box office, but the overhead was too high for significant profits. Immediately, a national tour was set up with the original cast that would carry the musical to Boston, Toronto, Detroit, Pittsburgh, Columbus, Indianapolis, St. Louis, and Chicago. Ethel welcomed the chance to get away from New York—and Eddie. During her travels, she was determined to come to some resolve over her relationship, to actually break it off. Friends in New York kept her informed of Mallory's activities, his comings and goings, his flirtations and infatuations, and the attentions he paid to Miss Sullivan.

The tour proved fruitful. Accompanying her was a secretary-assistant, most likely Elida Webb. Her old friends Butterbeans and Susie joined the touring cast. Dancer Archie Savage was also around. Advance bookings in Boston at the Colonial Theatre were sold out, and the show was held over in Detroit. In March, together with other stars from around the country, including, among others, Marian Anderson, Duke Ellington, Louis Armstrong, Bill Robinson, Eddie "Rochester" Anderson, Ella

Fitzgerald, and Anne Wiggins Brown, Ethel performed on a national CBS radio hookup for the Urban League urging "equal participation" in the nation's defense program. This was a continuation of her race work. With growing anxieties about the war abroad, President Roosevelt had begun production of munitions at war plants. Black leader A. Philip Randolph had called for a march on Washington—100,000 African Americans to protest the blatant discrimination in the munitions plants and the military. To avert such a protest, Roosevelt met with Randolph and other Negro leaders. In June, FDR issued Executive Order 8802, which in effect ended racial and religious discrimination in the plants, in government training programs, and in government industries; the military would remain segregated. Nonetheless, A. Philip Randolph called off the proposed march.

Other appearances in other cities followed. In St. Louis, she threw out the first ball of the Negro American League game between the Kansas City Monarchs and the Chicago American Giants. In May, she attended the opening of the Chicago South Side Community Art Center, an event broadcast by CBS. The master of ceremonies was Alain Locke, professor of philosophy at Howard University and a leading light of the Harlem Renaissance. But the ceremony's highlight was the arrival of Eleanor Roosevelt, who greeted Ethel warmly. Ethel believed it was part of her civic and race responsibility to promote opportunities for young African Americans. In June, she learned that she became the first African American elected to the governing board of Actors' Equity. She joined such other board members as Cornelia Otis Skinner, Lillian Gish, and Margaret Webster. Not only did it mark the respect accorded her in New York theater but also a new respect for African Americans as well.

"The notices here were very favorable and the critics kind which I hope will help boost the box office," she wrote Fania Marinoff from Pittsburgh. But something else excited her. "There is some talk of the show going to the coast," she wrote. "I do hope so as it will be a maiden's answer to a prayer." That prayer was indeed answered. *Cabin in the Sky* was booked to open at Los Angeles Philharmonic Auditorium as part of its Civic Light Opera Festival.

California remained an intoxicating breath of fresh air for her, but

now the West Coast represented a different kind of freedom. In New York, she had proven herself and risen to the very top of her profession in music and theater. She had partied and socialized in the upper echelons of the entertainment world. The white stars—from Jolson to Ethel Barrymore to Katharine Cornell—had been forced to recognize her. So had the critics. Audiences from around the country had made special trips to New York to see her perform. Wherever she traveled on her tours, she carried the aura of her extraordinary success in New York with her. But now she sought escape—partly from Mallory, partly from the first half of her life. She was now forty-six years old, and she yearned for rest, for relief. Perhaps she would find it in Los Angeles. Perhaps also she would finally succeed in a medium that still had not fully opened its doors to her—the movies.

# Part Three

# California Dreaming

ONCE SHE STEPPED OFF THE TRAIN in the City of Angels, she was determined to do whatever was necessary to ensure that indeed something did develop. She alerted Gumm back home and the William Morris Agency that she wanted work in pictures. Well aware that an actress, especially on the West Coast, had to be seen, had to make sure she was on everyone's mind, she set out to meet as many people as possible. Fortunately, she remained the kind of star from the East that movie folks still looked up to.

*Cabin in the Sky* opened at the Philharmonic Auditorium—as part of the Light Opera Festival—to a packed house and glowing reviews. "Again and again was Miss Waters applauded," wrote the critic for the *Los Angeles Times*. The musical grossed a whopping $35,000 its first week and was held over for a second. Ethel was booked for an appearance on Bing Crosby's radio show *The Kraft Music Hall*. Among the songs she performed was "Sometimes I Feel Like a Motherless Child," which marked another attempt to take her repertoire in a new direction.

Once *Cabin in the Sky* completed its run, the show played for four weeks in San Francisco. Afterward Ethel informed Gumm and others that she was returning to Los Angeles for a three-month rest. Could that be possible? Of course, it didn't quite happen that way. In San Francisco, Todd Duncan had taken ill with pneumonia, and Ethel and company returned to Los Angeles for a ten-day rest. By then, *Cabin in the Sky* had

been rebooked into LA for an engagement at the Biltmore to open on July 21. At this point, Ethel was earning $5,000 a week.

In Los Angeles, her thoughts returned to the character Hagar. *Cabin in the Sky* was a great showcase for her, the type of musical that movie people loved and showed up to see. But it didn't afford her the opportunity to demonstrate that she could act. *Mamba's Daughters* had never opened on the West Coast. Now was the time. She let Gumm know. She let William Morris know. She was a good pitchwoman as it turned out. "Everyone of importance with whom I have talked in Los Angeles and San Francisco seems anxious for a showing of *Mamba's Daughters*," she told reporter Fay Jackson.

Negotiations also started for a role in an RKO movie called *Syncopation*, to be directed by William Dieterle. In the vein of such previous Hollywood features as *Blues in the Night* and *The Birth of the Blues*, *Syncopation* chronicled the struggles of jazz musicians to find acceptance in the musical world. But of course the jazz musicians in such Hollywood films were white. In this case, the leader of the jazz combo would be played by Jackie Cooper. The leading female character, to be played by Bonita Granville, would be a lively lass, a pianist no less, who, having grown up in New Orleans where she is exposed to those Basin Street melodies, just cannot get that music out of her pretty head. Ethel must have howled at the script. Here she was, a woman who had worked with the best and most creative of jazz artists, from Fletcher Henderson to Ellington to Armstrong; a woman whose blues songs had helped lay the foundation for jazz. Now she was seeing history being rewritten. Though she also worked with and respected such swing masters as the Dorsey Brothers and Benny Goodman, she still must have bristled at the movie's storyline: this Black-created art form, of which she was an important part, was being transformed on the screen into an ofay's thing. Nonetheless, if she could get a role in the film, it would be a few weeks' work that might help her make inroads in pictures.

While she waited to see what developed with *Syncopation*, she accepted an engagement at the Paramount in Los Angeles that proved successful and lucrative. Her estimated earnings from her engagements in Los Angeles and San Francisco were $45,000. Ethel had Reginald Beane

flown in to accompany her. Also on the bill at the Paramount was Katherine Dunham. The atmosphere between the two women was frosty at best. Archie Savage had turned up the heat in his pursuit of Ethel, and for her part, Ethel enjoyed the new friendship. On September 1, she also performed on a special CBS one-hour radio program called *Jubilee*, broadcast from New York and Los Angeles. Inspired by a script by Langston Hughes and Arna Bontemps that had not been produced, the first half of the show highlighted the achievements in Negro theater, hosted by Orson Welles in New York. From Los Angeles, Ethel and Duke Ellington appeared in what was essentially a variety show. Of special interest to Ethel, no doubt, were reports that Welles wanted to present a "true" picture of jazz history by filming the life of Louis Armstrong. Though the Armstrong picture never developed, the thought of it may have sparked Ethel's imagination to one day tell her own life story, perhaps in a book.

In the end, *Syncopation* cast such musicians as Benny Goodman, Charlie Barnet, Gene Krupa, and Harry James. Also cast were Todd Duncan, the Hall Johnson Choir, and Black actress Jessie Grayson as an ever helpful maid. Ethel did not appear in the film, but now something far more important loomed on the horizon.

After hurried negotiations, *Mamba's Daughters* was to begin rehearsals under the direction of John Cornell on August 26. Arriving from the east were Fredi Washington, Willie Bryant, Georgia Burke, Maude Russell, and J. Rosamond Johnson, all repeating the characters they had played on Broadway or during the national tour. Her friends Butterbeans and Susie joined the cast, as did Vincent Price, who played the role of St. Julien Wentworth, originated by José Ferrer. Ethel rented a house and settled in. It now looked as if she intended to stay in Los Angeles.

On September 10, *Mamba's Daughters* opened at the Biltmore Theatre. "Words aren't sufficient to describe the fine acting of Miss Waters," wrote John L. Scott in the *Los Angeles Times*. He also commented on another actress: "Fredi Washington, whom you may remember from the picture *Imitation of Life*, gives a splendid, emotional performance as Lissa." Like others in the film capital, Scott had not forgotten the promise Washington had shown in films. Perhaps both Ethel and Fredi would find work now. Nightly, Ethel and cast received rousing ovations from the audience.

Vincent Price considered her performance "the greatest dramatic acting" he had "ever seen in the theater." The run of the play was extended two additional weeks. With the revived *Mamba's Daughters*, Ethel had accomplished what few actresses before her had ever dreamed of: within a matter of months, she had two theatrical triumphs in Los Angeles. That was not lost on anyone.

Fired up by the dreams of what *Mamba's Daughters* might do for her career and her desire to stay in Los Angeles, she was about to make one of the most dramatic changes in her life. She may have still loved Mallory, but she resolved that it was over between them. The other women in his life, his lack of regard for her, his refusal to meet her midway in untangling the knotty conflicts had taken their toll. New York had taken its toll on her too. There were too many memories there. And the road—the constant traveling, the lack of stability from one night after another in a different city—had drained her. Or so she believed. Ultimately, the road would prove to be too much in her system for her to ever completely leave it. When friends in New York informed her that Eddie had temporarily left the city to play in a Joe Louis golf tournament in Detroit, she made her decisive move. From Los Angeles, she had her secretary make arrangements for movers to go to her home on West 115th Street. Her furniture, her clothes, her personal effects were rapidly packed and loaded into moving vans that brought everything to Los Angeles. Eddie would return home to an empty apartment—and perhaps he would understand the feelings of abandonment and dislocation that she had experienced in the relationship. Next, she wanted Eddie himself out of the house. It was, after all, her home.

When Mallory returned home to find only his clothes and personal items in the apartment, he was shocked, but apparently it did not take him long to recover. A rather relieved and even jubilant Eddie "got on the phone and spread the word that the 'coast was clear.'" He was now in "a mood to play." In the days and weeks that followed, Eddie "held court nightly at Fat Man's on Sugar Hill to scaddles and scoodles of righteous young hens; the little 'handful of nothing' type as well as the lean, willowy class and those with a little meat on their bones." To all who would listen, he let it be known that he had "gained five pounds and lost 15

wrinkles in his face since that moving van took Ethel Waters out of his life." Glad to be done with her once and for all, he was ready to let the good times begin. The fact that Eddie made no attempt to win her back simply poured salt on Ethel's wounds.

The story of the breakup was picked up by the Negro press. So was something else. In coded language that made reference to the war abroad as compared to Ethel's personal life, it was revealed that Ethel was finding solace from a new friend. "Meanwhile, the Russians are counter-attacking; the Nazis are stalled," reported New York's *Amsterdam News*, "and Archie Savage, the bounding dance ace of the Kay Dunham mob, is bouncing higher and higher toward the 'Cabin in the Sky' out where the Pacific laves the California beaches!" Drawing as much attention as Ethel's breakup was this unexpected "friendship" with Miss Dunham's very special dancer. In the meantime, Ethel put off offers for a national tour to concentrate on finding movie work.

# Settling In

O N OCTOBER 4, *MAMBA'S DAUGHTERS* ended its run at the Biltmore, then immediately moved on to San Francisco. Ethel settled into her rented home, in the Negro section of Los Angeles, at 1610 West Thirty-sixth Street. Looking at this sprawling glamorous city, she had to learn the very layout of Los Angeles and figure out how to navigate her way through it, with its canyons and hills, its winding roads and dreamy palm trees that seemed to symbolize the romanticism of the place. In a sense, she was starting out all over again, just as she had done when she first arrived in New York. She had mastered New York's grid, though she kept as close as possible to Harlem. Los Angeles was a car city, which was fine for Ethel, who always loved her custom-made automobiles. Yet unlike New York, Los Angeles, according to its longtime resident Geri Branton, was a very segregated city. Its colored people knew where they could go and where they were not welcome. There were restaurants, department stores, nightclubs, shops, and cafes that catered exclusively to a white clientele. Restrictive housing covenants kept the city divided along racial lines. Deeds to homes specified in some areas that homeowners could not later sell their residences to people of color. Thus Los Angeles' Negro population, as well as its Latino, Japanese, and Chinese citizens, all had their parts of the city where they resided and socialized together. Most African Americans still lived on the east side of the city but gradually were extending the borders to

the west side. In some neighborhoods, African Americans resided with other ethnic groups—without problems.

Within Hollywood, there was a separate community—Black Hollywood—of entertainers with their own neighborhoods, nightclubs, restaurants, after-hours joints, shops, theaters, and cafes. The main thoroughfare in Black Los Angeles was Central Avenue, one of the most glittering streets in town, lined with giddy, steamy clubs, restaurants, shops, and cafes. Talent scouts and studio executives had long come to the Black nightclubs for fabulous nights on the town where the sepia chorus girls were always stunning and the singers, dancers, and comics often extraordinary. Quiet as it was kept, the nightclub and music scene in Black Los Angeles was every bit as vital and vibrant as Harlem's. The centerpiece of Central Avenue was the Dunbar Hotel, once known as the Somerville Hotel, built in the late 1920s under the leadership of African American dentist John Somerville. Aware that the main hotels like the Roosevelt, the Ambassador, and the Beverly Hills closed their doors to prominent Black visitors, Somerville established a place with all the amenities of any first-rate hotel. In time, stars like Ellington, Armstrong, Lena Horne, Count Basie, Langston Hughes, Billie Holiday, Thurgood Marshall and W. E. B. DuBois all stayed there, ate in its well-tended restaurant, hopped over to the adjacent nightclub, and stargazed as much as any tourist. On any given day, one might see the Nicholas brothers, the young Dorothy Dandridge, Eddie "Rochester" Anderson, the team of Buck and Bubbles, or other stars. Such white stars as Cary Grant, Randolph Scott, James Cagney, and Gary Cooper also dropped into the Dunbar's cocktail lounge.

The big names in Black Hollywood were now Eddie "Rochester" Anderson, who had risen to fame on the radio and in movies as the right-hand man of Jack Benny and, of course, Hattie McDaniel, whose Oscar win as Best Supporting Actress of 1939 for her performance in *Gone with the Wind* signaled a new day for African Americans in the movie capital. What most people did not realize in 1941 was that the movies were about to undergo a major transition, comparable to the change that occurred in 1929 with the dawn of sound, but this one brought about by World War

II. At present, however, the old regime reigned, and it welcomed Ethel. In September, Hattie McDaniel hosted a series of buffet dinners to honor entertainers at her Westside home, where she resided with her third husband, James Crawford. At the first such evening, she paid tribute to Ethel, along with the vaudeville team Butterbeans and Susie. This welcoming party drew an array of personalities. Her unprecedented success on Broadway—perhaps more than her best-selling records—made her a prized item for Black Hollywood as well as the larger Hollywood community. Almost no African American performer working in movies garnered the kind of respect and admiration that she did.

"Everyone was impressed because here was this Broadway star," recalled actor-singer-dancer Lennie Bluett. As a boy, he had seen her in *Rufus Jones for President.* "I was very excited about meeting a big Black star. She had a great voice. She was very ladylike and had a great sense of humor. She kept herself very together. She reminded me of my mother, who was also stately and tall. She was very well groomed."

FINALLY, A MOVIE ROLE APPEARED. Darryl F. Zanuck, who had headed production at Warner Bros. when Ethel first arrived in Los Angeles and had put her in *On with the Show*, now was production chief at Twentieth Century Fox, which was about to go into production on the feature *Tales of Manhattan*, to be directed by Julien Duvivier and shot by cinematographer Joseph Walker. The film was an episodic five-part saga that traced the travels of a tailcoat—a dress coat—as it was passed from one owner to another, most of whom seemed cursed by it. Twentieth Century Fox had engaged an all-star cast: Rita Hayworth, Charles Boyer, Ginger Rogers, Henry Fonda, Charles Laughton, Edward G. Robinson, and W. C. Fields, whose episode ended up being edited out of the picture. The concluding section follows the tailcoat, filled with money, as it is dropped from an airplane onto a field where Negro sharecroppers toil. They assume it is a gift from God. For that segment, the studio signed Ethel, Paul Robeson, Eddie "Rochester" Anderson, and the Hall Johnson Choir. Ethel's services would be required for ten days, beginning in early December. Though not a movie version of *Mamba's Daughters*, it was a major production.

The job offer came at just the right time. Over the years, she had continued to make substantial donations to the small Catholic school in Pennsylvania run by the Carmelite order of nuns. When the order asked for help in putting in a new sewage system that would cost $5,000, Ethel was not sure what she would be able to do. "I didn't have that amount of money," she said, "so I just started praying." That very night, she said, a call came from producer S. P. Eagle, with news of *Tales of Manhattan*. The money she earned from the film would go to the school in Pennsylvania.

While preparing for the film, she searched for a home to buy, which proved frustrating. Residential areas that appealed to her were closed to Negroes. Though preoccupied with her housing situation, she also thought about Mallory. Resolved as she was that their relationship was over, she still hadn't gotten him out of her system. On November 2, she wrote the Van Vechtens:

Yes, I've at last made the break and decided to try and make a go of it out here in the west. Regardless of what is said against me, God and I know what I've stood and [taken] in silence for the past four years—and because I kept my temper and mouth shut, people thought I was just dumb and blind. And things kept on getting bolder and worse instead of better so *it* got to the place of choice again between my career or temper. So God stepped in again & got me out [of] that situation before it was too late as I was at the breaking point. Now for something pleasant at this writing, I'm feeling fair and not yet used to so *much peace & tranquility*—smile. . . . I'm also looking for a house as my furniture is here but so far have been unfortunate due to the Color Question and because I'm only renting. But God will also work that out at the right time.

With the help of Los Angeles realtor Albert Bauman, she bought and quickly moved into a charming home at 2127 Hobart Street, which was located in what was first known as the Blueberry Hill section but now called Sugar Hill (after Harlem's famed area). With beautifully landscaped and manicured lawns on wide tree-lined streets, many of the spacious, well-attended homes had once been owned by affluent whites who

had sold their homes at good prices and fled to other areas when they saw that Los Angeles' Negro community was stretching its boundaries and moving farther west. Here some of the top stars in Black Hollywood now resided. Her neighbors were Ben Carter, an actor who also was an agent for Black performers in desperate need of representation; actress Louise Beavers, best known for her role as the submissive mother in the 1934 *Imitation of Life*; and the grande dame herself, Hattie McDaniel. Eddie "Rochester" Anderson lived nearby. Their images on-screen were as accommodating comic servants with wide smiles and bright eyes. Off-screen, however, they lived in high style with their own servants. Many, like Beavers and McDaniel, were active in the Negro community and were well thought of and admired.

The stars all naturally knew one another, and true to Hollywood's lifestyle, they drove beautiful cars and entertained on a lavish scale, with elegant teas, dinners, receptions, and parties. Louise Beavers liked poker games that ran into the early hours of the morning. Eddie Anderson, who lived in a home designed by African American architect Paul Williams, opened his swimming pool to the Black kids in the neighborhood. Hattie McDaniel collected books and antiques. "She had the most exquisite home I've ever seen in my life," said Lena Horne. "The best of everything." Ethel's new three-story home had ten rooms. Out front "were stately old trees." Ethel quickly took up gardening and also set up a badminton court on her lawn.

"This is where I'm going to live for a long *time*," she told the Van Vechtens. She also discussed her role in *Tales of Manhattan*. "I'm praying I make good at my part which is not very large but it's my first character part and I'm hoping it's not my last because I've exhausted every one of my talents to prove to them out here I can do other than sing and dance."

Visiting Ethel at this time was Zora Neale Hurston, who, like Ethel, had Hollywood dreams. Hurston hoped a studio might adapt one of her books for the screen. In October, Paramount Pictures hired her as a "story consultant," and she also worked on her autobiography *Dust Tracks on a Road*, in which she wrote that Ethel was one of the two women she most admired. The other was novelist Fannie Hurst. Still as much under the

spell of Ethel as before, Hurston seemed endlessly fascinated by her. "She is gay and somber by turns," recalled Hurston. "I have listened to her telling a story and noticed her change of mood in mid-story. I have asked her to repeat something particularly pungent that she has said, and had her tell me, 'I couldn't say it now. My thoughts are different. Sometimes when I am thinking that same way, I'll tell it to you again.'" Clearly, Ethel, ever the performer, was usually onstage, even when off. Her daily conversations—punctuated with showy gestures—seemed a part of a self-created dramatic narrative, or sometimes a dramatic monologue.

Moving into the home with Ethel was dancer Archie Savage, who now had become her close friend, confidant, secretary, and assistant. Seeing Ethel and Archie together, Hurston commented that "the affair is on." Hurston was convinced that Ethel was in love with Savage and that the two would marry "because they are eternally together." She also believed Savage had broadened Ethel's interests, and that part of the attraction for Ethel was the world he had opened up to her. "He has given her a taste for things outside the theater like art museums and operas. He has sold her on the pictures, statues, and paintings." Perceptive as Hurston was, she may have romanticized this aspect of the relationship because, even before meeting Savage, Ethel had already socialized with some of the most creative people in the arts. Yet perhaps Savage helped deepen some of her interests.

Uppermost in Hurston's mind, however, was her own friendship with Waters. Entranced by Ethel, she seemed at times to have a crush on her. "One day I sat in her living room on Hobart Street," she recalled, "deep in thought. I had really forgotten that others were present. She nudged Archie Savage and pointed at me. 'Salvation looking at the temple forlorn,' she commented and laughed. 'What you doing, Zora? Pasturing in your mind?'" "It's nice to be talking things over with you, Zora,' Ethel told her. "Conversation is the ceremony of companionship."

IN A SHORT PERIOD OF TIME, Ethel participated in several fundraisers to aid Los Angeles' Black community. With Robeson and Eddie Anderson, she attended a benefit to raise money to build a residence for young

women who were members of the Young Women's Christian Association. No matter how much she might rant and rave with her fellow actors, her charitable work, always genuine, helped her redeem herself in the eyes of her compatriots. With growing rumblings of the United States' future involvement in the European war, celebrities were being mobilized to help boost the morale of the boys in uniform. Often overlooked, from Ethel's perspective, were the colored boys ready to fight for their country. Whenever possible, she did whatever she could to show her support for the Negro soldier. In November, she appeared at a dance for Negro servicemen from Camp San Luis Obispo and Camp Haan at the Elks Hall on Central Avenue. It was the first event of its kind held in Los Angeles.

Then came the event that stunned the nation. On the morning of December 7, 1941, 189 Japanese planes attacked Pearl Harbor, dropping torpedo bombs on the eight battleships there. At the time—around 7:30 a.m.—some sailors were sleeping, others were having breakfast. A Black messman named Dorie Miller on the USS *Arizona* manned a machine gun and brought down four planes. He was awarded the Navy Cross. In the end, 3,500 servicemen were killed by the Japanese. President Roosevelt rallied the nation. The United States was now at war.

ETHEL SPENT HER FIRST CHRISTMAS in Los Angeles with the war on her mind. There was also the strange sensation of a Christmas without snow and bitter cold, without overcoats, gloves, mittens, and scarves but with swaying palm trees, clear, balmy days, and sweetly cool nights. It might take some adjusting to, but she still felt Los Angeles was where she wanted to be.

In January, she learned that on New Year's Eve, Mallory, her onetime "Pretty Eddie," had married an African American blond model named Marion Robinson. A native of Philadelphia, Robinson had been the first Black model to be signed by the John Powers Modeling Agency. The couple had met on the golf course and fallen in love while Eddie was teaching her how to play the game. Robinson's parents had announced the nuptials. The two planned to remarry in an elaborate church ceremony on Easter Sunday. Eddie also opened a new cabaret in the Bronx.

The news of the marriage must have stunned and depressed Waters, and even led to one of her spells of "nervousness," those anxiety-ridden times when she wasn't sure what to do with herself. Yet though the marriage was reported by the Negro press and though Eddie was referred to as the former husband of star Ethel Waters, nothing was said about a divorce, when such a divorce had taken place, what the terms of the divorce settlement were, or who the attorneys for the two parties were. Nor did anyone publicly ask how the two could have divorced so quickly. Nor did Ethel or Eddie publicly speak about a divorce. There would have been no need for one if the two had indeed never married.

"At this writing I'm still relaxing *under pressure*," she told Van Vechten on January 5, 1942. "But in the meantime I'm busy getting my house straight & fixed up." She was still "praying I get another picture so I *won't* have to play a few vaudeville [dates] to keep the old Pot *a* boiling. Because I don't want to come east meaning New York unless I'd get a [Broadway] show. So if I do a few dates it will be west & central west. So pray for me Darling that it's either a New York show or a Calif. Picture." She added: "You & Fania & just a few of my other Nordic pals are the only ones I really miss out here because I was so terribly unhappy in New York. And where I can't say I'm so happy, I at least am finding peace."

Or so she hoped.

Nothing was firm yet about movie work, although the prospects were promising. Some studios balked at her asking price. "My studio wanted Ethel badly," said one executive, "but the figures asked for her services would leave little for the rest of the cast." Most likely Ethel's attitude was that if they were paying whites big salaries, what was the problem with giving her decent pay? In the meantime, she needed money. Consequently, despite her unhappiness in New York, she was forced to make plans for a trip east for some tour dates. "It's because of the monastery that I'm forced to it," she told the Van Vechtens. But she dreaded a return to Harlem. "At last I'm throwing myself on your mercy to get me accommodation in a white hotel," she wrote Van Vechten. 'Downtown Room & Bath no more than $5 a day which I'm used to paying *smile* or wkly Rates of 21 to 25. I know Marian [Anderson] stays in a quiet Hotel on a side street and I'm praying I'll be that fortunate as I have reason

for not wanting to live in Harlem. . . . So I'm asking St Theresa and St Martin who I *do* know very well to grant me this desire for my peace of mind." Uptown, there were too many memories of life with Eddie, the places they went, the people they knew. If anything, she wanted seclusion. But she wouldn't be alone. Archie Savage, or Sunny as she called him, would be making the trip with her.

ONCE EAST, she played movie houses. As she had always done, she performed between showings of features. But these tour dates were no ordinary run-of-the-mill affairs. On different occasions, she performed with both Duke Ellington and Count Basie. These major bandleaders demanded a different kind of discipline. Ethel did not treat them as she had Fletcher Henderson, yet she never hesitated to speak her mind. Both men had their own preferred singers. Ellington thought there was no one like Ivie Anderson. He also enjoyed not only the style but the heartthrob appeal of handsome Herb Jeffries, who had women swooning when he sang "Flamingo." Anderson and Jeffries were on the bill when Ethel appeared with the Duke in Boston, and then at the Stanley in Philadelphia, and later a return at the city's Earle Theatre. As usual, she liked being back in Philly, but she also could expect the handouts to family members. And she worried about her mother's fragile emotional state and the care she received. Family matters were still delegated to her sister Genevieve. She also was in communication with the Waters side of the family, which she most likely considered far more stable. With Basie, she played Chicago, Cleveland, and Detroit. She also appeared at Brooklyn's Strand with Stepin Fetchit and Les Hite's band. All the engagements went well. At the Cleveland performance with Basie, the box-office receipts came to $20,000.

In New York, Ethel, with Archie in tow, had dinner at the Van Vechtens'. She also performed, along with pianist Hazel Scott, for Black soldiers at the Stage Door Canteen on Broadway. During the war years, the Stage Door Canteen, and later the Hollywood Canteen, provided special entertainment for servicemen on leave. Sometimes the stars served food; other times they danced with the military men. In New York, the grand

theater stars—from Katharine Cornell to Helen Hayes—turned up. Once more, Ethel felt it crucial that the colored boys get attention too.

During the trip, a sore point for Ethel, to put it mildly, were the snide remarks in the press about her weight, even more pronounced than before. One columnist commented that Ethel "shows a gain of many pounds," which meant that the West Coast "must have agreed with her appetite if nothing else." Her lack of discipline was always a problem, said one of her secretaries. She still preferred a soul food diet: the fried chicken, the collard greens, the candied yams, the pies, the cakes. A special treat—one served to her as a child in Chester and Philadelphia—was a mix of cooked potatoes and onions. She also enjoyed sweets.

But she knew she'd have to do something about her weight because a deal had been negotiated for her to make a new film, *Cairo*, at MGM. Filming would start in April on the coast, and her part would take six weeks to shoot. Immediately, she called off plans for the rest of her tour and headed back to Los Angeles.

METRO-GOLDWYN-MAYER remained the largest and most powerful Hollywood studio. Established in 1924 and sitting on 167 acres in Culver City, MGM was a municipality unto itself, with its own police force of fifty officers, its own publicity and research departments, its own dentist, even its own chiropractor. There were vast soundstages, huge wardrobe and prop departments, and a foundry, as well as an in-house electrical plant, which supplied power to the studio. MGM owned forty cameras. At its peak, it employed 6,000 people. Some 2,700 people ate daily in its commissary. Known for its promotional slogan of having more stars than heaven, at MGM icons such as Garbo, Gable, Crawford, Harlow, Tracy, Hepburn, Garland, Rooney, the Barrymores, and Elizabeth Taylor were under contract at one time or another,. Not a bad place for Ethel to formally begin her movie career. All her other movie work had simply been a prelude. This was the real thing.

To be directed by Major W. S. Van Dyke II—known to everyone as Woody Van Dyke or "One-Shot Woody" because he worked quickly and rarely did retakes—*Cairo* would be a romantic caper, featuring MGM's

singing star Jeanette MacDonald and Robert Young. Van Dyke had previously directed such commercially successful films as *The Thin Man* and several of its sequels, *Manhattan Melodrama*, and *San Francisco*, which had also starred MacDonald with Gable and Tracy. When the Black press announced that *Cairo* was set for production, there was excitement that Hollywood was putting Ethel to work. But there was also disappointment and frustration when it was learned that Negro America's greatest star would play MacDonald's maid, a character named Cleona Jones. Ethel didn't like the idea either. But it was movie work, and MGM had met her demands, the kind Black stars in the film capital generally would not have dreamed of making. The studio agreed to fly in Reginald Beane to work with her on the arrangements of her musical numbers over which she had "full say." Songs by Harold Arlen, E. Y. "Yip" Harburg, and Arthur Schwartz were being used. Dooley Wilson was cast as a quasi-romantic interest for Ethel.

Prior to filming, Waters grew anxious about her forthcoming appearance on camera, especially in close-ups. Obviously, her weight was an issue. So was the gap between her front teeth. "Because of picture work she wants to have her gap in the front closed permanently," Archie wrote Van Vechten: "I suggested that she try to have a fixture which would be removable at will and also a permanent thing when necessary. She now uses a little gadget that falls and of which she is quite uncomfortable working with." In the end, her dentist created a special plate that could be removed when she wasn't on-screen and which proved more comfortable than the gadget.

At her home on Hobart, she underwent a sometimes frantic effort to lose weight. The camera, as everyone in Hollywood knew, added ten pounds. Stars sought to be pencil-thin because they would always look heavier on-screen. In the past, she fasted. But not this time. "She is losing weight," said Savage, "and it's done with ease no fasting and no dieting. How is a complete mystery to everyone." Savage learned, however, that Ethel had consulted a physician who gave her injections, and perhaps an early form of diet pills with Benzedrine. In these years, no one knew the effects of the drug, short-term or long-term, but Savage saw that she became more high-strung and nervous, easily agitated. She also installed a weight reduction machine in her home. There she'd sit, hoping the steam

would melt the pounds away. In time, it all helped, but in *Cairo* she would look heavier than anyone could remember.

As she waited to begin shooting her scenes, there was also a flurry of activity in the offices of Harold Gumm in New York and William Morris in Los Angeles. MGM planned filming *Cabin in the Sky*. Though Ethel had not signed up for the film, everyone assumed the role of Petunia would be hers. Also being negotiated was a deal for her to play Lavinia in the Vincent Youmans musical *Hit the Deck*, to be performed as part of the Los Angeles Civic Light Opera season. She also tested for the Warner Bros. film *Saratoga Trunk*, which would star Ingrid Bergman as Clio Dulaine, a Creole beauty in New Orleans, and Gary Cooper as the dashing Texas gambler who pursues her. The role Ethel hoped to play was another maid part, Angelique. So eager was she to appear in the film that she performed at a Warner Club. She was not particularly happy about the engagement. But, said Archie, "since it might aid her getting the part, it was the wise thing to do." Also considered for the role was the young Lena Horne, now on the West Coast and soon to be an MGM fixture in musicals.

In the end, Ethel lost the part. Her salary demands may have wrecked the deal. The studio cast British actress Flora Robson, in dark makeup, to play the role. By this date in film history, the use of what was essentially blackface was embarrassing and offensive. But Warner did not seem to give the casting a second thought. Still, for Ethel, it was a great disappointment. Shot in 1943, the film would not be released until 1945.

WORK ON *CAIRO* WENT SMOOTHLY. No outbursts. No loud use of profanity. She actually appeared to like her costars. "They are quite chummy, she, MacDonald, and Young," said Archie Savage, who often visited the set. Director Van Dyke was "very pleased with her work." Sometimes Ethel was playful with her costars. During preproduction, Ethel recorded her songs, one of which was "Robert E. Lee." Woody Van Dyke liked it so much that it was decided to have Jeanette MacDonald do an imitation of it in the film. When MacDonald did a shuffle and throaty impersonation of Ethel's number, Hedda Hopper reported that Ethel and Van Dyke "ganged up afterward and sent her a telegram signed 'Duke Ellington,'

offering her a job in the Central Ave. Cotton Club." Despite the relaxed attitude on set, Savage never liked the Waters role. For Waters herself, according to Savage, it was "a difficult piece" because she didn't "fit as a maid, whether personal or otherwise. In the first place her stature is not that of the average maid, and her regal appearance is definite." Both she and Savage must have asked why Hollywood could not come up with anything better for her. The Negro press had the same question. "And a lot of folks," wrote New York's *Amsterdam News*, "can't understand how Ethel Waters, our 'First Lady of the Theatre,' with all her prestige, ability and drawing power, would consent to play the part of a maid in these days and times." In the finished film, Ethel rarely looked wholly at ease. In some scenes, she appeared to just stand around. Actors always knew that in every scene, even in those in which they did not speak, they had to react in some way to what was being said. Even when not in close-up, they still had to be in character both with their expressions and their body language, signaling that they were involved in the action of the scene. Surprisingly, sometimes Ethel looked detached, as if unsure what to do, or perhaps covertly resentful of what she was supposed to be in the movie. Some of this detachment may have been the result of her inexperience in front of the camera. She had only done short films, musical interludes in features, and the episode at the conclusion of *Tales of Manhattan*. Interestingly, such detachment did not occur in her film roles that followed. It would appear as if she studied her *Cairo* character and determined never to be out of character again.

*Cairo*, however, did include a scene in which Ethel discarded her maid's uniform to perform a song in a nightclub setting—during which Dooley Wilson's character first sets eyes on her and is entranced. Here she was glammed up in a dark flowing gown—a caftan of sorts—and with sparkling jewels. Though she looked heavy, she was no frump, and she retained her sex appeal.

Production on *Cairo* fell behind schedule. Though no one was publicly saying it, the picture was in trouble. "They seem to be dissatisfied with some of the Jeanette scenes," Savage informed Van Vechten, "so they are rewriting some of the scenes, which means the pic won't be finished on schedule unless something happens. This I'm afraid will hold up her going

into 'Hit the Deck,' which I'll hate to see, but she had foresight enough to protect herself when signing to do it, it is a tentative agreement based on the fact of the pic being finished."

By late April, *Cairo* had further delays. That proved beneficial to Ethel because it enabled her to drop out of *Hit the Deck*. At her insistence, the book for the play had been reworked. But she still was dissatisfied. As far as she was concerned, it "stunk and at this late date she couldn't afford to take chances," said Archie. Nor did she like the casting. "It was one of those things where she was to carry the entire thing on her back and also pave the way for a few people Hollywood's trying to make stars of. This as she says would only hurt her and maybe queer her chances for other pictures." *Hit the Deck* opened with Ruby Dandridge in the lead. Glad to be out of the production, Ethel appeared to blame Gumm for getting her involved in the first place. It was a sign of conflicts between the two that would follow.

IN HOLLYWOOD, entertainers rallied around the war effort, attending benefits and fundraisers, selling war bonds, and entertaining the troops. Stars like Clark Gable and Jimmy Stewart enlisted in the military. Bette Davis and John Garfield set in motion the launching of the Hollywood Canteen, similar to New York's Stage Door Canteen, a place where servicemen on the West Coast could come for refreshments and entertainment. There, glamorous stars like Barbara Stanwyck, Ida Lupino, and Joan Crawford danced and talked with young military men. Duke Ellington and Lena Horne, still relatively new to Hollywood, entertained there. The wives of the Nicholas Brothers, Dorothy Dandridge and Geri Nicholas (later Geri Branton), also helped at the Hollywood Canteen. Other young Black women were dance hostesses. In Black Hollywood, there was a concerted effort to grant the Negro soldier the same attention and treatment as his white counterpart. At the Hollywood Canteen, there was occasionally interracial dancing, or "race mixing," as it was then termed, which led to controversy. But Bette Davis, a staunch liberal, announced that there would be no discrimination. Weren't Negro soldiers taking the same bullets as whites?

Major stars also made up the Hollywood Victory Committee. Hattie McDaniel served on it, along with Clark Gable, Jack Benny, Irene Dunne, James Cagney, Ginger Rogers, Charles Boyer, Claudette Colbert, Gary Cooper, Cary Grant, Bob Hope, Myrna Loy, Tyrone Power, Bette Davis, and John Garfield. McDaniel enlisted the services of such Black Hollywood luminaries as Fayard Nicholas, Louise Beavers, Ben Carter, and Lillian Randolph. Ethel also threw herself into a steady round of wartime work. Under the auspices of the committee, she appeared with the Nicholas Brothers at a huge star-studded program at the Wilshire Theatre on May 9. Waters also helped sponsor a licensed unit of Negro women in the California state militia. Working voluntarily without pay, the group purchased its own uniforms and could be called into service if there was an invasion along the California coast, as many feared. Because of her professional commitments, she could not participate in all the group's activities; thus she accepted an honorary membership. At a ceremony presided over by Governor Culbert Olson at the California State Armory, she boosted the morale of the troops with a deeply felt rendition of "God Bless America." But observers noted that she wasn't always sure of the lyrics. "It was too funny," said Archie, "as Mayor [of Los Angeles] didn't [know the lyrics] either and neither did most of the soldiers" who joined in for the second chorus.

Once again, it marked the appearance of the socially conscious Ethel who believed in fighting for the disadvantaged and the disaffiliated; the Ethel who continued to help the nuns in Pennsylvania; the Ethel who believed that her country had to rid itself of its social, political, and racial injustices. The work that she did during the war never had one false move, never one act of insincerity. It was Waters at her best, at her most patriotic and most heroic.

AT MGM, *Cabin in the Sky* started to fall into place. Originally, the studio had wanted Robeson as Little Joe and Cab Calloway in the role of Lucifer Jr. Neither was cast. For Robeson, it clearly would have been a mistake to play this likable but illiterate and dim character. There was some talk of casting Dooley Wilson in the role, but that didn't work out

either. Finally, Eddie "Rochester" Anderson, then the most popular Black actor working in Hollywood, was cast. Rex Ingram was signed to play Lucifer Jr. Cast to play the devil's henchmen were Louis Armstrong, Mantan Moreland, and Willie Best. Other roles went to Butterfly McQueen, Ruby Dandridge, Kenneth Spencer, and dancer Bill Bailey. In the big climactic nightclub sequence, Duke Ellington appeared, along with Buck and Bubbles—the spectacular John "Bubbles" Sublett and his partner Ford Lee Washington. Vivian Dandridge, the daughter of Ruby and sister of Dorothy, and Lennie Bluett were among the dancers.

For a time, there were whispers that the studio planned to cast Hattie McDaniel, then Hollywood's most important Black female star, as Petunia, but fortunately, this did not happen. For all her talent—and McDaniel was an immensely talented woman with a perfect sense of timing and a powerful screen persona—it's doubtful that she could have pulled off Petunia's sexuality, especially in the climactic nightclub sequence.

By now, Vincente Minnelli had left New York and was establishing himself in the film colony. During his apprenticeship at MGM, he had directed musical sequences of the studio's films. *Cabin in the Sky* would mark his feature film directorial debut. Afterward, he would become the master of the American movie musical, perhaps its most gifted director, with such movies as *Meet Me in St. Louis* and *Gigi*. As dazzled by Ethel's talents as he had been when he directed her in *At Home Abroad*, Minnelli let the studio know that no one, not even the Oscar-winning McDaniel, could play Petunia but Waters.

There was another big cast change, though. It was decided not to use Dunham and her dance company. The role of Georgia Brown would now be more of a glamorous seductress. There was talk that Fredi Washington would be cast as Georgia. In the end, Washington, however, was considered a dramatic actress, not a singer-dancer, even though she had performed in *Shuffle Along* and toured as a dancer in Europe. Had Washington played Georgia, the making of *Cabin in the Sky* might have been an entirely different kind of experience. In Ethel's mind, Washington was still Lissa, the angelic daughter of Hagar in need of protection.

But the studio opted for a singer from New York whom it had recently signed and who was getting a big buildup. The singer had already been

directed by Minnelli in the musical sequence of *Panama Hattie*. He had worked closely with her, believed in her talents, and was eager to have her in the picture. That singer, Lena Horne, was the perfect kind of young glamorous siren to be in competition with Petunia for Little Joe. The studio was happy about the choice of Horne, Minnelli was happy, but Ethel was most definitely not—a fact that she would eventually make known. *Cabin in the Sky* would end up being a difficult film for Waters—and for Horne.

During the preparations for the movie, Archie Savage saw an opportunity for himself. Earlier he had opened with the Dunham troupe at Felix Young's LA club, the Little Troc, where Lena Horne had been the headliner. Now he wanted work in *Cabin in the Sky*. "I think it's O.K. to tell you that I'm trying to get a contract from M.G.M. to stage the dances for 'Cabin' and I've had a few conferences with them," he told Van Vechten, "but in this business it's one suspense after another. So I wait at my phone as all Hollywood does watching, hoping and listening for their decision. All this is accompanied by prayers from Ethel and myself. Oh, yes, the rest of the household too." "All this" was also accompanied by Ethel putting in a good word for him at MGM.

In late June, Ethel opened for a two-week engagement at the Little Troc, and her war work continued. Joining Bette Davis, Hattie McDaniel, and other members of the Hollywood Victory Committee, she journeyed on July 28 to the southwest mountain desert town of Camp Lockett, California, for a seventy-fifth anniversary tribute to the legendary regiment of Negro soldiers, the Tenth Cavalry, known at one time as the Buffalo Soldiers. This was also the unit that in 1898 helped drive Spanish forces from positions at La Guosimas, Cuba, and later made the charge at El Caney to relieve Theodore Roosevelt's Rough Riders. By celebrating the Tenth Cavalry, the group was also encouraging the current Negro troops: their valor and dedication to their country were not going unnoticed or unappreciated.

HER SOCIAL LIFE in Los Angeles remained as full as ever too. Automobiles glided up the wide boulevards and into the drives of the beau-

tiful homes for evenings of lavish entertainment. The excitement was almost palpable as the maids, butlers, cooks, and guests who arrived early wondered what elegantly dressed person would emerge when the car doors opened. With the warm weather, the spacious back lawns, and the beautifully designed patios, hosts could entertain outdoors as well as in. Guests might stroll from the living rooms and dining areas outside for cocktails or buffets under lemon or fig trees. Sometimes tents were hoisted up. Sometimes guests might spot victory gardens in which celebrated Angelenos, like everyone else in a time of rationing, grew their own vegetables.

Hollywood personalities could be pretentious but not in the highly intellectualized manner of guests in the East. Here the emphasis was far more on conspicuous consumption. Often enough, the talk was about the latest acquisition, be it a car, a home, or some new gadget. Theater people in New York could be as materialistic as anyone out West, but the signs of money or wealth were far more subtle and less imposing. They certainly were not so openly discussed. Here also most conversations, in one way or another, centered around the film industry, what picture was about to go into production, who would direct, what parts were available for Black performers. Socially, Black and white Hollywood were separate entities. Some stars, like the Nicholas Brothers and their wives, were invited to the homes of white stars like Eleanor Powell or later Gene Kelly and his wife, Betsy Blair. Lena Horne would also be a guest at the home of Kelly and Blair and other major white players in the industry. Ethel was certainly in a position where she too might be invited to gatherings of white stars, but for her, integrated gatherings were nothing like those she had become accustomed to in New York, such as dinners and parties at the Van Vechtens' or Georgette Harvey's. For the most part in Hollywood, however, there was not much race mixing.

In August, she attended a huge party at the home of her neighbor McDaniel in honor of Count Basie. That evening it looked as if all of Black Hollywood's top stars had turned out: the Nicholas Brothers—Harold and Fayard—along with wives Dorothy Dandridge and Geri Pate Nicholas and their mother, Viola Nicholas; Hall Johnson; Lena Horne; Clarence Muse; Ernest "Sunshine Sammy" Morrison; Black film producer

William Alexander; bandleaders Cab Calloway and Les Hite; Lillian Randolph; Lennie Bluett; Nicodemus Stewart; Ben Carter; Black entertainment columnist Harry Levette; and countless others. Like everyone else in town, Ethel loved the big parties, the flashbulbs popping, the stunningly dressed stars greeting one another, and smiling through their teeth at people they could not otherwise stand: everyone eager to make contact and connections, often looking over their shoulders to see who was on the other side of the room who might be more important. During the war years, Black Hollywood was all the more cohesive, everyone eager to have fun and enjoy today or tonight because no one knew what tomorrow might bring.

WITHIN THE NEGRO PRESS, there was talk and excitement about the forthcoming *Cabin in the Sky*, the first all-Black Hollywood movie since *The Green Pastures*. Those who remembered *Hallelujah* and *Hearts in Dixie* knew it was only the fourth such Black feature in the movie capital's history. "Hollywood to Star More Race Artists: Ethel Waters Led Way with Superb Cabin in the Sky," read the headline in the July 4, 1942, edition of the *Philadelphia Tribune*. But at the same time, the Black press appeared guarded in its enthusiasm. It did not want another naïve depiction of the Negro as had been the case with *The Green Pastures*. "To this day Negroes have never forgiven the slanderous misrepresentation of *The Green Pastures*," said choral director Hall Johnson, "when after five successful years on the stage it was finally made into a picture, they do not hesitate to express their true feelings about it."

Now the Black press was also calling for "Double V" or "Double Victory," which meant a victory abroad against Nazism and fascism and a victory at home against racism and Jim Crow. That included, of course, a victory over Hollywood's past depiction of African Americans. Black newspapers, especially the *Los Angeles Sentinel* and the *Los Angeles Tribune*, had grown increasingly critical of the stereotyped roles played by Blacks in the movies. In the *California Eagle*, Earl Dancer had written columns criticizing Hollywood's Black movies of the past, and the stunning actress Theresa Harris had courageously spoken about the lack of

significant parts offered her. In 1942, the NAACP's executive secretary, Walter White, visited Hollywood, met with studio leaders, and asked for new treatment of the Negro as a normal human being. For White and many others, the movies' comic servants, with their outlandish dialects and antics, had to go. There was a determination to "discourage the making of pictures which obviously [held] the Negro character up to ridicule and burlesque," wrote the *Chicago Defender*.

Older established stars grew nervous, in some cases frantic, about their careers and their basic livelihoods. Hattie McDaniel may have won the Oscar, but her type of mammy character was starting to look like a relic from the past. So were the lazy-man characters of Willie Best and the bug-eyed shenanigans of Mantan Moreland. Already Stepin Fetchit was considered passé. Walter White and others saw Hollywood newcomer Lena Horne as a sign of progress, a ray of hope. He was determined that she not end up playing maid roles, that she be cast in dignified parts. Because of the support she had from White, Horne was viewed suspiciously by the older cadre of actors, though she said that an actress who offered support and wise counseling was McDaniel. Eddie "Rochester" Anderson also proved to be a friend.

For Ethel, one of the first signs of a backlash against the traditional way Blacks were depicted occurred when *Tales of Manhattan* opened to great criticism in August 1942. Black leaders and moviegoers were outraged by the concluding segment of the film in which the Black characters assumed that the tailcoat with all the money that had fallen out of an airplane had in fact been dropped from the Lord above. When *Tales of Manhattan* played the Loew's State Theatre in Los Angeles, pickets stood outside, led by Leon Washington, the publisher of the *Los Angeles Sentinel*, and Almena Davis, editor of the *Los Angeles Tribune*. "No one here hardly understands what the picketing was all about," reported Black columnist Lawrence LaMar, who at heart supported the Black Hollywood he covered. Though the protest was reported to have "fizzled down," a point had been made. In New York's *Amsterdam News*, Marian Freeman commented that the film "leaves much to be desired as entertainment." She also wrote: "It is difficult to reconcile the Paul Robeson, who has almost single-handedly waged the battle for recognition of the Negro as a true

artist, with the 'Luke' [Robeson's character] of this film." She added: "We have a battle to fight, and it's not solely with producers. It's with our Ethel Waters and Paul Robesons who, we believe, can lead the way by refusing roles like the 'Luke' and 'Esther' of 'Tales of Manhattan.'" She took her criticism even further: "It is also with the progressive elements of theatre audiences, both white and black, who can effectively voice their objections to Negroes being 'typed' in menial roles, and stifled of any true art that may have emerged."

The actors in *Tales of Manhattan* were stunned by the criticism. At his home, Eddie "Rochester" Anderson held a secret meeting with other Black performers to devise ways to prevent future picket lines at Black films. Apparently, neither Ethel nor Robeson attended the meeting. For his part, Robeson was angered not by the protests but by the film itself. He informed the Negro press that "only after he had signed the contract and commenced shooting on the picture did he fully realize the import of the scene. It was then that he approached producer Boris Morros and suggested that the script be changed. This was not done and the singer was forced to go through with his deal, since he was not able to buy himself out of the contract." In the past, Robeson had been criticized for his roles in *Sanders of the River* and *Song of Freedom*, even *Show Boat*. One of the great contradictions of his career was that he made such appalling choices in film roles. But in September 1942, Robeson made two statements that stunned Black Hollywood. "The criticism being leveled at me currently for my part in 'Tales of Manhattan' is justified and the film does reflect on my race," he said. He also commented: "If they picket the picture when it opens in New York, I'll join the picket line myself." Later Robeson said he would never again act in a Hollywood feature. That statement proved to be true.

The criticism had to have stung Waters as much as earlier criticism against *Rufus Jones for President*. She had the utmost respect for Robeson, one of the few entertainment figures she truly looked up to. Never good at dealing with criticism, she appeared angry with the protesters. Now as she sought to make a new life for herself in Los Angeles, to find work in pictures and leave behind all those memories of Eddie in New York, she did not appear to fathom what was happening. For her, it was an assault

on *her* aims and ambitions, *her* dreams of finding comfort after so much turmoil. Los Angeles—and movies—offered her the only chances for a new life. In this mood and state of mild confusion, she now had to focus on the movie version of *Cabin in the Sky*, which she hoped might bring her film stardom. Already she had voiced her objection to the treatment of religion in the play. Would she now be confronted with angry questions about its depiction of its Black characters? In time, her mood would turn foul, her paranoia would grow, and the making of *Cabin in the Sky* would prove difficult and eventually damaging to the life she sought in the film capital.

# The Making of *Cabin*

**P**RODUCTION ON *CABIN IN THE SKY* commenced on August 31. Because the play had ultimately lost $15,000, some MGM executives had questioned the decision to make the film, but the studio had paid $40,000 for the movie rights and was committed to it. The talents behind the scenes were part of the Freed unit, the creative staff of producer Arthur Freed, who would make some of the most celebrated musicals in film history, such movies as *Meet Me in St. Louis*, *Singin' in the Rain*, *An American in Paris*, *Gigi*, and *Silk Stockings*. "I will spare nothing and will put everything behind it," said Freed. "It will be a picture on a par with any major film under the M-G-M banner." For *Cabin in the Sky*, the musical adaptation was by Roger Edens, the musical direction by George Stoll, the orchestrations by Conrad Salinger and George Bassman. Other talents were brought in, including Hall Johnson for musical choral arrangements and Harold Arlen, E. Y. Harburg, and Duke Ellington for new songs. The screenplay was by Joseph Schrank with some work also by Eustace Cockrell and Marc Connelly. The film would be shot with a sepia overlay. Its cinematographer was Sidney Wagner. "We made the picture for around $600,000," said Freed. The actual amount was $662,141.82.

"If there were any reservations about the film," said Minnelli, "they revolved around the story, which reinforced the naïve, childlike stereotype of blacks. But I knew there were such people as the deeply pious Petunia and Joe, her weak gambler of a husband."

Taking precautions to avoid any controversy or protests, the studio had sent a copy of the script to Hall Johnson, who expressed his feelings in a letter to the movie's associate producer, Albert Lewis:

You are to be commended for your desire to include nothing which might give offense to the Negro race—a consideration too often overlooked in this business of motion-picture making. I think my nose is particularly keen in that direction but, so far, I have been unable to detect anything in this script which could possibly offend anybody. . . .

At the moment, the dialect in your script is a weird but priceless conglomeration of pre-Civil War constructions mixed with up-to-the-minute Harlem slang and heavily sprinkled with a type of verb which Amos and Andy purloined from Miller and Lyles, the Negro comedians; all adding up to a lingo which has never been heard nor spoken on land or sea by any human being, and would most certainly be "more than Greek" to the ignorant Georgia Negroes in your play. The script will be immeasurably improved when this is translated into honest-to-goodness Negro dialect. . . .

If your director is as sympathetic and intelligent as your script writer you will turn out a picture which will delight everybody and offend no one without an inferiority complex—an affliction, by the way, which has almost completely died out among modern Negroes. We love nothing better than to laugh at ourselves on the stage—when it is ourselves we are laughing at. MGM could now breathe a sigh of relief, well, at least, for the time being.

At the outset, Minnelli was concerned about the set design. "I wanted Petunia and Joe to look as attractive as possible, for the audience to be aware of their simple goodness," said Minnelli. "When the art department showed me sketches of a dirty cabin, they discovered a temper my bland exterior usually kept hidden. How could they have missed the point? These people were poor but not slovenly. Petunia would try to make her surroundings as pleasant as her limited funds would allow. At my suggestion, handsome but inexpensive wicker furniture was used

to transform the cabin." Minnelli also criticized the original designs for Lena Horne's residence, which looked like "a prettied-up version of a slum." It was redesigned.

With the design problems worked out, Minnelli had to concentrate on his actors. He had already helped Lena Horne maneuver her way around the studio, which had signed her to a seven-year contract, and took a keen interest in her development. He knew that MGM wanted to give Horne special treatment. Much time was spent deciding how best to light her and make her up. In the end, the makeup that was created to highlight her lush copper coloring, ultimately called Light Egyptian, proved all wrong for her and was used, so Horne said, only on white actresses cast as mulattoes or exotics. Her hairstyling also presented a problem for MGM. "No one wanted to touch her hair," said the great hairstylist at the studio, Sydney Guilaroff, referring to the studio hairdressers, all of whom were white. Guilaroff created the hairstyles for Waters and Horne, but he could not be on the set every day. At his insistence, Black hairdressers were hired for both Horne and Ethel. Addie Baker was brought in as Ethel's personal hairdresser.

A special bubble bath scene was also created for Horne in which she would sing the Harold Arlen song "Ain't It de Truth"—and be as glamorous and sexy as Rita Hayworth or Betty Grable. In the end, because of objections from the Production Code Office, the scene was cut from the film, but the Arlen song was used by him years later for the Broadway musical *Jamaica*, which starred Horne. Clearly, though, the studio saw Lena Horne as a breakthrough in Black female images. She became the first African American woman fully glamorized and publicized by her studio. In her debut film, *Panama Hattie*, she appeared only in a musical segment. *Cabin in the Sky* was the first film in which Horne had a real role. The same year she would be lent to Twentieth Century Fox for a role in *Stormy Weather*, and years later she would appear in a dramatic role in *Death of a Gunfighter*. Otherwise, her entire movie career was spent in musical interludes of films starring white performers. Seeing Horne's excitement about *Cabin in the Sky*, Minnelli wanted to groom her for stardom. "They dined together every night while *Cabin* was in preparation," said Gail Buckley.

"She was thrilled with Vincente's *Cabin* concept. She thought he was a genius." Of course, the attention that Minnelli paid to Horne was not lost on Ethel.

In Hollywood, as Ethel knew, talent meant something, but she also understood that the town prized youth and beauty. In New York theater circles, she was considered as glamorous as any Broadway leading lady. Out here she did not want to be regarded in the same manner as Hattie McDaniel or Louise Beavers. Off-screen, they retained a glamorous sheen with their fashionable clothes and beautiful homes, but the larger Hollywood culture tended to view them as likable frumps or mammy characters—the roles they played on-screen. Ethel no doubt had balked at an item that appeared in Hedda Hopper's column, which commented that she had won the role in *Cairo* "because Woody Van Dyke said Lena Horne was so light she'd have to wear burnt cork, so it seemed easier on the makeup department to use Ethel." Hopper, however, had added: "Tut, tut! Who else but Ethel could put over 'Stormy Weather'?" Still, the very idea that she might have been second choice for *Cairo* was enough to have her climbing the walls. She clearly understood the color caste system that the industry—and the United States—still operated on. In the end, her darker brown skin made her acceptable as a maid but could limit her in films as a glamour star.

Ethel steadily grew more resentful of Horne, who, ironically, was also represented by attorney Harold Gumm. He had negotiated Horne's role in the race movie *The Duke Is Tops* and also in Lew Leslie's *Blackbirds of 1939*. Now he was carefully supervising her Hollywood career. "Wise, astute Harold Gumm saw to it that her every move was circumspect," said the writer Albert Anderson, "that her every action was studied. She remained in Hollywood for some time without working, waiting for her real opportunity. Unlike most colored girls and indeed the majority of whites who approach Hollywood, she did not venture out alone. Always accompanied by an aunt, a cultured woman of fine education, she lived in Hollywood rather than in colored Los Angeles, observing a secluded life with every contact planned." Suspicious as ever, Waters may have believed that she had never received this kind of attention from Gumm. Of

course, she never would have permitted him to dictate when and where she could go out. But his management of Horne may have been another factor in Ethel's ultimate decision to drop Harold Gumm.

Despite Ethel's fears, Minnelli and MGM wanted to keep Waters happy. Harold Arlen and Yip Harburg had written a great new number for her, "Happiness Is a Thing Called Joe." She'd also sing again "Taking a Chance on Love" as well as the title song. These numbers would take their place in Waters' repertoire. Minnelli considered Ethel his talisman. Crediting her with helping to make his Broadway directorial debut such a success, he believed she would do the same with his feature film debut.

Archie Savage was hired as a dancer and an assistant dance director. His talent secured him those positions, but surely Minnelli knew that hiring Archie would please and perhaps pacify Ethel. Minnelli and others "appreciate what I have mastered in the dance on my first picture assignment," said Savage. "Monetarily speaking I'm being much underpaid, but if I am a success I will have gained much more than money can buy. This is the sort of thing I have been waiting for all my theatrical life." Minnelli "has given me wonderful support," and Savage believed he had "a lot to thank him for."

Preparing to face the unflinching eye of the camera, Waters was determined to be in shape, especially with the prospect of facing Horne on camera. Greater rivals than in the stage version, the older, heavier Petunia had to fight a younger, slinkier woman for her man Joe. Waters again agonized about her weight. "She is really reducing and you can see the progress as the days drift by," said Savage. "She is taking treatments from a doctor who is bringing her down. The needles are now taking effect on her nervous condition and she in turn is also feeling the weaking [sic] qualities of the treatments." Sometimes she felt tired and always she felt nervous and agitated. Her ailments were just beginning and would worsen in the years to come, especially with the onset of menopause.

Uppermost in her mind was the question, how would she fare in her two sequences with Horne? The first, which occurred when she spied Georgia flirting with Joe, was brief. But the second was the climactic nightclub sequence when Petunia and Georgia let the fur fly as they vie for Joe. She was prepared to get through that on her terms.

"When I had to work with her," said Lena Horne, "and even before, I was a little frightened about it because I'd heard she was not comfortable as a person." Everyone warned her that Ethel was difficult. "Because of her own background, Ethel Waters absolutely despised educated or light-complexioned Blacks," said Horne's daughter, Gail Buckley. "Miss Waters considered herself, quite rightly, to be an enormous star and regarded Lena as an upstart, and her enemy on every front. Lena herself stood in awe of the Waters reputation."

Minnelli tried to put Ethel at ease. The costumes were shrewdly designed to make her look less heavy. Only in the form-fitting gown in the nightclub sequence would her weight show. Perhaps filming would progress smoothly without major upsets. But on the day that Ethel reported to MGM's sound department to record her numbers, which would be played back while she lip-synched in front of the cameras, the first signs of real trouble showed. Once she listened to Horne's recording of "Honey in the Honeycomb," which Ethel was to parody in the nightclub sequence, she became openly angry. "Miss Waters did have one legitimate complaint against me," recalled Horne. "She claimed that I had imitated her and that it would be impossible for her now to parody the song. If I had imitated her, it was completely unconscious. She was a great singer, someone to be admired, and of course, some of her style had come into that number. I'd worked hard to get it there so her parody would come off. Still, sometimes it's hard to see things that way."

Once Ethel began her on-camera work, other explosions occurred. As with the play, she was perturbed by the treatment of religion. Though everyone learned to stay out of her way, that was not always easy. Sadly, her paranoia had grown, now coupled with new fears about her appearance and the emergence of her various physical ailments, to the point at which she did not always understand how much Minnelli was in her corner. For Waters, Minnelli was part of a conspiracy, along with all the top executives at the studio who had been so damned concerned about lighting and making up Lena. Her "extreme distrust of the studio," said Horne, "had, I heard, already led to many minor incidents in the course of shooting."

Actor Lennie Bluett recalled that in the middle of a scene, Ethel would "go off on a corner of the set and look up and talk to God." But

often "Ethel kept herself in check. She was very much the lady in front of the white folks." Of those in the cast, recalled Bluett, "I would say that John Bubbles was probably friendly with Ethel because they were old New York people who knew each other. I'm sure Duke Ellington was friendly with her too in a professional kind of way." The day that Joe Louis visited the set, she was gracious with the champ, as admiring as ever, but Louis also was photographed with Lena Horne. The two had a stormy love affair that was hotly discussed in Black Hollywood. No doubt, Ethel wondered how "my Joe" could lower himself to date Horne.

Once the sequence with Lena started shooting, everyone noticed that Ethel became more aggressively agitated. "Minnelli would be on his knees adjusting the creases of that white satin dress that Lena wore. He wanted everything in place," said Bluett. "It was very tense with Ethel, and the fact that she was once young and beautiful like Lena, and Lena was stealing her thunder. And I guess she was a very, very bitter woman. I think she felt that she was the star of the thing but she really wasn't the star of the film—and Ethel said that in various ways quietly to people that she knew well. She told her friends that Lena could not sing."

Still, no one was prepared for her outright hostility toward Horne.

"Ethel was religious, yes. But she would call Lena every name, like 'bitch' or whatever. I remember Ethel going off into the corner many many times and she'd be mumbling 'mother fucker' and she would be looking up at the sky and talking to Jesus . . . hoping maybe a light would fall on Lena but wanting the Lord to forgive her [for such thoughts]." Joan Croomes, who was a dancer in the film, remembered that Ethel spoke in her low rough-sounding voice as she used dialogue from the film to address Horne before the cameras started rolling. "'Georgia, ain't it time for your cooch dance?' And that's the way she said it, only nastier," said Croomes. "She just hated her. I mean, she acted like she just hated the woman. And everyone would say, 'Poor Lena.'" But, as Croomes noted, "Poor Lena wasn't so poor because she did all right." For her part, said Bluett, "Lena wasn't paying attention to how evil Ethel was."

"I was kind of a bulwark between them because I loved Lena and I loved Ethel," said Minnelli, "but Ethel didn't like Lena at all. It always seemed so ridiculous to me, because Ethel was such a great artist. In New

York it was her show, but now it was divided—there was a new element of the beautiful colored girl."

What compounded the Waters-Horne tensions was an accident that occurred shortly before their big scene together with the "Honey in the Honeycomb" number. While rehearsing a dance with Rochester, Horne slipped and chipped a tiny bone in her ankle. Hearing the crack, said Horne, Rochester joked that "Ethel had put a hex on me." A cast was put on her foot, and the nightclub scene had to be restaged. Now Horne would be filmed sitting on the bar as she performed the number.

"Be real small," Minnelli advised Lena. "You can never be stronger than Ethel. Just be vulnerable and coquettish." At one point, Horne's Georgia, being cute and adorable, says of Petunia, "She's just jealous 'cause she ain't got what I got." Immediately thereafter, Waters, obviously relishing her own dialogue, put her hands on her massive hips and said: "I've got everything you've got and a whole lot more." At another point when Georgia said, "I'm just speaking my mind," a commanding Ethel responded, "And I ain't heard a sound." The off-camera tensions ultimately made the sequence stronger, funnier, more dramatic, with bite and vigor, thanks, of course, to Waters. But in her debut role, Lena Horne was no slouch. Hers was an adroit and very charming performance. When Ethel had to dance to show she was just as sexy as Horne's Georgia, Waters went to town in a dance number with John Bubbles that would delight audiences for decades to come. "Ethel would get up and do her thing. When she would get out there, baby, she would outdance Lena," said Croomes. "And she was much older, of course. But she could outdance her. I mean, she could kick high. You talk about a high kicker. She had long legs."

Still, despite her "bitch" and "mother fucker" mumblings, Waters basically kept her temper in check—until someone in the cast offered Lena a pillow for her injured foot. That enraged Waters. "Miss Waters started to blow like a hurricane," recalled Horne. "She flew into a semicoherent diatribe that began with attacks on Lena and wound up with a vilification of 'Hollywood Jews,'" said Gail Buckley. "It was an all-encompassing outburst, touching everyone and everything that got in its way," recalled Horne. "Though I (or my ankle) may have been the immediate cause of it, it was actually directed at everything that

made her life miserable, the whole system that had held her back and exploited her."

"You could hear a pin drop," said Gail Buckley. "Everyone stood rooted in silence while Ethel's eruption shook the soundstage. She went on and on." Word reached the front office. No doubt even Louis B. Mayer heard of the explosion. Producer Arthur Freed, MGM executive Eddie Mannix, and Ethel's agent at William Morris all arrived on the set. "She was still more or less raving when Vincente dismissed the company," said Buckley. "Lena was shaking." "We had to shut down the set for the rest of the day," recalled Horne.

The next day the cast returned. The scene was rehearsed again, then shot. "We finished it without speaking," said Horne. "The silence was not sullen. It was just that there was nothing to say after that, nothing that could make things right between us."

The news spread throughout the town. "Ethel Waters is being accused of being temperamental out on the 'Cabin in the Sky' set at M.G.M. But it isn't that; the hard work and long hours, more exacting than stage work, are putting her through a hard order," wrote the columnist Harry Levette.

But no matter how delicately the press might write of the incident, everyone knew that Ethel had lost control, the very thing she had prized most about herself. In the midst of her past tirades, the fact that she had always held herself together made her anger all the more chilling. But the pressures had built horribly for her—her need to prove herself in this medium; her determination to shine in an industry that preferred its glittering youthful surfaces; her anxieties over the questions about images of African Americans in movies, notably *Tales of Manhattan*; her frustration at dealing with other changes in her body. To be fair to Waters, no one else recalled a comment about another ethnic group. For her, the enemy was the dreaded ofay, and many of her friends and associates throughout her show business career were Jewish. Something, which would remain unknown, had sparked her comment that day. Though she might never admit it, she would long agonize over this day at MGM.

"Just a line from your nervous friend," she wrote Carl Van Vechten and his wife Fania in October. "I'm sure if you were here with me you would understand what I'm going thru."

Waters always believed that "there was so much snarling and scrapping" that she didn't know how the picture was completed. Of course, never did she say nor did she admit that most of the snarling and scrapping was initiated by her. For a woman who in so many other respects was charitable and generous, for a woman who held such strong beliefs in Christian doctrine and philosophy, her behavior as it pertained to her career and her work was often mean-spirited—and in the case of Lena Horne, frankly appalling. Horne represented to the older Waters a new generation that threatened to usurp her position in entertainment. In less than ten years, Horne would find herself in a professional situation similar to Waters' as the press created a rivalry between herself and the younger Dorothy Dandridge. But Horne would handle the situation with more grace and less apparent anxiety.

Ironically, Ethel's fierce struggle to survive, even when it sprang from her paranoia rather than her circumstances, proved fascinating. It was a larger-than-life grandeur that drew both fear and awe from those who witnessed it—and which oddly and paradoxically enough seemed rather heroic. She had been born a fighter, with an emotional depth that those around her lacked. Ironically again, just as she had drawn a degree of sympathy and understanding from women such as Alberta Hunter and Maude Russell, she elicited the same from Minnelli *and* Lena Horne, who clearly understood the effects of Waters' childhood and early show business years on her disposition and outlook. "She had a very hard time coming up," said Horne, "and that leaves a blot on you." Nonetheless, Waters' actions on the set of *Cabin in the Sky* clearly damaged her chances in the film capital. "I won all my battles on the picture," said Waters. "But like many other performers, I was to discover that winning arguments in Hollywood is costly. Six years were to pass before I could get another movie job."

# Aftermath

**C**ABIN IN THE SKY WRAPPED on October 24, with retakes until October 28.

At first, life for Waters went on as if nothing monumental had occurred. On the Sunday afternoon of October 25, she hosted a tea for California's governor, Culbert L. Olson, at her home. It was a sign that she was fully a part of the prestigious West Coast entertainment and social scene. She also received word of her future inclusion in a new edition of *Who's Who in America*. Clearly impressed, she asked Van Vechten to help her gather information about her career for the publication. The personal details, especially regarding her "marriages," she could supply.

But immediately following the movie shoot, she also had to refocus on personal and professional matters that had often worn her down during the past few months. She realized her high lifestyle was draining her, and the monthly bills had piled up. Never one to think much about money, Ethel knew she now had to. She contacted the real estate agent who had sold her two apartment buildings in New York and told him to put them up for sale. Having argued with Harold Gumm about a number of projects, from *Hit the Deck* to movie work, she apparently decided to terminate their professional ties. All this proved time-consuming and emotionally exhausting. Her resentments and anger as well as her fears were getting the best of her. If she was ever close to emotional collapse, it was at this time.

On November 23, she responded to correspondence from a testy Van

Vechten, who was annoyed that she had not answered one of his letters. Preoccupied with the film, she had asked Savage to write Van Vechten. But no letter had gone out. Waters wanted Van Vechten to know why he had not heard from her as well as to understand the pressures she was then living with.

*Dear Carlo,*

*You letter just received and I'm answering at once as I am more than upset. To tell you that I'm not going Hollywood is not enough. To tell you that I'm going crazy is. Carl, darling, I'm serious and telling the truth when I say that I've been through Hell ever since August and at this time I feel that I'm on the verge of a nervous breakdown. I was very unhappy during the entire eight weeks of the filming of "Cabin." During that time I was also having Lawyer trouble and Property trouble plus a daily fight for that which I considered was due me at the studio. . . .*

*In addition to all of this I am trying to sell my property in New York and that has had me constantly on the go letters back and forth. You see it has been a constant drain on my pocket book as every clear dime seem needed for this deficit or that. And the [witch] I had was robbing me right and left because I wasn't a business woman.*

*Since this break was in the air I have had to (for the past three weeks) go over papers concerning the matter and plus the daily task of running to the lawyer here signing this paper and that. It was so bad that I found myself just standing not knowing whether I was coming or going.*

*That is why I have asked Archie to please at least do the important things like writing you and I also asked him to express my thanks and appreciation for your great kindness which he did not do. Yet until I received your letter I thought sure that it was well taken care of. . . .*

*Carl darling I can only say that you'll never know how your honest letter hurt me and how helpless I feel in not being able to do a thing about the situation as it now stands, other than ask your forgiveness. And if there is anything that I can do to assure yours and my friends that my heart bleeds for the wrong I have cause YOU Carl MY BEST FRIEND, please don't hesitate in letting me know. Altho I have never*

*found you unsympathetic I have always had the feeling you don't care to listen to worrisome problems from others. So in offering you these schoolgirl apologies I also ask that you overlook my having to bring them out.*

In early December, she attended a preview of *Cabin in the Sky.* "I personally think that it is fairly good," she told Van Vechten, but the studio was "still undecided as to what they will leave in and what they will take out." She also let him know she was feeling better. "Things have sort of calmed down now. . . . I am in a much clearer mind. You see I have gotten rid at last of the law office and I have had an offer for the property. God is still with me."

In late September, *Tales of Manhattan* had finally opened in New York at Radio City Music Hall, which was as prestigious a theater booking as Hollywood could hope for. Mainstream reviewers liked the picture. But criticism from the African American community continued. In early November, *Cairo* also opened in New York. Reviewers tended to like Ethel but felt the film was a tired spoof that failed. Within the Negro community, there were still grumblings that the great Black actress of the theater was playing a maid. Yet there was a belief that the very fact that Waters and others, like actor Rex Ingram, were working might ultimately signal changes in Hollywood for Black performers. Other films either released or scheduled for release that raised such hopes were John Huston's *In This Our Life* in which Black actor Ernest Anderson played a bright young man wrongly accused of a hit-and-run accident; *Casablanca* in which Dooley Wilson performed "As Time Goes By," the song that became an anthem for young lovers during the war years; *The Ox-Bow Incident*, which focused on the lynching of three innocent white men, with Black actor Leigh Whipper serving as a sort of symbolic conscience as he sang "You've Got to Walk That Lonesome Valley"; *Crash Dive,* in which Ben Carter played actual Black World War II hero Dorie Miller; and *Mission to Moscow*, in which Leigh Whipper was cast as Haile Selassie. In none of these features did the Black actors have a starring role, but a point was being made. Black characters were now depicted with a degree of dignity and without the dimwitted servant antics.

Now Twentieth Century Fox was reported to be planning an all-Negro film. Dooley Wilson and Katherine Dunham already were signed, but no offer came for Ethel's services, in that film or any other. Worse, Fox announced that the film, to be called *Stormy Weather*, would star Bill Robinson with Lena Horne, who would sing the title song. Of course, Ethel and everyone else knew that was *her* song. She would never forgive Lena for *that*. Before filming had even begun on *Stormy Weather*, *Philadelphia Tribune* columnist Jack Saunders commented: "Miss Horne will be beautiful and charming in her role, but she will not for two seconds be able to make you forget how La Waters sings 'Stormy Weather.'"

Though in need of a rest, she also needed work, as much for emotional reasons as financial ones. At this point, Ethel still had A-list status, and offers came in that were quickly accepted. On Christmas Eve 1942, she appeared on the radio show *Command Performance*. Produced by the War Department and broadcast over the four major radio networks of the time, the show was directly transmitted by shortwave to troops worldwide. Performers all donated their services. Joining her were headliners Cary Grant, Bob Hope, Bing Crosby, Dorothy Lamour, Dinah Shore, Edgar Bergen, and Red Skelton. In January 1943, she performed "The Star Spangled Banner" at a huge Hollywood Victory Committee benefit that raised $60,000 in war bonds.

Her agent at William Morris put together a deal for her to return to performances at theaters, and in January, she did an eight-day engagement with bandleader Les Hite at the Los Angeles Orpheum Theatre. Reginald Beane was flown in to accompany her. She was also set to perform a musical number in *Stage Door Canteen*, to be filmed in New York. But without important movie offers, she saw trouble ahead. Sadly, her recording career, in most respects, had peaked. The glory days of the new hits that everyone knew and swayed to were over. Audiences would now want to hear her oldies, but how long could that go on? Excellent recordings were made of her *Cabin in the Sky* numbers from both the stage and eventually the film versions: "Taking a Chance on Love," "Honey in the Honeycomb," "Cabin in the Sky," and "Happiness Is a Thing Called Joe." Had she concentrated on recording new material, maybe in the direction of jazz, or had she recorded "Songbooks" of composers, as Ella Fitzgerald would later

do, she might have saved herself from much of the career distress and frustration—and the lean periods—that would follow.

Feeling the effects of age, the passing of time, and the ongoing shifts in popular culture, she told the press rather defensively: "The finest testimonial to my theatrical efforts I've ever had is the fact that for years my audiences have included a liberal sprinkling of women from 60 years old up. . . . Another thing I've noticed is that men bring their wives and teenaged daughters to see me. This is quite a departure in respect to Negro entertainment." Obviously, she was not ready to relinquish her crown. "I still can handle a hip in the Main Street manner, and if you don't believe it, see the dance I do, with Bubbles in 'Cabin in the Sky.'" Ethel was forty-seven years old, just middle-aged in ordinary terms, but she understood a new generation as well as the men who controlled show business might soon see her as being ancient.

WITH HER SUITCASES and trunks packed, she boarded the *Super Chief* that took her east for her new tour. In New York, there was cause for some optimism when she performed the title role on the Readers Digest radio program *Rhoda Monroe*. Excited to have a dramatic acting role, she played the mother of nine who, following the death of her husband, takes in washing—and daily thanks the Lord for all he's done for her. "He's spoiling me," she says as she works herself to the bone. Later she dies peacefully. Ethel saw value in playing a woman who endures and helps her family and community.

But the production was scorned as being old-school and out of touch. "Then we wonder when it's all over, what she had really done. Here she had worked hard, but did she have a lovely house and a little farm of her own when she died? Did she send her kids through college?" the Negro press asked. "Naturally, Rhoda Monroe is a simple person with very little education and we should expect her to act the way she did. But we certainly didn't expect that at a time like this, when Negroes are doing so many things in every field of endeavor, that they should dig up a story of practically slavery days and give it to their hundreds of white listeners as a sketch of Negro life. Ethel Waters could have done well too in a

story about the Negro's progress." In the pages of the *Chicago Defender*, her old friend Langston Hughes asked why she and other Negro entertainers could not be given great works, playing historical figures of power and influence. He suggested that Ethel be cast as Black Patti. With this new criticism, along with the attacks on *Tales of Manhattan*, she appeared angry and bewildered by the changing world.

ON HER TOUR DATES, she played the usual haunts, everywhere from Newark, New Jersey, to Chicago, Boston, Philadelphia, and Danville, Illinois. During the part of the tour that carried her through parts of the Midwest, she performed with Earl "Fatha" Hines. Also on the tour was entertainer Tommy Brookins. Formerly a basketball player who was one of the members of the Globetrotters, the team that evolved into the Harlem Globetrotters, Brookins had joined a buddy, Sammy Vann, to become a dance team known as Brookins and Vann. The two young men had lived and performed abroad until Hitler's invasion of France. Brookins looked like a smooth operator, with his athletic build, quick smile, well-trimmed mustache, and friendly eyes—eyes that quickly focused on Ethel, who in turn focused hers right back on him. He appeared giddy whenever he and Ethel were together in public. Before Ethel could say much, the press was calling Brookins her "latest heart-beat." When a fellow excited her, she liked to say he made her shiver. If he failed to live up to her expectations, then he didn't make her shiver. Apparently, Brookins, at least for the time being, made her shiver quite a bit. Within a few months, there would be talk that she was "trousseau shopping," and not long afterward Tommy was referred to as yet another of her "husbands."

But Ethel was too much on the move to pant too hard for young Brookins. In a four-week run at New York's Strand Theatre, she gave yet another artistically daring performance when she performed a tribute to the Russian classical composer, pianist, and conductor Sergei Rachmaninoff. New war benefits followed. In May, she joined Frank Sinatra, Tallulah Bankhead, Myrna Loy, Kate Smith, Clifton Webb, Jeanette MacDonald, Alfred Lunt, Fredric March, Paul Muni, the Ritz Brothers, and others for a Red Cross fundraiser that brought in $275,000.

In May, *Cabin in the Sky* opened at New York's Criterion Theatre to good reviews from the mainstream critics. "A musical honey!" wrote Wanda Hale in the *New York Mirror*. In the *New York Times*, Thomas Pryor called it: "A bountiful entertainment! . . . Miss Waters is incomparable . . . Lena Horne a bewitching temptress. . . . A most welcome treat!" A dissenting voice came from *Time* magazine, which commented: "The Negroes are apparently regarded less as artists (despite their very high potential of artistry) than as picturesque, Sambo-style entertainers."

Within the Negro press, some newspapers, like the *Chicago Defender*, had good things to say about the film, but others did not. "A slap in the face to Negro intelligence," wrote Jack Saunders in the *Philadelphia Tribune*. "Another Propaganda Rap Against Negro," wrote New York's *Amsterdam News*. "The factor that makes the presentation of *Cabin in the Sky* so uncompromisingly reprehensible is the fact that the people used in the promulgation of false concepts are that of the most important Negro names in contemporary America." Once again, Ethel appeared baffled by the criticism.

In retrospect, *Cabin in the Sky* did project an image of a naïve community with a simple faith and an uncomplicated moral view of right and wrong. The old stereotypes had been softened but were still present: Rochester's Little Joe, weak and in need of supervision from his stronger, more intelligent wife, Petunia; Petunia herself, an all-nurturing woman of home and hearth whose primary focus is her husband's welfare; Joe's cohorts, gamblers, conmen, and connivers; Bubbles' Domino, a violent, sexual buck-style slickster hood just out of the can. Minnelli's demands for a set design that presented charming, well-ordered living spaces for his characters seem to gloss over the poverty in which they lived. The whole fantasy conception removed the characters from real issues facing African Americans at this time of war and a fight for racial progress. Because it had an all-Black cast, the film suggested that whatever problems the Negro might have were self-created and not the result of a system that had relegated African Americans to second-class citizen status. That was the feeling of some who saw the film in the 1940s—and also of some later generations.

At the same time, *Cabin in the Sky* would endure as a beautifully di-

rected and performed movie, a classic in the history of American musicals. Minnelli respected his cast and treated them accordingly. Rochester could be viewed as the perpetually perplexed and easily duped Common Man, struggling to do right but often tripping along the way. The dancing of John Bubbles was a living testament to his smooth, gliding style; a masterly piece of precision and élan. Kenneth Spencer as the reverend and Clinton Rosemond as the doctor provided the film with a sturdy Black male assurance and warmth. Louis Armstrong, Mantan Moreland, Willie Best, and Rex Ingram as the devil's disciples were perfectly in sync, creating a very funny world of their own. Lena Horne's Georgia, sexy and cute, really was a different kind of Black movie heroine. It may not have been a dramatic breakthrough, but she had escaped the dim antics so many Black women in Hollywood had been made to perform. *Cabin in the Sky* was a winning ensemble piece—up to a point. But soaring above them all was Ethel Waters.

When Minnelli said he loved her, he was being truthful. That could be seen in the tender close-ups that captured her vulnerability and sweetness, notably as she performed her second rendition of Harold Arlen's "Happiness Is a Thing Called Joe," when a tearful Petunia believes Joe has again taken up with Georgia Brown. In the climactic nightclub sequence that so troubled everyone in the cast and on the crew, Minnelli and Waters looked as if they had constructed a united front to call a lie to Hollywood's traditional way of desexing and deglamorizing browner, heavier, older Black women. As Petunia dances with the sexy Bubbles as Domino, she unleashes her sexuality, kicking up her legs, shaking and grinding her hips, shimmying her shoulders, and showing indeed, as the dialogue had indicated, that she has everything Georgia has and a whole lot more. Even though she's thirty or forty pounds heavier, she's still Sweet Mama Stringbean, and she's letting the audience know that too. Far better here than in her previous Hollywood outings, Waters, under Minnelli's direction, relaxed on-screen and came to understand—through his understanding of her—the subtle but still larger-than-life demands of film. Abandoning the broad gestures and speech patterns that the theater called for, she now knew that the camera recorded thoughts and feelings. In later years, new generations would go to revival movie theaters show-

ing *Cabin in the Sky* to see the all-star cast but especially Lena Horne. But those new generations would leave the theater afterward talking about Waters.

Despite the criticism, both *Cabin in the Sky* and *Stormy Weather*, which followed, did please a significant segment of the Black audience and were shown on army bases throughout the world much to the delight of Black GIs, said Lena Horne. By the fact of their all-star casts—*Stormy Weather* also featured Cab Calloway, Ada Brown, Fats Waller, Dooley Wilson, Flournoy Miller, and most spectacularly, the Nicholas Brothers—both films achieved classic status, though neither was a huge box-office hit.

OPENING IN JUNE 1943 was *Stage Door Canteen*, which had not received a drubbing from the Negro press. Produced by Sol Lesser and directed by Frank Borzage, the film was a "bulging and generally heart-warming" star-studded piece of wartime entertainment that offered a glimpse into life at New York's then famed entertainment center for military personnel on leave. In it were cameo appearances by such performers as Merle Oberon—whom Ethel had first met in London when she was known as Estelle O'Brien—Katharine Hepburn, Katharine Cornell, Gypsy Rose Lee, Alfred Lunt, Ethel Merman, Lynn Fontanne, and the bands of Benny Goodman, Guy Lombardo, and Count Basie. Ethel performed the song "Quicksand," standing by the piano, while Count Basie sat at the keyboard with his band in the background. The scene was a beautiful document of what Ethel, the singer, was like in clubs during the middle part of her career—a mature woman in excellent voice who still knew how to put a song across.

# Scandal

I LOVE YOU, CALIFORNIA," SHE SAID upon her return to Los Angeles in the late spring of 1943. "Yes, I really enjoyed my tour, but nevertheless, let me repeat, I am glad to be home. I guess the big cities are just too much for me any more. And do you know everything is rationed back there in a big way but one's breath! Milk is only available every other day—fresh vegetables, sometimes—fruits, maybe—we had a standing gag in New York on potatoes or rather the total lack of them. This California sunshine, my own home, flowers, and even a victory garden, are the life."

She quickly settled into the rhythm of being back at her home on Hobart Street. Archie had been taking care of matters for her, and in some ways, she had grown dependent on him. She had him write letters to friends back East, and he also tended to details of keeping the house in order. The two had their own private way of communicating when they were together. Archie could read her moods and anticipate her needs. He was always supportive of her career endeavors, encouraging her, flattering her, soothing her, keeping her company, and listening to all her stories of her travels, all her complaints, all her plans. At the same time, he continued his career pursuits, still dreaming of forming his own dance company. He was also now committed to a life of his own in Los Angeles. "Everybody thought because he was living with Ethel that something was going on," said actor Lennie Bluett. "But that wasn't true. The general public didn't know Archie was gay. But everyone else did."

Still, Savage was the person in Los Angeles closest to Ethel. Though

she was in Black Hollywood, she was never of it. "She didn't seem to have close friends," said Bluett. "Ethel, as I recall, was not friendly with Louise Beavers or Hattie McDaniel. Not at all." As for Ruby Dandridge, known as a likable yet gossipy social climber, Bluett felt that "they would have been at arm's length with each other." Or rather Ethel, who valued her privacy, would have kept Ruby at arm's length. Ruby lived with another woman with whom she had a long-term relationship. Though Ethel might listen to tales about Ruby's escapades, she was not about to let Ruby tell stories about hers.

Though there was clearly a circle of gay Black performers in Hollywood, Waters kept her distance from it. Bluett, like most people in Black Hollywood, was aware of the stories about Ethel's sexuality. "Ethel went both ways," he said, "but it was not evident. By then, when I knew her, she was past that." Or so the young Bluett assumed. "Ethel didn't socialize with anybody except a guy who made the lamps and lamp-shades for the house." Ironically, that man was gay, said Bluett, but he wasn't a Black Hollywood insider. Nor were a couple of other women friends who were in and out of the house and whom Ethel referred to as her secretaries. Her house in Los Angeles was never as bustling with people as her apartment on St. Nicholas Avenue had been, but it was not empty either. Whenever her accompanist, Reginald Beane—who remained one of her most valued friends, more so than Archie—was in town, he stayed at Ethel's. In June, Algretta also came for an extended visit. Despite the activity, Ethel managed to conduct her personal affairs rather privately. In fact, Bluett, who often stopped by the house on Hobart to play poker with Archie, recalled that he didn't even see Archie and Ethel together at the house. "I just knew Archie had one of her upstairs bedrooms," said Bluett.

Savage, however, was quite social, and when Ethel was away, he was king of the house. Friends were invited over to play poker, swap stories about show business, and talk about their careers. Among them was Joel Fluellen, a, handsome, intelligent, and shrewdly outgoing actor who made it his business to know everybody who was anybody in Black Hollywood—and in Hollywood in general, notably some of its closeted male stars and executives. Having already struck up friendships with Ethel's

neighbors, McDaniel and Beavers and especially the young Dorothy Dandridge, he was personable enough to become friendly, yet not close, to Waters. Fluellen's friendship with Savage gave him access to Ethel, although Fluellen could be very engaging and would have managed to establish a social relationship with her on his own without Savage's help. He had other reasons for his friendship with Savage—he obviously enjoyed Savage's company.

By this time, Savage's feelings about Ethel were mixed, more complicated than was at first apparent. Much as he liked her and all she offered him—free room and board, access to the upper echelons of entertainment circles, help in his own career aspirations—Savage also wanted *not* to need her—not to have to put up with her temperament and idiosyncrasies, not to have to run her errands, not to have to keep up with her correspondence, not to have to baby-sit her when she was feeling down or lonely, not to be financially in need of her help or largesse.

During his regular card games, he felt on his own. "When Ethel would be out of the house," said Bluett, a group of friends, mainly dancers working in movies, "would go directly over to her house" to see Archie. "One of the dancers was particularly adroit at poker and blackjack." The group often played for money. "Archie was a terrible poker player," Bluett remembered, yet even when he was down on his luck, he kept playing. All the guys noticed that when "he was losing and needed money, he'd go up and open her trunk and take $500 out and play poker with it. Everybody thought it was his, so nobody questioned where he got the money." But that trunk would soon be the subject of much discussion and the kind of public scandal that Ethel abhorred.

DURING JUNE, the house on Hobart was full. Algretta was still visiting. So was Reginald Beane. Her two secretaries and a friend known only as Marlene were also around. Ethel's time at home, however, was short— about one week since her return from the tour—and harried. Producer Ed Small had contracted her to star with Bert Wheeler and Frank Fay in a musical revue called *Laugh Time*. It was not a top-drawer production, but *Laugh Time* would be performed in San Francisco, in Los Angeles, and

possibly later on Broadway. Ethel's departure for northern California was delayed when she received word that her sister Genevieve had taken ill. Much as she always felt exasperated by Genevieve, Ethel could never turn her back on her family: despite her financial bind, she still sent money home on a steady basis. Clearly, she was upset about her sister's illness, perhaps because Genevieve was responsible for caring for Momweeze.

But that was not the only matter that made her anxious. A local group of white homeowners were organizing to protest the fact that homes on Sugar Hill were occupied by Blacks. The group planned to have the Black homeowners forced off their properties on the grounds that, because of Los Angeles' restrictive housing covenants, they had no legal right to be there. If the group's efforts continued, African American residents would have to fight, possibly in court, to keep their homes. It was one more thing to fatigue her. News also had come that Earl Dancer had married Viola Nicholas, the mother of the Nicholas Brothers, in Tijuana. The two honeymooned at a ranch he now owned in Elsinore, California, where he had a chicken farm! But Earl had not left show business. He still plugged away, having recently launched a revival of *Africana*, albeit an unsuccessful one. The news surely brought back memories of the years she had spent with him, for better or worse—the way he had worked so tirelessly to help her make it on the white time. Not long afterward, she would also learn that Harry Pace, who had given her big break at Black Swan, had died at the age of fifty-nine at his home in Chicago. The death of Mr. Pace, as she often referred to him, had to sadden her.

Still, as Ethel prepared for her trip, she asked Archie to accompany Algretta, now a teenager, to one of the city's better stores to purchase a new dress. She signed a blank check and handed it to Savage. On the day of her departure, July 1, Tommy Brookins arrived—seemingly out of nowhere—to drive Ethel to northern California. It was obvious that Ethel had been in communication with Brookins and that she had taken a liking to the well-built guy with the quick smile. Was this a serious relationship? No one could say for sure, but soon afterward, Archie moved out of the house.

\* \* \*

*LAUGH TIME* WAS A HIT in San Francisco. At the beginning of August, Ethel returned to Los Angeles to prepare for the opening of the show at the Biltmore. Archie was not at the house, but Waters did not appear greatly bothered by this. One afternoon she noticed a card from a locksmith but thought nothing of it. But she grew suspicious that something was amiss when one of her checks bounced. When she contacted the bank, she was informed she had "insufficient funds." Then she saw that the blank check she had given Savage had been cashed at a department store, for the sum of $732, a greater amount than she could imagine for the purchase of Algretta's dress. When she spoke to Algretta, Ethel learned that there was no dress. Nothing had been purchased. On August 9, as she was preparing for her evening performance of *Laugh Time* at the Biltmore, she searched for a piece of jewelry but couldn't find it. She then looked through her trunk, where she kept a zippered bag of jewelry and a great deal of cash. She was stunned. Missing was $10,000 in cash, which she later said she had earned from her work on *Cabin in the Sky* and which was being saved to pay her income taxes. Also missing was $13,400 worth of jewelry: a brooch worth $5,000, a $900 watch, and two rings, each valued at $3,500. In total, $23,400 in cash and jewels had disappeared. And so had her rosary.

In the days that followed, Ethel agonized, trying to figure out exactly where everything had gone. Had she put the money and jewels somewhere else? Who else had access to the trunk? Could one of Archie's friends have run off with everything? Finally, on August 13, a distressed Waters phoned Savage, then rehearsing with his dance class. "I called up over to the settlement where he was working and told him to come over and help me find my jewelry and money," said Ethel. Seemingly surprised to hear about the theft, Savage "promised he would get by there sometime during the day." When he arrived later that evening, both Algretta and Reginald Beane were in the house. In what became a very heated discussion, "I asked him," said Waters, "to aid me in finding my money and jewelry." Of course, that was the cleaned-up version of the conversation. It was not hard to imagine her language. If he didn't help her, she said she "would be forced to have those people you had in my home without my permission arrested on suspicion of robbery." Then she was shocked by his response.

"You don't have to have any of my friends arrested. I, Archie Savage, have your jewels and money and there is nothing you can do about it. It's your word against mine." According to Ethel, these were his words.

Said Ethel later: "I don't want to tell anyone how I prayed and pleaded with him to return my jewels and money."

Savage then left the house. After midnight, he called her. He had a change of mind and would return everything on certain conditions. He returned to Hobart Street shortly afterward. Another heated argument erupted. "Archie, let's don't go through the torture again. Just tell me what the conditions are," she told him. But she was caught completely off-guard when he said that in exchange for a return of the money and jewels, he wanted her to sign over her Lincoln Continental and the deed to the home in which she lived. "I then saw he didn't mean to put the things back, so I told him I would be forced to put him in jail."

Once Savage left, she contacted the authorities. She was too angry at this point to think of how all this would appear when the news broke. A handsome young man living in an older actress's home? Had a lovers' quarrel sparked the whole thing? She explained the situation to the police. Savage was apprehended as a suspect. But then Ethel, obviously emotionally torn, would not sign the complaint. She burst into tears. "God will take care of everything," she cried. "Well, I wouldn't enter a complaint against the boy and the Los Angeles police were pretty mad at me." The police pressed her for more information and some evidence, but since it really was her word against his, they released Savage. Then Ethel remembered the locksmith's card that was in her dressing room. Contacted by the police, the locksmith verified that he had come to Waters' home where he made duplicate keys to the trunk in question. Algretta, who had overheard the heated discussion between her foster mother and Savage, also corroborated Ethel's account of the conversations about the theft. Savage was arrested, this time by the district attorney's investigator, and booked on suspicion of burglary. He was released on a $10,000 bond.

The story made the pages of the major African American newspapers in the country. The *Los Angeles Times*, the New York *Daily News*, the *New York Times*, and others also reported the story. In a town that thrived on gossip, Ethel was at the center of a juicy story, the kind she had managed

to avoid thus far. But now with an arrest and an upcoming court case, the Bible-carrying, rosary-holding, "saintly" woman was whispered to be a sex-starved lady tied to a hunky young paramour. The newspapers did not dare discuss the sexuality or rumored sexuality of either Waters or Savage. Instead Ethel was sometimes painted as a rather naïve old broad taken in by a handsome young dude. One paper characterized it as "a bizarre relationship." "Ethel Waters sang a $23,400 rendition of the 'St Louis Blues' today in the district attorney's office," commented the *Daily News*. "But the old song had a new theme—it was all about the trusting gal who dumps—and then forgets—her money and jewels in an old trunk in the attic and then finds out one day that there ain't none left." At this time, Ethel's net worth was also reported to be $1 million, which may have been a high estimate, considering her expenses and also her need for work to keep herself financially afloat.

But much of the press's attention focused on Ethel's behavior—and appearance—when she made the first public accusations at a preliminary hearing in municipal court. Often her comments brought laughter into the courtroom. "Perhaps a bit heavier than she was in her role in 'Cabin in the Sky,'" reported the *Los Angeles Tribune*, "Miss Waters wore a ribbon in her hair, a plain brown dress and flat heeled shoes with bobby socks. With no obvious attempt at comedy, she convulsed the court with such lines 'Strike that, I guess' when she attempted to instruct the court in what portions of her testimony to regard." When asked to take the oath to tell the truth, "Miss Waters substituted a fervent 'So help me God, I will' for the usually prosaic answer of 'I do.' At another point: "Leveling her forefinger at Savage as she sat on the witness stand, Miss Waters answered the prosecution's question of 'Can you identify the man you say stole your jewelry and money?' in a manner reminiscent of her movie roles. 'Yes, that child there.'"

More laughter followed when Algretta took the witness stand. "The courtroom was thrown almost into panic during the testimony of the actress's god-child, Miss Allegretta [sic] Waters who declared that she called the actress 'mommie.' In all further reference to Miss Waters during the questioning of the girl, the attorney referred to Miss Waters as 'mommie' to the amusement of the entire court."

For many observers, the entire proceedings were something of a side-show, one more afternoon in Hollywood. But the theft made a serious dent in Waters' finances and added to the financial difficulties that would soon plague her.

MEANWHILE, ETHEL STILL PERFORMED in *Laugh Time*, which headed east after the Biltmore engagement ended. On September 8, it opened on Broadway to basically good reviews. "Any theatrical season that finds Miss Waters in the Forties naturally is a great season," wrote Lewis Nichols in the *New York Times*. "She has not changed out there where they make pictures—and assemble vaudeville bills. The jewels still sparkle, and the teeth, and the Waters voice breaks confidingly as she proves that happiness is a name called Joe." "Audiences can't seem to get enough of this Negro singer whether she sings hot or sweet," wrote Virginia Wright.

But the press also wanted to know about the recent headlines. "Somebody that I trusted stole from me. It was a blow," she told the writer Helen Ormsbee, explaining quickly what had transpired in Los Angeles, then getting off the subject. "If it's God's will, I'll get back some of what was stolen from me. I leave it at that." Mostly, she wanted to talk about her career, her struggles since childhood, and her faith—the very topics she always chose to discuss with the press. "Some of my friends don't like to hear me talk about kneeling down and thanking God," she said. "They don't like me to talk about religion, I mean. They don't understand and it makes them uncomfortable and then I feel uncomfortable. But I've got to say what's in my heart." Despite its reviews, *Laugh Time* had a short Broadway run.

A trial was set for Savage for November 3 but later postponed.

Waters tried her best to go on as if nothing in her life had changed. Along with such stars as Frank Sinatra, Bert Lahr, Milton Berle, and Henny Youngman, she attended a huge war bond drive that netted $2.5 million at the Capitol Theatre. On November 5, she began a one-week engagement at the Apollo. She was also honored by the New York Business and Professional Women's Club when over a hundred of its members

attended a performance of *Laugh Time* and presented her with a corsage of gardenias. In mid-November, she participated in another star-filled benefit, this one at Madison Square Garden for the United Jewish Appeal. Twenty thousand people attended, and $100,000 was raised. She also joined Carl Van Vechten and Langston Hughes, along with scores of others, at a birthday party for her friend Nora Holt at the Dorrance Brooks Apartments.

Christmas was spent in Philadelphia, where she opened at Fays Theatre. Traveling with her were her secretary Marie Joe Brown and Tommy Brookins, both of whom accompanied Ethel to a dinner given in her honor at the home of her half brother Benjamin Waters. For Ethel, the Waters side of the family had always been the uppity one. She hadn't forgotten that her paternal grandmother had not wanted to have much to do with her—until her early success. But members of the Waters branch were also upwardly mobile, middle-class residents of the City of Brotherly Love. Another brother, Wesley Waters, was a well-known minister who later ran for Congress. She also respected the musical talent of her half brother Johnny Waters. Ethel's innermost feelings about them remained in question, but socially they were preferable to her sister Genevieve. As far as Ethel was concerned, about the only thing Genevieve had ever done right was to give birth to her now deceased little niece Ethel.

ON JANUARY 1, 1944, the following appeared in the *Pittsburgh Courier*:

> The year 1943 has slipped into limbo, ending a golden year for colored thespians, entertainers, and musicians. . . . Miss Lena Horne's outstanding achievements in motion pictures succeeded in definitely weakening the studios' idea that Negroes must remain in "handkerchief head" roles to satisfy the moviegoers' taste. Her work in "Stormy Weather" was highly commendable as were all the performers in this finest all-colored cast film. With "Cabin in the Sky," "I Dood It," "Panama Hattie," and "Thousands Cheer" to her credit, the lovely Lena has scored higher than any preceding or current Negro screen

actress. She has paved the way for other race actors and actresses to receive better roles on the screen.

Reading about Lena Horne's impact on Negroes in movies and entertainment in general was not the way Ethel wanted to start the new year. It hadn't helped matters that *Stormy Weather*, though clearly not as good a film as the well-directed and -produced *Cabin in the Sky*, had been better received in terms of images of African Americans. There was also the ever-present fact that no new film offers had come in for her. One evening in late December as she dined with the actress Georgia Burke, the writer Constance Curtis, and another friend at Mom Baker's Tea Room in Harlem, her anger reached the boiling point when the conversation turned to the "popularity of a certain café singer and recording artist," said Curtis. Ethel declared that "it was only the primitive sex appeal of the singer which made her popular."

"It warmed the cockles of my heart," said Curtis, "to hear her discuss the subject with great authority. Using with absolute correctness terms which would be familiar to an ethnologist, an anthropologist, or a psychiatrist she held out that the singer had no more to offer than her primitive physical qualities." But hadn't the physical attributes of Sweet Mama Stringbean been important in Ethel's early career? And aside from that, if it was Lena Horne being discussed, there was absolutely nothing "primitive" about her appeal. But Ethel now found it even harder than in the previous decade, when Billie Holiday was on the rise, to accept the stars of a new generation and the altered tastes of the public.

WHILE IN NEW YORK—with *Laugh Time* closed and without either a movie or big theater prospects—she was booked to return to nightclubs, first at LA's Clover Club in January, then the next month at New York's Club Zanzibar. On her way back to Los Angeles, she and Reginald Beane departed from the train to make a stop in Chicago. There, she was guest of honor at the launching of a new nightclub, Cabin in the Sky, at Sixty-fourth and Cottage Grove. Run by none other than Tommy Brookins, the club was a kind of homage to Ethel—in part Ethel's homage to her-

self because she had poured money into the establishment. For some, the whole Brookins affair and the opening of the club looked like a replay of her investment in Eddie Mallory's restaurant in New York. But with Beane seated at the piano, she performed three impromptu numbers that evening that had the packed house screaming for more.

For Chicagoans, it was one of those fabulous nights when the woman considered Black America's greatest female star, full of vim and vigor, seemed eager to show that she still had what it took to be on top. She was a long-standing supporter of the *Chicago Defender* and had contributed to one charitable event after another. The city considered her one of its own, and a night like this was one of the reasons why. Jubilant and obviously having fun, she laughed, smiled, joked, and posed for pictures with her Tommy. It certainly looked as if she was ready to announce a new romance—or that indeed he was her new "husband"—but as the trim and fit Brookins stood next to the heavy Ethel, he looked more like her nephew or son than the star's paramour. That night, though, Ethel did not seem to give a hoot about her weight or what might be said. Nor did she appear concerned about the fact that she was seeing another younger man precisely at a time when she still faced ugly rumors about her relationship with Archie. Later an embarrassed Ethel confided to Carl Van Vechten that she had fallen hard for Brookins, and eventually this would lead to new financial problems. "I'm $5000 in debt," she said. "It's because every penny I was able too [sic] earn I invested in that club in Chicago Cabin in the Sky because I was in love with Tommy Brookins." But such thoughts were not on her mind as she performed at the club that evening. Before the night ended, Ethel let everyone know that they'd be seeing her next month as she made her train trek back to New York for the Club Zanzibar booking.

AMONG HOLLYWOOD NIGHTCLUBS, the Clover Club was one of the swankiest, a favorite hangout for stars and studio executives. Black entertainers rarely performed there. At the William Morris Agency, the idea must have been to get her seen again by the right people, to remind them that she remained the consummate entertainer, able to sing the old songs

many patrons had grown up on and also able to create a story and a mood in a number like "Stormy Weather" or "Miss Otis Regrets." She could chat between her songs and tell amusing anecdotes. The conversational Ethel no longer spoke in risqué double-entendres; now she was a worldly, experienced woman emanating a mature warmth. The club persona was now veering closer to Petunia. The Ethel magic worked. She was held over and later rebooked for a return engagement. But it didn't lead to a single movie offer.

On January 28, she also appeared on radio's hugely popular yet controversial *Amos 'n' Andy Show*, which followed the exploits of two coon-style Black men in and out of wildly absurd comic scrapes. The show had been created by two white entertainers, Freeman Gosden and Charles Correll, who also played the title characters with thick caricatured dialects and mangled English. Many African Americans listened to the show. Others despised and protested against it as one more instance of racial stereotyping. Now Ethel, like other Black stars of the era, made a funny guest appearance.

BUT THE IMPORTANT NEWS was the trial, which began on February 8, 1944, at Los Angeles' Superior Court, presided over by Judge Newcomb Condee. During three days of testimony, much dirty laundry was exposed as the public was given a rare glimpse of an imperious Ethel. Two locksmiths testified that, responding to a call from Archie Savage, they had gone to Waters' home. At Savage's request, they had made duplicate keys to the trunk. The opening testimony was tame, but sparks were ignited as Savage's defense attorney set out to have entered into the record the nature of Savage's relationship with Ethel. During her testimony, Ethel, in a rather roundabout way, stated that Savage was never anything "physical" to her. When pressed by the defense attorney for more information, a testy Ethel responded: "You should answer that yourself. You are getting paid for it with my money. You can't insult me." But refusing to back off, the attorney read a letter from Ethel to Savage that opened: "My darling, hard-working husband."

During his testimony, Savage offered a drawing of "the upstairs portion of the house and indicating a bedroom, stated casually, 'Here is where Miss Waters and I slept.'" Repeatedly, he used the term "our room." He added that he moved out of Ethel's home "because she had 'taken up' with one Tommy Brookins who drove her to San Francisco at the time of the alleged theft and has since opened a night club in Chicago called 'Cabin in the Sky.'"

Once again, the case struck many as a comic, and now seedy, sideshow. The entire proceedings ran counter to the image Ethel had carefully cultivated over the years. "Waters Denies Love Affair with Savage," read a banner in the February 14 edition of the *Los Angeles Tribune*. No matter how much she denied it—and despite Savage's sexual orientation, which most in Hollywood were aware of—she looked like an older woman involved in liaisons with two younger men, one of whom, no matter what she said about the relationship, was clearly living with her without the benefit of matrimony. For those in the industry, she looked desperate and a bit batty.

In the end, Archie Savage was convicted of the crime and sentenced to one to ten years in San Quentin. He was released on bail of $15,000 while he sought an appeal. Later, hoping to make a deal that would assure him freedom, Savage informed the police of a dream his mother had, which led him to take the authorities to a diamond brooch that was found buried one foot beneath the dirt basement floor of the home where Savage was then residing in the East Adams section of LA. The "dream" didn't help. The appeal was denied and Savage was sent to prison in 1945.

Ethel and Brookins remained an item—by long distance. Calls went back and forth between the two once Ethel returned east to appear at New York's Zanzibar while Brookins stayed at the restaurant in Chicago. Then the relationship fizzled out. Yet Ethel remained in contact with him, and it appeared as if there were requests from him for money when he was in a pinch. By then, he no longer made her shiver. Though Brookins married another woman, he often still found himself referred to as Ethel's "hubby" and then her "former husband." The restaurant itself was never the success Ethel had hoped for. A new owner came in, and the establishment eventually folded. More money had gone down the drain.

* * *

THOUGH ETHEL WAS IN NEED of work more than ever, her biggest engagement in 1944 was really the trial. Otherwise the pickings were slim. On a British Broadcasting Company presentation, she performed with Paul Robeson and Canada Lee in Langston Hughes' play *The Man Who Went to War*. Zora Neale Hurston hoped Ethel would star in her folk drama *Polk County*, but nothing came of that. Lew Leslie contacted her in hopes of starring her in a new production of *Blackbirds* as well as a musical, *Blue Notes and Black Rhythms*. True to life in show business, the old feuds, rivalries, and battles could quickly be forgotten at the prospect of a new hit. But even before the plans fell through, Ethel knew this was going backward, that this type of once innovative and rather daring big-star revue clearly belonged to the 1920s and 1930s.

Some club work turned up. In June, she performed at Chicago's Rio Cabana. The possibility of doing the play *I Talked with God*, by Ann Mercer, which dramatized the plight of New York's slave life in the 1800s, caught her interest but went nowhere. Yet not content to sit idle or even to sit and relax, she spoke of building a $100,000 church in Harlem. It would be grand, palatial, a landmark edifice for the community. Perhaps she herself could help conduct services. As word of this plan made the rounds, there were cracks that Ethel now saw herself as Aimee Semple McPherson—the onetime nationally famous evangelist who had disappeared and was later discovered to have run off with a young man.

The William Morris Agency still believed it was important to have her seen by the right people. In early August, she appeared at a party for Orson Welles and his wife, Rita Hayworth, at their lavish home in Brentwood. Though she did not perform until nearly four in the morning, much of the crowd, including major directors Alfred Hitchcock and Preston Sturges as well as actors Joseph Cotton and Robert Montgomery and studio executive William Goetz, were still around. She was booked for a return to the Clover Club as well as the famous Trocadero on the Sunset Strip, but otherwise the appearance at the party didn't lead to any other work.

Part of the problem for her now in the nightclubs was that her repertoire had not changed. Showing little interest in new material, she sang mostly old hits like "Dinah," "Am I Blue?" and "Stormy Weather." Club stars like Ella Fitzgerald, Billie Holiday, and Lena Horne might perform some standards, but they sang the new songs as well. Their images also worked well for the era. Though Fitzgerald, whose style owed a lot to Ethel, never had the young Ethel's raunchy sexuality, her polished and poised performances and her skill at scatting earned her the reputation of being the consummate professional in the clubs. Holiday's distinctive style also had a contemporary edge, and she was still hailed by fellow musicians and composers. Her troubled private life and the stories of her drug addiction actually intensified the enthusiasm for her. Seeing Billie was like viewing a musical psychodrama. Though Horne was developing rather quietly into becoming an important stylist with excellent, sometimes biting diction and beautiful eyes that flared and darted and perfect comprehension of a composer's lyrics, she was also the kind of glamorous performer patrons were paying to look at. There had never been a Black woman quite like her on the nightclub circuit. All the women owed a debt to Ethel, but Ethel was not ready to give up her throne. Despite the fact that acting appealed to her far more, she understood that her livelihood depended on clubs and theater.

What Ethel did not understand was the effect of the Archie Savage case. For Black Hollywood, there may not have been a single doubt that he was guilty of the crime. Yet there was also the sentiment that he was one of theirs, and for Ethel to have sent this fellow artist to prison—well, that seemed an extreme measure.

People still buzzed around—the secretaries, the friends, the associates at her home. Concerns about money were on her mind, but she could still keep the refrigerator full for the guests, could still give a loan if someone was in need. For a time, Algretta stayed with her and was enrolled in Polytechnic High School. Stories also circulated that Ethel had a mad fling with another prizefighter, Gene Buffalo, who was often referred to "as the most handsome man ever seen in a ring." But for Ethel, it was hardly a passionate relationship. "About Gene Buffalo," she told Van Vechten, "no,

I'm not married. Nor am I in love with him but I think he's a fine person in a rough rugged out spoken way, and at this writing he seems too [*sic*] me to be a companion and comfort during this terrible siege and crisis I'm going thru because *he is* fun and hands me a laugh and sort of makes me feel I'm still wanted bye [*sic*] man."

# An Ill Wind

**M**AYBE 1945 WOULD BE BETTER.

The two best projects to come her way were the very kind she knew would not work: offers to star in vaudeville revue-style productions. She accepted both. Dieting and resuming a regimen to lose weight—the steam cabinet, the massages—she trimmed off the pounds to appear in *Rhapsody in Rhythm*, which opened at Los Angeles' Mayan Theatre on April 6 for a two-week engagement. With her were a group of talented comics—Mantan Moreland, Ben Carter, Dusty Fletcher, and Timmie Rogers. Accompanying Ethel on piano was Marion Roberts. Opening night played to a full house. "Her climaxing numbers received cheers and bravos," wrote the *Los Angeles Times*. "Ethel Waters enjoyed a triumphal return to the stage of song." The producers hoped to take the show to Broadway, but after its limited run, *Rhapsody in Rhythm* was not heard of again.

The second production, which was scheduled to open at the Belasco Theatre on Broadway, appealed more to Ethel. Its original title, *The Wishing Tree*, was changed to *Blue Holiday*; it was a group of songs, skits, and dances built around Harlem's famous Tree of Hope, where Ethel had often sat early in her career with her dreams for the future. Its producer, Irvin Shapiro, had ambitious plans. "There will be no wildcat buffoonery nor distortion in this Negro revue," he said. "All of the show will be fresh and decided on the 'cultured side.'" In the cast were Josh White, the well-regarded folk artist; the Katherine Dunham Company; the pianist Mary

Lou Williams; the veteran actor Avon Long; and the Hall Johnson Choir. The music included new songs by Duke Ellington and Yip Harburg. Ethel would perform her old hits as well as act in a sequence from *Mamba's Daughters* with Willie Bryant. No doubt the latter was at her insistence. Supervising the production was the imaginative African American designer Perry Watkins, who had urged Ethel to sign up for *Blue Holiday*.

While still appearing in *Rhapsody in Rhythm*, Ethel and the entire company were stunned to learn—on April 12, 1945—that President Roosevelt had suddenly died of a cerebral hemorrhage in Warm Springs, Arkansas. For a few days, everything seemed to stop as a grieving nation sat glued to the radio, listening intently to hear details about the president's death and then his funeral. Less than a month later—on May 8—news came of V-E Day, the end of the war in Europe. Though still in shock over the president's passing, the nation nonetheless was ecstatic that the boys—and girls—would be returning home, that rationing would end, that the new postwar period would be a time of optimism and prosperity.

By this time, Ethel had returned east for rehearsals for *Blue Holiday*. If anyone thought her professional dry spell might have mellowed her, they had another thought coming. In the production was the young Eartha Kitt, then a member of Katherine Dunham's company. During an early rehearsal, she was shocked by the behavior of the very "religious" Miss Waters. "We girls were supposed to be Hawaiian dancers," said Kitt. "We were dressed in very scanty costumes, placed on a block and then told to wiggle wiggle our way across the stage. Here we were all doing our wiggles when a voice screamed in the harshest tones, 'Get those naked bitches off my stage!'"

Said Kitt: "This was the start of my experience in the theatre world. Thank God, this was only a rehearsal. We all looked in the direction from which the voice came, to be met by the thunderous sound of footsteps coming towards us from the wings. Ethel Waters came onstage with lightning speed, shooing us away with arms flailing."

"I don't want those naked bitches on my stage," screamed Waters. "Get them damn things out of here!"

"She and the producers and directors had a small conference onstage as we hovered in the wings trying to hear what was being said," recalled Kitt.

"Eventually we were called back to begin our routine again on the beach-like stage. We continued to wiggle wiggle along when suddenly without warning, a tap dancer—who turned out to be Ethel Waters' lover—entered onstage in front of us tapping on the beach in a routine from the Apollo Theatre. We all stood stunned, wondering how a tap dancer could tap on sand, but that was the way Ethel Waters wanted it and that was the way it stayed." Whether the tap dancer was actually Ethel's lover was open to question, but Ethel—during these years—needed solace wherever she could find it. Though she would have been enraged had anyone ever suggested she was promiscuous, she still believed in a healthy sex life.

Plagued with problems, *Blue Holiday*'s producers brought in Jeb Harris to doctor the show, but to no avail. "Vaudeville should have pace, excitement, humor," wrote Lewis Nichols in the *New York Times*. "*Blue Holiday* goes from one creeping number to the next." Nor was the critic excited by Ethel's performance. "Miss Waters used to take a song, strangle it, jump on it and then fling it at the gallery. Last evening she was respectful, she contributed less song and more mannerism; the calliope had turned into a music box that all but played 'Kitten on the Keys.'" In the *New York Herald Tribune*, critic Howard Barnes called it "repetitive and rather dull." Most critics felt the scene from *Mamba's Daughters* "ill-advised." "Needless to say, the show did not last," said Kitt. After ten performances, *Blue Holiday* folded.

Undaunted, Ethel managed to get backing for a revival in June of *Mamba's Daughters* that played what was known as New York's subway circuit—theaters in Brooklyn and the Bronx. Then she performed scenes of the play as part of her act for an engagement at the Apollo. She still could not let go of Hagar.

Theater was about to undergo even greater changes now that the war in Europe had ended. The war-year protests of African American leaders like A. Philip Randolph and Walter White had brought into sharper focus the racial inequities and disparities in American society. Influenced by social and racial shifts in American life and culture, theater productions would move away from the traditional images of African Americans as singers and dancers—as well as those docile images of contented Black maids and butlers. Opening at the same time as *Blue Holiday* was the musical *Memphis*

*Bound* with Bill Robinson. It, too, looked tired and dated. Already a dramatic play like *Anna Lucasta*, originally about a Polish family in America, had been successfully remounted with a Negro cast. *Deep Are the Roots* would follow. New dramatic stage stars like Ruby Dee, Ossie Davis, Gordon Heath, Hilda Sims, and James Edwards would impress critics and audiences alike with their characterizations of troubled, brooding figures. The stage was being set for more modern representations of African Americans. Disappearing were the happy-go-lucky attitudes of African Americans onstage and on film, the buoyant, optimistic characters seemingly untouched by the harsher realities of American life.

"The interesting thing about 'Lucasta' is the fact that it is not a 'Negro' play nor does it fall into the same mold as other productions with all-Negro casts. Any nationality can be cast in 'Lucasta,'" wrote Black critic George Brown. "But the late unlamented 'Blue Holiday,' 'Memphis Bound,' 'Blackbirds,' 'Porgy 'n' Bess' and numerous others in the same category are termed 'Negro' plays. These, of course, elicit more applause from the white theatre-goers than from the colored. In the first place the so-called 'Negro' plays are stereotypes that Negroes would rather forget. And these plays suffer because they are not always as tightly written as plays without racial identification. So for the most part, most of the 'Negro' plays and musicals are nothing more than glorified floor shows. . . . The Bill Robinsons and Ethel Waters are great, but they cannot continually hold up crippled scripts nor can they please everyone by accepting parts in things like 'Memphis Bound' and 'Blue Holiday.' If they do, colored fans as well as white will go see Roy Rogers and Trigger in a horse opera instead."

*Variety* also commented: "A rash of Negro shows reported for production on Broadway next season has caused a lot of concern in New York's Negro community. Expecting a continuation of the stereotyped characterizations that the Negro finds offensive and libelous, various cultural leaders have voiced their disapproval on the grounds of inaccuracy, bad taste and a creation of bad will."

Clearly, Ethel's career was at a crossroads. But what could she do? She knew that she had to keep working and that she'd have to take whatever came her way. In hope of finding work, she signed with Joe Glaser's Associated Booking Corporation, which handled such stars as Louis Arm-

strong, Billie Holiday, Louise Beavers, Butterbeans and Susie, and Stepin Fetchit. But still, not much was coming in. So worried was she that she lost thirty pounds. Consequently, in December, she accepted a role in a dimwitted production called *The Passing Show*, which opened in Pittsburgh. A sign of the bad times was that entertainer Willie Howard had billing over her. She looked as if she were growing desperate. Only five years earlier, she had starred on Broadway in *Cabin in the Sky*. Had such a decline set in so rapidly? Feeling isolated, alone, and lonely, she turned even more to her religious faith.

A brighter prospect was a booking at year's end at New York's Embassy Club. "I thought I was on the way out," she told columnist Earl Wilson in her dressing room at the Embassy. Wilson liked Waters, and he knew times had been tough for her. Now as she sat with her cross, her Bible, and her framed poem that served as inspiration, he asked her about her career setbacks. "The Lord tests those that He loves—and I'm back in His good graces," Waters said. "In 10 months, I didn't work. It was a management problem, but it's all right now. . . . I thought, though, I was about to retire." "Did it shake your belief any?" Wilson asked. "What, darling! Not once. I know, anyway, if He meant for me to retire, He'd find something else for me to do." But the truth was, Ethel did not know what else she could do.

Afterward she went to Chicago for a club date at the Frolics. There, the critic for the city's *Daily News* praised her but, despite her weight loss, also commented on the "175 pounds of her." The "haunting wistfulness of her tremulous voice belies her well-fed appearance."

BUT HER PRIORITY was to get back to Los Angeles. The gossip was that she wanted to put her house up for sale. The truth was that she wanted to hold on to her house in Sugar Hill, especially in the wake of a court case that made news throughout the nation.

When Negroes had moved into this once whites-only section of LA, many white homeowners had fled the area, but some had stayed on. Eight white property owners who were particularly distressed by the presence of Black homeowners in their area had formed a group called the West Adams Improvement Association. The group's goal was to force the Negro

residents out of their homes in Sugar Hill. It didn't matter that these were immensely successful and sophisticated residents who had a high standard of living and maintained their homes and lawns beautifully. According to the *Los Angeles Times*, the white property owners claimed that the original deeds to those properties had restrictive covenants, and that "the Negro owners have moved into homes in violation of an agreement under which white landholders in 1937 and 1938 said they would permit no occupancy in the area by persons not of the Caucasian race." The group also argued that property values would plummet because of these "illegal residents." The group also contended that allowing these homes to be occupied by African Americans—that is, allowing race mixing—might lead to racial clashes.

The Negro residents of Sugar Hill had also mobilized—precisely at the time that *Cabin in the Sky* was being filmed. Workshops were conducted by Black actress Frances Williams. The Black residents were united in their battle to keep their homes and end residential segregation in Los Angeles. Among the entertainers were Juan Tizol of Duke Ellington's band, actor Ben Carter, and orchestra leader Noble Sissle. Among the prominent business executives were Horace Clark, owner of the Clark Hotel, and Norman Hudson, president of the Golden State Insurance Company. A number of the residents hired attorneys to represent them individually. Then the Black attorney Loren Miller consolidated the individual cases—numbering around fifty—and fought the West Adams Improvement Association all the way to the California Supreme Court. Ironically, Miller had been critical of the roles that some of Black actors he was representing had played in films, but this was another issue altogether. He argued that such restrictive covenants were in violation of the Fourteenth Amendment, which guarantees "equal protection under the law."

On December 6, 1945, a crowd of more than 250 arrived at the courthouse to hear the decision. Superior Judge Thurmond Clarke dismissed the litigation of the white homeowners. "The court is of the opinion," said Judge Clarke, "that it is time that members of the Negro race are accorded, without reservations and evasions, the full rights guaranteed them under the 14th Amendment of the Federal Constitution. Judges have

been avoiding the real issue for too long. Certainly there was no discrimination against the Negro race when it came to calling upon its members to die on the battlefields in defense of this country in the war just ended." The NAACP's Walter White wrote that Judge Clarke's decision, which had been "won through the brilliant work of Loren Miller, may possibly prove to be the most important single event of 1945 so far as the Negro and other minorities are concerned."

The Black residents of Sugar Hill were in a celebratory mood. The Double V motto of the war years—victory abroad and victory at home— might be coming to fruition. But the white homeowners appealed the decision and the case dragged on for several years. Ethel, McDaniel, Beavers, and the others continued their fight. In October 1946 Black residents cited the recently ratified United Nations Charter, which guaranteed all citizens of the world freedom from racial discrimination. Eventually, Loren Miller argued the case before the U.S. Supreme Court, which in a landmark decision in 1948, *Shelley v. Kramer*, declared such restrictive convents unconstitutional.

Though she was working in the east when Judge Clarke gave his decision in 1945, Ethel rejoiced. Yet the court battle may well have intensified her suspicion and distrust of whites. No matter how high she had climbed, no matter how much she had accomplished, be it in the recording industry, theater, radio, and films; no matter how many awards she had won; no matter how many city and government officials—be it a mayor or a governor or a senator or even the first lady of the land—praised her, she was still regarded by some as a second-class citizen. Just as decades earlier when she had been in the automobile accident in Birmingham, she had forgotten neither the kindness of those who took up a collection for her nor the cruelty of the whites who had left her pinned under the car and called her a nigger. Now she might well remember Clarke's decision, but she could not forget those who had lodged the suit in the first place. Nor would she forget the ongoing battle that led to the U.S. Supreme Court decision.

SHE WAS FRANTICALLY in search of work, her anxieties were constant, and now she was diagnosed with ulcers that sent her reeling in pain.

There would be reissues of old recordings: for instance, a Decca album in May 1945. But the record companies had no interest in her otherwise. Still, in 1946, the influential music critic Leonard Feather wanted to get her back into the recording studio. In April, he pulled together a deal with Continental Records for Waters to record new versions of some old numbers plus some new material, including some compositions he had written. Feather remembered that "her career already was in a decline. It had been three years since she had last made a movie, and longer since she had recorded," he said. "Anxious to secure her for a series of sessions I was producing in New York for a small independent company, I located her and arranged to bring her out of this involuntary retirement. She was eager to be back in a studio, and we arranged to meet directly for a discussion of musicians and material."

"I had heard many stories," said Feather. "Everyone agreed about the unique nature of her talents, but there were rumors that alarmed me. She was not known to take kindly to the slightest criticism. She was said to resent the success of certain other women singers. Supposedly, she was given to tantrums." During the meetings with her, Feather didn't see any histrionic outbursts. "Our encounters never offered any evidence of this," he recalled. "Gracious and cooperative, looking a little heavier than I had expected but still attractively statuesque, she agreed on the tunes, which would include new versions of four of her old hits—'Dinah,' 'Taking a Chance on Love,' 'Cabin in the Sky,' 'Am I Blue,' and four of my own songs, two of which were blues." Carefully, he gathered the right musicians to work with her. George Treadwell was on trumpet; Dickie Harris, on trombone; Ray Perry, on violin and alto sax; Mary Osborne, on guitar; Al McKibbon on bass; J. C. Heard on drums; and, of course, Reginald Beane on piano. Once in the studio, Feather had no problems working with her. Actually, he enjoyed it.

Feather also recalled "a strange aftermath to my record date with Ethel. Many years later, in the early 1960s, I received a phone call at home. 'This is Barbra Streisand. Are you the same Leonard Feather who wrote some songs for Ethel Waters?' Streisand, in town for her first big date at the Coconut Grove, invited me to her hotel suite to demonstrate these and other efforts. We spent an hour or two together around the piano, and for the

moment she seemed enthusiastic, for which I will remain eternally grateful to Ethel Waters, even though Streisand's interest waned so fast that the next time I ran into her, a few months later, she offered a dim 'hello' of quasi-recognition. Obviously it was Waters' way with a lyric and a tune that had turned Streisand on, rather than the material itself."

IN MAY 1946, she opened at Harlem's Club Baron. On the bill were Dusty Fletcher, Hot Lips Paige, Edna Mae Harris, and the smart young emcee Larry Steele. Glad to have the work, Ethel knew the gig was a far cry from her glory days.

That same May, while in New York, she received a letter from Alberta Hunter. Despite past incidents, the two remained on friendly terms. Hunter had stayed in Ethel's Los Angles home for a few weeks that spring. In her letter, Hunter asked how much she should pay Ethel for being a houseguest. "It's like this, Pal," Ethel wrote back, "I don't charge any thing [sic] for helping out a Pal until you can get located because I don't have any rooms to rent." She informed Hunter she kept a room in her home for "any two women or two men who are close friends of mine that I personally ask to visit with me." She also referred to a young man, whom she called "29," who was then staying at her home. He wasn't her boyfriend, she said, but "he wants to be." She added that "the weather and the niggers here are just the same." The letter was signed: "Your buddy—Waters."

A couple of theater possibilities excited her. One was to play Sojourner Truth in the play *I Talked with God* by Ann Mercer. The other was an all-Black-cast version of Ibsen's provocative masterpiece *Ghosts*, in which Ethel would play the mother tormented by her doomed son's syphilis. Also slated for the drama were Rex Ingram, Clarence Muse, and Fredi Washington. It was to open for a test run in Long Beach, Long Island, in August and then go on to Philadelphia and other cities. Van Vechten had dreams of Ethel playing Medea, which would have been a great role for her. So too would Mrs. Alving in the Ibsen drama. It proved a great loss for the theater world. But both *Ghosts* and *I Talked with God* had financing problems that left them unproduced.

\*    \*    \*

BY THE END OF THE YEAR, work was so spotty that it looked as if she'd accept anything. One such job was an appearance in something called *Show of Shows* in which she performed with the "Irish minstrel," Morton Downey—who was billed over her—at the Syria Mosque in Pittsburgh. Fortunately, she was booked afterward into the Zanzibar Club in New York.

Ethel grew panicky. She had some money, but how long would it last? For a time, she stayed at a midtown hotel in Manhattan but went to Harlem for meals and to combat her feelings of isolation and loneliness. "Many nights I'd eat in Mrs. Frazier's Dining Room on Seventh Avenue, between 123rd and 124th Streets, where the cooking beats anything you'll find anywhere else," she said. "I'd often go to Welles' to listen to the wonderful organists who play there. I'd get music-drunk, if such a thing is possible. I'd also relax, hour after hour, sitting alone in the Catholic churches."

Though she kept her room at the downtown hotel, she often stayed at the Harlem apartment of Mozelle Holmes, who was birth mother to Algretta. But it proved unsettling and stressful because Ethel believed the neighbors gossiped that she was on her last legs. After all the acclaim, after the years of full, nerve-racking schedules, after all the big-time money and publicity, after all the years of being adored, in their eyes, she was now back in the ghetto where she had started. Another kind of speculation emerged because the two women were living together. In truth, their relationship was as complicated as that of Ethel and Archie.

Speculation also arose about other relationships. Oddly enough, in an item in the *New York Times*, Black talent manager Norman Rowe was referred to as her husband. Yes, yet another husband. Some talk centered on her friendship with the young singer Thelma Carpenter, who idolized Ethel. "I was raised on Ethel Waters' records," said Carpenter. "Ethel Waters was the only thing my mother and father agreed on—they fought about almost everything else." Attractive and admiring of Ethel, Carpenter had amassed a vast collection of Ethel's records, which was more extensive than even Ethel's personal collection. Carpenter's own mellow singing style had been influenced by Waters. Having been a performer since childhood, Carpenter was a winner at the Apollo's amateur night

contest. At age seventeen in 1939, she performed as a vocalist with Teddy Wilson's band. A year later, she appeared with jazz tenor saxophonist Coleman Hawkins and his group and recorded the classic "She's Funny That Way" for RCA Victor. By 1943, she was a vocalist with Count Basie. It was a rapid rise, but trouble came after another big career break—when she replaced Dinah Shore as the vocalist on comic Eddie Cantor's radio show. Listeners liked her, and Carpenter herself seemed happy with this opportunity. But Cantor made an off-hand comment about her crying "tears of ink." Many considered it racist. Apparently, Carpenter felt the same way, and she left his show. Undaunted, she continued to record, appeared in "soundies"—early precursors to music videos—and dubbed vocals for actors and actresses in the movies. Many, many years later, Carpenter would appear as "Miss One" in the movie version of *The Wiz*.

Because of Ethel's suspicion of younger female singers, the question was why she had opened herself up to Carpenter. But Carpenter publicly voiced her respect for Waters' singing style—as did another up-and-comer, Pearl Bailey. Ethel, whom Carpenter called "Mom," gave her advice that proved invaluable. "Mom has often checked my singing to suggest 'Do it this way' and the performance showed a vast improvement even to me." Ethel actually encouraging a young singer? Something else had to be going on, or so the gossips believed.

Usually, though, Ethel kept to herself, frequently depressed and reflective as she struggled to understand what had gone wrong in her career and life. For some time, she believed the studios had intentionally blackballed her because of the fireworks on *Cabin in the Sky*. Her initial feelings about the studios were most likely correct. Word spread quickly in Hollywood. As big a Broadway star as Ethel had been, she was hardly the movie industry's idea of a leading lady. Nor was she needed for musical interludes in films. Horne, Hazel Scott, and the young Dorothy Dandridge were already doing that. In short, from the studios' vantage point, Ethel was a disposable commodity; stories of her temperament made her even more so. Later she believed her booking agents—first Associated Booking, then Moe Gale—preferred pushing their new younger stars. No doubt, the agents did look at her as a star from yesteryear, but Ethel could also be demanding.

She was also still bruised and bloodied from the two headline court

cases. Archie Savage's "betrayal," which hurt her more than she was willing to admit, would take a long time to get over, if she ever did. But her private correspondence revealed that she actually prayed to be able to forgive him. The fact that she might be forced out of her home—before the Supreme Court's decision—presented her with other problems. Then came tax problems. The Internal Revenue Service demanded payment for back taxes for the years 1938 and 1939. These were the years following the death of Pearl Wright, who had once kept Ethel's taxes in order. Also on Ethel's mind was the emotional state of Momweeze.

Worse, her employment dilemma—and her loneliness—hit the pages of the Negro press. "Ethel Waters, who is among the cornerstones of the house built on entertainment, has been given an awful runaround in 1946," commented the *Pittsburgh Courier*, which urged producers to offer her work. "You can do something about that and see to it that she is given the spot which her great and varied talents deserve." New York's *Amsterdam News* commented on an unexpected sight: "Ethel Waters sitting quietly in a corner of Randolph's Shalimar, just enjoying the music."

Ethel rallied herself as best she could. Once again, she joined in the battle for equal rights. In late January 1947, she signed a pledge of one hundred performers to boycott the whites-only theaters of Washington, D.C. In this postwar period that saw the dawn of the civil rights era, a number of Black and white artists, including Ethel, Bill Robinson, Helen Hayes, Cornelia Otis Skinner, José Ferrer, Burgess Meredith, and Lillian Hellman signed an agreement that read:

> I condemn and decry the practice of discrimination in the theater as an action completely in disagreement with all the basic principles of the profession. As a first step to combat this evil, I will not knowingly contract to perform in any play in any theater in the city of Washington which practices such discrimination toward either audience or performer.

For Ethel, there were memories of those times when she and so many other Black performers had to answer critics from their own community about their performances at segregated theaters. She well remembered the

time in Kansas City when angry Black townspeople protested near the theater where she was contracted to perform. Now with a unified effort, the old segregated policies could be fought and defeated. Her charity work continued whenever possible. In May, she appeared at a benefit for the New York chapter of Jewish War Veterans.

But work still was slow coming in, if it came in at all. Occasional radio shows, but nothing major. There was also an appearance on the new medium, television, on *The Borden Show*. She traveled to New Orleans—where she had so many years ago given her first radio performance—to perform at Owen Brennan's Old Absinthe House on Bourbon Street. There, she was a hit. "Owen turned away hundreds of would-be customers," the press reported, "and every square inch of space inside was occupied by an audience that listened to her with entranced absorption." Buoyed up by the roar of the crowd, she knew nonetheless that this wasn't Broadway or Hollywood.

Also draining her emotionally were the tantalizing offers that raised her hopes and then suddenly vanished. One club manager dropped her and brought in Billie Holiday instead for an engagement at Chicago's Regal Theatre. She held her breath when feelers were put out for her to act in Robinson Jeffers' new adaptation of *Medea*, to star Judith Anderson, to be directed by John Gielgud, and to be produced by Robert Whitehead. Though Van Vechten still believed—rightly—that she should be cast as Medea, she instead was considered for the role of the nurse. Still it was an offer for an important production. When she lost the role, her depression deepened. Then director Otto Preminger wanted her to appear in his forthcoming movie *Dark Wood* with Tyrone Power, to be produced by Twentieth Century Fox. Hedda Hopper reported that Ethel would play the maid Octavia in the film. "The role is strictly dramatic, no singing," wrote Hopper. Then the film was called off.

Briefly, Earl Dancer came back into her life with ambitious plans to do a million-dollar film on her life titled *Am I Blue?* Actress Suzette Harbin would portray Ethel up to the age of eighteen while Ethel would play herself from then on. Of course, there was no way the fifty-one-year-old Ethel could perform as herself as a woman in her twenties, and no such film was ever produced.

The one quality engagement that materialized was a concert tour with the Hall Johnson Choir. Constitution Hall in Washington, D.C., still owned by the Daughters of the American Revolution, which refused to permit Marian Anderson to perform there in 1939, turned down Ethel and Johnson's choir. But she toured successfully with the choir in other cities. Briefly, a new manager, Harold Jovien, tried to pick up the pieces of her career. She played Las Vegas, then an up-and-coming postwar town that would become a mecca for gamblers and folks out for glamorous high-style entertainment. But Ethel was an old-time blues singer. Vegas would prefer its Lenas and later its Dandridges. At every turn, she was viewed as something of an anachronism, a period piece of an entertainer from the postwar era, the post–World War I era, that is.

A tour was arranged that reunited her with Fletcher Henderson. Grateful as she was, she wondered if she were going backward. But it was work. Much to Henderson's dismay, she still griped during rehearsals. Yet he understood and most likely respected the simple fact that Ethel Waters, struggling to keep a foothold in the business, was, come hell or high water, still an artist, demanding the best not only of those around her but of herself. Henderson must have understood something else: Ethel's voice was not what it had once been. For the woman who never smoked and rarely drank—out of concern for her vocal instrument—Father Time was nonetheless creeping into her sound. Yet Ethel knew the tricks of the trade, how to use her voice, how to cover for those notes when the voice might sound frayed, scratchy, or worn.

A four-night engagement that proved important was LA's Philharmonic Auditorium at the end of September 1948. Calling her show "Cavalcade of Hits," in which she sang and did scenes from plays, she was in excellent form. With Henderson conducting, she seemed rejuvenated, performing moody numbers like "Sleepy Time Down South," and romantic ballads like "Can't Help Loving That Man of Mine." Then she turned the tables with her wildly ribald renditions of some of the old stuff, songs like "Go Back Where You Stayed Last Night" and "Ain't Gonna Sin No More." She had the place rocking and laughing. When she sang "Summertime," there were "many moist eyes, because of the sincerity and deep feeling on the part of the singer." Yes, she was heavier than the town had

remembered, and yes, the gray in her hair was showing. But she glowed, she swayed, she flirted, she danced with her voice, and she still knew how to reach her audience. During those nights at the Philharmonic she knew the old girl had a lot of life left in her. The *Los Angeles Times* had nothing but praise:

> Popular music was raised to its highest level. Miss Waters, accompanied by Fletcher Henderson, gave a program which was liberally sprinkled with songs intimately associated with the singer herself, several from her Broadway successes. There are many singers more vocally gifted than Miss Waters who could give these same songs without arousing the slightest enthusiasm from an audience. But there is only one Ethel Waters and the delightful experience of hearing her songs, or rather her portrayals, is unique. There is nothing profound about the star's appeal. The exuberance with which she greeted her audience last night set the stage and put her listeners in the right spirit for the many mood pictures created by living the songs instead of just singing them.

Though an ill wind had overtaken her, her faith still sustained her, but, as she knew, it was indeed an ill wind that blew no good. In the midst of her despair, Ethel had visited her mother in Philadelphia. At first, because of her weight, Ethel's mother had not recognized her and even asked if she were pregnant. But her mother told her how happy she was that Ethel had come to see her. Aware of her daughter's tough times, she encouraged her. "You really have took a beating," Momweeze said. "But don't you worry none, because you're coming back." For the first time, she said, she felt her mother had accepted her.

Perhaps, after all these troubles, something extraordinary might be right around the corner. Surprisingly, standing in her corner and helping to engineer a new phase in her career—and the beginning of one of the greatest comebacks in the history of American entertainment—was the man from Twentieth Century Fox who had first put her in the movies, Darryl F. Zanuck.

# Coming Back

I N HIS OFFICES AT TWENTIETH CENTURY FOX, Darryl F. Zanuck studied the production plans for his studio's forthcoming films. Since his days at Warner Bros., Zanuck had become an even more power-ful player. In 1933, he and Joseph M. Schenck had established Twentieth Century. Two years later, Twentieth Century had merged with Fox Film Corporation to form Twentieth Century Fox, with Schenck as president and Zanuck as vice president in charge of production. In the 1930s and 1940s, the studio, respected for the technical polish of its features, could boast of such directors as Joseph M. Mankiewicz, Otto Preminger, Henry Hathaway, and Elia Kazan. Like other Hollywood studio heads, Zanuck knew he had to have entertaining films that brought in big bucks at the box office, crowd pleasers that might be here today and forgotten tomor-row. But he also believed in quality films that addressed social or politi-cal issues in a provocative yet entertaining fashion. Having been behind the classic John Ford adaptation of John Steinbeck's novel *The Grapes of Wrath* as well as such films as *I Am a Fugitive from a Chain Gang, The Ox-Bow Incident,* and *The Snake Pit,* Zanuck was attuned to the altered outlooks and attitudes of American audiences following World War II. Movie audiences had lost some of their innocence. Now they might be ready for more adult themes. In 1947, he had produced *Gentleman's Agree-ment,* which, under the direction of Elia Kazan, had examined the theme of anti-Semitism in America. *Gentleman's Agreement* walked off with Best Picture of the Year, and Kazan had won an Oscar as Best Director. Now

Zanuck was ready to tackle the nation's long-festering racial problems and divisions.

With that in mind, he set out to produce a film adaptation of a novel titled *Quality* by Cid Ricketts Sumner. To be titled *Pinky* with a script by Dudley Nichols and Philip Dunne, Fox's film version would tell the story of a light-skinned young Negro woman called Pinky. After having studied nursing in the North, where she passed as white, she returns home to the South—and to her grandmother, a hard-working, uneducated laundress. Soon the young woman is faced with an emotional dilemma. Should she remain in the South where she will face repeated racial humiliations and frustrations? Or will she seek a new identity for herself—and a chance at professional, social, and emotional fulfillment and a marriage to a young white doctor—by heading north and again living as a free "white" woman? Her great tie to the South, and the cause of much emotional distress, is, of course, her grandmother—whom she calls Granny but is otherwise known as Dicey. The grandmother has repeatedly sacrificed so that Pinky can be educated. When Dicey learns that Pinky has crossed the color line, she is outraged. Ultimately, she insists that Pinky help an older white woman, Miss Em, now impoverished, ill, and in need of a nurse. Resentful and embittered because the woman represents the South's old white aristocracy, she nonetheless does as her grandmother demands. Caring for the woman, Pinky comes to learn more about herself and her racial identity. *Pinky* ends with a court trial in which the young woman fights to hold onto the property that the now deceased Miss Em has bequeathed her. Throughout, the film dramatizes racial conflicts and tensions in the Deep South. It also heralds a new day for the American Negro.

Concerned with every aspect of the films released by his studio, even more so with those in which he was credited as producer, Zanuck hired John Ford to direct the film. The youngest of thirteen children of Irish immigrants who settled in Portland, Maine, Ford had arrived in Hollywood in 1913 where he joined his brother Francis, who acted, wrote, and directed at Universal Studios. Taking jobs as a prop man, a stuntman, and even as an extra in *The Birth of a Nation*—he said he had been one of D. W. Griffith's hooded Ku Klux Klan riders—Ford eventually directed such

silent films as *The Iron Horse* and *Four Sons*. During the sound era, he emerged as a major director of such films as *Stagecoach*, *Young Mr. Lincoln*, *The Grapes of Wrath*, and *She Wore a Yellow Ribbon*. He was celebrated for his sweeping visual style and his depiction of the archetypal American hero—direct, honest, hardworking with no frills or pretensions.

Once Zanuck began casting, even before he selected the actress to play the light-skinned heroine, he decided the best choice—perhaps the only choice—for the role of the sacrificing grandmother was Ethel. Like other Americans, Zanuck had followed the trajectory of her now storied and stormy career. He well remembered the slender woman who had sung the blues and helped alter the sound of popular music; the same assured woman who, when he was at Warner, had entered his office and negotiated her own deal to appear in *On with the Show*. He had seen Ethel conquer Broadway, attaining the kind of success in mainstream white shows that no Negro woman before her had ever been able to do. He had been impressed and perhaps startled by her transformation into a stunning dramatic actress in *Mamba's Daughters*. Stories of her temperament on and off the *Cabin in the Sky* set must have reached him, and he must also have known that this now heavy, middle-aged woman was down on her luck. What may have brought Ethel back on the radar screen for the rest of Hollywood—she must have always been on Zanuck's—was that appearance at LA's Philharmonic Auditorium.

Still, once Ethel's management was contacted, she had to test for the role. "Everybody got screened before they picked me," said Ethel. "Yes, sir, Ethel was the last one." Of course, Ethel always enjoyed depicting herself as an underdog who would triumph over all adversities, all doubters. Going through the script pages sent to her, Ethel was able to draw on her personal experiences to develop the character. Just as Hagar had grown out of her fierce dream to tell Momweeze's story, Ethel's Dicey—a laundress who has probably never known much other than hard work—would be used to tell the story of her grandmother, Sally Anderson. It was that conviction that would give her character an emotional spine and an unexpected power.

On February 2, 1949, the *New York Times* announced that Waters had signed for the film. On March 6, 1949, the *New York Times* reported that

*Pinky* was one of five Negro-themed films in production or about to go into production: the others were *Home of the Brave*, the story of a Black soldier enduring racism within the military; *Lost Boundaries*, a drama about a light-skinned Black couple forced by circumstances to pass for white; *Intruder in the Dust*, based on William Faulkner's novel about a Black man falsely accused of having killed one of his white neighbors; and *No Way Out*, a stark drama about a young Black doctor at the center of a racial explosion in a big city. Even before filming, *Pinky* was being discussed and anticipated. Ethel's contract stipulated that she was to receive $1,500 a week for—initially—two weeks of work.

News broke that white actress Jeanne Crain was cast in the title role. The fact that no Black actress had been seriously considered for the role drew criticism. Fredi Washington was deemed too old for the part. So was Nina Mae McKinney, who was cast in the film as an older woman resentful of Pinky. Such actresses as Ava Gardner and Cyd Charisse were apparently considered. So too was light-skinned African American actress Hilda Simms. One story was that Zanuck had even considered Dorothy Dandridge. Most likely Fox believed Crain, though not a major star, was well enough known to get people into theaters. She was also under contract to Fox. But the selection of white actress Crain also helped the studio navigate its way around the theme of interracial love. Pinky was in love with a white doctor, played by actor William Lundigan, she has met in the North. When the movie audience saw the two embrace and kiss, it could relax, knowing that there was no real interracial coupling on-screen.

Ethel Barrymore was to play the role of the aristocratic but impoverished Miss Em. Frederick O'Neal won the role of the disreputable Black character Jake who has cheated Granny out of money that was supposed to be sent to Pinky up north. Cast as a young Black Southern doctor, whom the script conveniently depicted as being married so there would be no thoughts that he and Pinky might become involved, was the handsome football player Kenny Washington.

Just before the film went into production, Ethel was still on the road with Fletcher Henderson. "I didn't have the money to get to Hollywood to make the picture," said Waters, "but I did have a car. I knew I had to

get there, and my faith told me I would. When I started west with my accompanist Fletcher Henderson, there were awful snow storms in the West. Everyone advised me not to try to drive. But I had to. That was February, 1949. Sure enough, the snow was awful, and one town after another was closed to traffic just after we got through. In some places, we had to crawl through drifts ten feet high. But we got there. That was my faith helping me again." She quickly settled into her home.

Ford began shooting with scenes between Ethel and Jeanne Crain. Almost immediately problems erupted on the set, and in this case, not necessarily caused by Ethel. True, the two clashed on the conception of her character. But Ford—a tough, gruff, grizzled filmmaker who wore a black eye patch that could make him look menacing—ran a tight ship. There usually was not much time for discussion about how a scene was to be played. Ford knew what he wanted, and he expected cast and crew to give it to him. Ford, however, apparently did not understand how Ethel had to be approached. Moreover, having directed Stepin Fetchit in such films as *Judge Priest* and *Steamboat Round the Bend*—in which the Black actor personified the lazy, dimwitted coon stereotype—Ford had set ideas, now dated, on the depiction of Black characters. He would be criticized later for his treatment not only of African Americans but also of Native Americans. Later in his career, Ford appeared to be making amends when he directed *Sergeant Rutledge*, the story of a Black man wrongly accused of raping a white woman, but that was yet to come.

Employing a technique that worked when he directed John Wayne and other actors, Ford barked and shouted at Waters on the set, trying to whip her into submission. She, in turn, angrily withdrew. "When he indicated the least disfavor with what she was doing," said Elia Kazan, "her reaction was not fear but resentment and retreat." For one of the few times in her career, she appeared stunned by the behavior of a director. Too much was on the line with the film. Deep in debt and unsure where her next job would be, she had to be a success here. She also was determined to bring Sally Anderson to the screen. Her nerves were frayed. Her stomach bothered her. Yet word reached Zanuck about the problems. As he viewed the dailies—footage of what had been shot the day before—Zanuck became alarmed. To him it was clear that Ford did not understand

the character Ethel was trying to create. "Ford's Negroes were like Aunt Jemimas. Caricatures. I thought, we're going to get into trouble." Zanuck met with Ford. "Jack said, I think you better put someone else on it. I said, finish out the day and I took Ford off the picture. Some directors are great in one field and totally helpless in another field." The significant thing here was that powerful studio chief Darryl F. Zanuck dumped the A-list director John Ford, not Ethel Waters.

Zanuck had to act quickly. The picture could not fall behind schedule. He wanted it released before the year's end. He contacted director Elia Kazan in New York. Having directed such major postwar Broadway productions as Tennessee Williams' *A Streetcar Named Desire* and Arthur Miller's *Death of a Salesman*, Kazan was the hottest director in American theater. His direction of *A Tree Grows in Brooklyn* and his Oscar for *Gentleman's Agreement* also meant that Kazan was hot in Hollywood too. But Kazan was scheduled to head abroad to stage the London version of *Death of a Salesman*. On the phone, Zanuck told Kazan that John Ford had an attack of shingles and could not continue *Pinky*. He wanted Kazan to come out immediately to take over the picture.

"I've never been higher in my profession than I was after I'd directed *Salesman* and *Gentleman's Agreement*," said Kazan. "I was now of a rank so secure that I could afford to do Darryl Zanuck a favor." Because John Ford "was the American director I most admired," said Kazan, "I thought it would be an honor to stand in his shoes on his set. What a romantic I was! I made up my mind to do the favor, but in the manner of a grand gesture. Darryl had offered to rush me the script by transcontinental messenger. I told him that wasn't necessary. I'd do the job sight unseen, read the script when I arrived and be ready to shoot the next morning. What a fool!"

But Kazan did insist that he "not use any of Jack's stuff, no matter how good it was." For Zanuck, that would not be a problem. "Darryl was happy to junk Jack's film, and when I saw it I understood why. Something must have been bothering the old man besides shingles. I soon found out why."

Arriving early on the Fox lot, Kazan talked to the members of the crew, who filled him in on the details. Then Kazan met with Zanuck. "Jack's not sick, is he?" said Kazan. "He just wanted out."

To the press in later years, Zanuck said, "It was a professional differ-ence of opinion." To Kazan that day, Zanuck was blunt about Ford: "He hated that old nigger woman, and she sure as hell hated him. He scared her next to death." Of course, he was referring to Ethel. The fact that Zanuck could speak of her in such a way remains shocking and ugly. Here, after all, was a man who believed in her talents, who was doing every-thing he could to keep her in the film. But Zanuck was a man of his gen-eration, and he could be crude and vulgar. The kind of language he used might have hurt Ethel but not surprised her. Her whole life had been one in which, no matter how friendly she might be with whites professionally, she never felt she could trust them—and for good reason. Ford, so Kazan learned, had tyrannized the cast and appeared bewildered by Ethel, who he "didn't know what to do with." "He couldn't curse her, as he did 'Duke' Wayne." Right away, Kazan realized: "Handling Ethel would be half my battle." The initial meeting between the two may have been awkward at first. But Kazan, born in Constantinople of Greek parents, had grown up something of an outsider, which Ethel may have detected right away. Not yet forty, he may also have struck her as a kid, and she must have liked the idea that a major talent had been brought in to work with her.

For his part, Kazan knew she had to be regarded respectfully, and he had to maneuver around her paranoia. That was what Minnelli had un-derstood instinctively. That was what actress Fredi Washington had done in *Mamba's Daughters*. Aware that he had to be "patient and work the long road," Kazan "gentled Ethel and treated her as if she was intelligent—which she was, in a rather paranoid way—and pretty soon the old girl knew I liked her and settled down to good work. . . . I'd never been this close to an old-line Black before, but pretty soon she was kissing me every morning when she arrived on the set, doing whatever I asked, and at the end of the afternoon, when I told her she'd done well, asking the Lord to pour down His blessing on me. My problem was not Ethel, who was a tal-ent, but my leading lady."

Pleasant and agreeable, Jeanne Crain seemed detached and inexpres-sive, lacking the emotional depth the character needed—and which Ethel was so expert at in her performance. Having been an actor himself with the Group Theatre, Kazan knew that it was best not to become impa-

tient with her. Oddly enough, Kazan later believed her detachment and inexpressiveness worked for the character, who seemed confused, partly numbed, by the hand fate had dealt her. Crain "perfectly represented a victim of an unfortunate trick of the genes, her light complexion, and was, in the end, effective in the role."

Ethel appeared to work with Crain without any conflicts. She might have preferred someone like Fredi Washington in the role, a real colored girl who endured some of the very problems the character was confronted with. Yet she now came to believe that Crain *was* Pinky, much as she believed she was Dicey. She admitted that she was "living this part." "It seems that Miss Crain is really Pinky my granddaughter. I can feel the sorrow that nearly struck me down when her mother, my daughter died and left me with her to raise. I suffer the hurt and disappointment when I realize she is ashamed of her race and plans to desert it to pass for white."

Both she and Barrymore were now old-time theater pros, acclaimed and adulated and ready to accord each other mutual respect. To her, William Lundigan was probably just a handsome young man who caused no on-set hassles. In turn, he appeared to look up to her. She had no scenes with her onetime rival for the attention of the Negro press, Nina Mae McKinney. Ethel knew her career had been far more rewarding than that of the now sad-eyed McKinney, who had fallen into drink and drugs in part to cope with her professional frustrations and disappointments.

Dicey afforded Ethel the opportunity to play things hot and to play them warm and sweet. Upon learning that Pinky has passed for white, she is angered but still loving and forcefully tells her granddaughter to get down and ask the Lord for forgiveness. When Pinky refuses at first to nurse Miss Em, she cannot fathom her granddaughter's lack of compassion and poignantly tells her: "I worked long and hard to give you an education. But, if they done educated the very heart out of you, everything I worked and slaved so hard for is wrong." Then she turns righteous and commands her: "Now hear me, you're going up to Miss Em's. You're gonna take good care of her like the nurse you is. Or I swear on the holy Bible I'll whip the living daylights out of you." There were also moments when Ethel the woman could reveal her suspicion of whites. When Lundigan as Pinky's Northern doctor-lover, sees Ethel sitting on

her broken-down porch, Ethel's distrust of him and her resignation and sadness—that her granddaughter might return north to pass in an interracial marriage—resonated brilliantly. Like all skilled screen actresses, she speaks with her eyes and facial expressions. When Miss Em's relatives are about to take Pinky to court over the property, Dicey fears it is useless to fight them. "Pinky, I've lived in this world a long time," she says, "long enough to know for sure if there's something white folks don't want you to have—that they want for themselves—you might as well forget all about it." Though the part was written with the characteristics of the traditional self-sacrificing mammy, she nonetheless distinguished her Dicey with a warmth and humanity that transformed the character and transcended the stereotype itself.

One aspect of the film that Fox was cautious about was the then taboo topic of miscegenation. The studio's concern was not so much about Pinky's interracial relationship with Tom. Not only had the casting of Crain alleviated any fears the audience might have. But the relationship would end with the two separating. Instead, the studio believed it might have problems if the script commented on a past relationship of Ethel's character. In response to correspondence from Francis Harmon at the Motion Picture Association office in New York regarding the topic of miscegenation, which had already been discussed with the Production Code office of Joseph Breen, Zanuck wrote: "You will recall that the book, 'Quality,' went a lot further than our script but not as far as your suggestion with respect to miscegenation. In the book it was quite evident that an unnamed relative of Miss Em's, probably her brother, was the father of Pinky's mother. This relationship was used for an entirely different purpose in the book. It caused Miss Em to hate Pinky when she was a child while, at the same time, she condoned Granny as probably having been taken advantage of." Zanuck continued: "As you know, we have consulted the Negro representatives of many different Negro points of view, and without exception they have objected to the suggestion of miscegenation even to the slight phrase which is still in the picture in which Granny says, in effect, upon Pinky's arrival, 'I hope you haven't gotten yourself in trouble as your mother did,' or some such phrase." That line of dialogue or "some such phrase" was not in the film when it was released. At the same time, audiences were left to

ponder Pinky's biological background. Nothing was said about the young woman's parents. Consequently, it was never explained why she looked so white. Nor was there any suggestion that Granny had ever had any sexual relationship with a family member of Miss Em. Had there been more back story on Ethel's character, her relationship with Miss Em would have been more complex; so would Pinky's relationship with the older woman. That also would have added another factor to Em's decision to will Pinky the property; in essence, it would have explained that Pinky had long been an unacknowledged family member.

*Pinky* was completed in eight weeks. When the last scene was shot, Kazan eagerly prepared to get back to New York and move on with his life. He recalled, "My most vivid memory is the end-of-the-schedule party." Surrounded by cast and crew, Kazan remembered that he got drunk. Though Ethel still abstained from alcohol, this was one of the two occasions during the 1949–1950 period that she had something to drink, which was noted by those around her. Clearly curious and fascinated by her, Kazan remembered: "Ethel Waters and I were especially cozy until she put down one drink too many. I saw this was my chance to ask her what I'd been meaning to ask for weeks."

"You don't really like any white people, do you, Ethel?"

"No, I don't," she answered.

He felt she had momentarily dropped her "religious mask."

"Not even me?" Kazan asked.

"Not even you," she told him. "I don't like any fucking white man. I don't trust any of you."

The next day, said Kazan, "the mask was back on, and she kissed me and thanked me and once again called down the Lord's blessing on me. She was sorry to leave. There weren't many parts waiting for an old Black woman. I was happy that she was friendly again, but I knew that when she'd been high, she'd spoken the truth."

MUCH AS SHE ENJOYED being back in her home, seeing her garden outside her window, enjoying the space and openness of this sprawling city, she could not linger long. The *Pinky* paycheck helped her financially,

but the IRS was hanging over her head. She had to work and would have to take anything she could get. So it was back on the road at whatever clubs or theaters booked her.

Unknown to Ethel, she was on the mind of producer Robert Whitehead in New York. Elegant and handsome with a dash and flair reminiscent of Errol Flynn, the thirty-three-year-old Whitehead had attended Trinity College School in his native Montreal. Having begun his career as an actor and having worked in New York, he had enlisted in the American Field Service in 1942 and was an ambulance driver, first in North Africa and then Italy. Following the war, he returned to New York. Within a few years, he produced the Robinson Jeffers version of *Medea*, starring Judith Anderson, the same production in which Ethel had hoped to appear as the nurse. Over the years, he became, said Arthur Miller, one of "a handful of producers . . . who longed for artistically ambitious and socially interesting plays and could put their money where their mouth was."

By 1949, Whitehead wanted to produce—along with his partners Oliver Rea and Stanley Martineau—Carson McCullers' adaptation of her 1946 novel *The Member of the Wedding*. It was a coming-of-age story about a young small-town girl, Frankie Addams, struggling with the pangs and pains of adolescence, feeling like an outsider and desperately trying to fit in. Or perhaps it might best be described as a story of three outsiders: Frankie; her six-year-old cousin, John Henry; and their close friend, the Addams family's one-eyed cook, Berenice Sadie Brown, a bruised and battered survivor of failed relationships and unfulfilled dreams. The one man she had loved fiercely—her husband Ludie—had died. Could she ever forgive life for this loss? With the children Frankie and John Henry, Berenice was able to open her heart and reveal its ache. Once she learns of the lonely Frankie's plans to join—uninvited—her brother Jarvis and his new bride on their honeymoon, Berenice tries to reason with the girl and bring her to her senses. McCullers' novel had been a literary sensation that drew a great deal of attention; so had her desire to see her dramatic adaptation open on Broadway. The prestigious Theatre Guild had optioned her play but let its option lapse. Afterward, Whitehead stepped in.

In the history of American popular culture, only on rare occasions were there mad, intense searches to find the right African American ac-

tress for a role onstage or on screen. One such occasion had been the search for the light-skinned young woman who passes for white in the 1934 version of *Imitation of Life*. Finally, Fredi Washington had been discovered, and the studio went through pains to sign her. Later there would be the search by director Otto Preminger to find the right actress to portray the lead in his film *Carmen Jones* that finally resulted in the casting of Dorothy Dandridge. The other occasion was the casting of Berenice in *The Member of the Wedding*. The difference was that from the outset, Robert Whitehead and others affiliated with the production knew the actress they wanted. It could only be Ethel Waters. But he knew it would be like pulling teeth to persuade her to do the play. Ethel had already turned down the proposed Theatre Guild version. Having read the novel, she bristled at the characterization of Berenice, who smoke, drank, and worse, for Ethel, had no faith in God. *The Member of the Wedding*, she said, was a "dirty play." "I don't drink," she said. "I don't smoke and I'm not promiscuous. I'm no saint though. Just the same, Berenice was a bit rugged. She needed a little house cleaning." Refusing to have anything to do with the play, she frankly admitted that she was down on her luck but not *that* down. In May 1949, Whiteman approached Ethel with a revised script. But still she would not commit.

He did sign Harold Clurman to direct. A major man of the theater who helped found the Group Theatre in the 1930s, produced Arthur Miller's *All My Sons*, and wrote reviews and essays on theater, dance, music, and film, Clurman at first didn't think *The Member of the Wedding* was a play at all. Nor did he think the public would understand it. Then he met with McCullers. "What's your play all about?" he had asked her. "Togetherness," she answered. Clurman then thought he might be able to make something of the drama.

Now Whitehead was all the more determined to get Ethel on board. Having gone to Italy, Whitehead wrote Carson McCullers on June 28:

> There seems to be have been some small misunderstanding between
> [agent] Audrey Wood and myself regarding the submitting of your
> play to Ethel Waters—I was under the impression that I had told
> Audrey that we would send a script to Miss Waters if her response to

my letter written in May was enthusiastic. I am, of course, dreadfully sorry if this has been a tactical error but am naturally anxious to bring her in on our plans as soon as possible so that we can count on her availability. Though we have all agreed to withhold rewrite plans till Harold Clurman returns, I still think, as I told you on the phone, that the play does not need any large scale revision, particularly in the case of "Berenice" who seems to me already drawn with great substance.

Though Ethel Waters' reaction to playing the part was disappointing, I have not given up hope about her at all. I think she would be making a tremendous mistake in refusing the part and hope she will seriously reconsider after we have had a chance to discuss it with her ourselves.

Once back from Europe, Whitehead had his office locate Ethel. He would have to use all his powers of persuasion on her. On September 1, 1949, the *New York Times* reported that Whitehead had gone to Chicago to talk to her about *The Member of the Wedding*. As he sat with her at the boardinghouse where she was staying, Ethel told him, "Every night I get on my knees by that bed and pray that God will send me a good booking." "I have a good booking," he said. Waters, however, insisted there was no God in the play. "I was lookin' for God in the book. I couldn't find Him." But she did consent to meet Carson McCullers if she got to New York. Waters recalled: "I asked myself, 'Why do you constantly reject this?' This play is the only thing that keeps comin' up." A few weeks later, Whitehead took Waters to McCullers' home in Nyack, New York. As soon as she saw the frail, ill McCullers, who by age twenty-nine had suffered three strokes, which left her partially paralyzed, Ethel saw that this was an outsider-child—so much like herself—whom she could not reject. She had felt the same way about the character Frankie Addams. But Ethel could not put aside her feelings about the depiction of Berenice. On that occasion, she spoke openly and honestly. If Carson would agree to let her make changes—in essence, to bring God into the drama—she would do it. McCullers consented. Berenice now would not smoke. Nor would she be a drinker. "It is official," the *New York Times* reported on September 15.

"Ethel Waters will star in [the] forthcoming production of 'The Member of the Wedding.'" Ethel also would receive top billing *above* the title.

On October 11, the *New York Times* reported that twenty-three-year-old Julie Harris, from Grosse Pointe, Michigan, would play Frankie Addams. That past summer McCullers had seen Harris in *The Glass Menagerie* with Helen Hayes, and she believed immediately that she was perfect for the play. Ethel also must have taken one look at the slender, girlish, sensitive Harris and felt about her as she did about McCullers: here was another outsider-child, perhaps as awkward and vulnerable as she herself was. "Our first meeting," recalled Harris, "was at Robert Whitehead's apartment. Ethel had come there so we could meet and leisurely read the play. . . . She talked about missing her soap operas on the radio! I loved her immediately. I had seen her in *Cabin in the Sky* and *Mamba's Daughters* . . . and I worshiped her." Here, too, was someone like Fredi Washington whom Ethel could mother, someone to whom she could relate, which in turn could help her *believe* all the more in the role she was playing. Ethel always thought of Harris as her "precious baby girl." The two became lifelong friends.

QUICKLY EDITED and well publicized, *Pinky* opened in New York on September 29 at the Rivoli Theatre to mixed reviews. The *New York Times* complained: "The message of *Pinky* seems to be that colored girls, however fair, will find more happiness conducting themselves as Negroes in the warm-hearted South than they could passing as whites in Boston. I'm not sure I'm willing to take Mr. Zanuck's word for that." Also among those disappointed was the NAACP's Walter White. "I have never in all my life wanted so much to like a moving picture as much as I did *Pinky*," wrote White. "Unhappily for me, I have to say that as far as my judgment is concerned, Mr. Zanuck has failed. Some new ground has been broken but they were mere scratches in the vast field of human relationships the picture sought to play." White added: "Consider, for example, the roles played by those two great actresses, Ethel Barrymore and Ethel Waters. Because they are the artists they are, Misses Barrymore and Waters extract from the parts they play every last ounce of drama. But the roles

given them are absolutely nothing but worn-out stereotypes of the domineering old mistress of the plantation and the blindly faithful servant." The Negro press noted that an important opportunity had been lost for a young Black actress with the casting of Jeanne Crain. But, generally, the Negro press supported the film. The *Los Angeles Times* also had a different point of view, writing that "the film proffers its fascinating, sometimes sentimental narrative with rare feeling. It holds its audience under a singular spell." "Darryl Zanuck hit the bull's eye again with *Pinky*," exclaimed columnist Hedda Hopper.

Still, Fox remained cautious about the picture. Screenwriter Philip Dunne wrote an article titled "An Approach to Racism," in which he stated: "The production of 'Pinky' marks another break with the longstanding taboo against films dealing with the problems of racial and religious prejudice. . . . I think it should be understood that the taboo existed, not because Hollywood producers are reactionary or socially illiterate, as some have maintained, but because the production of a controversial film of this nature entails a very real financial risk. A formal or informal boycott by any group or in any area can turn a legitimately anticipated profit into a loss. In this sense, it takes courage on the part of studio management to embark on such a venture." On the subject of race, Dunne wrote that the film "will present no one point of view as the definitive one. We try to tell a completely personal story. Jeanne Crain, as Pinky, portrays not a race but an individual. The story is Pinky's, not ours, and while the tragic dilemma of her life is induced by the facts of racial prejudice, the solutions she finds are her own and affect only her." Dunne's article was sent to the Negro press. Clearly, the studio did not want a Black backlash.

But whatever compromises were built into the film, *Pinky*, along with the release of the other "Negro problem" pictures in 1949—*Home of the Brave, Lost Boundaries*, and *Intruder in the Dust*—heralded a new day in Hollywood. The race theme had come front and center. Ethel may have played a servant, but it was no giggling maid. Now the Black character was a troubled motion picture character, who struggled, as exemplified by Pinky herself, to break through the racial barriers and humiliating discrimination that were so much a part of American life. In his essay "The

Shadow and the Act," Ralph Ellison wrote of the "Negro problem" pictures: "And yet, despite the absurdities with which these films are laden, they are all worth seeing, and if seen, capable of involving us emotionally. That they do is testimony to the deep centers of American emotion that they touch."

In the long run, *Pinky* proved to be a better film than some reviewers indicated. Kazan infused it with feeling for the young woman's odyssey for self-awareness and racial pride. He also captured some of the slow-moving ambience of life in the South where beneath the placid surface, racism could unexpectedly rear its ugly head. It was also an actor's film. From his three female leads—Waters, Crain, and Barrymore—he had drawn engrossing performances. Also commendable were the performances of Evelyn Varden, Nina Mae McKinney, Basil Ruysdael, and Frederick O'Neal.

There was much excitement about the film. Smelling a hit, Zanuck set up promotion tours for Jeanne Crain and William Lundigan. Ethel found herself back in demand in a way she could never have anticipated. Twentieth Century Fox set up personal appearances for her—along with the chance for her to pick up some extra cash—at select theaters throughout New York's five boroughs, where she would perform accompanied by Fletcher Henderson. When Ethel arrived by train in New York from Chicago, Fredi Washington and William Lundigan, along with representatives from Fox and members of the Negro press, were at Grand Central Station to meet her. Fredi Washington cautioned the press and the Fox people: "You never know what 'Mother' will do. If she's in one of her good moods she'll come out smiling. If she isn't—she might walk right past us and go on about her business." "So when the train shuttled into the station," the press reported, "we all stood around nervously." Once Ethel stepped onto the platform, many must have done a double-take. No matter what her weight or her age or her finances, she looked magnificent, the silver in her hair showing, the face beautifully made up, the smile as warm and entrancing as ever. "Ethel Waters, who has a reputation for emerging into public limelight swathed in a mink but wearing flatheeled shoes, didn't disappoint us," one reporter wrote. "There was the fur coat. And there, true to tradition, were the flatties."

Right away she spotted Washington, still her Lissa. "My child!" she exclaimed as she kissed Fredi on the cheek. "Ethel," William Lundigan called out. She kissed him too. "All the guys from 20th Century Fox felt it safe to gather around."

Basking in the attention, she attended a round of parties, receptions, and dinners, many in tribute to her. On September 23, she was the guest of honor at a reception at the Skyline Room at Harlem's Hotel Theresa. Much of Ethel's old crowd showed up, including Noble Sissle, singer Maxine Sullivan (her reported one-time rival for Mallory's attentions), and actor Leigh Whipper. For many, the surprise guest was Algretta, then living in New York and possibly a young mother by this time. Also there to greet her was Bill Robinson. It was one of Robinson's last public appearances. On November 25, he died. He was seventy-one.

At the Rivoli Theatre on October 24, the Negro Actors Guild honored Ethel for "dramatic achievement" in *Pinky*. Serving as master of ceremonies that evening was influential columnist Ed Sullivan, then becoming all the more famous because of his variety show on the new medium, television. Some fifteen hundred people turned up that evening to honor her. Later she joined other performers for the "Night of Stars" benefit on behalf of the United Jewish Appeal. In November, she also christened a health and beauty center in Harlem; a $45,000 building had been purchased by twenty-five Black women; the first salon of its type for African American women in uptown New York. Helping her greet the five hundred invited guests was her new friend Thelma Carpenter. Waters beamed. At a benefit for Freedom House, she sat on the dais with Eleanor Roosevelt and Bernard Baruch.

Had it all really turned around for her? Yet Ethel couldn't forget the torment of the past years. "People don't seem to associate trouble with me . . . reckon they feel nobody could look so happy and be hiding trouble inside," she told her new friends, former model Jinx Falkenburg and her husband, Tex McCrary. "But, honey, I'm afraid to cry. If you cry, you have to cry alone . . . and if you cry alone, sometimes you can't stop. . . . I been through hell for ten years, waiting to come back to New York the right way—but now I'm back. And the same people that shut me out—denied me—I'm proud I can shake their hands—and wish them well. I could have evened

up a few scores . . . but now I say God bless 'em all, because God blessed me and brought me back. I say thank you, God."

On October 19, the *Los Angeles Times* reported: "Attendance records for a picture at popular prices were smashed by 'Pinky' during the first week's run at the Rivoli Theatre in New York." The next month, the film had its Los Angeles premiere and continued to draw in large audiences. Already there was Oscar talk for Ethel.

*Pinky* did run into problems in the South. Censors in Marshall, Texas, banned it because of its interracial love theme. It had "depicted a white man retaining his love for a woman after learning she was a Negro, depicted a white man kissing and embracing a Negro woman, and included a scene in which two white ruffians assault Pinky after she has told them she was a Negro," reported the *New York Times*. When one local exhibitor defied the ban, he was fined $200 for showing it. He fought the fine, and eventually the case went to the Supreme Court, which struck down the censorship ordinance of Marshall. Justice Felix Frankfurter felt "the Marshall city ordinance offended the Constitution's due process of law clause because of indefiniteness."

ON OCTOBER 28, rehearsals began for *The Member of the Wedding*. Yet there remained one important role still not cast, that of the six-year-old John Henry. Someone remembered that actor Fritz de Wilde, who played Frankie's brother Jarvis, had a son, but de Wilde said his son Brandon was much too young and could not even read. When Clurman and the others talked with the boy, they all agreed that Brandon was perfect. Working with the boy on his lines, Fritz de Wilde dropped out of the role of Jarvis and became the production's stage manager.

Now it was a real company as cast and crew prepared for the out-of-town tryout at Philadelphia's Walnut Theatre on December 22. The real problem, though, was Ethel, who at first could not adjust to Clurman's direction. "His way of telling you when you are good is to say nothing," she said. Later she came to respect him greatly. Mystified by Ethel and unable to figure out how to get her to perform as directed, Clurman described her as a "strange person." Directing her, he said, was like "training a bear."

She found it hard to coordinate her dialogue with her movements. "We had trouble, but it wasn't that she made trouble," said Clurman. "She had a great deal of difficulty in remembering lines, and when she remembered lines, she forgot the business." Cast and crew were amused to see Brandon de Wilde, who learned his dialogue quickly, prompt her, feeding her the lines to come. Ethel herself was amused and charmed by the boy—at first. But when the prompting continued, she firmly told the boy, "Now, honey, I don't want you to bother me any more." The child shut up.

For Ethel, there was the added pressure of performing in Philadelphia. While Hagar in *Mamba's Daughters* had been her labor of love for Momweeze, her character Berenice, much like her Dicey in *Pinky*, would be her attempt to express some of the pain and wisdom of her grandmother, Sally Anderson. She was determined not to fail, yet as she prepared to travel to Philadelphia, there were so many problems—and memories. The entire cast and crew was aware of her inability to get the dialogue right, which simply added to her tensions. Her stomach bothered her, she also had cramps, and she was also conscious of yet another weight gain. Audiences would be startled, even shocked, to see that she now weighed about three hundred pounds.

Yet Ethel brought something else to the play that no one had expected. There were different versions of how this "something" came to be. There was a Russian lullaby in the original script. According to one version of the story, during a meeting with producer Whitehead and Julie Harris, Ethel asked Whitehead if she could instead perform the song her grandmother had often sung, "His Eye Is on the Sparrow." Its lyrics were simple but haunting:

> *So why should I feel discouraged*
> *Why should the shadows come,*
> *Why should my heart be lonely*
> *Away from heaven and home,*
> *When Jesus is my portion?*
> *My constant friend is he.*
>
> . . . .
>
> *I sing because I'm happy,*

*I sing because I'm free.*
*For His eye is on the sparrow*
*And I know He watches me.*

That day she performed it just for Whitehead and Harris. Afterward Harris cried. In another version of the story, Carson McCullers asked Ethel if she knew a song to sing to the children. "I sang it for Carson and when I finished, she got in my lap and cried just like Frankie does in the play," said Ethel. Regardless, Harold Clurman didn't like the original ending of the second act. Ultimately, "His Eye Is on the Sparrow" would prove perfect for closing that act, and no theatergoer would ever forget it. "The hymn brought more God into the show," said Ethel.

After seeing Ethel and Harris in a run-through, Clurman's wife, actress and acting coach Stella Adler, liked it so much that she invested in it without telling him. Other investors included the wives of Robert Whitehead and Oliver Rea as well as set designer Lester Polakov. Television director James Sheldon recalled that one of the young women who did casting for Whitehead "put a package of people together, and for 50 bucks each, we were investors." That investment paid off, said Sheldon. "I must have made $1,200." It cost $75,000 to mount the show.

THE WEEK BEFORE the play's Philadelphia debut, the cast and crew boarded special cars on a train that carried them and the sets to the city. A contingent of Carson McCullers' friends traveled from New York to see the play on its opening night. Coming up from Key West, Florida, was McCullers' close friend Tennessee Williams, the most talked about American playwright of the postwar era. A highly nervous McCullers was distraught. She didn't know what would happen with her drama. Everyone noted the cold and gray weather, which for theater folk was not a good sign. It would be harder to warm the audience up.

At the Walnut Theatre, as Ethel prepared to go onstage, "she was being cued in the dressing room through the first night," said Harold Clurman. "You're only nervous, Ethel," he gently said. "You'll be wonderful tonight—just don't you worry about a thing."

"You're very reassuring, Mr. Clurman," she told him, "but I'm not reassured."

She explained to Clurman her long-held belief that the responsibility was always greater for a Negro actor than for a white performer. She still believed that she represented a race of people that could not endure a failure.

What she didn't tell Clurman that night was something else she was aware of that simply added to the pressure. "All the play is, is a narration, and there's not a moment onstage when the play carries itself," said Ethel. "My part isn't written as the starring role. I knew it when I took it. But I had to make it that way or get out."

Before going onstage, she performed her dressing room ritual, saying her prayers, placing her faith in God. "I got on my knees and told Him, 'God, you know this means everything to me.'" Then, when she was braced with the determination to play Berenice exactly as she felt the part, something else occurred that drew out her warmth and helped her momentarily push her fears aside. "In Philadelphia, where we opened," recalled Julie Harris, "that first night we assembled on the stage—places, please!—and heard the suppressed roar of the audience from behind the curtain. Brandon looked astonished and then troubled as it dawned on him that all those people would be watching the play, and the tears started falling down his cheeks. Fritz walked onstage from the wings to comfort him. Ethel put her arms around him. We all said he would be O.K."

Onstage, something miraculous happened. "She had a great deal of trouble getting it all together," said Clurman. "But when she got it all together, she was wonderful." Ethel remembered her lines, and she, Harris, and de Wilde worked beautifully together. "Miss Waters, Brandon, and I became one person—all of us in the play really," said Harris. Though the play was some four hours long, and would later be cut, that night the audience sat mesmerized.

Backstage, an enthralled Tennessee Williams asked for Ethel's autograph. But she said she wanted his. No, he wanted hers. Finally, Ethel told the playwright, "Honey, I'm not from the South, but I can keep this up as long as you can."

"'The Member of the Wedding' could very likely be that play you wait

for all season; the one play that suddenly lights up the theater with a dramatic impact that makes the previous offerings, no matter how well written and acted, seem on the frail side," wrote the critic for the *Philadelphia Inquirer*. "Ethel Waters is a constant delight as she tries, out of ripe worldliness of her experience, to bring some common sense into the emotionalism of her young charge."

Relieved that she had gotten through opening night, that she had done Sally well, Ethel grew more confident. Yet she was never at ease. She still had to face the audiences and the critics in New York.

ON JANUARY 6, 1950, Ethel and company opened in *The Member of the Wedding* at the Empire Theatre, the very house where *Mamba's Daughters* had its New York premiere. Surely, there were many memories as she walked through the stage door entrance. Eleven years earlier she had to prove herself as a dramatic actress in this same theater. Now she had to do the same all over. Perhaps the theater itself was a sign of good fortune to come.

Though theatergoers may have felt like Harold Clurman when he first read McCullers' script—that it wasn't a play at all—they settled into its rhythm and responded to the poignant characters onstage. With the advent of the 1950s, the oncoming Eisenhower era, and the cold war—a time when the nation, as if afraid of its own shadow, feared communism and valued conformity—the three primary characters were distinct nonconformists, each a touching individualist finding unity in the presence of the others. Holding it all together was Waters' Berenice. In many respects, the character grew out of a long-held national dream, that of finding safety in the arms of a large, dark Black woman willing to comfort and nurture. Putting her own concerns and anxieties aside, Berenice, the nourisher, who is shown providing comfort in the kitchen of the Addams household, was partly a mammy conception, just as Dicey had been. Yet McCullers had offered something else about the character that lifted her out of the old timeworn stereotype. The character was not devoid of sexuality. The character T. T. Williams was Berenice's minister boyfriend. In her sweeping monologue, Berenice had talked of her past loves and mistakes and

clearly revealed herself as having a life apart from those she served. In a sequence with her foster brother, Honey, a tormented young musician, unable to adjust to the culture of the apartheid South, she revealed family ties and an awareness of the pressures a Black man must endure.

In the hands of another actress, Berenice might still have been flat and emotionally uninvolving, but Ethel lifted the entire production up. Her warmth, her fundamental sense of right and wrong, her refusal to play nice with Frankie, her common sense, the suggestion of another past that the play may not have known anything about, were used by Ethel to create a full-dimensional, highly moving character. Despite the weight gain and the perceptions about heavier women, Ethel still had a sexual component to her personality. Clurman had also been wise to close the play with Ethel alone onstage. John Henry had died. Frankie had taken the crucial steps toward womanhood. Her foster brother Honey had been arrested. Berenice might have felt sad and lonely, but she would endure.

Martha Orrick, then a young actress, eager to see as much theater as possible and learn as much about acting technique as she could, found Waters stunning. "I was just saturating myself with theater then," Orrick recalled. "I remember that Ethel Waters was just weary. And these little children had no one else but her. I remember thinking—I know something about what this play is because when my brother and I spent time in Virginia as children, there was a woman who cooked and cleaned for my grandmother. We spent a lot of time with her. I thought about the relationship of this Black woman who the kids related to—but you don't know what she's thinking. I thought that was what Ethel Waters did in *The Member of the Wedding*. When she sang 'His Eye Is on the Sparrow,' it was like time stopped. It came from outside that play. It was just breathtaking. That's the part I remember best. The other people were *acting* but she brought reality to it."

Emery Wimbish, the young librarian from Lincoln University, the African American institution of higher education not far from Philadelphia and Chester, also found the performance a once-in-a-lifetime theater experience. "I remember how she sang 'His Eye Is on the Sparrow.' Time had its effects on her voice. But she put that song across. She made it speak for her and her talent. The entire audience sat silent. It was so moving."

Actor Tony Randall commented that Laurette Taylor was the greatest actress he had ever seen, and Ethel was the greatest who was still living. Director James Sheldon, who had first seen her when he was a teenager, had similar feelings about her performances in both *Mamba's Daughters* and *The Member of the Wedding*. "I rank them with Laurette Taylor in *The Glass Menagerie*. You rank them with those great performances that are incandescent. You're just lucky to have been there."

Standing tall and proud, with an eye patch to cover her bad eye, Berenice was a mythic figure to behold, a symbol of endurance and, well, yes, the indomitability of the human spirit. Though her anxieties were even greater than in Philadelphia, once again Ethel triumphed to thunderous applause.

LEAVING THE THEATER, Ethel attended the cast party at the apartment of producer Stanley Martineau, where, as part of an old theater tradition, everyone waited for early editions of the newspapers to read the reviews. This was the second occasion on which Ethel was remembered to have taken a drink. Sitting on a sofa, she was joined by Carson McCullers, so moved by Waters that she embraced her and briefly sat in her lap. A photograph taken of Ethel with McCullers and Julie Harris would become nationally famous. For better or worse, Ethel looked like a mighty earth mother, strong enough to bear the burdens of the world on her shoulders—or her lap.

The first review—from the *New York Herald Tribune*—was not a good one. But the others were raves, especially for Ethel. "Miss Waters gives one of those rich and eloquent performances that lay such a deep spell on any audience that sees her," wrote Brooks Atkinson in the *New York Times*. In the *New York Post*, Richard Watts commented: "Ethel Waters, a distinguished actress of stature and quality, gives a remarkable performance." But New York's *Daily News* critic John Chapman probably summed it up best: "Miss Waters is giving her best performance in the theatre . . . a piece of acting that is loving and lovable and profoundly expert. She is the one who can make Mrs. McCullers' long pages from a novel come alive. Whenever the author fails to take command of the

stage, Miss Waters takes command and it is a pleasure to fall under the spell of her quiet authority."

Hers was a towering performance—a fitting tribute to the tragic Sally Anderson. Within eight and a half weeks after the play's opening, *Variety* said it had earned back its original $75,000 investment.

Ethel had come back from the lower depths.

AS THEATERGOERS FLOCKED to see the drama, Ethel again was celebrated, adulated, and adored, but now with a depth of respectability she must have felt her other performances, with the exception of Hagar, had not bestowed on her. And she enjoyed every minute of it. The parties. The tributes in her honor. The requests for her appearances at charity benefits. The press corps that showed up for interviews. The flirtatious encounters—she still knew how to turn it on and turn it off—with younger men and women. The fans and followers, the famous and the infamous, who rushed backstage to see her, praise her, sit at her feet, hear her tell what would soon become an oft-told tale, of her phoenixlike rise from the ashes. Night after night, the dressing room was full. One time it might be Mary McLeod Bethune. Another time it might be former first lady Eleanor Roosevelt. Langston Hughes recalled the day he went backstage. Ahead of him "were many theatre-goers who did not personally know the star, numbers of them young people who had probably pinched pennies to buy a seat away up in the top balcony. In the backstage crowd there were Negroes and whites. To everyone who came into her dressing room to shake her hand or seek an autograph, Ethel Waters was courteous and friendly. She offered her hand, she smiled, she said a friendly word. There was no quick scrawling of her name with a frown on a program. Ethel Waters projected the same warmth and humanity in her dressing room as she did on the stage."

On such occasions, Ethel, always an actress offstage as much as on, was animated and dramatic. One of those coming to her dressing room was that young librarian from Lincoln University, Emery Wimbish. When he told her his background, she said bluntly, "The people at the colleges have never liked me. They never have appreciated my work." When Wimbish explained

that many at Lincoln knew of her talents and respected her achievements, Waters seemed grateful to hear that she had won the approval of some of the dictys. Yet he still was not sure she really believed him.

Now, though, she wanted to avail herself of the new window of opportunities. Striking up negotiations were executives from ABC-TV, the budding medium that she had worked on during 1939. As television sets were starting to appear in more and more American homes, as the entire family gathered round the set for entertainment, much as they had done with radio, plans were being laid to bring the show *Beulah* to the small screen. *Beulah*—the story of a Negro maid working contentedly for a white family, the Hendersons—was already a hit on radio. Originally, Beulah was a supporting character on radio's *Fibber McGee and Molly.* Then there was a spin-off revolving around Beulah, which starred a white actor, Marlin Hurt, as Beulah. When Hurt died, another white actor, Bob Corley, assumed the role. Finally, Hattie McDaniel played the part on the radio show. ABC planned to continue with McDaniel on radio on the West Coast while Ethel, if she agreed, would shoot it at a studio in the Bronx. She was intrigued by the prospect.

But most promising of all the offers and proposals was the prospect of telling her life story in a book. One night, as Mary McLeod Bethune sat in her dressing room, a journalist named Charles Samuels came backstage. Samuels, who had been reading about Waters' life over the years, felt hers was a powerful narrative, an inspirational story of a woman who through drive, talent, and a belief in God had pulled herself up and out from an experience that would have destroyed others. Again, Ethel was intrigued.

NOW THAT *THE MEMBER OF THE WEDDING* was an established hit, Whitehead and the other producers were informed that Ethel had to have more money. After all, she was the only name in the production. People were coming to see her. Carson McCullers was opposed to such a pay hike, which would cut into her profits, but Ethel reportedly would not back down. The producers knew they needed her. Who else could play the role? It was the same predicament the producers of *As Thousands Cheer* had found themselves in. In later years, such actresses as Claudia

McNeil, Pearl Bailey, and Theresa Merritt would all try their hand at Berenice, but no one was ever able to give the character the dimensions and mythic power of Waters. Eventually, Ethel got the raise. She also agreed to stay in the play until July 1, 1951.

BUT WHAT OF ETHEL away from the footlights, the private Ethel? As the great lady of theater, now practically a national institution, had she forsaken her former personal peccadilloes? Had she put aside any notions of romance? Apparently not. Whatever their relationship, she and the young singer Thelma Carpenter still spent time together—and were still talked about. Whenever Carpenter saw the older Ethel, there were stars in her eyes. Aside from Carpenter's appearance at events featuring Ethel, the two also enjoyed quiet, cozy evenings together and dreamy dinners at Red Randolph's Shalimar restaurant on Seventh Avenue, which the press described as "their regular dinner spot." Perhaps Ethel, sometimes lonely and blue, simply enjoyed the company. Interestingly enough, during this time, there was no new talk of a new "husband," but within a short period of time, Ethel would show that she had not lost her interest in younger men.

THE BENEFITS AND THE HONORS continued. In late February, nominations for the 1949 Academy Awards were announced. Neither *Pinky* nor Kazan was nominated, but the principal actresses were all singled out. Jeanne Crain was nominated for the Oscar for Best Actress. Both Ethel Barrymore and Ethel Waters were nominated for Best Supporting Actress. This marked only the second time in Hollywood history that an African American performer had been up for the award; in 1939, Hattie McDaniel was nominated, and won, the Oscar for Best Supporting Actress in *Gone with the Wind*. In 1949, Celeste Holm and Elsa Lanchester, both in *Come to the Stable*, and Mercedes McCambridge in *All the King's Men*, were also among the nominees for Best Supporting Actress. Ultimately, McCambridge won, but *Pinky* became Twentieth Century Fox's top-grossing film of 1949.

*The Member of the Wedding* was named Best Play by the New York

Drama Critics and later received the Donaldson Award for Best Play of the season. Nominated for Best Actress, Ethel lost to Shirley Booth in *Come Back, Little Sheba*. Still, at this time in entertainment history, nominations for African Americans were almost tantamount to winning. To raise funds for the NAACP, Ethel and Todd Duncan, then on Broadway in the apartheid musical drama *Lost in the Stars*, were guests of honor at a dinner sponsored by a group of prominent women.

But for Ethel, the excitement was tempered by the pressures of mounting financial difficulties. The IRS still pursued her for back taxes. She took up residence at the St. Moritz Hotel in midtown Manhattan, which proved costly. Her home in Los Angeles incurred monthly expenses. So did a staff to answer letters, field interview requests, return phone calls, and run errands. She continued to support Momweeze in Philadelphia. And Ethel still felt compelled to look and live like a star. Clothes, furs, jewels were all expensive. Money came in—and went right back out. With all this in mind, she accepted two of the new projects dangled before her. First, she signed a contract with Doubleday to write her autobiography, with the help of journalist Charles Samuels. The book would have to be done quickly because Doubleday wanted it out by year's end. Overseeing the book would be Kenneth McCormick, one of publishing's most gifted and successful editors. The second commitment was to star in ABC's television version of *Beulah*.

*Beulah* went into production in the summer of 1950. The ABC contract stipulated that Ethel had to remain in New York and could not travel while the program was in production. As on radio, TV's *Beulah* recounted the domestic exploits of the maid Beulah—in service to the white family the Hendersons. The episodes were—at best—lightweight. Usually, the Hendersons had some problem that Beulah resolved. Much of her life was spent catering to their needs, pleasing them, advising them, joking and laughing and loving them. Typical was an episode in which Beulah, who is planning a trip to Birmingham to celebrate her Aunt Lucinda's seventy-fifth birthday, changes her plans because dear little Donnie Henderson has been hurt. Could America have asked for a more caring, devoted domestic? The program did create some semblance of a Negro community for Beulah, the idea that there was some kind of life for her apart from

her white employers. On the series, there was Bill Jackson, an often lik-able but lazy beau who halfway courts Beulah. There was also her friend Oriole, another domestic in the neighborhood, whose ditzy comments and antics were always good for a laugh. Working with her were Butterfly McQueen as Oriole, Percy "Bud" Harris as Bill Jackson, and William Post Jr., Ginger Jones, and Clifford Sales, respectively, playing the Hendersons and their son Donnie. Obviously, the series reverberated with stereotypes.

The same year that *Beulah* premiered on TV, *The Hazel Scott Show* aired briefly. This fifteen-minute musical variety show featured pianist Hazel Scott, an immensely sophisticated woman who played both classi-cal music and boogie-woogie, sometimes turning the classics into boogie-woogie. When she sat at the piano, she maintained her composure and poise; when she sang, she clearly owed some of her singing style to Ethel. Although Scott's show was a summer series, there was reason to believe it would become a regular feature on TV. But then Scott was called to tes-tify before HUAC, the House Un-American Activities Committee. In her testimony, she blasted the committee for being un-American, carrying out anticommunist witch hunts and ruining careers as it did so. Subsequently, Scott's show was dropped, probably because of her testimony, according to her son, Adam Clayton Powell III, and others. Thus, an image of a so-phisticated African American woman on the weekly prime-time schedule went by the wayside, while *Beulah* proved successful with viewers. The great irony was that Ethel, who had been so forward-looking in the early part of her career, now seemed to be stepping backward.

The schedule was grueling. Nightly, she performed as Berenice, then met with friends and acquaintances in her dressing room, had a bite to eat, and headed back to the midtown hotel where she resided. Daily, ex-cept on Wednesdays when she had matinee performances, she was up at seven in the morning, spent an hour being driven to a studio in the Bronx, where *Beulah* was rehearsed and shot from 8:30 a.m. to 5:30 p.m. Then she was transported to the Empire Theatre—an hour's ride—for the evening performance of *The Member of the Wedding*. During her lunch and dinner breaks, she would rest. For four months, she also devoted several hours a day, five days a week, to work on her autobiography. "Every day but matinee days and Sundays—from the 10th of January, 1950 to last July

11th, I'd dictate four hours to Charles Samuels," said Ethel. On Sundays, she relaxed. No phone calls. No interviews. She had to rest her voice; so she rarely spoke much. Then, too, there was the psychological transition of playing such vastly different characters. "All day long I'm Beulah—a happy-go-lucky domestic with a talent for saying clever things," she said. "Then two hours after I finish being a kitchen queen, I take on a serious dramatic role in the theater." Surprisingly, Ethel didn't present any major problems for the producers. She was glad to have the work in this new medium.

An indelible impression was left on future singer and star Leslie Uggams, who as a little girl made a guest appearance on *Beulah*. Her aunt Eloise Uggams and her cousin Avis Andrews had worked with Ethel in the theater, and young Leslie, who was taken by her mother each day to the studio, also had nothing but pleasant memories of Ethel. "When I worked with her on *Beulah*, my parents were just Wow!" Uggams recalled. "She was very nice and so accessible to my mother and me, and she took a liking to me. She invited my mother and me to see *The Member of the Wedding*. In looking back at seeing her in the play, the fact that I wasn't fidgeting or getting bored proved how incredible she was. I sat there spellbound. I was moved by everything she did. I just thought she was amazing. Even at age six, I knew I was seeing something wondrous on the stage."

Throughout her *Beulah* days, Ethel had to recall the experiences on her short-lived radio series of the 1930s, which had been run off the air. But now she entered American homes without sponsor problems. The show premiered on October 3, 1950, airing thereafter on Tuesday evenings from 7:30 to 8:00 p.m.

Television reviewers, however, were critical of the show's images. In the *New York Herald Tribune*, John Crosby wrote that it presented "the candy-coated stereotype of Negro life under the beneficent protection of the white man." He took particular umbrage at the depiction of Beulah's beau Bill who "is a composite of all the Bills that have been celebrated as good-for-nothings since the song of that name. He talks big, is everlastingly jobless, tries to fix things and generally messes everything up beautifully." Crosby added: "I didn't know whether we will forgive this sort

of stereotyping on television nearly as readily as we did on radio." Even harsher were critics in the Negro press. The *Pittsburgh Courier* wrote that the show "defiles and desecrates colored people. The dread and despised stereotype—that of colored people presenting themselves as buffoons, slavish menials and ne'er-do-wells." The paper's other comment no doubt rankled Ethel to the bone: "Lena Horne, likewise, has refused to lend her talents in roles that will reflect upon her people. In the opinion of this reporter, Miss Waters deserves condemnation." "What's uplifting or educational in 'The Beulah Show'?" asked a writer in New York's *Amsterdam News*. "NOTHING. It is obnoxious and downright disgraceful."

Among the cast, there were complaints. Actor Percy "Bud" Harris grew dissatisfied with his character Bill. "The writers," he said, "are sending scripts that require Bill Jackson, Beulah's boyfriend, to eat chicken, use dialect, fight and do things that are really degrading to my race. This I refuse to do." Finally, he left the series, replaced by Ethel's old *Cabin in the Sky* stage costar Dooley Wilson. Publicly, Ethel was mum on the subject of the show's controversy, but on set, she was keenly aware of problems. Leslie Uggams recalled an incident Waters spoke out about. "They wanted my hair to be in pickaninny braids," said Uggams. They weren't going to budge about the matter until Ethel stepped forward and told them, "That ain't going to happen. You see how her hair is. You leave it like that."

Yet she was angry with the critics, especially the African American ones, who she believed should be supportive of Negro talent—and who should understand the importance of the fact that this was the only television program starring Black performers. "I like being Beulah—she says such clever things," she told the press. "I keep appropriating her comments for my private life."

Certainly, she knew the character had none of the range or depth of Berenice or Dicey. She wouldn't even have mentioned Hagar in the same breath. Still, she made the best of what she had to work with. Throughout, Waters herself exuded a warmth and sensitivity that brought human dimensions to the role. She could never play it as a crude stereotype. Yet likable as she was, she never committed to the character as she did to Berenice. Basically, she kept everything on the surface without any signs of anger or discontent. *Beulah* appeared to find a Black audience, eager as

always for some form of representation, especially on this new medium. It was never as outlandishly typed (or as outlandishly funny) as TV's *Amos 'n' Andy*, which, following its success on radio, debuted the next season on television on CBS. Still, Waters understood she was above the role. After a year and a half, she withdrew from the show. According to the Black weekly magazine *Jet*, she had left the "white folks kitchen comedy role." Hattie McDaniel was set to become TV's Beulah but took ill after filming several episodes. She died in 1952. Louise Beavers assumed the role, but she too was said to grow weary of Beulah's tired antics. The series ran for three seasons in total. *Beulah*, however, left Waters resentful. What was she expected to do? As Kazan had said at the completion of *Pinky*: "There weren't many parts waiting for an old Black woman." Ethel was now fifty-five.

IN NOVEMBER 1950, an excerpt from Ethel's forthcoming autobiography *His Eye Is on the Sparrow* ran in *The Ladies' Home Journal*, a top-selling monthly women's magazine. A photograph showed Ethel standing in the city of her birth, Chester. That same month, she was presented with the Sojourner Truth Award by the National Association of Negro Business and Professional Clubs. A few months later, in March 1951, *His Eye Is on the Sparrow* arrived in bookstores. Few books, Black or white, generated as much excitement. It was a Book of the Month Club selection, and portions were also published in the *Atlantic Monthly*. "The day the book was published," said Ethel, "I was so nervous, so restless." Hitting the publicity trail, a jubilant Ethel attended packed book parties, receptions, and tributes to promote the book, including a luncheon held under the auspices of the *New York Herald Tribune* and the American Booksellers Association. Her editor McCormick sometimes looked as excited as Waters. "It is no book," proclaimed Ethel. "It is my life. There is no mechanics. You don't live a life span and say it to one paragraph or in one line. There's nothing commercial or melodramatic in it. I told my life story to stop people from having curiosity, to stop them from having to ask me questions, from wanting them to know my life so that maybe it could help somebody." The title had come from the song her grandmother Sally had

loved to hear—which Ethel had performed so movingly in *The Member of the Wedding.*

The reviews were mostly raves. Later the American Library Association selected it as one of the year's notable books.

Of course, Ethel did not dare tell everything. Much was glossed over or evaded. Not a word was uttered about her same-sex relationships, which, because of the times, she could not reveal. The same would be true for Billie Holiday when she published her autobiography *Lady Sings the Blues.* Yet Ethel could not refrain from discussing, albeit in a very sanitized way, her friendship with Ethel Williams, who had meant so much to her. Readers had to read between the lines. The same was true of other women she referred to, such as Mozelle. Intriguing, perhaps puzzling, also was her brief reference to novelist Radclyffe Hall. Nor did Ethel tell all about her "husbands." Interestingly, not once in the book did she refer to Mallory as her husband. Her birth year was still listed as 1900 rather than the actual 1896. Nonetheless, writer Samuels had given the book a fine structure and narrative flow. He proved most adept in capturing Ethel's voice: both her language—minus the rough profanity—and her rhythms and perspective. The autobiography also captured the energy of the early years in show business.

Yet within the Negro press, some reviewers strongly criticized her for having revealed—in the sections about her childhood and family—too many seamy details. "The people are going to sell a million copies anyway, so go ahead and read Ethel Waters' story in the current issue of the Ladies Home Journal," wrote the *Philadelphia Tribune.* "She makes all of us in this area boiling mad in the first part and she never goes all out in giving Negroes in show business their full desserts. For many years we have heard about the background of Ethel Waters and how she overcame it. . . . We praised her but when she openly tells the filthiest things among an ignorant and underprivileged people at a time when there was little hope for anything else, we can't go along with her fanatic, masochistic, humble groveling before 10 million whites and unofficially declaring herself a spokesman for the Negro. Read it and bite a nail in half."

The esteemed Alain Locke, however, expressed his enthusiasm for the book in the pages of *Phylon. Ebony* ran a cover story on Ethel titled "The

Men in My Life," with excerpts from the book. *Tan* magazine also ran a cover story titled "The Tragic Love Life of Ethel Waters." When one thinks of important autobiographical works by African Americans that were published later and hailed for their gritty truths and social realism—such as *The Autobiography of Malcolm X* and Claude Brown's *Manchild in the Promised Land*—the criticism of Ethel may now seem unfair. Her work in some respects was forward-looking. In 1960, an article in the magazine section of the *New York Times* cited it in a discussion of the new style of tell-all autobiography that became popular in the postwar years. But the criticism, like that of *Beulah*, angered her and perhaps alienated her, especially from the Negro press. Likewise she became resentful of Walter White's critical comments about the roles played by Black actors in Hollywood and about her role in *Pinky*, and perhaps all of this led to some of her later critical comments about the NAACP. Nonetheless, *His Eye Is on the Sparrow* was a huge bestseller with readers Black and white. Later it was published in paperback to great success.

Not publicly discussed by Ethel was her family's reaction to the memoir. Much in the book may have troubled Momweeze—still in fragile health—and Genevieve. The story of her mother's rape had not been told before. But Ethel's attitude was that it was *her* story, and after such painful experiences, she had the right to speak about them, for cathartic reasons if no other.

With *The Member of the Wedding* still running on Broadway, with *Beulah* on television, with the release of a new album, and now with *His Eye Is on the Sparrow*, she may well have been again, as she was in the 1920s through the early 1940s, the most famous African American woman in the country, as well as one of the famous women *period*. Her chief rival may have been Marian Anderson. Yet, interestingly enough, her work and public appearances during the 1950s also seemed to wipe from the public record her innovative achievements of the past as a singer and sexy entertainer. The Ethel of the Eisenhower decade—heavy, middle-aged, refusing to talk about much other than her love for God and Jesus—was a rather desexed (in the public's imagination, but not in Ethel's), nurturing and nourishing heroine ever ready to comfort others, to extend her hand in friendship, to give love and warmth. Ethel never did come across wholly as

a goody-two-shoes Pollyanna. She still had too much energy and temper for that. Her hearty, gutsy laughter also suggested a rich, maybe ribald past. But despite her autobiography, the current generation, and the one that followed, had little idea of what Sweet Mama Stringbean had been all about or how she had changed popular music and popular culture.

AFTER ALMOST FIFTEEN MONTHS on Broadway, *The Member of the Wedding* closed on March 17, 1951. But Ethel stayed with the play for its national tour, in which Betty Lou Holland played Frankie. In New York, she hired a young educator named Floretta Howard as her "personal secretary," to keep things in order while she was on the road. Later Howard assumed similar responsibilities in Los Angeles, where she oversaw Ethel's home and handled all West Coast correspondence. From the 1950s and well into the 1960s, Howard became increasingly important to Ethel, especially when she was forced to put her home up for sale. From 1951 to 1963, as the two corresponded on a regular basis, Howard was clearly both friend and confidante with whom Ethel could let down her hair, shoot the breeze, and discuss personal matters.

For her part, Floretta idolized Ethel and referred to her as "My Advisor," "My Critic," "My Inspiration," "My Big Sister," and "My Boss." Delighting in Ethel's self-deprecating humor, Howard also described Ethel as an "Absolute Humorist," who was "hilarious." As close as the two women were, Floretta always referred to her employer as Miss Waters. For her part, Ethel would often address Floretta, as she did her other Black female friends, as "Girl!" "Girl, let me tell you this" or "Girl, I've been through it" was the way in which she might begin a story she felt Floretta had to hear. As an employee, Howard also knew that whatever instructions Ethel gave her, they had to be followed and usually quickly. In a short period of time, she could look at a letter from Ethel and determine that "The SIGNATURES of ETHEL WATERS revealed her moods and her temperaments, as well as other traits." Seeing Ethel's signature "may have occasionally prompted me to delay reading the letter at some particular time," said Howard. "I was 'duty bound' to read them, for it was my job and the letters conveyed instructions but not always. Sometimes I'd find myself

'living' out of sympathy, what Miss Waters signed as 'Your Unhappy Boss or Your Frantic Boss.'" Nonetheless, as Ethel toured, she wrote Floretta as often as she could.

FIRST STOP ON THE TOUR was the Colonial Theatre in Boston on March 26. At this time, Harold Clurman, not traveling with the company, grew concerned by the complaints of some cast members that Ethel was "tending to overplay her role, both on and off the stage." She seemed more divalike than ever. Set designer Lester Polakov recalled that during the tryout in Philadelphia, she would come offstage where she'd see him in the wings and give him a kiss. But now some cast members felt she became "haughty" and "arrogant and attempted to upstage the others." Even before the tour, the kisses between Waters and Polakov had ceased, and from Polakov's perspective, she had changed greatly, "remarkable, of course, in the role, but different as a person."

As the tour continued, the situation grew worse, said Clurman, as Ethel "began to 'improve' it and then she got to be very naughty, and she acted as if she had really created everything—she was the light, she was the thing. And she began to say naughty [things]." Clurman recalled that after the play first opened, Ethel had exclaimed of him: "This is a great man—this wonderful angel." Now all that changed after Clurman made a visit to see the play on its tour. "The minute I said, 'Ethel, don't do this' or 'don't do that because you don't have to do that,' she got a little edgy and began to do things which really threw the thing out of whack to the point where when I saw her in New Haven—I went up to see it, and I was absolutely in distress. I said, 'I feel like taking my name off the show.' And I told her this, but I was very gentle—I said, 'You don't need these improvements—you're giving a wonderful performance.' Well, she added more—until she went to another out-of-town engagement and a critic said, 'This isn't the performance she gave in New York.' In other words, she wouldn't listen to the director, but when an out-of-town critic said the same thing, she would. So in that sense she was troublesome. And she began to make slurs against Whitehead and myself. It was as if to say, 'I want all the credit. To hell with those bums.' But I never had any words

with her." Clurman added: "Miss Waters became angry, but soon settled down and played the role to perfection."

BETWEEN *THE MEMBER OF THE WEDDING'S* tour dates, she accepted other engagements, one of which was a hugely successful appearance at New York's Capitol Theatre. Another was at Chicago's Oriental Theatre. From 1950 to 1952, she also performed on such television programs as *General Electric Guest House, Songs for Sale, This Is Show Business* (some five episodes), and as the mystery guest on the popular quiz show *What's My Line.* Usually, she appeared relaxed and good-natured, her charm and warmth always showing through. On *The Chesterfield Supper Club,* she chatted with host Perry Como—when he mentioned *The Member of the Wedding,* she told him, "All I can say is—I ain't the bride"—and performed briefly in a card game comedy skit with other guest stars Burgess Meredith and Franchot Tone. But the moment the television audience no doubt had been waiting for occurred when she performed "Taking a Chance on Love" and, most grippingly, "Supper Time." On a specially created set, Ethel stood in a kitchen-dining area where she was preparing her family's evening meal. Older and perhaps more emotionally intense than she had been on Broadway, she gave a highly dramatic and stunning rendition of the Berlin song. This was the closest later generations would get to see-ing why the original version—set, costume, lighting—had so transfixed audiences in 1933. On *The Texaco Star Theatre,* starring Milton Berle, she was a guest star, along with Tony Martin, and performed a medley of her hits that included "Heat Wave," "Dinah," "Memories of You," and "Am I Blue?" There was also an appearance on *The Jackie Gleason Show.* Televi-sion kept her visible and introduced her to a new generation, and more often than not, the hosts appeared thrilled to be in her company.

Around this time in Chicago, she also embarked on a love affair or would-be affair that would have shocked her followers. A young man— whom she identified to Floretta Howard simply as Teddy or T.—had come into her life. She was immediately and intensely attracted to him. She was the pursuer; Teddy, the pursued. Had her weight—still about three hun-dred pounds—cooled his ardor? she wondered. It seemed to take forever for

the relationship to be consummated, and even then, it appeared as if he was not sexually satisfied. There was also another woman in his life, and from Ethel's comments to Floretta Howard, it appeared that the woman was Teddy's wife. Her passion for Teddy, however, invigorated her, and much of her time was spent if not with him, then certainly with him in her thoughts. At one point, she grew concerned that one of her employees—a man who drove her to engagements and ran errands, who she sometimes referred to as "the sissy"—was in pursuit of Teddy. It was the kind of chaos that she always appeared to thrive on—as did new disputes with cast members in the touring *Member of the Wedding*.

Back on the road, she traveled to Kansas where she had a standout performance and broke new ground as the soloist—performing such perennials as "Cabin in the Sky" and "Summer Time"—with the eighty-five-piece Kansas City Philharmonic Orchestra under the direction of Hans Schwieger. Here it was, the eve of the civil rights movement, and Ethel witnessed the familiar discrimination: a group of whites in the area protested her appearance. But Ethel was proud to say that "the colored people turned out—and sat all over the auditorium—and that didn't happen in a Jim Crow town."

Amid her travels and engagements, Ethel began to feel time might be catching up with her as her health problems mounted. Often she felt uncomfortable and fatigued. Because of her weight, she was having problems breathing, and she had to admit that her voice had suffered from the strain, the stress, and the added poundage. Would she ever be able to sing as she once had? Shortly before her performance at New York's Capitol Theatre, she consulted her physician, who was frank with her. He warned her that she had to lose seventy-five pounds—her health had started to deteriorate. So she underwent a strenuous program to reduce, which often left her feeling weak and drained. An additional impetus to lose weight was her fascination with Teddy and her determination to lure him back into her bed.

*The Member of the Wedding* continued through major American cities and parts of Canada. Then the play opened at the Biltmore in Los Angeles in December. She still loved the city, still loved her home, but she had little time to enjoy them. By now, she was absolutely exhausted

and needed rest. Dogged by her deteriorating health, she also had to face the IRS. Unable to pay the back taxes, she had worked out an agreement to pay in increments, but that meant she *had* to keep working, no matter how fatigued or weak she was. A tax consultant and an attorney worked to straighten out the problems.

"Aren't you going to look for a new play?" a reporter from Los Angeles' *Daily News* asked her in reference to her plans upon the completion of the tour. "No, I don't want to do nothin' the way I feel now," she answered. "What's the use since they tax it all away leaving you with the 15 cents that's left. I don't mean to sound unpatriotic, but I just can't break my neck like that forever and get nothin.' This thing takes too much out of me."

But on she went—with the play, the relationship with Teddy, and new engagements to keep herself busy, to ward off a loneliness that was growing daily, and to earn money to support herself and pay the IRS. On NBC radio's *Cavalcade of America*, she gave a tender performance in a drama, "Sixteen Sticks in a Bundle," playing the mother of fourteen children who struggles to provide them all with an education. The touring *Member of the Wedding* moved on to such cities as Pittsburgh and Philadelphia, Portland, Oregon, and Norfolk, Virginia, and closed with performances in May 1952 in Brooklyn and the Bronx. In total, the drama played thirty-six cities, traversed over twelve thousand miles, and grossed more than an estimated $2 million. Ethel had not missed one of the drama's 850 performances.

"Yes, I'll retire . . . for a while at least," she told the press. "You see my health hasn't been too good lately." But she added, "Now whether I stay in retirement or return to the stage, only the Lord has the answer to that question. I may decide to do a few recitals which would lead back to my singing. I think I would like that and it would be less strenuous." Still, there was another fact she could not escape. "Right now," she said, "I don't make enough money to pay both my bills and my taxes."

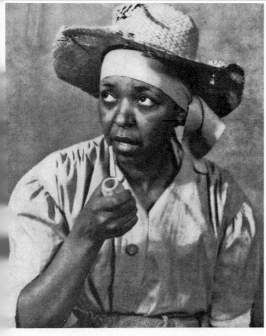

## THE PLAYBILL
### FOR THE EMPIRE THEATRE

# THE EMPIRE THEATRE

FIRE NOTICE: The exit, indicated by a red light and sign, nearest to the seat you occupy, is the shortest route to the street.
In the event of fire or other emergency please do not run—WALK TO THAT EXIT.
**JOHN J. McELLIGOTT, Fire Chief and Commissioner**

THE · PLAYBILL · PUBLISHED · BY · THE · NEW · YORK · THEATRE · PROGRAM · CORPORATION

BEGINNING
MONDAY EVENING,
MARCH 13, 1939

MATINEES
WEDNESDAY AND
SATURDAY

GUTHRIE McCLINTIC
Presents

## ETHEL WATERS
in
## MAMBA'S DAUGHTERS

A Play by
**DOROTHY and DuBOSE HEYWARD**
(Dramatized from the novel "Mamba's Daughters" by DuBose Heyward)
with

| FREDI WASHINGTON | GEORGETTE HARVEY |
|---|---|
| ANNE BROWN | JOSE FERRER |
| WILLIE BRYANT | J. ROSAMOND JOHNSON |

Staged by Guthrie McClintic
Production designed by Perry Watkins
The song, "Lonesome Walls," composed by Jerome Kern,
from the lyric by DuBose Heyward.

Undergoing yet another major image change, Waters was hailed by the critics for her dramatic role in Broadway's *Mamba's Daughters* in 1939.

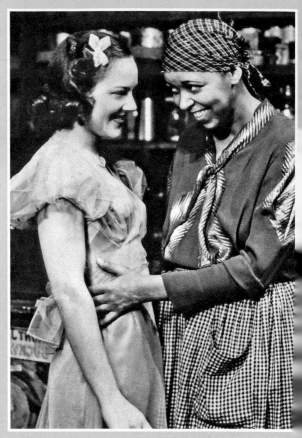

The undersigned feel that ETHEL WATERS' superb performance in "Mamba's Daughters" at the Empire Theatre is a profound emotional experience which any playgoer would be the poorer for missing. It seems indeed to be such a magnificent example of great acting, simple, deeply felt, moving on a plane of complete reality, that we are glad to pay for the privilege of saying so.

| | |
|---|---|
| Judith Anderson | Helen Hall |
| Tallulah Bankhead | Oscar Hammerstein |
| Norman Bel Geddes | Paul Kellogg |
| Cass Canfield | Edwin Knopf |
| John Emery | Ben H. Lehman |
| Morris L. Ernst | Fania Marinoff |
| John Farrar | Aline MacMahon |
| Dorothy Gish | Burgess Meredith |
| Jules Glaenzer | Stanley Reinhardt |
| Carl Van Vechten | |

Outraged by critic Brooks Atkinson's review of Ethel in *Mamba's Daughters*, an influential group of theater artists took out an ad in protest.

Ethel as Hagar, with Fredi Washington as her daughter Lissa, in *Mamba's Daughters*.

With Eddie "Rochester" Anderson (*center*) and Paul Robeson in *Tales of Manhattan*, which drew protests.

After a love affair that had gone wrong, she fled in the early 1940s to Hollywood, where she ended up playing the maid to Jeanette MacDonald in *Cairo*.

Another Broadway triumph, *Cabin in the Sky*. But her temper and outbursts alienated her from cast members.

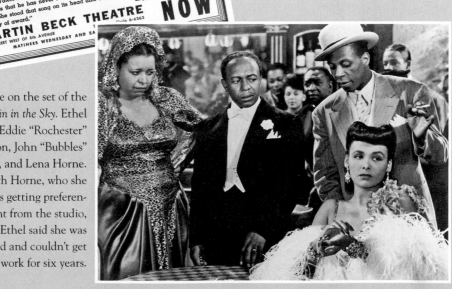

Trouble on the set of the movie *Cabin in the Sky*. Ethel with Eddie "Rochester" Anderson, John "Bubbles" Sublett, and Lena Horne. Clashing with Horne, who she believed was getting preferential treatment from the studio, MGM, Ethel said she was blacklisted and couldn't get movie work for six years.

Another image change.
Waters in her Oscar-
nominated role as
Granny/Aunt Dicey in
*Pinky*, with Jeanne Crain
as her granddaughter.

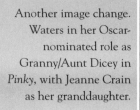

Waters with Frederick
O'Neal as the scheming Jake.

# AN APPROACH TO RACISM

### by
### PHILIP DUNNE

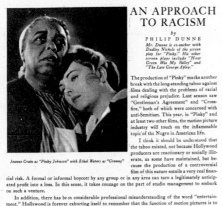

*Mr. Dunne is co-author with Dudley Nichols of the screen play for "Pinky." His other screen plays include "How Green Was My Valley" and "The Late George Apley."*

The production of "Pinky" marks another break with the long-standing taboo against films dealing with the problems of racial and religious prejudice. Last season saw "Gentleman's Agreement" and "Crossfire," both of which were concerned with anti-Semitism. This year, in "Pinky," and at least two other films, the motion picture industry will touch on the inflammable topic of the Negro in American life.

I think it should be understood that the taboo existed, not because Hollywood producers are reactionary or socially illit-

*Jeanne Crain as "Pinky Johnson" with Ethel Waters as "Granny"*

erate, as some have maintained, but because the production of a controversial film of this nature entails a very real finan-

cial risk. A formal or informal boycott by any group or in any area can turn a legitimately anticipated profit into a loss. In this sense, it takes courage on the part of studio management to embark on such a venture.

In addition, there has been considerable professional misunderstanding of the word "entertainment." Hollywood is forever exhorting itself to remember that the function of motion pictures is to entertain. To some, this has meant that the industry should confine its efforts to musicals, boy-meets-girl comedies, whodunits and Westerns. But others, I think with more wisdom, have maintained that entertainment can also be fashioned from the raw materials of contemporary life. They have seen the problem as one of presenting these materials, not as preachments, but as living dramatic stories.

When Darryl F. Zanuck assigned me to "Pinky," he laid no injunction on me other than to remember that my function was not to lecture but to tell an emotional human story capable of capturing and holding the imagination of the audience. He could (and did) point to his own "Gentleman's Agreement" as a persuasive example of what he meant.

From the technical point of view, my task was not difficult. I had the advantage of some excellent

preliminary writing by Dudley Nichols, who had had to drop the job half finished because of a prior commitment elsewhere. I also had the advantage of the fact that Mr. Zanuck had already accompanied Mr. Nichols up most of the blind alleys such a story offers and thus was able to save me a good deal of useless exploration.

Politically, the script posed a much more difficult problem. Every American citizen, white or Negro, has his own ideas on the subject of race in America. Few Americans have been able to approach it without passion or prejudice. (It is significant that perhaps the only truly dispassionate and unprejudiced appraisal of the problem is the work of a foreigner, Gunnar Myrdal, in his monumental "An American Dilemma.") Like every other American, I hotly defended my own views, as Mr. Zanuck defends his, which differ from mine in detail if not in essence. Mr. Nichols and Elia Kazan, who is directing the picture for Twentieth Century-Fox, hold still different opinions.

We were well aware of our problem: lacking agreement even among ourselves, how could we hope to reach 140,000,000 Americans, representing nearly 140,000,000 differing points of view?

The answer, of course, is that our film will present no one point of view as the definitive one. We try to tell a completely personal story. Jeanne Crain, as Pinky, portrays a race but an individual. The story is Pinky's, not ours, and while the tragic dilemma of her life is induced by the facts of racial prejudice, the solutions she finds are her own and affect only her. Pinky is acted upon by many other characters in our screen play. Some are kind, some brutal, some condescending, some just but harsh. We have tried to present them fairly and objectively, as we have tried to avoid preaching and confine ourselves to the facts. In many ways the writing and production of such a story is a tactical exercise in democratic practice.

But I would not give the impression that we have remained completely neutral, because neutrality is as sterile dramatically as it is politically. Liberal democracy stultifies itself when it rationalizes away all conflict and passion. In our case, I feel that I can safely predict that no member of the Ku Klux Klan will find our film either entertaining or edifying. We neither deny or condone the bitter fact of racial prejudice; we simply try to dramatize its effect on a girl who might be anyone's daughter, sister or sweetheart. We are propagandists only in so far as we insist that every human being is entitled to personal freedom and dignity.

We have throughout remained conscious of our obligation to society in projecting such a film. The experience of the war has taught us that the motion picture is a powerful and persuasive vehicle of propaganda. What we say and do on the screen in productions of this sort can affect the happiness, the living conditions, even the physical safety of millions of our fellow-citizens.

Beyond that we have tried to consider what the impact of such a film might be on audiences overseas, on friend and antagonist alike. For this reason, among others, we have championed no glib solution of the problem. We have tried only to present it fairly and realistically. We hope that each member of the audience will be moved to seek a solution of his own. If he finds it in his heart, our venture will have been a success.

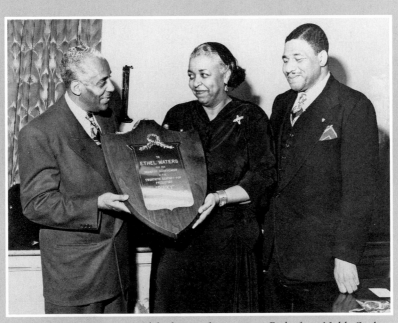

Waters receives an award for her performance in *Pinky* from Noble Sissle and actor Frederick O'Neal.

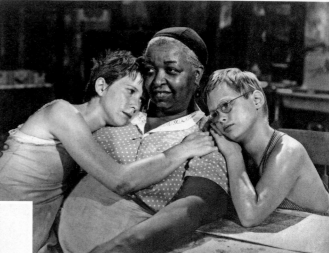

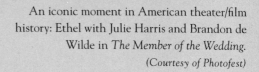

An iconic moment in American theater/film history: Ethel with Julie Harris and Brandon de Wilde in *The Member of the Wedding*. *(Courtesy of Photofest)*

Rehearsing with her accompanist Reginald Beane, an overweight and often depressed Ethel feared her career might be over.

As Dilsey in Faulkner's *The Sound and the Fury*. Her weight had ballooned to over 300 pounds. Plagued by heart problems, hypertension, and diabetes, she now lived in pain and fragile health. But she kept working. She had to.

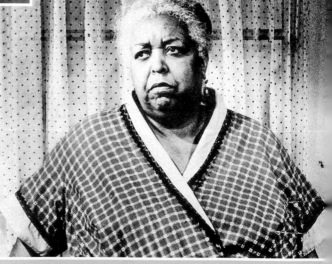

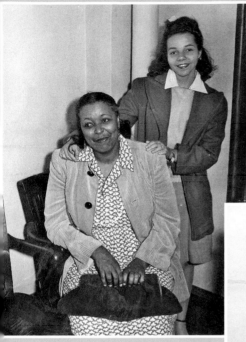

With her "goddaughter" Algretta at the time of the trial that put Waters in the headlines.

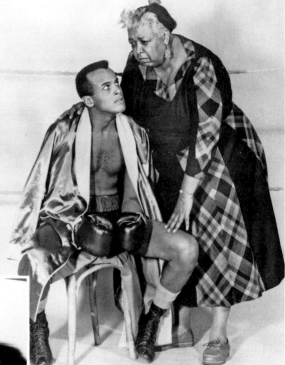

Ethel with Harry Belafonte in the TV drama *Winner by Decision*.
(*Courtesy of Photofest*)

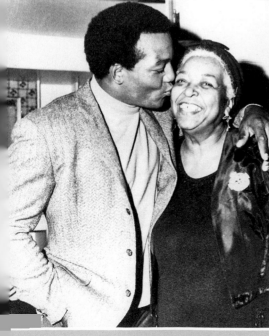

With former football player Jim Brown, one of the stars in the "new" Black Hollywood of the 1970s.

With *Tonight Show* host
Johnny Carson.

Experiencing yet another career setback, Ethel—at the invitation of Jim Malcolm (*left*)—arrives for one of her college appearances. Struggling to stay afloat financially, she sometimes appeared on college campuses and also at churches, where she received a nominal donation.

By now best known for her appearances at Billy Graham's Crusades, she arrived at the White House wedding of Tricia Nixon with Graham and his wife, Ruth.

# The Long Winter of Her Discontent

**T**HE BEST NEWS FOR ETHEL was that in February 1952, producer Stanley Kramer bought the movie rights to *The Member of the Wedding* for $75,000 plus 10 percent of the film's gross. One of Hollywood's great liberals, Kramer had produced *Home of the Brave* and would go on to direct such films as *The Defiant Ones*, *Guess Who's Coming to Dinner*, and *Judgment at Nuremberg*. With a script by Edward Anhalt and cinematography by Hal Mohr, the film would be directed by Fred Zinnemann. Highly skilled at getting the best out of his actors, pushing them to reveal their vulnerabilities, their restlessness, their sense of isolation, he had previously directed Montgomery Clift in *The Search*, Marlon Brando in *The Men*, and Gary Cooper in *High Noon*. He would later direct *From Here to Eternity*, *The Nun's Story*, and *A Man for All Seasons*.

Ethel was set to star along with Julie Harris and Brandon de Wilde. Cast as her foster brother Honey was James Edwards, the young Black actor who had generated much excitement with his sensitive performance in *Home of the Brave*. For many, Edwards represented a new style of acting for African American actors in Hollywood. Preceding Sidney Poitier, Edwards, like Brando and Clift, had a brooding and sensitive quality that leading men in movies were generally not encouraged to reveal.

Columbia Pictures, headed by a notoriously ill-tempered Harry Cohn,

would release the film. No one had any idea if *The Member of the Wedding* would make money because it was so offbeat. Then, too, the only name for the marquee was Ethel, "the old nigger woman," as Zanuck had once so cruelly referred to her. Though Kramer acknowledged that none of his principals "were film stars, their performances in the stage version of *The Member of the Wedding* had made them famous enough that many would have felt cheated had they not been cast again in the film." He added: "I felt assured of the picture's quality." Somehow Ethel would have to regain her strength and be prepared for the cameras.

Rehearsals started on June 9. Once filming began, Ethel was at ease with Harris and de Wilde. For director Zinnemann and writer Anhalt, the problem was opening the drama up, making it cinematic. McCullers' dialogue could not be scrapped—that was the beauty of the work. So the camera would have to explore the setting itself and the faces of the characters. "The difficulties of directing such a film seem obvious," said Kramer, because it had a "static setting and scarcity of overt action. Zinnemann, however, said that his job was easy. He felt that the three principals interacted so well together, and the blending of their emotions was so powerfully dramatic, that he had only to stand back and let them perform their stage roles. In fact, he did much more than this. Zinnemann brought the entire production to life by using a probing camera that moved in close to study the faces and read the moods of the actors at key moments. He also explored the fascinating details of the old and rather shabby kitchen to create a sense of precise locale."

Throughout, James Edwards stood in awe of Ethel. Their brief scenes together would be tender and moving, two gifted Black actors, from different generations and vastly different approaches to acting, responding to each other's rhythms and personal hurts. There would be a sweet sadness in the eyes of both. That alone would be a reason for those interested in evolving images of African Americans in films to see the movie.

Zinnemann liked Waters, but at times it was exasperating to get a "movie" performance out of her. "Ethel was a wonderful, sad woman," recalled Zinnemann. "Between scenes, she'd sit in her dressing room and listen to her old records. But she was also a very headstrong lady." She "clung to the play, and it was difficult to get her to change or to unlearn some of

her lines and stage movements," said Zinnemann. "She was very amiable, but she did have very crystallized ideas of her own. I remember that on several occasions when she disagreed with the directions I was giving her, she would look up to heaven and say: 'God is my director.' You can imagine that it wasn't easy to find a comeback to that kind of remark."

Still, through the moody close-ups of his principals, he helped explore their individual characters and also expressed their feelings of isolation and loneliness. When the camera came close for Waters' soliloquy about Ludie, the man she loved so passionately, and the self-destructive path she set on after losing him, her face was unlike any that Hollywood had ever recorded of an African American performer. Intimate. Warm. Sad. Heartbroken. Passionate. Humane. Zinnemann got inside her heart, her soul. Ethel gave herself to the camera. As with the play, she had no distance between herself and the character. She *was* Berenice. Ultimately, it would be her greatest screen performance.

But once Columbia's chief Harry Cohn saw the completed picture, he hit the roof. What kind of picture was this? "Zinnemann was praised for his work by many critics, but not by Harry Cohn," said Kramer. After "screenwriter Dan Taradash turned in his script for *From Here to Eternity*, he suggested Zinnemann as the director. Cohn erupted at the sound of Zinnemann's name. 'I won't let that son of a bitch on the lot,' he shouted. 'He's the bastard who directed *The Member of the Wedding*.'"

Otherwise the reactions were quite different. Before the film's release, there was an immediate buzz. James Edwards exuberantly predicted that Ethel might walk off with an Oscar. Others felt the same way. "There are two glorious performances in 'Member of the Wedding,'" said Hedda Hopper, "those given by Ethel Waters and Julie Harris. I'm sure both will be nominated." "Miss Waters, that dramatic queen of them all, got the prized top billing in the credit sheets," wrote Black columnist Harry Levett, "and on the main title curtain. So watch for a new episode in racial and movie history, when a Negro woman star, heads a white cast." Levett also predicted, "I'll bet a dollar to a thin dimwit that it gets an 'Oscar.'"

The film opened on Christmas Day at Los Angeles' Beverly-Canon Theatre and shortly afterward at New York's Sutton Theatre. "Miss Waters is one of our finest artists, Black or white; it is she who keeps the

play solidly planted on the ground," wrote Philip K. Scheuer in the *Los Angeles Times*. "Ethel Waters' performance of the mammy," wrote Bosley Crowther in the *New York Times*, "glows with a warmth of personality and understanding that transmit a wonderful incidental concept of the pathos of the transient nurse."

BUT FOR MAINSTREAM AUDIENCES, *The Member of the Wedding* looked more like a European art house film than a Hollywood production. Critic Pauline Kael believed it was "a remarkable film," which indeed it is. "The Carson McCullers dialogue is one of the high points of literacy in American films—sharp and full of wit, yet lyrical," said Kael. "Fred Zinnemann's direction respects Carson McCullers' intensity and humor." But *The Member of the Wedding* "failed commercially, perhaps for want of a conventional 'story'; it is said that in some towns viewers didn't understand the material and, for most of the film, thought that Frankie was a boy. The movie company then cut a crucial 20-minute segment (which included Ethel Waters' finest scene) and tossed the film into the lower half of double bills." Carson McCullers herself was stunned when she slipped into a small theater in Macon, Georgia, and discovered Ethel's scene in which she sang "His Eye Is on the Sparrow" was no longer there. She "never recovered from the shock," said Rex Reed. Cutting Waters' great soliloquy had been the cruelest blow of all. It also revealed the cynicism of the studio and exhibitors. A rare film examination of the inner torments of a Black woman was expendable; it meant next to nothing to them.

Publicist Orin Borsten recalled that Harry Cohn at Columbia, seeing the great reviews, thought some profit might be earned if the film garnered some awards. But if Waters and Julie Harris were both nominated for Best Actress, they might cancel each other out. Waters had received top billing; therefore she could not be nominated in the Supporting Actress category. "The studio," said Borsten, "decided that it would push Harris, not Waters. I was the one who had to tell Ethel Waters." He remembered talking to her in a dressing room at a club. He approached her gingerly and with sadness, knowing what a disappointment it would be to her. "I kept saying, 'They've got a lot of *chutzpah* to do this. Just real *chutzpah*. But they're not going

to push for you to be nominated." Waters looked at him intently. "Well, I don't know what you're talking about with all this *chutzpah* business," Waters told him bluntly. "But they've got a lot of fucking nerve!" In the end, the Oscar nominees for Best Actress of 1952 were Harris in *The Member of the Wedding*, Shirley Booth in the movie version of *Come Back, Little Sheba*, Joan Crawford in *Sudden Fear*, Bette Davis in *The Star*, and Susan Hayward in *With a Song in My Heart*. Shirley Booth won the award. With all due respect to those nominated actresses and with the possible exception of Harris, none of their performances in those particular films would ever match Ethel's. To be overlooked for Oscar consideration had to be one of her greatest professional disappointments.

ANOTHER DRY SEASON BEGAN. In November, she returned to New York to open at the Chicago. Also on the bill were Dizzy Gillespie and his band. In December, she performed at the posh La Vie en Rose in New York. In February, she flew to Las Vegas to perform at the Desert Inn Resort. A new generation of slinky goddesses were playing at the hip clubs and gambling casinos of Vegas. How could she compete with these younger women in the steamy, sexed-up atmosphere of nightspots?

"Do you know why I'm back muscling at night clubs?" she said to a young interviewer for *Down Beat*. "It's because I want children like you to hear me and remember what you heard. People of my generation remember, but those of the second and third generations have heard bits and snatches of what I started from a whole lot of other singers. Now I want to go the rounds once more and have them hear the original." She also explained: "The funny thing about me going back to the nightclubs is when I come in to meet the owner the first day of the engagement, I look like something the Salvation Army's brought. And I can see he's dragged. He's probably thinking: 'Well, I guess I have to take her from the office to get [Nat] King Cole. And he introduces me sort of apologetically to the audience. Well, in the cool of the evening, when I've stepped down, my, how he's changed." She wanted it known that she still could put a song across. On the club scene, Ethel looked tired, worn, passé—an overweight, middle-aged, if not elderly, woman singing songs from another

age. In truth, she really didn't want to be anywhere near the clubs, and certainly not in the casinos. But she needed the work.

In March, when she played Storyville in Boston, music producer George Wein recalled that his experience with "the majestic Ethel Waters" was not friendly. "I had heard rumors about Miss Waters," said Wein, "but this didn't prevent me from presenting her in Boston. On Miss Waters' first night in Storyville, I welcomed her warmly and asked if there was anything I could do for her."

Ethel responded: "I will let you know, Mr. Wein."

"Please call me 'George,'" said Wein, who was then twenty-six years old.

"I will call you 'Mister Wein,'" said Ethel.

Wein recalled: "She was advising me, in no uncertain terms, that we were not yet acquainted. To her, I was not a friend or an appreciative fan but the man running the club." After all these years, Ethel still could not trust the club managers, owners, and producers. Reginald Beane had come to the engagement to accompany Ethel. But she "used the house rhythm section. Yet she all but ignored Jo Jones and John Field, as if they weren't sharing the same stage." Nightly, Wein watched as she asked the audience to give "a round of applause for one who so richly deserves it, our pianist, Mister Reginald Beane." Nothing was said about the great musician Jo Jones. When Wein asked Jones "how he felt about not being introduced," Jones said: "Ah, you don't understand Miss Waters."

"By this time," recalled Wein, "her career was finished. She didn't make things any easier. When she arrived in Boston, she was invited to a reception on Beacon Hill—a group of people who appreciated her artistry had organized a party in her honor. Inexplicably, she had declined the invitation—an insult that her admirers repaid by assiduously avoiding her performance." Wein added: "She was so miserable that she just lashed out at everyone around her."

SHE COULD FEEL much slipping away from her. In 1951, Fletcher Henderson had suffered a cerebral hemorrhage that left him paralyzed and a shell of his old self. The thought of never performing with him again, despite their battles, must have saddened her. In late December 1952,

Fletcher Henderson had another stroke and died at Harlem Hospital at age fifty-five.

In May 1953, she learned that the Empire Theatre in New York— the scene of her triumphs in *Mamba's Daughters* and *The Member of the Wedding*—was now sixty years old and about to be demolished. It was a potent sign for Ethel that must have frightened and depressed her. At a ceremony to celebrate the theater's history, she joined a cavalcade of stars, directors, writers, and producers. In attendance were such luminaries as Cornelia Otis Skinner, Shirley Booth, Howard Lindsay, Brandon de Wilde, Thomas Mitchell, Maureen Stapleton, Ilka Chase, and Jessie Royce Landis. Actors performed scenes from their past work at the theater. It was a glorious yet melancholy evening, with every artist at his best. When Ethel rose, the anticipation and admiration were palpable. Her weight made it hard to walk onstage. Her breathing was labored. Yet she summoned up her energy and took her place onstage and spoke with eloquence. Age was robbing her of her strength but not her power or grandeur. Henry Hewes of the *Saturday Review* remembered:

> Ethel Waters, who through sheer faith projects more of herself across the footlights than any actress on our stage today, seemed to be saying, 'In spite of all your compliments, I've had only two dramatic triumphs in my career and they were both here at this theatre.' The applause was so tremendous after her reprise from 'Mamba's Daughters' that she consented to an unprogrammed encore. . . . As she sang . . . "His eye is on the sparrow and I know He watches me," Miss Waters soothed the condemned building with the serenity of her personal acceptance of physical mortality. . . .
>
> Miss Waters' performance was the most moving.

Some work trickled in. Sometimes she performed at intimate gatherings. "Whenever she would perform at these soirees," remembered Leslie Uggams, "she would invite my mother and me, and we would go. It would be just a small group of people. And she'd sing at the piano. I don't remember it being a huge crowd. I just remember her at a piano singing." For Uggams, those were lovely memories.

Producers Richard Barr and Charles Bowden wanted to get her back on Broadway in a one-woman show. It would just be Ethel singing her hits as well as some religious songs, talking, reminiscing, joking—the whole Waters package on beautiful display, with Reginald Beane at the piano. The rehearsals proved physically agonizing. Often it was hard for her to stand. First, there was a tryout at the Sea Cliff Summer Theatre in Sea Cliff, Long Island. "Stormy Weather." "Sleepy Time Down South." "Am I Blue?" "Heat Wave." The famous songs were all there. But now, as everyone at the Empire Theatre engagement could attest to, she was an all the more compelling and moving presence. Despite her breathing problems and the fact that her voice was not the instrument it once had been, she knew how to compensate for what she had lost. Critic Whitney Bolton wrote that "[nothing this season] ever will top that magnificent talent, Ethel Waters."

Afterward Barr and Bowden titled the show At Home with Ethel Waters and took it to Broadway for a limited six-week engagement. Oliver Smith designed a set that looked like a living room, helping to create the feeling of intimacy that Ethel herself always projected. On September 22, 1953, At Home with Ethel Waters opened at the 48th Street Theatre. Again the reviews were glowing. "No matter that the years have lightened her hair and erased her waistline," wrote critic Walter Kerr. "No matter that the voice is reedy where it used to be magically mellow. No matter that the scenery around her strongly suggests its summer stock origins, or that the costumes she is wrapped in are just this side of dreadful. Ethel Waters is her own woman, she knows exactly what she can do, and she does it with joyous command. She stands in the fear of the Lord and of nobody else."

Sadly, At Home with Ethel Waters closed after three weeks—just days before a citywide celebration of her talents. New York's Mayor Vincent Impellitteri proclaimed October 16 "Ethel Waters Day." Members of the Negro Actors Guild turned up as part of the salute to her. Pictures were taken of her with the mayor and Eubie Blake and Noble Sissle. Ethel smiled and beamed, was gracious and charming, but inside she asked herself what lay ahead.

Nonetheless, a sign of her enduring fame was an interview on January

8, 1954, by Edward R. Murrow on CBS's popular television show *Person to Person*. Only the most prominent, the most discussed, the most fascinating were interviewed by Murrow, who sat in the studio in a comfortable chair, often with cigarette in hand, while the celebrity was shown in his or her home. It was a live broadcast that took days of preparations, with CBS crews at the celebrity's home, laying cable lines, checking on light sources. Be it Elizabeth Taylor and Mike Todd or Humphrey Bogart and Lauren Bacall or then senator John F. Kennedy or Fidel Castro or anthropologist Margaret Mead or John Steinbeck, the Murrow interviews were highly prestigious. Ethel was interviewed at a home in the Crown Heights section of Brooklyn where she was temporarily residing. She occupied the second floor of a redbrick house, which, as Murrow pointed out, was next door to a private school and across the street from a Baptist church. Once Murrow had introduced her, Ethel entered the room where the cameras were set up. "I'm here," she said, "all two hundred and fifty-three pounds of me."

She was in a reflective mood and clearly felt she was down on her luck. "What do you do for relaxation?" he asked. "Well, there's two kinds of relaxation," she answered. "There's a compulsory relaxation. And then there's a voluntary relaxation. Right now I'm on the compulsory one. So while I'm waiting for the phone to ring for me to get some employment while I'm in between dates, I just waste away my time reminiscing." As for her singing style, she told him, "I don't call myself a singer. All I do is recite musically. I try to paint a musical picture. And if it gets across, then I'm grateful because the story is important and the message it gives."

At one point, she played one of her old records for Murrow—"I Got Rhythm" with Benny Goodman's orchestra. She listened intently, told Murrow, "Get this chorus," and then sang to the record. She couldn't resist telling Murrow, "I was doing some of the things they call theirselves creating today." No matter what, she could still communicate a pure joy in singing, in entertaining. She also discussed her childhood and the nuns who had been so kind to her.

"Do you want to do another play?" Murrow asked.

"I would love to," she answered, "if it wasn't too serious." She explained that she did not want to do anything "related to my past life. I don't act. I

relive unhappy experiences." She added: "I want to be gay." Then she told him: "I constantly can't live in my tragic past."

Most moving was when she quoted dialogue spoken by her character Hagar. "One of the scenes I love most was the scene where Hagar is talking to her daughter and in her slow, inarticulate way, she's trying to rebuild the girl's courage and morale. . . . She takes the girl's face in her hands," said Waters. Then she delivered the lines that still meant so much to her: "Lissa, listen, we Black folks got one ting over white folks. And that is there ain't no trouble so big, we can't sing bout them. Best ting for trouble, honey, is singin' and workin.' And when your work is singin', then you is holding a chile against trouble." As always, Ethel really said very little about herself. Yet one sensed her sadness and her longing for happier times.

Of all the interviews Murrow did, possibly the two most haunting were those with Ethel and Marilyn Monroe. Neither had the high spirits of most other guests. Each seemed alone and lonely, weary and wistful, melancholic and mellow, disillusioned yet dreamy. But, paradoxically, Ethel also projected an optimism, an unexpected belief that maybe life would change for her—or even if it did not, her Lord had given her much to be thankful for.

For Ethel, memories were everywhere. One evening, there was a warm encounter with Vivian Wright, the daughter of Pearl Wright, at the Red Rooster in Harlem. On another occasion, she ran into Harold Arlen at Sardi's. Continuing her charitable work, she participated in a major fund drive for the American Cancer Society. Everyone, including passers-by, registered surprise upon seeing her. Despite her physician's warnings, she had lost no weight; in fact, she appeared to have gained more. Clearly, the eating was compensation for a loneliness that she feared might never end. Much of her time was spent alone, sometimes listening to her old recordings.

With not much else happening, she accepted a job as a regular on the daily TV talk show *Tex and Jinx*, which starred newspaper columnist Tex McCrary and his wife, Jinx Falkenburg. A stunning model, actress, and former tennis star, the sophisticated, intelligent Falkenburg clearly admired Waters, who had appeared previously on the couple's radio pro-

gram. Falkenburg understood that Ethel was having hard times. A thir-
teen-week deal was negotiated that would provide her with much-needed
income, keep her visible for the continually growing television audience,
and also provide viewers with the pleasure of hearing Ethel in song. There
to accompany her was Reginald Beane. On her ten-minute segment, Ethel
also talked in a folksy way, dispensing advice and praising the Lord.

Other broadcast hosts sought her out. Steve Allen on *The Tonight
Show*. Dave Garroway on *The Today Show*. All appeared to sincerely ad-
mire her and value her talent. By now, this was a generation of television
and radio personalities that had grown up knowing her. As for Ethel,
she had adopted a very workable public persona with such broadcasters
on- and off-camera. No great tantrums. No great demands, although she
still insisted on some things being done in a certain way. Always pleas-
ant, even cheerful, warm, and comforting. Much as she had been on
*Beulah* and on the various small-screen dramas in which she appeared,
she had an intuitive grasp of the medium of television, with its cool,
rather conservative demands. The very hot Ethel of the Broadway shows
of the 1930s and of *Africana* in the 1920s was nowhere to be seen. It
turned out that few African American women of the period—save the
young Dorthy Dandridge, Lena Horne, and perhaps Eartha Kitt—had
the visibility of Waters.

In June 1954, she journeyed to Chicago, where she appeared in a re-
vival of *Mamba's Daughters* at the Salt Creek Summer Theatre in Hins-
dale, Illinois. Except for Alberta Hunter who reprised her role as Dolly,
none of the original cast members appeared. They were too old for their
roles. Ethel was really too old for the role of Hagar and probably should
have played Hagar's mother, Mamba, but the character was still in her
system.

Traveling was harder for her now. She hated airplanes because she had
grown too large to fit comfortably into the seats. But she had to, to make a
living. In early 1955, she signed a contract with producer Charles Green to
tour in her one-woman show *An Evening with Ethel Waters*, which would
carry her to such cities as Pittsburgh, Harrisburg, and Chicago. But in
Pittsburgh, she became ill, and the performance had to be canceled. Re-
fusing to say anything to the press or even theater managers about her

ailments, she feared if word got around she might not be hired for future work. Rebounding quickly, however, she continued the tour, accompanied by Reginald Beane, making her way to Los Angeles by the end of February. Afterward she turned up at the Crescendo on the famed Sunset Strip. She must have hated performing on this fast-moving, very hip, very *now* boulevard, with sparkling, glamorous clubs like the Mocambo and Ciro's, favored by the movie colony's stars. No one was more aware than she that Hollywood could be unforgiving to those who grew old or overweight. Would there be chatter in the audience about her weight, her matronly looks in this youth-obsessed town?

Yet sometimes Hollywood can honor its own. She opened to a standing-room-only crowd. Afterward, Nat "King" Cole's chic young fashion plate of a wife, Maria Cole, rushed backstage to congratulate her. Gossips always said it took a lot to impress Maria Cole, that about the only things that really impressed her were Nat and herself. But as Maria Cole looked at the veteran Ethel, there was clearly admiration and respect in her eyes. Later when Maria Cole performed at the Strip's Ciro, she did a medley of Ethel's hits, in tribute to her. That night at the Crescendo, the blond bombshell Jayne Mansfield, bubbly and giddy, appeared equally impressed as she too went to Ethel's dressing room to embrace her. Other stars streamed in and out.

Still shrewd in understanding that in Hollywood, a performer has to be seen and talked about if she wants work, Ethel succeeded in doing precisely that. She landed three dramatic roles in television. One was called *Dance*, an adaptation of an F. Scott Fitzgerald story that costarred Janet Blair and Richard Kiley and aired on June 30, 1955. On *General Electric Theatre*, she also made a touching appearance as the mother of a young prizefighter played by Harry Belafonte in the drama *Winner by Decision*. Also in the cast was the young Diahann Carroll. Here was yet another meeting point of the generations. Throughout this production and others—as had been the case with *The Member of the Wedding*—Ethel had problems remembering her lines, which caused delays and frustration for everyone involved.

Ruby Dee, who later appeared with Ethel in the TV drama *Go Down Moses*, recalled the memory lapses and questioned if this were not perhaps

a tactic used by Ethel. "We kept doing the thing over and over and over again because at some point, she would have trouble with her lines. And we'd have to go back and do it over. And somehow the director did not get angry with her or upset. He just started it over until she got [it]. And meanwhile I'm doing the best I could in every single take. But there came a take when she passed that area where she had been making a mistake, and she didn't make the mistake, and it threw me. I stopped in amazement because it dawned on me quickly and in a flash that she did that deliberately. It almost amused me that I was gullible," said Dee. "She never lost her temper. But in a sense, it would not have served her to lose her temper. I think what happened to me was worse than losing. I didn't lose my temper. The director didn't lose [his temper]. I fell into the rhythm of a mistake. That was wrong. That was the mistake. And I accept it. Never fall into the rhythm of a continual mistake. But I learned that the hard way. So, in a sense, I'm indebted for teaching me an actor's trick when you want to. The take that was not my take, that was not the best take, was the one when she continued on, when I did a take that was not very good, that's when she continued."

Dee believed that Waters had "a complete understanding of her gifts. That's something to be admired. I couldn't even get angry with her. I think she knew her virtues as a performer. Her greatness, she knew that. And she knew it precisely, where to place it and how. And I liked that. I liked her confidence, the confidence that she could keep and not let arrogance overshadow it. That I liked about her. But she also taught me something about confidence. . . . She didn't have benefit of or understanding [of] Stanislavski or the method or anything. She came up through some hard times and I imagine great competition for the few roles we were allowed to get. So she knew how to annihilate competition."

OTHER TV DRAMAS FOLLOWED. Most interesting was *Playwrights '56* adaptation of William Faulkner's *The Sound and the Fury*, which starred Lillian Gish, Franchot Tone, and Janice Rule and was directed by Vincent J. Donehue. Here Ethel was cast in the role that should have been perfect for her, as Dilsey, the family retainer who represents the moral conscience

of the story. The drama caught the eye of Twentieth Century Fox, which mulled over the idea of doing a movie version. Fox also considered a film about the Cotton Club that would star Ethel with Dorothy Dandridge, then the industry's most important Black actress after her historic Oscar nomination as Best Actress for *Carmen Jones*. Fox also planned to cast Lena Horne, Cab Calloway, and Duke Ellington, but ultimately the idea was shelved. Each delayed or canceled production frustrated and depressed Ethel.

Still, with her television roles in the 1950s and early 1960s, Ethel had accomplished something no other Black woman of the age had achieved. African Americans on the tube were still cast in comic roles on weekly series. Dramatic roles turned up for actors like Sidney Poitier and James Edwards, but Ethel was the only dramatic Black star who worked relatively consistently in leading roles. Though generally cast as a comforting mammylike soul, she still brought another dimension to these presentations. Even the most casual viewer sensed her mythic powers—and her very look, the almost unreal poundage, made her all the more compelling a heroine.

BRIEFLY, SHE TOURED in a new production of *The Member of the Wedding* at small theaters outside Philadelphia and Boston. RCA also reissued some of her recordings from 1938 and 1939 on its Vault Origins series, along with those of Bing Crosby, Russ Columbo, Ethel Merman, Fred Astaire, and Helen Morgan. A nice honor, but no bucks coming in. Back in New York, she was sometimes seen walking alone down Harlem's famed 125th Street "at a slow, easy gait, a bandanna on her head and a shopping bag swinging." Other than Reginald Beane and Thelma Carpenter, there were few companions for her now, few she felt close enough to really open up to. But both Beane and Carpenter had active careers. Beane appeared on a television variety show in the 1950s. Carpenter played clubs. One evening, though, when Carpenter had to fill in at the last minute for an ailing performer at New York's Bon Soir, she very touchingly brought Ethel along to sing "Happy Birthday" to a guest. But then Ethel had a disagreement with Beane that caused a serious rupture in their relation-

ship. At one point, she confided to Floretta Howard that she no longer intended to work with Beane unless it was absolutely necessary. The breach continued for several years.

AT THE END OF 1955, an offer for a low-budget film came in from the independent company Splendora Films. Its president was Warren Coleman, a former actor who had created the role of Crown in *Porgy and Bess*. Splendora's vice president was Noble Sissle. The production company hoped to do at least three features starring mostly Black actors and actresses. Ethel signed for their first film, *Carib Gold*, which was directed by Harold Young and shot in Key West, Florida; she costarred with Coley Wallace, who had made a splash playing the title role in *The Joe Louis Story*. Also in *Carib Gold* were dancer Geoffrey Holder, Richard Ward, and two sweetly ambitious young actresses who later made significant names for themselves, Cicely Tyson and Diana Sands. In this story of the discovery of hidden gold—and the effect it had on its discoverers—*Carib Gold* cast Ethel as a woman who ran a club and was also the mother of the character played by Wallace. Hoping to shoot the film in six to eight weeks, producer Coleman often appeared nervous around Ethel, perhaps on guard for fear of her famous temper. Could anyone blame him? Cicely Tyson remembered him often saying, "I've got to get Ethel Waters out of here." But Tyson herself found Ethel to be warm and sweet. In the evenings, she asked Tyson to comb her hair. "She was wonderful to me," recalled Tyson.

But there was an incident one day that startled the cast. In the cafeteria at lunchtime, Noble Sissle was calmly talking to Waters, when she suddenly exploded. Something had upset her, though no one was sure what it was. Ethel "used all kinds of foul language. She cursed everyone from the White Man to everybody's mother, brother, and sister."

Whatever hopes Ethel, the cast, or the producer had for *Carib Gold* evaporated when it premiered later in Key West and briefly opened in Harlem. The few reviews were blistering. "The plot is nothing new, nothing exciting, nothing," wrote New York's *Amsterdam News*. "Miss Waters, one of the most revered actresses on the American stage, added no new glory to her name. . . . Her performance, at best, is mediocre."

\* \* \*

SCATTERED APPEARANCES FOLLOWED. Steve Allen brought her on *The Tonight Show* where, much like Jinx Falkenburg and Maria Cole, he treated her like a queen. She also did Arlene Francis' morning show *Home* and Mitch Miller's radio show. Other dramatic roles followed in television's *Speaking of Hannah* on *The Twilight Theatre* and a special color broadcast of *Manhattan Tower*, which took her back to the West Coast. Here and there, she accepted dates in small productions of *The Member of the Wedding.*

But nothing could lift her spirits, and she sank into a greater depression. Her tax problems mounted. The IRS demanded $25,000 in taxes on her book royalties for *His Eye Is on the Sparrow*. Ethel didn't have the money to pay, yet there were some offers that might have saved her financially. Twentieth Century Fox offered her $50,000 for the movie rights for *His Eye Is on the Sparrow*. Discussions and negotiations went back and forth. Finally, Ethel flatly turned the studio down "because they wouldn't let me play myself," she said. "They said I couldn't sing, that I was too old, and that I wouldn't have public appeal. I'm not dead. And I'm not dated. Why, I feel I could get out there and put them all to shame in a part like that."

Restless, she moved into the Empire Hotel on Manhattan's Upper West Side. Her secretary, Floretta Howard, now remained on the West Coast, fielding calls and answering letters, while living at the home on Hobart Street—which Ethel was eager to sell. She had permitted Floretta to use the home as a school for disabled children, but eventually the IRS put a lien on the house for Ethel's back taxes. Few things could have distressed her more. Most times she sat alone at the Empire Hotel, listening to the radio or her old recordings, eating dinners she should have stayed away from, brooding about her state, and always, always lifting her head in prayer. In the past, she had suffered through a dry season, an ill wind. Now a long winter of discontent, ironically starting from the time of the release of the film *The Member of the Wedding*, had set in, perhaps permanently, she feared. Her paranoia grew. Why had all this happened? Who or what had caused it?

During this time, the period of McCarthyism and witch hunts against entertainers who (like Paul Robeson) were thought to be communists or communist sympathizers, many performers found themselves listed in *Red Channels* (like Lena Horne, Hazel Scott, and Fredi Washington) or blacklisted from TV and radio appearances. Stars like Dorothy Dandridge and Sidney Poitier were asked by the studios to sign loyalty oaths, which both refused to do. The careers of many actors, Black and white, were destroyed. For some reason, Ethel began to think that her career problems were the work of communists out to get her. No one could ever say for sure what led her to such a belief. But her long-standing paranoia appeared to intensify as she grew older and politically more conservative.

Some of her interviews amused people. When asked about the rising popularity of rock and roll among the young in 1956, she blasted the music's renditions of religious songs. "They're trying to desecrate and belittle God, and I don't go for that," she said. "I think they're messing around too much with the religious numbers. They're changing songs that were wrought in suffering and born in a spiritual outlet. They're now just making jam sessions out of them, which I think is wicked." But no one seemed to understand exactly what rock and roll songs she was referring to. The current generation did not see any irony or contradictions in her comments, but for those who had known Ethel during the days when she sang raunchy songs like "Shake That Thing" and "My Handy Man," she didn't seem so much hypocritical as delusional or batty. Her music had once shocked and delighted while it was also condemned. Didn't she remember her own history, her own impact on the path that popular music and culture had taken?

Other comments, however, angered not only a new generation but Ethel's contemporaries as well. Broadcaster Mike Wallace, apparently another great fan, tapped her for an exclusive interview in late 1956 on his television show *Night Beat*. Mostly, she talked about her career. But then Wallace asked, "Are you a member of the NAACP?" Ethel was hesitant before she answered, "No."

"You aren't a member of the NAACP—an organization trying to find equality for the colored people?"

"No," she answered again.

"Do you agree with their work? You don't agree with their work."

Ethel simply smiled but said nothing.

"They are trying to help the Negro—," Wallace continued.

"I do my own thinking," she said, "and Ethel isn't interested. I'm just not interested."

She said that with what she had attained in life, she didn't feel any white had deprived her of anything. "I don't miss what you have," she told Wallace, "because I don't desire it, and don't want it." A few years later, she would do a second, longer interview with Wallace.

To many, Ethel seemed shockingly out of touch at a time when the civil rights movement was on the rise. In 1955, Black Americans had rallied around the Montgomery bus boycott, which catapulted Rosa Parks to national prominence, a seamstress who had refused to give up her seat on the bus to a white. The young minister Martin Luther King Jr. had launched a massive protest around the incident in December 1955. Sit-ins, protests, and demonstrations were about to explode around the country. Schools would be integrated amidst angry outcries, insults, and violence from whites. Three young civil rights workers in Philadelphia, Mississippi, would be murdered. At precisely this time, Ethel appeared to be critical of the very organization that had for decades fought for equal rights. Ethel's strange comments made her seem like someone living in a very distant past.

Following articles in the Negro press on the Wallace interview, angry letters from readers—at this time and in the months and immediate years to follow—were sent to publications about Ethel. "Although she's in a position to do much for better race relations," wrote one reader, "she showed a stupid lack of knowledge of the struggle for justice and equality such as is being waged by the Reverend Martin Luther King and others who represent the new type of Negro in America today." "Things must be getting pretty bad when Louis Armstrong starts complaining and protesting," commented another letter writer. "Let us hope the racial situation doesn't get bad enough to make Ethel Waters start complaining. Things will really be bad then." Another letter writer commented: "Ethel Waters—still great in our book as an actress and a singer despite the thinning voice— but is an awful bore on the race relations subject. She's talking more these

days than ever before on what the Negro ought to do. If she would only keep to the things she does so well and not try to out talk or outthink the NAACP, she could grow old gracefully." Another referred to her as "Mrs. Uncle Tom." Having long admired Ethel, actress Juanita Hall, who played Bloody Mary on Broadway and in the film *South Pacific*, also spoke out. "One of the greatest women on earth and should have been one of the greatest actresses was Ethel Waters—but she missed the boat," said Hall. "People get tied up with fear and they go off the deep end and don't know how to get back." As the civil rights movement gained momentum, galvanizing young and older generations, Black entertainers were expected to be a part of the new movement, to speak out against inequities and injustices. Where was Ethel Waters' mind? What was she thinking?

In the midst of this, no one seemed to recall that Ethel Waters had once prided herself on being a race woman, that she had done countless fundraising benefits for the NAACP and other social and political organizations. Publicly, she rarely voiced her anger toward whites, especially those in show business, but backstage she made it apparent that no one dared mess with her. Never had she trusted ofays, or as she had told Elia Kazan, "any fucking white man." Never had she really cared to socialize with whites, with the exception of Van Vechten or someone like the most Negro white man she had ever met, Harold Arlen. Ethel, the old outspoken fighter, seemed nowhere in sight. Perhaps her comments in the Wallace interview could be attributed to her anger with the NAACP's executive secretary, Walter White.

Perhaps her reasoning was clouded by her fears about her health and her unending financial problems, which had escalated to the point where she must not have known if she could survive. Then a story made headlines.

"Broke—But All Ethel Waters Wants Is a Job," read the banner in the *New York Post* on January 2, 1957.

"'Stormy Weather' Has Waters Singing 'Blues,'" read the banner in the January 3, 1957, issue of the *New York Journal-American*.

"Ethel Waters Sings the Blues over Finances," was the headline in the January 3, 1957, edition of the *Philadelphia Inquirer*.

Sitting in her room at New York's Empire Hotel on West 63rd Street,

Ethel had met with reporters and made startling revelations about her finances. Her comments were so personal that many found them embarrassing for a woman of her position to make. "I am unemployed," she told the press. "I don't have a quarter to my name.

"No, don't say I'm destitute, for I'm not. I couldn't be living in this hotel room if I were. I'm not going on relief.

"How will I manage? The good Lord takes care of me. Always has. I guess it's because I don't plague him.

"They are trying to put me down as a has-been. What rot, I'm anything but, even if I was sixty on my last birthday.

"Only trouble is, some folks have seven or eight jobs, and some don't have any. Something will come up. It better. It has to.

"They're trying to say I'm trapped like Joe Louis, but I never made a million dollars the way he did. All I need is a job—that's all—and I'd get in the clear. I can eat. I can pay my hotel bill."

Compelling as her comments were, they had also been contradictory. But she looked as if she were unable to stop talking. It was similar to her stream-of-consciousness monologue after the opening of *Mamba's Daughters*.

"It's true. I'm completely busted and I owe back income tax, but it's nothing that a little work won't clear," she said. "I'm in debt to the government. I owed about $25,000, but I've whittled it down to about $15,000. My home is being used for classes for slightly retarded children. I think it's the human thing to do for the darling little children. It's not rented. I just let a woman use it to teach the children."

"I fell behind on paying [taxes] on my royalties from the book because I wasn't working steady. I guess it has happened to many people. It's nothing to be alarmed about. All I need is work."

"Baby, I still think this is a wonderful country. Aside from the government, I don't owe a soul. I'm sure work will be coming along soon. When you have faith, the day never is dark. I'm not going around belly-aching. I still sleep nights, and I don't have to take any pills. I know the Lord will provide for me. He has taken care of me all my life."

The press had a good story and ran with it in the days that followed. Ethel was not hesitant to keep talking. "People called me up breathless

to pay my hotel bills," she told one reporter. "I'm afraid they'll start coming up to me soon to ask me: 'Where's your cup?' But the Lord keeps me independent. I have been meeting my hotel obligations. Otherwise I've been broke for so long. I'm reconciled to it. Just call me the happy pauper."

She also informed the press of her expenses. "I have to earn $850 a month to keep up with my demands. I have a home in California and my mother lives in Philadelphia. I'm living in New York now because I have to be on the ground in case a job shows up." But she wanted the press to know that there were some things she would not sink to, such as letting Twentieth Century Fox do a movie version of *His Eye Is on the Sparrow.*

It was all a deliciously mournful saga that newspaper readers and television viewers were fascinated by, especially on January 9, when Ethel appeared on the television quiz show *Break the $250,000 Bank.*

Originally, contestants on the show—everyday Joes and Josephines, who were selected from the studio audience—had to answer questions in a category of their choosing. In this early reality show, the rest of the in-studio audience—as well as millions at home—might bite their nails in sympathy as a contestant struggled to come up with the right answer. Some contestants came on the show to raise funds for their families. Others— the victims of hard times—wanted to use their winnings for a fresh start. By the time Ethel appeared on the show, its format had changed. Now "experts" were brought in to answer the questions. They stood in a box called the "Hall of Knowledge" and could be assisted by family members seated in the audience. Of course, the very idea that Ethel Waters had fallen so low that she had to resort to a quiz show for money was almost inconceivable.

On the night of her appearance, viewers held their breath at a real-life spectacle that was partly sad, partly frightening, partly surreal entertainment. A nation was watching one of its greatest stars—a woman larger than life in her talent, her personality, her aspirations, now, ironically, in her physical presence. Yet Ethel never failed to surprise. On-screen, she looked like a beloved grandmother. With the camera on her, her warmth showed, and her powerful presence enabled her to own the screen and audience.

Answering "several questions in her selected category of music, prin-

cipally religious hymns and songs," during her first week on the show, she won $5,000. On her next appearance the following week, she won another $5,000. By her third week, the show, for some mysterious reason, had changed its title to *Hold That Tune*. That evening, though, Ethel lost. Still, she had walked away with $10,000, and the appearance on the quiz show invigorated her and outweighed any feelings of humiliation that she might have had. Mostly, she was relieved—at times even overjoyed—at having the earnings she had won. She also struck up a friendship with another contestant, a young African American woman from Philadelphia named Sue Smith McDonald. The two would remain friends to the end of Ethel's life and Ethel would sometimes visit McDonald's home in Philadelphia.

But the saga had not ended. Having second thoughts about her earlier statements to the press, she granted an exclusive interview to Evelyn Cunningham of the *Pittsburgh Courier* in which she branded all the stories about her finances—and the people who spread them—as "lies and liars." Other stars, such as Joe Louis and boxer Sugar Ray Robinson, had recently filed for bankruptcy, but under no circumstances did Ethel want to be lumped into the same category. Insisting that "things aren't all bad for me" and that "false impressions have gotten about," she announced she had rejected "propaganda plays—offered by left-wing elements." "Certain Communist elements have been trying to break down my spirit for the last four years," she said. "They've wanted to do just what is being done to me now. They've shown me no dignity or respect." Some job offers "would have turned your stomach," she told Cunningham. "Negroes would have been mad at me for life. I am not going to sacrifice my principles, my integrity and the way I feel about God to make money."

For many readers, Ethel Waters looked as if she might be losing her marbles! Others took her statements about communists seriously. Yet what drove Ethel to such conclusions remained unclear.

Still, others urged her to get a grip and pull herself together, starting with her looks. "Why has Ethel Waters allowed herself to look so old?" asked African American columnist Hazel Washington. "She isn't that far gone . . . her face is sweet as ever, but she has taken on an 'old look'! Please reduce, Ethel, it will do wonders for you."

\* \* \*

IN LATE MARCH 1957, she performed in a one-woman show called *Musical Memories with Ethel Waters* at New York's West Side Young Men's Christian Association. She announced she was performing for charity, but for many, the question was: Why on earth was Ethel Waters entertaining at a YMCA? The next month she performed *The Member of the Wedding* at the Suburban Playhouse in West Orange, New Jersey. There was talk of her playing the grandmother in a new Harold Arlen-Yip Harburg Broadway musical, *Jamaica*, but when Lena Horne was cast in the lead, whatever consideration Ethel might have given the show now went out the window. At one point, there was talk of her playing the grandmother of W. C. Handy in the Black-cast film *St. Louis Blues*. For whatever reasons, it never happened. At another time, she was set to do a new play, *Solitaire Lady*, in summer stock but she backed out. She remained difficult, if not impossible, to deal with. Two booking agencies were said to have "blackballed her due to personal differences." In the *Chicago Defender*, Langston Hughes, still a fan of hers, wrote sympathetically about her fundamental kindness and lack of pretense. "I wish some of our younger stars who are brusque and unfriendly to admirers," wrote Hughes, "would learn to behave as Ethel Waters did when she was riding the Broadway wave at its crest."

More embittered than ever, unhappy, restless, lonely, even bewildered because she was cut off from the one thing that had always enabled her to hold herself together—work, the chance to win approval from audiences, those "wonderful people out there in the dark," as Norma Desmond said—she found refuge listening to the radio in her room at the Empire Hotel. But always she was faced with her own discontent, her own impenetrable sadness. Her days were long, her nights longer. At times, her thoughts must have gone back to the early days of her career, the glory years in the late 1920s and 1930s, her passionate relationships. Yet she did not want to live in the past. Nor did she care to spend her time reflecting on it. There had to be a way out.

For a spell, she toyed with the idea of moving to Englewood, New Jersey. Mozelle had presented her with an appealing proposition. Their

relationship had remained complicated and stormy. Mozelle continued to be in and out of Ethel's life. At one point, Ethel apparently put Mozelle on her payroll to perform general chores. But she also referred to her as a snake who could not be trusted. Still, the women stayed in communication with one another. Now working as a domestic in New Jersey, Mozelle hoped to buy a home in Englewood with a female friend. To raise money for the down payment, Mozelle had asked Ethel for a loan. Or Ethel could buy herself an interest in the home. With some of her winnings from the quiz show or from the sale of her house in California, Ethel thought a home in Englewood might offer her relief from life at the Empire Hotel. There she paid $225 a month for her two-room suite. Yet there were always hassles at the Empire, she confided to Floretta Howard. She didn't like having to tip bellhops whenever they ran errands for her. She didn't like not being able to use her air conditioner at the hotel—and having to suffer through the stifling heat. She didn't like having to board buses to get around town. Often she felt—rightly so—that passengers stared and whispered about her, the great star using public transportation. Nor did she like the neighborhood around the Empire. Constantly, there were the sounds of sirens and fire engines outside. That neighborhood on the Upper West Side would later undergo a great transformation when it became the site of Lincoln Center for the Performing Arts. But at this point, Ethel just wanted to get out. Because she still needed a New York base in case there was work for her, she considered maintaining a small residence somewhere else in the city. But she also envisioned spending leisurely, hassle-free time in Englewood. She even wanted Floretta Howard to return east where she too could reside with Ethel in Englewood. Ultimately, that did not pan out. But she prayed for a dramatic change in her life.

# A New Day

R ELIGIOUS CONVERSIONS CAN PUZZLE everyone except the
converted. What causes someone to immerse him or herself in
a fervor of religious faith almost to the exclusion of everything
else—every other interest, every other ideal, every other aspiration, every
other relationship? What drives someone to cut off ties with the past, in
a sense to strip oneself clear of it, to start anew? Perhaps Ethel's disap-
pointments, her frustrations, her fears, or her anger with the way people
and events in her life had turned out drove her to her stance. Perhaps she
sought redemption. Perhaps she sought solace and security. Perhaps she
sought escape from the other "real" world. Regardless, Ethel could believe
now only in her personal idea of her Lord. What she needed was a new
pathway to him, a new messenger with whom she shared beliefs, aspira-
tions, sentiments. That messenger turned out to be a young, charismatic
evangelist from North Carolina named Billy Graham.

Ethel met him through the radio at the Empire Hotel. Nightly, as
she turned her radio dial, feverishly trying to find something to take
her mind off herself, nothing seemed to please her more than a good,
fiercely old-school preacher with a fire-and-brimstone sermon. But she
soon discovered Graham on the airwaves. He was then an evangelist ris-
ing in popularity around the country. Not the kind of preacher Ethel had
searched for, but a new-style man of God with a passionately delivered
message and an engaging personality. From the moment she heard him,
she sat transfixed.

Born Franklin William Graham in 1918 on a dairy farm near Charlotte, North Carolina, Graham grew up a Presbyterian; he studied first at Bob Jones College (later University) in Cleveland, Tennessee, then transferred to the Florida Bible Institute, where he graduated with a bachelor's degree in theology. In 1943, he earned another bachelor's degree with a major in anthropology from Wheaton College in Illinois. At Wheaton, he met an attractive, engaging young woman, Ruth Bell, who had been born in China, the daughter of Presbyterian missionaries. Her father was also a surgeon. Graham always said it was love at first sight. As their relationship became serious, Ruth Graham wrote: "If I marry Bill, I must marry him with my eyes open. He will be increasingly burdened for lost souls and increasingly active in the Lord's work. After the joy and satisfaction of knowing that I am his by rights, and his forever I will slip into the background." She added: "In short, be a lost life. Lost in Bill's." Married in August 1943, the two, in many respects, were an ideal couple, both with strong religious convictions, both energetic and ambitious in spreading the word of the Lord. Eventually, Ruth Graham would author or coauthor fourteen books. For a time, they lived in a log cabin that was designed by Ruth, in Montreat, North Carolina. They had five children. Graham also served as the pastor of the Village Church in Western Springs, Illinois. In 1947, he became president of Northwestern College in St. Paul, Minnesota.

A turning point in his early professional life occurred through a friend in Chicago, who had a radio show called *Songs in the Night*. No longer able to finance the show, the friend asked Graham to take over. With support from his parishioners, Graham turned the show around, bringing in new listeners and spreading his ministry further. Aware that the Christian movement must communicate with a new generation, he founded Youth for Christ, and in 1949, he gave a series of revival meetings in Los Angeles that was originally set for three weeks, then extended to eight. Graham had mastered a new style for reaching the people. His venues were huge arenas—tents, stadiums, whatever could accommodate a large crowd. His choir would number some five thousand people. Those coming to the revivals and rallies could speak with counselors about their faith. With his matinee-idol good looks and well-attired in attractive suits and ties, he now was onstage with a broader audience.

Graham's ministry had caught the eye of publishing czar William Randolph Hearst, who believed that Graham's Christian base, possibly a conservative one, might aid in the battle against communism. At one point, Hearst reportedly told his editors to "puff Graham," meaning build him up in the Hearst corporation's newspapers and magazines. By 1954, Graham made the cover of Henry Luce's *Time*, which was one of the great professional status symbols for decades. Eventually, his Billy Graham Evangelistic Associates, with headquarters first in Minneapolis and later in Charlotte, North Carolina, grew into a massive organization with a weekly radio program, *Hour of Decision*; a syndicated newspaper column, *My Answer*; a magazine, *Decision*; World Wide Pictures, which produced and distributed more than 130 productions; and *Christianity Today*.

Graham did have his critics. In 1950, after meeting with President Harry Truman at the White House, Graham told the press about discussing how to fight communism in North Korea. Annoyed, Truman labeled him a "counterfeit" publicity seeker. Afterward Graham learned not to reveal private conservations with leaders. Eventually, he would meet with all the nation's presidents in the twentieth century. As President Dwight David Eisenhower neared death, he asked to see Graham. Though perhaps thought of as a Republican conservative, especially later when he visited Richard Nixon at the White House, Graham was a registered Democrat.

Early on, Graham also opposed segregation. Following Martin Luther King Jr.'s imprisonment at the time of the Montgomery bus boycotts, Graham contributed bail money to help with his release. During Eisenhower's presidency, he wanted federal troops sent to Little Rock at the time schools were being desegregated. Later he refused to go to South Africa until the government would permit desegregated audiences to attend his revivals.

But in the 1950s, as postwar America was about to enter an unprecedented era of financial prosperity, Graham called for the nation to renew itself, to find God, to honor Jesus Christ, its savior. As his national prominence grew, so did his ambition to reach more of the country. Now he launched his Crusades, a series of large-scale revival-style religious rallies. In May 1957, he was due to bring his Crusade to New York's Madison Square Garden.

Before the Crusade's arrival, an entranced Ethel listened to Graham on the radio and believed she was rediscovering a faith and a love for Jesus that had been dormant for decades. That didn't mean she had not sung her Lord's praises all this time. But now she reexamined her life, her goals, her actions. Graham struck a nerve, which was surprising because when she thought of good old-time preaching, it was with a Black minister in the pulpit. The fact that Graham was white would lead to a shift in her attitudes about the ofays.

On the *Tex and Jinx Show*, Tex McCrary asked if she planned to attend the Graham Crusade. Not having seriously considered doing so until that moment, she answered yes and also predicted: "The Garden's not only going to be full, but the meeting will be extended." Later she professed that she had not known what led her to make such a comment. Finally, she attributed it to the Lord leading her down a new path. Regardless, she received a call from Lane Adams, a member of the Graham organization, who had heard her statements and offered her tickets to the first week of rallies.

With a group of nine friends, she arrived at Madison Square Garden, then located at 50th Street and Eighth Avenue. Ethel was very familiar with the old Garden, its splendors and its history. Here was the site for the circus when it came to town, for hockey and basketball games, for great boxing bouts. Here she had performed in many benefits and fund-raisers. That night Madison Square Garden was filled to capacity for the Crusade. The Crusade Team, as members of the organization were called, was on the lookout for her. "We were shown the entrance where to my surprise they were expecting me," Ethel recalled. Right away, it appeared as if the team believed she could be important to the Crusade, if that meant no more than her speaking well of the Crusade on future television broadcasts. That evening, though Ethel may not have thought of it in such a way, was another form of theater. The lights, the music, the speakers, the choir, the amplified sounds, the beautiful choir robes, the crowd itself, and the charismatic centerpiece, Reverend Graham himself, were all there to lift the spirit, to alter consciousness, to create a scintillating communal reverie—as foot soldiers helped both the committed and

the wayward, the devoted and the backsliders, to reach into themselves and thereby *find* themselves, and therefore find the Lord.

Mesmerized by Graham's sermon, she admitted, "I couldn't tell you a single thing he said in so many words." But she knew he had opened a door, that his inspired message had given her hope and direction, and that her life was about to change. Leaving Madison Square Garden in an exalted state, she returned the next night and the nights that followed. But she no longer wanted to take friends with her. Nor did she want to wait in line to enter the arena. Her legs were weak and her fatigue was as debilitating as ever. At that point, she called Lane Adams to ask if she might be given a special "button" that would allow immediate entry. Adams informed her that if she joined the group's choir, she would automatically be guaranteed such a button. But Ethel balked. "The last thing I wanted to do was to sing in that choir. I did hate group-singing," she said. When Adams insisted, Ethel finally agreed. "If I had to say I'd sing in the choir in order to get into the meeting, I'd do it. All I wanted was to get in without dropping dead outside." That night, as she was about to take a seat in the alto section of the choir, she was so large that a man was brought in to saw off an arm of the chair so she could be seated.

Thereafter, Ethel Waters nightly took her position with the choir. Not long afterward, the flashbulbs popped and the press followed the story. Once again, she made for good copy. The famous singer, having endured tough financial times, believed herself safe and saved now in the arms of the Lord, thanks to the words and encouragement of this new-style evangelist, Billy Graham. "This is the most wonderful thing that could happen for New York," she told the press. "Billy Graham is one of God's disciples. He and I speak the same language. You see, I'm hipped with God." At this point, Ethel looked as if she wanted simply to blend in with the group. But, of course, that would not last. At one of the gatherings, a request was made for Ethel to sing "His Eye Is on the Sparrow." Though hesitant, she performed the song, which was perhaps the highlight of the evening.

Though possibly unfair to say that the organization used her, she was indeed of use. It never hurt to have an endorsement, by her mere presence and then by her statements to the press, from this famous woman. Many

assumed that Graham's followers were mainly white. Her presence sug-
gested that Graham could communicate with all Americans, white and
Black. The presence of this Black earth mother—a comforting, devout,
trustworthy, kind-hearted, thoughtful, wise woman—also enhanced and
amplified the image of the Crusades themselves. No one could ever say
that either Reverend Graham's organization or Ethel had planned things
this way, but certainly these were part of the effects.

By the time she met the Crusade's musical director, Cliff Barrows, he
was well aware of the impact of her presence at the Crusades. One evening,
shortly after it was learned that the New York Crusade would be extended
for four additional weeks, Barrows, as Ethel recalled, took the microphone
to announce that a request had been made from someone in the audience
for Ethel Waters to perform "His Eye Is on the Sparrow" on next Tuesday
evening's television broadcast. He repeated the request. Naturally, Ethel
agreed. On the following Tuesday, after performing her now signature
song, Waters said she "knew something deeper was taking place." Hav-
ing wrestled with the thought of her show business career versus her new
recommitment to Christ, she "found out that the two lives could not mix."
After performing "Sparrow" five times at the New York Crusade, she sug-
gested to Cliff Barrow, "who was still pretty much a stranger to me," that
a recording should be made of her singing. "I thought they'd get in a lot of
money. They did," said Ethel. An estimated 842,000 people had attended
the Graham Crusade in New York.

For Ethel, the sixteen weeks of the Crusade had been an exhilarating
experience, but she soon prepared to return to Los Angeles to look into
the sale of her home. She had postponed her trip for too long. "Three
times I made reservations back to Los Angeles and each time I canceled."
But Floretta Howard had written to tell her it was imperative to return to
Los Angeles: there was a buyer for her home. A sprawling urban center
that was called "72 suburbs in search of a city," Los Angeles had been
undergoing a major transformation with the construction of a vast system
of freeways—the Pasadena, Hollywood, San Bernardino, Santa Ana, and
Terminal Island—which unified the metropolitan area. Now, ambitious
plans were under way for the Santa Monica Freeway, which would cut into
Sugar Hill. Many of the great homes of the Black elite were being bought,

later to be torn down to make way for the new freeway. Though she was grateful for the prospect of a buyer, she had loved the home on Hobart and hated to see it go.

But before her Los Angeles plans were finalized, she was contacted by another member of the Graham team, George Wilson. While en route to Los Angeles, could she stop in Minneapolis for a Youth for Christ event? Never having heard of Wilson, she was annoyed by his calls. "I was getting a little hot under the collar." Finally, she told him she would do no such thing. No doubt that team member saw flashes of Ethel's formidable temper that day. Finally, Wilson "had to call Billy long distance and get him to call me," she said, "and tell me it was all right before I'd stop over and sing at Youth for Christ."

A call from Graham was not an everyday occurrence. Those who had read press accounts and seen pictures of Ethel at the Crusades often assumed that she and Billy Graham had become close friends, but while her admiration for him was and would remain unfaltering, she did not know Graham personally. Nor had she actually met his musical director, Cliff Barrows. "I hadn't met either of them," she said. "That was the funny part. Wild horses couldn't have kept me away from that Crusade because I felt so much love and as though everybody was my friend, but I'd never met most of the main ones. . . . I still had only nodded at Billy." Graham's ministry kept him constantly on the go. He respected Waters and was moved by her faith, but, frankly, it appeared as if he rarely had time for significant new personal relationships. The same was true no doubt of his wife, Ruth. For her part, Ethel must not have expected to be chummy with Graham. His message was far more important than socializing. Yet the public perception would always be that they were the closest of friends.

Ethel attended the Youth for Christ session in Minneapolis. She also appeared with the Crusade in San Francisco. Over eighteen thousand people attended.

IN SEPTEMBER 1957, Ethel surprised many when she flew with Lillian Gish, Burgess Meredith, Eileen Heckart, James Daly, playwright Thornton Wilder, and other American artists to West Berlin. All were par-

ticipants in a festival of seven one-act plays by Eugene O'Neill, William Saroyan, Tennessee Williams, and Wilder. It was her first trip outside the country since her visit to Paris and London in the late 1920s. Considered an important cultural exchange in this era of the cold war, the dramas were performed at West Berlin's new $5 million Congress Hall, which had been constructed under the auspices of the United States and Germany. The opening program was a performance by modern dance's Martha Graham, with Virgil Thomson conducting the RIAS Orchestra of Berlin. Ethel agreed to appear in two one-act plays by Wilder—*Bernice* and *The Happy Journey to Trenton and Camden*. The plays teamed Ethel with a young generation of African American actors such as Bill Gunn, Vinnie Burrows, Billie Allen, and Richard Ward. Despite her health problems— shortness of breath, difficulty in walking and maintaining her balance, a familiar fatigue and weariness—the entire experience gave Ethel the opportunity to stretch her talents. Her participation also suggested that she was not yet ready to forsake her career. Perhaps all she really needed now were solid, challenging roles to play. Upon returning to the States, she also appeared on television in the "Sing for Me" episode of *Matinee Theatre* in October.

But during 1958, her work with the Graham organization once again became her primary focus. The rallies. The revivals. The telecasts. The interviews with the press. When Reverend Graham gave a compelling sermon at San Francisco's Cow Palace, in which he said that the church must speak out on the issues of race, alcoholism, and mental illness, Ethel informed the press that she had come to the Bay Area "because my child needs me, so I came out here to smile at him and let him know he was on the right track." The press reported that Waters' "appearance in the huge arena, swelled the crowd to the largest total in twenty-three days. Seventeen thousand five hundred overflowed the place and doubled the previous high."

She also appeared in the Graham organization's Christian movie *The Heart Is a Rebel*. A deeply religious nurse named Gladys, Waters' character is instrumental in helping the mother of a boy with a heart condition cope with his illness through faith. Ultimately, both parents must rededicate themselves to prayer and their religious convictions as their

son recovers. Once again, she played a nurturing Black woman making it her business to help the whites around her. She also sang in the film, and though the writing was far from the complex beauty of *The Member of the Wedding*, Ethel somehow made the character Gladys believable and likable. Premiering at the Pasadena Civic Auditorium on June 3, 1958, *The Heart Is a Rebel* had a series of one-night showings in forty cities, followed by screenings in local churches, clubs, and auditoriums. Though Ethel agreed to help publicize the film, the promotion tour often was hard on her physically. When she arrived at the Toronto opening where she was to speak to an audience of three thousand, there was a foul-up in the request to have a large chair onstage for her. By now, Ethel weighed 350 pounds. After Ethel sat uncomfortably in a regular-size chair, she rose to leave. But the chair stuck to her, and two men had to come onstage to remove it. Ethel handled it all graciously, but obviously it was an embarrassing moment. On June 4, her film *Carib Gold* finally had a Los Angeles opening at the RKO Hillstreet Theatre. But it soon vanished from sight. Later she was briefly seen in the documentary of the 1957 New York Crusade called *Miracle in Manhattan*.

She still took work wherever she could find it. In July, she arrived in Flint, Michigan, to appear in a local production of *The Member of the Wedding* at Flint Junior College. How this engagement came about is anyone's guess. She performed with students from Flint Junior College. Cast as her foster brother, Honey, the student Clisson Woods didn't recall being particularly nervous about working with her. Somehow he knew she was important, but years later, he admitted he didn't really comprehend what a major talent she was. During the brief rehearsals, he never saw any signs of the Waters temperament. Mainly, she seemed grandmotherly to him, and frankly, he thought she was just old. One afternoon he received a message requesting that he come to her hotel room to speak to her. "When I got there," he said, "she sat me down and told me that my English was too proper for the character of Honey. She said, 'Child, you've got to drop the consonants at the end of your words. Drop those 'g's and 't's. Say goin', not going.'" He thought she had a point. He did as she instructed and everything was fine. At the end of the production's brief run at the college, she signed his copy of the play.

During this period, she appeared at other colleges. Jim Malcolm recalled her appearance at Hope College in Holland, Michigan, in the early 1960s, where he was a professor. "It was a church-related school," said Malcolm. Arrangements for her to come had been made through Reginald Beane, whom Malcolm had contacted in New York. "She arrived at the airport. And I remember that students met her there and gave her flowers. She agreed to come only because of Beane," recalled Malcolm. That evening she performed. "Her voice wasn't what it had once been. But she had command of her effects. The only song I remember her singing was 'His Eye Is on the Sparrow.' It was a very large auditorium. Actually, a chapel that could have easily held over a thousand. She was very good-natured and sweet, but she had requirements. I can't remember what they were. But the wife of the college president made it her business to make sure Waters was comfortable in the guest house."

SURPRISINGLY, HOLLYWOOD approached her again. Briefly, a producer launched new plans for a movie about her life. Pearl Bailey hoped to play the lead. Ethel's demands, however, killed the project once more. Actress Juanita Moore recalled that when there were plans to remake *Imitation of Life*, originally the producers thought of doing it as a musical, with Ethel as the self-sacrificing mother whose daughter passes for white. Eventually, Moore played the mother in the 1959 movie version for which she received an Oscar nomination as Best Supporting Actress.

The offer, however, that Ethel considered important came from producer Jerry Wald at Twentieth Century Fox for the plum role of Dilsey in the screen adaptation of William Faulkner's *The Sound and the Fury*. Her appearance in the television version a few years earlier had been the most memorable thing about it. With Martin Ritt set to direct, producer Wald gathered A-list stars for this Technicolor presentation. Cast as the wayward Quentin was Joanne Woodward, still aglow after her Oscar win a few years earlier for *The Three Faces of Eve*. Playing Jason was another Oscar winner—for *The King and I*—Yul Brynner. British actress Margaret Leighton was cast as the lost and doomed Caddy. Sexy Southern dramas suddenly seemed in vogue. At MGM, Elizabeth Taylor and Paul Newman

had starred as Maggie and Brick in Tennessee Williams' *Cat on a Hot Tin Roof*. At Fox, Newman and Woodward had joined Orson Welles, Lee Remick, and Anthony Franciosa in *The Long Hot Summer*, directed by Martin Ritt. With all the heat and steam in *The Sound and the Fury*, some may have questioned how Ethel accepted the role. Was there God in this drama? No matter: she knew an A-list movie when she saw one, and she was signed.

Preparing for the film, she dieted and took off forty-five pounds, but she was still heavy, weighing about three hundred pounds. During a week of rehearsals, the actors were thrilled to meet her. She might give the film the "moral" and emotional gravitas it would desperately need. Though she rarely socialized publicly, she turned up one evening in late November at Hollywood's Coconut Grove to see a performance by Carol Channing, who had been an admirer of Waters since the days of *As Thousands Cheer*. Overtures were apparently made to her about a role in a Broadway-bound drama by a young African American playwright, Lorraine Hansberry, *A Raisin in the Sun*.

WHATEVER HOPES ETHEL or the rest of the cast had for *The Sound and the Fury* disappeared upon the film's release in March 1959. A role that might have been ideal for her—producer Wald felt only she could play Dilsey—was underwritten and weakly conceived. The film opened on a strong dramatic note with Waters awakening in the early morning in her cabin and immediately sensing that something is wrong in the Compson household, where she works. As she voices her concern and gives orders to her grandson, she is vivid and vibrant, totally in command of the screen. As she runs from her cabin to the "big house," she moves, despite her weight, like a girl and is rather charming and endearing. But the writers continue to have her snap out orders and assume control of the household—in a way similar to that of Hattie McDaniel's Mammy in *Gone with the Wind* during the sequence when Scarlett O'Hara's mother first arrives home in the evening. The conception was all wrong for the character Dilsey. Waters, however, anchored the opening ten minutes of the film better than any other actor, and she was fascinating to watch. It almost

looked as if *The Sound and the Fury* might be a halfway decent film. But, for the most part, it was a mangled mess that did no one's career any good. Waters' weight also did not go unnoticed. "You know what?" wrote African American columnist Hazel Washington, who had criticized Waters for this in the past. "Ethel Waters has put on so much weight that I now remember that I was looking at her rather than watching the picture, and somewhere along the line, I missed the clues and punch lines, that might have made for me, at least, an entertaining story." Moviegoers must have asked themselves what had happened; what torments had driven her to this point. Oddly enough, as before, the excess weight made her all the more compelling. She appeared monumental, towering above what should have been a tragic drama that was now reduced to tepid soap opera. Sadly, *The Sound and the Fury* was her last important feature film.

Despite the recommitment to her faith and her protestations that she was at peace, she still ate excessively and too much of the wrong things, and her health continued to decline. With hopes of reviving her career, she returned to New York. Financing had been acquired to mount a new production of yet another one-woman show, *An Evening with Ethel Waters*, which opened on April 8, 1959. Not much different from its predecessor, *At Home with Ethel Waters*, the show was also set in a living room, with Reginald Beane accompanying her as she sang one old song after another. But now she was in a small theater off-Broadway, not in a Broadway theater. "While Miss Waters packs a lot of charm and is an old hand with both a swivel of the hip and a tear-filled eye, nostalgia was not enough to sustain the evening," wrote Arthur Gelb in the *New York Times*. Gelb also characterized her rendition of "Dance Hall Hostess" as "tasteless." Scheduled to run for four weeks, *An Evening with Ethel Waters* folded after little more than one week. Its early closing must have alarmed and saddened her. It was her last important show.

Returning to the West Coast, she performed on the *Tennessee Ernie Ford Show*. A more promising project was her role in "The Big Lie" episode of the TV series *Whirlybirds*, directed by Robert Altman, but the episode proved another disappointment. She would have one more surprising success on television, but Ethel must have known her career now was almost effectively over. Her depression deepened.

What was she to do? Where was she to go? Without work, how would she live?

In January 1960, she returned to her appearances with Graham's Youth for Christ, performing religious songs to adoring crowds. Other religious groups asked her to appear. Some she accepted. Most she turned down. Her primary focus remained on Graham's rallies and revivals. Curiously, in late January, she joined such stars as Dorothy Dandridge and Ella Fitzgerald at the Coconut Grove for a tribute to Nat "King" Cole. At this glittering affair, she was a queen, surrounded by showbiz friends, many of whom had admired her from afar. That included Maria and Nat Cole. Having grown up in Chicago, the young Cole had seen her perform at the Regal in 1935.

In the early part of the year, she recorded an album of spirituals for a Christian recording company, but on May 25, she had problems breathing. Feeling that she was coming down with a cold, Ethel visited her doctor. During a routine examination, he grew alarmed and asked her to agree to an immediate full examination at a hospital. There, she was put into a wheelchair, taken to a private room, and given oxygen. Afterward, a heart specialist arrived, examined her thoroughly, and informed her she had congestive heart failure and hypertension. For eleven days, she was kept under oxygen. After twenty-three days, she was released from the hospital and taken home by ambulance.

A long road to recovery followed. 'I weighed 340 pounds when I entered the hospital," she said. "I was so big that when I traveled on the plane the only seats I would fit in were the first-class ones. And I used every bit of the safety belt." She was also diagnosed with diabetes. Under her doctor's advice, she dieted, losing some ninety-five pounds. But it was a constant effort to keep the weight down. She rested and read. For a time, she rarely left the house. In late May, Eddie Mallory, having suffered a heart attack, died at the age of fifty-four. After he and Ethel had broken up, his career continued but slowed down. In 1952, he divorced Marion Robinson and married a woman named Dollie Thomas. Leaving show business, he became a salesman for an automobile dealership in New York. The fact that there had never been any resolution between the two, no classic reunion in which they might have come to terms with each other

and all the things that had gone wrong with their relationship must have troubled her; the fact that she had outlived her "Pretty Eddie" must have saddened her.

"I found it harder and harder to handle myself," Waters said. "I was ill—too sick to work." When her physician told her she "absolutely could not live alone," she made a new living arrangement. A couple—Elwood and Donna Wilson—who were affiliated with the Crusades moved into her home with their two sons. Finally, she sold the house on Hobart, which brought her some much-needed income. Many of her possessions were sold, although there were some items she could not part with. But once she paid the IRS and cleared other debts, little was left. Priding herself on always having a small nest egg, she held onto $7,500. Still, the constant stress and fears about her financial state worsened her condition.

In December 1960, Ethel moved with the Wilsons into a home in Pasadena. She insisted on paying them something each month. Now she lived primarily on a Social Security check in the amount of $119 a month. One of the few possessions she took with her from Hobart was a portrait of her painted by an Italian artist over thirty years earlier.

In late June 1961, the news of her physical condition—and her dire financial straits—hit the public. Dave Garroway spoke of her illness. Newspapers like the *Los Angeles Times* and the *Los Angeles Mirror* rushed to interview her. For a woman who had been so private in the early part of her life, she was once again surprisingly open about her finances. Broke for the past five years, she said, she had nonetheless turned down work. "They don't like it when you tell the truth about them, so they stopped sending scripts to me and then the agents stopped trying to get work for me. They'll tell you that I 'retired,' but any retiring that was done wasn't voluntary." She added, "I had a nice home and big cars, and everything that money could buy. But, Lord, was I lonely. I used that money wrong. I tried to buy friends. I sold everything I owned to pay off that bill [to the IRS]. I sold my house, my car, and everything else. But I paid 'em. I don't owe a cent to anyone. Oh, precious, if half of the people that owed me money would pay it back, I'd be a rich woman again." Yet she had no regrets. "I've made fortunes in my day, but until now I've never found real peace and happiness. Money has never been a god to me," she told reporters.

The pictures accompanying the articles were of a white-haired, heavy yet frail-looking woman who was clearly down on her luck. Afterward there was an outpouring of sympathy. Thousands of letters were sent to her. Carl Van Vechten and Fania Marinoff sent her money. Ethel was reminded of the statement that Van Vechten had made years earlier, that she never asked anyone for anything and that she had never thanked anyone either. Now she wanted him to know how thankful she was for all he had done.

But why had she agreed to such interviews? Why had she put herself in this position that many saw as a form of public humiliation? Was it yet another role for her to play? Was it her way of dealing with her heartache by acting as if it were a performance that might end later in the evening? Were there other factors that she did not reveal to the press or perhaps even to the family she stayed with?

THE PRESS COVERAGE, however, did put her back on the radar of various producers. An offer came in for a special appearance in a musical, *Rhapsody in Rhythm*, but Ethel appeared not even to have seriously considered it. Another offer came for a role in an episode of the television series *Route 66*. "My agent called one day," she recalled, "and said, 'How you feel, doll?'" When she responded that she felt fine, "He said he'd like me to go with him the next day to an interview." *Route 66* producer Herbert Leonard and writer Leonard Freeman wanted to take a meeting with her. Somehow she summoned up her strength and put on that radiant Waters smile. "The following day we went to the office of these darling children," she said. By now, she called just about anyone younger than her, her child. She was, in turn, to be called Mom. "They took one look at me and were they shocked. I guess they were expecting an old creature, but I walked in, all sweetness and light, maybe with even a little sex appeal!" said Waters. *With even a little sex appeal.* "They told me about the play and it sounded wonderful. It was a part I could do without too much strain. And I was impressed with the fact that these children had so much respect for my beliefs."

*Route 66* focused on the experiences of two vastly different young men

as they traveled through the country in a snazzy Corvette. Tod Stiles, played by Martin Milner, came from a wealthy background, while Buz Murdock, played by George Maharis, had grown up in Hell's Kitchen. Though the two pursued adventure, they were also searching for meaning in life. With such heroes and such a theme, *Route 66* was a rather offbeat television series with heroes who, in many respects, represented the disaffiliated and disengaged members of a new generation. The series connected to the young of the early 1960s, the very same generation that would soon express itself in the hippie or counterculture movement as well as the antiwar movement. Ethel's episode was called "Good Night, Sweet Blues."

It wasn't hard to understand why this episode of *Route 66*—with its outsider heroes and its particular storyline—appealed to Ethel. It focused on the plight of a bedridden dying blues singer named Jennie whose last wish is be reunited with her former band for one last jam session. Traveling long and far to reunite the band, Tod and Buz witness the sad course of the lives of some of the men. One former band member is in jail. Another makes a living by shining shoes. Another has died, leaving behind an embittered son. Yet another has become a successful attorney. By focusing on the jazz musicians, the episode was acknowledging the importance of jazz in America's cultural history while also examining the frustrations and sacrifices of some of the nation's great musical artists. Directed by Jack Smight and written by Will Lorin, the episode had a stellar cast that included Juano Hernandez, Frederick O'Neal, actress Billie Allen, and young Bill Gunn, who had appeared with Ethel in West Berlin and *The Sound and the Fury* and who later wrote the screenplay for the film *The Landlord* and directed the film *Ganga and Hess*. Also cast were such jazz musicians as Coleman Hawkins, Roy Eldridge, and Jo Jones. Even at this point in her life, when she sang mostly with the nonjazz sounds of the Graham team, Ethel still appreciated the kind of top-notch musicians she had performed with and demanded earlier in her career. In turn, the musicians realized that she had opened the door for many, that in essence, she was the mother of them all.

Shot in about seven or eight days, *Route 66*'s various episodes were filmed on location. For "Good Night, Sweet Blues," actor George Maharis recalled, the cast and crew traveled to Pittsburgh. That gave Ethel the

opportunity to perform in the city with the Crusade. She was also able to visit Momweeze, whose health continued to deteriorate. Marharis remembered that before filming, "I didn't know a lot about Ethel Waters. The thing I knew her for was *The Member of the Wedding* on Broadway. I didn't know her as a jazz singer. I didn't know she had started that way." On the set, "I never saw any outburst," he said. "She was willing to do everything asked of her and she was very sweet. She was very cooperative and mellow. But it was difficult for her because of her weight and her age. She told me when she was a young woman, she weighed ninety-eight pounds. How is it that this frame is holding all that weight? she asked."

He remembered, "There was somebody there to assist her. She had trouble getting around. In many cases, we had to do things slowly because she couldn't move rapidly. She told me she was close to four hundred pounds. I'm pretty sure she had somebody who was helping her. She arrived with a friend. When lunch came, people would bring the food to her as opposed to going to where the rest of the cast and crew ate. But she was very sweet. You didn't mind doing things for her. She had little sweet pet names for everybody like 'child' or 'sweetheart.' And she really liked everybody on the set. She had that wonderful smile with that gap in her teeth."

Maharis believed there may have been "changes in the script once she decided to do the episode. Most of the time, because the scripts were written in California, they would fly them out to us on location. And we'd have to adjust them to the locality we were in. But I'm not sure many changes were made on location for her. The director was always open to suggestions because you only run through once. So a lot of times if there were things that she felt worked for her, she'd say it the way she felt. Everything was done in one or two takes."

"She seemed to have more of an affinity with the musicians than with the actors," said Maharis. "There was something you could tell was a connection—much much more. You could feel it. She would perk up when the musicians came around as opposed to when the actors were around. These musicians had great respect for her, and vice versa. It wasn't like people who didn't know each other having to act together. Instead it was like people who had been away from one another for a long time."

In one sequence, Ethel had to sing. "Her singing was almost like her speaking voice," said Maharis. "I thought to myself she's not really singing. She's talking. It wasn't like sustained singing. It wasn't a voice like Nancy Wilson. She was half-speaking, half-singing. She was talking with a little hum in her voice. I remember when she was doing it, I thought that was almost conversational." That was perhaps his fondest memory of the episode. "When she was singing, for me it was like looking in on a portion of her life that I knew nothing about. So when she sang, I could understand what she was communicating. It was like a walk back in history. A walk into a generation I had no communication with. That was really special for me to experience."

Still, Ethel had problems with her voice. Marni Nixon, then a young singer who later acquired a large following after it was revealed that she dubbed the singing voices of such stars as Deborah Kerr and Audrey Hepburn in the respective films *The King and I* and *My Fair Lady*, recalled that she was hired to dub portions of Waters' singing voice—in a new version of Waters' old hit "I'm Coming, Virginia." It was for a sequence in the drama in which one of Ethel's character's old records is heard playing.

"She was supposed to be singing [on the recording]," recalled Nixon. "I had to imitate her recording, and for some reason, they couldn't just play the recording and she couldn't mouth to her previous recording. There was some legal reason why they couldn't do it."

In Los Angeles, "They called me in because she could no longer sing it the way she sang it because her voice was much lower."

Nixon recalled that she probably knew of the session about "a week beforehand. And then I tried to get hold of her. I don't think I had that recording and they wanted me to imitate her phrasing and everything. They didn't tell me that she actually was going to be there, which was really supposed to be a help to me, and probably it was. But she couldn't demonstrate to me how it should be different. She was probably thinking, 'Oh, what's this little WASP doing—trying to be Black.' I don't know what she was thinking. But she certainly didn't reveal that. She was such a gracious lady. I was struggling so much to do it. I just felt so embarrassed."

And what about Ethel's notorious temperament and impatience? Fortunately, said Nixon, "I didn't remember the information that she was

supposed to have any temperament. Nobody had told me that, to warn me or anything. And she certainly didn't reveal it." That day an older, wearier Ethel simply tried to be helpful. No doubt she was troubled that her voice was no longer the instrument it had once been. "She'd sort of nod her head during rehearsal or would stop. And I would say, 'Is this better?' 'Oh, yeah.' That's all it was. I was just impressed."

OBVIOUSLY, THERE HAD BEEN WARM, tender moments for her during the filming; this clearly showed in the finished product, which aired on October 6, 1961. When she first appears, she has fallen ill in her car. Tod and Buz offer her help. "Are you in pain?" they ask. "It's gone away," Ethel's Jennie replies after taking her medicine. "How about you? Yours gone?" she asks perceptively. Upon later learning that the young men are jazz aficionados, Waters delivers a line she no doubt deemed perfect for her: "Could be the good Lord had in mind for us to meet today." Once one of the young men says, "We're sort of looking for a place where we fit," Ethel explains that she knows what they mean. After the reunion of the band for their last jam session, Ethel's Jennie, on her deathbed, says: "Thanks, Lord. . . . God bless you, Buz. And you too, Tod. And thank you, dear Lord." Such dialogue had to have been written in the initial draft of the script to play on Ethel's public image—and her intense beliefs. After all, this was the woman who had first turned down *The Member of the Wedding* because there was no God in the play. Still, perhaps only Ethel Waters could have delivered such lines with a conviction and sweetly sorrowful warmth that made the dialogue utterly convincing and moving. Ethel walked off with an Emmy nomination for Outstanding Single Performance by a Lead Actress. "It was a heart-breaker," said Hedda Hopper, "and should have won her an Emmy." The award went to Julie Harris for *Victoria Regina* on *Hallmark Hall of Fame*. Afterward Alan J. Pakula and Robert Mulligan reportedly wanted Ethel for a role in *To Kill a Mockingbird*, but for whatever reasons, she did not appear in the film.

\* \* \*

HER $119 MONTHLY Social Security check could be stretched only so far. To earn money, Ethel began singing at various churches, where she was paid $50 as an honorarium and sometimes given an additional "love offering." She always paid $25 to the pianist who accompanied her. At such events, she also sold the religious album she had recorded. She charged $3; of that amount, she had paid $1.89 for each copy, which meant she profited $1.11 on each album she sold. Not like the big bucks days. But the appearances and sales brought in something. Her work with the Crusades continued. But all this took a toll on her fragile health. In March 1962, she collapsed while performing at a Youth for Christ event and spent time afterward recuperating.

Yet while many looked on sympathetically at the great Ethel Waters, so pathetically down on her luck, and while some might have found satisfaction in being able to pity her, there was another Ethel with another life that most were unaware of.

# Life Away from the Team

A S MUCH AS ETHEL had her bouts of loneliness, there were occasions when she was anything but lonely. Not long after moving to Pasadena, she had become friendly with a younger woman named Joan Croomes. Originally from Tulsa, Oklahoma, Croomes had settled in Los Angeles, married, and performed mainly as a dancer in films. Appearing in *Cabin in the Sky*, she had seen Ethel's treatment of Lena Horne. Years later, their paths crossed again when Croomes worked in a television movie starring Ethel. Working as Ethel's stand-in was a feisty veteran named May Johnson. On the set, some found it hard to believe Johnson was the stand-in for Ethel because the women looked nothing alike. Johnson was "slim trim." One day Johnson pulled Joan Croomes aside and asked if she would be willing to replace her as Ethel's stand-in. She wanted to get off the production. "I have something else, and I'm sick of this bitch," Johnson told Croomes. But Croomes was also slender. "Honey, a shadow would do," Johnson said. "The studio doesn't care. They want to get her out of here." "So I took the job," Croomes recalled. When Ethel later saw her on the set, she asked Croomes what she was doing there. "Well, I think I'm here to work." "Well, then, what are you going to do?" Ethel asked her. Once Croomes explained that she would be her new stand-in, Ethel told the director, "Here's another girl. That other girl left."

Happy to have another Black woman working on the picture and perhaps relieved that Johnson was no longer around, she confided in

Croomes. Frankly, she didn't "like the way they did my hair. They got a lot of spray on it. Would you wash my hair for me?" Surprised by Waters' request, Croomes said she'd try. "So I went in and washed her hair and put some rinse on it. She was very pleased about that." "Where do you live?" Ethel asked her. Once she heard the address, she said, "Well, I've got to stop by your place." True to her word, Ethel arrived at Croomes' home in Los Angeles. Looking around, Ethel told her, "That entry space . . . a nice portrait of me would look nice there." Croomes couldn't understand what Ethel meant. "She kept talking," said Croomes. "I thought the woman was mental."

"Do you have a room to rent?" Ethel asked. "Because I live in Pasadena. And I need something closer." As it turned out, Ethel wanted a place right in Los Angeles so it would be easier to get back and forth to the studios for work that might turn up. As Croomes later realized, she also seemed to want some breathing space, to spend time on her own and possibly away from the family she lived with. "I'm selling my house on Sugar Hill," she told Croomes. "And I'm getting rid of a lot of things. My painting would look good right there as you enter the door."

"She wanted her painting put in the entry hall. And then she looked at the bottom of the stairway." Waters told Croomes: "I have a bust that would look real good on the top level of the stairway. I want you to come to my house." Once Croomes arrived at the home on Hobart, Ethel pointed to a beautiful chandelier. "Like that?" she asked. "You can have that. Girl, what else in here do you need? I got to get out of this place." Ethel had also given away other items from her home. In some respects, so Croomes believed, she had been taken advantage of. One actor friend of Ethel's had "cleaned it out," said Croomes.

Soon afterward—as Croomes was in the process of converting part of her home into apartments to be rented out—Ethel became a tenant, "taking the best apartment" on the second floor. "Upstairs I had my quarters," said Croomes. Those quarters became Ethel's. "I had two bedrooms, two baths, and I had a sun deck in the back. She later covered it up and made a library out of it. A nice living room. A kitchen. And a small dinette." That marked the beginning of a friendship between the two women.

Croomes became privy to a side of Ethel that generally was not on public view.

People were often in and out of the place. "I gave her a party while she was living there," said Croomes. "It was beautiful." No matter her circumstances, Ethel still lived like a star. A woman came regularly to clean her apartment, but Ethel proved demanding. "She's killing me," the woman told Croomes. Ethel insisted that she "move the furniture around everything she cleaned. Clean. Clean. Clean." Finally, the woman said she had to quit. Contrary to the grandmotherly housedresses that she wore when interviewed by the press, she could still be stylish. "Oh, she was a dresser. She had a lady that came to the house and measured her garments. She didn't care what they cost. Measured her garments and made them for her," said Croomes. "I thought she was pretty even though she was fat. . . . She took care of her skin. Sometimes I had to help her into the bathtub. And stuff like that. I did all of those things for her. I think that's why I have no back now. . . . I was pretty young. I could help her. I didn't feel any pain. . . . Her face was still pretty. And she had magnificent hair. She did let her hair go white. I took care of her hair after she moved here. But she had bought a piece of false hair and put it up here [on the top of her head], and she wore a scarf all the time. And she stopped having me shampoo her hair. And so one day I saw her, and her hair had gotten bald right in the front. So she had a piece that she stuck on there. But the idea was long, long hair, pretty long hair."

Sometimes Ethel took pleasure in preparing meals. "She could cook. Sometimes she'd cook white beans. Oh, boy, could she cook that. I could always eat some of that," said Croomes. "The best memories I have of her is when she would cook something and you enjoyed it," recalled Croomes. "Oh, girl, I can cook, can't I?" Ethel would say. Other times she enjoyed taking Croomes to her favorite buffet-style restaurant in Pasadena, where the two women would chat and laugh. "The place was called the Beetle," Croomes recalled. "They had good fish out there. I never cared that much for fish. But, honey, she'd get it. I'd get it. She'd sit down and I'd bring her hers. I'd get in the line. And she'd say, 'Get some more of that. Get you some more of it. Get some more of that.' I didn't want it. And then when

I started eating, I'd kind of push the plate back. 'Girl, eat all that food. You need that food. You and your skinny self.'" Usually, Ethel urged her, "Loosen up your belt, girl. . . . You can't leave this food on your plate. Eat all this food." "She wanted me to eat as much as she did. I couldn't hold it," said Croomes.

Still, Croomes cherished the times she spent with Ethel. The self-deprecating humor, the witty asides, the shrewd observations on people and places—all the old hallmarks of Ethel's personality had not been dimmed or diminished by the years or her poor health. She still liked a good hearty laugh. "Her facial appearance was always beautiful. And when she smiled, you had to smile with her. She had it going on. She had a personality like nobody else, really. She was *the* Ethel Waters. Really."

In time, Ethel confided details about her earlier life and her tangled relationships with family members. Even now, "She sent money every week to her sister Genevieve and her mother. 'Cause her mother was kind of senile. And she paid the rent. She sent the rent religiously every month. And she sent money for food. And her lazy sister, as she called her, 'didn't do nothing.'" Touchingly, Croomes saw that Ethel never deserted her mother, never stopped caring for her, never stopped loving her. As for other family members, "She didn't like them. She didn't really like her relatives. Yet she took care of them. And she would fuss about it. But she still sent money. She said her sister was a slut." It's doubtful that she ever spoke in such an open way about her family with members of the Graham team. Perhaps Ethel's easy rapport with Croomes grew partly out of the fact that Croomes was African American, someone with the same cultural bearings and outlooks as herself. With Croomes, there was never anything she had to explain. They spoke the same language, had the same cultural references. Much as she had done with Floretta Howard and her Black female friends in the past, she often began a sentence with "Girl, you better . . ." or "Girl, you gotta hear this . . ."

It's also doubtful that she ever spoke openly with members of the Graham team about another matter. Waters was candid—and rather nonchalant—about her sexuality in general. "She was a lesbian," said Croomes. "She told me that she was the best that ever did it. She told me that." Once she showed Croomes a picture of herself "dressed in men's clothes,"

said Croomes. "She had on pants and a jacket, and she had short hair." "This was when I was a boy," said Ethel. Happily married, Croomes sometimes wondered if Ethel had an interest in her. "She used to sit and watch me when I took a bath. I was scared of her sometimes. Not really. She was a big woman." Clearly, Ethel had no guilt or hang-ups about her sexuality. Nor did it conflict with her religious beliefs. That, as far as she was concerned, was who she was. Her Lord understood.

Yet Ethel, as always, could never be put fully into a sexual category. With Croomes, she also spoke of the man she had loved so intensely, Pretty Eddie. Even now, the thought of him could make her "shiver." "She liked him to her dying day," said Croomes. "Ethel said he was the only man she ever loved." While she stayed in the apartment at Croomes' home, she became very friendly with a young white man, then in his thirties. Croomes questioned the man's motives, but Ethel didn't. "I think that was another reason she . . . moved to my house, so she could have Tom there," said Croomes. But how did she keep that hidden from the Billy Graham people? "Easy," said Croomes. "He knew when to come. She had two phone numbers. And he had all kinds of stuff. And they would talk. And there comes Tom maybe in the middle of the night sometime. But she was secure up here because nobody entered unless she allowed them to. So she and Tom could be very private when they wanted to be. I never used my key. I never would go up unless I called her because I don't do that." But Ethel did not seem to care what anyone thought—at least not in the Croomes household.

Afterward when the press chronicled Ethel's financial woes, Croomes felt they got it all wrong. "She was never broke. Never a day in her life was she broke," said Croomes. "She sold some property in New York." Perhaps that was the "nest egg" Ethel referred to when speaking to reporters. "She had money of her own," said Croomes. "When she would go on those Crusades trip . . . honey, when she'd get back . . . sometimes she'd stay a week at a time . . . but when she got back, there was money for everybody. She was generous. But Ethel was never broke. Ethel could sell one piece of jewelry and get quite some money. She never sold any of it."

\*   \*   \*

IN THE SPRING OF 1962, Ethel flew to Chicago for a Crusade and then on to Philadelphia, where she was honored at the Philadelphia Arts Festival. She agreed to make the trip, it seemed, primarily because the Arts Festival paid her travel expenses. Thus she had a chance to visit her ailing mother. Her mental state frightened Ethel. Momweeze suffered even more from disorientation and possible dementia. "They had to keep her mother kind of isolated . . . not isolated but in a second-story building," said Croomes, "because she sang long and loud, and it would disturb other people."

Leaving Philadelphia, she stopped in New York on a Saturday where she spent time with Reggie Beane and all of her godchildren, more than twelve of the kids she had cared for so many years ago. By now, she and Beane had patched up their differences. The next day she performed at Soldier Field for Graham, and then it was off to Dallas. Hard as the traveling was on her—there were still problems getting into and out of seats on airplanes, still problems maneuvering her way around airports, usually in wheelchairs, still days when she had no energy—she kept it up. For the Crusades, her traveling expenses were taken care of, and she also received what she called "a small fee." But the question on the minds of some must have been if she was subtly pressured into these engagements. Apparently, she remained a drawing power at the Crusades. People still loved seeing her, still were moved by her rendition of "His Eye Is on the Sparrow." When she traveled to Nassau, in the Bahamas, for a Crusade, over nine thousand people attended the service. But with all said and done, surely someone should have encouraged her to rest more—and perhaps also make financial arrangements so that she received not "a small fee" but a more substantial one. For her part, Ethel was at least momentarily invigorated by the Crusades. The huge crowds, the applause, the enthusiasm. In time, she had a standard way of greeting the audiences by walking onto the stage, looking out at the sea of faces, and energetically saying, "Hi!" She also wrote the song "Partners with God" with Eddy Stuart. No matter what, she was still an entertainer, and nowhere else would she now be able to sing for thousands in huge arenas.

In October 1962, she opened at a Detroit nightclub. No drinking or smoking were permitted. Patrons just listened to Ethel perform sacred

music and religious monologues. Not very exciting nightclub fare. Her birthday was spent at another Crusade in Texas. On November 8, she left for Charlotte, North Carolina, followed by a return to Philadelphia in early December; this gave her another chance to spend time with her mother. She also recorded an album of mostly sacred music, *Ethel Waters Reminisces.*

Her performances at churches for a $50 fee continued. In February 1963, she appeared on Steve Allen's television program and later performed on Ed Sullivan's anniversary show. Then she was signed for another television movie, the "Go Down Moses" episode of the series *Great Adventure*, in which she worked with Ruby Dee, Ossie Davis, and Brock Peters. A dramatization of Harriet Tubman's experiences on the Underground Railroad as she led some three hundred slaves to freedom, *Go Down Moses* starred Dee as Tubman, a character Ethel must have yearned to play. Instead she was cast as Tubman's mother.

DEVASTATING NEWS CAME from her sister in Philadelphia on September 24. Their mother had been rushed to the hospital. Now Ethel was being asked to give her consent for the amputation of one of her mother's legs. Ethel agreed to the operation, and the next day Genevieve called again to say she had just left the hospital. The operation had been performed and their mother was still under sedation. Another call came on September 26. "Well, she's gone," said Genevieve. Ethel was in a state of shock. Her mother's death had been the last thing she had expected. No doubt, she held Genevieve responsible for not having informed her earlier that her mother's leg had become infected. Now she had to pay for her mother's funeral. Fortunately, her salary for "Go Down Moses" had added to her nest egg. There was also money from her various church recitals.

"She took it very badly," said Croomes. Ethel debated whether or not she should attend the funeral. "Should I go? Should I stay?" she asked. Finally, she told Croomes, "Well, I just sent $2,000 back there. That'll take care of everything. I can't make it."

In some respects, Ethel was thankful the death had occurred. Never had she wanted Momweeze to outlive her. Who then would have cared

for her mother? Then, too, had her mother recovered from the operation, she might have suffered and been unable to accept the amputation. Her mother's funeral was on October 2. The next day Ethel performed at one of the churches. Her belief was that God had worked everything out in the best way. Yet nothing could alleviate her sorrow.

Throughout her entire life, there had been but two people she had loved without holding back, her grandmother Sally and her mother, Louise. Telling their stories in some way or another had been at the heart of her greatest performances, as Hagar and Berenice, and to another extent, Dicey in *Pinky*. She had not been able to tell their stories in her music. But acting had enabled her to reach deep inside herself and lift out the pain and torment and oddly triumphant moments of otherwise very ordinary lives.

Her grief was long and unrelenting. On many days, she asked Joan Croomes to prepare a dish she apparently had loved as a child. "She liked potatoes and onions cooked together," said Croomes. Waters would walk into Croomes' kitchen and say, "I smell those potatoes, girl. You got them ready yet?" She'd also comment, "This is kind of a funny way to grieve, isn't it? But I just don't know why, I just want potatoes and onions." She'd turn sad. "Maybe I should have gone." Said Croomes: "I never want to see [potatoes and onions] anymore because [that's how] she grieved her mother. She didn't let go."

A few days after Momweeze's burial, word came that Earl Dancer had died alone at his home in Elsinore, California.

SHE WAS PROBABLY NEVER AGAIN the same person. Perhaps much of her reason for living was now gone. Often she spoke of being ready for her Savior to take her. At times, she couldn't understand why he had not, but she said she trusted his wisdom and would be ready for death whenever the time came.

On she went, an embattled old matriarch now, white-haired and weary yet unexpectedly transcendently beautiful.

Again talk circulated of filming her life story with Diahann Carroll in the lead, but no such film went into production. Producers from the Pasadena Playhouse asked her to star in a February 1964 remounting of

*The Member of the Wedding*. Physically, she was hardly up to it, but she agreed, again for financial reasons and also the chance to perform for that audience out there. In the eight-hundred-seat theater, she played to capacity audiences. She had kept to her diet. Though she was obviously slower now and suffered from shortness of breath, she managed to give a powerful performance. Audiences loved her. Then during a performance on a Friday night in March, she suffered a slight heart attack. Apparently, she knew exactly what had happened as she struggled to regain her composure. A fire department rescue team, which had been called to the theater, stood in the wings ready to administer oxygen, if needed. Miraculously, she completed her performance that evening! The audience seemed unaware of any problem. Though she was urged to take it easy, the very next day—a Saturday—she gave two more performances, at the matinee and in the evening.

"You know I've had a bad heart for many years now. This was just another slight attack," she told the press. "I had to finish the performance. Those people came to see me. They didn't know how I felt."

"I don't believe I'll ever think old. I'll always be able to laugh. Negroes know how to laugh. We should be proud of ourselves as Negroes. We know how to enjoy life. I'm not sorry I'm a Negress," she told another writer. "They tell me that lots of my early records are collectors' items now. No, I don't have many of them. I lost my voice, you know. All I sing now is hymns. I sing the Lord's songs, but He overlooks my voice and lets me do it."

During the run at the Pasadena Playhouse, Algretta arrived in Los Angeles for a visit. "And she came to the show. And after the show Ethel was talking about some property that she had," said Croomes. "That was as much as I ever saw of her . . . when she wanted something. Ethel got notes and stuff [from Algretta]. Or maybe. She never even talked about that woman."

On September 17 she was in New York as the guest of honor for an Ethel Waters Day at the World's Fair. As she looked out at the crowd, her smile was as broad and warm as ever, and somehow she managed to give the appearance of being in good spirits. Shortly afterward, she was back on the West Coast.

Not long afterward, she learned that Carl Van Vechten had died, on December 21, 1964. She wrote Fania immediately.

IN APRIL 1965 she was a special guest at the Oscar presentations, along with such other "old-timers" as Buster Keaton, Pola Negri, Mary Astor, and Francis X. Bushman. At the post-Oscar party at the Hilton ballroom, she sat at a table with Gregory Peck and others. Columnist Hedda Hopper stopped by to say hello, a sure sign that Ethel still commanded respect from the industry's A-listers. Of course, Hopper and Ethel had something in common. Both were fervent in their feelings about the evils of communism. A few months later, Ethel turned up with Dale Evans, Don Grady, and others at a Memorial Day service at the Pasadena Rose Bowl to honor those "Christians who have been martyred and murdered by Communists."

None of Ethel's old friends could figure out what her anti-communism sprang from. Nor could anyone understand some of her feelings about the civil rights movement. Rather than joining the fight for rights, she seemed to dismiss or ignore some of the very blatant racism she had endured throughout her career. An interviewer asked, "In your long career, Miss Waters, you must have been refused admission to certain restaurants because of your . . . er . . . race. Have you suffered because of it?" She replied, "Land, no, Honey? I can't stand white cooking!" Perhaps she simply wanted to avoid any controversy. Of course, her comment was a kind of putdown, suggesting that she had no desire to socially or culturally integrate into a system that didn't offer her much. But she still seemed removed from the contemporary issues, struggles, and attitudes of Black America. In fact, she abhorred the use of the word "Black" and always used the term "colored" or "Negro." In that respect, she was like some others of her generation who had grown up at a time when "Black" was the worst thing you could call anyone of color.

Other times she applauded social and racial progress. "The improvement in the Negro community is tremendous," she said when she returned to Philadelphia in November for an appearance on *The Mike Douglas Show.* "When I was a girl we had almost nothing. But now I see Negroes living in all sections of the city and working in stores of the city and

banks—why, it was unheard of." She also took the opportunity to express her feelings about her life in show business. "I have met some of the finest people," she said.

WHENEVER AN "ACCEPTABLE" television movie came her way—even though her criterion for what made certain parts acceptable must have puzzled many—Ethel leapt at the roles and appeared happy to be back in front of the cameras with showbiz folk. TV viewers got to see her in the *Vacation Playhouse* drama "You're Only Young Twice," a pilot for a projected series. They also saw her in Jello-O commercials at a time when Blacks were rarely used to pitch products. Advertisers believed their mainstream customers would respond negatively to products that African Americans promoted. But in 1968 Young and Rubicam thought consumers felt differently about Waters. Bill Cosby would be another Black celebrity with whom the advertising agencies felt comfortable. He too would do Jell-O commercials. But in many respects, Ethel broke new ground. "We weren't even surprised when they turned out to be some of the highest-scoring commercials we ever made," said a representative from Young and Rubicam. "What did surprise us a little were all the fan letters Miss Waters got. But, after all, star quality is star quality—even in a commercial."

Often Joan Croomes drove Ethel to her appointments and engagements. On such occasions, Ethel was the Ethel of old, not the grandmotherly figure of the Crusades but a high-flung diva. When she was scheduled to appear on TV's *Hollywood Palace* with some new reigning stars of the late 1960s, Diana Ross and the Supremes as well as Stevie Wonder, she told Croomes, "Bring me my jewelry. . . . I'll show them bitches." "She had all this jewelry," said Croomes. "Out of it, she took this diamond watch. And it was something to be had, baby. And then she had on several of her rings. And she had the diamond earrings and all." She had also carefully selected her wardrobe. "I'll show them bitches how to dress." Said Croomes: "I tell you, honey, when Miss Ethel Waters walked in, everybody acknowledged her."

On the broadcast, a rather subdued Diana Ross gave Waters a proper

laudatory introduction: "Ladies and gentlemen. If I seem to take special pride in presenting our next guest, it's because I really am honored to be appearing with her on *Hollywood Palace* tonight. Miss Ethel Waters and I never met until this week. And for me, this is a show business legend come to life. Ladies and gentlemen, Miss Ethel Waters."

Ross then joined Ethel, who was seated on a bench. They were a physical and stylistic contrast in eras and perspectives. Ross was decked out in a mini with a curly hairdo, not really an Afro but not one of the lacquered wigs that she wore during the rise of the Supremes to stardom. Ethel wore a grayish print dress with her white hair pulled back and held in place by a sparkly wide headband—and with a ponytail that hung down her back. The two stars chatted, just small talk to lead into their duet together. Throughout, Ross was surprisingly restrained without the energetic extroversion that was one of her trademarks. As she hugged and kissed Ross, Ethel was pure pro. She was like warm honey, sweet and engaging, supremely sincere, presenting the perfect image of a well-traveled matriarch without any competitive feelings for the new stars. When the slender Ross referred to her skinniness, Ethel informed her of the days when she too was slim—and was called Sweet Mama Stringbean. Actually, Ethel said "Sweet Mama Stringbeans."

"I was tall and skinny and was shaped like a stringbean. Now I guess I'm known and better known and shaped like a brussel sprout." Ethel suggested that Ross come to her house so she could fix her a soul food meal—black-eyed peas and rice, honeyed yams, collard greens, the whole works. That led to Ethel, joined by Ross, singing "Bread and Gravy." It was a very nice television moment. Immediately afterward, Ethel, following another intro by Ross, performed "Supper Time" with little more than a small table and chair to serve as a setting for the number. Though at one point it looked as if she might be too dramatic, ultimately her brilliant theatricality made the song powerful and emotionally affecting for the studio audience.

Ross must have been impressed with Waters, perhaps even in awe of her and a bit guarded because of stories about the Waters temper. In the next decade on one of her television specials, she would pay tribute to great Black goddesses who had preceded her: one was Josephine Baker, another was Ethel Waters.

Another television appearance with yet another new era star was on *The Barbara McNair Show*. "May I call you Ethel?" McNair asked. "You certainly may, you little tiny thing, you," replied Ethel. Keenly aware of the image she wanted to project, she had deflected any comments viewers might have about her weight by making fun of it herself. She also clearly wanted to let viewers know she was a woman of great faith. "I know you have been doing a lot of work with Mr. Billy Graham," McNair said. "It's a labor of love with my precious children, and they just humor me because I don't do nothing," said Ethel, "but . . . I love being around them, and they give me an opportunity to talk about my precious savior." Then Ethel commented on McNair's good looks. She was considered a beauty in the tradition of Lena Horne and Dorothy Dandridge. "But I want to say something about you," said Ethel. "You know I've been looking at you for a long time, and I want to say in front of this viewing audience and the children here in the studio. You're a very sweet girl, and the beauty that I see in you isn't only surface. It's from within, and it's lovely. I'm glad you have it." Much like Diana Ross, McNair did not seem to be fully herself as she sat with Ethel. It would be hard to say if Ethel had had one of her outbursts, which might have inhibited McNair. Regardless, the two women performed a duet of "Holy unto the Lord." McNair was the principal singer; Ethel mostly provided the chorus, her voice now very husky and deep. There was not much of a voice left. Still, she carried off the duet and provided it with a structure and an emotional depth. Then—standing alone, she said to the audience, "I got to say 'Hi'"—she performed a solo of "Partners with God." Again the voice was no longer a dazzling instrument. But she understood how to rhythmically communicate the religious meaning of the song.

Such programs as *The Hollywood Palace* and *The Barbara McNair Show* made Ethel aware that now she was a matriarch for yet another new generation. Already she had seen several new eras of stars: from the days when she held onto her turf against Billie Holiday, Ivie Anderson, and Ella Fitzgerald; to the early 1940s, when she appeared with Katherine Dunham and Lena Horne; to the Eisenhower era of Dorothy Dandridge and Eartha Kitt in the clubs and actors like Harry Belafonte, Ruby Dee, Ossie Davis, and James Edwards, with whom she appeared in television

or films. Now she was working with stars of the politically restless 1960s. For her, the stars of this new era could never be real rivals. She was too confident, too weathered, and perhaps too emotionally battered to feel she had to stake her claim. If need be, she would always speak her mind. That would never change. But no one could really take anything from her, and she could appear to be genuinely gracious. She was now the queen mother of them all.

Another TV performance—when she sang and did not act—was on *The Pearl Bailey Show*. Clearly, Bailey still idolized her.

"I THINK SHE WAS HAPPY when I was around," said Croomes. "Sometimes when I was driving her, she'd sing. She'd say, 'Now pick up the chorus.' I'd say, 'I can't sing.' 'If you can talk, you can sing.' That's what she said. I think the happiest thing I can see is her singing."

Other times for a woman in failing health Ethel proved surprisingly resilient. "They had a storm one night. We had to drive from a theater—by the sea—back to where we lived," Croomes recalled. "The rain was blowing and I couldn't see, and then something got wet and I couldn't turn the wheel or something. She took that wheel, honey, and leaned up and drove that [car]. She got us there. I gave up. I said, 'I got to pull to the side.' And I mean she got us there. But she was a brave woman, and she never gave up on anybody or anything."

She also still exhibited the discipline that had been so important during the heyday of her career. "If she set out to do something, she was going to do that. Like when she went on this diet," said Croomes. With her diabetes and high blood pressure, Ethel had been instructed again by her physician to lose weight. "It was a hard thing for her. But she stayed with it. She stayed with it till she made it through," Croomes recalled. "She had to eat special foods and everything. I made the meals for her. But the only thing she would renege on was if I fried some chicken. Boy, she'd have her friends come over. 'Take some of this chicken,' she says. 'It's the best chicken in the world.'"

"She had a lot of people that came by to see her. But somehow I remember more people coming to Pasadena than my house to see her. She

had a lot of company up there," said Croomes. "She had a baby grand piano sitting in my living room. . . . [It was later moved out of my house] . . . But it looked good in there. And she would sing and rehearse her music there. And I enjoyed that. I enjoyed hearing her sing. And I enjoyed her when her friends would come over. She was happy. She liked people. She really liked people. When they were gone, [she'd] probably say they were 'a bunch of bitches.'" Croomes also noted that most who visited were white. But while the crowd was around, Ethel clearly enjoyed them. "I used to drive her to Pasadena. I went back and forth. She went other places too. We went to Eartha Kitt's one night for dinner. Juanita Moore was there. Ethel wanted collard greens, and Eartha Kitt cooked the greens for her. I went to San Diego with her. We had to drive to the theater. I remember that Joel Fluellen did a lot of things for Ethel. He tried to write her story. We went a lot of places."

With Croomes, she could also be protective and motherly. "But, girl, you shouldn't have done that," she might admonish Croomes about something of which she had not approved. "Once I was leaving with a friend of mine . . . going out to have a good time. She was upstairs. And she came out. 'Joan, Joan, you come back here.' And I said, 'I don't have to. You don't own me.' Oh, she was mad at me. And I went on with my friend. So when she did see me, she was angry. But she wasn't really that angry. . . . I think when she loved you, she sincerely loved you. With all your faults, she would love you still. She always still wanted to be friends."

But eventually tension flared up between Ethel and Croomes because of the young man with whom Waters was still involved. Croomes felt he took advantage of Waters. "I just couldn't stand it." He also was untrustworthy, and she didn't want him in her home. When Croomes discovered that jewelry and other items were missing from her home, she was convinced that he had taken them. But Ethel refused to believe it. "She fell in love with this young man. Or she thought she was in love with him," said Croomes. Croomes found him crude and disrespectful to Ethel, but Ethel ignored his dishonesty and the way he treated her. "It's what you would call elderly abuse. And she didn't know that. That's my saddest moment when I saw how he abused this elderly, gray-haired old lady who had nothing but good. And when I saw he had complete control over her.

And I kept his name and number for a long time because I wanted to turn him in." So enamored was Ethel that she became rather reckless and indiscreet. Croomes knew her neighbors were clearly aware that Ethel's relationship with him was a sexual one. She was also convinced that Ethel had used some of her savings to help him purchase a home—and also to help with the purchase of the home in Pasadena in which she lived with the couple from the Graham organization.

Croomes' disapproval of the young man eventually led Ethel to leave the apartment. "She didn't leave right then," said Croomes. "She started going on tour more. So then when she'd come home, she'd call me on the phone. She had a buzzer on the phone. She could buzz me downstairs. I wouldn't pick it up because I just didn't want to do it anymore. . . . He was still coming around. I didn't want to do it anymore. So I just said, 'That's it.' And I never would answer the phone. So she wrote me a note. 'Well, you're not answering your phone. So I guess you don't want to be bothered with me.' It made me cry. That's the saddest thing. She moved. When she first left me—he moved [her things out]."

Ethel also moved out of the home in Pasadena. "Now the people she lived with—the Wilsons—they moved somewhere. They sold the house." Croomes had long questioned the intentions of the couple, especially when Ethel "found out that Billy Graham was sending them a check every month for her." Said Croomes: "And I mean it wasn't no little money check. She showed it to me. I think it was a thousand and something a month that they were sending to the Wilsons. And she didn't know it. And she was giving them money, too, thinking that she had to pay them."

# On Her Own Again

A T THE START OF THE 1970S, Ethel lived on her own on the fifteenth floor of the high-rise Bunker Hill Towers in downtown Los Angeles. There, she had privacy. Her cozy apartment was filled with furniture and possessions from her glory days—a large Victorian sofa, plush armchairs, her baby grand piano, a glass-top coffee table. On the walls was photo after photo of—who else—Ethel. No matter how much her life had changed, she was still a great star who enjoyed seeing reflections of herself. From her living room window she could look down on the Los Angeles Music Center. Not a bad view at all. In all likelihood, the young man was in and out of the apartment, so Croomes believed, but without the knowledge of others—and not for very long. Looking in on Ethel was a young woman named Twila Knaack. Previously a member of the Graham team who had left to study interior design, she was called back to do temporary work for the organization. At Graham's 1970 Crusade at New York's Shea Stadium, she and Ethel had run into each other. Now Knaack visited on Saturdays; she helped Ethel with her mail, did some of her shopping, and took her on various errands. Knaack also recalled that she "wasn't penniless. The Billy Graham Association faithfully supported her, and she had tucked away royalty checks in savings accounts. She used to get so upset at reports that she was broke."

Though she performed at the Crusades—and despite her comment that her religious work and show business could no longer mix—she still

was unable to leave show business behind. Attending parties and gatherings with showbiz friends, she was occasionally spotted at nightclubs too. At such times, the old playful Ethel surfaced. At one club, she was introduced as "Mrs. Ethel Waters." Ethel immediately stood up and shouted, "Stop right there. It's Miss, not Mrs. . . . Don't ruin my chances."

She also embarked on some ambitious projects. In the "Mama Cooper" episode of the television series *Daniel Boone*, she played the title role, that of the long-lost mother of a slave played by Roosevelt Grier. Routine as the drama was, her performance once again was warm and engaging. Shortly afterward, she traveled to Chicago for a major six-week revival of *The Member of the Wedding* at the Ivanhoe Theatre. Opening on February 19, 1970, the revived play was now twenty years old, and after her heart attack while playing Berenice in Pasadena, many wondered if she had the stamina to perform the role again. So fatigued and lethargic was she that she did very little else during the run of the drama. Usually, she rested in her hotel room until it was time to head to the theater. But the play provided a decent salary, which she could use to pay bills and also add to her nest egg. She knew that inevitably the day might come when she wouldn't be able to work at all and would need something other than her monthly Social Security check to live on. Her performance won the city's Jeff Award for Best Visiting Star. When there was an offer to take the revival elsewhere, however, she turned it down.

RETURNING TO LOS ANGELES, Ethel signed a contract with Harper and Row to write a new book. Working with the writers Eugenia Price and Joyce Blackburn, she set out to complete the story of her life, which would be a record of her recommitment to Christ. Perhaps it might bring the kind of royalties she earned with *His Eye Is on the Sparrow*. Published in 1972, the book, called *To Me It's Wonderful*, was written with sincerity and honesty. She revealed her actual age and was open about her financial problems. But *To Me It's Wonderful* lacked the dramatic urgency of her earlier work. Once again, she chose not to discuss certain aspects of her life. She understood she had a new image—a new identity as a very devout woman—to protect.

* * *

MORE AND MORE, she was confined to her apartment at the Bunker Hill Towers, venturing forth now only for special occasions. In January 1971, she accepted an invitation by President Richard Nixon to sing at a White House morning prayer service. She had known Nixon since his days as a California congressman—and at one time a fervent anti-communist. He had waged a fierce, ugly campaign against Helen Gahagan Douglas for his seat in Congress that liberals never forgot. Admiring his battle against communism, she had visited the Nixon home in California and knew his two daughters, Julie and Tricia. She also had met his mother at the Quaker meeting place that Mrs. Nixon attended. Both Richard and Pat Nixon appeared to genuinely like Ethel, who once again went into her mothering mode, sweet-talking them as well as everyone else in sight. To her, Nixon was her "Dickie Boy." His wife, Patricia Nixon, was her "Patty Girl." On the morning of the White House service, Quaker "minister" T. Eugene Coffin led a prayer. But it was Ethel—dressed in a pink-sequined pillbox hat and a purple dress—whose renditions of three spirituals proved to be the morning's highlight. Nixon himself recalled that many of the three hundred guests had told him "they had tears in their eyes as she sang three solos in the East Room."

A FEW MONTHS LATER, she returned to the White House for the wedding of President Nixon's daughter Tricia to Edward Finch Cox, one of the big social events in the nation's capital. The wedding invitations went to some four hundred guests, including former first lady Mamie Eisenhower; Norman Vincent Peale; Billy and Ruth Graham; Art Linkletter; Red Skelton; Freeman Gosden (co-creator of *Amos 'n' Andy*), as well as members of Nixon's cabinet, and, surprisingly, consumer advocate Ralph Nader, for whom the young bridegroom, Cox, had once worked.

The night before the ceremony, Ethel arrived at the Hotel Madison in Washington, D.C. There, she received a phone call from Ruth Graham, who invited Ethel to join her in her hotel room for dinner. Billy Graham had not yet arrived in Washington. Overjoyed by the invitation,

Ethel said, "I hope I didn't hug her too hard, but I was so glad to see her!" The next day she rode with both Grahams to the White House and was photographed arriving for the ceremony, which again gave the impression that she and the Grahams were close personal friends. But the truth was another matter. "That was the closest I'd ever felt to Billy and Ruth. The talk Ruthie and I had the night before was beautiful, but walking into the White House between those two precious people was like a long-time dream come true for me. . . . They were like my own children to me as I went with them up those stairs to that wedding. I felt like a million dollars with my babies." The Grahams did become closer to her later, and Billy Graham would speak of visiting her at times when she was hospitalized.

Much as the whole affair pleased Ethel, public perceptions, especially within a vocal segment of the African American community, were far different. Her appearances at the White House added to the impression that she was cut off from Black America. At a time when the nation had witnessed uprisings and riots in major American cities from Detroit to Newark to Watts to Harlem to her hometown of Philadelphia, the civil rights movement had evolved into the Black Power movement—and among the young, there had increasingly been calls for cultural separatism. In this age of the Afro and the dashiki, of "Say It Loud / I'm Black and I'm Proud" and "Black Is Beautiful," two separate cultures existed side by side. While there had been criticism of Lyndon Johnson, his Great Society's War on Poverty had sought to end racial and economic inequities in Black America. Richard Nixon, whether fairly or not, was not viewed as a racially progressive president. At the same time, as the war in Vietnam raged on, the young of America did not view him as progressive either. The question remained, as it had now for years, why had Ethel aligned herself with such conservatives? Photographs that circulated of her laughing with Nixon contributed to her image—for a new generation—as a politically antiquated figure.

The current generation wanted its entertainers committed to political ideologies or ideals, mainly of dissent and revolt, to be in opposition to the established order. Ethel, Sammy Davis Jr., Pearl Bailey—all of whom were photographed in chummy settings with a smiling Richard Nixon— often found themselves lambasted. Ironically, Ethel had for decades lived a separatist existence. Her closest friends, her husbands and lovers and

confidants had usually been African American. Van Vechten had been an exception. But even with this man, known as a Negrophile, it's doubtful that Ethel was ever as open as she was with Floretta Howard or even Archie Savage or Mozelle or Joan Croomes. But now here was a woman, who recently had proclaimed that "land, no, she didn't like white cooking," immersing herself in a conservative white world—and from the viewpoint of some, a possibly politically bigoted one. Such judgments may be unfair. But in the world of perceptions, Ethel's "conservative connections" may also have influenced the way in which her early career—as a singer—was analyzed by newer critics, or perhaps, it might be better to say, was ignored. Her stylistic contributions, her voice itself, her ability to tell a story seemed to have been overlooked.

That was evident in 1973 when Columbia reissued a remarkable two-record set of her early recordings—from 1925 to 1934—titled *Ethel Waters' Greatest Years*. Clearly, it was an attempt to reestablish her for a new generation. Critic John S. Wilson commented:

> Amidst the recent flurry of interest in Billie Holiday and Bessie Smith the third basic voice in the jazz-blues-pop panorama of the twenties and thirties has been almost overlooked. Maybe it's because Ethel Waters is known too well now as an actress. Or maybe it's because her important days in the jazz and pop, if not the blues, fields were too long ago (although, in actuality, no longer ago than Bessie Smith's). For whatever reason, in the current discovery of such seminal singers as Miss Smith and Miss Holiday, Miss Waters's contributions have received relatively little credit. This set not only emphasizes Miss Waters's early jazz relationships, but also traces the changes in her style of singing (along with her type of accompaniment) and gives a revealing glimpse of the foundation she provided for innumerable later singers by setting a standard with songs, new at the time, that have since become everyday favorites.

Music promoter and producer George Wein believed that Waters' temperament had driven many to ignore her. "Perhaps this was the main reason why her place in the history of jazz singing has been so sadly over-

looked—she had few friends to help perpetuate her memory," said Wein. He believed her time with Billy Graham "was a much needed solace for her, and when I met Reverend Graham . . . I thanked him for giving her that precious opportunity."

IN LATE 1972, she briefly entered a convalescent home. Soon afterward she was diagnosed with cataracts and entered Presbyterian Hospital for surgery on one of her eyes. Young Twila Knaack sought to keep Waters' condition private, and fortunately, the news did not hit the press. Once Ethel recovered, she still did not seem able to sit still for long. To the surprise of those aware of her illness, she agreed to appear in the "Run, Carol, Run" episode of the television series *Owen Marshall, Counselor at Law*. Cast once more as a loving elderly woman, known as Aunt Harriet, she acted with series star Arthur Hill, young actor Lee Majors, Keenan Wynn, and her *Pinky* costar Jeanne Crain. It proved to be her last television role. She also appeared in 1972 on the Johnny Carson–hosted *Sun City Scandals*. It was rather touching to see how the hip Carson seemed delighted to be with her.

Then came a special invitation. Since the early 1960s, a young woman named Ruth Tabron, from Chester, Pennsylvania, had dreamed of having an Ethel Waters day. "I had been a fan of hers since I was nine or ten years old," said Tabron. But until now she had been unable to reach Ethel. At first Ethel balked at participating in such an event, but after much persistence and cajoling by Tabron, she consented. On a Friday, she arrived in New York, where she stopped over at the St. Regis Hotel. The next day she arrived in the city of her birth. Though there were still so many painful memories, she served as the grand marshal of a twenty-four-car motorcade that made its way from the foot of the Delaware River, about two blocks from Ethel's birthplace, through Chester. Officially, it was a Law Day Parade, sponsored by the Delaware County Bar Association, but Pennsylvania governor Milton Shapp had proclaimed that Saturday as Ethel Waters Day throughout the state. An estimated forty-five thousand people, Black and white, turned out to see her. "Ethel, we love you!" they shouted and screamed.

That night a dinner was given in her honor. Among those present was actress Julie Harris. "It's hard to say what I really feel in my heart. I love you, Ethel," said Harris. "I love you with all my heart. I thank God for you. I feel I belong to you." A special citation from President Nixon was read by Ruth Tabron. Telegrams of congratulations had come from California governor Ronald Reagan and Billy Graham as well as from others around the country. "This child is really the reason I'm here. She's been hounding me for three years!" Ethel told the dinner guests, referring to Tabron. "Love begets love. I felt it here today. All those beautiful little children, their eager little faces. I felt love here today. That's God's love. We need that to dispel hate." Later she said, "Everyone was just wonderful to me. I even gave a concert at the Schwartz Athletic Center and Julie came to visit with us."

"She was very happy," said Tabron. "Afterward she cried and said it was one of the most beautiful things that had ever happened to her." The attorney William Archibald Jr., who had been instrumental in organizing the trip, said that afterward he kept in touch with her. "She called me 'soul brother,'" he said. "We had a great time. She had a tremendous sense of humor."

With this return to Chester, perhaps something had come full circle for Ethel.

THERE WERE GREATER CONCERNS now about Ethel's health. Perhaps there were fears that death might come at any time. Perhaps there was just a strong desire to show appreciation and love for her work with the Crusade, which she now had performed with for fifteen years. Whatever the reasons, Billy Graham mounted a star-studded testimonial for Ethel. Engraved invitations were sent out for the event to be held at Los Angeles' Century Plaza Hotel on October 6, 1972.

At her apartment in the Bunker Hill Towers, Ethel spent days preparing for the evening. There was much discussion with Twila Knaack about the dress she would wear. Knaack and a friend had shopped around the city, but the only store that carried clothes large enough to fit Ethel was Lane Bryant's in Beverly Hills. Once Knaack had selected what she

believed was a lovely pink dress, she called to tell Ethel the news. She remembered that an incensed Ethel informed her, "Pink is *not* my color, and besides what are you doing at Lane Bryant's. That's a store for fat people." In the end, Ethel wore a dress that had been designed for her in the 1940s.

On October 6, Ethel arrived at the Century Plaza radiant and aglow. The host for the ceremony was television personality Hugh Downs, and among the nine hundred guests were such old-guard Hollywood stars as Bob Hope, Randolph Scott, the Gene Autrys, Robert and Rosemary Stack, Mrs. Clark Gable, Robert Young, and Joanne Carson. Singer Billy Daniels also performed. A special surprise guest was Tricia Nixon. During the evening's proceedings, Ethel was in true form. Twila Knaack recalled that Graham told the audience, "She made it in show business when it was difficult for a Black actress to make it."

"She stopped him short," recalled Knaack. "I cringed. I knew what was coming."

"Please, not the word 'Black,'" said Ethel. "I'm a Negress and proud of it." But the *Los Angeles Times* also quoted her as saying, "It was hard for everyone." Of course, that statement, in the eyes of some Black Americans, appeared to minimize the struggles of African Americans.

And once again, Ethel appeared moved by the presence of Julie Harris. Of the many friends from Waters' years in show business, Harris was among the most caring and affectionate. In July, news that Brandon de Wilde—John Henry in *The Member of the Wedding*—had been killed at age thirty in a traffic accident left Ethel stunned and saddened. In the middle of a rainstorm, he was driving his van when it collided with a truck on the side of the road. "I remember when we closed after our long Broadway run and tour," Ethel recalled. "We all cried, Julie, Brandon, and I. Holding Brandon on my lap, I sang to him and told him that he could keep his John Henry glasses. He didn't want to give them up. All those long months together, the three of us were a family and he was the heart of us. His death was a terrible shock to us all." Now Ethel and Harris maintained the bond that had been created more than twenty years earlier.

That evening, Billy Graham presented Ethel with an engraved silver tray. It read: With Love and Appreciation for 15 Years of Singing in Our

Crusades. Two weeks later, said Knaack, Ethel gave the tray to her. "You'll get more use out of it than I will," Ethel told her. "But don't let anyone from the team know I gave it to you!"

AS 1972 CLOSED, another award was bestowed on Ethel, this one from the NAACP, which, despite her past statement about not being a member of the organization, honored her with its Image Award for her blues, gospel, stage, and pulpit performances.

The tribute and testimonial proved well timed because now she found herself more confined than ever to the apartment. She made a trip to Charlotte, North Carolina, where she had a second cataract operation. Recuperating, she sat daily in front of her small television set and near her radio. Sometimes both were turned on at the same time. In July 1975, she attended an event at the Variety Club of Southern California, where a minibus was presented to a home for needy and handicapped boys in her honor. Then in May 1976, she accepted an invitation to attend a benefit at the Pacific Cinerama Dome of *That's Entertainment Part 2*, a compilation film of some of the great musical sequences from MGM movies. Included was a clip of Ethel in *Cabin in the Sky*. Surrounded by such stars as Gene Kelly, Fred Astaire, Cyd Charisse, Kathryn Grayson, Johnny Weissmuller, Marge Champion, and Margaret O'Brien, she was frail, weak, and often in pain, but she graciously greeted old friends and acquaintances. For these old-timers from the Golden Age not only of Hollywood musicals but of Broadway as well, there was the recognition that she was one of the giants of American musical history. Helping to promote *That's Entertainment Part 2*, she also appeared on *The Mike Douglas Show*, which was taped on the MGM lot. The studio could not have been more pleased.

In the summer of 1976, Cliff Barrows asked if she was well enough to attend a Crusade in San Diego in August. After she agreed to go, she told a friend, "Well, this is probably my last Crusade. So I'll be looking for ya' in heaven."

During this time, she was in and out of the hospital. Twila Knaack recalled that shortly after the Crusade in San Diego, Waters entered the

City of Hope Hospital in Duarte, California. It had not been an easy decision for her to make, but she had almost no energy now, and she was racked with pain. After undergoing tests, she was informed by a physician that she had cancer of the uterus; it was inoperable, but it was arranged for her to undergo daily radiation treatment. At one point, the doctors suggested that she take a ride around the hospital grounds in a wheelchair. "I'm not about to go outside," she told Knaack. Ruth Graham came to the hospital to see her, but Ethel was too weak to fully respond to her friend's visit. She stayed at the City of Hope Hospital for three months and then the doctors let her return home. There was nothing more they could do for her.

Now she was faced with another dilemma. She was too weak to remain in the Bunker Hill apartment alone, but under no circumstances did she want to enter another convalescent home. Ethel recalled that a married couple, Paul and Juliann DeKorte, whom she had known for several years and referred to as her children, once had offered her a place to live in their home. For Ethel, the decision to move to the DeKortes' had to have been a hard one. It meant the days of her independence had come to an end. It also meant that she was about to make the last stop on her long life's journey. Though she was in great pain and often questioned why her Lord had not yet taken her, though she let those around her know that she was ready to go and not afraid to die, she nonetheless would be saying good-bye to the people and places she had known for so long.

Paul DeKorte was a singer who, along with pianist Dick Bolks, had performed with Ethel at some of her sacred concerts. Juliann DeKorte was a registered nurse. With their two children, the DeKortes lived in a home in Chatsworth, California. One of Ethel's physicians told Juliann DeKorte, "Might I say, while we all love her, she has been a very difficult patient." The very day she was preparing to leave the hospital, Ethel had fussed with a nurse who had offered her a wheelchair. "No!" Ethel brusquely told her. 'I don't want any wheelchair. I'm going to leave this place the same way I came in—walking!"

In a room that had been Paul DeKorte's study, a hospital bed and, later, oxygen tanks were installed. So too were Ethel's television and radio. Here Ethel would live for the rest of her life. Juliann DeKorte remem-

bered that the radio was on continuously, playing at all hours of the day and night. The paintings that originally were on the walls were in time replaced by photographs of Ethel at various times in her career. Ethel also requested that her recordings be brought from her Bunker Hill apartment. Eventually, her furniture was also moved to the DeKortes', but Ethel did not immediately give up the apartment. Insistent on paying rent to the DeKortes, she clearly still wanted it known that, contrary to the published reports, she was not broke. She still had her nest egg.

"One thing I found out right away," said Juliann DeKorte, "was that it was impossible to win on a point in which I differed in opinion from her." DeKorte said that she gave up on trying to understand Ethel, who was such a "complex personality." "She could be stern and stubborn—yet gentle, loving, and kind. She could be blunt, unyielding, and strict—yet wise, generous, and forgiving. She even became frustrated at times with her own many-faceted personality. She once admitted, 'I'm more comfortable with Ethel Waters, now that she's a Christian. But I don't understand her all the time.'" And Ethel appreciated her time with the DeKortes— with all the activity in the house with the children. "I want to be a part of things," she told Juliann. "I've been a loner all my life, and I'm tired of it." When visitors came, she gave away her possessions.

When Joan Croomes learned that Ethel was in Chatsworth—and nearing the end of her life—she called her. "I talked to her once or twice. But I never went out there. That's why my husband said—I got the call to go—but he said, 'I wouldn't go. I want you not to go.' And I said, 'Well, yes, we must go.' And he said, 'I'm not going.' And I know I couldn't have made it without him or somebody like that. I just couldn't go."

While she was living at the DeKortes', there were other hospital stays. At one point, she was admitted to Westpark Hills Hospital to be treated for blood clots in her right leg. At another time, gangrene developed in her foot, and she was taken to the Motion Picture County Hospital in Woodland Hills. There, physicians discovered that her kidneys were failing; therefore, they couldn't operate on her foot. There was another trip back to Westpark. Eventually, she returned to the DeKortes'. For a time, she refused pain medication, but when the pain became even more intense, she did take medication for relief. Juliann DeKorte remained by her side.

On September 1, 1977, Ethel Waters died. Juliann DeKorte recalled that her last words were: "Merciful Father—precious Jesus."

THE NEWS OF HER DEATH, though certainly not unexpected, seemed to surprise many. She had lived so long amid so many ills and severe discomforts—for almost twenty years—yet she had remained a figure on the nation's cultural landscape. It had looked as if she couldn't die. The *New York Times*, the *Los Angeles Times*, the *Philadelphia Bulletin*, and other newspapers ran front-page obituaries. Later, writers Leonard Feather, Gary Giddins, Alvin White, Sally Placksin, Susannah McCorkle, and others gave fine appraisals of her work.

Some two hundred mourners gathered at Forest Lawn Cemetery in Glendale, California, for her funeral services. Arrangements for the service and burial had been made by Twila Knaack. The funeral rites were conducted by members of the Graham team, led by Dr. Grady Wilson. Billy and Ruth Graham were traveling in Eastern Europe at the time and were unable to attend. But the couple sent a cablegram "praising Ms Waters, as 'a superstar' not only onstage and screen but in her personal religious faith." Some show business friends were in attendance as well: Reginald Beane; Pearl Bailey, who had always been open in her admiration of Waters; actress Lillian Randolph; pianist Dorothy Donegan; actor Joel Fluellen; Ethel's friend from Philadelphia, Sue McDonald; and a woman identified as Oletha White, who said she was Waters' foster sister and had traveled as a dancer in Waters' tours in the South. Flowers had come from Pearl Bailey, Sammy Davis Jr., Irving Berlin, and MGM. The Graham team also sent floral arrangements. According to Twila Knaack, the ribbon on the arrangements said "Mom." During the service, a tape was played of Waters singing.

Later it was revealed that on August 20—less than a month before she died—Ethel had drawn up a will. Its executor was a Los Angeles attorney, John Caldwell. Her assets, listed at approximately $10,000, were to go to the Ethel Waters Trust Agreement. Her only heir was her half-sister, Genevieve Howard, who was to receive for the rest of her life $175 a month plus $100 a month for living expenses. To the very end, Ethel had been

determined to take care of her family. Upon Howard's death, the trust was to be distributed to the World Evangelism and Christian Education Fund of the Billy Graham Evangelistic Association.

Later generations would often think of Waters, if they thought of her at all, as an elderly matriarch who had occasionally appeared on television—and who, so they had been told, had once been a singer. Few might realize her great contributions to popular culture. On those songs of the late 1920s and 1930s when she spoke to the guy in her life, laying down the law, she had surely been a precursor to rap—with her insistent, steamy, rhythmic messages about the way life should be lived. When she sang with that crystal clarity, she had led the way for countless other stars who strove to do as she had: to tell a story in song; to express through lyrics an emotion or an attitude; to carry in melody the sweet rhythm and drive of a popular song—and to make her listeners sometimes swoon and wander off into a sweet dream all their own. In her music, she had also challenged attitudes and assumptions about a woman's place and a woman's sexuality. Her independence and assertiveness were an integral part of her style, her presence, her allure. Her glamour had been important too, especially at a time when most African American women, especially browner Black women, were thought not to possess it. She had thrown such assumptions aside and lived like a queen, like a daring goddess—and set the stage for decades of gorgeous "dark divas" to follow. As an actress, she had, for a time, gone where no African American woman—and few African American men—had been able to travel: to use a role to unlock her personal agonies; to make visible the otherwise invisible torment of seemingly ordinary people, *her people*; to force open the doors of Broadway to a highfalutin powerful African American actress. Through it all, she may have kicked and screamed and raised holy hell in a way that mystified and even frightened those around her. But she had to claim her turf; she had to do that from the time she was a girl in Philadelphia and Chester. And throughout, her humor—self-deprecating and ribald—had never failed her. In that later period of her life, her religious faith and endurance had been a source of inspiration for millions.

Later generations might have forgotten or never learned who she was. But all anyone had to do was see her in *Cabin in the Sky* or *Pinky* or *The*

*Member of the Wedding* to understand her power and supreme talent. All anyone had to do was hear her sing "Am I Blue?" or "Stormy Weather" or "Heat Wave" or "Taking a Chance on Love" or "Happiness Is a Thing Called Joe" to understand as well. Better still, all anyone had to do was hear "Shake That Thing" to know, as Joan Croomes said Ethel liked to say, that even with divas of a later age, Miss Ethel Waters could still show those bitches.

# Acknowledgments

No book is ever completed without the assistance, generosity, and encouragement of others. It is a pleasure to acknowledge the many individuals and research institutions and archives that proved important during the four years it took to research and write *Heat Wave: The Life and Career of Ethel Waters.*

Foremost I would like to express my gratitude to those who graciously consented to be interviewed about Ethel Waters. Joan Croomes, Leslie Uggams, Lennie Bluett, Marni Nixon, George Maharis, and Clisson Woods all discussed the experience of working with Waters. Some also shared personal impressions. Emery Wimbish, James Sheldon, Martha Orrick, Jim Malcolm, and Miles Kreuger provided telling comments on the thrill of seeing Waters perform. Also helpful were perceptive observations that sprang out of seemingly casual conversations with Cicely Tyson, Diahann Carroll (whom I had unexpectedly encountered one afternoon in New York), and the wonderful Olga James.

Other comments and firsthand observations were drawn from lengthy interviews (or occasionally conversations) that were conducted as I researched and wrote earlier books, including: *Dorothy Dandridge: A Biography; Bright Boulevards, Bold Dreams: The Story of Black Hollywood;* and *Brown Sugar: Over 100 Years of America's Black Female Superstars.* Other comments have come from conversations and interviews I conducted for the PBS/German Educational Television documentary adaptation of my book *Brown Sugar.* Among those previously interviewed were Fredi Washington, Ossie Davis, Ruby Dee, Maude Russell, Fayard

Nicholas (who possessed an absolutely astounding memory), Harold Nicholas, Bobby Short, Herb Jeffries, Alberta Hunter, Phil Moore, John Hammond, Dorothy Nicholas Morrow and her husband, Byron Morrow, Clora Bryant, Dorothy McConnell, Isabel Washington Powell, Mantan Moreland, and the great director King Vidor. Highly intelligent and highly political, Fredi Washington, who had worked with Waters in the drama *Mamba's Daughters*, was of special help. At her home in Stamford, Connecticut, she still bristled at the very thought of Ethel's behavior, but she respected her searing talent and provided insights into Waters' complications. Spending time with Washington was always an altogether extraordinary experience, not only for her insights on other performers but, of course, for her enlightening comments about her own career. Also extremely helpful was Bobby Short. With his stunning knowledge of Black entertainment history, Bobby was always generous and able to provide the proper historical context and perspective for so much of what he discussed. At their home in New Rochelle, New York, Ossie Davis and Ruby Dee were thoughtful and splendidly reflective. Ossie clearly (and with admiration) saw Ethel in a larger context. I also have to express my gratitude to actor Wren Brown, who hails from one of the great families in entertainment history (in general) and Black Hollywood history (in particular). His maternal grandfather was the great Lee Young. Wren's great-uncle was Lee's brother, the extraordinary saxophonist Lester Young. His paternal grandfather was the actor Troy Brown. During one of our conversations, Wren mentioned his aunt Joan Croomes, at whose home Ethel had once resided in her later years. Thanks to Wren, I was able to meet and interview Croomes, who was a real find and an absolutely wonderful person to spend time with. My gratitude is also extended to Stephanie Wills, the secretary to Reverend Billy Graham. Though Reverend Graham was unavailable for an interview because of his health, Stephanie was quite helpful in suggesting sources for information on Waters.

Of course, no biography of this scope could be written without the resources of research institutions and archives. One can get lost in the rich treasures (sometimes having little to do with the subject at hand) found in such places. Research always moves more smoothly when you are fortunate enough to have librarians and staff members who open more doors for you.

I'd like to express my gratitude to the staffs of the New York Public Library for Performing Arts at Lincoln Center, where I did my initial research and especially to Edie Wiggins there; the Schomburg Center for Research in Black Culture, especially my friends Sharon Howard and Betty Odabashian, who are among the most knowledgeable and helpful librarians I encountered while researching this book; the Beinecke Library at Yale University, where I immersed myself in the James Weldon Johnson Collection and where Patricia Willis as well as June Can were quite helpful; the Margaret Herrick Library of the Academy of Motion Picture Arts and Sciences; the Free Library of Philadelphia, especially Andy Kagan and Geraldine Duclow; the Institute of Jazz Studies at Rutgers University; and the Music Division of the Library of Congress. My research at the film and television archives of UCLA—while I was working on my book *Primetime Blues: African Americans on Network Television*—also proved important for this volume.

One of my great research delights was spending time at the Paley Center for Media, where I was able to screen a number of Ethel Waters' television appearances. At the Paley Center, curator Ron Simon proved gracious and helpful, as did Richard Holbrooke, who assisted me during screenings. There was also the rather incredible Jane Klain, who helped me locate TV programs and made special screening arrangements for me at the center. Always it was a pleasure to talk to this very knowledgeable and engaging woman. It was also interesting to hear Jane's recollection of the time she had seen Waters while studying at UCLA. Also delightful were the times spent with Jean Franz, formerly of Turner Classic Movies, who took me on a guided tour of Pasadena, where I was able to see one of the homes in which Ethel had once lived. Jean also accompanied me on one of my visits to the Institute of the American Musical, where its director, Miles Kreuger, led me on a glorious tour of the institute's collection and also screened brief rare footage of Ethel in *At Home Abroad*. Miles also recounted his experiences when—while still very young—he met and sketched Waters during the run of *The Member of the Wedding* at the Empire Theatre. It was also a pleasure to search for photographs at Photofest. Howard Mandelbaum and his brother, Ron Mandelbaum, as well as their staff, which includes Theresa Demick, could not have been more helpful. It was a joy to discuss films and personalities with them.

A number of my former students provided invaluable research assistance. The enterprising David Aglow did some of the very early research and also came to my rescue by securing CDs of a number of Ethel's important recordings, most of which are no longer commercially available. I cannot thank him enough. Then there was Dreysha Hunt, my former student at the University of Pennsylvania, who studiously went through microfilm of weekly articles from the African American newspaper the *Pittsburgh Courier.* It was long and tedious work but she came up with some real discoveries that were of great use. At New York University's Tisch School of the Arts, a rather casual conversation with graduate writing student Ayanna Maia Saulsberry led to an interesting adventure as she found information on the location of the Brooklyn home where Waters once resided. Energetic and industrious, Wesley Barrow found contact information for some of Waters' associates. Zac Kline plowed through clippings files at Lincoln Center's Library for the Performing Arts. Then there was Mia Kai Moody, my teaching assistant, who made sure that while I was working on the book, everything pertaining to my classes at Tisch was kept in excellent shape. It was also good to bounce ideas off Mia, Ayanna, and another former Tisch graduate student, Robin Williams, all of whom have a great interest and enthusiasm for my work and also for the field of African Americans in film and television.

My gratitude goes also to Kim Mason, who used her remarkable Internet skills to great effect, locating rare and significant material; Rick Scheckman, who provided DVDs of Waters' films, including the very obscure *Gift of Gab*; Becca Bender, who labored tirelessly to find Waters' marriage/divorce records. Also important is my dear friend, the fantastic entertainment correspondent Marian Etoile Watson. Over the years, there have been many occasions during which we have observed up close, thanks to her ingenuity, the famous and the fiercely creative, which has often been an eye-opening experience.

I would like to thank my colleagues in the Dramatic Writing Department of New York University's Tisch School of the Arts, especially David Rhangelli, Janet Neipris, Mark Dickerman, Gary Garrison, Yolanda Culler, and department chair Richard Wesley. My gratitude is also extended to my colleagues at the Center for Africana Studies at the Uni-

versity of Pennsylvania: Gale Garrison and Carol Davis as well as former Center colleague Audrey Smith-Bey. I could not ask for a more agreeable and pleasant group.

Friends and colleagues who proved especially important during the writing and researching of this book include my very dear friend Carol Leonard; my very good friend Sarah Orrick, who opened the door of the home she shares with Jeff Christiansen in Harpers Ferry, where I stayed while doing research at the Library of Congress in a sweltering Washington, D.C.; Dr. Harry Ford and Peg Henehan, at whose home in Boston I've had many relaxing hours and from there, many delightful trips (to unwind) to L. L. Bean's in Freeport, Maine; my long-standing friends from a special summer at Harvard—Susan Peterson and Nigel Forrest; my good friends from my days at *Ebony* Barbara Reynolds, Steven Morris, and Herma Ross Shorty; Rigmor Newman, who helped me locate a rare photograph of Ethel with Eddie Mallory along with the young Harold Nicholas, at the Cotton Club; Ronald Mason; filmmaker William Greaves and Louise Greaves; Robert Katz; Martin Radburd; Alan Sukoenig and Hiroko Hatanaka; Grace and Jim Frankowsky; my friends at the Newark Museum, Gloria Buck, museum director Mary Sue Sweeney Price, Clement Price, and Pat Faison; Celeste Bateman, who fields so many calls for me and also handles many of my speaking engagements; Carmen Smith of Disney; Judith Osborne; Nels Johnson; Cathie Nelson; Billie Johnson; Jeanne Moutoussamy-Ashe; Catherine "Kay" Nelson; and the divine Anna Deavere Smith, who years ago gave me a very rare edition of *His Eye Is on the Sparrow*.

As always, my dear friend, writer Sally Placksin, the author of the invaluable *American Women in Jazz*, provided great insights as she discussed music history with an emphasis on jazz and the great blues singers. Another good friend, Joerg Klebe, of German Educational Television, also was helpful. At Turner Classic Movies, there were many people who were encouraging without even realizing it: the terrific host Robert Osborne; Darcy Hettrich; and especially my friend Charles Tabesh, TCM's vice-president, who was of immense help in locating films for me and making sure I could screen them. His sense of humor and sane view of the world proved more important than he may have realized.

Other associates, friends, and family members whom I wish to thank

for their patience and enthusiasm include Jacqueline Bogle Mosley; Robert Bogle Sr., publisher of the *Philadelphia Tribune*, and Marie Kanalas Bogle; Roslynne Bogle; Jeanne Bogle Charleston and Fred Charleston; Janet Bogle Schenck and her husband, Jerry Schenck, both of whom are great movie enthusiasts and always encouraging; Roger Bogle; Gerald Grant Bogle and Carol Bogle; Jay Kevin Bogle; Fred "Pele" Charleston; Ayana Charleston; Hassan and Denise Charleston; Bettina Glasgow Batchleor; Robert Bogle Jr.; Mariskia Bogle; Michelle Mosley Palmer and Hermon Palmer; Shaaron Bogle; Carol White; Carolyn and Chris Jackson; Ann Marie Cunningham; Patricia Ferguson; Margaret Crosthwaite Pascuzzi; David Crosthwaite; Michael Pascuzzi; Denise Pascuzzi and her husband, Richard; my former editor Robert Silverstein and his wife, Hameda; Deesha Hill; Josslyn Luckett; Daniel Beer; Logan Johnson; Marcia White, the arts director of the national organization of African American women, the Links; Kathe Sandler; Marie Orlandi, who has always been supportive and encouraging; Jennifer Calderone; Kaz Wilson-Wright; Heidi Stack; Doug and Liza Rossini; dear Rae Taylor Rossini; Arthur and Joanie Rossi; Ruth Lazar; Barbara, Ellen, and James LaGow; Pam Mosley; Ann Marie Cunningham; Monica Freeman; Jamal Bogle; Alex Bogle; Karin Leak; Sylvia Ghoston; Franchesa Pannell; Georgtte Scheer; Clifford Laurent; Andrew Carl; Fotini Lomke; Linda "Doll" Tarrant Reid and Stuart Reid; Bret Haber; Jamie Vega, guardian of my Los Angeles hideaway who always makes sure everything is in shape for my arrival; Winsome Carey; Keiko Kimura; Luellen Fletcher; Mimi Goldstein; and my darling goddaughter, YeMaya Bogle.

Phil Bertelsen, who is my former researcher and now a director, provided valuable comments and advice as he read various drafts of the book. At this point, he has a solid knowledge of Black entertainment history. My former editor Evander Lomke also read the manuscript and offered excellent suggestions. In Los Angeles, Jerald Silverhardt was always good to bounce ideas off. He knows contemporary Hollywood as few others do. The same can be said of the wondrous drama coach and acting teacher Janet Alhanti.

Bruce Goldstein also carefully read the manuscript and gave very informed suggestions for ways to tighten the material and further clarify some topics. Bruce was one of the people who urged me to write a bio-

graphy of Waters, who he believed too important not to have a book detailing her accomplishments. With his remarkable memory and broad knowledge of film history, he remains one of few people with whom it is always a sheer pleasure to discuss films and early popular culture.

It has also always been wonderful, invigorating, and exciting to discuss films and film history with my very dear friend, the terrific film producer Debra Martin Chase, who has a special interest in and enthusiasm for the history of African American women in popular culture. Though our schedules don't permit us to get together as often as we'd both prefer, she remains a real jewel. There is no one with whom I'd rather talk about the old classic Hollywood than the dazzling Debra.

Also of great help was my good friend, the novelist and attorney Enrico Pellegrini. His wisdom, humor, and intelligence have all proven important as I worked on this book.

Marie Brown has always been encouraging and insightful. In the midst of her demanding schedule, she takes the time to answer questions and offer advice. For so many of us in publishing, she's a rock of strength and steady reserve and perceptiveness—a one-of-a-kind woman who makes so many lives brighter and more focused.

Gratitude is also extended to my agent on this book, Jennifer Lyons, who has been on top of so many issues during the writing of this book. I value her energy, her resilience, and her intelligence—as well as her tough-minded deal-making powers.

I also have to express my gratitude to Bill Strachan of HarperCollins, who stepped in as my editor during the later stages of the book. I have really valued his patience and his expert advice as he read the manuscript. It has been a pleasure to work with him. I would also like to thank Kate Whitenight at HarperCollins and copy editor Martha Cameron.

Finally, my heartfelt thanks and deepest gratitude go to my original editor, the phenomenal Elisabeth Dyssegaard, who has been my editor on four books. There are few people I trust and respect as much as Elisabeth. For some time, she encouraged me to write a biography of Ethel Waters. She read an early draft of the manuscript and was encouraging and insightful. When she left HarperCollins, I felt a little lost. But her spirit remained with me—and with the book. She is the absolute best.

# Notes

Interviews from the author's personal archives have provided invaluable information. New interviews were conducted with Joan Croomes, Leslie Uggams, Marni Nixon, Lennie Bluett, George Maharis, James Sheldon, Miles Kreuger, Martha Orrick, Emery Wimbish, and others. Also important is information that has been drawn from past interviews conducted by the author with Fredi Washington, Geri Branton, Ossie Davis, Ruby Dee, Maude Russell, John Hammond, Bobby Short, Olga James, Alberta Hunter, Harold and Fayard Nicholas, Dorothy Nicholas Morrow, Herb Jeffries, Orin Borsten, Phil Moore, Mantan Moreland, Leonard Feather, and many others.

Such volumes as James Weldon Johnson's *Black Manhattan* and *Along the Way*, Jervis Anderson's *This Was Harlem*, David Levering Lewis' *When Harlem Was in Vogue*, Steven Watson's *The Harlem Renaissance*, and many others have provided excellent accounts of the history of Harlem and New York theater. So, too, have scores of articles in such African American newspapers as the *Pittsburgh Courier*, the *Chicago Defender*, the *Amsterdam News*, the *New York Age*, the *Philadelphia Tribune*, and others. Allen Woll's *Black Musical Theatre: From Coontown to Dreamgirls* remains a remarkable source on African Americans in musical theater. Among the books that have provided significant information and insights on African American women in blues and jazz are Sally Placksin's *American Women in Jazz: 1900 to the Present: Their Words, Lives, and Music*; Chris Albertson's biography *Bessie*; Billie Holiday and William Dufty's *Lady Sings the Blues*; Frank C. Taylor and Gerald Cook's *Alberta Hunter: A Celebration in Blues*; Eileen Southern's *The Music of Black Americans: A History*; Albert Murray's *Stomping the Blues*; and Amiri Baraka's *Blues People*. Numerous biographies and personal memoirs have also proven important in the discussion of Waters' life and career. The author's books *Bright Boulevards, Bold Dreams: The Story of Black Hollywood*; *Brown Sugar: Over 100 Years of America's Black Female Superstars*; *Dorothy Dandridge: A Biography*; and *Toms, Coons, Mulattoes, Mammies, and Bucks: An Interpretive*

*History of Blacks in American Films* have proven significant for the discussion of Waters' years in theater and especially in Hollywood.

Ethel Waters' memoirs *His Eye Is on the Sparrow* and *To Me It's Wonderful* remain the best source—looking from the inside out—for an exploration of her childhood and her early career, especially the early years on the road.

Dates for periodicals from which material is quoted are not given in the notes if they already appear within the text. If the source for quoted material runs consecutively from one paragraph into the next, the source is listed only for the first quotation. For the most part, dates, titles, and page numbers are provided. But page numbers and on very rare occasions dates or publications themselves are not always provided for material that has been gathered from the clippings files at the New York Public Library for the Performing Arts at Lincoln Center, the James Weldon Johnson Collection at Yale University, the Free Library of Philadelphia at Logan Square, and the author's extensive private collection. CF indicates that material has come from such clippings files.

## Chapter 1 • Two Women, Two Cities

Details on Ethel Waters' childhood and family have been drawn from Waters' numerous statements in interviews in newspapers, magazines, and television programs during her career as well as from her two memoirs *His Eye Is on the Sparrow* and *To Me It's Wonderful*, as well as her album *Just a Little Talk with Ethel*. Ancestry.com was also consulted for additional information on the Waters family history and genealogy. Other information has been drawn from interviews with Waters' friends and professional associates.

7 "Sally could fight like": Ethel Waters with Charles Samuels, *His Eye Is on the Sparrow* (Garden City, NY: Doubleday, 1951), 2.

9 "Seems like I was": Tex McCrary and Jinx Falkenburg, "New York Close-up," *New York Herald Tribune*, November 16, 1949, CF.

9 "My close kin didn't": William Hawkins, "Theater: Ethel Waters Discloses How Religion Helps Her," *New York World Telegram*, June 4, 1949, CF.

9 "I was imaginative": Ibid.

10 "They were just girls": Ethel Waters, *Just a Little Talk with Ethel Waters* (Word Records Limited, 1977).

11 "I always wanted to": Ibid.

12 "I've always had great": Waters and Samuels, *His Eye Is on the Sparrow*, 17.

12 "Whatever moral qualities I": Ibid., 19.

12 "I didn't fit nowhere": Hawkins, "Theater: Ethel Waters Discloses How Religion Helps Her," *New York World Telegram*, June 4, 1949, CF.

12 "in the same room": Waters and Samuels, *His Eye Is on the Sparrow*, 19.

13 "I never had a": "Ethel Waters Talks of Her Rise to 'Tops' on Broadway," *Chicago Defender*, October 12, 1935, 9.

13 "I loved to dance": McCrary and Falkenburg, "New York Close-up," *New York Herald Tribune*, November 16, 1949, CF.

13 "I was constantly": Ethel Waters, *Person to Person*, CBS, January 8, 1954.

14 "The only place I": Hawkins, "Theater: Ethel Waters Discloses How Religion Helps Her," *New York World Telegram*, June 4, 1949, CF.

14 "The beauty that came": Waters and Samuels, *His Eye Is on the Sparrow*, 50.

15 "But all my life": McCrary and Falkenburg, "New York Close-up," *New York Herald Tribune*, November 16, 1949, CF.

15 "I began to grow": Ethel Waters, "The Blackbird of the Blues," *Ethel Waters Souvenir Album* (Decca Records, May 1943).

15 "I felt betrayed": Waters and Samuels, *His Eye Is on the Sparrow*, 58.

16 "I had done practically": Ben Washer, "Ethel Waters Likes Changes of Songs in Lew Leslie Show, 'Rhapsody in Black,'" *Chicago Defender*, May 23, 1931, 3.

17 "on my knees, as": Leonard Lyons, "Lyons Den," *Chicago Defender*, October 1, 1960, 8.

18 "I got $3.00": Waters, "The Blackbird of the Blues," *Ethel Waters Souvenir Album* (Decca Records, May 1943).

19 "Each Saturday and Sunday": Russell Lee Lawrence, "I'm Not Afraid to Die, Honey . . . I Know the Lord Has His Arms Around This Big Fat Sparrow," *Sunday (Philadelphia) Bulletin/Discoverer*, October 21, 1973, CF.

19 "poise, dignity, and whatever": Waters and Samuels, *His Eye Is on the Sparrow*, 68.

19 "They let me go": Lawrence, "I'm Not Afraid to Die, Honey . . . I Know the Lord Has His Arms Around This Big Fat Sparrow," *Sunday (Philadelphia) Bulletin/Discoverer*, October 21, 1973, CF.

21 "She had a tough": Maude Russell, *Brown Sugar: Eighty Years of America's Black Female Superstars*, PBS/German Educational Television, 1988.

21 "She had a very": Lena Horne, ibid.

## Chapter 2 • On the Road

Some information on Ethel Waters' family and her early show business experiences has been drawn from Waters' statements in interviews as well as from her memoirs *His Eye Is on the Sparrow* and *To Me It's Wonderful* and comments on her album *Just a Little Talk with Ethel Waters*. Other information comes from interviews with Waters' friends and associates. Information on the early blues singers

and the years of Black vaudeville has been drawn from the author's book *Brown Sugar: Over 100 Years of America's Black Female Superstars*; Sally Placksin's *American Women in Jazz*; Allen Woll's *Black Musical Theatre: From Coontown to Dreamgirls*; Chris Albertson's *Bessie*; Robert Toll's *Blacking Up*, as well as transcripts of oral histories at Rutgers Institute of Jazz and other sources.

23  "Minstrel shows were in": Lee Young, Oral History Transcripts, Institute of Jazz Studies at Rutgers University.

26  "Your makeup was cork": Ibid.

28  "I was so frightened": "Ethel Waters Talks of Her Rise to 'Tops' on Broadway," *Chicago Defender*, October 12, 1935, 9.

28  "The audience there was": Ibid.

28  "But they were also": Waters with Samuels, *His Eye Is on the Sparrow*, 7.

31  "I think it was": Young, Oral History Transcripts, Institute of Jazz Studies at Rutgers University.

33  "Often, we girls would": Jean-Claude Baker and Chris Chase, *Josephine: The Hungry Heart* (New York: Random House, 1993), 63.

36  "I was as crazy": Waters with Samuels, *His Eye Is on the Sparrow*, 91.

38  "Come here, long goody": Ibid., 92. There are two versions of the last word of this quote. In her memoirs, Waters ends with the sentence: "And you know damn well that you can't sing worth a ___." The other version, which appears in Chris Albertson's biography *Bessie*, ends with Bessie Smith saying: " . . . you can't sing worth a fuck."

42  "He took C, H": Ibid., 115.

42  *Hello, 1919!*: In *His Eye Is on the Sparrow*, Waters wrote that she thought—obviously she was not certain—that she appeared in the show *Hello, 1919!* after temporarily leaving Edmond's. But other sources indicate that she appeared in *Hello, 1919!* before working at Edmond's.

## Chapter 3 • The Big Apple

48  "a great appeal to": James Weldon Johnson, *Black Manhattan* (New York: Atheneum, 1972), 172.

52  "This was the era": James Weldon Johnson, *Along the Way* (New York: Penguin, 1990), p. 380.

53  "After you worked there": Waters with Samuels, *His Eye Is on the Sparrow*, 128.

53  "I'll show them bitches": Author interview with Joan Croomes.

53  "for showing her laundry": Waters with Samuels, *His Eye Is on the Sparrow*, 126.

54 "I was just a": Wilson, "V: Ethel Waters—Torch Singer to Dramatic Actress," *New York Post*, December 6, 1940, CF.

55 "I never was like": Sidney M. Shallet, "Harlem's Ethel Waters," *New York Times*, November 10, 1940, 149.

55 "It's the story told": Waters with Samuels, *His Eye Is on the Sparrow*, 129.

55 "I used to work": Wilson, "V: Ethel Waters—Torch Singer to Dramatic Actress," *New York Post*, December 6, 1940, CF.

56 "For three years, Ethel": Geraldyn Dismond, "Through the Lorgnette of Geraldyn Dismond," *Pittsburgh Courier*, September 17, 1927, CF.

57 "The Williams woman is": *New York Age*, June 3, 1922, CF.

57 "to great local crowds": Johnson, *Black Manhattan*, 173.

58 "color complex": Frank C. Taylor with Gerald Cook, *Alberta Hunter: A Celebration in Blues* (New York: McGraw-Hill, 1988), 51.

58 "too young . . . too small": Josephine Baker and Jo Bouillon, *Josephine* (New York: Harper & Row, 1976), 27.

59 "the first colored girl": W. C. Handy, *Father of the Blues: An Autobiography* (New York: Da Capo Press, 1969), 200.

60 "once they'd drawn the": Sally Placksin, *American Women in Jazz: 1900 to the Present: Their Words, Lives, and Music* (New York: Wideview Books, 1982), 11.

61 "was a handsome young": Handy, *Father of the Blues: An Autobiography*, 125.

63 "While in Atlantic City": Roi Ottley and William J. Weatherby, eds., *The Negro in New York: An Informal Social History, 1626–1940* (New York: Praeger, 1969), 233.

63 "very prissy and important": Waters with Samuels, *His Eye Is on the Sparrow*, p. 141.

64 "There was much discussion": Ibid.

64 "Fletcher was in charge": Garvin Bushell as told to Mark Tucker, *Jazz from the Beginning* (Ann Arbor: University of Michigan Press, 1988), 31.

65 "little bitty studio": Taylor with Cook, *Alberta Hunter: A Celebration of the Blues*, 51.

66 "I sold 500,000 copies": Ottley and Weatherby, eds., *The Negro in New York: An Informal Social History*, 233.

68 "Ethel had been in": Bushell as told to Tucker, *Jazz from the Beginning*, 32.

68 "'the damn-it-to-hell'": Waters with Samuels, *His Eye Is on the Sparrow*, 147.

68 "Very few singers could": Bushell, *Jazz from the Beginning*, 32.

69 "Before they left New York": Walter Allen, *Hendersonia: The Music of Fletcher Henderson and His Musicians: A Bio-Discography* (Highland Park, NJ: Jazz Monographs No. 4), 24.

70 "Coming Your Way": Advertisement, *Chicago Defender*, October 22, 1921, 7.

70 "Ethel Must Not Marry": *Chicago Defender*, December 24, 1921.

72 "Greatest Social Event": "20,000 People Will Attend the Great Football Classic," *Philadelphia Tribune*, November 19, 1921, 1.

74 "Gibson's New Standard Theatre": Advertisement, *Philadelphia Tribune*, November 19, 1921, 3.

75 "Like every band that": Bushell, *Jazz from the Beginning*, 33.

75 "He did some": Ibid., 33.

75 "She literally sang with": Ibid., 32.

76 "All right": Waters with Samuels, *His Eye Is on the Sparrow*, 153.

76 "I could like a": Ibid., 154.

77 "Preceding Miss Waters' appearance": *Baltimore Afro-American*, December 2, 1921, CF.

77 "We didn't play any": Bushell, *Jazz from the Beginning*, 36.

78 "Congratulations on your wonderful": *New York Age*, January 7, 1922, np.

79 "One week only—Starting Monday": Advertisement, *Chicago Defender*, 7.

79 "When she sang the": Hubert Saal, "Music: Rebirth of the Blues," *Newsweek*, October 31, 1977, 101.

79 "Put some change in": Author interview with Alberta Hunter for PBS/German Educational Television production of *Brown Sugar: Eighty Years of America's Black Female Superstars*.

80 "What will people say?": Ibid., 72.

81 "The work of the": "Ethel Waters Packs Grand: Lulu Coates & Co. Top Great Bill at Avenue; Good Bill at the Monogram," *Chicago Defender*, January 21, 1922, 6.

81 "In those days": Bushell, *Jazz from the Beginning*, 39.

81 "She felt it her duty": "Musicians Quit; Ethel Waters Goes South," *Chicago Defender*, February 11, 1922, 7.

82 "It has been voted": *New York Age*, April 29, 1922, CF.

83 "The concert was heard": Ibid.

83 "I heard this young man": *Down Beat*, July 14, 1950, 4.

84 "Ethel Waters and her": "Black Swan Jazz Babies Are Great," *Chicago Defender*, June 3, 1922, 7.

## Chapter 4 • Back in the City

89 "Ain't I gonna": Author interview with John Hammond for PBS/German Educational Television production of *Brown Sugar: Eighty Years of America's Black Female Superstars*.

90 "However, there is a": Waters with Samuels, *His Eye Is on the Sparrow*, 151.

91 "It ain't no novelty": Ibid., 153.

92 "The show was lousy": Taylor with Cook, *Alberta Hunter: A Celebration in Blues*, 54.

94 "ever in the background": Etta Moten, "'Trust in God' Is Secret of Ethel Waters' Stage Success," *Washington Tribune*, August 11, 1936, CF.

96 "they were set up": Ottley and Weatherby, eds., *The Negro in New York: An Informal Social History*, 234.

96 "The Black Swan Company": Handy, *Father of the Blues: An Autobiography*, 211.

96 "Immediately dealers began to": Ottley and Weatherby, eds., *The Negro in New York: An Informal Social History*, 234.

98 "He was very handsome": Author interview with Lennie Bluett. Other comments by Bluett in this chapter are from the same interview.

98 "We heard Ethel singing": Earl Dancer, "Star Undimmed in 30 Years," *Amsterdam News*, March 11, 1950, CF.

100 "I just didn't like": Waters with Samuels, *His Eye Is on the Sparrow*, 172.

102 "'stood up' with the": "Dotson Wed?" *Chicago Defender*, March 1, 1924, 7.

102 "After Ethel Williams left": Dancer, "Star Undimmed in 30 Years," *Amsterdam News*, March 11, 1950, CF.

104 "would need a little": "Raves over Show," *Chicago Defender*, March 29, 1924, 6.

104 "After exactly one year": Dismond, "Through the Lorgnette of Geraldyn Dismond," *Pittsburgh Courier*, September 17, 1927, CF.

105 "when I first stepped": Waters and Samuels, *His Eye Is on the Sparrow*, 74.

106 "A Jewish friend and": Alvin White, "Ethel Waters Remembered," *Amsterdam News*, November 19, 1977, 16.

106 "One who has seen": "Plan Benefit Show to Help Cathedral," *New York Times*, February 21, 1925, 16.

106 "Every top act in": White, "Ethel Waters Remembered," *Amsterdam News*, November 19, 1977, 16.

108 "That's when the Plantation": Marshall Stearns and Jean Stearns, *Jazz Dance: The Story of American Vernacular Dance* (New York: Schirmer Books, 1979), 142.

109 "for Ethel to go": Earl Dancer, "Flo Ziegfeld Sees, Is Conquered by Ethel; Earl Arrives as Star Maker," *Amsterdam News*, March 18, 1950, CF.

109 "Will Marion could take": Baker and Chase, *Josephine: The Hungry Heart*, 83.

110 "I was still in": Baker and Bouillon, *Josephine*, 36.

110 "Lew Leslie had the": Baker and Chase, *Josephine: The Hungry Heart*, 82.

111 "The performers were *white*": Baker and Bouillon, *Josephine*, 36.

111 "I wasn't going to": Geoffrey C. Ward and Ken Burns, *Jazz: A History of America's Music* (New York: Alfred A. Knopf, 2000), 109.

112 "She is a natural": Carl Van Vechten, "Negro Blues Singers," *Vanity Fair*, March 1926, 108.

112 "It was in this": Dancer, "Flo Ziegfeld Sees, Is Conquered by Ethel; Earl Arrives as Star Maker," *Amsterdam News*, March 18, 1950, np.

113 "Ethel arrived at the": Baker and Bouillon, *Josephine*, 40.

113 "When I returned to": Ibid.

113 "The next evening I": Ibid.

113 "Your success cured her": Ibid.

114 "I preferred to see": Waters with Samuels, *His Eye Is on the Sparrow*, 186.

115 "the highest figures ever": "Long Time Contract for 'Blues' Singer," *Pittsburgh Courier*, May 23, 1925, 10.

120 "went to hear her at every": Leonard Feather, "More Than Blues: Remembering Ethel Waters," *Los Angeles Times*, September 3, 1977, B9.

120 "the source of her genius": Sally Placksin, *American Women in Jazz: 1900 to the Present: Their Words, Lives, and Music* (New York: Wideview Books, 1982), 24.

120 "The subtlety of her": Gary Giddins, "Ethel Waters: Mother of Us All," *Village Voice*, October 10, 1977, 63.

120 "Will her individual approach": Placksin, *American Women in Jazz: 1900 to the Present—Their Words, Lives, and Music.*

121 "first five releases": Frank Driggs, liner notes, *Ethel Waters' Greatest Years*, Columbia Records, 1972.

122 "All you had to": David Levering Lewis, *When Harlem Was in Vogue* (New York: Alfred A. Knopf, 1981), 127.

122 "When the Frigidaire needs": Etta Moten, " 'Trust in God' Is Secret of Ethel Waters' Stage Success," *Washington Tribune*, August 11, 1936, CF.

124 "flippantly fastidious and a": Ann Douglas, *Terrible Honesty: Mongrel Manhattan in the 1920s* (New York: Farrar, Straus and Giroux, 1982), 288.

125 "Chief Long Lance": Langston Hughes, *The Big Sea* (New York: Hill and Wang, 1940), 253.

126 "Miss Smith, you're *not*": Chris Albertson, *Bessie* (New York: Stein and Day, 1974), 143.

126 "A blow in the": Anderson, *This Was Harlem*, 219.

126 "I'd heard of his": Waters with Samuels, *His Eye Is on the Sparrow*, 194.

127 "White people generally bored": Ibid.

128 "When Mr. Van Vechten": Johnson, *Black Manhattan*, 226.

129 "red and gold Oriental": Kellner, *Carl Van Vechten and the Irreverent Decades* (Norman: University of Oklahoma Press, 1968), 285.

129 "thrived on his own": Anderson, *This Was Harlem*, 214.

129 "Occasionally, she came to": Bruce Kellner, *Keep A Inchin'* (Westport, CT: Greenwood Press, 1979), 167.

129 "When I got there": Waters with Samuels, *His Eye Is on the Sparrow*, 195.

129 "I don't eat caviar": "Ethel Turns 'Philosopher,'" *Pittsburgh Courier*, February 25, 1928, 3.

130 "I've seen a lot": Emily Bernard, ed., *Remember Me to Harlem: The Letters of Langston Hughes and Carl Van Vechten* (New York: Alfred A. Knopf, 2001), 56.

130 "Her innate shyness and": Dismond, "Through the Lorgnette of Geraldyn Dismond," *Pittsburgh Courier*, September 17, 1927, np.

130 "At any rate, it": Kellner, *Keep A Inchin'*, 167

130 "She came to me": Zora Neale Hurston, *Dust Tracks on a Road* (Philadelphia: J. Lippincott, 1942), 197.

131 "one of the strangest": Ibid., 199.

131 "I broke down part": Kellner, *Keep A Inchin'*, 167.

131 "Ethel, you never ask": Waters with Samuels, *His Eye Is on the Sparrow*, 198.

132 "for admission to the": "Ethel Waters' 'New Vanities' and Latest Affair of the Heart Keeping Her Before Public Spotlight," *Pittsburgh Courier*, March 20, 1926, 1.

132 "the main floor—and": "President of T.O.B.A. Jim Crows Patrons in Nashville Theatre," *Pittsburgh Courier*, May 8, 1926, 10.

134 "This class of performance": *Pittsburgh Courier*, January 1, 1927, np.

134 "Miss Waters created a furor": *Pittsburgh Courier*, January 8, 1927, np.

135 "In consequence of the": *Pittsburgh Courier*, January 15, 1927, np.

135 "While there was more": Ibid.

135 "probably deluding themselves": "Criticizes Stage Star, Attacked," *Pittsburgh Courier*, February 12, 1927.

136 "were hurled from the": Ibid.

## Chapter 5 • Broadway Beckons

Two excellent sources for the history of African Americans on Broadway have been James Weldon Johnson's *Black Manhattan* and Allen Woll's *Black Musical Theatre: From Coontown to Dreamgirls*.

140 "Negroes should look to": Allen Woll, *Black Musical Theatre: From Coontown to Dreamgirls* (New York: Da Capo Press, 1991), 6.

140 "had thrown all these": Johnson, *Black Manhattan*, 173

142 "In the 'Broadway' houses": Johnson, *Along the Way*, 202.

143 "combined noble sentiments with": Lewis, *When Harlem Was in Vogue*, 99.

145 "You know, I don't": Bide Dudley, "Africana," *New York Daily Mail*, July 2, 1927, np.

145 "gave a generous series": Ibee, "Prancin,'" July 12, 1927, CF.

145 "Each time she answered": W. Rollo Wilson, "Africana," *Pittsburgh Courier*, September 17, 1927, 2.

146 "It has no music": Ibee, "Prancin'," July 12, 1927, CF.

146 "Strange the colored folk": Burns Mantle review of *Africana* in *New York Daily News*. Reprinted: "Africana and the Midnight Matinees," *Pittsburgh Courier*, September 3, 1927, 3.

146 "while Edith is around": H. B., "Edith Waters, a Harlem Favorite, Saves the Show in 'Africana,'" *New York World*, July 12, 1927, np.

146 "by the presence of": Ibee, "Prancin,'" July 12, 1927, CF.

146 "For the most part": E.B.W. [E. B. White], "Texas White Magic—The Forces of Darkness," *The New Yorker*, July 23, 1927, 36.

147 "traditional pattern of Negro": Johnson, *Black Manhattan*, 210.

147 "They do say that": Wilson, "Africana," *Pittsburgh Courier*, September 17, 1927, 2.

147 "pure African, made entirely": "Ethel Waters Coming to Nixon Theater Next Week," *Pittsburgh Courier*, January 21, 1928, 2.

148 "a pioneer in a new": *Pittsburgh Courier*, CF.

148 "When any of our": "'Africana' Endorsed by N.Y. Preachers," *Pittsburgh Courier*, August 24, 1927, 2.

148 "is one of the": Floyd Calvin, "Prominent New Yorkers Congratulate Ethel Waters on 'Africana' Success," *Pittsburgh Courier*, July 30, 1927, np.

148 "Ethel Waters' *Africana* is": Bernard, ed., *Remember Me to Harlem*, 56.

149 "possess one of the": Viola Woodlyn James, "New York Society," *Pittsburgh Courier*, August 20, 1927, 7.

149 "Ethel Waters, now starring": *Pittsburgh Courier*, August 27, 1927, CF.

151 "Through my friend Carl": Dancer, "Flo Ziegfeld Sees, Is Conquered by Ethel; Earl Arrives as Star Maker," *Amsterdam News*, March 18, 1950, CF.

153 "is considered a great": Chappy Gardner, "Along the Rialto," *Pittsburgh Courier*, October 1, 1927, 3.

153 "Ethel was shoved all": Dancer, "Flo Ziegfeld Sees, Is Conquered by Ethel; Earl Arrives as Star Maker," *Amsterdam News*, March 18, 1950, np.

153 "As is usual in": Gardner, "Along the Rialto," *Pittsburgh Courier*, October 1, 1927, 3.

153 "On opening performance": Dancer, "Flo Ziegfeld Sees, Is Conquered by Ethel; Earl Arrives as Star Maker," *Amsterdam News*, March 18, 1950, CF.

153 "Probably honors went, by": "Variety of Singers Entertain at Palace," *New York Times*, September 20, 1927, 33.

154 "Ethel Waters at the": "White Star Quits," *Pittsburgh Courier*, October 11, 1927, 3.

155 "He had blackbirds flown": Author interview with Maude Russell for the

PBS/German Educational Television documentary series *Brown Sugar: Eighty Years of America's Black Female Superstars.*

155 "The white newspapers played": "Bitterness May Follow Florence Mills Funeral," *Pittsburgh Courier,* November 19, 1927, 1.

156 "the most dynamic colored": "Theatrical Critics Throughout Country Sing Praise of Ethel Waters in Her Big Revue, 'Africana,'" *Pittsburgh Courier,* January 28, 1929, 2.

157 "a revolver looking for": Bernard, *Remember Me to Harlem,* 56.

157 "Everything appeared to be": "'Africana' Will Not Be Able to Show in London—Dancer," *Pittsburgh Courier,* January 21, 1928, Second Section, 2.

157 "At the close of": Gardner, "Along the Rialto," *Pittsburgh Courier,* July 14, 1928, 2.

158 "We didn't get paid!": Waters with Samuels, *His Eye Is on the Sparrow,* 193.

159 "Get Up off Your Knees": *Pittsburgh Courier,* January 8, 1928, Illustrated Features Section, 3.

159 "Organ Grinder Blues": *Pittsburgh Courier,* November 17, 1928, Illustrated Features Section, 5.

159 "secreting mortgaged property": "Two Stage Celebrities Come Without Range of Long Arms of John Law," *Pittsburgh Courier,* September 15, 1928, Second Section, 1.

160 "Miss Waters Owes $50,000": "Ethel Waters of 'Africana' Files Petition for Bankruptcy," *Amsterdam News,* September 26, 1928, 7.

160 "I thought that being": Waters with Samuels, *His Eye Is on the Sparrow,* 201.

161 "I was bitter with": Ibid., 202.

161 "exclusive of my pay": Ibid., 197.

162 "la grippe and acute": "'Deep Harlem' Producer, Ill," *Pittsburgh Courier,* December 1, 1928, 8.

## Chapter 6 • Stretching Boundaries: Hollywood and Europe

166 "for eight years before": Ethel Waters, "The Men in My Life," *Ebony,* 1952, 34.

169 "I wanted Robeson for": Author interview with King Vidor.

169 "The talent man Vidor": Waters with Samuels, *His Eye Is on the Sparrow,* 198.

169 "Crowds from all over": "Ethel Waters in Golden West," *Pittsburgh Courier,* February 16, 1929, Third Section, 1.

170 "I just match the": Fred W. Cousins, "Songs of Own Dire Need Bring Ethel Riches, Joy," *Detroit News,* October 9, 1936, np.

170 "You drive a pretty": Waters with Samuels, *His Eye Is on the Sparrow,* 199.

175 "To the best of": "Who's Ethel Waters' Newest Husband," *Baltimore Afro-American,* August 10, 1929, np.

176 "Hits Boulevards of Gay": *Chicago Defender*, August 17, 1929, np.

177 In New York, her physician: The specialist is identified as Dr. M. Wicant in *Baltimore Afro-American*, November 30, 1929. In *His Eye Is on the Sparrow*, the physician is identified as Dr. Weisant.

178 "None of you spoke": Waters with Samuels, *His Eye Is on the Sparrow*, 207.

178 "several of Europe's leading": J. A. Rogers, "Ethel Waters Still London Sensation," *Baltimore Afro-American*, December 28, 1929, CF.

179 "She was the talk": Bricktop with James Haskins, *Bricktop* (New York: Atheneum, 1983), 183.

180 "I never birthed no": Ethel Waters, *To Me It's Wonderful* (New York: Harper and Row, 1972), 25.

181 "at this present age": Ethel Waters, Letter, James Weldon Johnson Collection, Yale Collection of American Literature, Beinecke Rare Book Manuscript Library, Yale University.

181 "Ethel Waters as Bernice": Mordaunt Hall, " 'Broadway' as a Film," *New York Times*, June 2, 1929, CF.

181 "The stage portion is mostly": *Variety*, June 5, 1929, CF.

181 "For anyone who wants": Pauline Kael, "On with the Show," *5001 Nights at the Movies* (New York: Henry Holt, 1991), 547.

182 "to select": "British May Censor Ethel Waters' Songs," *Chicago Defender*, November 2, 1929, np.

183 "Ethel Waters continues to": J. A. Rogers, "Ethel Waters Still London Sensation," *Baltimore Afro-American*, December 28, 1929, CF.

## Chapter 7 • Depression-Era Blues, Depression-Era Heroine

187 "Dressed in the latest": "Lew Leslie Will Open Sept. 1," *Pittsburgh Courier*, August 30, 1930, A6.

191 "Sure enough": Barry Singer, *Black and Blue: The Life and Lyrics of Andy Razaf* (New York: Schirmer Books, 1992), 247.

191 "blacking brown faces": Brooks Atkinson, "The Play," *New York Times*, October 23, 1930, 40.

192 "Our show was a": Waters with Samuels, *His Eye Is on the Sparrow*, 215.

194 "There is no doubt": Chappy Gardner, "Lew Leslie's 'Blackbirds' Close on Broadway," *Pittsburgh Courier*, December 13, 1930, A8.

194 "Knowing the Negro as": Floyd G. Snelson Jr., "Leslie's 'Rhapsody in Black' Sounds a New Note in Theatricals," *Pittsburgh Courier*, May 9, 1931, 8A.

196 "It was something quite": George B. Murphy Jr., "Ethel Waters Wants to Play Scarlet Sister," *Baltimore Afro-American*, 1931, CF.

196 "It lacks the punch": John Mason Brown, "The Play," *Evening Post*, May 5, 1931, 12.

196 "It is Harlem oratorio": Gilbert W. Gabriel, "Rhapsody in Black," *The American*, May 5, 1931, np.

197 "After complaining so often": "New Yorker Praises Leslie for Giving Race Actors Something 'Worthy of Their Talent,'" *Pittsburgh Courier*, June 6, 1931, B7.

197 "a new step forward": Snelson Jr., "Leslie's 'Rhapsody in Black' Sounds a New Note in Theatricals," *Pittsburgh Courier*, May 9, 1931, 8A.

197 "This lady's personality has": "New Yorker Praises Leslie for Giving Race Actors Something 'Worthy of Their Talent,'" *Pittsburgh Courier*, June 6, 1931, B7.

197 "Mr. Leslie has tried": Walter Winchell, "'Rhapsody in Black' Opens: Departure in Sepia Shows," *New York Mirror*, May 5, 1931, CF.

197 "What did this man": Ben Washer, "Ethel Waters Likes Changes of Songs in Lew Leslie's Show 'Rhapsody in Black,'" *New York World-Telegram*, Reprinted in *Chicago Defender*, May 23, 1931, 5.

198 "filing her nails": Murphy Jr., "Ethel Waters Wants to Play 'Scarlet Sister,'" *Baltimore Afro-American*, 1931, CF.

203 "It tears my heart": Julia McCarthy, "Star by Meditation, says Ethel Waters," *New York Daily News*, January 17, 1939, CF.

203 "her husband, Eddie Matthews": Jay Gould, "Race Track Gossip," *Chicago Defender*, February 16, 1935, 17.

203 "What she wanted": Rob Roy, "Cash No Longer Yardstick in Stars' Romance, Marriage," *Chicago Defender*, May 29, 1954, 19.

205 "Negroes sit in the": Chappy Gardner, "Negroes Jim-Crowed in the Theaters in Atlantic City, N.J.," *Pittsburg Courier*, July 11, 1931, A8.

205 "I learned from good": Chappy Gardner, "Chappy Gardner—Says," *Pittsburgh Courier*, August 22, 1931, A9.

207 "as one of the": "Ethel Waters Tells of Race's Contribution to Art and Stage," *Chicago Defender*, May 28, 1932, 3.

## Chapter 8 • Broadway Star

210 "the cream of sepia": Edward Jablonsky, *Harold Arlen: Happy with the Blues* (New York: Da Capo Press, 1986), 54.

211 "There were brutes": Ibid., 53.

211 "The chief ingredient was": Ibid., 55.

213 "the Negro-est white man": John Lahr, "Come Rain or Come Shine," *The New Yorker*, September 19, 2005, 89.

213  "I'll work on it": Waters with Samuels, *His Eye Is on the Sparrow*, 220.

214  "is the greatest of": "Ethel Waters Says Duke Is Best of All," *Chicago Defender*, July 1, 1933, 5.

214  "My dear, she wrote": Gail Lumet Buckley, *The Hornes: An American Family* (New York: Alfred A. Knopf, 1986), 165.

215  "That song was the perfect": Waters, "The Men in My Life," *Ebony*, January 1952, 34.

216  "the biggest song hit": A. H. Lawrence, *Duke Ellington and His World* (New York: Routledge, 2001), 191.

217  "Did you ever hear": Laurence Bergreen, *As Thousands Cheer: The Life of Irving Berlin* (New York: Viking Press, 1990), 316.

219  "I've never missed a": Ibid., 318.

219  "part vitriol and part": Steven Bach, *Dazzler: The Life and Times of Moss Hart* (New York: Alfred A. Knopf, 2001), 108.

220  "I'll show them bitches": Author interview with Joan Croomes.

221  "the most unusual song": Bach, *Dazzler*, 110.

221  "I couldn't sleep": Waters with Samuels, *His Eye Is on the Sparrow*, 221.

222  "Thought you'd like to": Pearl White, Note, James Weldon Johnson Collection, Yale University.

223  "Her attitude to her": Marvel Cooke, "Ethel Waters Does Best amid Turmoil," *Amsterdam News*, July 6, 1935, 7.

223  "with a dash of": Wilson, "V: Ethel Waters—Torch Singer to Dramatic Actress," *New York Post*, December 6, 1940, np.

223  "You might just as": Al Monroe, "Swinging the News," *Chicago Defender*, March 18, 1944, 8.

223  "I'm the kind of": Wilson, "V: Ethel Waters—Torch Singer to Dramatic Actress."

223  "She was very religious": Author interview with Maude Russell.

224  "The song is a": Russell Lee Lawrence, "I'm Not Afraid to Die, Honey . . . I Know the Lord Has His Arms Around This Big Fat Sparrow," *Philadelphia Bulletin*, October 21, 1973, 14.

224  "It's your show": Bach, *Dazzler*, 110.

225  "There's nothing I like": Ibid., 108.

227  "If one song can": Waters with Samuels, *His Eye Is on the Sparrow*, 222.

228  "moved slowly down to": Helen Dundar, "On the Road with Carol Channing," *New York Post*, November 11, 1969, np.

228  "a superb panorama of": Brooks Atkinson, "The Play," *New York Times*, October 2, 1933, 22.

229  "Once the show got": Cooke, "Ethel Waters Does Best amid Turmoil," *Amsterdam News*, July 6, 1935, 7.

229 "For several weeks, Ethel": "Ethel Waters Gets Contract," *Chicago Defender*, September 23, 1933, 5.

230 "If there was the": George Wein and Nate Chinen, *Myself Among Others* (New York: Da Capo Press, 2004), 95.

230 "quality of their": Frank Driggs, liner notes, *Ethel Waters' Greatest Years*, Columbia Records, 1973.

231 "When you hear Ethel": Bruce Kellner, *Radio Stars*. Reprinted in *Looking at the Stars* by Ralph Matthews, *Baltimore Afro-American*, December 16, 1937, CF.

232 "Lovely Jewels and Clothes": "Lovely Jewels and Clothes Have Not 'Made' the Great Ethel, but They Have Glorified Her," *Pittsburgh Courier*, December 12, 1933, 8.

234 "Rumors are going the": "South Hits Ethel Waters' Air Contract," *Pittsburgh Courier*, January 20, 1934, A6.

234 "Ethel Waters' Sponsors Cut": *Pittsburgh Courier*, February 17, 1934, CF.

234 "South Demands Ethel Waters": *Chicago Defender*, February 17, 1934, 5.

236 "knew all the time": "Ethel Waters and Hubby O.K. Apart," *Chicago Defender*, June 9, 1934, 9.

237 "sumptuous seven room apartment": Moten, "'Trust in God' Is Secret of Ethel Waters' Stage Success," *Washington Tribune*, August 11, 1936, np.

238 "the premiere singing actress": "Ethel Waters Is Honored Guest; Harlem Celebrities," *Chicago Defender*, May 12, 1934, 8.

239 "The response of the": "Fashionable '400' in Tears as Ethel Waters Croons Campaign Theme Song," *Pittsburgh Courier*, June 2, 1934, 8.

240 "a seemingly endless troop": Lois Taylor, "Backstage at the Benefit," *Pittsburgh Courier*, June 23, 1934, A7.

242 "the subtle implication in": Ralph Matthews, "An Open Letter to Miss Ethel Waters," *Baltimore Afro-American*, April 5, 1934, np.

## Chapter 9 • A Woman of the People, Back on Broadway

245 "infrequent interviews": "Ethel Waters Craves for Serious Roles," *Pittsburgh Courier*, October 6, 1934, 8.

246 "guest in fashionable white": *Pittsburgh Courier*, November 17, 1934, CF.

246 "Happiness was heavy in": Fred W. Cousins, "Songs of Own Dire Need Bring Ethel Riches, Joy," *Detroit News*, October 9, 1934, CF.

246 "Miss Waters was attractively": "Fete Ethel Waters in Motor City," *Pittsburgh Courier*, October 27, 1934, 8.

247 "While she was singing": Conrad Clark, "Twas 'Stormy Weather' When Ethel Met Him," *Baltimore Afro-American*, February 26, 1938, 10.

249  "Queen of Waitresses": Cephus Jones, "Chicago Waitresses Do Charity Bit," *Chicago Defender*, December 1, 1934, 8.

249  "One of the most": Ethel Waters, "Ethel Waters Thinks 'Stevedore' Is Fine Play," *Chicago Defender*, December 15, 1934, 8.

251  "She was a unique": Elia Kazan, *A Life* (New York: Alfred A. Knopf, 1988), 374.

252  "of the white actors": "'As Thousands Cheer' Revamped for Dixie," *Pittsburgh Courier*, March 16, 1935, A9.

253  "Ridiculous": "Race Is Barred from 'As Thousands Cheer' in Tenn.," *Chicago Defender*, March 23, 1935, 1.

254  "introduced them to the": Moten, " 'Trust in God' Is Secret Ethel of Waters' Stage Success," *Washington Tribune*, August 11, 1936, CF.

256  "Nobody else in this": Ashton Stevens review in *Chicago American*, reprinted in "Chicago Turns Out to Greet Ethel Waters," *Chicago Defender*, June 15, 1935, 7.

258  "whistling, wise-cracking, gun-snapping, foot-stamping": Cooke, "Ethel Waters Does Best amid Turmoil," *Amsterdam News*, July 6, 1935, 7.

259  "The Shuberts had started": Vincente Minnelli with Hector Acre, *I Remember It Well* (New York: Doubleday, 1974), 68.

260  "I would also have": Ibid., 69.

260  "The concept was to": Ibid., 70.

261  "We started rehearsing in": Ibid.

262  "She was a huge": Ibid., 72.

266  "Miss Waters can do": *Variety*, September 25, 1936, np.

## Chapter 10 • A Chance Encounter

269  "After the cyclonic career": Brooks Atkinson, "The Play," *New York Times*, January 31, 1936, 17.

269  "In sex appeal to": "The Theatre," *Time*, February 10, 1936, np.

270  "I still felt like": Waters with Samuels, *His Eye Is on the Sparrow*, 238.

271  "There was no 'I'm'": Ibid., 238.

271  "But this is very": Ibid.

271  "I nearly dropped dead": Mabel Green, "Ethel Waters Gets Her Wish," June 2, 1939, CF.

273  "I explained that Mamba's": Waters with Samuels, *His Eye Is on the Sparrow*, 238.

273  "I told her I": Green, "Ethel Waters Gets Her Wish," June 2, 1939, CF.

274  "Would you some day": "Daughter of Mamba," *New York Times*, January 1, 1939, CF.

274 "Well, when she said": Green, "Ethel Waters Gets Her Wish," June 2, 1939, CF.

275 "Ethel Waters rakes in": Jay Gould, "Race Track Gossip," *Chicago Defender*, September 7, 1935, 14.

275 "had influenced other members": Earl T. Morris, "Names of Ethel Waters, 'Jo' Baker on Tongues of Broadway, Harlem," *Pittsburgh Courier*, February 15, 1936, 7.

276 "I couldn't hog her": "Now, What's the Rub in the Broadway Snub?" *Amsterdam News*, February 15, 1936, 8.

276 "This article alleged that": *Chicago Defender*, February 15, 1936, 9

276 "My dear Ethel": Morris, "Names of Ethel Waters, 'Jo' Baker on Tongues of Broadway, Harlem," *Pittsburgh Courier*, February 15, 1936, 7.

277 "The real tiff was": "Now, What's the Rub in the Broadway Snub?" *Amsterdam News*, February 15, 1936.

277 "how much pleasure": Jean-Claude Baker and Chris Chase, *Josephine: The Hungry Heart* (New York: Random House, 1993), 193.

277 "Talk the way yo'": Lynn Haney, *Naked at the Feast: A Biography of Josephine Baker* (New York: Dodd, Mead, 1981), 201.

278 "But still certain professional": "Now, What's the Rub in the Broadway Snub?" *Amsterdam News*, February 15, 1936, 8.

278 "Every performance [for] a": Lucius Beebe, "Stage Asides," *New York Herald Tribune*, December 25, 1938, np.

278 "I just happened to": "Now, What's the Rub in the Broadway Snub?" *Amsterdam News*, February 15, 1936, 8.

278 "Bone structure like": "English Authority Says Ethel Waters Is 'Perfect Example of Modern Beauty," *Pittsburgh Courier*, March 14, 1936, A6.

## Chapter 11 • Waiting for *Mamba*

281 "I suppose you know": Waters, Letter, James Weldon Johnson Collection, Yale University.

281 "an entire prepared radio": Joe Richards, "Jo Baker Could Give Jesse Owens a Few Pointers, Boys," *Chicago Defender*, September 12, 1936, 20.

282 "due to low wind": "Harlem Airman and Youth Die in Crash," *Amsterdam News*, July 18, 1936, 1.

282 "Mom thought she knew": Billie Holiday with William Dufty, *Lady Sings the Blues* (New York: Lancer Books, 1969), 64. In *Lady Sings the Blues*, Billie Holiday wrote of her encounter with Ethel Waters at the Nixon Grand in Philadelphia, but she stated that Duke Ellington and the Brown Sisters were also on the bill. It appears, however, that Ellington was not a headliner at this engagement.

283 "Pearl was as mean": Author interview with Bobby Short.

283 "Ethel Waters was an": Wein and Chinen, *Myself Among Others*, 95.

284 "We got very fond": Waters with Samuels, *His Eye Is on the Sparrow*, 227.

286 "Darling Pal": Waters, Letter, James Weldon Johnson Collection, Yale University.

287 "she would sing much": "Talk of the Town," *Pittsburgh Courier*, March 6, 1937, 9.

287 "the girl who came": Jay Gould, "Race Track Gossip," *Chicago Defender*, March 13, 1937, 16.

288 "Ethel Waters, awaiting a": "Grand Town Editor Advises 'Skip It . . . And Fo'get It,'" *Pittsburgh Courier*, March 6, 1937, 19.

288 "triumphed at the Paramount": Philip K. Scheuer, "Stage Show High Light of New Bill," *Los Angeles Times*, January 29, 1937, A16.

284 "I love my people": "Kansas City People Stage 'Sit at Home' Strike Against Ethel Waters," *Pittsburgh Courier*, March 6, 1937, 24.

284 "cried onstage because": "Victim of Race Boycott," *Pittsburgh Courier*, March 13, 1937, 19.

289 "The famous singer was": "Kansas City People Stage 'Sit at Home' Strike Against Ethel Waters," *Pittsburgh Courier*, March 6, 1937, 24.

289 "One of the advantages": Theophilus Lewis, "The Theatre of Life," *Pittsburgh Courier*, March 27, 1937, 18.

## Chapter 12 • Living High

291 "While the show's billing": "Celebrities See Cotton Club's New Show," *Chicago Defender*, March 27, 1937, 20.

293 "Maybe it's a gag": Earl J. Morris, "Grand Town," *Pittsburgh Courier*, October 2, 1937, 20.

294 "with all the necessary": "Ethel Waters Buys 20-Family Apartment," *Chicago Defender*, September 18, 1937, 3.

294 "she frequently goes to": Wilson, "V: Ethel Waters—Torch Singer to Dramatic Actress," *New York Post*, December 6, 1940, np.

295 "If you will accept": Waters, Letter, James Weldon Johnson Collection, Yale University.

297 "He could play to": Waters with Samuels, *His Eye Is on the Sparrow*, 232.

298 "She thought that they": Young, Oral History Transcripts, Institute of Jazz Studies at Rutgers University.

298 "After all, it was": Waters with Samuels, *His Eye Is on the Sparrow*, 229.

299 "the foremost lady of": "Public Mingles With Stars at Guild Ball," *Amsterdam News*, March 5, 1938, 16.

300 "hasn't been around since": "Gossip of the Rialto," *New York Times*, March 6, 1938, 149.

300 "I'm no has-been": "'I'm Not a Has Been' Declares Ethel Waters Answering Critics," *Pittsburgh Courier*, April 21, 1938, 16.

300 "Dear Ethel Waters": Porter Roberts, "Praise and Criticism," *Pittsburgh Courier*, May 21, 1938, 21.

301 "My approach would be": Vincente Minnelli with Hector Acre, *I Remember It Well* (New York: Doubleday, 1974), 103.

303 "DuBose arranged an appointment": Waters with Samuels, *His Eye Is on the Sparrow*, 242.

304 "I nearly passed out": Waters, Letter, James Weldon Johnson Collection, Yale University.

306 "He was tall and slender": Author interview with Jim Malcolm.

307 "it was difficult to": "Ethel Waters Sings," *New York Sun*, November 12, 1938, np.

307 "Since Miss Waters is": "Other Music in Review," *New York Times*, November 21, 1938, 15.

## Chapter 13 • *Mamba's Daughters,* at Last

310 "I just walked into": Taylor with Cook, *Alberta Hunter: A Celebration in Blues*, 143.

310 "No, no, no": "Jerome Kern Saved the Day with 'Lonesome Walls,'" *Journal-American*, January 15, 1939, CF.

311 "I don't plan": McCarthy, "Star by Meditation, Says Ethel Waters," *New York Daily News*, January 17, 1939, CF.

311 "I've got to rest": Elliot Arnold, " 'I'm No Actress'—Ethel Waters Collapses After Ovation," *New York World Telegram*, January 21, 1939, CF.

311 "She was the kind": Taylor with Cook, *Alberta Hunter: A Celebration in Blues*, 147.

312 "Everyone had to like": Ibid., 146.

312 "She was suspicious of": Author interview with Fredi Washington.

313 "I was a teenager": Julie Harris interview in Rick McKay's *Broadway: The Golden Age: One Filmmaker's Search for a Broadway That Was Lost, and the 100 Legends That He Found*, DADA Films, DVD.

314 "Seldom have I seen": Van Vechten, "*Mamba's Daughters*: A Review," CF.

314 "I'll never forget that": Taylor with Cook, *Alberta Hunter: A Celebration in Blues*, 143.

314 "the greatest actress of": *New York Sun News*, May 18, 1941, CF.

315 "howling for her": Arnold, " 'I'm No Actress'—Ethel Waters Collapses After Ovation," *New York World Telegram*, January 21, 1939, CF.

315 "I just bawled": Mabel Green, "Ethel Waters Gets Her Wish," January 2, 1939, CF.

315 "I get choked and": Arnold, " 'I'm No Actress'—Ethel Waters Collapses After Ovation," *New York World Telegram*, January 21, 1939, CF.

315 "A performance such as": *Amsterdam News*, February 25, 1939, 17.

315 "the Negro's progress in": Van Vechten, "*Mamba's Daughters*: A Review," CF.

316 "limp, plodding style, which": Brooks Atkinson, "The Play," *New York Times*, CF.

316 "The undersigned feel that": *New York Times*, January 6, 1939, 28.

317 "Dear Fania and Carl": Waters, Letter, James Weldon Johnson Collection, Yale University.

317 "Perhaps it was the": Brooks Atkinson, "Concerning Mamba's Daughters," *New York Times*, January 15, 1939, CF.

318 "They said such fine": Arnold, " 'I'm No Actress'—Ethel Waters Collapses After Ovation," *New York World Telegram*, January 21, 1939, CF.

319 "The emotion of the": "Ethel Waters Gets Her Wish," June 2, 1939, CF. No publication listed.

319 "There were Haig and Haig": Thelma Berlack-Boozer, "Lorde Churchill Has Party-of-the-Week," *Amsterdam News*, January 21, 1939, 8.

320 "required her to sit": Doris Kearns Goodwin, *No Ordinary Time: Franklin & Eleanor Roosevelt: The Home Front in World War II* (New York: Touchstone, 1995), 163.

321 "Mrs. Roosevelt, please hug": Nahum Daniel Brascher, "Random Thoughts," *Chicago Defender*, March 18, 1939, 17.

321 "Ethel Waters really achieved": Eleanor Roosevelt, "My Day," *New York World Telegram*, CF.

321 "Stay till the last": Johnson, *Black Manhattan*, 207.

322 "Being Hagar softened me": Waters with Samuels, *His Eye Is on the Sparrow*, 249.

322 "Later she wrote me": Taylor with Cook, *Alberta Hunter: A Celebration of the Blues*, 147.

323 "It was obvious that": Author interview with Ossie Davis.

## Chapter 14 • Eddie

326 "Every night is an": "Ethel Waters Recalls Being Stranded in 1931," *Chicago Defender*, December 2, 1939, 15.

326 "40 suits with shirts": Tommy Berry, "Eddie Mallory, America's Best Dressed Bronze Actor," *Chicago Defender*, January 1, 1938, 18.

327 "a big slice of": Waters with Samuels, *His Eye Is on the Sparrow*, 240.

327 "When in New York": *Pittsburgh Courier*, May 11, 1940, np.

328 "*Mamba's Daughters* was the": Helen Ormsbee, "A Mirror, and Her Simplicity, Only School for Ethel Waters," *New York Herald Tribune*, November 10, 1940, CF.

329 "Miss Waters' performance was": "Television Reviews," *Variety*, June 21, 1939, CF.

330 "had been approached—separately": "New Show Will Star Miss Ethel Waters," *Chicago Defender*, June 3, 1939, 20.

330 "shopping for a serious": "Busy Man Bojangles," *Amsterdam News*, March 25, 1939, 20.

332 "Ethel Waters was doing": "Ashton Stevens," *Chicago Herald American*, October 3, 1939, CF.

332 "I had to overcome": "Ethel Waters Tells Sorors 'Power of Prayer,'" *Pittsburgh Courier*, November 25, 1939, 10.

333 "For what was the": Waters with Samuels, *His Eye Is on the Sparrow*, 251.

333 "I tried to be": Ibid., 252.

334 "Your telegram addressed to": "Fight Theatre Bar in Capital," *Pittsburgh Courier*, January 27, 1940, 1.

336 "I couldn't do the": Ormsbee, "A Mirror, and Her Simplicity, Only School for Ethel Waters," *New York Herald Tribune*, November 10, 1940, CF.

337 "something prevents me": Waters with Samuels, *His Eye Is on the Sparrow*, 241.

## Chapter 15 • On the Run

339 "after having lived prosperously": Bernard Taper, *Balanchine: A Biography* (New York: Times Books, 1984), 195.

339 "Do you think I'd": Ormsbee, "A Mirror, and Her Simplicity, Only School for Ethel Waters," *New York Herald Tribune*, November 10, 1940, CF.

340 "Her performance with her": John Lee Martin, "The Dance: A Negro Art," *New York Times*, February 25, 1940, 114.

342 "Anybody who could make": Gail Lumet Buckley, *The Hornes: An American Family*, 164.

343 "Oh, everybody knew Archie": Author interview with Lennie Bluett.

343 "We gave a preview": Ormsbee, "A Mirror, and Her Simplicity, Only School for Ethel Waters," *New York Herald Tribune*, November 10, 1940, CF.

344 "Exciting up to the": Richard Watts, *New York Herald Tribune*, CF.

344 "Ethel Waters has never": Brooks Atkinson, "The Play," *New York Times*, October 26, 1940, 19, CF.

344 "light and amusing": Eleanor Roosevelt, "My Day," *New York World Telegram*, November 11, 1940, CF.

344 "The Venetian blinds were": Sidney Shallett, "Harlem's Ethel Waters," *New York Times*, November 10, 1940, 149.

346 "I used to have": Earl Wilson, "V: Ethel Waters—Torch Singer to Dramatic Actress," *New York Post*, December 6, 1940, CF.

## Chapter 16 • California Dreaming

353 "Again and again was": Edwin Schallert, " 'Cabin in Sky' Unique Event of Operetta Season," *Los Angeles Times*, June 10, 1941, 15.

354 "Everyone of importance with": Fay M. Jackson, "Todd Duncan Ill on Coast," *Amsterdam News*, July 19, 1941, 21.

355 "Words aren't sufficient to": John C. Scott, "Ethel Waters Hit in Biltmore Drama," *Los Angeles Times*, September 11, 1941, A10.

356 "got on the phone": "Dan Burley's Back Door Stuff," *Amsterdam News*, September 13, 1941, 15

## Chapter 17 • Settling In

360 "Everyone was impressed because": Author interview with Lennie Bluett. Other comments by Bluett in this chapter are from the same interview.

361 "I didn't have that": "Hedda Hopper's Hollywood," *Los Angeles Times*, November 27, 1941, 17.

361 "Yes, I've at last": Waters, Letter, James Weldon Johnson Collection, Yale University.

362 "She had the most": Donald Bogle, *Dorothy Dandridge: A Biography* (New York: Amistad Press, 1997), 96.

362 "This is where I'm": Waters, Letter, James Weldon Johnson Collection, Yale University.

363 "She is gay and": Hurston, *Dust Tracks on a Road*, 201.

363 "the affair is on": Ibid., 200.

363 "One day I sat": Ibid., 201.

365 "At this writing I'm": Waters, Letter, James Weldon Johnson Collection, Yale University.

365 "My studio wanted Ethel": "Hollywood Liked Everything About Miss Ethel Waters but the Price on Her Work," *Chicago Defender*, April 11, 1942, 23.

365 "It's because of the": Waters, Letter, James Weldon Johnson Collection, Yale University.

365 "At last I'm throwing": Waters, Letter, James Weldon Johnson Collection, Yale University.

367 "shows a gain of": "Rowe's Note Book," *Pittsburgh Courier*, March 14, 1942, 20.

368 "Because of picture work": Savage, Letter, James Weldon Johnson Collection, Yale University.

369 "ganged up afterward and": "Hedda Hopper's Hollywood," *Los Angeles Times*, April 20, 1942, A8.

370 "a difficult piece": Savage, Letter, James Weldon Johnson Collection, Yale University.

370 "And a lot of": "Dan Burley's Back Door Stuff," *Amsterdam News*, June 20, 1942, 16.

370 "They seem to be": Savage, Letter, James Weldon Johnson Collection, Yale University.

371 "stunk and at this": Savage, Letter, James Weldon Johnson Collection, Yale University.

374 "I think it's O.K.": Savage, Letter, James Weldon Johnson Collection, Yale University.

376 "To this day Negroes": Hugh Fordin, *The World of Entertainment: Hollywood's Greatest Musicals* (Garden City, NY: Doubleday, 1975), 74.

377 "discourage the making of": Lawrence F. LaMar, "Coast Citizens Picket House Using Film 'Tales of Manhattan,'" *Chicago Defender*, August 28, 1942.

377 "leaves much to be": Marian Freeman, "Paul Robeson, Ethel Waters Let Us Down," *Amsterdam News*, August 15, 1942, 15.

378 "only after he had": "Robeson Replies to Critics of Role in 'Tales of Manhattan,'" *Pittsburgh Courier*, September 5, 1943, 21.

378 "The criticism being leveled": "Robeson Agrees His Role in Tales of Manhattan Was Insulting to Race," *Amsterdam News*, September 5, 1942, 14.

378 "If they picket the": "Robeson Replies to Critics of Role in 'Tales of Manhattan,'" *Pittsburgh Courier*, September 5, 1943, 21.

## Chapter 18 • The Making of *Cabin*

380 "We made the picture": Fordin, *The World of Entertainment: Hollywood's Greatest Musicals*, 76.

380 "If there were any": Minnelli with Acre, *I Remember It Well*, 121.

381 "You are to be": Fordin, *The World of Entertainment: Hollywood's Greatest Musicals*, 74.

383 "because Woody Van Dyke": "Hedda Hopper's Hollywood," *Los Angeles Times*, May 5, 1942, 22.

383 "Wise, astute Harold Gumm": Albert Anderson, "Lena Horne Mum on Marriage to Young Arranger," *Pittsburgh Courier*, September 32, 1946, 1.

384 "appreciate what I have": Savage, Letter, James Weldon Johnson Collection, Yale University.

385 "When I had to work": Lena Horne, PBS series *Brown Sugar: Eighty Years of America's Black Female Superstars.*

385 "Because of her own": Gail Lumet Buckley, *The Hornes: An American Family*, 164.

385 "Miss Waters did have": Lena Horne and Richard Schickel, *Lena* (Garden City, NY: Doubleday, 1965), 152.

385 "extreme distrust of the": Ibid., 151.

385 "go off on a corner": Author interview with Lennie Bluett. Other comments by Bluett in this chapter are from the same interview.

386 "Georgia, ain't it time": Author interview with Joan Croomes. Other comments by Croomes in this chapter are from the same interview.

386 "I was kind of": Fordin, *The World of Entertainment: Hollywood's Greatest Musicals*, 76.

387 "Ethel had put a hex": Horne and Schickel, *Lena*, 153.

387 "Be real small": Buckley, *The Hornes: An American Family*, 165.

387 "Miss Waters started to": Horne and Schickel, *Lena*, 154.

387 "She flew into a": Buckley, *The Hornes: An American Family*, 165.

387 "It was an all-encompassing": Horne and Schickel, *Lena*, 154.

388 "You could hear a": Buckley, *The Hornes: An American Family*, 165.

388 "We had to shut": Horne and Schickel, *Lena*, 154.

388 "Ethel Waters is being": Harry Levette, "Through Hollywood," *Chicago Defender*, October 10, 1942, 20.

388 "Just a line from": Waters, Letter, James Weldon Johnson Collection, Yale University.

389 "there was so much": Waters with Charles Samuels, *His Eye Is on the Sparrow*, 258.

389 "She had a very hard time": Horne, PBS series *Brown Sugar.*

389 "I won all my": Waters with Samuels, *His Eye Is on the Sparrow*, 258.

## Chapter 19 • Aftermath

391 "Dear Carlo": Waters, Letter, James Weldon Johnson Collection, Yale University.

392 "I personally think that": Waters, Letter, James Weldon Johnson Collection, Yale University.

394  "The finest testimonial to": Philip Carter, "Accent on Youth Is Not Part of Ethel Waters' Vocabulary," *Chicago Defender*, January 23, 1943, 18.

395  "latest heart-beat": Al Monroe, "Swinging the News," *Chicago Defender*, July 3, 1943, 18.

396  "A musical honey!": Wanda Hale, *New York Mirror*, May 28, 1943, CF.

396  "A bountiful entertainment!": "The Screen," *New York Times*, May 28, 1943, CF.

396  "The Negroes are apparently": *Time*, April 12, 1943, CF.

396  "A slap in the": Jack Saunders, "I Love a Parade," *Philadelphia Tribune*, May 22, 1943, 11.

396  "Another Propaganda Rap Against": "'Cabin' Film Seen as Another Propaganda Rap Against Negro," *Amsterdam News*, May 17, 1943, CF.

## Chapter 20 • Scandal

399  "I love you, California": Herman Hill, "Ethel Waters Returns from Eastern Tour," *Pittsburgh Courier*, July 3, 1943, 20.

399  "Everybody thought because he": Author interview with Lennie Bluett. Other comments by Bluett in this chapter are from the same interview.

403  "I called up over": "Actress' Quaintness Convulses Court," CF. Unless otherwise indicated, other quotes are from this same article.

404  "God will take care": Harry Levette, "Ethel Can Recoup Loss by Giving Up Car and Home to Secretary," *Baltimore Afro-American*, September 4, 1943, CF.

404  "Well, I wouldn't enter": Helen Ormsbee, "Ethel Waters Tries to Make Song Feel 'Like I Felt It in My Heart,'" September 19, 1943, CF.

405  "a bizarre relationship": "Ethel Waters Story of 'Missing $23,400 to Be Aired on Sept. 13," *Baltimore Afro-American*, September 11, 1943, CF.

405  "Ethel Waters sang a": Florabel Muir, "Ethel Waters Loses $23,000 out of Old Trunk in the Attic," New York *Daily News*, August 24, 1943, CF.

405  "Perhaps a bit heavier": "Actress' Quaintness Convulses Court," CF.

406  "Any theatrical season that": Lewis Nichols, "The Play," *New York Times*, September 9, 1943, 35.

406  "Audiences can't seem to": Virginia Wright, "Stage Review," September 9, 1943, CF.

406  "Somebody that I trusted": Ormsbee, "Ethel Waters Tries to Make Song Feel 'Like I Felt It in My Heart,'" September 19, 1943, CF.

408  "popularity of a certain": "New York's Album by Constance Curtis," *Amsterdam News*, January 1, 1944, 9.

409 "I'm $5000 in debt": Waters, Letter, James Weldon Johnson Collection, Yale University.

410 "You should answer that": "Jury Gets Waters Jewel Case Today," *Los Angeles Tribune*, February 14, 1944, CF.

414 "About Gene Buffalo": Waters, Letter, James Weldon Johnson Collection, Yale University.

## Chapter 21 • An Ill Wind

415 "Her climaxing numbers received": Edwin Schallert, "Sepia Star Welcomed at Mayan," *Los Angeles Times*, April 7, 1945, 15.

415 "There will be no": Sheila Guys, "'The Wishing Tree' Takes Shape; Notes on 'Carmen,'" *Amsterdam News*, April 7, 1945, 7B.

416 "We girls were supposed": Eartha Kitt, *Confessions of a Sex Kitten* (New York: Barricade Books, 1959), 44.

417 "Vaudeville should have pace": Lewis Nichols, "The Play," *New York Times*, May 22, 1945, 13.

417 "repetitive and rather dull": Howard Barnes, "The Theater: Ethel Waters, Bill Robinson, Come to Town," *New York Herald Tribune*, May 27, 1945, CF.

417 "Needless to say, the": Kitt, *Confessions of a Sex Kitten*, 44.

418 "The interesting thing about": "Billy Rowe's Note Book," *Amsterdam News*, June 9, 1945, 21.

418 "A rash of Negro": Arthur Bronson, "Harlem's Prospects for Broadway Set with Question Mark," *Variety*, Reprinted in *Chicago Defender*, July 14, 1945, 14.

419 "I thought I was": Earl Wilson, "It Happened Last Night," *New York Post*, December 28, 1945, 16.

419 "175 pounds of her": Billy Rowe, "Ethel Waters Wins Acclaim in Chicago," *Pittsburgh Courier*, February 9, 1946, 18.

420 "The court is of": "Negro Owners Win Contest on Occupancy," *Los Angeles Times*, December 7, 1945, A1.

422 "I had heard many": Leonard Feather, "More Than Blues: Remembering Ethel Waters," *Los Angeles Times*, September 3, 1977, B9.

423 "It's like this, Pal": Taylor with Cook, *Alberta Hunter: A Celebration in Blues*, 177.

424 "Many nights I'd eat": Waters with Samuels, *His Eye Is on the Sparrow*, 263.

424 "I was raised on": Hank O'Neal, *Ghosts of Harlem: Sessions with Jazz Legends* (Nashville, TN: Vanderbilt Press, 2009).

425 "Mom has often checked": Hilda See, "Critic Finds Ethel Waters' Style a 'Natural' Employed by Many Stars," *Chicago Defender*, June 14, 1947, 18.

426 "Ethel Waters, who is": "Billy Rowe's Note Book," *Pittsburgh Courier*, January 4, 1947, 16.

426 "Ethel Waters sitting quietly": Bill Chase, "All Ears," *Amsterdam News*, September 27, 1947, 8.

426 "I condemn and decry": Venice T. Spraggs, "Theatres May Shut as Actors Join Boycott," *Chicago Defender*, February 1, 1947, 1.

427 "Owen turned away hundreds": Evan Rodgers, "Ethel Waters at Brennan's," *New Orleans Item*, November 4, 1947, CF.

429 "Popular music was raised": "Ethel Waters' Song Program Delights," *Los Angeles Times*, September 30, 1948, p 21.

## Chapter 22 • Coming Back

432 "Everybody got screened before": McCrary and Falkenburg, "New York Close-up," *New York Herald Tribune*, November 16, 1949, CF.

433 "I didn't have the": *Boston Globe*, April 1, 1951, CF.

434 "When he indicated the": Kazan, *A Life*, 374.

435 "Ford's Negroes were like": Mel Gussow, *Don't Say Yes Until I Finish Talking: A Biography of Darryl F. Zanuck* (Garden City, NY: Doubleday, 1971), 151.

435 "I've never been higher": Kazan, *A Life*, 373.

436 "It was a professional": Gussow, *Don't Say Yes Until I Finish Talking*, 374.

436 "He hated that old": Kazan, *A Life*, 374.

437 "living this part": Harry Levette, "Gossip of Movie Lots," *Pittsburgh Courier*, May 24, 1949, 12.

439 "My most vivid memory": Kazan, *A Life*, 376.

441 "dirty play": Virginia Spencer Carr, *The Lonely Hunter: A Biography of Carson McCullers* (Garden City, NY: Doubleday, 1975), 330.

441 "I don't drink": Vernon Rice, "Curtain Cues," *New York Post*, January 4, 1950, CF.

441 "What's your play all": Carr, *The Lonely Hunter*, 332.

441 "There seems to be": Ibid., 331.

442 "Every night I get": Mel Gussow, "Robert Whitehead, Who Brought Top Playwrights to Broadway, Dies at 86," *New York Times*, June 17, 2002, B6.

442 "I was lookin' for": Rice, "Curtain Cues," *New York Post*, January 4, 1950, np.

443 "Our first meeting": Twila Knaack, *I Touched a Sparrow* (Minneapolis, MN: World Wide Publications, 1978), 133.

443 "I have never in": Walter White, "Regrets He Has No Words of Praise For Pinky," *Chicago Defender*, October 29, 1949, 7.

444 "the film proffers": Edwin Schallert, " 'Pinky Fascinates as Race-Issue Film," *Los Angeles Times*, October 22, 1949, 13.

444 "Darryl Zanuck hit the": "Hedda Hopper's Hollywood," *Los Angeles Times*, October 6, 1949, A6.

444 "An Approach to Racism": Philip Dunne, *New York Times*, May 1, 1949.

445 "And yet, despite the": Ralph Ellison, *Shadow and Act* (New York: Signet, 1966), 270.

445 "You never know what": " 'Ma' Waters in Good Mood as She Arrives in N.Y.," *Philadelphia Tribune*, October 8, 1949, 9.

446 "People don't seem to": McCrary and Falkenburg, "New York Close-up," *New York Herald Tribune*, November 16, 1949, CL.

447 "Attendance records for a": " 'Pinky' Hit in New York," *Los Angeles Times*, October 19, 1949, B8.

447 "depicted a white man": "High Court Ends Another Film Ban; Cites 'Miracle' View in 'Pinky' Case," *Chicago Defender*, February 16, 1952, 34.

447 "His way of telling": Waters and Samuels, *His Eye Is on the Sparrow*, 274.

447 "strange person": Edited by Marjorie Loggia and Glenn Young, *The Collected Works of Harold Clurman: Six Decades of Commentary on Theatre, Dance, Music, Film Arts, Letters, and Politics* (New York: Applause Books, 1994), 979.

447 "training a bear": Carr, *The Lonely Hunter*, 334.

448 "Now, honey, I don't": Ibid.

449 "I sang it for": Henry Hewes, "Ethel Waters and a Hymn," *New York Times*, CF.

449 "The hymn brought more": Susan Buckingham, "Ethel Waters Gives Credit for Success to Granny's Hymn," *Philadelphia Tribune*, July 25, 1950, 12.

449 "put a package of": Author interview with James Sheldon.

450 "All the play is": David Bongard, "Miss Waters Says She's Through," Los Angeles *Daily News*, December 20, 1951, CF.

450 "I got on my": Vernon Rice, "Curtain Cues," *New York Post*, January 4, 1950, CF.

450 "In Philadelphia, where we": Julie Harris, "He Was a Golden, Loving Child," *New York Times*, August 6, 1972, D1.

450 "She had a great": Loggia and Young, *The Collected Works of Harold Clurman*, 979.

450 "Miss Waters, Brandon, and": Harris, "He Was a Golden, Loving Child," *New York Times*, August 6, 1972, D1.

450 "Honey, I'm not from": Carr, *The Lonely Hunter*, 335.

451 "Ethel Waters is a": Henry T. Murdock, "McCullers' 'Member of Wedding' Bows at Walnut," *Philadelphia Inquirer*, December 23, 1949, CF.

452 "I was just saturating": Author interview with Martha Orrick.

452 "I remember how she": Author interview with Emery Wimbish. All comments by Wimbish in this chapter are from this interview.

453 "Miss Waters gives one": Brooks Atkinson, "At the Theatre," *New York Times*, January 6, 1950, 26.

453 "Ethel Waters, a distinguished": Richard Watts, *New York Post*, CF.

453 "Miss Waters is giving": John Chapman, " 'Member of the Wedding' and Its Cast Earn Cheers at the Empire," *New York Daily News*, January 6, 1950, CF.

456 "their regular dinner spot": Allan McMillan, "Allan's Alley," *Amsterdam News*, January 28, 1950, 14.

458 "Every day but matinee": Cyrus Durgin, "His Eye Has Been upon Ethel Waters, Who Lives by Faith," *Boston Globe*, April 1, 1951, CF.

459 "All day long I'm": " 'Keep Gong Forward'—Ethel's Key to Fame," *Chicago Defender*, October 21, 1950, 20.

459 "When I worked with": Author interview with Leslie Uggams. Other comments by Uggams in this chapter are from this interview.

459 "the candy-coated stereotype": John Crosby, "Radio and Television," *New York Herald Tribune*, April 29, 1951, CF.

460 "defiles and desecrates colored": Joseph Bibb, "'Beulah' Flayed," *Pittsburgh Courier*, May 19, 1951, 21.

460 "What's uplifting or educational": S. W. Garlington, "Amusement Row," *Amsterdam News*, March 3, 1951, 23.

460 "The writers": "Bud Harris Tells Chicago Defender Why He Quit 'Beulah,' " *Chicago Defender*, November 25, 1950, 21.

460 "I like being Beulah": " 'Keep Going Forward'—Ethel's Key to Fame," *Chicago Defender*, October 21, 1950, 20.

461 "The day the book": Marie Torre, "It's Nice to Be Myself Again," *New World Telegram*, June 23, 1951, np.

461 "It is no book": Harvey Breit, "Talk with Ethel Waters," *New York Times*, March 18, 1951, CF.

464 "The SIGNATURES OF ETHEL WATERS": Floretta Howard, Introduction to Unpublished Letters of Ethel Waters.

465 "tending to overplay her": Carr, *The Lonely Hunter*, 367.

465 "remarkable, of course, in": Ibid., 348.

465 "began to 'improve' it": Ibid., 368.

465 "This is a great": Loggia and Young, *The Collected Works of Harold Clurman*, 979.

466 "Miss Waters became angry": Carr, *The Lonely Hunter*, 369.

467 "the colored people turned": Philip K. Scheuer, "Ethel Waters Weary, but Goes On and On," *Los Angeles Times*, December 9, 1951, E3.

468 "No, I don't want": Bongard, "Miss Waters Says She's Through," *Los Angeles Daily News*, December 20, 1951, np.

468 "Yes, I'll retire. . . . for": Hazel Garland, "Ethel Waters to Retire for a

While; Here for 'Member of the Wedding,' " *Pittsburgh Courier*, March 22, 1952, 24.

468 "Right now": "Ethel Waters May Leave Theatre," *Philadelphia Tribune*, April 8, 1952, 12.

## Chapter 23 • The Long Winter of Her Discontent

470 "were film stars, their": Stanley Kramer with Thomas M. Coffrey, *A Mad, Mad, Mad, Mad World* (New York: Harcourt Brace, 1997), 100.

470 "difficulties of directing": Ibid., 101.

470 "Ethel was a wonderful": Guy Flatley, "At the Movies," *New York Times*, September 30, 1977, CF.

470 "clung to the play": Carr, *The Lonely Hunter*, 333.

471 "Zinnemann was praised for": Kramer with Coffrey, *A Mad, Mad, Mad, Mad World*, 101.

471 "There are two glorious": "Hedda Hopper's Hollywood," *Los Angeles Times*, January 1, 1953, 20.

471 "Miss Waters, that dramatic": Harry Levett, "This Is Hollywood," *Chicago Defender*, January 3, 1953, 22.

471 "Miss Waters is one": Philip K. Scheuer, "Gifted Three Re-enact 'Member of Wedding,' " *Los Angeles Times*, December 12, 1952, A12.

472 "Ethel Waters' performance of": Bosley Crowther, "The Screen in Review," *New York Times*, December 31, 1952, 10.

472 "a remarkable film": Pauline Kael, "The Member of the Wedding," *5001 Nights at the Movies* (New York: Henry Holt, 1991), 474.

472 "never recovered from the": Rex Reed, "'Frankie Addams' at 50," *New York Times*, April 16, 1967, CF.

472 "The studio": Author interview with Orin Borsten.

473 "Do you know why": "Ethel Reminds Kids: 'I'm Hip,' " *Down Beat*, March 25, 1953, CF.

474 "the majestic": Wein and Chinen, *Myself Among Others*, 95.

475 "Ethel Waters, who through": Henry Hewes, "The Empire—From 'Strawberries' to 'Ravioli,' " *Saturday Review*, June 13, 1953, 28.

475 "Whenever she would perform": Author interview with Leslie Uggams.

476 "[nothing this season] ever": Whitney Bolton, "Ethel Waters Is Magnificent in Two-Hour Festival of Song," *Morning Telegraph*, July 1, 1953, CF.

476 "No matter that the": Walter Kerr, "Broadway in Review," *Los Angeles Times*, September 27, 1953, D2.

481 "We kept doing the": Author interview with Ruby Dee. Other comments by Ruby Dee in this chapter are from the same interview.

482  "at a slow, easy": "Manhattan Scene," *Chicago Defender*, November 12, 1955, 2.

483  "I've got to get": Cicely Tyson in conversation with the author.

483  "used all kinds of": Anonymous interview with the author.

483  "The plot is nothing": Clyde Reid, " 'Carib Gold' Has Beautiful Photography, Nothing More," *Amsterdam News*, April 21, 1956, 15.

485  "They're trying to desecrate": 'Ethel Waters Blasts Rock 'n' Roll Singing of Religious Songs," *Philadelphia Tribune*, November 29, 1956.

485  "Are you a member": Delores Calvin, "Ethel Waters Finds NAACP Bias Problem Is Not Hers," *Chicago Defender*, January 5, 1957, 15.

486  "Although she's in a": "Pulse of the Public," *Amsterdam News*, January 12, 1957, 14.

486  "Things must be getting": "The People Speak," *Chicago Defender*, September 23, 1957, 11.

486  "Ethel Waters—still great": *Chicago Defender*, November 1, 1958, 19.

487  Mrs. Uncle Tom: Al Monroe, "So They Say," *Chicago Defender*, October 22, 1958, A18.

487  "One of the greatest": "Eye to Eye," *Amsterdam News*, January 25, 1958, 9.

488  "I am unemployed": "'Stormy Weather' Has Waters Singing 'Blues,'" *Journal* [*American*], January 3, 1957, CF. Unless otherwise indicated, the comments that follow are also from this interview.

488  "It's true. I'm completely": Joseph Kahn, "Broke—But All Ethel Waters Wants Is a Job," *New York Post*, January 2, 1957, 4.

488  "People called me up": Helen Dudar, "Ethel Waters ISN'T Broke—for Friends," *New York Post*, January 4, 1957, CF.

489  "I have to earn": James L. Kilgallen, "Ethel Waters Plagued by Tax Troubles, Too," *Chicago Defender*, January 12, 1957, 9.

490  "lies and liars": Evelyn Cunningham, "'All Lies . . . I'm Not Broke'—Ethel Waters," *Pittsburgh Courier*, January 19, 1957, 9. Unless otherwise indicated, the comments that follow are from this article.

490  "Why has Ethel Waters": Hazel A. Washington, "This Is HOLLYWOOD," *Chicago Defender*, February 5, 1957, 7.

491  "blackballed her due to": Masco Young, "The Grapevine," *Pittsburgh Courier*, April 10, 1957, A7.

491  "I wish some of": Langston Hughes, "Week by Week," *Chicago Defender*, May 25, 1957, 10.

## Chapter 24 • A New Day

496  "The Garden's not only": Ethel Waters, *To Me It's Wonderful* (New York: Harper and Row. 1972), 21.

496   "We were shown the": Ibid., 22.

497   "I couldn't tell you": Ibid., 25.

497   "The last thing I": Ibid., 30.

497   "This is the most": Evelyn Cunningham, "Says Ethel Waters: I'm Loaded with Faith!" *Pittsburgh Courier*, July 5, 1957, CF.

498   "knew something deeper was": Waters, *To Me It's Wonderful*, 33.

498   "who was still pretty": Ibid., 35.

498   "Three times I made": Ibid., 29.

499   "I was getting a": Ibid., 37.

499   "had to call Billy": Ibid., 38.

499   "I hadn't met either": Ibid., 31.

500   "because my child needs": "Billy Lists Race as Top Problem," *Chicago Defender*, June 12, 1958, A2.

500   "appearance in the huge": Hazel Washington, "This Is HOLLYWOOD," *Chicago Defender*, June 30, 1958, 17.

501   "When I got there": Author interview with Clisson Woods.

502   "It was a church-related": Author interview with Jim Malcolm.

504   "You know what?": Hazel A. Washington, "This Is HOLLYWOOD," *Chicago Defender*, March 24, 1959, 18.

504   "While Miss Waters packs": Arthur Gelb, "Theatre: Ethel Waters," *New York Times*, April 9, 1959, 36.

505   "I weighed 340 pounds": Doug Mauldin, "Motherwise She's Getting Along: Ethel Waters Is Rich Spiritually," *Los Angeles Times*, July 6, 1961, F1.

506   "They don't like it": "'Sitting on the Edge of Heaven,' Says Ethel Waters, Ailing at 61," July 10, 1961, 20, CF.

507   "My agent called one": Aleene B. MacMinn, "Ethel Waters to Bow as Guest in TV Series," *Los Angeles Times*, October 6, 1961, A11.

509   "I didn't know a": Author interview with George Maharis. Other comments by Maharis in this chapter are from this interview.

510   "She was supposed to be": Author interview with Marni Nixon. Other comments by Nixon in this chapter are from this interview.

511   "It was a heartbreaker": Hedda Hopper, "Veteran Actress Honored at Party," *Los Angeles Times*, July 31, 1963, E7.

## Chapter 25 • Life Away from the Team

513   "slim trim": Author interview with Joan Croomes. Other comments by Croomes in this chapter are from this interview.

518   "a small fee": Waters, Letter, James Weldon Johnson Collection, Yale University.

519 "Well, she's gone": Waters to Van Vechten, Letter, James Weldon Johnson Collection, Yale University.

521 "You know I've had": "Ethel Waters Goes on Despite Heart Attack," *Chicago Defender*, March 10, 1964, A3.

521 "I don't believe I'll": Murray Schumach, "Career Discussed by Ethel Waters," *New York Times*, February 22, 1964, np.

522 "In your long career": Jere Witter, "Great Television Interviews—Held on, off the Screen," *Los Angeles Times*, July 19, 1965, C23.

522 "The improvement in the": J. Brantley Wilder and Jacob Sherman, "Singer Now 69, Has Been Away Since Teenager," *Philadelphia Tribune*, November 20, 1965, 13.

## Chapter 26 • On Her Own Again

530 "Mrs. Ethel Waters": New York *Daily News*, November 12, 1970, CF.

531 "Dickie Boy": Ethel Waters, *To Me It's Wonderful* (New York: Harper & Row, 1972), 110.

531 "they had tears in": "Quaker Gives Sermon: Ethel Waters Sings at White House Rites," *Los Angeles Times*, January 25, 1971, A4.

532 "I hope I didn't": Waters, *To Me It's Wonderful*, 122.

532 "That was the closest": Ibid., 123.

533 "Amidst the recent flurry": John Wilson, "Records: Ethel Waters," *New York Times*, March 2, 1973, CF.

533 "Perhaps this was the": Wein and Chinen, *Myself Among Others*, 96.

534 "Ethel, we love you!": Theodore W. Graham, "40,000 Blacks, Whites in Chester Salute 'Ethel Waters, Christian,'" *Philadelphia Tribune*, May 2, 1972, CF.

535 "It's hard to say": Sandy Pearse, "Ethel Waters Honored," *Philadelphia Bulletin*, May 1, 1972, CF.

535 "She was very happy": Mary T. Henderson, "Ethel Waters . . . 'Wonderful Person,'" *Philadelphia Bulletin*, CF.

536 "Pink is *not* my": Twila Knaack, *I Touched a Sparrow* (Minneapolis, MN: World Wide Publications, 1978), 82.

536 "She made it in": Jody Jacobs, "A Loving Tribute to Ethel Waters," *Los Angeles Times*, October 9, 1971, D1.

536 "She stopped him short": Knaack, *I Touched a Sparrow*, 83.

536 "It was hard for": Jacobs, "A Loving Tribute to Ethel Waters," *Los Angeles Times*, October 9, 1971, D1.

537 "You'll get more use": Knaack, *I Touched a Sparrow*, 83.

537 "Well, this is probably": Ibid., 109.

538  "I'm not about to": Ibid., 139.

538  "Might I say, while": Juliann DeKorte, *Finally Home* (Old Tappan, NJ: Fleming H. Revell, 1978), 40.

538  "No!": Ibid., 57.

539  "One thing I found": Ibid., 35.

539  "She could be stern": Ibid., 59.

# Selected Bibliography

Allen, Walter C. *Hendersonia: The Music of Fletcher Henderson and His Musicians: A Bio-Discography.* Highland Park, N.J.: Jazz Monographs, 1973.

Alpert, Hollis. *The Life and Times of Porgy and Bess: The Story of an American Classic.* New York: Alfred A. Knopf, 1990.

Anderson, Jervis. *This Was Harlem.* New York: Farrar, Straus and Giroux, 1982.

Bach, Steven. *Dazzler: The Life and Times of Moss Hart.* New York: Alfred A. Knopf, 2001.

Baker, Jean-Claude, and Chris Chase. *Josephine Baker: The Hungry Heart.* New York: Random House, 1993.

Baker, Josephine, and Jo Bouillon. *Josephine.* New York: Harper and Row, 1976.

Basie, Count, as told to Albert Murray. *Good Morning Blues: The Autobiography of Count Basie.* New York: Random House, 1985.

Bennett, Lerone, Jr. *Before the Mayflower: A History of Black America.* New York: Penguin Books, 1993.

Bergreen, Laurence. *As Thousands Cheer: The Life of Irving Berlin.* New York: Viking Press, 1990.

Bernard, Emily, ed. *Remember Me to Harlem: The Letters of Langston Hughes and Carl Van Vechten.* New York: Alfred A. Knopf, 2001.

Berry, Faith. *Langston Hughes: Before and Beyond Harlem.* Westport, Conn.: Lawrence Hill, 1983.

Blockson, Charles L. *African Americans in Pennsylvania: A History and Guide.* Baltimore: Black Classic Press, 1994.

Bogle, Donald. *Bright Boulevards, Bold Dreams: The Story of Black Hollywood.* New York: Ballantine Books, 2005.

———. *Brown Sugar: Over 100 Years of America's Black Female Superstars.* New York: Continuum, 2008.

———. *Dorothy Dandridge: A Biography.* New York: Amistad, 1997.

————. *Primetime Blues: African Americans on Network Television*. New York: Farrar, Straus and Giroux, 2001.

————. *Toms, Coons, Mulattoes, Mammies, and Bucks: An Interpretive History of Blacks in American Films*. 4th ed. New York: Continuum, 2001.

Bricktop, with James Haskins. *Bricktop*. New York: Atheneum, 1983.

Bryant, Clora, Buddy Collette, William Green, Steven Isoardi, Jack Kelson, Horace Tapscott, Gerald Wilson, and Marl Young, eds. *Central Avenue Sounds: Jazz in Los Angeles*. Berkeley and Los Angeles: University of California Press, 1999.

Buckley, Gail Lumet. *The Hornes: An American Family*. New York: Alfred A. Knopf, 1986.

Carr, Virginia Spencer. *The Lonely Hunter: A Biography of Carson McCullers*. Garden City, N.Y.: Doubleday, 1975.

Charters, Ann. *Nobody: The Story of Bert Williams*. New York: Macmillan, 1970.

Cook, Blanche Wiesen. *Eleanor Roosevelt: Volume One, 1884–1933*. New York: Viking, 1992.

————. *Eleanor Roosevelt: Volume 2, 1933–1938*. New York: Viking, 1999.

Cooper, Ralph, and Steve Dougherty. *Amateur Night at the Apollo: Ralph Cooper Presents Five Decades of Great Entertainment*. New York: HarperCollins, 1990.

Davis, Mike. *City of Quartz: Excavating the Future in Los Angeles*. New York: Vintage Books, 1992.

DeGraaf, Lawrence B., Kevin Mulroy, and Quintard Taylor, eds. *Seeking El Dorado: African Americans in California*. Los Angeles: Autry Museum of Western Heritage in association with University of Washington Press, 2001.

DeKorte, Juliann. *Finally Home*. Old Tappan, N.J.: Fleming H. Revell, 1978.

Douglas, Ann. *Terrible Honesty: Mongrel Manhattan in the 1920s*. New York: Farrar, Straus and Giroux, 1995.

Driggs, Frank, and Harris Lewine. *Black Beauty, White Heat: A Pictorial History of Classic Jazz, 1920–1950*. New York: Morrow, 1982.

Duberman, Martin Bauml. *Paul Robeson*. New York: Alfred A. Knopf, 1988.

Dunning, John. *On the Air: The Encyclopedia of Old-Time Radio*. New York: Oxford University Press, 1998.

Ellington, Duke. *Music Is My Mistress*. Garden City, N.Y.: Doubleday, 1973.

Eyman, Scott. *The Lion of Hollywood: The Life and Legend of Louis B. Mayer*. New York: Simon and Schuster, 2005.

Feather, Leonard. *The Encyclopedia of Jazz*. New York: Bonanza Books, 1960.

Finch, Christopher, and Linda Rosenkrantz. *Gone Hollywood: The Movie Colony in the Golden Age*. Garden City, N.Y.: Doubleday, 1979.

Fordin, Hugh. *The World of Entertainment: Hollywood's Greatest Musicals*. Garden City, N.Y.: Doubleday, 1975.

Fraser-Cavassoni, Natasha. *Sam Spiegel: The Incredible Life and Times of Hollywood's Most Iconoclastic Producer, the Miracle Worker Who Went from Penniless Refugee to Show Biz Legend, and Made Possible "The African Queen," "On the Waterfront," "The Bridge on the River Kwai," and "Lawrence of Arabia."* New York: Simon and Schuster, 2003.

Giddins, Gary. *Bing Crosby: A Pocketful of Dreams: The Early Years 1903–1940.* Boston: Little, Brown, 2001.

———. *Satchmo.* New York: Dolphin Books, 1988.

Glazer, Irvin R. *Philadelphia Theatres, A-Z: A Comprehensive, Descriptive Record of 813 Theatres Constructed Since 1724.* Westport, Conn.: Greenwood Press, 1986.

———. *Philadelphia Theaters: A Pictorial Architectural History.* Philadelphia: The Athenaeum of Philadelphia in association with Dover Publications, 1984.

Goodwin, Doris Kearns. *No Ordinary Time: Franklin and Eleanor Roosevelt: The Home Front in World War II.* New York: Simon and Schuster, 1994.

Graham, Billy. *Just as I Am: The Autobiography of Billy Graham.* New York: HarperCollins, 1997.

Gussow, Mel. *Don't Say Yes Until I Finish Talking: A Biography of Darryl F. Zanuck.* Garden City, N.Y.: Doubleday, 1971.

Hammond, John, with Irving Townsend. *John Hammond on Record.* New York: Summit Books, 1977.

Handy, W. C. *Father of the Blues: An Autobiography.* New York: Macmillan, 1941.

Haney, Lynn. *Naked at the Feast: A Biography of Josephine Baker.* New York: Dodd, Mead, 1981.

Harris, Sheldon. *Blues Who's Who: A Biographical Dictionary of Blues Singers.* New Rochelle: Arlington House, 1979.

Harvey, Stephen. *Directed by Vincente Minnelli.* New York: The Museum of Modern Art/Harper and Row, 1989.

Holiday, Billie, with William Dufty. *Lady Sings the Blues.* Garden City, N.Y.: Doubleday, 1957.

Horne, Lena, and Richard Schickel. *Lena.* Garden City, N.Y.: Doubleday, 1965.

Hughes, Langston. *The Big Sea: An Autobiography.* New York: Thunder's Mouth Press, 1990.

Hurston, Zora Neale. *Dust Tracks on a Road.* Philadelphia: J. Lippincott, 1942.

Jablonski, Edward. *Harold Arlen: Happy with the Blues.* New York: Da Capo Press, 1986.

Johnson, James Weldon. *Along This Way: The Autobiography of James Weldon Johnson.* New York: Penguin Books, 1990.

———. *Black Manhattan.* New York: Da Capo Press, 1991.

Jones, LeRoi. *Blues People.* New York: William Morrow, 1963.

Kael, Pauline. *5001 Nights at the Movies.* New York: Henry Holt, 1991.

Kantor, Michael, and Laurence Maslon. *Broadway: The American Musical.* New York: Bulfinch Press, 2004.

Katz, Ephraim. *The Film Encyclopedia.* New York: HarperPerennial, 1994.

Kazan, Elia. *A Life.* New York: Alfred A. Knopf, 1988.

Kellner, Bruce. *Carl Van Vechten and the Irreverent Decades.* Norman: University of Oklahoma Press, 1968.

———. *Keep A Inchin' Along.* Westport, Conn.: Greenwood Press, 1979.

Kimball, Robert, and William Bolcom. *Reminiscing with Sissle and Blake.* New York: Viking Press, 1973.

Kitt, Eartha. *Confessions of a Sex Kitten.* Fort Lee, N.J.: Barricade Books, 1989.

Knaack, Twila. *Ethel Waters: I Touched a Sparrow.* Minneapolis: World Wide Publications, 1978.

Kramer, Stanley, with Thomas M. Coffey. *A Mad Mad Mad Mad World: A Life in Hollywood.* New York: Harcourt, Brace, 1997.

Lawrence, A. H. *Duke Ellington and His World.* New York: Routledge, 2001.

Loggia, Marjorie, and Glenn Young, eds. *The Collected Works of Harold Clurman: Six Decades of Commentary on Theatre, Dance, Music, Film Arts, Letters, and Politics.* New York: Applause Books, 1994.

Louis, Joe, with Edna Rust and Art Rust Jr. *Joe Louis: My Life.* New York: Harcourt Brace Jovanovich, 1978.

McBride, Joseph. *John Ford: A Life.* New York: St. Martin's Press, 2003.

Manchester, William. *The Glory and the Dream: A Narrative History of America, 1932–1972.* Boston: Little, Brown, 1973.

Mapp, Edward. *Directory of Blacks in the Performing Arts.* Metuchen, N.J.: Scarecrow Press, 1978.

Marks, Carole, and Diana Edkins. *The Power of Pride: Stylemakers and Rulebreakers of the Harlem Renaissance.* New York: Crown Publishers, 1999.

Minnelli, Vincente, with Hector Arce. *I Remember It Well.* Garden City, N.Y.: Doubleday, 1974.

Murray, Albert. *Stomping the Blues.* New York: McGraw Hill, 1976.

Nichols, Charles H. *Arna Bontemps: Langston Hughes Letters, 1925–1967.* New York: Dodd, Mead, 1980.

O'Neal, Hank. *The Ghosts of Harlem: Sessions with Jazz Legends: Photographs and Interviews by Hank O'Neal.* Nashville: Vanderbilt University Press, 2009.

Osborne, Robert. *75 Years of the Oscar: The Official History of the Academy Awards.* New York: Abbeville Press, 2003.

Ottley, Roi, and William J. Weatherby. *The Negro in New York: An Informal Social History, 1626–1940.* New York: Praeger, 1969.

Pitt, Leonard, and Dale Pitt. *Los Angeles: A to Z: An Encyclopedia of the City and County.* Berkeley and Los Angeles: University of California Press, 1997.

Placksin, Sally. *American Women in Jazz: 1900 to the Present: Their Words, Lives, and Music.* New York: Wideview Books, 1982.

Rampersad, Arnold. *The Life of Langston Hughes: Volume I: 1902–1941: I, Too, Sing America.* New York: Oxford University Press, 1986.

———. *The Life of Langston Hughes: Volume II: 1941–1967: I Dream a World.* New York: Oxford University Press, 1988.

Reed, Tom. *The Black Music History of Los Angeles: Its Roots.* 4th ed. Los Angeles: Black Accent on LA Press, 1992.

Richards, Larry. *African American Films Through 1959: A Comprehensive Illustrated Filmography.* Jefferson, N.C.: McFarland, 1998.

Rose, Al. *Eubie.* New York: Schirmer Books, 1979.

Shipton, Alyn. *A New History of Jazz.* New York: Continuum, 2001.

Short, Bobby. *Black and White Baby.* New York: Dodd, Mead, 1971.

Singer, Barry. *Black and Blue: The Life and Lyrics of Andy Razaf.* New York: Schirmer Books, 1992.

Southern, Eileen. *The Music of Black Americans: A History.* New York: W. W. Norton, 1971.

Stearns, Marshall, and Jean Marshall. *Jazz Dance: The Stories of American Vernacular Dance.* New York: Schirmer Books, 1968.

Story, Rosalyn M. *And So I Sing: African American Divas of Opera and Concert.* New York: Amistad, 1990.

Summers, Barbara. *Skin Deep: Inside the World of Black Fashion Models.* New York: Amistad Press, 1998.

Taylor, Frank, with Gerald Cook. *Alberta Hunter: A Celebration in Blues.* New York: McGraw-Hill, 1988.

Toll, Robert. *Blacking Up: The Minstrel Show in Nineteenth-Century America.* New York: Oxford University Press, 1974.

Tucker, Mark, ed. *The Duke Ellington Reader.* New York: Oxford University Press, 1993.

Vidor, King. *A Tree Is a Tree.* New York: Harcourt, Brace, 1952.

Ward, Geoffrey C., and Ken Burns. *Jazz: A History of America's Music.* New York: Alfred A. Knopf, 2000.

Waters, Ethel. *To Me It's Wonderful.* New York: Harper and Row, 1972.

Waters, Ethel, and Charles Samuels. *His Eye Is on the Sparrow.* Garden City, N.Y.: Doubleday, 1951.

Watson, Steven. *The Harlem Renaissance: Hub of African-American Culture 1920–1930.* New York: Pantheon Books, 1995.

White, Walter. *How Far the Promised Land?* New York: Viking Press, 1955.

## Also

*Brown Sugar: Eighty Years of America's Black Female Superstars.* Episodes 1 and 2. PBS/German Educational Television Broadcast, 1989.

Oral History Archives. Institute of Jazz Studies. Rutgers University.

Waters, Ethel. *Just a Little Talk with Ethel Waters.* Word, 1977.

# Index